Tradiciones Nuevomexicanas

Tradiciones Nuevomexicanas

Hispano Arts and Culture of New Mexico

MARY MONTAÑO

The University of New Mexico Press

Albuquerque

Library of Congress Cataloging-in-Publication Data

Montaño, Mary Caroline.
 Tradiciones nuevomexicanas : Hispano arts and culture of New Mexico / Mary Montaño.—1st ed.
 p. cm.
Includes bibliographical references and index.
 ISBN 0-8263-2136-4 (cloth : alk. paper)—ISBN 0-8263-2137-2 (pbk. : alk. paper)
1. Arts, American—New Mexico. I. Title.
NX510.N43 M66 2001
700'.9789—dc21 00-011474

Printed in Hong Kong

Cover art: *Los Musicos #6*, by Bernadette Vigil, 1989. Permanent Collection, Millicent Rogers Museum. Used with permission of the artist.

Contents

Preface

THIS BOOK IS THE DIRECT RESULT of the Southwest Hispanic Arts Curriculum Symposium and the Hispanic Steering Committee, both initiated in 1994 by Dean Thomas A. Dodson of the University of New Mexico's College of Fine Arts in an effort to infuse local Hispano and Native American arts and culture into its curricula. Members of the Hispanic Steering Committee included Dr. Enrique Lamadrid (professor of Spanish at UNM and noted scholar of Nuevomexicano music, literature, and folkways), Dr. Helen R. Lucero (former curator at the Smithsonian Institution and currently Director of Visual Arts at the National Hispanic Cultural Center), Dr. Susan Patrick (professor of musicology and former associate dean of the College), Miguel Gandert (noted photographer and associate professor at the UNM Department of Communications and Journalism), and myself (writer, arts advocate, and graduate of the College of Fine Arts).

In the years following the symposium—and with the abiding support of the U.S. Department of Education's Fund for the Improvement of Post-Secondary Education (FIPSE)—Drs. Lucero and Patrick developed a 200-level course entitled "Survey of Hispanic Arts and Culture." Dr. Lucero proposed and designed the course because she saw a real need to integrate Hispanic materials into the predominantly Anglo-based arts curriculum at the University of New Mexico.

Drs. Lucero and Patrick team-taught the course for several semesters with the assistance of numerous guest speakers, including Father Tom Steele and Felipe Mirabal (Hispanic Catholicism in New Mexico), Robin Farwell Gavin and Dr. Ward Alan Minge (secular art), Dr. Enrique Lamadrid (Matachines and folk plays), Dr. Sylvia Rodríguez (Matachines), Dr. Charles Carrillo (*bultos* and *retablos*),

Dr. Cipriano Vigil (religious and secular music), Charles Aguilar (religious music), Roberto Martínez and Los Reyes de Alburquerque (secular music), Ramón Flores and M. Salomé Martínez (secular theater), Oma Sandoval (social dances), Jesus "Chuy" Martínez (*corridos*), Maclovia Zamora (healing arts), Dr. Donna Pierce (religious art and architecture), and myself (*zarzuelas*). Dr. Lucero was the lead presenter for sessions on weaving, *colcha* embroidery, marriage celebrations, and other traditions; Dr. Patrick taught the music sessions.

Realizing that there was no single publication that could serve as a text for this or other similar courses, Dr. Lucero suggested to the committee that a textbook would greatly increase the impact of the course. The committee commissioned the book to be written, again with funding from FIPSE and from the UNM College of Fine Arts.

Tradiciones Nuevomexicanas brings together, under one cover, information on traditional Nuevomexicano arts and culture from the earliest days to the present. In researching each subject, I came across many fascinating and revealing bits of knowledge that I suspected never got beyond the scholarly journals and papers to those who would most benefit from them—*la gente*, the people. I have attempted to distill these "new" treasures from their specialized and detailed studies into a narrative that is both accessible and enjoyable by readers of all backgrounds.

The term *Nuevomexicano* is used throughout the text to indicate the *Hispanos* of New Mexico. Most Nuevomexicanos know that "what to call ourselves" is a never-ending source of spirited debate, with the choices including "Latino," "Mexican-American," "Hispano," "Spanish-American," "Neomexicano," "Chicano," and the controversial "Hispanic." It is a tricky issue because each term implies many subtle

meanings, positive and negative, depending on one's own background. I have yet to hear of any consensus. Interestingly, in their documents, our forebears referred to themselves as *Españoles Mexicanos* (Spanish Mexicans), which resolves the very basic question of how Spanish or how Mexican we are. However, a contemporary term was needed for the purposes of this book. I first read the term *Nuevomexicano* in *Arellano,* a publication issued by the cultural activist Estevan Arellano of Embudo, New Mexico. I was struck by its cultural simplicity. It seems to work well in this book, with its suggestion of the uniqueness of New Mexico's Hispanos as a subculture.

I am a native of southern Colorado, born in the San Luis Valley and reared in Albuquerque from the age of six. It was to the San Luis Valley that my ancestors had traveled in the 1850s, armed with a land grant and the determination to settle the area around Conejos. There is a plaque there today, honoring a Montaño ancestor who built the first church in Colorado. Yet another ancestor was captured by Apaches or Utes while tending sheep. He returned to his family with increased awareness and understanding of another culture.

In Albuquerque, I earned two degrees in music at the University of New Mexico and began writing for newspapers and magazines. Not until I joined the staff of the Hispanic Culture Foundation did I begin focusing on my culture and familial past, first with the publication of *The New Mexico Directory of Hispanic Culture* (Hispanic Culture Foundation 1991; a joint effort with Juanita Wolff and Carol Guzmán) and then with increased participation in the Nuevomexicano arts community as a journalist, presenter, publicist, grant writer, and advocate.

The experience of researching and writing this book has brought me closer to the culture I left as a child—like my ancestor, I have returned with increased awareness and understanding. I hope that this book will have the same effect on all Nuevomexicanos while also nurturing cultural appreciation and understanding among non-Nuevomexicano readers.

MARY MONTAÑO

Acknowledgments

THE RESEARCH AND WRITING of this book was made possible by a grant from the Fund for the Improvement of Post-Secondary Education, a program of the U.S. Department of Education, and by the University of New Mexico College of Fine Arts. Its publication was funded in part by the McCune Charitable Foundation, the Center for Regional Studies, and Nancy Meem Wirth of Santa Fe.

This book would not be possible without the vision and leadership of Thomas A. Dodson, Dean of the College of Fine Arts. In addition to setting the stage for the production of this long overdue book, he has further arranged for royalties from its sale to go into a scholarship program to fund continued studies of the topics touched on here.

Dr. Lucero's pivotal contributions are described in the preface. She continues to work diligently on the development and dissemination of materials related to Hispanic arts and culture.

The contents of *Tradiciones Nuevomexicanas* were vastly enriched by the multifaceted knowledge and considerable insights of Dr. Enrique Lamadrid, whose poetic sensibilities are matched only by his deep understanding of the genesis and underlying influences of Nuevomexicano arts and culture.

The elegant and expressive photographs of Miguel Gandert have added much to this book. Mr. Gandert also served on the Hispanic Steering Committee.

Professionals and scholars who carefully reviewed each section and provided valuable expertise include: Dr. Adrian Bustamante (historical overview), Robin Farwell Gavin (religious art), Dr. Enrique Lamadrid (celebrations, music, language arts, secular arts, religious arts), Dr. Helen R. Lucero, Dr. Donna Pierce, Frank Turley, Maurice Dixon (secular arts), Ken Keppeler, Jeanie McLerie and Rudy Ulibarrí (social dance), Joseph Evans (foodways), Elena Avila and Maclovia Zamora (healing arts), and Irene-Oliver Lewis (language arts).

Additional input was provided by Dr. Reeve Love (technical assistance), Carlos Corral, Girard Martínez, Steve Ortiz and Ramón Flores (language arts), David Quintana, Anamaría Martínez and Frances Luján (social dance), Dr. Susan Patrick, Dr. Sylvia Rodríguez, Dr. Peter García and Jack Loeffler (music), Felipe Mirabal (religious arts), James Wright (historical overview), Arsenio Córdova, Mónica Mitchell and Emma Mitchell (celebrations), Julie Anna López and Celida Montaño (foodways), Orlando Romero and Bonifacio Sandoval (secular arts), and Eliseo Torres (healing arts). I was also able to incorporate the tinworking techniques of the late master tinsmith Robert Romero as I learned them from him firsthand during workshops he presented in 1995. Assisting with funding research were Concha Ortiz y Pino de Kleven and Clara Apodaca. I also extend my warmest thanks to Luther Wilson and his outstanding staff at the University of New Mexico Press.

This book owes much to the Nuevomexicano artisans and people, whose renaissance of interest and activity since the 1970s provided the momentum that led to this book, and many other fine publications, exhibits, recordings, and festivals. Thanks are also due to everyone who has ever preserved or appreciated Nuevomexicano art and culture, including numerous collectors, scholars, and respectful observers of all cultures.

To My Father
José Nestor Montaño
(1917–1979)

He was a teacher who was passionate about cultural education and

its influence on young people demoralized by racism and poverty.

One of my earliest memories is watching him direct

his high school students at Las Mesitas School

as they brought to life the dramas of Spain's Golden Age.

Then the people of Las Mesitas—

a farming village near Antonito, Colorado, in the 1950s—

gathered to enjoy the plays spoken in their ancestral language.

His ideals continue to inform my vision.

1

Conquistadores y Pobladores: Historical Overview

Exploration and Conquest, 1536–1598

In 1527, six hundred persons set off in five ships from Spain bound for settlement in Florida under the leadership of Pánfilo de Narváez. They found that the coast of Florida offered hostile natives, swarms of mosquitoes, swamps, storms, and no recognizable food. By 1528, the expedition had perished save for four men: Alvar Núñez Cabeza de Vaca, the expedition's treasurer, Capitán Alonso Castillo, Capitán Andrés Dorantes, and his Moroccan slave, Estebanico. For the next eight years, the four men lived with the native tribes either as prisoners or as visitors, and even gained fame as healers. They traversed the Gulf Coast, then progressed inland from present-day Galveston to the Río Grande. From there they headed south to Corazones (in present-day Sonora) where they were rescued in 1536. This was the first appearance of Spaniards in the Southwest.

During their meanderings, Cabeza de Vaca heard stories from the natives of wealthy northern cities inhabited by highly civilized tribes. A legend already existed that Christian bishops, fleeing the Moors, had arrived in the Americas and established the "Seven Cities of Gold." When the Viceroy of New Spain, Don Antonio de Mendoza, heard their tales, he determined to explore the North.

In 1539, he authorized a reconnaissance expedition led by Marcos de Niza, a Franciscan friar, to set out from Culiacán. The Spaniards of the Cabeza de Vaca party declined the invitation to accompany Niza; but Estebanico, who had been sold to Mendoza, was pressed into service as a guide. The expedition ended in disaster—Estebanico was killed at Hawikuh, a town near present-day Zuni—and Niza retreated immediately to Culiacán. Some historians believe that Niza continued to report fantastic stories of northern riches; others believe that Mendoza promoted the stories.

Mendoza then sent a second exploratory expedition in 1540 under the leadership of Vásquez de Coronado, governor of Nueva Galicia (Culiacán was its capital) and the younger son of a Spanish nobleman of Salamanca. With three hundred soldiers and eight hundred natives, Coronado defeated Hawikuh in battle and explored Arizona as far as the Grand Canyon and Colorado River, known to the explorers as the Río del Tizón, or Firebrand River. He then visited

The Origin of the Term "New Mexico"

Although a modern reader might surmise that "New Mexico" is derived directly from the place name of "Mexico," as we now identify that modern country, it has instead a somewhat more complicated history. Nueva México, as a place name, was first given to present-day Mexico City in the sixteenth century; and Mexico did not replace New Spain as a place name until after its independence in the nineteenth century. The term Nuevo México was used by Francisco de Ibarra, viceroy of Nueva Vizcaya, in 1563, to refer to those unknown lands to the north first reported in glowing terms by Cabeza de Vaca and Fray Marco de Niza. The term represented a hopeful association between the vast geographic area later known as the American Southwest and the fabulous Aztec Empire discovered by Cortéz (Bancroft 1962).

the Hopi mesas, set up a base camp in Bernalillo, explored central New Mexico to Taos, and then ventured east to Kansas, ever in search of the fabled cities of gold.

In sixteenth-century European manner, the Spaniards were hard on resistant natives. Punishment ranged from enslavement, to mutilation, to death by burning. For the native peoples of North America, this was the beginning of an invasion that would not end until most of the buffalo were shot and the last Indian relocation was completed by Anglo-Americans in the late nineteenth century.

Coronado found only straw encampments in Kansas. Beset by problems, including a threat of mutiny, Coronado returned to Mexico in 1542. Exploration of the region did not begin again for forty years, when, in 1581, Capitán Francisco Chamuscado and Fray Agustín Rodríguez blazed the trail later known as the Camino Real. This "royal road" would be used by colonists, supply trains, and the military for the next three centuries. Like the friars left behind by the Coronado expedition, the handful of friars that accompanied this expedition remained in New Mexico and were killed by natives while waiting for reinforcements.

Authorized expedition leaders bore the entire expense of their ventures, as it was considered an important investment. Any gold discovered during the venture would be divided between the Crown and the investor. Hence, unauthorized expeditions were declared illegal. Two illegal expeditions did enter New Mexico. Gaspar Castaño de Sosa's exploratory party was actually apprehended in New Mexico by government agents and returned to Mexico to face charges. Two more unauthorized explorers, Francisco Leyva de Bonilla and Juan de Humaña, were killed by natives.

The Spanish Colonial Period, 1598–1821

Juan de Oñate was a successful soldier, landowner, and silver mine operator from Zacatecas, Mexico. His father, Cristóbal de Oñate, was one of four mine owners made rich in the silver mine strike of 1548. Juan de Oñate applied, along with many others seeking new fortunes and frontiers, for the right to settle the new northern territory. In 1598, after three years of delays, he finally won authorization to establish a permanent settlement in the North. The expedition set out in the middle of winter, and included four hundred soldiers, farmers, and small craftsmen, 130 of whom were accompanied by their families and by seven thousand head of livestock. Eighty-three ox-drawn carts and wagons stretched for four miles. One of the soldiers, Capitán Gaspar de Villagrá, would later record the events of the expedition in his *La Verdada Historia de la Nueva Méjico*, an epic poem that would be the first literary work written about New Mexico and North America. The poem tells in lyric, florid language of the trials and triumphs of Oñate's northern expedition.

Place Names Then and Now

Modern Place Name	Spanish or Original Pueblo Place Names
Colorado River	Río del Tizón (Firebrand River)
Hopi mesa	Tusayán
Bernalillo	Tiguex
Taos	Braba (officers) or Valladolid (soldiers)
Kansas	Quivira
Canadian River	Río del Espíritu Santo (River of the Holy Spirit)

Historian Arthur L. Campa points out that the lengthy inventories of Oñate's settlers indicated that they expected to pursue more farming and stock raising than mining for gold or silver. He writes, "It is noteworthy that even the soldiers and individual members of the expedition also mention in their personal possessions many farm implements, horses, and mules but seldom are pick-axes, shovels, and other mining tools included in the inventories" (Campa 1979). In fact, only eleven pickaxes are listed officially. These settlers, he continues, "laid the foundation for a pastoral culture that became characteristic not only of New Mexico but also of a major portion of the Southwest and continued unchanged for several centuries."

En route, Oñate's advance guard suffered a "killing thirst" for days, but was saved at last by a downpour. The main expedition also ran out of water before reaching the *Río Grande* (meaning Big River, but known then by the Tewa natives as *P'osoge*)—the people and animals were frantic with thirst. On the morning of the fifth day, they came upon the river, which they named *El Río del Norte* (River of the North). This occurred near present-day El Paso.

Exhausted, the expedition spent days in the *bosque* (woodland) along the river, hunting, fishing, and resting. They built a great bonfire to roast the meat and fish for a great repast. Some Pueblo Indians had brought them fresh fish and showed them a safe crossing on the river; the soldiers offered them clothing in return. According to Villagrá, the settlers had built a graceful church in the "pleasant, leafy" *bosque*, "with a nave of such size that all the camp at once might be contained in it without crowding." After a solemn high mass held there on April 30, 1598, the Spanish presented a "great drama the noble Captain [Marcos] Farfán [de los Godos] had composed, whose argument was but to show to us the great reception of the Church that all New Mexico did give, congratulating it upon its arrival" (Villagrá 1991). There followed "solemn and pleasing festivals of splendid men on horseback, and in honor of that illustrious day a gallant squadron was released." On that day Oñate declared the *Toma de Posesión*, in which he announced the taking of the new land on behalf of the king of Spain. This April day was seen centuries later by New Mexico writers Vincent García and Brother Steve Armenta as the first Thanksgiving in America, twenty-five years prior to the November celebration at Plymouth Rock.

By July, the group had traveled further north to make temporary camp on the east bank of the Río Grande, near present-day San Juan Pueblo. They named the settlement San Juan de los Caballeros. Some historians attribute the "caballeros" designation to the possible gentlemanly mien of the natives; other historians refer to the Spaniards' view of themselves in this regard. A few months later, however, Oñate moved his headquarters across the river to the village of Yunqueyungue and named the new settlement San Gabriel.

There were sixty pueblos in New Mexico when Coronado first arrived; there were twelve pueblos alone in the Bernalillo area. By the time of Oñate's governorship in the late sixteenth century, the number of pueblos had begun to diminish due to intertribal rivalries and, later, smallpox and other European diseases. By the mid-eighteenth century, the remaining pueblos in New Mexico would number nineteen. Historians estimate that the Indian population had dropped to one-fourth its size at the time of Coronado, though there is no way to determine exact figures.

Problems arose almost immediately. For example, the residents of Acoma Pueblo refused to provision the new settlers a second time and attacked and killed a number of soldiers who had gone to the Pueblo to collect tribute. Oñate responded with a full attack on Acoma, which resulted in the deaths of about seven hundred inhabitants. Those Pueblos who did not escape were enslaved. In addition, sixty girls were sent to convents in Mexico, and all males over twenty-five had one foot cut off. Two Hopis who had been at Acoma and took part in the fighting had a hand cut off. They were sent home to deliver the soldiers' warning. Thus was the way of European warfare in the sixteenth century.

Two years later, a similar punitive episode occurred at Abó, where three Pueblos were burned and hundreds killed. In the meantime, the first winter at San Gabriel had been harsh. The crops were disappointing and the settlers began eating the

livestock. Several settlers abandoned San Gabriel and returned to Mexico with accusations against Oñate's administrative management. Oñate continued to pursue reconnaissance expeditions to Kansas and the mouth of the Colorado River, still seeking the elusive riches, hoping it would calm the increasingly unsettled settlers and convince them to stay. On one of these missions, Oñate paused at the foot of El Morro—a well-known watering hole on the trail between Zuni and Acoma—and inscribed his name on the sandstone of that large landmark. It is still visible today, along with inscriptions of travelers of each succeeding century. Eventually, the difficulties of life on the frontier and settlers' complaints following this expedition led to Oñate's recall to Mexico in 1608. There, among other charges, he was to face charges of cruelty to the Indians at Acoma.

The new governor, Don Pedro de Peralta, estab-lished La Villa Real de Santa Fe in 1610. He laid out the town and plaza, and built the Palace of the Governors as his headquarters. From 1610 to 1680, increasing numbers of colonists established haciendas and settlements along the Río Grande and its tributaries from Taos to Socorro. On arriving in New Mexico, the Franciscan friars proceeded to supervise the building of mission churches at or near the Pueblos. From the outset, all church activity was for the benefit of the Indians; the Spanish settlers were expected to see to their own religious needs. By 1625, fifty churches had been built under the supervision of fourteen friars. Many others would be built in succeeding years. Individual Pueblo Indians found to be adept in language were taught the catechism so that they might teach it in their own languages. Instruction also took the form of singing and playing musical instruments, such as flutes brought by the friars. Friars at Santo

1.1

Don Diego de Vargas's 1692 inscription at El Morro, as sketched by a member of the James H. Simpson expedition in the 19th century. From Gregg, Andrew K., *New Mexico in the Nineteenth Century: A Pictorial History*. (Albuquerque: University of New Mexico Press, 1968), 20.

Domingo Pueblo formed a boys' choir that accompanied itself with bird whistles. Painting images of saints on church walls and hides was yet another form of religious instruction. In addition, carved and painted statues of saints brought from Mexico were used to furnish the churches; and pageants, such as *Los pastores*, served to teach religious doctrine as much as to celebrate it. Thus was European music and art first introduced into New Mexico. The melding of Spanish and Pueblo music and art would not begin until much later, as ethnocentrism was still virtually a territorial policy.

For the colonists, life was a continuous challenge. With Mexico City twelve hundred miles to the south, isolation and material shortages were a way of life. New Mexicans of moderate means learned to make it, make do, or do without essential items such as weapons, medicine, and education. The area's isolation is evident even today, as the Spanish language of northern New Mexico is sprinkled with seventeenth-century colloquialisms and word forms rarely heard elsewhere. Wealthy colonists brought in finer material goods, which were replenished via caravans that traversed the Camino Real between Santa Fe and Chihuahua once every three years. The long lines of pack mules and ox-driven *carretas* and wagons took forty days to complete the arduous trip from Chihuahua to Santa Fe.

While disagreements regarding authority over the Pueblos were frequent between civil and church leaders, mistreatment continued due to the friars' forced conversion approach and to the settlers' *encomienda* system—an arrangement practiced throughout Latin America in which a Spanish landowner protected and converted Indians to Christianity in return for their labor and tribute. The *encomienda* system originated during the reconquest of Spain. Raiding Apaches made matters worse at the outlying Pueblos, several of which were finally abandoned, including Galisteo, Piro, Tompiro, Quarai, Abó, and Gran Quivira. Equally serious was the continued attempt by the Franciscans to stamp out the Pueblo religions. Finally, in 1680, the Pueblo Indians revolted.

It was the first of only two instances in North American history when Indians banded together to beat their foes and won. The other was the Battle of the Little Bighorn, two centuries later. The leader of the revolt was Popé, a San Juan Indian who organized the Pueblos to drive the Spanish settlers as far as El Paso del Norte. Even their natural enemies, the Apaches, joined in the effort. In fleeing Santa Fe, the settlers took with them a small wooden statue of Our Lady of the Assumption, which had been brought from Spain to New Mexico in 1625. This statue was to have a long history as La Conquistadora, one of the oldest religious images in New Mexico.

The Pueblo Revolt was significant, for in the fires of suffering and violence, a new intercultural understanding was forged between the Indians and the Spanish. It also served as a catalyst to establish more equitable treatment of the Pueblos by the Spanish. Contemporary historian Joe Sando of Jémez Pueblo has noted that in no other North American region have the Native Americans survived in such numbers, and with such freedoms—of religion, government, and language—as those of New Mexico and Arizona. He considers this a legacy of the Pueblo Revolt and of Spanish rule. Spanish kings had long decreed that Spaniards were not to encroach upon Indian lands. Thus, tribes in New Mexico and Arizona were the only Native Americans to remain on their ancestral lands in such large numbers, and into the present day. This spirit of *vecindad* (neighborliness) between the Indians and the Spanish manifested itself in subsequent centuries in the emergence through intermarriage of a new mestizo culture. It also resulted in a unique and longlasting military alliance against increased raids by surrounding nomadic tribes. In the twentieth century, the Pueblo Indians would be criticized by descendants of nomadic tribes for this historical alliance.

In the twelve years after the Pueblo Revolt of 1680, two Spanish governors made unsuccessful attempts to reconquer New Mexico. In 1691 the governorship went to Don Diego de Vargas, a Spaniard of nobility born in Madrid in 1643. His first foray into the area occurred in 1692. Vargas was received by the Pueblos without incident throughout New Mexico. The following year, he returned with one hundred soldiers, seventy-three families, eighteen Franciscans, and the statue of Our Lady of the Assumption, carefully wrapped and crated.

On reaching Santa Fe, Vargas encountered a walled city occupied by Tano Indians who refused to surrender despite their earlier promise to do so. It was a difficult winter, as the new settlers camped in the area of the present-day Rosario Chapel. For two weeks, Vargas negotiated unsuccessfully with the Tanos. In that time, twenty-two Spanish, mostly children, died of severe cold. The colonists complained repeatedly to Vargas about their hardships. Remembering Oñate, he was concerned about possible accusations of cruelty to the Indians, so he asked permission from the friars to pursue a "holy war" against the infidel Pueblo Indians who were occupying the town. Then, as the women in the camp uncrated the statue of the Virgin and prayed novenas in the snow, Vargas and his men stormed the town and recaptured it in two days of torturous fighting. There followed another three years of resistance before the reconquest could be called complete.

The statue was renamed La Conquistadora in honor of the temporal and spiritual victory in Santa Fe that day. A chapel was later built in her honor at the site of the settlers' camp. In 1992, the statue was renamed Nuestra Señora de la Paz (Our Lady of Peace) in recognition of the intercultural peace for which New Mexicans continue to strive.

From 1693 to 1821, New Mexico was ruled from Mexico City as Spain's northernmost frontier. Land grants, or *mercedes*, were made to an increasing number of incoming settlers. In 1695, New Mexico's second town, or *villa*, was established at Santa Cruz de la Cañada, near present-day Española, to more effectively administer the Río Arriba area. (The Río Arriba, meaning upstream, is that part of New Mexico that is north of what is today called La Bajada Hill near Santa Fe; the Río Abajo, meaning downstream, is that part of the state that is south of that landmark.) In 1706, a third town was established at Alburquerque, as it was then spelled, to administer the Río Abajo area. The site was chosen for its steady water supply, fer-

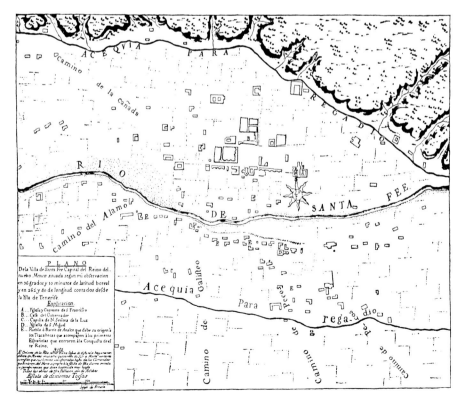

1.2
Earliest known map of Santa Fe, drawn by José de Urrutia around 1766–68. From Gregg, *New Mexico in the Nineteenth Century*, 84.

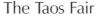

The Taos Fair

In 1739, Gallic traders, led by the brothers Peter and Paul Mallet, reached Santa Fe with a few mules loaded with goods. A joyous pealing of bells welcomed them, for the cloth and cutlery they brought were far cheaper than similar articles carried north from Chihuahua with the annual supply caravan.

Uneasy about the unprecedented situation, the governor wrote Mexico City for advice and was told crisply that Spanish law forbade trade with foreigners. The Mallets, who by then had sold their stock, were deported. Other traders, hearing of the starved market, soon took to their trail. To escape observation they moved their business to Taos and incorporated it into the annual summer fair that for decades had been drawing Hispanos [who actually referred to themselves as Españoles Mexicanos], Pueblos, Utes, Navajos, and the Indians of the plains together under the shelter of a week-long armistice. Soon the event was so rousing an economic and social success that governors forgot its illegality and came north, they said, to maintain order—or, to be more accurate, to skim off whatever profits they could.

The setting was spectacular: the soaring, green-blue backdrop of the Sangre de Cristo Mountains, a dance of crystal streams, a gray sage plain [sage was not present until two centuries later], and then the deep basaltic gorge of the Río Grande. Trails converged like crooked spokes. During each gathering thousands of horses grazed on a swampy meadow near Taos Pueblo. Its inhabitants, dressed in white cotton, and Hispanos gay in bright serapes, wandered among the encampments with a proprietary air. Utes adorned in necklaces made of grizzly bear claws offered deerskins they could tan better than any other tribe, and hollow-eyed children stolen or purchased with horses from poverty-stricken parents in rancherías as far away as central Utah. Navajos brought piñon nuts, blankets, and Spanish prisoners for ransom. Comanches had captive Apaches to sell, plus dried meat, thick buffalo hides, and softer ones that they passed off as white elk skin. The French and growing numbers of traders from Chihuahua—about 1750 the Chihuahuans took over the running of the annual supply caravans—brought in calico, mirrors, vermilion, bridles, metal pots, hatchets, and, quite against the law, guns, powder, lead, and liquor. There were horse races, war dances without war, and exuberant fornications. In general, according to one friar, the New Mexicans got the best of their Indian visitors "because our people ordinarily play infamous tricks on them." Small matter. The Indians evened the balance by robbing some ranch on their way home. (Lavender 1980)

tile land, and nearby timberlands. By the mid-eighteenth century, there were 3,400 settlers centered around Santa Fe, Alburquerque, and Santa Cruz de la Cañada. Their number grew to over ten thousand by the end of the eighteenth century, making New Mexico one of Spain's most populous outer provinces at that time.

During this time, Spain barred entry to non-Spanish traders from all of its provinces, including New Mexico, but found this difficult to enforce. New Mexico had become a buffer zone between French and English North American settlements and the rest of Spanish America. Despite the prohibition, French traders had been trading with Plains Indians for years and occasionally skirted or entered Spanish territory, where their goods were welcomed. It was illegal for Spaniards to trade with foreigners, yet the Taos and Pecos Fairs continued to be the most popular open markets every year for trade with Plains Indians. Everything from horseshoes to pelts were traded at these gatherings, including captive Indian children sold by the Plains

tribes to the colonists. These children worked off the sum paid for them through servitude to the family that bought them. On reaching marriageable age, they were generally set free, but were by then Hispanicized and known as *genízaros (janissaries)*. Later, when Plains tribes were no longer able to deliver captive Plains children, Hispanos captured Navajo youths, an affront that caused retaliation from the Navajos, who began stealing Hispano children.

Indian raids increased in New Mexico after the Utes acquired horses (brought in by the Spaniards) in the late sixteenth century. The Utes—whose territory covered southern Colorado and further east—introduced the horse to the Comanches, who then emerged as the dominant tribe in eastern New Mexico, Texas, Colorado, and the southern Plains. They forced out the Apaches of New Mexico's eastern plains. When the Apaches began using horses not long afterward, Spanish settlers outside the Río Grande Valley would long be plagued by raiding parties. The raiders took women, children, horses, sheep, food, and other goods. These "hit and run" raids threatened not only the Spanish but Pueblos as well.

In the eighteenth century, the Pueblo Indians joined forces with the Spanish to fight the raiding Apaches and Navajos and to form Pueblo militias. A peace was forged with the Comanches after Juan Bautista de Anza led a force of Spanish and Pueblo men in battle in 1779, killing the Comanche leader Cuerno Verde. In 1786 the Comanche leaders met with Anza at Pecos Pueblo to declare a lasting peace patiently cultivated by Anza in several years of talks. From then on, the Comanches traded instead of raided, and even joined the Spanish in their fight against the still hostile Apaches.

In 1775 Fray Francisco Atanasio Domínguez was appointed to make an official visitation to New Mexico and report on the spiritual and economic status of the missions. It is from his detailed report that modern historians know of the lifestyles, material culture, and economic conditions not only of the missions, but also the settlers and Pueblo Indians.

A pivotal event occurred at the beginning of the nineteenth century that would usher a new culture

into New Mexico. In 1807, American explorer Zebulon Pike wandered into New Mexico, "lost" after a difficult winter at the base of the Rocky Mountains in Colorado. He had been charged with exploring the southwestern portion of the territories of the Louisiana Purchase, though contemporary historians now agree he was most likely on a spy mission to explore Spanish territory for the American government. He was quickly apprehended by Spanish soldiers and brought to Santa Fe. Later released, Pike reported to Americans in the East that the Southwest was not a dry Sahara-like desert as had long been assumed, but viable and prosperous agricultural and grazing land with many friendly inhabitants in need of modern goods. Pike wrote about his discoveries in a widely read book of his journals that inspired Anglo-Americans in search of new trading opportunities. New Mexico's secret was out, as were its years of isolation.

The Mexican Period, 1821–1846

In 1821, New Spain gained its independence from Spain through the Treaty of Córdova, and officially changed its name to Mexico. Because New Mexico had been part of New Spain, it was also free of Spanish rule. This was good news and bad news for New Mexico. Good news because it opened up the area to the rest of the world in terms of trade, communication, and transportation; and bad news because Mexico City proved to be a less-than-competent ruler of its provinces, ultimately leading to a rebellion in New Mexico.

Under the new government, Pueblo Indians were granted full citizenship and the term genízaro was abandoned as that population was absorbed into the general population. In fact, all other *casta* terms used for centuries to classify bloodlines—such as *mestizo* (mixed Spanish and Indian parentage), *mulato* (Spanish/black), and *coyote* (Indian/mestizo)—were eliminated in favor of the more universal *Mexicano*. Titles with feudal origins such as *señor* and *señora* were briefly replaced with *ciudadano/a* (citizen) as used after the French Revolution. The Pueblo Indians continued to practice their civil and religious customs, and the Spanish continued to protect Indian lands as a

1.3

Map drawn by Don Bernardo de Miera y Pacheco in the 1770s. The text reads "Map of the Río del Norte from San Elzeario to the Paraje de San Pascual, by Don Bernardo de Miera y Pacheco, on which are traced its borders, sierras, and narrows. The Paraje de Robledo, proposed site for a presidio, is shown, where there are obstacles to establishing it because of the narrow space between sierra and hills and the lack of a water supply. Five leagues downstream are two locations facing each other, ample and extensive enough for every purpose. These are La Mesilla on the El Paso bank and La Ranchería Grande on the other side, 15 or 16 leagues from said pueblo of El Paso. Six leagues upstream, beyond the narrows of said Robledo, begin the spacious meadows of Santa Bárbara, with good water resources for farming and many convenient places for pasture, firewood, and timber, on the same side as said pueblo of El Paso.

"This establishment must necessarily be very strong because of its location in the midst of the habitations of the enemy Apaches. And if it were put into effect, it would cut their communications with the Indians of Sierra Blanca and with the Natajes and throw them into great confusion. And if it were feasible to place another fort on the same side, opposite the stage at the Paraje de San Pascual, then the said river could easily be populated all the way from

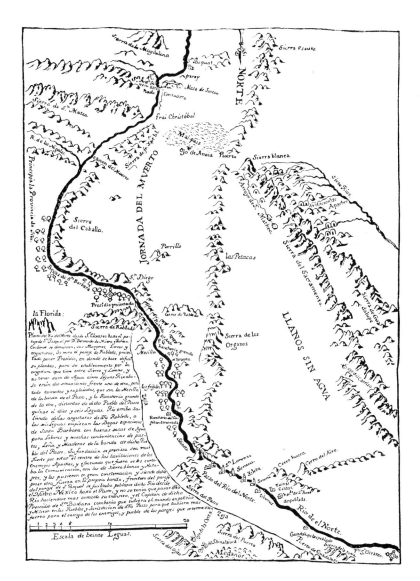

"Scale of twenty leagues." From Adams, Eleanor B. and Fray A. Chavez. *The Missions of New Mexico, 1776.* (Albuquerque: University of New Mexico Press, 1956.)

New Mexico down to El Paso, and it would not be necessary to cross the river, since travel along it would become more convenient.

"And the captain of said Presidio de Santa Bárbara should have political and military command over the pueblos and jurisdiction of said El Paso so that he might have greater strength to punish the enemy and to settle the intervening stages."

matter of policy. Apaches, Utes, and Navajos continued raiding well into the nineteenth century.

The Spanish policy of prohibiting trade with foreigners was dropped. By 1822, entrepreneur William Becknell had begun transporting much needed goods to New Mexico over the Santa Fe Trail, which led from Franklin, Missouri, to Santa Fe. This sudden increase in trade with the East broke the monopoly long held by Chihuahua merchants and profoundly changed the material culture of New Mexico.

Imported items included cloth goods, building materials, housewares, foods, medicines, and books. Even the wagons used to transport goods were bought by New Mexicans because there was a shortage of wagons in New Mexico and because they had metal-rimmed wheels, unlike the all-wood wagons made locally. The caravans also traveled past Santa Fe to trade in Chihuahua and to California over the Gila Trail. While New Mexico's new government attempted to collect import taxes on these shipments, Anglo traders often found ways to avoid compliance, contrary to earlier reports that the tax shortage was due to corrupt Mexican officials. The result was that the new government was continuously short of operating funds, as the trade balance was heavily in favor of the United States.

Anglo and French-Canadian fur trappers who had illegally worked the beaver streams of New Mexico for decades now openly moved among the Taoseños and Santa Feans, marrying into old families, becoming naturalized citizens, and even holding office. Kit Carson was among those who were thus integrated.

Starting in the mid-eighteenth century, the Franciscan friars were no longer replaced as they died or were recalled from their missions. Their purpose in New Mexico had never been to minister to the colonists, but to convert the Indians to Christianity. By 1821, they were almost all gone. The bishop of Durango was now responsible for the faithful of New Mexico, yet there was a chronic shortage of secular priests. New Mexico's Catholics responded by ministering to their own religious needs through the use of religious images, prayer books, and community rituals such as *entriegas*. Circuit-riding secular priests visited about twice a year. Santos, *retablos*, reredoses, and other religious art objects had long been created locally to decorate community chapels, or *capillas*, which were maintained and used by the people and by the visiting priests. The religious isolation of the settlers also gave rise to La Hermandad de Nuestro Padre Jesús Nazareno, popularly known as the Penitentes, a lay religious society that has survived to contemporary times. As in centuries past, its members devote themselves to year-round acts of charity and to performing ritual ceremonies and disciplines during Holy Week. The colonial brotherhood is thought by many to have been a New World manifestation inspired by the *cofradías* of Spain.

With the arrival of Bishop Jean-Baptiste Lamy in 1851, the priest shortage was alleviated by French and Italian priests who spoke no Spanish and who looked on the handmade chapels and decorations as crude and even disrespectful. St. Francis Cathedral in Santa Fe was built in the mid-nineteenth century out of stone and imported furnishings to replace what the new bishop called "the mud palace" that had served Santa Fe's faithful since the eighteenth century.

One who saw the changes coming and attempted to prepare his people for them was Padre Antonio José Martínez of Taos—a priest, teacher, writer, elected legislator, publisher, and advocate for his people. He acquired a printing press to write and publish educational materials for his home school for boys and girls. He also edited and published a newspaper and religious materials. The son of a wealthy Taos merchant, Martínez sent eighteen of his brightest male students to the Catholic seminary in Durango, Mexico, where he financed their training as much-needed native priests for New Mexico. His school produced many of New Mexico's leaders of this era. As a statesman, he traveled to Washington as advocate for New Mexican political objectives, while at home he prepared his fellow New Mexicans for the inevitable American incursion. He had no qualms about questioning Bishop Lamy's judgment over church matters, and was eventually excommunicated. Despite his good works, Padre Martínez was severely denigrated in Willa Cather's *Death Comes*

for the Archbishop, from which most twentieth-century New Mexicans have learned of this folk hero.

Official directives from Mexico between 1821 and 1846 were frequent, arbitrary, and often contradictory as regimes changed quickly and word was slow to reach Santa Fe. While Mexico refused to finance its government in New Mexico, it continued to tax its people. To make matters worse, Mexico's many new leaders insisted on new governmental structures in New Mexico with each change in the Mexican government. In the 1830s, a newly imposed constitution further curtailed Santa Fe's power and purview, and increased taxes. This led directly to the Revolt of 1837 in which New Mexicans refused to pay the next year's taxes or to restructure their local government one more time. Rebel leaders appointed their own genízaro governor, José Gonzales, after killing and decapitating the Mexican-appointed governor, Albino Pérez. Former Governor Manuel Armijo gathered a militia, suppressed the revolt, executed the rebel leaders, and was again appointed governor.

Mexican matters faded in importance as Armijo dealt with the failed invasion of New Mexico by Texas in 1841, and by continued Indian raids. Lack of funds to run the government and to pay troops continued to plague Armijo and his successors. President James K. Polk was a firm believer in Manifest Destiny, an ideology maintaining that the United States was destined and even morally correct in expanding westward across the continent regardless of any previous occupation there. In 1846, he declared a state of war between the United States and Mexico, and sent Brigadier General Stephen W. Kearny to turn his words into action by invading and occupying New Mexico. Kearny was successful, largely because Governor Armijo fled at the last minute, leaving behind his demoralized volunteer army. On August 18, 1846, New Mexico became a territory of the United States.

The Territorial Period, 1846–1912

The occupation by American troops was peaceful, but Kearny, taking no chances, immediately built Fort Marcy north of Santa Fe's plaza. Fort Marcy was never used as more than a military garrison.

Kearny also appointed Taos merchant Charles Bent as governor and organized a new territorial government based in Santa Fe. He confiscated Padre Martínez's press to publish the Kearny Code, a new set of laws borrowed from the previous Mexican law and United States laws. He then set out west to conquer Arizona and California as part of the president's plan for expansion. Another American military expedition, headed by Colonel A. W. Doniphan, engaged and defeated Mexican troops near present-day Las Cruces in New Mexico's only battle of the Mexican-American War.

Meanwhile, in Taos, a band of Mexican loyalists plotted with a group of Taos Pueblo Indians who were not convinced that the United States would respect their land rights. In January 1847, they attacked the Anglo-Americans in Taos and nearby Arroyo Hondo, killing Governor Bent, who was visiting his family, and two local officials. The uprising continued until July with skirmishes or battles also at Las Vegas, the Canadian River canyon, and finally at La Questa (now Villanueva). American reaction was typically swift. Mora and San Agustín were completely razed by U.S. troops. Those troops, with a mountain-man militia and some of the Hispano elites under Colonel Sterling Price, left Santa Fe, striking at Santa Cruz and Embudo on their way to Taos, where they found the rebels entrenched within the adobe mission church of San Gerónimo at Taos Pueblo. They were no match for the military. The rebels were routed and six were hanged after a very short trial in which they were charged with treason, despite the fact that they were not U.S. citizens. Cannons had virtually leveled the church and many souls within. In a subtle yet purposeful reminder to itself, the Pueblo has, to this day, left the church ruins undisturbed. About four hundred New Mexicans were killed, and more than forty were ordered hanged. Martial law went into effect for the next four years.

The Treaty of Guadalupe Hidalgo was signed in 1848 by the United States and Mexico to end the Mexican-American War. Among other items, the treaty officially transferred New Mexico to the United States. It also allowed New Mexicans the option of becoming U.S. citizens or moving to Mexico to retain their Mexican citizenship.

1.4
Nuevomexicano farmer and family, Mora Valley, New Mexico, 1895. Courtesy Museum of New Mexico neg. #22468.

Property and civil rights were to be protected by the new government. Although Indians had been full Mexican citizens, they were not offered U.S. citizenship until the middle of the next century. Women also lost legal ground in the transfer of power. Prior to 1848, New Mexican married women could own their own property, keep their wages and their maiden names, and divorce or sue their husbands. Under American law, the property, wages, and many legal rights of a woman transferred to her husband at marriage. American widows were liable for their husbands' debts. This was not the case in New Mexico prior to 1848 (Jensen and Miller 1986).

The Treaty of Guadalupe Hidalgo also stipulated that property rights that had been legitimate under Mexican law would be respected by the United States. The process by which existing grants were recognized, however, required review and approval at the state level followed by ratifica-tion by Congress on each grant. Between 1854 and 1880, only 136 cases were submitted to Congress out of more than a thousand; Congress acted on only forty-six. Differences in Spanish and American land grant procedures hampered progress and precipitated startling changes for New Mexicans. For example, much of the common grazing land guaranteed under the Spanish and Mexican systems was now in the hands of private Anglo lawyers and landowners, much to the dismay of New Mexicans who could no longer use their ancestral communal lands for grazing, hunting, or fishing—activities that were necessary for survival.

Congress's lack of concern for New Mexico's land grant issues is reflected in the fact that it authorized funding for only one person, without a staff, to handle this huge and complex task. It is also significant that Congress sent a surveyor rather than a lawyer versed in land issues to deal with

New Mexico's claims. While U.S. approval on small grants languished for years, a very large grant case sped through the system with appalling ease. The Maxwell Land Grant will go down in history as the largest (1.7 million acres) land grab in the United States, representing greed in its most spectacular manifestation. The Hispanos' loss of their land is a dramatic story of political pressure, fraud, corruption, ambush, murder, speculation, rigged elections, riots, buy-outs, nepotism, vigilante raids, and hangings (Ferguson 1975). At the center was the "Santa Fe Ring," a group of Santa Fe-based Anglo lawyers and industrialists masterminding the whole moneymaking scheme. George Washington Julian, the relatively honest surveyor general sent by Grover Cleveland's administration to clean up the mess, said of the Ring:

> They have hovered over the territory like a pestilence. To a fearful extent they have dominated governors, judges, district attorneys, legislators, and surveyor-generals—they have . . . subordinated everything to the greed for land. (Lavender 1980)

Two years after the arrival of Bishop Lamy, New Mexico was separated from the Diocese of Durango to create a new diocese. Lamy saw to the building of forty-five new churches during his tenure, as well as several parochial schools. In 1875, Lamy was consecrated as archbishop of Santa Fe. During this time, the first Baptist, Presbyterian, Episcopal, and Methodist missionaries arrived in New Mexico. They, too, built churches and schools while concentrating on proselytizing the Indians. Mormons moved into western New Mexico and settled near Gallup in the 1870s.

The Pueblo Indians, in the meantime, were quietly developing an economic base on which to subsist in the new political and social climate, selling baskets, woven blankets, and pottery to the hundreds of nineteenth-century newcomers. When the Spanish colonists introduced sheep to the area, they impacted not only the Pueblo foodways, but their weaving materials. Later, the Navajos began weaving blankets, then changed to rugs in the late 1880s. Both Navajo and Pueblo Indians mastered silversmithing at this time, having learned the techniques from their Spanish *vecinos* using the Mexican silver peso as raw material.

Between 1850 and 1860, New Mexico's population grew from sixty-one thousand to ninety-three thousand. After centuries of isolation, New Mexico experienced great influxes of people from the eastern United States and from Europe, especially after the discovery of gold in California in 1849. Throughout the second half of the century, New Mexico's population continued to grow as more and more people arrived to settle, farm, ranch, open businesses, serve as soldiers, proselytize, mine, and build railroads. Still, Congress

How Alburquerque Became Albuquerque

One of the first things arriving Americans saw at the Albuquerque train depot was the sign reading "Alburquerque." Many of them found "Alburquerque" difficult to pronounce, so the first "r" was dropped. The sign was changed. A popular New Mexican myth attributes the villa's name not to the Spanish Duke of Alburquerque, but to the apricot—albaricoque in Spanish—which apparently was abundant in the valley near the Sandía *(watermelon) and* Manzano *(apple) Mountains. Popular though it may be, no serious historian considers this idea credible. The name actually derives from the Latin,* Albus quercus, *meaning white oak.*

refused to grant New Mexico statehood because its people were predominantly Spanish-speaking, and because of a covert racial prejudice within Congress (Lamar 2000).

In terms of cultural impact, the most important development in New Mexico during the second half of the nineteenth century was the building of the railroads. Most of New Mexico's tracks were laid between 1878 and the 1890s, forever linking its inhabitants with the rest of the continent. Following the path of the Santa Fe Trail, the Atchison, Topeka & Santa Fe Railroad heralded the end of that historic wagon route. Today, Santa Fe Trail buffs stage wagon train expeditions, conferences, and other gatherings, and wagon ruts are still visible from train windows and highways.

The ATSF bypassed Santa Fe, which was deemed too mountainous for a railroad. It sped to Albuquerque, then south to El Paso to link up with the Southern Pacific Railroad. The Denver & Río Grande Railroad lost its bid to the ATSF, but was allowed to build its newly developed narrow gauge railroad in 1880 from southern Colorado to Española via Chama; thus situated, it served the lumber, ranching, and farming industries in northwestern New Mexico. It also eventually reached Santa Fe. The portion of its track between Antonito, Colorado, and Chama—representing some of the most expensive track ever laid, at $140,000 per mile in places—was jointly purchased by New Mexico and Colorado, and serves today as a tourist attraction.

Railroad lines were under construction in other portions of the state as well. The immediate benefits were jobs in building the lines. New towns sprang up along the train routes, including Ratón, Maxwell, Springer, Watrous, and Wagon Mound. Older towns were affected as well—Albuquerque and Las Vegas were not on a railroad route. Even so, trade increased and new residents arrived more often at Albuquerque.

In remote portions of New Mexico, farming and ranching were enhanced and assisted by the railroad. The railroad also facilitated the "discovery" of New Mexico by Americans, particularly artists who were drawn by the expansive vistas and skyscapes, crystalline sunlight, and brilliant colors. At the turn of the century, Taos had become home to a variety of Anglo and European artists who formed clubs, called themselves the Taos Art Colony, and proceeded to redefine the southwestern cultures. They idealized the Indian as a "noble savage," living the life of the spirit in his natural habitat. On the other hand the mixed-blood Hispano was painted as a kind of "ignoble savage," engaged in humble chores. Neither vision was consistent with the reality of New Mexico life. It was not unlike the literary license that Willa Cather took in demonizing the character of Padre Antonio José Martínez, who is now revered as a culture hero by Hispanos.

With the railroad came artwork from the East, including prints for home use, and religious art from France and Italy. The work of New Mexico Hispanic artisans was replaced with the new art; consequently certain forms and techniques almost died out. Beginning in the 1920s, the New Mexico State Department of Vocational Education succeeded in encouraging the revival of several types of Hispanic folk arts, including weaving, colcha embroidery, woodcarving, and tinwork.

Free public education became law in 1891; three colleges were established in 1889; and by 1900 there were five English-language daily newspapers in New Mexico. In recent decades, it has been assumed that journalism and literacy were introduced to the region from the East, but Spanish-language newspapers had flourished in New Mexico and southern Colorado by the turn of the twentieth century—as many as 190 such newspapers operated between 1880 and 1925. Poetry contests among its readers were conducted via these newspapers, indicating the level of literacy among many Spanish-speaking residents.

Architecture was eclectic for a time as newcomers built their homes and stores in a fanciful potpourri of American and European styles. Nevertheless, a territorial style eventually evolved from a combination of the existing Spanish-Pueblo style and a Greek revival movement popular in the Midwest.

From 1897 to 1906, Miguel A. Otero served as Governor of New Mexico. During this time, the Spanish-American War broke out and Otero mus-

tered New Mexico's quota of Rough Riders in only a few days. New Mexico's military record in foreign wars has been exemplary if judged by the disproportionately high numbers of volunteers, decorations reflecting valor in combat, and by exceptional contributions such as the martyrs of the Bataan Death March and the renowned Navajo Code Talkers, whose "secret code" was their own native language.

Statehood to the Present

New Mexico's show of military fervor and patriotism is one of the reasons why, after decades of rejection, New Mexico was finally signed into statehood by President Taft in 1912. Rejection came primarily because New Mexico was perceived by Washington as being "too Mexican" and "too Indian." After many attempts throughout the territorial period, New Mexico also had finally produced a state constitution conservative enough

to appease Congress. It preserved bilingual education and forbade segregated schools, a reflection of the strength of Hispanic political action.

Of all the events in the twentieth century, the Second World War had the most impact on Hispanic culture in New Mexico. Prior to this war (1939–45), three-quarters of the state's Hispanic people still led rural, agrarian lives and continued to pursue centuries-old practices in all aspects of religious and workaday life. A family could survive by living off the land and bartering for items they couldn't produce themselves (although this was more of a challenge after communal grazing lands became off limits in the twentieth century).

World War II took the young men from these remote communities and exposed them to different places, cultures, peoples, and ideas. Those who returned at the close of the war grew restless, even as their agrarian economy crumbled; many moved to urban areas in search of modern American life and jobs. Thus began the gradual exodus from pastoral

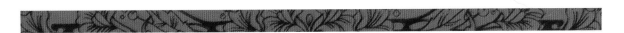

Beware of Visitors

The following item appeared in the Albuquerque Journal in 1984, when Peter MacDonald was still chairman of the Navajo tribe.

"Navajo Means Business" is tribal Chairman Peter MacDonald's favorite slogan these days, as he tries to promote economic development on the reservation. But before he got down to business last week in a speech before many of Albuquerque's top community leaders, the chairman told a well-received story that sparked loud laughter. It seems that back in 1971, MacDonald said, the National Aeronautics and Space Administration was conducting training near Tuba City, Arizona, for the Apollo moon mission. As

astronauts Dave Scott and Jim Erwin trained in their moon suits, an old medicine man happened along with his sheep herd. "What in the world are those two men doing?" the old man asked MacDonald. "They're training to go to the moon," MacDonald said he replied. The medicine man was intrigued; Navajo legend said Navajos have visited the moon and may still be there. The old man wanted MacDonald to give the two astronauts a message to take to the moon. MacDonald relayed the message to the astronauts in Navajo. "What does it mean?" they asked. MacDonald replied: "Beware of these two fellows—they will try to make a treaty with you." (Awalt 1987)

New Mexico to Albuquerque, Santa Fe, and similar urban centers throughout the Southwest. From the end of the war to 1960, Albuquerque's population increased by five hundred percent, to 225,000. Many of the new immigrants were people who had

been assigned to New Mexico during the war and then decided to stay. Los Alamos alone brought ten thousand persons to assist in the building of the atomic bomb that would end the war in the Pacific.

In the meantime, Anglo contributions to His-

Perspective in the Writing of History

In approaching historical accounts, the reader is cautioned that "truth" is relative. Often, objectivity is not always within the reach of the contemporary or retrospective historian. The histories of New Mexico and the New World have been related from many perspectives, as the three examples here illustrate. Conscientious readers, and especially those readers who will ultimately teach, are advised to learn about the historian, as much as about his or her work, in order to gain an understanding of that writer's unique point of view and its origins.

For example, the point of view of this textbook is to present a balanced history of the art and culture of Hispanic New Mexico with no overt or covert "jabs" at any particular culture. All cultures involved in the history of New Mexico have their strengths and weaknesses. The purpose of any history is to learn from these strengths and weaknesses, and it is easier to do so when they are clearly presented. Being human, it is not so easy to set aside one's subconscious prejudices, which may slip in with the choice of one word over another. For example, the use of "assimila-tion" rather than "mispronunciation"—one word makes excuses for the act; the other does not.

The following excerpts present the same event, a Texas military expedition to New Mexico in 1841. The event is presented by two contemporary historians writing for secondary-school students; a contemporary historian of the Southwest writing for adult readers; and the writer(s) of an undated nineteenth-century Nuevomexicano folk

drama entitled Los Tejanos, *presumably written for celebratory festivals in New Mexico following the expedition.*

Excerpt 1:
> *The revolt in New Mexico in 1837 troubled the Mexican government. Mexican officials suspected that Anglo-Americans had aided the anti-Pérez rebels. Such was not the case. In fact, Anglo-Americans had supplied Pérez. Some of them had later given money to Armijo for his actions against the rebels. They had welcomed New Mexico's return of order in 1838.*
>
> *Still, Mexican officials struck out at Anglo-Americans. In New Mexico, for example, Armijo blamed the Anglo-Americans for every problem. He took away some of their property. He hurt the Santa Fe trade by taxing each Anglo-American wagon bringing goods into the capital. And he acted harshly against a force of 270 Texans.*
>
> *The 270 Texans approached New Mexico in the summer of 1841. They said their visit was to discuss trade and military matters. The president of Texas might really have wanted to conquer New Mexico. Whatever their goal, the Texans never reached Santa Fe. Instead, they got lost on the plains. They lost their horses to roving Indians. They ran short of food and supplies. So when Armijo promised them a pardon, the Texans gave up.*
>
> *Manuel Armijo promptly broke his promise.*

panic arts and culture in New Mexico centered on successfully organizing and instituting clubs, museums, and preservation societies, and in collecting works for preservation. Several Anglo-American artists gravitated to Taos, where they found a new lifestyle and creative energy. The Santa Fe Art Museum was built in 1917 as a division of the Museum of New Mexico. A permanent artists' colony known as The Santa Fe Artists Club established itself in Santa Fe by the early 1920s. Five

He sent the captives on a 2,000-mile march to Mexico City. Tied together and given little to eat, the Texans suffered every step of the way. Those who lagged behind were shot. Some who made it to Mexico were released. Some escaped. Most captives did not, however, gain their freedom until 1842. (Roberts and Roberts 1991)

Excerpt 2:

One harebrained program for economic salvation, dreamed up by Mirabeau Buonaparte Lamar, Houston's successor as president of the republic [of Texas], was an invasion of New Mexico . . . [H]e hoped . . . the adventure might help distract his disgruntled citizens and strengthen Texas's shadowy claim of reaching to the Río Grande. He fully expected, on the basis of reports from agents in the west, that his invaders would be enthusiastically received by the New Mexicans.

In June, 1841, off went approximately 320 men of all ages, from striplings to grandfathers . . . Few expeditions have been less prepared for reality. Their late departure guaranteed them miseries from thirst. They were undisciplined and untrained. They had no guides and no knowledge of the country . . .

The situation, when [Manuel Armijo] learned of it, looked like easy glory for him. Drums beat in the plazas; the militia, commanded by sadistic Damasio Salazar, poured forth with bows, arrows, lances, and antiquated muskets . . . [Salazar] subverted W. S. Lewis, one of the emissaries the Texans had sent ahead to calm the authorities, and with his aid persuaded both groups of Texans to lay down their arms. Then the militia pounced, chained the lot, and marched them by slow, arduous stages to Mexico City; a dreadful ordeal that was relieved somewhat by outpourings of sympathy from the humble folk of the towns through which the captives limped. (Lavender 1980)

Excerpt 3:

Spoken by the Mexican officer who captures the Texans:

"¡Ah, tejanos atrevidos!	*"Ah, you insolent Texans!*
¿Se atreven a profanar las tierras del mejicano?	*You dare profane the lands of the Mexicans?*
Ahora su temeridad le pondrá freno a su orgullo,	*Now your recklessness will put your pride in check.*
¡Y a todos he de acabar!"	*And I will put an end to you all!"*

(Espinosa and Espinosa 1931)

Santa Fe artists called themselves Los Cinco Pintores and began exhibiting their works as well. The New Mexico Art League was formed in that decade in Albuquerque. Writer Mary Austin and artist Frank Applegate founded the Spanish Colonial Arts Society in Santa Fe in 1929, dedicated to reviving and preserving the Spanish colonial arts and crafts of New Mexico and southern Colorado. Part of its mission was to present an annual art exhibition, which continues today as the Spanish Market. As part of its preservation effort, the Society today maintains an excellent collection of over 2,500 pieces. In 1929, the organization purchased El Santuario de Chimayó, which was on the verge of disintegration due to dwindling numbers of pilgrims and financial difficulties, in effect saving it and its furnishings from dispersal. Other conservation and restoration projects included the Oratorio de San Buenaventura at Chimayó, a church at Ojo Caliente, and the Chapel of La Conquistadora in St. Francis Cathedral in Santa Fe.

In the early 1930s, the New Mexico State Department of Vocational Education (SDVE) established vocational training schools throughout New Mexico to train individuals in traditional New Mexican crafts with the goal of establishing an economically viable cottage industry and a source of income for those adversely affected by the Great Depression. Some Anglo administrators also perceived the need within New Mexico's Hispanic communities to revitalize their arts, which had been rendered anemic through neglect as a result of cultural assimilation and economic stress. The old barter system had been replaced by a cash economy with the arrival of Anglo-Americans. Seeking income, Nuevomexicano men began taking jobs as migrant farmworkers, which kept them away from home for months at a time. In their absence, the social fabric of family and community began to weaken.

By 1936, there were forty community vocational schools in towns all over New Mexico, funded by monies from the Work Projects Administration (WPA), state funds, school funds, and in-kind donations of sites. Students were even paid to attend (federal funds). The centers offered training in weaving, tanning and leatherwork, carving, wagon building, furniture-making, and ornamental ironwork. When the war broke out, the schools were closed as federal funds were diverted to the war effort. Still, the war was good news for New Mexico because it ended the economic distress that had created the need for the SDVE training program.

A similar effort was conducted by the University of New Mexico's San José Experimental School in Albuquerque where, between 1930 and 1935, rural-bound teachers were taught Nuevomexicano woodworking, weaving, tanning, tinwork, folksongs, and storytelling.

In 1935, Franklin D. Roosevelt launched the Works Progress Administration nationwide, an unprecedented program that employed persons qualified in art, music, drama, and writing to create, collect, present, and record the arts of the nation. This program, which continued through 1942, was designed to relieve the massive unemployment resulting from the Depression. In New Mexico, WPA projects saw New Mexicans gathering and cataloging Hispanic folk music, and organizing adult and children's traditional music groups and performances of folk drama. WPA administrators established art training and exhibition centers around the state as well. Visual arts projects are still evident today in public buildings statewide. At the Albuquerque Little Theater, the works of woodcarver Patrociño Barela, painter Pedro Cervantes, straw-appliqué craftsman Ernesto Roybal, carver Juan Sánchez, colcha embroiderer Stella Cervántez García, woodworker George Segura, and tinworker Eddie Delgado grace its interior.

New Mexico's traditional isolation came to an end. Just as Nuevomexicanos learned new trades and professions to compete in the mainstream work force, a new eclecticism emerged in Hispanic artistic expression, made possible by exposure to new styles and influences, new tools and materials, and new social issues. Chicano art and theater dealt with social justice and the struggles of the 1960s as Nuevomexicanos struggled to maintain a cultural identity while gaining a place in the American cultural and social landscape.

The Chicano Movement—also known as the Mexican American Civil Rights Movement—and

the Farmworkers Movement of the 1960s greatly affected New Mexico, despite the fact that those struggles originated in California, Texas, Colorado, and Washington, D.C., eventually spreading across the nation and to Europe, where dockworkers refused to unload boycotted farm products. Chicano art was born in this crucible: California's Teatro Campesino recruited workers to play the parts of their oppressors on open-air flatbed stages. The experience transformed many of them, and several movement leaders emerged from this grassroots role-modeling experience. In 1977, La Compañía de Teatro de Alburquerque was founded in Albuquerque, partly inspired by Teatro Campesino, which it later hosted for performances and workshops. Strikers and boycott leaders used visual art to gain access to the media, when words weren't direct enough. Mural art and posters were highly effective in galvanizing the people and in making a visual impact on the evening news. "De Colores" became the unofficial hymn of the movement and was even recommended by the National Music Teachers Association as part of a group of classic American songs that should be known and sung by every American in the nation.

The Museum of International Folk Art was established in 1953; in 1989 it opened the Hispanic Heritage wing, a permanent exhibition space featuring the art and culture of over four hundred years of Hispanic presence in the region. Other significant museums include the Martínez Hacienda and the Millicent Rogers Museum, both in Taos, and El Rancho de las Golondrinas, a two-hundred-acre, thirty-three-structure replication of a Spanish colonial village situated south of Santa Fe.

By the 1980s and 1990s, Hispanic and Native American traditional art, and non-native contemporary art, had become a multi-million-dollar industry in New Mexico, relying heavily on its artists to draw national and international visitors and art buyers to the state. The state that was once "too Mexican" and "too Indian" was now drawing enthusiastic visitors for that very reason. Several major exhibits became the focal point for this industry, including summer and winter annual Traditional Spanish Markets, Contemporary Hispanic Market, Albuquerque's Fiesta Artística De Colores—manifesting as either an outdoor arts-and-crafts fair or a major indoor exhibit, depending on funding—and the state fair's Hispanic Arts Exhibit.

The lively arts continue unabated as part of regular annual fiestas, where old time dances, historical pageants, and ancient plays are often part of the festivities. In urban areas, many locally-based grassroots and professional *ballet folklórico* companies flourish with the support of schools, communities, and parents. Mariachi music is studied and celebrated annually in Albuquerque at the annual week-long Mariachi Spectacular. The longest lasting of the performing arts groups to flower in the late twentieth century is La Compañía de Teatro de Alburquerque with its mix of classics, adaptations, and new works by local playwrights dealing with local issues and history. Flamenco enjoys much popularity in New Mexico, as reflected by the continuing work of several companies in Santa Fe and Albuquerque, and by a new program in flamenco studies at the University of New Mexico.

In 1965, the federal government established the National Endowment for the Arts (NEA), which began providing grants to organizations, and fellowships to individuals, for projects in the arts. It also recognized outstanding contributions in the arts by traditional artists through its National Heritage Fellowships. To date, Nuevomexicano recipients include tinwork masters Emilio and Senaida Romero (who is also a colcha embroiderer), the late *santero* George López, the late storyteller-musician Cleofes Vigil, santero and metalsmith José Ramón López, and colcha embroiderer Frances Varos Graves. The NEA also provides state governments with funds for allocation at the state and local levels, where they are used in part to make the arts available to low-income and rural audiences, and to school children.

While the NEA and state allocations helped audiences who couldn't otherwise afford to attend or take part in arts events, it was viewed as difficult to tap into by most Nuevomexicano artists, particularly since their art was not considered mainstream and was therefore categorized as "expansion" (i.e., ethnic) art by the NEA. Contemporary, or fine, artists also found it difficult to reach audiences through New Mexico institutions such as the museums and

galleries of Santa Fe and Albuquerque, so they sought to help themselves by organizing into advocacy groups such as La Cofradía de Artes y Artesanos Hispánicos and the Organization of Hispanic Artists in Santa Fe, the Taos Hispanic Arts Council, and El Centro Cultural de Nuevo México in Albuquerque. Many of these groups are still actively involved in advocating for Hispanic visual and performing artists, providing venues for their members' works, and promoting the establishment of venues. The Organization of Hispanic Artists was successful in establishing a contemporary art market held side by side with the Spanish Colonial Arts Society's annual Spanish Market, which exhibits only traditional art. El Centro Cultural de Nuevo México was pivotal in the early efforts to establish the National Hispanic Cultural Center in Albuquerque. The Taos Hispanic Arts Council filled a need for exhibit space, marketing and business training, and advocacy efforts on behalf of the Hispanic artists of northern New Mexico.

In the summer of 1992, New Mexico was the featured state for the Smithsonian Institution's annual Folklife Festival on the Mall in Washington, D.C. Approximately two hundred traditional artisans and contemporary artists, scholars, and other cultural interpreters traveled to Washington for the two-week event to showcase New Mexico's multicultural arts and lifeways before thousands of national and international festival visitors.

In 1993, the New Mexico state legislature established a new Division of Hispanic Culture in order to "create a greater appreciation and understanding of the Hispanic culture for the public at large." The division operates the National Hispanic Cultural Center, located in Albuquerque, not far from the Río Grande where the first settlers passed almost four hundred years ago.

Chronology

1527 Cabeza de Vaca party begins eight-year odyssey through American Southwest.

1539 Fray Marcos de Niza and Estebanico encounter Zuni Pueblo.

1540 Coronado leads first large exploration of Arizona, Río Grande Valley, and northeast to Kansas.

1598 Oñate establishes first Spanish colony and first permanent European settlement in North America, in New Mexico; first evidence of performance of Spanish folk drama.

1609 New Mexico becomes a royal colony.

1610 Villa Real de Santa Fe founded.

1680 Pueblo Revolt drives Spanish out of New Mexico for next twelve years.

1692 Vargas makes first exploratory journey to New Mexico.

1693 Vargas returns with settlers; siege of Santa Fe.

1695 Villa de Santa Cruz de la Cañada established north of Santa Fe.

1706 Villa de Alburquerque established in lower Río Grande Valley; Comanches appear in New Mexico.

1779 Anza defeats Comanche leader, Cuerno Verde, and begins forging lasting peace.

1807 Pike enters New Mexico and is imprisoned.

1821 Mexico declares independence from Spain and claims New Mexico as its province.

Santa Fe Trail opens; Spanish trade restrictions officially lifted.

1837 Northern New Mexico Rebellion; Padre Martínez brings first printing press to New Mexico.

1841 Texas military expedition to New Mexico.

1846 Mexican-American War declared; Kearny invades New Mexico in bloodless attack; end of 250 years of Spanish and Mexican rule in New Mexico.

1847 Taos Rebellion; New Mexico placed under military rule.

1848 Treaty of Guadalupe Hidalgo officially ends Mexican-American War.

1850 New Mexico becomes a United States territory.

1851 Bishop Lamy arrives in New Mexico and eventually builds forty-five new churches and several parochial schools.

1862 Confederates invade New Mexico.

1879 Beginning of railroad building in New Mexico.

1891	Free public schools open.
1898	New Mexico Rough Riders fight in war with Spain.
1910	Mexican Revolution begins. Civil war rages throughout Mexico, leading to increased migration into New Mexico by political refugees and migratory labor.
1912	New Mexico becomes a state.
1915	Migration of professional artists from the eastern United States begins.
1917	Navajo Code Talkers baffle the Germans in World War I (see bibliography).
1930s	The New Mexico State Department of Vocational Education establishes vocational training schools throughout New Mexico to train individuals in traditional New Mexican crafts.
1935	President Franklin D. Roosevelt launches the Works Progress Administration nationwide. In New Mexico, the program employs persons qualified in art, music, drama, and writing to create, collect, present, and record the arts of the region and establish art training and exhibition centers.
1939–45	Navajo Code Talkers baffle the Japanese in World War II; inordinate number of New Mexico Hispanic men serve in World War II; the New Mexico National Guard is captured by the Japanese, who send them on the Bataan Death March.
1948	New Mexico's Native Americans given right to vote.
1989	The Museum of International Folk Art opens its Hispanic Heritage wing, a permanent exhibition space featuring the art and culture of over four hundred years of Hispanic presence in the region.
1992	Two hundred New Mexican artisans and scholars travel to Washington, D.C., to present the cultures of New Mexico at the Smithsonian Institution's annual Folklife Festival on the Mall in a two-week showcase series of events.
2000	National Hispanic Cultural Center opens its doors.

Glossary

Buffer zone—Outlying province that served as first line of defense against an enemy. New Mexico was a buffer zone for New Spain; Abiquiú was a buffer zone for Río Grande Valley settlements.

Conquistador—Spanish for conqueror. Name given to explorers of the New World in the name of the king of Spain.

Genízaro—Hispanicized Indians who had been captured or freed from captivity by the Spanish. Many worked in Spanish households, intermarried with Spanish, and became part of Spanish society. The majority of genízaros were youth bought from tribes such as the Comanches.

Land grant—The tract of land in New Mexico granted by Spain and Mexico to a group of individuals to settle and develop.

Manifest Destiny—An ideology that the United States should expand westward across the continent, that this expansion was the nation's destiny regardless of previous occupation in the new lands.

Merced or Grant—Permission from the Spanish monarch, or Mexican government after 1821, to an individual to own and settle and develop parcels of land in the provinces. In New Mexico, grants prior to 1821 were executed by the governor in the name of the king of Spain.

Mission—A post or station with a priest whose purpose is to introduce and promote religion in a foreign land. In the case of New Mexico, the Franciscan friars promoted the Roman Catholic faith.

Nuevomexicano—Hispanic New Mexican.

Pueblo—Spanish for town; also used to describe the permanent Indian communities of New Mexico. Its inhabitants were called Pueblos or Pueblo Indians.

Villa—Spanish for town; used to describe the Spanish settlements established by royal order in New Mexico, including El Paso, Albuquerque, Santa Fe, and Santa Cruz de la Cañada.

Bibliography

Adams, Eleanor B., ed. *Bishop Tamaron's Visitation of New Mexico, 1760*. Albuquerque Historical Society of New Mexico, 1954.

Adams, Eleanor B., and Fray Angélico Chávez, trans. and annot. *The Missions of New Mexico, 1776: A Description by Fray Francisco Atanasio Domínguez with Other Contemporary Documents*. Albuquerque: University of New Mexico Press, 1956.

Anaya, Rudolfo A., and Simon J. Ortiz, eds. *Ceremony of Brotherhood, 1680–1980*. Albuquerque: Academia Press, 1981.

Awalt, Jeff, ed. "State Lines." *Albuquerque Journal* (30 August 1987).

Bancroft, H. H. *History of Arizona and New Mexico: 1530–1588*. Albuquerque: Horn and Wallace, 1962.

Bolton, Herbert E. *Coronado: Knight of Pueblos and Plains*. Albuquerque: University of New Mexico Press, 1981.

Briggs, Charles L., and John R. Van Ness, eds. *Land, Water, and Culture: New Perspectives on Hispanic Land Grants*. Albuquerque: University of New Mexico Press, 1987.

Bustamante, Adrian, and Marc Simmons, trans. *The Exposition on the Province of New Mexico by Don Pedro Baptista Pino*. Albuquerque: University of New Mexico Press, 1995.

Cabeza de Vaca, Alvar Núñez. *Adventures in the Unknown Interior of America*. Translated and annotated by Cyclone Covey. Albuquerque: University of New Mexico Press, 1983.

Campa, Arthur L. *Hispanic Culture in the Southwest*, 21. Norman: University of Oklahoma Press, 1979.

Castañeda, Pedro de, et al. *The Journey of Coronado*. Translated and edited by George Parker Winship. 1933. New York: Dover Publications, 1990.

Chávez, Fray Angélico. *But Time and Chance: The Story of Padre Martínez of Taos, 1793–1867*. Santa Fe: Sunstone Press, 1981.

———. *Coronado's Friars*. Washington, D.C.: Academy of American History, 1968.

———. *My Penitente Land: Reflections on Spanish New Mexico*. Albuquerque: University of New Mexico Press, 1974.

Chávez, John R. *The Lost Land: The Chicano Image of the Southwest*. Albuquerque: University of New Mexico Press, 1984.

Coues, Elliott. *The Expeditions of Zebulon M. Pike*. 1810. New York: Francis P. Harper, 1895.

Deutsch, Sarah. *No Separate Refuge: Culture, Class, and Gender on an Anglo-Hispanic Frontier in the American Southwest, 1880–1940*. New York: Oxford University Press, 1987.

Durán, Tobías. *We Come as Friends: The Social and Historical Context of Nineteenth-Century New Mexico*. Albuquerque: Southwest Hispanic Research Institute, University of New Mexico, 1984.

Dutton, Bertha P. *American Indians of the Southwest*. Albuquerque: University of New Mexico Press, 1983.

Ebright, Malcolm. *Land Grants and Lawsuits in Northern New Mexico*. Albuquerque: University of New Mexico Press, 1994.

Espinosa, Aurelio M. and José Espinosa. *Los Tejanos*. Manuscript collected in 1931.

Etulain, Jacqueline J. *Mexican Americans in the Twentieth-Century American West: A Bibliography*. Occasional Papers, No. 3. Albuquerque: Center for the American West, University of New Mexico, 1990.

Etulain, Richard. *Contemporary New Mexico, 1940–1990*. Albuquerque: University of New Mexico Press, 1994.

Ferguson, Harvey. *Grant of Kingdom*. Albuquerque: University of New Mexico Press, 1975.

Fontana, Bernard L. *Entrada: The Legacy of Spain and Mexico in the United States*. Albuquerque: University of New Mexico Press, 1994.

450 Años del Pueblo Chicano/450 Years of Chicano History in Pictures. Albuquerque: Chicano Communications Center, 1976.

Gallegos, Bernardo P. *Literacy, Education, and Society in New Mexico, 1693–1821*. Albuquerque: University of New Mexico Press, 1992.

Gómez-Quiñones, Juan. *Chicano Politics: Reality and Promise, 1940–1990*. Albuquerque: University of New Mexico Press, 1990.

———. *Mexican American Labor, 1790–1990*. Albuquerque: University of New Mexico Press, 1994.

———. *Roots of Chicano Politics, 1600–1940*. Albuquerque: University of New Mexico Press, 1994.

Gonzales-Berry, Erlinda. *Paso por Aquí: Critical Essays on the New Mexican Literary Tradition, 1542–1988*. Albuquerque: University of New Mexico Press, 1989.

Gregg, Josiah. *Commerce of the Prairies.* Edited by Max L. Moorhead. Norman: University of Oklahoma Press, 1954.

Griswold del Castillo, Richard, and Richard A. García. *César Chávez: A Triumph of Spirit.* Norman: University of Oklahoma Press, 1995.

Hammond, George P. *Don Juan de Oñate and the Founding of New Mexico.* Santa Fe: El Palacio Press, 1927.

Hewett, Edgar L., and Reginald G. Fisher. *Mission Monuments of New Mexico.* Albuquerque: University of New Mexico Press, 1943.

Horne, Gerald, ed. *Thinking and Rethinking U.S. History.* New York Council on Interracial Books for Children, 1988.

Jenkins, Myra Ellen, and Albert H. Schroeder. *A Brief History of New Mexico.* Albuquerque: University of New Mexico Press, 1974.

Jensen, Joan M., and Darlis A. Miller, eds. *New Mexico Women: Intercultural Perspectives.* Albuquerque: University of New Mexico Press, 1986.

Jones, Oakah L. Jr. *Los Paisanos: Spanish Settlers on the Northern Frontier of New Spain.* Norman: University of Oklahoma Press, 1979.

Kessell, John L. *Kiva, Cross, and Crown: The Pecos Indians and New Mexico, 1540–1840.* Albuquerque: University of New Mexico Press, 1987.

———. *Letters From the New World: Selected Correspondence of Don Diego de Vargas.* Albuquerque: University of New Mexico Press, 1992.

———. *The Missions of New Mexico Since 1776.* Albuquerque: University of New Mexico Press, 1980.

Kessell, John L., et al., eds. *Remote Beyond Compare: Letters of Don Diego de Vargas to His Family from Spain and New Mexico, 1675–1706.* Albuquerque: University of New Mexico Press, 1989.

Kessell, John L. and Rick Hendricks, eds. *By Force of Arms: The Journal of Don Diego de Vargas, New Mexico, 1691–1693.* Albuquerque: University of New Mexico Press, 1992.

———. *The Spanish Missions of New Mexico. 2 vols.* New York: Garland Publishing, 1991.

Kessell, John L., Rick Hendricks, and Meredith D. Dodge, eds. *To the Royal Crown Restored: The Journals of Don Diego de Vargas, New Mexico, 1692–1694.* Albuquerque: University of New Mexico Press, 1995.

Lamadrid, Enrique R., and Jack Loeffler. *Tesoros del Espíritu: A Portrait in Sound of Hispanic New Mexico.* Albuquerque: El Norte/Academic Publications, 1994.

Lamar, Howard R. *The Far Southwest 1846–1912: A Territorial History.* Rev. ed. Albuquerque: University of New Mexico Press, 2000.

Lavender, David. *The Southwest.* Albuquerque: University of New Mexico Press, 1980. 124–25.

Lewin, Stephen, ed. *Hispanic America to 1776.* Englewood Cliffs, N.J.: Globe Book Company, 1993.

Long, Haniel. *Interlinear to Cabeza de Vaca: His Relation of the Journey from Florida to the Pacific, 1528–1536.* 1936. Tucson: Peccary Press, 1985.

Lujan, Josie Espinoza de. *Los Moros y Cristianos: A Spectacular Historic Drama.* Chimayó, N.Mex.: Josie Espinoza de Lujan, 1992.

Mares, E. A., Bette S. Weidman, Thomas J. Steele, Patricia Clark Smith, and Ray John de Aragón. *Padre Martínez: New Perspectives from Taos.* Taos, N.Mex.: Millicent Rogers Museum, 1988.

Meléndez, Gabriel. *So All Is Not Lost: The Poetics of Print in Nuevomexicano Communities.* Albuquerque: University of New Mexico Press, 1997.

Moorhead, Max L. *New Mexico's Royal Road: Trade and Travel on the Chihuahua Trail.* Norman: University of Oklahoma Press, 1958.

New York Times News Service. "Code Talkers Were Used Earlier, Documents Show" in *Albuquerque Journal*, 1995.

Noble, David Grant. *Pueblos, Villages, Forts, and Trails: A Guide to New Mexico's Past.* Albuquerque: University of New Mexico Press, 1994.

Norquest, Carol. *Río Grande Wetbacks: Mexican Migrant Workers.* Albuquerque: University of New Mexico Press, 1972.

Nostrand, Richard L. *The Hispano Homeland.* Norman: University of Oklahoma Press, 1992.

Otero, Miguel Antonio. *My Life on the Frontier, 1864–1882.* Albuquerque: University of New Mexico Press, 1987.

Roberts, Calvin A. and Susan A. Roberts. *A History of New Mexico*. Albuquerque: University of New Mexico Press, rev. ed. 1991. 172–73.

Sánchez, Joseph P. *The Río Abajo Frontier, 1540–1692: A History of Early Colonial New Mexico*. Albuquerque: The Albuquerque Museum, 1987.

Sando, Joe. Personal communication, October 1991.

Simmons, Marc. *Along the Santa Fe Trail*. Albuquerque: University of New Mexico Press, 1986.

———. *Coronado's Land: Essays on Daily Life in Colonial New Mexico*. Albuquerque: University of New Mexico Press, 1991.

———. *New Mexico: An Interpretive History*. Albuquerque: University of New Mexico Press, 1988.

Tobias, Henry. *A History of the Jews in New Mexico*. Albuquerque: University of New Mexico Press, 1992.

Weber, David J. *Foreigners in Their Native Land: Historical Roots of the Mexican Americans*. Albuquerque: University of New Mexico Press, 1973.

———. *The Mexican Frontier, 1821–1846: The American Southwest Under Mexico*. Albuquerque: University of New Mexico Press, 1982.

———. *Myth and the History of the Hispanic Southwest*. Albuquerque: University of New Mexico Press, 1990.

———. *On the Edge of the Empire: The Taos Hacienda of Los Martínez*. Santa Fe: Santa Fe Museum of New Mexico Press, 1996.

———. *Spanish Frontier in North America*. New Haven, Conn.: Yale University Press, 1992.

Weigle, Marta, and Peter White. *The Lore of New Mexico*. Albuquerque: University of New Mexico Press, 1988.

Villagrá, Gaspar Perez de. *Historia de la Nueva México, 1610*. Translated and edited by Miguel Encinias, Alfred Rodriguez, and Joseph P. Sánchez. Albuquerque: University of New Mexico Press, 1992.

Zeleny, Carolyn. *Relations between the Spanish-Americans and Anglo-Americans in New Mexico*. New York: Arno Press, 1974.

2 Artes del Espíritu: Religious Arts

Santos stand like sentinels in that sacred space where form and faith intersect.
—*Jim Sagel*, "No Hay Mal Que Por Bien No Venga:
The Life of Master Santero Horacio Valdez"

NEW MEXICO WAS FOUNDED on Good Friday in 1598 on the banks of the Río Grande. Since then, the work of the Nuevomexicano artisan has always served religion. In fact, the term "art" is not found in old Spanish dictionaries, and, according to Boyd, it was considered blasphemy for Nuevomexicano artisans to sign their works.

A saint's representation in carved wood and pigment was not considered a work of art but rather the representation of the presence of a holy personage who possessed the power to make things happen—to help a people settle a new land, win a battle, make crops grow, heal a sick child, or find a lost item. They protected and provided. For the friars, painted pictures on hides or wooden panels brought the Bible to life and carried forth the principles of Christianity. The images taught and guided.

New Mexico's geographic isolation had a negative impact on the availability of artisans' materials and tools, but not in the development of its distinctively austere style. Late-twentieth-century research shows that Nuevomexicano artisans were fully aware of prevailing Mexican artistic styles, and that they chose from those elements to develop their own distinct regional style.

In the seventeenth century, the Spanish Crown had generously provided the Mexican-made gilt statues and altar screens for New Mexico's missions, even as it provided orchestral instruments, silver chalices, and fine altar cloths. But after the Pueblo Revolt in 1680, the Crown lost interest in New

Mexico's potential as a viable outpost, and the funding decreased. Friars and settlers were forced to rely on their inventiveness to create devotional and instructional art. At first they copied elaborate baroque images from engravings or pictures in Bibles imported from Mexico. Then in the late eighteenth century, an anonymous artisan known today as the Laguna Santero—for his work at the church at Laguna Pueblo—led the transition from baroque ideals to a new regional style.

For about sixty years thereafter, New Mexico experienced a golden age of religious imagery, which continues to influence the artisans of today—the innovative and traditional descendants of those old masters of an art unknown as Art until the late twentieth century.

Definitions

The religious art of New Mexico took several forms, including:

- painting on buffalo, elk, and deer hides;
- bulto, a three-dimensional statue of a saint or holy personage; (Also known as a *santo de bulto. A bulto de vestir* is a statue with a carved torso and head, and with its bottom half dressed. While fully carved bultos can also be dressed, they are not bultos de vestir.)
- *crucifijo*, or crucifix;
- reredos, or altar screen, a large flat, decorated

structure placed behind the altar in a church; (Its separated sections hold bultos or paintings, or both, as well as columns and other decorative items. The reredos [the plural is reredoses] was also known as a *tabla*, *retablo*, *colateral*, and *altar mayor*. The word reredos is not a Spanish word and was not a term used in colonial times; however, it is used considerably in the late twentieth century.)

- *retablo*, painting on a rectangular wooden panel;
- gesso relief, a retablo rendered in bas-relief through the use of gesso and cloth, which was applied, molded, and allowed to dry, then painted (gesso could also be carved).

Bultos were carved from cottonwood, aspen or juniper, to which a base coat of gesso was applied. Hands and heads might be carved separately and attached to the body. Bultos could be molded with cloth soaked in gesso. All eighteenth- and nineteenth-century bultos were painted. The retablo was cut—often to predetermined proportions developed during the Middle Ages—hand-adzed, smoothed, covered with gesso, and painted with water-soluble pigments made from carbons, earth oxides, vegetable matter, and imported dyes. Gessos were created from animal hide, fat, and gypsum.

The term *santo* is used to designate the saints, the Trinity, and the Virgin Mary, as well as the two- and three-dimensional art that represents them. According to artisan Charles Carrillo, a santo may also be a Sacred Heart, a cross, and even a small plastic statue on a car's dashboard. The defining element is that it is a holy image. Death-cart images, on the other hand, are not santos. The skeleton of the death cart is known as Doña Sebastiana, one nickname among many others, including: La Huesuda, La Pelona, La Parca, and La Calaca.

Each saint or holy personage is usually depicted with its attributes, or objects, with which it is associated. An example is the flowering staff of San José (traditionally the hollyhock, or *Vara de San José*) or the plow and oxen of San Isidro.

The term *santero* was never used in colonial New Mexico to designate a maker of religious images; instead the image maker was called a *pintor* (painter), *escultor* (sculptor) or *maestro* (master). By contrast, a santero was one who cared for a church or chapel and its furnishings, or who repaired or repainted the santos. In the late twentieth century, the term santero means a maker of santos.

To understand these extraordinary works of devotional art, it is necessary to understand the religion for which they were created.

Hispanic Catholicism in Eighteenth- and Nineteenth-Century New Mexico

Members of the Hermandad de Nuestro Padre Jesús Nazareno (brotherhood)—more widely known as the Penitentes (penitents)—were the first preservers of the traditional religious art of New Mexico. In the late nineteenth century, when most native New Mexicans were fascinated by the imported color lithographs distributed by Bishop Lamy's priests, the Hermandad consistently kept and carefully maintained the old reredoses, retablos, and bultos in their homes or in the *moradas* (chapter houses); in other households, the retablos or bultos were stored away and in many cases forgotten in favor of the large European-made plaster-of-Paris statues introduced into churches by Bishop Lamy. The Gothic and Romanesque Revival style statues of the new pieces were more to the bishop's liking, as was the large sandstone cathedral he set about building. He was anxious to replace the older adobe church—which he referred to as a "mud palace"—that had served Santa Fe's faithful for years.

The Hermandad originally called itself La Santa Hermandad de la Sangre de Nuestro Señor Jesucristo (Holy Brotherhood of the Blood of Our Lord Jesus Christ), but after 1860, the name was changed to La Cofradía de Nuestro Padre Jesús Nazareno (Confraternity of Our Father Jesus of Nazareth). The change was precipitated by Bishop Lamy's objection to the term "blood of Christ," with its overtones of flagellation. He sought to suppress the Hermandad itself, for its practices of public penance during Holy Week. Flagellant societies in Spain and throughout Europe had been performing public acts of penance since the eleventh

century, with their activities accelerating during troubled times, such as after a plague or during a drought. In 1777 Charles III of Spain outlawed public penance in Spain and her colonies. New Mexico's extreme isolation made it easy for residents to ignore the Crown's wishes for decades.

Lamy might have succeeded in banning the cofradías altogether had it not been for their advocate, Padre Antonio José Martínez of Taos, who saw the attack on the Hermandad as symptomatic of the growing criticism of Nuevomexicano culture by new arrivals to New Mexico. Ultimately, Martínez's successful efforts to maintain the cofradías and their activities also meant the maintenance of the traditional religious art of the eighteenth and nineteenth centuries.

New Mexico's cofradías were a direct legacy of colonial Mexico, where hundreds of them served as lay religious and charitable organizations in virtually every community. In Zacatecas alone, there were thirty-six such organizations in 1732, each dedicated to worshiping a specific advocation of Jesus,

the Virgin Mary, or the saints. Some popular advocations were the *Santísimo Sacramento* (Most Holy Sacrament), *Animas Benditas* (Blessed Souls), *Jesús Nazareno* (Jesus the Nazarene), *Santo Entierro* (Holy Burial of Christ), *Vera Cruz* (Holy Cross), and *Sangre de Cristo* (Blood of Christ). The members of a cofradía were obligated to maintain the holy image, the altar, the *capilla* (chapel), and/or the church of their patron, and to organize and fund public processions during Holy Week or for their patron's feast day. They also provided for the mutual benefit and protection of their members, from paying for funeral services and masses of members who died, to founding and operating hospitals. It was the most active way for lay persons to be involved in their church.

In addition to lay cofradías, the Jesuits, Franciscans, Augustinians, Dominicans, and Mercedarians all had several cofradías each. The cofradías of the Franciscans, or the Franciscan Order of Friars Minor (their full name), and Dominicans included those known as the Third

2.1

Hermanos praying atop El Cerro at Tomé, New Mexico, 1992. Photo by Miguel Gandert.

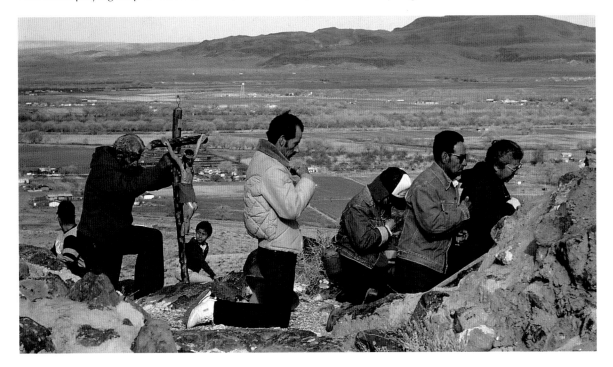

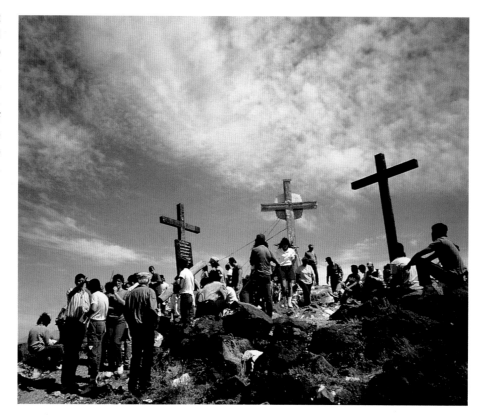

2.2
Hermanos and other pilgrims atop El Cerro at Tomé, New Mexico, December 12, 1989, the feast day of Nuestra Señora de Guadalupe. Photo by Miguel Gandert.

Order of Penance, which were active in New Mexico. In Mexico, the Franciscan Third Order was a lay group that emulated the monastic life of the Franciscans by banding together in semi-monastic settings. Their contribution to public worship was the building and maintenance of the *Via Crucis*, or the Way of the Cross, a series of fourteen events, or stations, that occurred on the day Jesus was crucified, culminating in his burial. In colonial times, these were observed outdoors along a road, leading to a hill, with permanent markers for each event. These Stations of the Cross grew more elaborate as wealthy patrons built chapels. Later, the cost of maintaining the chapels, and the fact that the homeless were using the chapels for shelter, led ultimately to the markers being moved to church interiors. In modern Catholic churches, the *Via Crucis* is displayed by plaques or small high relief tableaux along the walls of the nave; yet in New Mexico, as well as in Spain and Mexico, the Stations of the Cross con-

tinue to be reenacted outdoors during Holy Week in certain communities.

New Mexican cofradías, and the Third Orders in particular, were probably established soon after the reconquest in the 1690s, and were active by the mid-eighteenth century in Albuquerque, Santa Fe, and Santa Cruz de la Cañada, New Mexico's three largest towns. Prior to that, penitential practices of the cofradías—if not the cofradías themselves—were introduced into the area by military and civilian members of Oñate's party in 1598. The specific New Mexico cofradía dedicated to the Blood of Christ was probably introduced from Parral, Mexico, where not only was there a similar cofradía, but also one dedicated to the *Santo Entierro*, an advocation that became prominent in New Mexican religious art as Christ in the Sepulchre. Much of the imagery of Parral is also found in New Mexico, including the death cart, which is widely used during Holy Week activities in both Mexico and New Mexico. Holy Week

encompasses all the activities between Palm Sunday and Easter Sunday, including the Last Supper (known to Protestants as Maundy Thursday), the Suffering and Crucifixion of Christ, and the Resurrection. Elaborate processions reenacting the Stations of the Cross, together with church ritual, fill the week during which the cofradías take the lead in both reenactments and penitential flagellation. Cofradías are still widespread in Spain and Mexico in the late twentieth century and take an active part in Holy Week observances.

The often life-size images of Christ with a Cross, *Santo Entierro*, Christ in the Sepulchre, or Nuestra Señora de Soledad are found in moradas all over New Mexico. Oñate's chronicler, Villagrá, writes of the *Santo Entierro* being displayed during Holy Thursday, which was observed by the settlement party en route to New Mexico. As such, it is probably one of the earliest images to appear in New Mexico.

Death is represented as a female skeleton sitting in a cart holding a bow and arrow or a hatchet. This image is used in Mexico and New Mexico during Holy Week as part of the observance of Christ's Descent and Burial. The cart has come to represent penance and Death's unpredictability. Another possible origin of this startling image is the apocalyptic chariot of death, which features the bow and arrow.

The sorrowful post-Crucifixion Virgin dressed in black is another Holy Week image represented in three-dimensional art as Nuestra Señora de Soledad (Our Lady of Solitude). The continuity of religious practice from Mexico—and prior to that, in Spain—to New Mexico is most notable in the processions where these life-sized bultos are carried on platforms through worshipful crowds. In Spain, the platforms are elaborately decorated with flowers, candles and gilded frames, and are carried by up to sixty men.

Yet New Mexico was far from Spain, and their only connection to the Church was the Franciscan friars, who introduced and maintained religious art in New Mexico. Their spirit of piety, spirituality, poverty, charity, and obedience dominates the daily life and the art of seventeenth- and eighteenth-century New Mexico. William Wroth (1991) writes:

[T]he New World attracted the "spirituals" among the [European] Franciscans, those friars closest to the original spirit of Saint Francis. This spirit of reform still survived among the friars of eighteenth-century Mexico, particularly on the northern frontier [New Mexico], where, in contrast to the settled and wealthy life of central Mexico, there remained a challenging field for their missionary spirit.

The colonists relied on the friars' preservation of the traditions and dogma of the Catholic Church. From this tie grew the lay Third Order of St. Francis, known as Los Tercios, who dedicated themselves to living pious and moral lives. When, in 1760, the Archdiocese of Durango decided to withdraw the Franciscan friars from New Mexico, Los Tercios became even more active to compensate for the friars' absence. In 1831, Bishop Zubiría of Durango denounced the cofradías for their penitential activities, causing them to pull back, but not out.

As in Mexico, the members of the New Mexico cofradías, known as *Hermanos*, also performed much needed community work, called *actos de caridad* (acts of caring). These acts included finding homes for orphaned children, teaching reading and writing, caring for the sick and incapacitated, burying the dead, and donating food, money and/or labor in emergencies. Creating images of devotion for the chapels, churches, and moradas was a natural addition to these tasks in a remote land, where God helped those who helped themselves. In this context, religious art served at many levels. In the home, religious art representing a patron saint of the household or of individuals was displayed and venerated in a special place decorated with flowers, embroidered cloth, and candles. Santos could also be buried with the deceased. In larger homes, religious art was placed in family chapels where visiting priests said mass for the family and neighbors, or from which feast day processions carried bultos from family chapels to the church and back.

On another level, religious art was maintained in common by the members of cofradías and even businesses. Villages named plazas after specific holy personages, and whole communities chose specific

saints for protection. Individuals were assigned to the upkeep of the community's religious artwork housed in the church. At yet another level, there were parishes that included more than one village and that had specific patron saints. La Conquistadora, or Nuestra Señora de la Paz, is considered the patron for all of New Mexico.

As mentioned earlier, the saints served as mediators. An example is the annual vigil held on the feast day of San Isidro (Saint Isidore) on May 15. It begins with a procession that carries the image of San Isidro on *andas* (platforms) from the chapel to the uppermost fields, accompanied by recitation of prayers, singing of *alabanzas* dedicated to the saint, and followed by a communal meal and a night-long vigil. The purpose of the wake is to ensure the saint's blessing for good crops. As patron saint of *rancheros* (farmers/ranchers), Isidro stood for good crops (prosperity) as well as for neighborliness and the respect due to the individual. The relationships between the saints and the people were not static, due to changing weather and village economics, and annual ritual provided the opportunity for their renewal. It is known that processions and transfers of bultos and retablos took place between village and pueblo, thus adding a new dimension to the idea of mediation (Briggs 1980).

The Franciscans and European Influence, 1598–1796

In 1625, a supply train arrived in Santa Fe carrying a gilded, three-leveled altar screen made in Mexico. Later shipments included more altar screens, sculptures, and paintings by seventeenth-century Mexican masters such as Juan Correa and José de Alzibar. These works are still to be found in the San Miguel Church and the Santuario de Guadalupe in Santa Fe, and the churches at Santa Cruz de la Cañada and San Francisco de los Ranchos de Taos.

No confirmed New Mexican-made items have survived from the seventeenth century, but scholars know there was activity at that time, principally through the friars' proselytizing efforts. According to written records, Pueblo Indians painted much of the artwork on church walls and animal hides, under

supervision of the friars. The models for these works were illustrations out of books brought to New Mexico by the friars. These illustrations, together with the shipments of Mexican artwork, introduced New Mexicans to the elaborate baroque religious art initiated by the Counter Reformation in the previous century. At the Council of Trent (1545–63), Roman Catholic Church leaders reaffirmed the use of devotional imagery, despite criticism from proponents of the Reformation. This reaffirmation was to be expressed, over the next two hundred years, in theatrical, artful, and dazzling church interiors and highly realistic artwork calculated to inspire awe and renewed faith, not to mention a rededication to the Church. Furthermore, artists were directed to humanize the saints' appearances in order to inspire the viewer to emulation of their holy lives. As a result, new techniques were devised to achieve realism in statuary, including *encarnación*, in which flesh areas were rendered lifelike by varnishing and sanding up to ten times over. Glass eyes, real eyelashes, ivory teeth, crystal tears, real hair and clothing, thinly carved wood for veils, all were part of the artisans' materials in achieving realism.

Another technique used by Spanish and Mexican artisans was *estofado*, or the application of paint over a layer of gold leaf. The artisan then scraped away small areas of the paint to create patterns, usually on those surfaces representing fabric. This patterned look harkened back to the Moorish passion for busy surfaces.

Several new religious images arose from the baroque enthusiasm for realism and naturalism. According to scholar Donna Pierce, one was a Christ on the cross with his eyes open (all previous representations were of a dead Christ on the cross), gazing downward, head inclined to the right, and mouth open as if to say, "I do this for you." Early-seventeenth-century Spanish sculptor, Juan Martínez Montañés, created this highly emotional image of Christ that eventually spread throughout the New World. In New Mexico, the image was used by santeros Antonio Molleno, José Rafael Aragón and Pedro Antonio Fresquís. The second most reproduced image in the Hispanic New World was Christ gasping as if taking his last breath, according to Pierce whose research in this area has

illuminated the ties between Spain and the New World. Christ in the Sepulchre also spread throughout the New World. In two-dimensional painting, the baroque aesthetic was characterized by realism achieved through attention to perspective (perception of depth and space relationships), shading to create perspective, careful use of color, use of dark colors, sentimental facial expressions, and elaborate robing and busy backgrounds showing buildings and landscapes.

In the seventeenth century, missionary friars in New Mexico enjoyed the full support of the Spanish Crown in their efforts to establish missions and churches throughout the region. After the Pueblo Revolt and the withdrawal of much of the royal funding, both friars and colonists found themselves essentially on their own on a remote frontier. In addition, most of the ornate Gothic and baroque altar screens, sculptures, and paintings brought to New Mexico during the seven-

teenth century had been destroyed during the Revolt. With the expense and difficulties of importation from Mexico, the religious art of eighteenth-century New Mexico was created locally using whatever materials were available.

Animal Hide Paintings

The earliest surviving examples are paintings on tanned animal hides and textiles, dating from at least 1630. Fray Domínguez reported seeing large numbers of such hide paintings during his official visit in the early eighteenth century. Sixty-eight have survived to this day. Transparent dyes were used to paint on hides of elk, buffalo, and deer, depicting New Testament scenes and various saints, with baroque borders painted to resemble gilded wooden frames. The style of the paintings reveals a rudimentary understanding of European artistic techniques, including perspective, shading, and attention to architectural detail.

Religion and Respect

Twentieth-century observers note that the faces found on bultos and retablos are inadvertent self-portraits of Nuevomexicanos. The religious art of New Mexico also reflects the long-internalized respect, earnestness, and quiet, if somewhat staid, dignity of the faithful it serves. In a morada, for example, one never crosses the legs, which would be a sign of relaxing and a lack of respect. One is never relaxed in such settings, but rather at attention in the presence of the holy. Such physical stances are comparable to the rigid look of carved bultos, forever at attention in the same holy Presence. During Holy Week, children outdoors were not to run, shout, or even bounce a ball. Housekeeping was kept at a minimum; meals were prepared in advance because cooking was discouraged from Thursday to Sunday of Semana Santa *(Holy Week).*

The respect engendered by religious adherence

was carried over into daily life as well. In the early twentieth century, young people stood while elders sat. One resident of the San Luis Valley remembered that as a young boy he was expected to stand virtually at attention to one side of his visiting elders, ready to fetch whatever was requested (Montaño 1979).

So all-pervasive was religion in the lives of the founding Spanish that they named valleys and other landmarks after saints and religious concepts: Santa Fe (City of the Holy Faith), Santa Cruz de la Cañada (Holy Cross of the Ravine), the Sangre de Cristo (Blood of Christ) Mountains, the Río del Espíritu Santo (the Holy Spirit River—the Mississippi and Missouri Rivers thus named by de Soto), the Sacramento (Sacrament) Mountains, the San Juan (Saint John) Mountains, and the San Luis (Saint Louis) Valley.

2.3
Hide painting, *Nuestra Señora de Guadalupe*, early 18th century. Courtesy Museum of International Folk Art, 66.56–1. Photo by Miguel Gandert.

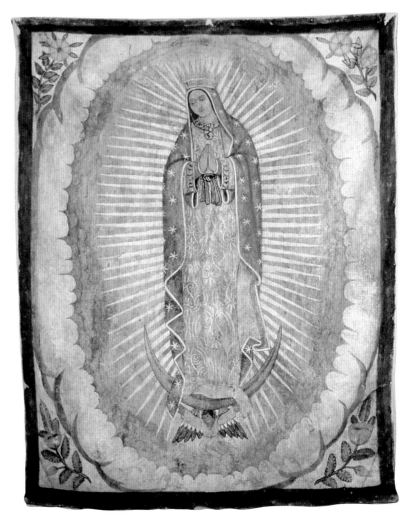

Ecclesiastical disapproval of hide paintings was almost immediate, but artisans continued to produce them well into the nineteenth century (the famed santero Antonio Molleno created hide paintings in the early nineteenth century). Visiting Mexican clerics, and later Bishop Lamy, disapproved of the painted hides and endeavored to encourage other forms of decoration. Many were cut up and used to patch sacks or bind books. Those of northern Mexico were destroyed in Apache raids.

At the same time that hide painting was flourishing in New Mexico, the Altar of the Kings, one of the largest and most florid altar screens ever created, was installed in the cathedral at Mexico City. Scholars have come to call its trademark profusion of carved and gilded vines and flowers "the golden jungle." A direct result of the baroque backlash to the Reformation, the Altar of the Kings represented the most ornate of four styles in use in Hispanic America during the eighteenth century. The other styles were a simplified Renaissance style, Mexican rococo style, and a newly emerging folk style that will be discussed in the next section. In the simplified Renaissance style, the artisan focused on perspective and architectural detail, as well as on the realistic representation of faces, the human form, and robing, with less emphasis on profuse baroque flourishes. The Mexican rococo style was characterized by the use of pastel colors, patterned surfaces, com-

plex iconography, narrative subject matter, and asymmetrical compositions.

Imported religious art in eighteenth-century New Mexico consisted mostly of oil paintings on canvas for churches or wealthy homes. However, New Mexico also was home to two prominent part-time artists who were assigned from Mexico to serve in New Mexico—one as a friar and the other as a military captain and cartographer. A third, anonymous artist is known by scholars as the Eighteenth-Century Novice.

Captain Bernardo Miera y Pacheco

Born near Burgos, Spain, Miera y Pacheco lived in New Mexico from 1756 until his death in 1785. He used some oils (unusual for New Mexico) as well as tempera to paint on canvas, bultos, and retablos, which he then sold to native converts. He painted in the baroque and Mexican rococo styles, creating the bulto of San Felipe for the San Felipe Pueblo church, as well as two archangels for Zuni Pueblo, and a bulto of San José for the church of San José de Gracia in Las Trampas. His most important work, however, is the large stone altar screen created for La Castrense, the military chapel that once stood on the plaza in Santa Fe. This imposing reredos was completed in 1761 and today is part of the Church of Cristo Rey, also in Santa Fe. It was carved in bas-relief and painted, and is the first instance of the appearance in New Mexico of the *estípite* column (discussed in the section on architecture). The idea of columns separating panels holding separate saints was copied by New Mexican artisans through the late twentieth century. It also influenced the makers of gesso reliefs, including the Laguna Santero and, through him, Molleno and other nineteenth-century artisans.

Fray Andrés García

Fray García served in New Mexico from 1747 to 1779, where he renovated several churches and provided them with images, altars, pulpits, confessionals, and balustrades. Like Miera y Pacheco, Fray García worked in the prevailing styles of the day. His works reveal attention to composition and balanced proportions. He used lighter touches of

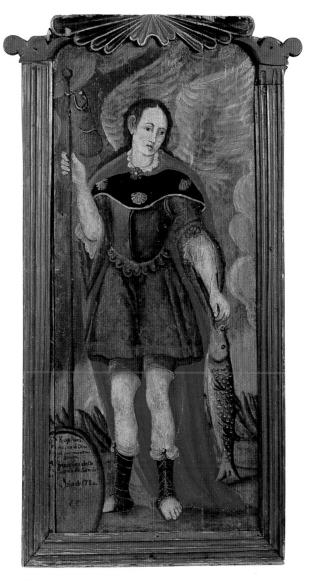

Fig. 2.4
San Rafael Arcángel (St. Raphael the Archangel) by Bernardo de Miera y Pacheco, 1780. Commissioned by Doña Apolonia de Sandoval, wife of Salvador García de Noriega of Santa Fe. Courtesy Spanish Colonial Arts Society Collection, acc. #L.5.54–77. Gift of Frank E. Mera. Photo by Jack Parsons.

paint, applied delicately for subtle effects. His paintings were done in oils, while his bultos were done in tempera. The sculptures of *Nuestra Señora del Rosario* and the *Santo Entierro* at the church at Santa Cruz de la Cañada, as well as pieces at the churches of San Gerónimo in Taos and San José in Laguna Pueblo, are thought by some scholars to be his works. In subsequent years, some of his work has been painted over by others, making it difficult to attribute the works correctly.

Eighteenth-Century Novice

A third artisan who flourished at this time is known today as the Eighteenth-Century Novice, but may have been Miera y Pacheco's son, according to Pierce. This artisan's work, done mostly in oils, shows less skill than Miera y Pacheco, but with an attempt to imitate his style.

Transition and the Golden Age, 1796–1860

When the Franciscans were pulled out of New Mexico in the late eighteenth century, local artisans began to develop a unique regional style that disregarded perspective, shading, dark colors, attention to robing, dense backgrounds, or other elements of the baroque style as practiced in Mexico. Instead, the new style of early-nineteenth-century New Mexico emphasized stylized facial features, hands, and robing outlined in black lines, and the use of bright colors. Using materials available to them, these local santeros drew on their study of Mexican and European artisans' works—which were more available in colonial New Mexico than was formerly believed—as well as their own aesthetics, to create the distinctive style designated by

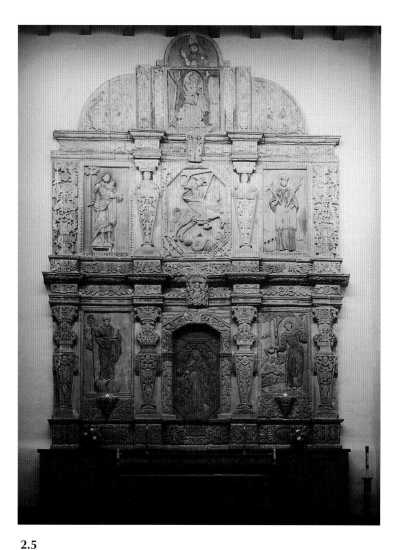

2.5
Stone reredos at the Church of Cristo Rey in Santa Fe.
Courtesy Museum of International Folk Art.

twentieth-century scholars as New Mexico's golden age of religious art.

The Laguna Santero

The anonymous artisan who led the transition to the new folk style is named after his final work, an altar screen at Laguna Pueblo. This artisan flourished from 1796 to 1808, a surprisingly short time during which he operated a highly organized and productive workshop where apprentices created

reredoses, retablos, hide paintings, gesso reliefs, decorative niches, and possibly bultos.

The significance of the Laguna Santero is his position as a stylistic "bridge" between the eighteenth-century imitation of European styles and the new regional style of New Mexico. His work greatly influenced subsequent golden-age artisans of New Mexico by simplifying baroque elements while retaining certain elements, such as decorative shells, ovals, and diamonds. He added translucent white dots to decorate clothing. Faces are Byzantine in their beauty and simplicity, eyes are slightly shaded, and hands are drawn large. Backgrounds no longer show dark buildings or landscaping, but rather elaborate floral designs—a simplification of the baroque "golden jungle"—or saint's attributes, such as a cross or other item.

Unlike baroque or rococo artisans, the Laguna Santero painted not in oils, but in water-based pigments. Oils were an expensive import-item given the region's remoteness. The Laguna Santero's use of tempera would set the standard for the nineteenth century. In addition, according to Taylor and Bokides, the workshop used medieval proportional measurements based on multiples of the *vara* (equal to 33 inches) when producing altar screens for the Chapel of San Miguel and the Parroquia (parish church) in Santa Fe, and churches at Pojoaque, Zía, Santa Ana, and Acoma. The workshop also used standard formats, techniques, colors, and styles, including the use of Solomonic (twisting) columns on altar screens. Solomonic columns were a baroque architectural feature that was copied throughout the nineteenth century in two-dimensional painting. Some of the gesso reliefs featured heads carved of wood and attached to the panel. These low-relief pieces recall a similar tradition in Spain involving high-relief carved wood. Most surviving gesso-relief panels are surmounted by a truncated triangle, a variation of the semicircular lunette or shell pattern used in two-dimensional works and used by late-twentieth-century graphic artists as a typically "Hispanic" pattern.

The workshop of the Laguna Santero came as close to a guild as anything before or after this time. It was highly organized and produced large quantities of items in a short period of time, while simul-taneously training apprentices whose works became known as the School of the Laguna Santero, according to Pierce and Wroth. In addition, art historians trace his influence in the works of Antonio Molleno, José Aragón, and José Rafael Aragón, leaders of New Mexico's golden age, who took the work of the Laguna Santero to its fullest expression.

Antonio Molleno

Known by the name found on the back of a retablo, this santero is from Chimayó and may have been a genízaro (Hispanicized Indian), judging from the Indian elements in his work. If this is so, then Wroth suggests that Molleno's work

Fig. 2.6
Nuestra Señora de los Dolores (Our Lady of Sorrows) by the Laguna Santero. Photo by Susan Einstein, from the Gene Autry Western Heritage Museum, Los Angeles.

represented the blending of European religion with Native American artistic values, resulting in a unique style derivative of no other.

Molleno's altar screens are at the chapel in Talpa, New Mexico, completed in 1828, and the Santuario de Chimayó, probably completed by 1818. A second screen at the Santuario was completed after 1820. Molleno also produced retablos and was probably a student of the Laguna Santero, as revealed by similar stylistic elements in his early period. Molleno's three distinct periods of art production move from the colorful and complicated to the use of limited color and a more simplified, even severe, style. In his mature phase, Molleno delineated faces and figures with a minimum of lines, and with no shading that might indicate depth. Bodies are elongated, with heads and hands proportionally larger than the rest of the body. Molleno uses Solomonic columns, oval frames within a rectangular field, and floral borders.

Quill Pen Santero

The Quill Pen Santero, who flourished in the 1830s and 1840s, was a follower of Molleno. The term "quill pen" refers to the presence of thin lines that look as if they were made with a quill pen. This painter's work is characterized by a clear, sharp outlining of faces, bright colors, and the use of symbolic images, floral designs, and ovals within rectangular fields. His use of the Pueblo cloud symbol and other Native American designs prompted Boyd to speculate that the artist may have been Native American. Like the Laguna Santero, the Quill Pen Santero uses only two-dimensional perspective. In nineteenth-century retablos, this resulted in such unusual visual effects as a tile floor in which the tiles seem stacked vertically next to the main figure, rather than laid flat and leading into the background.

José Aragón

One of the few santeros of the nineteenth century who signed and dated his work, José Aragón made mostly retablos. He flourished in the 1820s and 1830s and may have emigrated from Spain. His work shows that he could read and write, and he copied prayers directly onto his works, often in-cluding references to his sculpture workshop (*escultería*).

Aragón's style is closer to the pre-Laguna-Santero realism than other santeros of this period, with proportionally correct figures, a greater sense of depth, and less abstraction both in the folds of clothing and in the backgrounds of each piece. His work featured pastel colors, light backgrounds, floral corners, and oval frames. He was known to create several of the same paintings and, like many santeros of his day, he drew inspiration from engravings. Wroth considers him to be the most "European" of the nineteenth-century santeros. Aragón is said to have left New Mexico after 1835.

Arroyo Hondo Painter

One of the best known followers of Aragón's style is the Arroyo Hondo Painter, who created a twelve-panel altar screen that once stood in the Church of Nuestra Señora de los Dolores in Arroyo Hondo and is now part of the Taylor Museum collection in Colorado Springs. His characteristics include the use of space-filling dots and dashes, a pattern borrowed from Aragón and elaborated. This artisan limited his palette to red, black, and white, but took care to add shading to faces.

Pedro Antonio Fresquís (1749–1831)

While this artisan did not sign his name to his works, documents attribute the artwork in several churches to him, including those at Truchas, Chimayó, and Santa Cruz. By comparing his style, scholars have identified his work elsewhere, including Chamita and the Rosario Chapel in Santa Fe. He was probably active in the late eighteenth century through the 1820s. His work is influenced by the Mexican rococo style, with pastel colors, asymmetrical composition, and light, delicate patterns in otherwise empty spaces, such as border areas or backgrounds. It is thought that his relatively busy compositions were copied from Mexican prints.

Scholars speculate that works previously attributed to two other anonymously named santeros—the Calligraphic Santero and, later, the Truchas Master—came from the hands of Fresquís. The pursuit of attribution and authentication of works to specific names is an ongoing scholarly puzzle with

pieces generally missing. Variables can include tree-ring dating, overpainting of earlier works, over-cleaning of any work, restorations, discoveries, and the presence or absence of initials, writing, or other clues on each piece or on the reverse side of retablos.

A. J. Santero

A follower of Fresquís was the A. J. Santero, named after the initials found on one retablo. This artisan favored heavily applied gesso, unusual colors such as orange, pink, and purple, and compositions derived from Mexican rococo prints. An unusual feature is the lack of black outlines on faces.

José Rafael Aragón (ca. 1795–1862)

Probably the most skillful and proficient santero of the golden age, José Rafael Aragón was also highly popular in his time, and created many works on commission. His numerous reredoses, retablos, and bultos represent the highest achievement of the age, and an inspiration to santeros for decades after. Contemporary santeros continue to look to his works as their model. "When I carve a santo, I think of the graceful figures José Rafael carved. When I paint a santo, I think of the bright, clear colors this santero used to paint his work," said santero Félix López in 1997 (Miller 1997).

José Rafael Aragón spent the majority of his life in Santa Fe where he was well known as a santero and community leader. While not related to José Aragón, this artisan shares with him not only stylistic similarities, but the unusual habit of signing his works. Rafael Aragón's altar screens may be seen in the churches at Córdova, Chimayó, Pojoaque, El Valle, Picurís, Chama and Llano Largo, among others. The Taylor Museum acquired the altar screens that were at Talpa and Santa Cruz.

Scholars have identified four separate styles in Aragón's work, but the overriding characteristics of his pieces are his technical mastery and what Wroth calls his "powerfully expressive visualization" of the spirituality of the people of New Mexico (Wroth 1982). His work is characterized by clean, confident brush work, careful attention to facial expression and body proportions, bold use of color, and the influence of both the baroque and the Mexican

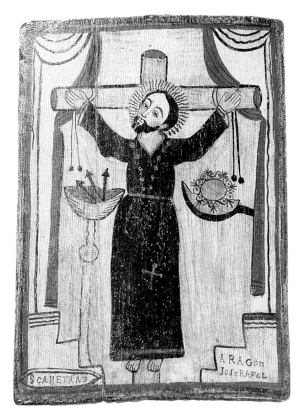

2.7
San Cayetano by José Rafael Aragón. Courtesy Spanish Colonial Arts Society Collection, acc. #L.5.54–54. Gift of Amelia E. White. Photo by Jack Parsons.

rococo, particularly in terms of choice of colors, shading, and expressiveness through body language.

Santo Niño Santero

Aragón's followers included his son, Miguel, and the Santo Niño Santero, named for the large number of representations he created of the Santo Niño de Atocha. His colors were darker, reminiscent of baroque coloration, while still maintaining a refinement and spirituality similar to the works of José Rafael Aragón.

Serving the Brotherhood, 1860–1907

In the second half of the nineteenth century, the demand for retablos and small bultos declined as

European-made lithographs, woodcuts, engravings, and plaster-of-Paris statues continued to be imported in large quantities. At this time, French clergy were, whenever possible, continuing to replace traditional altar screens with neoclassic combinations of statues and altar screens containing niches for statues. The imports were equally venerated. Smaller ones were placed side by side with the retablos and bultos on household altars and in chapels. However, demand increased for life-sized bultos of Passion figures such as *Jesús Nazareno* (a standing figure clothed in real fabric, with movable arms to accommodate the various activities of the Stations of the Cross), *Santo Crucificado* (Christ on the Cross), *Santo Entierro* (Christ in the Sepulchre), *Nuestra Señora de Dolores* (Our Lady of Sorrows), and *Nuestra Señora de Soledad* (Our Lady of Solitude), which were not available from European or American suppliers. As in contemporary Europe, these large figures were carried on *andas* in procession during Semana Santa activities led by the Hermandad. The large bultos were built using hollow frames covered with gessoed cloth in order to render them lightweight for carrying. They were dressed in as beautiful a fabric as was affordable; human-hair wigs and glass eyes were also added by certain makers. The result was striking, particularly in procession. These large bultos were maintained at the moradas during the year. Two of the most popular images in New Mexico were the *Cristo Crucificado* and *Nuestra Señora de Soledad*, which were the two basic images kept by a morada if none other could be had.

Individuals, cofradías, and churches placed orders for images from resident or itinerant santeros. The itinerant santeros, such as Velásquez, lived with families in a community while completing a commission, and also carried some inventory. Payment consisted of crops, livestock, and occasionally, cash. The church sometimes received santos gratis as acts of devotion, or for payment by third parties for religious services such as weddings and burials. Individuals might commission a piece to be presented to a church. Identification of certain santeros has been possible because a number of altar screens bear inscriptions listing the name of the donor, the date of completion, and the santero. New Mexico practice dictated that it was blasphemous for the artist to inscribe his name prominently on images, yet according to Pierce, several santeros did anyway, including José Aragón and José de Gracia Gonzales—those whose training or background reached beyond New Mexico. In the late nineteenth century, a wide distribution of the works of individual santeros indicates their popularity or the fact that they traveled widely.

The masters of this period were José Benito Ortega, José de Gracia Gonzales, Juan Miguel Herrera, and Juan Ramón Velásquez. Lesser known santeros, and those whose names are as yet unknown, are named by scholars as follows:

- The Abiquiú Santero
- The Taos County Santero
- Retablo Styles I through IV
- The Quill Pen Follower
- Front Range Styles I and II (works from east of the Rocky Mountains in Colorado) and
- San Luis Valley Styles I and II—followers of Velásquez, who is said to have worked the Valley (Resident San Luis Valley santeros were Francisco Vigil, Antonio Herrera, and Juan Ascedro Maés.)

2.8

Nuestra Señora de los Dolores (Our Lady of Sorrows) by José Benito Ortega. 24 inches high. Courtesy Taylor Museum, acc. #1595.

José Benito Ortega (1858–1941)

Ortega flourished near Mora, and was, until his name was known, referred to as the Mora Santero and the Flat Figure Santero, for his use of flat milled lumber to create three-dimensional pieces. His bultos were widely dispersed east of the Rocky Mountains, even as the works of Velásquez were widely known west of that range in the Río Arriba area. Ortega was very prolific, and holds the record for the most bultos in public and private collections (two hundred). In addition to the Passion figures he created for the Hermandad, he created popular saints for homes and churches in the remote villages of eastern New Mexico, where plaster images were probably too expensive to be had. Demand for the saints decreased in the 1880s, however, while demand for the Passion pieces continued into the first decade of the twentieth century. Ortega is also thought to have made retablos, but none have been positively identified as his; still, many such pieces are in his style, and accompanying inscriptions match those of his bultos. His bulto style is energetic, but he tended to carve the same stoic face on all the bultos, both male and female, and there is little definition in the bodies. His work reveals influences ranging from the patterning of surfaces as in Mexican rococo, to the medieval and baroque practice of painting the crucified Christ blue to indicate impending death. Ortega stopped making religious art in 1907 when his wife died. He became a house painter and died in 1941.

José de Gracia Gonzales (ca. 1835–1901)

Born in Chihuahua, Gonzales was twenty-five when he moved to Las Trampas, New Mexico. He painted new altar screens and renovated many old ones for chapels throughout the area. In the 1870s, he and his wife and son moved to Trinidad, Colorado, where he lived out the rest of his life with an ever-growing family. His work is in the provincial

2.9

Santo Entierro (Christ in the Holy Sepulchre) by José Benito Ortega, created between 1875 and 1907. Courtesy Museum of International Folk Art, 71.31–116 a, b. Photo by Miguel Gandert.

neoclassical style of northern Mexico. He was a careful painter, using rich colors, oil instead of tempera, floral and other decorative designs, and refined, expressive faces. As a youth in Mexico, Gonzales was apprenticed to an artist where he probably learned to create his own molds, cast them in plaster, and paint them. His work can be found in churches in Las Trampas, Arroyo Seco, Llano de San Juan, Rodarte, and Llano Largo.

Juan Ramón Velásquez (ca. 1830–1902)

Another prolific artisan, Velásquez created many Passion pieces and a handful of smaller pieces for many communities in the Río Arriba area and possibly the San Luis Valley. According to his son, the santero had enough out-of-town commissions to make it practical to take his family on the road for three to six months. His striking bultos feature concave faces, high pronounced eyebrows, wide, high foreheads, high cheekbones and pointed chins.

Juan Miguel Herrera (1835–1905)

A native of Canjilón (like Velásquez), Herrera's working years were spent in Arroyo Hondo, north of Taos, where he was also a musician. His surviving works are large and highly graphic Passion figures emphasizing Christ's suffering. On one of his *Santo Entierros*, he added a spring so that the

mouth was movable, creating quite a stir and a lot of visitors from far away. Other elements are sharply defined ribs, patterned rivulets of blood, and the blue skin color on the *Cristo Crucificado*, also used by Ortega.

Herrera's name came to be known when Cleofas Jaramillo (1972) wrote about her life in Arroyo Hondo in the 1870s and 1880s:

> On Good Fridays, when the little statue was placed on a little table in the middle of the church during the prayer of the stations of the cross, mother called it Nuestra Señora de la Soledad, Our Lady of Solitude . . . Miguel de Herrera, the Santero, had used my aunt as his model. Don Miguel el Santero, who had modeled the sad-looking statue of Nuestra Señora de la Soledad after Aunt Soledad, now came and asked grandmother to let my mother pose for the statue of Nuestra Señora del Rosario, the pretty little statue of Our Lady of the Rosary, carried with Saint John on his feast day.

Herrera was assisted in making large santos by his brother Candelario.

Redefinition and Renaissance, 1908–Present

The early twentieth century saw the traditional santero changing his materials and methods to suit a nonreligious market in a revival initiated by Anglo-American art collectors. In the 1970s, a genuine revival took place among Nuevomexicanos, who took up the art of the santero with new vigor and imagination. Patrociño Barela (1900–1964) broke new stylistic ground with numerous insightful and profound works in the surreal/cubist style. La Escuelita, an informal gathering of eleven santeros in the 1980s, began meeting once a month to carve and exchange ideas. Women who had been working anonymously for their spouses demanded visibility as artisans, thus inspiring other women to pick up the carving knife, power tool, and paint brush to begin producing and exhibiting santos with great success. Indian artisans began creating *nacimientos* (nativity scenes) for sale to the public. Color disappeared in the works of José Dolores López and his followers, but made a comeback in the works of Horacio Valdez, Luis Tapia, and Charlie Carrillo forty-five years later. Subject matter was pushed in new directions as well, particularly in the late twentieth-century works of Luis Tapia, whose religious pieces include nontraditional, contemporary iconography, and whose secular bultos are whimsical and informed with the *Chicanismo* of his formative years. For example, he created bultos of a car's dashboard, a modern prison scene with its attendant sadness, a celebrated flamenco dancer, and a pair of tourists with a camera and a fistful of money as their iconography.

The typical santero/santera of the late twentieth century is an educated urban professional who saw only plaster-of-Paris statues and European reproductions in church as a youth. In most cases, it was

2.10

Jesús Nazareno (Jesus the Nazarene) by Juan Miguel Herrera. This sculpture consists of painted wood, cotton cloth joints and waist cloth. Formerly in the Medina family chapel in Arroyo Hondo, New Mexico, it originally held a 20-inch × 24-inch black wooden cross. Courtesy Taylor Museum, acc. #3859.

necessary to seek out the work of the old masters in books, museums, and collections. After much research on techniques, media, and iconography, the work began, followed not long after by exhibits. Most of today's santeros began exhibiting in the 1970s and 1980s. Their number has grown since the early 1970s, leading to what many call a renaissance of Nuevomexicano art of all types, but especially religious art. Contemporary artisans bring to their work more knowledge of modern Western art, Anglo-American culture, world history, and scholarly literature on the santero tradition. They can make copies of historic pieces, or make eclectic pieces with more Mexican or European influence. They have also carried the traditional style to its apogee.

Santeros and santeras of the late twentieth century know little of the isolation of their ancestors of previous centuries. They are true global citizens, with their works widely exhibited and collected by museums and private individuals worldwide. They travel to give talks and to demonstrate their work, and they are included in numerous books and documentaries on their works. The Spanish Colonial Arts Society has one of the most comprehensive collections of religious art in the world, with about twenty-five hundred pieces, as does the Museum of International Folk Art in Santa Fe, with about five thousand pieces. The museum has mounted exhibits of Spanish colonial objects since the early 1950s when Elizabeth Boyd joined the staff as curator of the collection. In 1989, the museum opened its Hispanic Heritage Wing, the first permanent exhibit of Spanish colonial treasures. Other collections are to be found at the Smithsonian Institution in Washington, D.C., the Millicent Rogers Museum in Taos, the Taylor Museum of Southwestern Studies in Colorado Springs, the Gene Autry Western Heritage Museum in Los Angeles, the Heard Museum in Phoenix, and The Albuquerque Museum.

Throughout the twentieth century, a number of individuals have expressed an abiding interest in collecting and preserving Spanish colonial art and objects, including Ann Healy Vedder and Alan C. Vedder, Ward Alan Minge, Thomas Harwood, Larry Frank, Cady Wells, Mary Austin, Frank Applegate, Fred Harvey, Mary Colter, Jesse Nusbaum, John Gaw Meem, Frank Mera, Leonora Curtin and others.

Redefinition

By the 1910s and 1920s, Nuevomexicanos were struggling with the cash economy introduced by necessity when Anglo-American speculators and the U.S. government acquired much of the land of northern New Mexico. The old economy, which centered on barter and use of communal lands, was no longer possible. To make ends meet, men left home for months at a time to pursue migrant farm work throughout the Southwest. Their absence meant the gradual unraveling of traditional home and community life. To make matters worse, the Semana Santa rituals of the Hermandad fascinated and repelled Anglo-Americans who attended in greater numbers, not to worship, but to watch. In response, the Hermandad retreated. They began holding their rituals far from roadside villages, further into the hills. This prompted even more curiosity and media censure.

In the 1920s, the Taos and Santa Fe art colonies were established by Anglo-American artists who had recently moved to New Mexico, attracted by the climate and exotic local cultures. They sometimes painted *Hispanos* and santos into their own works, but only as elements of local color. In no way did local painting styles or subject matter influence their own styles. Several artists studied and collected the old santos. Frank Applegate is credited with approaching the old retablos and bultos as genuine works of religious art rather than as curios. He became one of the most active buyers of Spanish colonial art, and together with Mary Austin, founded the Spanish Colonial Arts Society in 1929. Since that time, the Society has been responsible for the rescue, restoration, and collecting of numerous works of religious art, from small pieces to an entire church (the Santuario at Chimayó). It continues today to promote and encourage the research and production of traditional arts of New Mexico and to host the annual Spanish Market, a yearly outdoor exhibit and the most important exhibit of traditional Nuevomexicano art in New Mexico.

An example of the economic and stylistic impact

the Anglo-Americans had on local artisans is illustrated in the Spanish Arts Shop, which was operated by the Society in Santa Fe from 1929 to 1934. The staff's selection, or rejection, of certain pieces for sale in the shop influenced the development of artwork through the principle of supply and demand. Further, artisans were chosen to demonstrate in the shop; those artisans whose work didn't meet the Anglo staff's stylistic standards were not invited to demonstrate. Overnight, artisans began altering their styles or items to meet the demand of the new arbiters of Nuevomexicano art, according to Charles Briggs. Anglo-American staff went into the villages where they delivered materials, picked up finished items, and offered advice on techniques and designs that were specific to their tastes and market. They encouraged artisans to produce more goods in less time for higher profits, and they emphasized originality and quality.

In 1980, Charles Briggs wrote *The Woodcarvers of Córdova*, in which he traced the history and impact of these activities on the woodcarvers of Córdova, who over the decades since 1920 have produced numerous examples of secular and religious art. "Most of the patrons . . . were newcomers," writes Briggs (1980):

> They took it upon themselves, however, to inform the Hispanos that they had lost track of their own traditions and sought to teach them both the characteristics of Hispano art and the way in which it was to be adapted to the modern world. The annual fiesta prize competition and the quality test of the Spanish Arts Shop and Native Market judges provided effective forums for the regular reassertion of the current definitions of each type of Spanish colonial arts and crafts.

In addition, the newcomers embraced the Pueblo cultures as mysterious—the archetypal "noble savage" who was inherently good and authentic—while rejecting the Hispano culture as stereotypically untrustworthy, dangerous, and "dirty." Good examples of these attitudes can be seen in early films made in New Mexico by the emerging moviemaking industry.

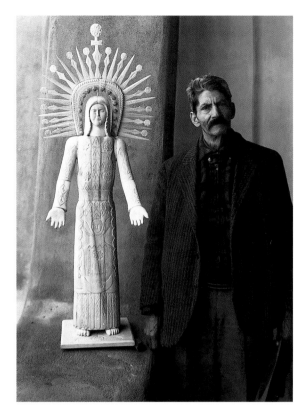

2.11
Portrait taken in 1935 of José Dolores López with a bulto of his making, *Nuestra Señora de la Luz* (Our Lady of Light). Photo by T. Harmon Parkhurst, Courtesy Museum of New Mexico neg. #94470.

For their own purposes, the artisans themselves had only a little familiarity with their artistic heritage after their churches had been redecorated in European styles by Bishop Lamy's French and Italian priests. Yet these artisans were looking for a way to avoid the migrant farm circuit and make ends meet at home. Thus did José Dolores López (1868–1937) of Córdova agree to carve nontraditional items such as lazy susans, record racks, and screen doors in addition to the more traditional pieces. José Dolores López was the son of Nasario López (who may have worked with José Rafael Aragón), father of George López, and grandfather of Gloria López Córdova, Sabinita López Ortiz, and Eluid Martínez, all excellent carvers.

The most significant and long-lasting result of this interaction was that López stopped painting his carvings as suggested by Applegate and Austin, who regularly sold his work in Santa Fe. They found the house paints he used too bright and bold. Thus began the unique Córdova School of carving, which is distinguished from all other work by its lack of paint, and its reliance on detailed incising and chip carving to delineate the features of each piece. By influencing López's output and style, Applegate and Austin were able to combine his artistic inclinations with the tastes of the Santa Fe Anglo market. In following their advice, López found a market niche created for him, and in turn he created a new style of woodcarving that was closer to contemporary Western art than authentic Spanish colonial works of New Mexico. Interestingly, it was only at the suggestion of Applegate and Austin that López began carving santos late in life.

Because of Briggs's book, José Dolores López is probably the most documented santero of New Mexico. Born in 1868, he began as a carpenter and filigree jeweler. His unique and intricate chip-carved style also was introduced by Anglo-Americans who had seen chip-carved pieces in Switzerland. Today, it is the signature style of the villages of Córdova and Chimayó.

As *hermano mayor* of his cofradía and sacristán of the chapel at Córdova, López came under some criticism from his neighbors for selling religious images to Anglo Protestants. A friend of the Lópezes said:

> I remember talking to José Dolores . . . before he died. He told me that the santos he was making weren't from the heart, they weren't religious, but "God won't mind if I make enough money to live. God is happy for anybody who has the initiative to work his own way. This way was good," José Dolores said, "because you were working for yourself." (Briggs 1980)

He didn't call them santos, but *monos*, meaning dolls or figures, especially deformed ones. The controversy over selling religious images to nonbe-lievers, or for money, continues today. Some santeros feel it is a sin to sell santos to nonbelievers, and will sell only secular items to the general public. Others, like late twentieth-century santero Charles Carrillo, believe a santo is not a holy object until it has been blessed.

López's children, George and Liria, also gained reputations as fine carvers. Of his grandchildren, Gloria López Córdova, Sabinita López Ortiz, and Eluid L. Martínez are the most well known. They carve offertory boxes, nacimientos, rosaries, crosses, and tableaux of several figures in one piece (on a flat surface). Secular items include a variety of *animalitos* (animals), plants, death carts, roadrunners (the official state bird of New Mexico), Christmas trees, and doves.

Another avenue for artisans of the 1930s to earn money was the federal programs instituted to help people survive the Great Depression. The Federal Art Project subsidized santeros such as Celso Gallegos (1864–1943) of Agua Fría and Patrociño Barela of Taos. Other santeros sold their work to the Federal Art Project, which brought them national attention through exhibits.

Patrociño Barela

Born in Bisbee, Arizona, around 1900 to impoverished parents, Barela's mother and baby sister died when he was small. His father, a day laborer, migrated with his sons, Patrociño and Nicholas, to Taos, arriving in 1908. His father, who was known to beat him, turned Patrociño out at age twelve. Thereafter, he worked as a child laborer in Taos, then took to the road doing migrant work, mining, whatever was available. He had only a few weeks of formal education, and never learned to read or write. When found unconscious in Denver, he was turned over to an African-American foster family. They were good to him and even taught him to speak English. He returned to Taos in 1930, and married Remedios Trujillo y Vigil, who bore him three children.

He began carving after having repaired a bulto for a priest. He commented later that the bulto, which was constructed of separate parts, prompted him to see if he could make a bulto all of one piece of wood. "Barela believed that the spiritual power

2.12
Portrait of Patrociño Barela by Edward Gonzales. Courtesy of Edward Gonzales.

any way to the illnesses that persisted in the family. With its unrelenting poverty, Barela's life was indeed a challenge. Barela became a posthumous hero in his Taos community.

In 1935, he became a Federal Art Project employee, working as a full-time carver. In 1936, the FAP mounted an exhibit at the Museum of Modern Art in New York, which included eight pieces by Barela, more than any other Federal Art Project artist. It brought him national attention, with positive reviews in *Time Magazine*, the *Washington Post*, and the *New York Times*, which all hailed him as the outstanding artist of the show. Unfortunately, it did not result in representation in a single gallery because the FAP officials who employed Barela botched any interest by agents and galleries. The government terminated the FAP in 1943, and Barela went back to day labor. He died in 1964 when the workshop he slept in went up in flames in the middle of the night.

The significance of Barela's work is that it redefined the traditional parameters of santero art. Santeros since Barela have claimed some degree of influence by his work in developing their own styles. It was very different from what had gone before; it was a complex style of surrealism, expressionism, and eleventh-century Romanesque art. It has also been compared to the folk art of Africa and Oceania. Picasso, Braques, Miró and Dali— Barela's contemporaries—explored primitivism through surrealism and cubism, but Barela did it naturally. Like all santeros of his day, he was self-

of the santo he worked on that day was diminished by its physical weakness, even after having been repaired" (Gonzales and Witt 1996).

The poverty continued unabated and Patrociño carved when he could not find work. He also drank and often traded his works for wine and money. When he found day jobs, he carved at night. Eventually, the drinking and late nights caused his wife to move him to a nearby shed. She didn't understand his need to carve and ultimately the marriage suffered, aggravated by suspicion among neighbors and in-laws, who knew him as an outsider, someone who spent nights carving strange images, and who refused to attend church. He loved the Bible but rejected organized religion. They felt he might be in league with the devil, and wondered if his carvings were connected in

taught. In his art, he explored familial relationships, the human psyche, and the soul. He worked juniper, cedar, and pine to create mostly secular pieces. When a Taos priest asked him to carve "perfect" santos, Barela told friends his answer had been, "I can no carve perfect santos, I not perfect. He [the priest] not perfect either" (Gonzales and Witt 1996).

His work transcends place and time, yielding penetrating insights into human emotional and spiritual life.

> [Barela] delivered brilliant soliloquies on the human condition using only rough, gnarled *trozos de cedro* (chunks of cedar) and his simple knife to produce the words. For reasons known only to him, Barela chose to explore the depths of the human soul and to interpret its myriad aspects through the aromatic and richly colored ox blood or honey gold wood of the heart of cedar. (López 1995)

Renaissance

The renaissance of the 1970s through the 1990s can be traced to several developments in the early 1970s. One was the establishment of La Escuela Artesana (The Artisans' School)—now more popularly known as La Escuelita—an informal, monthly gathering of Nuevomexicano carvers. José Benjamín López of Española founded La Escuelita after returning from serving in the army. He called the men together to carve and exchange ideas, tools, techniques, and to critique. They still met in the 1990s and have exhibited together about four times. The members include José Benjamín López, his brother Leroy of Santa Cruz, Luisito Luján of Nambé, José Alberto Baros of Las Vegas, Félix López of La Mesilla and his brother Manuel of Chilí, José Griego of Embudo, Olivar Rivera of Nambé, Olivar Martínez and Clyde Salazar of La Villita, and Tim Roybal of Medanales.

The members of La Escuelita began meeting at a time when Hispanic woodcarving and painting were not popular among Nuevomexicanos. Outside interest was focused strongly on Native American art, so exhibition opportunities for Hispanic artists were infrequent. Today, the members of La Escuelita sell through exhibits and galleries in the United States and Mexico.

At about the same time, Santa Fe artist/activists Luis Tapia and Frederico Vigil, fired by the Chicano activism of the 1960s and 1970s, traveled throughout northern New Mexico interviewing Nuevomexicano elders in an effort to learn about the rich cultural heritage of their forefathers. They knew that their cultural lives had been shaped by outside forces and were anxious to recapture and explore what had gone before. They co-founded La Cofradía de Artes y Artesanos Hispánicos (The Confraternity of Hispanic Art and Artisans) to encourage the revival and growth of both traditional and

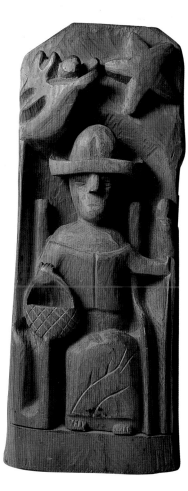

2.13
El Santo Niño by Patrociño Barela. Courtesy The Albuquerque Museum, acc. #89.45.1. Gift of George Schweinitz in memory of Constance I. Morris. Photo by Michael Mouchette.

Tools and Techniques

Woods traditionally used for carving include cottonwood root, juniper, aspen, and willow, with cottonwood root and aspen the most frequently used. Luis Barela, a santero and grandson of Patrociño Barela, uses juniper, which he gathers himself, as do most master santeros and santeras of the twentieth century. The use of cottonwood root is thought to derive from the fact that all kachinas are carved from cottonwood root. It is probable that the Franciscan friars observed this and adopted it not only because it was easy to carve, but as a cultural concession to the Indian craftsmen who created the early church furnishings. It is interesting to note that cottonwood is not used for carving in Mexico. Late twentieth-century santeros use traditional woods as well as cedar, mahogany, ebony, cherry, apricot, Russian olive, elm, basswood, and purple heart. They also carve alabaster.

Cottonwood is very light and has a straight grain. It carves cleanly and has a good tensile strength, which means noses on bultos won't chip off, nor will the wood crack or split. To prepare it for carving, the bark is peeled off, and the wood is split to facilitate drying in the sun. Aspen is good for making santos' hands because it's harder and better for shaping detail. While some contemporary santeros use traditional hand tools to split and shape the wood panels, others use milled lumber, which has been available in New Mexico since the U.S. Army built a mill in 1850. Many master artisans make their own tools, which in the old days probably included pieces of obsidian. Santeros and santeras of the late-twentieth-century also use power tools.

Once the wood is shaped and sanded, a layer of gesso is applied. Gesso is made by baking gypsum rock to draw off the moisture, then grinding it to a powder and mixing it with animal-hide fat, which itself is made by boiling the hide. Gesso provides a smooth surface on which to paint.

Traditional santeros use pigments derived from minerals, insects, and plants. Some nineteenth-century santeros used oil paints when available. Traditional pigments include micaceous clay, iron ore, walnut hulls (walnut trees grow along rivers in New Mexico), and carbon for tans, browns, and blacks; chamisa, yellow clay, and marigolds for yellows; clays and imported vermilion and cochineal for reds and magentas; and azurite and imported indigo for blues. A resin is applied to seal the pigments. Contemporary artisans take advantage of the availability of acrylics, often using them together with natural pigments, which can be expensive (Mexican indigo sells for about $450 per pound) or require tedious preparation or locating and gathering in the wild.

In the twentieth century, renovation and conservation efforts of old works have been pursued by parishioners and museums. Removal of layers of overpainting have restored earlier works to their original condition. One of the most notable restorations is that of the reredos by José Rafael Aragón at Santa Cruz de la Cañada, completed by four noted santeros, Félix López, Manuel López, José Benjamín López, and Gustavo Víctor Goler in 1996. On discovering an earlier painting by either Molleno or the Laguna Santero under Aragón's work, it was decided to conserve Aragón's work. The santeros who worked on the piece later said they learned much about Aragón's style and method during the process. They stabilized and cleaned, added missing gesso, and replaced pigment. José Rafael Aragón is buried in this church, in the chapel of Our Lady of Carmel.

contemporary arts and crafts of Spanish New Mexico. Scholars suggest that Tapia and Vigil chose the term *cofradía* because of its history in New Mexico, and its association with defiance and struggle. To remedy the lack of exposure also experienced by La Escuelita, the group organized numerous exhibits in a variety of grass-roots venues, including community centers and churches. They did not allow or accept Anglo criteria of what constituted traditional art. Part of the reason for establishing these organizations was the need to provide alternative venues to the Spanish Market, whose primarily Anglo jurors continued to determine what was officially "Spanish" and "colonial" and acceptable.

The work of these two groups helped to establish an awareness of heritage among their membership and their growing audiences. The religious art of New Mexico became a tool of cultural resistance, as described by Dr. Enrique Lamadrid (1991):

> Anglo-American tourism, ownership and domination have complicated cultural relations in the upper Río Grande region. As Indian and Hispanic New Mexicans gradually lost control of 80 percent of their land and natural resources, mostly to the United States government, the land and water began to take on symbolic cultural value. The *acequia* is no longer just an irrigation ditch; the *santo* is more than a religious image. Everyday objects and traditions become emblems of a way of life under siege. Religion takes on the added significance of a cultural as well as spiritual refuge. Traditional symbols are reinvested with a new urgency and power upon which rests the very survival of group identity.

Cultural resistance is defined as a people's maintenance of traditional ways, arts, and culture in defiance of imposed change by another people and as an expression of cultural independence.

A direct expression of cultural independence was the deliberate return to painted santos. After Applegate and Austin discouraged José Dolores López from using paint on his bultos, it was several decades before santeros such as Luis Tapia and Horacio Valdez made a deliberate return to painted images. Because the painted, or polychrome, pieces of the late twentieth century are closer in spirit and impact to historic pieces of the eighteenth and nineteenth centuries, they continue to attract serious buyers with greater knowledge of the significance of color in the history of the genre. It also attracted more men and women to study and pursue santo-making.

The polychrome santos were first shown at the Spanish Market in the mid-1970s. Until then, only the unpainted, chip-carved, and incised work of the Córdova School had been exhibited. Throughout the 1970s, the number of exhibitors at Santa Fe's Spanish Market hovered around thirty. Then in the early 1980s, it began to rise gradually, reaching an average of 160 in the late 1990s, not including some one hundred children who exhibit at fifty booths each year. In the 1990s, the Spanish

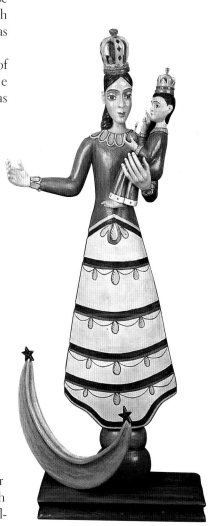

2.14

Nuestra Señora del Rosario (Our Lady of the Rosary) by Félix López, 1994. Courtesy University of New Mexico Maxwell Museum.

2.15
Members of *La Escuelita* at work. From left, Luisito Luján, Félix López, Leroy López, Manuel López, and Benjamín López. Courtesy Spanish Colonial Arts Society, Spanish Market Magazine. Photo by William Clark.

Colonial Arts Society began providing technical assistance workshops to adults and introductory workshops in primary schools to children in a variety of traditional arts. In addition, Northern New Mexico Community College in Española and El Rito began offering courses in santo-making, as well as other traditional Nuevomexicano arts and crafts.

A new phenomenon of the late twentieth century is the rise of the santera. Women had been carving and painting santos alongside their husbands since at least the 1920s, but not until the 1970s did they begin demanding independent credit for their work. The idea of learning to carve and paint santos, with or without a husband, also appealed to women. In 1993, the Museum of International Folk Art in Santa Fe mounted an exhibition of works by santeras, featuring the works of Marie Romero Cash, Gloria López Córdova, María Fernández Graves, Mónica Sosoya Halford, Anita Romero Jones, Ellen Chávez de Leitner, Benita López, Teresa Montoya, Zoraida Ortega, Guadalupita Ortiz, Sabinita López Ortiz, Paula Rodríguez, Tomasita Rodríguez, Rosina López de Short, Carmelita Valdez de Houtman, María Vergara Wilson, Donna Wright de Romero and Irene Martínez Yates.

As religious art greatly increased in popularity and price in the 1980s and 1990s, the idea that it should be reserved primarily for religious purposes in homes or churches rather than as art objects in museums and exhibits, was more frequently artic-

ulated by those who were aware of the negative impact of tourism on the culture. Scholars and santeros alike became concerned over the selling of historic pieces out of the state. Santeros regularly donated pieces to churches or moradas, and sold them to friends and neighbors at lower-than-market costs. Some santeros claim never to have sold a santo.

The Catholic Church in the Twentieth Century
The Hermandad continued to flourish in the late twentieth century in both urban and rural settings. As Hermano Felipe Mirabal put it, "There is a constant call to conversion." One of the most significant developments of the period was the installation in 1974 of Robert Sánchez as archbishop of Santa Fe, who openly embraced Nuevomexicano cultural expression within the church. He encouraged folk masses featuring New Mexican music and appeared in public ceremonies (which were broadcast statewide) wearing vestments of Mexican weaving designs. In 1975, he proceeded to organize the moradas of New Mexico into a *concilio* (council) with newly codified laws. This organization, known as the Concilio Arzobispal, communicated regularly with the archdiocese in a new spirit of cooperation. All of this led to a florescence of religious zeal in New Mexico that expressed itself in increased involvement in the Hermandad, masses and hymns written and published by local composers, the appearance in many churches of the image of Nuestra Señora de Guadalupe, and increased attendance at Holy Week activities, particularly at the Santuario de Chimayó, which emerged as the rallying point for Hispanic Catholicism in New Mexico.

When Archbishop Sánchez left the Archdiocese in 1993, the Concilio was reorganized by his successor, Archbishop Michael J. Sheehan. While the new order gave more offices and power to more people, some Hermanos wonder if that is wise. Others find the reorganized structure, in which power flows from the top to the bottom, a complete reversal of Sánchez's structure, where it flowed from the bottom to the top.

Another significant development in the resurgence of cultural and religious awareness was the national bicentennial celebration in 1976, which inspired urban Nuevomexicanos to examine their cultural and religious heritages for the first time. A morada was established in the 1970s in Albuquerque's South Valley. It is a liberal and open morada, headed by Juan Sandoval, a prolific santero of unpainted bultos and cement sculptures.

As more urban Hispanics rediscovered their rich religious legacy, they encountered a language barrier. In 1995, Hermano Felipe Ortega (also known as a fine potter), created a stir within the Hermandad when he translated into English a *cancionario*, or *cuaderno*, a typically handcopied and recopied collection of Spanish prayers and songs used primarily in the morada. His action acknowledged the fact that Spanish-only activities were on the decline, and that the non-Spanish-speaking faithful should be able to worship in the old ways.

To bridge the old and new, Catholic parishioners in Santa Fe and Albuquerque endeavored to return to traditional art when building a new church. When Albuquerque West Side residents decided in 1985 to build a new parish church on Fortuna Road near Coors Boulevard, they chose to include santos by Gustavo Víctor Goler, Luis Tapia, Horacio Valdez, Leonardo Salazar, and Félix López. These works were installed in niches in the contemporary Southwestern interior, and in a meditation garden. Works by Native American and Anglo artists also grace the interior. The new church, named Our Lady of the Most Holy Rosary, was dedicated in 1992. In 1994, the new mission-style church of Santa María de la Paz was dedicated in south Santa Fe, fully furnished with newly wrought santos, Stations of the Cross, processional crosses, tin-sculpted lamps, hand-carved pews and a traditional altar screen by thirty-six artisans, including santeros, tinsmiths, wood carvers, straw appliqué artists, and weavers. Among the santeros are Ramón José López, Félix López, Marie Romero Cash, and Charles Carrillo.

The last two decades of the twentieth century have seen the rise of numerous fine santeros and santeras. Listed here are only a few of the better-known artisans. While they are divided here into traditionalists, followers of Patrociño Barela, the Córdova School, and innovators, it should be

noted that there is much overlap. Most, if not all, of these santeros and santeras are represented in the museums mentioned above.

The Traditionalists

The largest group of artisans working in the late twentieth century, the traditionalists, draws inspiration and technique from the old masters of the eighteenth and nineteenth centuries.

HORACIO VALDEZ (1929–1992)

Known as the santero's santero and a master, Valdez was also deeply spiritual and not given to exhibiting his works. He was a carpenter by trade until 1974 when he was injured in a construction accident. He then took up carving and became a Penitente. Until his death in 1992, he favored making crucifixes in many sizes; his death carts are unique for their technical merit and style. He made 225 crucifixes and 50 death carts in his later years. His work is characterized by symmetry of form, vibrant colors, a finely polished finish, elegant faces, and finely carved curves and contours on bultos. He was a friend and mentor to many other santeros and was instrumental in bringing national and international attention to the santero tradition of New Mexico.

CHARLES CARRILLO

Carrillo is a primary example of an educated urban Nuevomexicano whose work is based on serious study and research in the carving tools and styles, pigment and varnish preparation, traditional iconography, and painting styles of the old masters. He holds a Ph.D. in anthropology, and teaches and demonstrates traditional santo-making around the country, following his own idea that an artist who does not teach others, teaches no one. His work is colorful, detailed, and animated, as influenced by José Rafael Aragón, the Laguna Santero, Fresquís, and Luis Tapia. One of the most active and visible of the santeros, he creates bultos (including those with built-up gesso relief), reredoses, retablos, and hide paintings. He created a new santo for the protection of the Gulf War troops, which was a Virgin Mary releasing a dove.

Born and reared in Albuquerque, Carrillo now lives in Santa Fe and is an Hermano at the morada at Abiquiú. A book has been written about his life and work, entitled *Charlie Carrillo: Tradition and Soul* (Awalt and Rhetts 1994). In the early 1990s, he contracted to mass produce a five-piece *nacimiento* (nativity scene) to market in the United States. Many were dismayed, and many were pleased to finally afford santo art.

MARIE ROMERO CASH

A member of the prolific and talented Romero family of Santa Fe, her family includes parents Emilio and Senaida Romero (tinwork, colcha), her brother Robert Romero (tinwork), and sister Anita Romero Jones (santera), to name a few. One of her first pieces incorporated a colcha stitch pattern painted on a bulto. She also conducts restoration work, lectures, consults, and

2.16
Death cart by Horacio Valdez. Courtesy Taylor Museum, acc. #7772.

writes on the subject. In 1993, her NEA-funded survey of eighteenth- and nineteenth-century santos in the churches of northern New Mexico was published (*Built of Earth and Song*). In creating her own pieces, she works primarily with watercolors on basswood or pine, emphasizing reds, yellows, and blues. Her styling stresses originality, detail, and lively postures and expressions. She uses gessoed fabric on bultos. Cash (1993) conducted much research on the art of the santero, studying books, museum pieces, and her family's work as her sources.

> Contrary to what many people think, most of us who were raised in Santa Fe were not exposed to the carved wooden *santos* made by the master *santeros* of old. We had St. Francis Cathedral, Our Lady of Guadalupe, and St. Anne's, churches that were filled with marble altars and plaster of Paris statues, waxed pews and tile floors. . . . I didn't know what an altar screen looked like; we didn't have one in the churches in Santa Fe. (Cash 1993)

She has created altar screens for churches at Ojo Caliente, Arroyo Hondo, Española, the Archdiocese Chapel in Albuquerque, and churches in San Luis and Pueblo, Colorado.

Other notable traditionalists are Gustavo Víctor Goler, who is also a trained conservator and whose work emphasizes craftsmanship and attention to detail; Félix López—whose family includes santero Manuel López, and artist and writer on the Hispanic culture, Alejandro López—occasionally incorporates straw appliqué into his work; Guadalupita Ortiz, whose work most closely reveals the influence of Fray Andrés García and Miera y Pacheco, with much shading and attention to realism; Frank Alarid, whose work is influenced by the woodcarvers of Germany and Austria where he was stationed in the military, and by the color sense of Randall Davey, who took the young Alarid into his Santa Fe studio; and Manuel López, the son of a carpenter who painstakingly makes his own pigments and gesso.

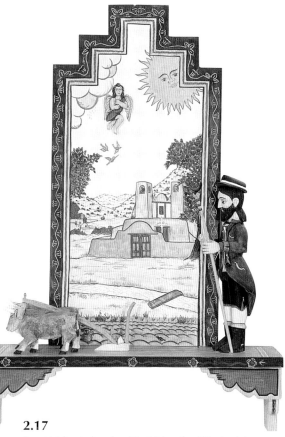

2.17
San Ysidro Labrador (St. Isidor the Worker) by Charles Carrillo. Courtesy New Mexico Capitol Art Collection, New Mexico Capitol Art Foundation, Santa Fe.

Followers of Patrociño Barela
In addition to traditionalists, many twentieth-century santeros show the influence of Patrociño Barela's work in varying degrees, as described here.

LUIS BARELA
Grandson of Patrociño Barela, he began carving soon after attending a show of his grandfather's work at the Santuario de Guadalupe in Santa Fe in 1980. He lives in Taos where he works on images similar to santos, focusing on the family structure of father, mother, and child. While he carves primarily secular pieces, he favors depictions of shepherds and prophets. He brings his wood to a high

polish, but will also leave a rough bark-covered finish when appropriate. He is adept at using the light and dark parts of cedar to create highlights in the figures' bodies and clothing.

LEO G. SALAZAR (1933–1991)

Salazar apprenticed with Patrociño Barela, and developed his own abstract style. His work is found in churches in Taos, Dixon, Santa Fe, and Albuquerque, as well as the Smithsonian Institution, the Berlin Museum of Fine Art, the Taylor Museum, the Museum of International Folk Art and the Millicent Rogers Museum.

There was no spacious studio with north light for this native artist. In summer he sat on an old car seat beneath a pick-up camper shell propped up on some pieces of plywood in his backyard. In winter he moved into a tin storage shed and fed cedar chips and branches into an old wood stove. With his

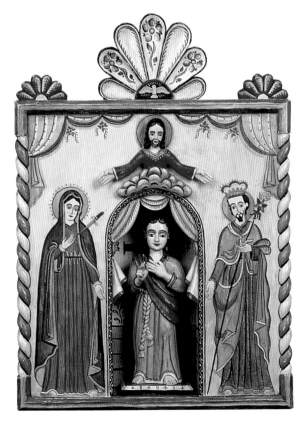

black beret pulled down over his thick graying hair and the company of his cassette player and collection of Spanish music, he'd work a twisted cedar trunk with a chisel salvaged from the fire that killed his friend and mentor Barela. (Hammett 1991)

His sons, Leonardo and Ernesto, and nephew Ricardo, have also taken up carving.

JOSÉ BENJAMÍN LÓPEZ

Bold colors, sculptural quality, and monumental works all describe the style of this santero, who was greatly influenced by santeros Barela and Horacio Valdez, Santa Clara sculptor Michael Naranjo, and Buddhist sculpture, which inspired his fourteen-foot *Cristo* with tangled hair, gaping wounds, and long narrow limbs in the manner of El Greco. López is a master woodcarver and sculptor who is well versed in art history and Native American cosmology. His materials include traditional and exotic woods, and stone.

Other artisans influenced by Barela include Olivar Martínez, whose work in filigree jewelry-making informs his carving style; José Alberto Baros, a surrealist working in a great variety of woods; Leroy López, who also works in many woods and in stone to achieve simple lines, soft colors, and carefully wrought facial expressions; Juan Sandoval, whose large unpainted tableaux of Biblical stories are rarely seen, has provided santos for the church of San Martín de Porres in Albuquerque's South Valley; and Ricardo Salazar, who uses twisted cedar to create singular religious imagery with light carving.

The Córdova School

This group represents santeros whose unpainted religious imagery is sold in shops and converted

2.18
La Santa Familia (The Holy Family) by Gustavo Víctor Goler, 1994. Courtesy University of New Mexico Maxwell Museum and Penny and Armin Rembe.

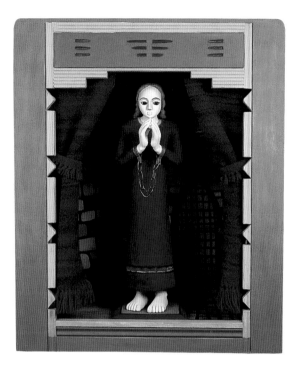

2.19
Santa Barbara by José Benjamín López, 1994. Courtesy University of New Mexico Maxwell Museum.

tions worldwide. Like other artisans of this school, she will combine aspen and cedar in one piece, using the cedar as a decorative item, contrasting with other wood. She also carves screen doors, another item introduced by her grandfather.

SABINITA LÓPEZ ORTIZ
As a niece of George López, she was actually raised in his household from the age of five, developing her own style characterized by closer designs with deeper cuts, using cedar and aspen as contrasting colors.

The Innovators
Separate but equal are the innovators, whose work breaks new ground or combines crafts to create striking new images. Others use their art to fill social needs within contemporary urban society.

LUIS TAPIA
Tapia began making and restoring furniture as well as making santos after much museum research. His work was among the first in the mid-1970s to be painted. He experimented with natural pigments to get as brilliant a color as possible, then turned to commercial watercolors, egg tempera, and acrylics, which was considered a bold departure from tradition. He continued to make changes. He broke away from the established iconography, blending old themes with contemporary life, which he saw as giving new life to traditional ways. An example of his work is his St. Dimas—the thief crucified next to Jesus, and patron of prisoners— depicted by Tapia with tattoos on his hands, legs, and chest, including one of a prison ID number behind a row of bars. Tapia's involvement in the traditional Spanish Market lasted for only a few years, then he broke away because his work was outside the parameters of the Society's definitions of Spanish colonial art.

living rooms in the area known as the High Road to Taos, most notably in the villages of Córdova and Chimayó.

GEORGE LÓPEZ (1900–1993)
Son of José Dolores López, George did not take up carving until he was twenty-five, and then he left carving during his working years at Los Alamos. Upon retiring, he began carving full time. His style differed from his father's in that he incorporated less filigree ornamentation. The effect was that his work appeared less ethereal, yet more substantial and complex. He created all types of carved items, including furniture, animals, and santos. His works are in museums and private collections nationwide.

GLORIA LÓPEZ CÓRDOVA
López Córdova is a seventh-generation santera from Córdova who specializes in the unpainted, chip-carved santos, birds, animals, and other items that her grandfather, José Dolores López, developed in the 1930s. Her uncle is George López. Her work also is found in museums and private collec-

2.20
Tree of Life by George López, Córdova, New Mexico, ca. 1950. Carved cottonwood, 21 inches × 26 inches, Museum of International Folk Art. Photo by Michel Monteaux.

ANITA ROMERO JONES

Daughter of renowned tinsmiths Emilio and Senaida Romero, Romero Jones took the next step with santos by adding tinwork as skirts, rays, crowns, and other elements in her reredoses, retablos, and bultos. Like her sister Marie Romero Jones, she studied the santero tradition in museum collections and books, and specializes in elaborate miniature altar screens that incorporate tinwork.

RAMÓN JOSÉ LÓPEZ

López's religious work reveals his affinity with the work and style of José Rafael Aragón. Yet he has the ability to evoke unmistakable contemporary expression within traditional golden-age styles and methods (he prefers traditional tools and natural pigments). He incorporates Native American elements into his work because his mother was half Indian, and he adds silver embellishments or jewelry to his santos, reminding his viewers that he is also an accomplished silversmith and jewelry maker. On a more personal note, he uses his children as models, particularly for angels' faces. His son, Leon, was the model for the *Santo Niño Perdido*. López's works are in museums and private collections nationwide and he is the recipient of numerous awards. He was featured in a solo show at the Museum of International Folk Art in 1997.

Fellow innovator Luisito Luján was also inspired by Aragón, and enjoys updating attributes, such as adding a tiny television for Santa Clara, the patroness of communication.

Defying categorization are painters (and siblings) Bernadette Vigil and Frederico Vigil of Santa Fe, whose religious subject matter is close in spirit to the santero tradition. While their styles are widely differing, they are both masters of the art of *buon*

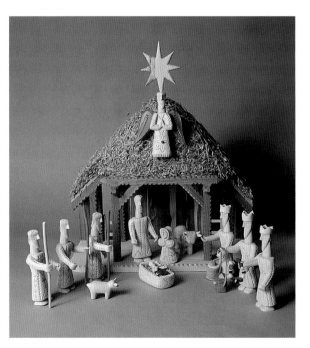

2.21
Nacimiento (nativity) by Gloria López Córdova, 1993. Courtesy The Albuquerque Museum, acc. #93.64.1 a-n. Photo by Michael Mouchette.

2.22
José y María (Joseph and Mary) by Luis Tapia. Courtesy Owings-Dewey Fine Art Gallery, Santa Fe, from the collection of Barbara Windom and Victor DiSuvero.

fresco, which Bernadette has used in church commissions.

Selected Saints and Their New Mexican Iconography

The saints and holy personages most frequently represented in New Mexican art included the many representations of the Virgin Mary, and Saint Joseph; the Apostles Peter, James, and John; the archangels Michael, Raphael, and Gabriel; founders of orders, including Francis of Assisi, Anthony of Padua, Dominic of Guzmán, Ignatius Loyola, and Francis Xavier; the mystics Teresa of Avila, Rita of Cascia, and Gertrude; and the New World saints, Felipe de Jesús from Mexico, Rosa of Lima from Peru and the Virgin of Guadalupe. The Holy Family and stories of Christ's life were also popular (Pierce and Weigle 1996).

La Conquistadora (The Conqueress)

The most beloved santo in New Mexico, La Conquistadora is a twenty-eight-inch statue of Our Lady of the Assumption, thought to have been made in Spain. Fray Alonso de Benavides brought her to the Santa Fe parish church in 1625. She later earned her name during the reconquest, when it is said that the women knelt in the snow to pray to her as the men stormed the walls of Santa Fe. Vargas had made a *promesa* (holy vow) to the santo that if they were successful in retaking Santa Fe, he would build a chapel to house the santo. This is the Rosario

Chapel located in north Santa Fe, to which La Conquistadora—recently renamed *Nuestra Señora de la Paz*—is taken in procession from her side altar in St. Francis Cathedral during the September Fiesta celebrations. She is arrayed in one of numerous beautiful dresses, a fifty-thousand-dollar diamond necklace, and gem-studded crown crafted from three types of gold.

Nuestro Padre Jesús Nazareno (Our Father Jesus the Nazarene)

The devotion to this image is a centuries-old tradition during Holy Week celebrations when life-size statues of *Jesús Nazareno* are carried in processions reenacting the Passion and Crucifixion. The statues are dressed in red and often outfitted with movable arms to accommodate the activity of the Stations of the Cross. This image is also known as the Man of Sorrows.

Nuestro Señor de Esquipulas (Our Lord of Esquipulas)

This figure originated in Guatemala, where this dark-skinned Christ has been the focus of worship there since it was adopted in 1704 as the patron saint against earthquakes by the city of Santiago de Guatemala. Esquipulas is a pueblo in Guatemala where the original miraculous image is kept and venerated in a church. The image shows a dark-skinned Christ on a green flowering cross, or a "living" cross, which is used in New Mexican iconography. The implication of a living cross is that death is not final and that God is merciful as well as demanding. Wroth postulates that the name Esquipulas came to be venerated in New Mexico, specifically at Chimayó, through the Franciscan friars who worked in both New Mexico and Guatemala, and whose knowledge of Esquipulas was passed on through their mutual connection at the monastery at Querétaro, Mexico.

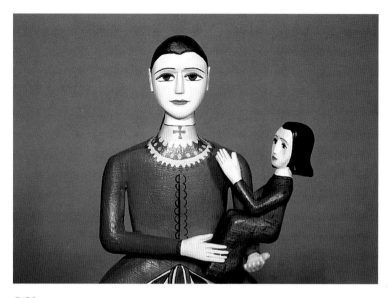

2.23
Nuestra Señora Reina de los Cielos (Our Lady Queen of Heaven),
detail of a bulto by Anita Romero Jones, 1985. Courtesy Museum of
International Folk Art, Photo by Miguel Gandert.

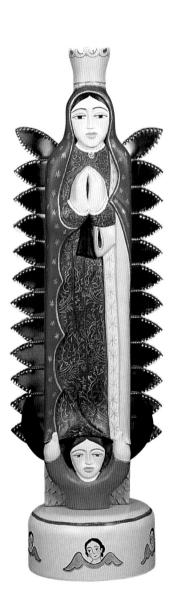

2.24
Nuestra Señora de Guadalupe
by Anito Romero Jones, 1994.
Courtesy University of New
Mexico Maxwell Museum.

There is also the legend that an image of *Nuestro Señor de
Esquipulas*—the same one now venerated at the Santuario—was
found in the ground at Chimayó, carried away, and found again,
carried away again, and found again in the same spot in the
ground, leading to the building of the Santuario over that spot. The
image's connection with Guatemala might eventually help explain
how the unique weaving techniques of Guatemala made their way
to New Mexico (see the section on weaving in the chapter on sec-
ular arts). The main altar of the Santuario de Chimayó is dedicated
to Our Lord of Esquipulas.

La Sagrada Familia (The Holy Family)
Patron of families, travelers, and refugees, the Holy Family is a
reflection of the Holy Trinity of the Catholic faith, and is usually
depicted with the Christ Child in the center holding His parents'
hands. The Holy Family became popular in medieval Europe and
was promoted heavily by the Franciscans.

San Antonio de Padua (St. Anthony of Padua)
Along with the Cristo Crucificado and Nuestra Señora de Dolores,
this is the most popular saint in New Mexico. San Antonio was
born in Lisbon in the twelfth century. He became a Franciscan
who was known throughout Europe for his learned and gentle ser-

mons. A vision he had of the Christ Child is remembered in all representations of this saint. One calls on San Antonio to help find lost objects and worthy husbands.

San Francisco de Asís (St. Francis of Assisi)
St. Francis is the patron of New Mexico and Santa Fe, as well as of nature, animals, and children. Founder of the Order of the Franciscans, whose friars brought Christianity to New Mexico, San Francisco is depicted by New Mexican santeros wearing a long grey or blue habit with a knotted cord belt. Blue habits were worn by Franciscan friars from the Province of the Holy Gospel, which included Mexico and northern New Spain. Other symbols for San Francisco are the cross, skull, and the stigmata.

San Gerónimo (St. Jerome)
St. Jerome is the patron of orphans and of Taos Pueblo, and against lightning. In Europe, San Gerónimo is depicted as a scholar; in New Mexican iconography, he is principally seen as a Penitente hermit wearing a long red robe, pictured alone in the desert performing penance. He may also have a lion at his feet to symbolize strength. In New Mexico, the lion became a monster to symbolize the saint's triumph over evil.

Santa Gertrudis (St. Gertrude)
Patroness of students, educators, mystics, of the West Indies (New Mexico was considered part of the West Indies), and of the Sacred Heart, Santa Gertrudis is depicted as a Benedictine nun in a black robe carrying a staff in one hand and in the other, a heart surrounded by thorns. The real St. Gertrude was a European mystic who gave up her scholarly pursuits to dedicate herself to the worship of Christ and the Sacred Heart.

San Isidro Labrador (St. Isidore
the Husbandman)
Patron of farmers, laborers, shepherds, and land deals, he is appealed to in fending off drought, storms, and pests. The real San Isidro was a laborer for Juan de Vargas, an ancestor of Don Diego de Vargas. San Isidro's goodness inspired God to send an angel to help him with his plowing. San Isidro

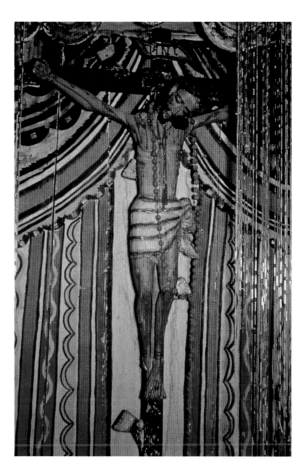

2.25
Nuestro Señor de Esquipulas. Attributed to Molleno, ca. 1815–25. Courtesy Museum of International Folk Art.

brought forth an eternal spring by striking the ground with a gourd; his wife was also a saint, Santa María Toribia de la Cabeza. In New Mexican iconography, he is shown with an angel and oxen with plow, and wearing the clothing of an eighteenth-century gentleman with a wide brim hat and a staff.

San Miguel Arcángel
(St. Michael the Archangel)
One of the most visible holy personages in New Mexican art, San Miguel is patron of the sick and defenders of the faith and of people, such as

policemen and soldiers. As protector of the Church and warrior against evil, San Miguel holds a sword. He also holds scales of judgment as the Lord of Souls who weighs the deeds of the deceased before recommending heaven, hell or purgatory.

Santiago (St. James)

In their seven-hundred-year crusade against the Moors, the Spanish invoked the aid of the saints and other holy personages. The Moors were driven out of Spain the same year Columbus discovered the New World. From then on, the saints were invoked in the Spanish crusade to win converts among the Native-American populations. Santiago, or Saint James (Sant' Iago), was known in Spain as the Moor Killer (*Matamoros*) and in the New World as the Indian Killer (*Mataindios*). In New Mexico, he was called upon to aid in the battles against invading or recalcitrant Indians, and many soldiers reported seeing him in battle alongside the Spanish. He was sighted fifteen times in the New World, including at the battle at Acoma Pueblo in January 1599, where he was seen on a white horse, wearing white, with a red emblem on his chest, holding a spear. He is the patron saint of Spain and of professional soldiers, horsemen, and horses. In New Mexico, the converted Pueblo Indians adopted him as patron of horsemen and horses, according to Pueblo scholar Alfonso Ortiz. He is portrayed in religious art on a white horse with a red emblem on his chest.

Santo Niño de Atocha (Holy Child of Atocha)

The legend of the Santo Niño tells of the city of Atocha in Spain during the Moorish occupation. Prisoners were off-limits to all but little children for errands of mercy. It is said that Jesus himself responded to the constant prayers of wives and mothers by appearing as a pilgrim child with a basket of bread and a gourd of water; after everyone in the prison had been served, there was still bread in the basket and water in the gourd. In New Mexico he walks through the countryside at night performing good deeds. The walking wears out his shoes, precipitating a tradition among the faithful of leaving new shoes near the bulto. His attributes

include pilgrim's clothing (although twentieth-century santeros like to dress him in contemporary clothing), a staff, water container, basket, and leg irons. The Santo Niño is strongly associated with the healing powers at Chimayó, and is the patron of prisoners and travelers, and against sudden misfortune. His feast day is Christmas.

Chronology

1531 The Virgin Mary appears to the Indian Juan Diego on a hill near Mexico City, establishing herself in the New World as *Nuestra Señora de Guadalupe*, patroness of New Spain and Native Americans.

1599 St. James, or Santiago, appears at Acoma Pueblo to assist the Spanish soldiers in battle. It is one of fifteen appearances by Santiago in the New World.

1610 Era of mission building begins in New Mexico, with each mission decorated with hide and wall paintings, and later by reredoses and retablos.

1625 Fray Alonso de Benavides transports a statue from Spain known as *Nuestra Señora del Asunción*, but it becomes known as La Conquistadora by the New Mexican settlers, and in the late twentieth century as *Nuestra Señora de la Paz*.

1680 Most of the churches of New Mexico, along with their religious artworks, are destroyed in the Pueblo Revolt.

1692–93 Don Diego de Vargas reconquers New Mexico, reestablishing Spanish rule in Santa Fe. During the battle over Santa Fe, the Spanish settlers pray to La Conquistadora.

1747 Mexican friar and santero Fray Andrés García arrives in New Mexico.

1748 Church at Santa Cruz is completed. Its main altar and walls contain a total of eight oil-on-canvas paintings from Mexico with images of several saints and holy personages.

1749 Santero Pedro Antonio Fresquís is born at Santa Cruz. His known output consists of three pieces dating from the early nineteenth century.

1756 Santero, cartographer, and military captain Bernardo Miera y Pacheco arrives in Santa Fe.

1761 Pacheco y Miera completes the large stone reredos at La Castrense. It is the earliest known example of the baroque estípite column in New Mexico, and served for decades as a stylistic model for local santeros.

1789 A nativity, one of the earliest dated and signed pieces of carved woodwork on a religious subject, is completed by Lorenzo Ortega.

1796– Artisan known as the Laguna Santero
1808 flourishes in New Mexico. This santero may be the artisan who created the oldest dated wooden reredos in New Mexico, at Santa Cruz, and the reredos at Santa Fe's chapel of San Miguel.

1796 Santero José Rafael Aragón is born in Santa Fe.

1798 Reredos in the chapel of San Miguel in Santa Fe is completed. It features eighteenth-century oil paintings and the first appearance of Solomonic columns in New Mexico.

1858 Santero José Benito Ortega is born.

1860 José de Gracia Gonzales of Mexico arrives in northern New Mexico where he earns a living as a santero and restorer of reredoses.

1868 Santero José Dolores López is born.

1901–7 Period during which Juan Ramón Velásquez, Juan Miguel Herrera, and José de Gracia Gonzales, major santeros of the late nineteenth century, pass away, essentially drawing the traditional period of santero-making to a close. A fourth major artisan, José Benito Ortega, stopped creating artwork in 1907.

1915 Migration of professional visual artists and art patrons from the Eastern United States to New Mexico begins.

1925 The Spanish Colonial Arts Society is founded in Santa Fe by writer Mary Austin and Frank Applegate to "revive," preserve, and foster traditional Spanish colonial arts of New Mexico. Over subsequent decades, it falls into dormancy and is revived.

1953 The Museum of International Folk Art begins mounting exhibits of Spanish colonial objects under the direction of curator Elizabeth Boyd.

1965 Spanish Colonial Arts Society's Spanish Market in Santa Fe is reactivated and continues today as New Mexico's annual market for traditional religious and secular artwork. A Winter Market is added in the 1990s.

1970s First meetings of La Escuela Artesana. La Cofradía de Artes y Artesanos Hispanicos is established.

 Several museums, including the Taylor Museum in Colorado Springs, The Albuquerque Museum, and the Old Ciénega Village Museum at El Rancho de las Golondrinas, present Spanish colonial religious art in a museum setting.

1980s Several national touring exhibits feature the work of New Mexican santeros, including "Hispanic Art in the United States," "Chicano Art Resistance and Affirmation," and the Smithsonian's Festival of American Folklife in Washington.

 The Hermandad experiences a revival in New Mexico.

 Feria Artesana showcases Nuevomexicano artisans in an annual exhibition in Albuquerque for several years.

1988 The Museum of International Folk Art in Santa Fe opens its Hispanic Heritage Wing, which includes religious art and artifacts.

Glossary

Advocation—A specific aspect of a saint or holy person. Examples of advocations of the Virgin Mary include Our Lady of Sorrows, Our Lady of Solitude, Our Lady of the Rosary, the Virgin of Guadalupe, Our Lady of the Immaculate Conception, and Our Lady of Peace.

Andas—The platform on which large-scale bultos are placed to carry in procession. The term always appears as plural; *el andas* (because it starts with an *a*) or *las andas*.

Attribute—An object associated with a given saint or religious image and considered symbolic of that saint's character, quality, or function. For example, the flowering staff associated with Saint Joseph, or the scapulars associated with Our Lady of Mount Carmel.

Bulto—A three-dimensional statue of a saint or holy personage.

Bulto de Vestir—A statue with a carved torso and head, and with its bottom half dressed. While fully carved bultos can also be dressed, they are not bultos de vestir.

Cofradía—Confraternity or brotherhood.

Iconography—The subject matter and conventional meanings attached to images in art.

Lay organization—An organization made up of persons who are not a member of the clergy.

Morada—Chapter house of a cofradía where worship takes place. In the twentieth century, it is not usually open to nonmembers, and is located in remote areas.

Nacimiento—Nativity scene; creche.

Penitente—The common term for a member of La Cofradía de Nuestro Padre Jesús Nazareno. Also called La Hermandad (the Brotherhood), an order of laymen trained by elders to continue the Catholic traditions of worship in New Mexico and to maintain community cohesiveness through various acts of charity.

Polychrome—Literally, many colors. A santo is polychrome if it has been painted.

Reredos—Altar screen. In Spanish, called *altares, colaterales,* or *retablos.* It is French in origin, and utilizes several retablos within an architectural framework for use in missions, chapels, or churches. The plural of this term is *reredoses.*

Retablo—A two-dimensional painting depicting a saint, holy personage, or biblical event. The retablo may be hung by itself, with other single retablos, or as part of a reredos.

Santo—Spanish word for image of a saint, holy personage, or biblical event.

Santero (santera)—A person who creates santos.

Bibliography _____

Ahlborn, Richard E. *The Penitente Moradas of Abiquiú.* Washington, D.C.: Smithsonian Institution Press, 1986.

Awalt, Barbe, and Paul Rhetts. *Charlie Carrillo: Tradition and Soul.* Albuquerque: New Mexico LPD Enterprises, 1994.

Bird, Kay. "Daniel Blea's Hope: Santero Reaches Out to Troubled Youth." *Spanish Market Magazine,* July 1996, 31–33.

Boyd, E. *Saints and Saintmakers of New Mexico.* Santa Fe: New Mexico Laboratory of Anthropology, 1946.

——. *Popular Arts of Spanish New Mexico.* Santa Fe: Museum of New Mexico Press, 1974.

——. *New Mexico Santos: Religious Images in the Spanish New World.* 1966. Santa Fe: Museum of New Mexico Press, 1995.

Briggs, Charles L. *The Woodcarvers of Córdova: New Mexico Social Dimensions of an Artistic Revival.* Knoxville: University of Tennessee Press, 1980. 17, 52, 193.

Brown, Lorin W., Charles L. Briggs, and Marta Weigle. *Hispano Folklife of New Mexico: The Lorin W. Brown Federal Writers' Project Manuscripts.* Albuquerque: University of New Mexico Press, 1984.

Carrillo, Charles M. Personal communication, May 1997.

Cash, Marie Romero. *Santos: A Coloring Book of New Mexican Saints.* Santa Fe: Published by the author, 1990 (contact Ms. Cash at P.O. Box 1002, Santa Fe NM 87504, for copies).

——. "Portrait of a Santera." *Spanish Market Magazine,* July 1993, 9–11.

——. *Built of Earth and Song: Churches of Northern New Mexico.* Santa Fe: Red Crane Books, 1993.

Chapman, Al. *Santos of Spanish New Mexico: A Coloring Book.* Santa Fe: Sunstone Press, 1973 (with Spanish/English text).

Chávez, Fray Angélico. *La Conquistadora.* 1975. Santa Fe: Sunstone Press, 1983.

Clark, William. "Santero School: La Escuelita Wood Carvers Preserve Artistic Legacy." *Spanish Market Magazine,* July 1994, 49–50.

Cortez, Carlos E., ed. *The Penitentes of New Mexico.* New York: Arno Press, 1974.

Crews, Mildred T., Wendell Anderson, and Judson Crews. *Patrocinio Barela: Taos Wood Carver.* Taos: Taos Recording & Publications, 1962.

DeBuys, William, and Alex Harris. *River of Traps: A Village Life.* Albuquerque: University of New Mexico Press, 1990.

Denver Art Museum. *Santos of the Southwest: The Denver Art Museum Collection.* Denver: A. B. Hirschfeld Press, 1970.

Domínguez, Francisco Atanasio. *The Missions of New Mexico, 1776.* Translated and edited by Eleanor B. Adams and Fray Angélico Chávez. Albuquerque: University of New Mexico Press, 1975.

Dunton, Nellie. *The Spanish Colonial Ornament and the Motifs Depicted in the Textiles of the Period of the American Southwest.* Philadelphia: H. C. Perleberg, 1935.

Espinosa, José E. *Saints in the Valley: Christian Sacred Images in the History, Life, and Folk Art of Spanish New Mexico.* 1960. Albuquerque: University of New Mexico Press, 1967.

Flores-Turney, Camille. "Santa María de la Paz: New Santa Fe Church Boasts Traditional Religious Art Treasures." *Spanish Market Magazine*, July 1995, 52–54.

Frank, Larry. *New Kingdom of the Saints: Religious Art of New Mexico, 1780–1907.* Santa Fe: Red Crane Books, 1992.

Gavin, Robin Farwell. *Traditional Arts of Spanish New Mexico.* Santa Fe: Museum of New Mexico Press, 1994.

Gonzales, Edward, and David L. Witt. *Spirit Ascendant: The Art and Life of Patrociño Barela.* Santa Fe: Red Crane Books, 1996. 27, 75.

Hammett, Kingsley. "Leo G. Salazar, Santero, 1933–1991." *Spanish Market Magazine*, 1991, 7.

Hotz, Gottfried. *The Segesser Hide Paintings: Masterpieces Depicting Spanish Colonial New Mexico.* 1970. Santa Fe: Museum of New Mexico Press, 1991.

Jaramillo, Cleofas M. *Shadows of the Past.* Santa Fe: Ancient City Press, 1972. 61.

Kalb, Laurie Beth. *Santos, Statues, and Sculpture: Contemporary Woodcarving from New Mexico.* Los Angeles: Los Angeles Craft and Folk Art Museum, 1988.

———. *Crafting Devotions: Tradition in Contemporary New Mexico Santos.* Albuquerque: University of New Mexico Press, 1995.

Lamadrid, Enrique. "Cultural Resistance in New Mexico: A New Appraisal of a Multi-Cultural Heritage." *Spanish Market Magazine*, 1991, 24–25.

López, Alejandro. "The Soul of Cedar Wood Carvers Reveal Many Faces of Cedar." *Spanish Market Magazine*, 1995, 20–21.

Martínez, Eluid Leví. *What is a New Mexico Santo?* Santa Fe: Sunstone Press, 1978.

Mather, Christine, ed. *Colonial Frontiers—Art and Life in Spanish New Mexico: The Fred Harvey Collection.* Santa Fe: Ancient City Press, 1983.

Metropolitan Museum of Art. *Mexico: Splendor of Thirty Centuries.* New York: Bullfinch Press, 1990.

Miller, Michael. "Santa Cruz Church Returned to Former Beauty." *New Mexico Magazine*, March 1997, 38–43.

Mills, George. *The People of the Saints.* Colorado Springs: Taylor Museum, 1967.

Mirabal, Felipe. Personal communication, July 1997.

Montaño, José Nestor. Personal communication, June 1979.

Monthan, Guy, and Doris Monthan. *Nacimientos: Nativity Scenes by Southwest Indian Artisans.* Flagstaff, Ariz.: Northland Press, 1979.

Nestor, Sarah. *The Native Market of the Spanish New Mexican Craftsmen, 1933–1940.* Santa Fe: The Colonial New Mexico Historical Foundation, 1978.

Padilla, Carmella. "SCAS Helps Bring Morada Back from the Ashes." *Spanish Market Magazine*, 1993, 32–34.

———. "Eye on the Spanish Colonial Art Society Collection: Donna Pierce Carries on Boyd, Vedder Legacies." Spanish Market Magazine, 1993, 7.

———. "The El Rito Santero Nicholas Herrera and the Ride of His Life." *Spanish Market Magazine*, 1994, 6–8.

———. "Frank Alarid and the Art of Silence." *Spanish Market Magazine*, 1995, 6–8.

———. "Guadalupita's Pretty Little Heaven Street." *Spanish Market Magazine*, 1996, 6–8.

———. "Spanish Market Santera Chosen to Create Cathedral Art." *Spanish Market Magazine*, 1996, 19.

Palmer, Gabrielle, and Donna Pierce. *Cambios: The Spirit of Transformation in Spanish Colonial Art.* Albuquerque: Santa Barbara Museum of Art and University of New Mexico Press, 1992.

Pierce, Donna. "From New Spain to New Mexico: Art and Culture on the Northern Frontier." In *Converging Cultures: Art and Identity in Spanish America*, edited by Diana Fane. New York: Harry N. Abrams, 1996.

Pierce, Donna, and Marta Weigle, eds. *Spanish New Mexico: The Spanish Colonial Arts Society Collection*, 20. Vol. 1, *The Arts of Spanish New Mexico.* Santa Fe: Museum of New Mexico Press, 1996.

Sagel, Jim. "Horacio Valdez: Master Santero." *New Mexico Magazine*, July 1986, 25–29.

———. "No Hay Mal Que Por Bien No Venga: The Life of Master Santero Horacio Valdez." *Spanish Market Magazine*, 1993, 42–43.

Salvador, Mari Lyn C. *Cuando Hablan Los Santos: Contemporary Santero Traditions from Northern New Mexico.* Albuquerque: Maxwell Museum of Anthropology, 1995.

Shalkop, Robert L. *Wooden Saints: The Santos of New Mexico.* Colorado Springs: Taylor Museum, 1967.

Steele, Thomas J. *Santos and Saints: The Religious Folk Art of Hispanic New Mexico.* 1974. Santa Fe: Ancient City Press, 1994.

Steele, Thomas J., Barbe Awalt, and Paul Rhetts. *The Regis Santos: Thirty Years of Collecting, 1966–1996.* New York: Independent Publishers, 1997.

Taylor, Lonn, and Dessa Bokides. *Carpinteros and Cabinetmakers: Furniture Making in New Mexico, 1600–1900.* Santa Fe: Museum of International Folk Art, 1984.

Toomey, Don. "La Escuelita: Part I." *Tradición Revista,* Spring 1997, 70–74.

Topo, Greg. "Surrounded by Saints: The Rapid Rise of Santero Victor Goler." *Spanish Market Magazine,* 1993, 40–41.

Varjabedian, Craig, and Michael Wallis. *En Divina Luz: The Penitente Moradas of New Mexico.* Albuquerque: University of New Mexico Press, 1994.

Weigle, Marta. *Brothers of Light, Brothers of Blood: The Penitentes of the Southwest.* Albuquerque: University of New Mexico Press, 1976.

Weigle, Marta, Claudia Larcombe, and Samuel Larcombe, eds. *Hispanic Arts and Ethnohistory in the Southwest: New Papers Inspired by the Work of E. Boyd.* Albuquerque: University of New Mexico Press, 1983.

Wilder, Mitchell A., and Edgar Breitenbach. *Santos: The Religious Folk Art of New Mexico.* Colorado Springs: Taylor Museum, 1943.

Wroth, William. *Christian Images in Hispanic New Mexico: The Taylor Museum Collection of Santos.* Colorado Springs: Taylor Museum, 1982. 131.

———. *Images of Penance, Images of Mercy: Southwestern Santos in the Late Nineteenth Century.* Norman: University of Oklahoma Press, 1991. 31, 33.

Videography

En Divina Luz. Colores segment. Albuquerque KNME-TV, 1990.

Familia y Fé. Colores segment. Albuquerque KNME-TV, 1989.

The Romero Family: Santa Fe Artisans. Albuquerque KNME-TV, 1985.

Santero. Colores segment. Albuquerque KNME-TV, 1991.

Los Santeros. Blue Sky Productions, 1979.

Santos and Saintmakers. Blue Sky Productions, no date.

3 Fiestas y Rituales:
Religious and Secular Celebrations

THE SPIRIT OF A COMMUNITY and its culture are most joyfully on display at its celebrations, be they *fiestas*, weddings, reenactments, or religious pageantry. Much can be learned and absorbed about a culture at these gatherings, where one can hear, see, and touch the essence of a people. The symbols of a community's identity, its hierarchy, and its art forms, are all on display, reinforcing its unity and continuity through the centuries.

The idea that Nuevomexicano traditions have survived as a result of cultural resistance to the presence and traditions of the Anglo culture is most evident in the *fiesta* and *entriega* practices. They reveal the resourceful self-sufficiency of the communities, particularly in the area of religion and milestones in life. By contrast, the swift disappearance of certain traditions, even within generations, is astonishing. The traditional dance band, Bayou Seco, joined musician Cleofes Ortiz in a old-time jam session at a bar in Pecos in 1988 and many elders joined them to dance many of the old traditional dances. They returned in 1993 and the number of dancers had diminished. The old traditions are no competition for the appeal of mass media and entertainment; however, new traditions emerge as times change.

Types of Celebrations

Fiesta (Feast Day Celebration)

The *fiesta* or *función* is a day of celebration in honor of a saint or religious personage to whom there is a special allegiance by the community. The saint might be the patron of a region, town, church parish, or historical event. The Roman Catholic Church assigned saints to specific days of the year so that, for example, December 12 is the worldwide feast day of Our Lady of Guadalupe. A fiesta may be held in her honor on this day anywhere. If a village or town

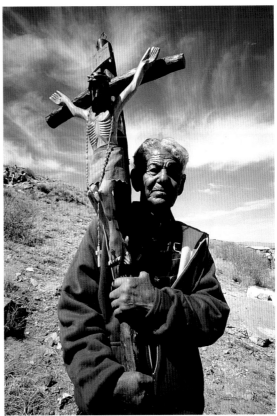

3.1
Guadalupe Rael carrying the crucifix to El Cerro in Tomé, New Mexico, on December 12, 1989. Photo by Miguel Gandert.

is named Guadalupe, or considers the Virgin of Guadalupe its patron saint, it will hold a celebration on December 12. Fiestas may also be held for secular occasions, such as the Fourth of July.

The sequence of events for a feast-day celebration is as follows, with variations from location to location:

- Prior to the day of the fiesta, one or more *mayordomos*—or fiesta stewards and guardians of the patron saint and church—begin preparing for the celebration. Duties are varied and may include taking up a collection in the community for anticipated expenses. If the collection comes up short, the mayordomo must make up the difference as needed. Throughout the previous twelve months, mayordomos have been responsible for the care and repair of the church or chapel and now are expected to prepare it by carrying out any repairs and dressing the church interior as for a special occasion. Vigas are scrubbed, pews are repainted, and the walls may receive a coat of whitewash. If a visiting priest is expected, as in smaller communities, then the mayordomo must make arrangements for the priest's accommodations, or put him up in his own home. Mattresses and blankets are washed and the priest's room cleaned thoroughly. If there are to be *luminarias* (bonfires), wood must be gathered and prepared.

- On the night prior to the day of the fiesta, the santo of the honored saint or personage is taken in procession, accompanied by singing, ritual dancing in some communities, and guns fired into the air. Everyone wears

3.2
Festival procession in San Antonito, New Mexico, 1989. Photo by Miguel Gandert.

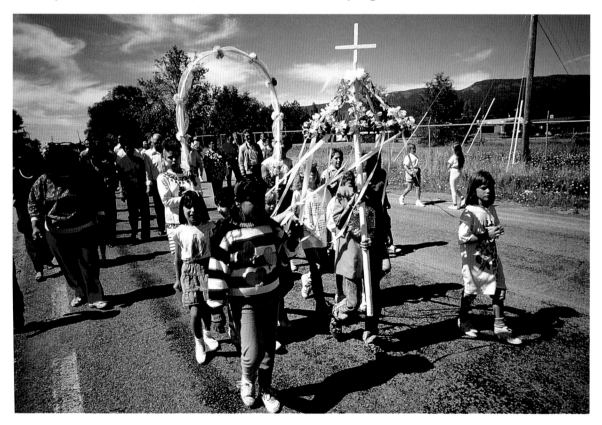

their finest clothing. The santo is taken to the church and placed before the altar. Vespers begin as the faithful go to confession so that they may take communion at mass the next day. Men continue to fire guns in the air just before and during the vespers as a gesture of protecting the saint.

- In some communities, a torchlight procession or a procession to and from the planting fields is central to the solemnities, which may include an all-night prayer vigil or midnight mass, or both. At the mass, the mayordomos sit in front and hold candles.
- The fiesta begins the next morning after a celebratory mass. In earlier days, two or three days of food, music, and dancing were sometimes supplemented by performances by *maromeros* (traveling theater groups) or by the presence of *caballitos* (merry-go-rounds). Other forms of entertainment included the private *merienda* (luncheon), the *corrida de gallo* (rooster pull), and foot, sack, and horse races. The rooster pull was an occasion for gambling, but there were also other types of gambling when it was allowed, according to Lucero-White Lea, including *monte*, *cunquián*, *ajedrez*, roulette, and dominos. Ranchers who lived too far away to travel back and forth each day camped at the edge of town and ate at the many food booths. In the twentieth century, the crowning of a fiesta queen adds glitter and competition to the proceedings, as do fireworks and burnings of giant figures like the *Cucui* bogeyman or Zozobra, Old Man Gloom. Also in the late twentieth century, the caballitos have expanded into complete carnivals. The mayordomo holds an open house with much hospitality, including a table full of food for casual visitors, and a special dinner for invited guests.
- Historic reenactments or costumed *bailes grandes* (grand balls) are also popular in larger towns, particularly if a fiesta is connected to a significant historic event, such as the settlement of New Mexico by Oñate, Cinco de Mayo, or the reconquest of Santa Fe.
- At the end of the fiesta, the santo is taken in

procession to the home of the new mayordomo, who assumes the mayordomo's duties for the next twelve months. In many communities, Matachines dance throughout the processions and at the homes of the outgoing and new mayordomos.

Bautismo (Baptism)

Compadrazgo, or ritual parenthood, virtually confirmed social order and tradition within a community, as it is difficult to ignore or mistreat someone to whom a lifelong pledge has been made. As such, compadrazgo has served as a very powerful cohesive element in New Mexican communities. A baptism is a Roman Catholic ritual established by St. John the Baptist's baptism of Jesus at the river. It is the initiation of an infant (or a convert) into the Church. The ritual calls for the pouring of water over the head to wash away original sin, which is inherited from the fall of Adam and Eve as described in Genesis.

The baptism is usually set for forty days after the birth of the child (called the *ahijado*, or godchild) so that the mother may recover fully and take full part. It often occurs on a Sunday after mass. If the child seems frail, the baptism may occur at any time. *Padrinos* (godparents), parents, family, and friends attend the ritual service at the church. In some communities, the parents stayed home, according to Lucero-White Lea, presumably to prepare the food and set the house in order. By virtue of their presence at the service, all observers accept responsibility for rearing the child. The infant is dressed in a fancy long white dress with long petticoats and ribbons and lace, if possible. These dresses are family heirlooms and used for subsequent children.

On leaving the church, the padrinos give coins to children waiting outside. In early days, the *dádiva* was the giving of the baptized infant to its parents by the padrinos. It occurred at the church or at the threshold of the parents' home. The padrinos exchanged the verses of the *Entriega de los Ángeles* (the baptismal delivery ceremony).

Then everyone joined in a feast, often accompanied by music and dancing, including *La Cuna* or the Cradle Dance. Guests gave coins to the

mother, and *compadres* gave gold coins if they could afford it, although coins were scarce in eighteenth-century New Mexico. Espinosa explains that the New Mexico baptismal ritual is the same as in many Spanish villages, including the giving of coins and certain *entriega* verses.

Dando los Días (Saint's Day)

On a given saint's day, everyone in a town or village who is named after that saint receives special treatment. Traveling singers and musicians come to their homes and serenade them, then are invited to enter for refreshments. Members of each household join the singers on their visit to the next home, and so on until at the last house visited, a large group is on hand. Occasionally, the last honoree hosts a dance in his or her *sala* or *patio*, with the visitors providing refreshments, but no gifts. This practice is still observed in Mexico, where celebrating the anniversary of one's actual birth is not a tradition. *Dando los Días* translates loosely as wishing many happy returns on this day.

Prendorio and Casorio (Betrothal and Wedding)

In some wealthy families, parents arranged their children's marriages when the children were still quite young. While not announced, these arrangements ensured the child's future and kept other families from attempting a match. In other households, a marriage was proposed in a letter delivered by the young man's parents to the young woman's parents. If the response was yes, plans began. If the response was no, it was called *dando calabazas*, or "giving pumpkins," a popular phrase used throughout Spain.

The *prendorio*, or engagement ceremony, was held at the young woman's home eight days prior to the wedding. The term prendorio derives from *prenda*, meaning jewel or something highly prized. It refers to the young woman, who is considered a jewel. Members of both families attended as the young woman received gifts as tokens of friendship and love, and was introduced to the young man's family by his father. The young man was then introduced to the young woman's family by her father. Gifts were either gold rings, called *memorias*, or gold, silver, coral or pearl rosaries. According to

Jaramillo, the couple knelt before the oldest male relative of the bride as he placed a rosary first over the young man's head, then another over the young woman's head. In some households, the double rosaries, or *lazos*, were used instead of engagement rings. Following the introductions and gift-sharing, the feasting and *baile de prendorio* began. Espinosa writes that the prendorio in New Mexico is essentially the same as that in Spain.

The traditional Nuevomexicano marriage takes place at the church. The bride-to-be enters the church on the arm of her padrino, followed by the groom-to-be, accompanied by the matron of honor. Parents and others follow. In the early days, after the wedding mass, the principals proceeded to the bride's home for a light breakfast. Then they received well-wishers in the parlor, where guests slipped silver and gold coins to the bride as they shook her hand.

The wedding party might also proceed directly to the reception hall, led by the musicians and accompanied by guns fired in the air. Pueblo religious processions also included firing guns as a gesture of protection and blessing. In addition to the dinner served for invited guests, a table in another room was laid out with refreshments for well-wishers (usually at the host's home). The groom's father had previously provided enough food and drink to feed the groom's family and friends. In addition, the groom presented the *donas*, or personal gifts, to the bride consisting of a chest containing the wedding gown, accessories, and additional gowns for the wedding dance. During the dance, the bride was expected to change her gown two to three times. In recent times, the donas might be a decorated box of jewelry. Families of limited means followed as many of these customs as they could afford.

In the evening, everyone attended the wedding dance held at a community hall or, in wealthier households, a sala within the home. As the dance ended in the early morning, the *Entriega de los Novios* was carried out. In recent times, it is held at the reception. The *entriega* is the delivery of the newlyweds to their parents by the padrinos for a final blessing before their departure. The ceremony is sung in verse before the entire wedding party and

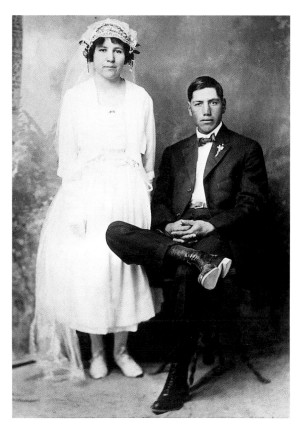

3.3
Wedding portrait of Refugio de Herrera and Nicolás Montaño, ca. 1930. Courtesy of Stella Sandoval.

guests, taking from thirty to ninety minutes to sing up to fifty *coplas*. The coplas are partly prepared and partly improvised, and include names of guests and principals. Through verse, the singer, or *entregador* or *entregadora*, congratulates the couple, provides them with advice on how to maintain a happy marriage, and finally, blesses them. Occasionally, the members of the wedding party will sing the verses. The verses range from solemn and touching to humorous and light-hearted. The entire ritual is in five parts: *La invocación* (the invocation), *Los versos de la Santa Escritura* (verses from the Holy Scriptures), *Los versos de la iglesia* (verses from the church), *Los consejos o parabienes* (the advice) and *Los versos de la gente* (verses for the people).

The entriega was born of necessity in the late eighteenth and early nineteenth centuries when priests were scarce and communities found it necessary to "marry" couples in their own ritual until a circuit-riding priest could come along and solemnize it. Lamadrid (1990) writes, "In older *entriegas*, there is suggestive textual evidence that these verses *were* the ceremony, although there is no documentary proof in historical accounts prior to the turn of the [nineteenth] century." The need for a timely ritual is also the basis for the *Entriega de los Ángeles* for baptisms and the *Entriega de los Difuntos* for funerals. It evolved into what Lamadrid calls a "regional folk Catholicism" with its own "distinctive para-liturgy" based on the old Franciscan teachings expressed in invented verse. Hence, for example, the emphasis on Joseph and Mary, rather than Adam and Eve, as marital models.

The cofradías and Hermandad figured largely in this phenomenon. As Carol Jensen (1983) wrote, "For more than three hundred years, these basically religious people maintained against great odds the closest link to the heart of Catholicism that historical conditions allowed." In the mid-nineteenth century, Bishop Jean-Baptiste Lamy arrived with numerous French priests whose new intellectual, abstract approach to Catholicism didn't quite blend with the practical folk approach found in the entriegas. The people's response was a resistance to the set rules of the Church. They fell back and held fast to the old rituals, the entriega rituals. One result was that even though weddings were officiated in churches by priests, no one considered the couple really wed until after the entriega was completed. Resistance also found expression in other areas of folklife, as well as literature and Spanish-language journalism (see chapter 8).

Lamadrid (1990) describes the critical contrasts between the Church-sanctioned wedding and the Entriega de los Novios. The former is held in a church, the latter is held in a home or community center; the former is held in the morning, the latter is held in the evening; the former is carried out by a priest, the latter by the entregador(a); in the former, the couple speaks, saying "I do," and in the latter they are silent as the community speaks to them; in the former the teachings are mythical and abstract and in the latter they are practical and

specific; in the former, Adam and Eve are held up as marital models, and in the latter the models are Joseph and Mary; in the former there is sacred church music, in the latter the entriega verses are sung to a waltz tune.

Entriegas also are sung when transferring a santo from one mayordomo to another, for a fiftieth wedding anniversary, and as part of the Matachines Dance. Lamadrid reports that the Entriega de los Novios is experiencing a renaissance in the late twentieth century. In 1990, Lamadrid and musicologist and musician Cipriano Vigil collected over fifty versions of the Entriega de los Novios in southern Colorado and New Mexico. Each one is unique.

Velorio (Wake or Vigil)

The body of the deceased was not to be left alone the night before the funeral, so the community gathered to pray, sing, and visit through the night while keeping vigil over the body. It was a community effort. The women brought food; the men dug the grave and chopped wood for cooking and warmth. The women covered mirrors or turned them to the wall; the men built a coffin. The parlor was rearranged to accommodate the coffin and many benches or chairs. As new visitors arrived, weeping began anew. In the evening, two women began the velorio by leading the praying of a rosary and the singing of *alabados*. Then all paused for supper, the children being served last. While most of the visitors went home before midnight, designated individuals stayed through the night, taking turns praying, singing, and conversing inside or outside around bonfires providing warmth and light. If the deceased was an Hermano, the members led the velorio and a procession from the morada to the home, including flagellations. Another meal was served after a rosary said at midnight.

The following day the body was taken to the church or chapel by truck or horse-dawn wagon. The *eulogio*, or eulogy, is still practiced as an art form in New Mexico, according to Lamadrid. The ideal eulogio, he adds, balances verbal virtuosity and basic human feelings. While all attended the funeral mass, only men and boys accompanied the coffin to the graveyard, chanting alabados along the way. They stopped to rest at *descansos*, or resting places, marked by small crosses. When the chanting stopped, according to Lucero-White Lea, the women knew the men had arrived at the gravesite. *Despedimientos*, or graveside hymns, are traditional and still sung today by members of the Hermandad. On the way from the graveyard, they said prayers at the descansos for the repose of the departed soul. After the burial, there was another meal at the family's home.

The tradition of velorios also required the making of a headstone from whatever stones were available,

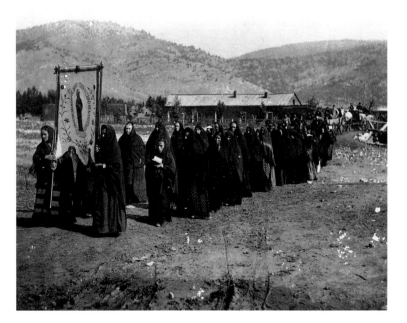

3.4
Funeral procession in Mora, New Mexico, ca. 1895. Courtesy Museum of New Mexico, neg. #14757. Photo by Tom Walton.

such as flagstone. The house of the deceased remained in mourning for one year, with mirrors draped in black, shades drawn, and women dressed in black. When children died, the mourning period was short because it was understood that the child had gone straight to heaven. For families with greater financial resources, velorios did not include chanting, according to Lucero-White Lea, and only close friends attended the vigil. In addition, the priest accompanied the coffin to the gravesite.

Velorio for the Saints

When it was appropriate to thank or request a favor of a saint, the upper classes commissioned or bought jewelry to be placed on the santo, and the lower classes held prayer vigils, according to Lucero-White Lea. To prepare for a prayer vigil in honor of a saint, the parlor was prepared for the participants. An altar was created to hold the santo, and decorated with fine fabrics, lace, and paper or field flowers. Benches were placed around the room. A *rezador*, or prayer leader, led the prayers and alabados, with the group singing the choruses. At breaks in the vigil, the men went outside for a smoke, women visited or managed children and cooking. Supper was served at midnight. If the weather was mild, the participants remained until daylight.

The Sociedad Folklórica in Santa Fe holds an annual prayer vigil for Santa Ana, patron saint of family life, including a ceremony of reverence for family life, a buffet supper, a decorated home altar, mass at twilight, and the singing of songs.

Feria (Fair)

The tradition of an annual fair for the exchange of trade goods reaches back to Spain and Mexico. In Mexico, famous Spanish colonial ferias were held at Chihuahua, Saltillo, Coahuila and elsewhere. In New Mexico, three eighteenth-century ferias were

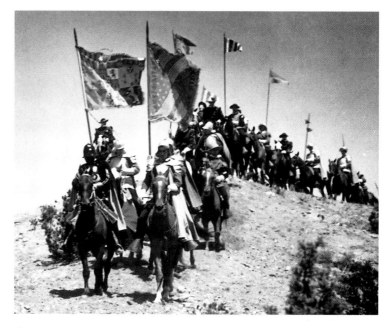

3.5
Reenactment of the Coronado Entrada from the 1940 Cuarto Centenario celebrations in Santa Fe. Courtesy Museum of New Mexico, neg. #135147. Photo by Harold D. Walter.

established to develop local trade with native populations as well as visitors from other parts of New Mexico. The Taos Fair was held in early fall, the fair at Pecos was held in February, and the Abiquiú Fair was held in late October or early November. Hispano settlers and Pueblo Indians traded with Comanches at Taos and Pecos, and with the Utes, Navajos, and Apache at Abiquiú. A Taos Fair exists today as a tribute to the old feria of colonial times (see listing below).

Invented Celebrations

This is a term created by anthropologists to describe cultural events that are purposefully initiated, in contrast to those that arise from a long community tradition. While they may not have a long history, invented celebrations provide concentrated educational and cultural discovery experiences that some might describe as "self-conscious," in a way that traditional celebrations are not. Examples are the Mariachi Spectacular, the festivals at Las

Golondrinas, and Spanish Market. Invented celebrations are usually planned and carried out by nonprofit cultural organizations.

Celebrations by Season

The following calendar provides a sampling of feast days and other celebrations of Hispanic New Mexico, with origins ranging from the sixteenth century to the late twentieth century. While not intended to be comprehensive, it includes both traditional and invented celebrations.

Spring Season

SEMANA SANTA (HOLY WEEK)

In the Roman Catholic tradition, this is the period beginning with Palm Sunday and ending with Easter Sunday. It is the culmination of the Lenten season, which consists of forty days of fasting, praying, and performing penance. It coincides with the season of the year (mid-February through early April) when in most agrarian cultures, the stored foods were nearly depleted, thus providing another incentive to fast or eat less for the common good.

In New Mexico, Semana Santa consists of regular church-sanctioned rituals and gatherings, and rituals and pageantry developed over the decades by the people themselves, including a kind of paraliturgy developed and maintained to this day by the Hermandad. The cofradías and Hermandad carry out the Passion play at this time (see chapter 8 for the layout of the play's components, and chapter 5 for a discussion of alabados). Like the entriegas, the Passion play is another reminder of the years when there were a handful of friars and priests to serve all of New Mexico. In addition to the Passion play, other rituals were followed. On Holy Thursday, immediately after the noon meal, people from different parishes visited *las capillitas*, or surrounding chapels, a tradition observed in Spain and Latin America.

At church services officiated by priests, the Blessed Sacrament was put away on Thursday evening after mass and not brought out again until *Sábado de Gloria* (Glorious Saturday or Holy Saturday). On Friday morning processions emerged featuring *El Encuentro*, the dramatization of the fourth Station of the Cross, where Jesus meets his mother. In the afternoon everyone attended the Stations of the Cross. In the moradas the *Tinieblas* or *Tenebrae* service was held, simulating the darkness and chaos following the Crucifixion.

Also on Good Friday, approximately thirty thousand Hispano and Indian *peregrinos* (pilgrims) make their way on foot from throughout New Mexico to the Santuario de Chimayó where they wait patiently for a chance to touch the *tierra bendita*, or holy earth, that is said to heal (see chapter 7). A number of peregrinos carry heavy, wooden crosses or images of holy personages on their long treks, which begin early in the week.

During the services on Sábado de Gloria, the black curtains that had covered the religious images throughout the week were pulled down on cue during the singing of the *Gloria*. That evening, Easter midnight mass preceded a vigil. In other communities, faithful did not drink water from Saturday before noon in anticipation of receiving communion the next morning. In some areas, water was avoided only from midnight on. Special foods were prepared during the week (see chapter 7). On the day after Easter, a dance was held to celebrate the end of a season of penance (see *Baile de Cascarones* in chapter 6). In recent years, the dance has been scheduled anytime during the month of April.

FOUNDERS' DAY

Established in 1988 in Albuquerque's Old Town with the dedication of a statue of Don Francisco Cuervo y Valdez, the founder of Alburquerque, this two-day event, which takes place during the third weekend in April, is comprised of a parade, proclamation reading, continuous entertainment, and a craft market. A thirty-minute film of a historical play about the city's founding, entitled *I Certify to the King*, is played throughout the weekend.

CINCO DE MAYO

This invented holiday emerged in San Francisco, California, in the early 1960s when various *Latino* groups, inspired by Asian-American cultural holidays, sought a holiday of their own. They settled on what is essentially a Chicano-American fiesta to celebrate the victory of the Mexican army over the

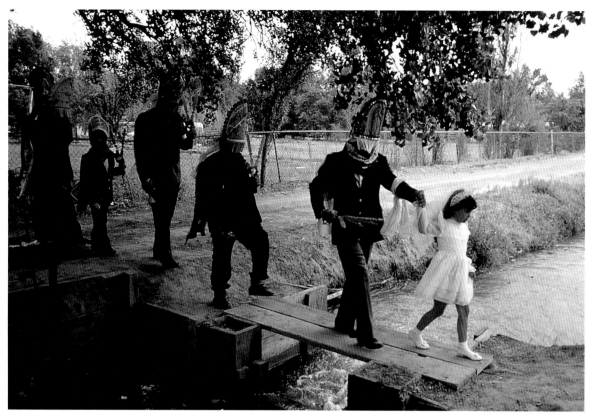

3.6
Malinche crossing acequia during Fiesta de San Isidro in Albuquerque, 1989. Photo by Miguel Gandert.

French army at Puebla in 1862. Ironically, *Cinco de Mayo* is a minor holiday in Mexico. Southern communities such as Mesilla, Truth or Consequences, Roswell, Hobbs, and Belen hold Cinco de Mayo fiestas on or near May 5. Mesilla, near Las Cruces, has celebrated Cinco de Mayo since 1985 with ballet folklórico, mariachi, craft and food booths, coronation, a basketball tournament, and evening dances.

FEAST DAY OF SAN ISIDRO LABRADOR
The patron saint of agriculture is especially revered in agrarian New Mexico. The actual saint was an ancestor of Don Diego de Vargas and is also popular throughout Spain, which is all the more reason to celebrate in New Mexico. Processions for San Isidro are especially beautiful because they often lead through fields and along acequias where flower petals are dropped in the water as it is blessed. San Isidro's feast day is May 15.

Summer Season
FEAST DAY OF SAN ANTONIO
As celebrated at the San Antonio Catholic Church in Cedar Crest, this feast day begins with vespers the evening before the fiesta. Matachines dancers approach the altar by twos, and on their knees, carrying a cross between the two rows of dancers. The dancers lead the procession after the mass on the following morning, accompanying the santos of St. Anthony and the Blessed Virgin almost a mile to a mountainside spring (Cedar Crest is located on the east slope of the Sandía Mountains). The dancing continues all the way to the spring, which

3.7
Rose petals in an acequia near Albuquerque. Photo by Miguel Gandert.

is then blessed to assure the abundance of water in the acequia that year. The santos are then returned to the church.

Later in the day, the santos are placed in the shade of trees while a new mayordomo is selected. He then receives the santos and the Matachines dance once again. At the church the mayordomo presents each dancer with a gift. An entriega is also sung to return the dancers to their families. A month before the feast day of San Antonio (June 13), the mayordomo and *El Monarca* (the lead dancer) go from house to house with a santo of the Child Jesus, asking the men to perform the Matachines at the fiesta.

FEAST OF SAN LUIS GONZAGA
Although observed throughout New Mexico, this feast day has special meaning for the people of San Luis, New Mexico, who sing and dance to San Luis as promesas for favors granted or requested. Also, the *Indita de San Luis* provides the poetry and music for a unique dance (described in chapter 6), which is performed in the aisle of the church. The faithful also observe this day with a prayer vigil for San Luis in a private chapel in Albuquerque. Because San Luis Gonzaga died at an early age from the plague, he is the patron saint for persons suffering from

AIDS and HIV (the new plague). He is also known as the patron of dance, youth, soldiers, and the disabled. June 21 is his feast day.

FEAST OF SAN JUAN BAUTISTA
The magic of this feast day is that all water becomes holy and healthful, inspiring early morning bathing in the river or acequias to ensure good health throughout the year. The emphasis on water reflects the saint's baptism of Jesus at the river. The fiesta is celebrated on June 24 and includes the mass, procession, and subsequent fiesta activities, with the addition of the corrida de los gallos, or rooster pull. This somewhat dangerous game is played on horseback, with riders at full gallop leaning over to grab the head of a rooster buried up to its neck in the ground. The idea is to pull it out of the ground. It is then thrown to any newlyweds in the crowd. The number of counts it takes for the rooster to land from this throw represented the number of sons the couple would have (Lamadrid and Loeffler 1994). While Hispanic communities stopped holding the corridas in the 1940s after at least two men were killed by a kick to the head, pueblos such as Santo Domingo and Acoma still hold the event every year.

NOVENA OF NUESTRA SEÑORA DE LA PAZ
A tradition in fulfillment of Vargas's promesa, this centuries-old event commemorates the Virgin's help in retaking Santa Fe during the reconquest and the survival of the Spanish settlers and soldiers that winter. The santo formerly known as La Conquistadora and now known as *Nuestra Señora de la Paz*, is honored with a novena. The process begins on the Sunday following the feast of Corpus Christi in June, which varies annually according to the date of Easter. The santo is carried in procession from her chapel in St. Francis Cathedral in Santa Fe to the Rosario Chapel, built in 1807 near the site of Vargas's encampment. It was at this site in the winter of 1692–93 that the women of Vargas's reset-

tlement party unpacked the santo and began praying, reportedly kneeling in the snow, as the attack on Santa Fe continued for several days. The novena is held at Rosario Chapel during the next week.

The following Sunday, the statue is carried in procession back to St. Francis Cathedral, where the Archbishop officiates at a high mass attended by members of *La Cofradía de Nuestra Señora de la Paz,* one of the oldest cofradías in New Mexico. According to Fray Angélico Chávez, who wrote extensively about *Nuestra Señora de la Paz,* the Spanish settlers began the tradition of annual novenas immediately in the same year as Vargas's victory. In recent years, the date of the novena was moved from October (the month of the rosary) to June to ensure better weather for the procession. The Santa Fe Fiesta, held in early September, is also held in commemoration of the recapturing of Santa Fe.

FEAST DAY OF SAN FELIPE DE NERI

Held at Albuquerque's oldest church, in Old Town, this large and widely attended three-day fiesta features the usual elements, including a procession following mass and vespers, parties, entertainment in the Old Town gazebo, a fiesta queen coronation, game and food booths, bingo, and an arts-and-crafts fair in nearby Tiguex Park. The feast

day is on May 26, but the festivities are held on the following weekend.

OÑATE FESTIVAL

This invented celebration was established in 1969 in Española to celebrate the settlement of New Mexico by Don Juan de Oñate in 1598. Held during the second weekend of July from Thursday to Sunday, it includes a fiesta concert with music and dance on Thursday evening, traveling mariachis, a candlelight procession, fireworks, street dancing, a fiesta queen coronation, a children's parade and picnic, piñata breaking, a pageant reenacting Oñate's taking possession of New Mexico, a grand ball in traditional dress on Saturday night, a grand parade on Sunday morning with mounted caballeros in sixteenth-century dress, floats, music, an afternoon merienda, vespers, a torch relay, more dancing, food booths, and more fireworks.

FEAST DAY OF SANTIAGO AND SANTA ANA

The patron saints of Taos are St. James, the patron saint of Spain, and St. Anne, the grandmother of Jesus. Their feast days are observed around July 25 and 26, with a traditional fiesta, candlelight procession, special mass, parade, horse races, Spanish folk dancing, Indian dances, mariachi

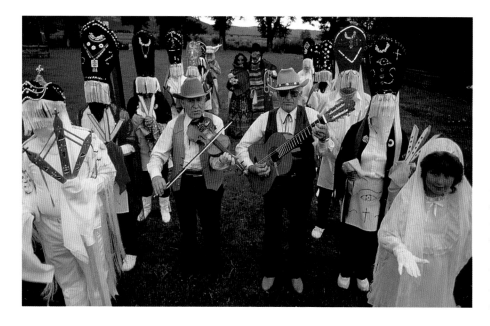

3.8
A portrait of Los Matachines de Arroyo Seco. Photo by Jack Parsons from his book *Santa Fe and Northern New Mexico,* 1991.

3.9
Rooster pull at Agua Fría, New Mexico, ca. 1920. Courtesy Museum of New Mexico, neg. #57659. Photo by T. Harmon Parkhurst.

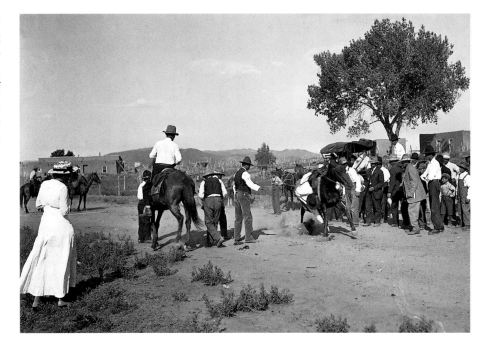

music, and food and craft booths. The fiesta, as celebrated in Taos, has been held every year since 1934. The crowned fiesta queen attends the Queen's Ball, then begins a grand march from one hall to another visiting various fiesta dances. For centuries, the patron saint of Taos was San Gerónimo, but in the mid-twentieth century the residents of Taos Pueblo felt they were losing control over the fiesta as tourism grew. The solution was to take over the San Gerónimo feast day while the Taos Chamber of Commerce embraced Santiago and Santa Ana as its patron saints, with the appropriate annual fiesta in their honor. It was a logical transition because Santiago and Santa Ana are important saints in Spain and Latin America, and already widely celebrated in New Mexico, according to Lamadrid. Both fiestas are community-oriented and very much events of, by, and for the people, illustrating how even in the face of tourism, a community can reclaim its lost traditions.

FESTIVAL FLAMENCO INTERNACIONAL
Flamenco performances are held at this two week festival in June at Rodey Theater in Albuquerque. Performances culminate a week of classes and workshops on flamenco performance, music, and history, featuring local and international guest artists and teachers. This highly popular event is organized and presented by dancer/teacher Eva Encinias-Sandoval, and the National Institute of Flamenco.

MARIACHI SPECTACULAR
Albuquerque hosts a week of performances and workshops in various venues throughout the city, including a street festival with music, food, and Mexican *folklórico* dancing. This popular festival brings together masters and students from all over the Western hemisphere. This event is sponsored annually by the University of New Mexico's Division of Continuing Education.

SPANISH MARKET
Traditional Spanish Market is held during the third weekend in July on the Plaza in Santa Fe and the Courtyard of the Palace of the Governors. Concurrently, Contemporary Spanish Market is held adjacent to the Plaza, featuring nontraditional art and nontraditional art inspired by traditional art. Hundreds of crafts persons sell their wares and con-

duct demonstrations while traditional music and dance acts perform on a stage in the Plaza and elsewhere. The market also features a children's exhibit area. Prizes for both adults' and children's works are awarded. Traditional Spanish Market is produced by the Spanish Colonial Arts Society; Contemporary Spanish Market is presented by the Santa Fe Arts Council. Winter Spanish Market is held indoors in venues near the Plaza, most recently in Sweeney Auditorium. The number of exhibitors increased dramatically in the last two decades of the twentieth century, as has the number of museum, gallery, and private-collector purchasers who attend. It is not unheard of to see booths on Saturday morning with all of their contents sold in the first minutes of the market.

Feast Day of San Lorenzo

The first Christian saint born in Spain, San Lorenzo is revered throughout the Spanish-speaking world. His feast day of August 10 has special resonance in New Mexico because on that day in 1680, the Indian Pueblos rose up in the only successful native rebellion in colonial Spanish America. According to oral history, the Bernalillo area was spared the devastation of the revolt because of the good relations with neighboring Sandía Pueblo. San Lorenzo is also celebrated in commemoration of the 1692–93 reconquest of New Mexico by Don Diego de Vargas, who died in Bernalillo. The fiesta features some of the finest Matachines dancing in New Mexico, with a great many participants. Women have been participating as dancers since 1976. There are so many people devoted to the dance that there are two complete Matachines groups. Even more dancers join in the *corridas* or dance processions. In addition, many other people with *promesas* (holy vows for blessings petitioned or received) take part in the portion of the Matachines known as *La Patadita*, a dance characterized by swift footwork.

The fiesta begins on August 9, when the santo of San Lorenzo is carried in procession from the mayordomo's house to the church for vespers, as bells ring and rifles are shot. Along the way, the Matachines dance. Dancing continues through August 10 and 11. On the last day, in ceremonies called the *despedimiento* and the *recibimiento*, the saint is exchanged from the old to the new mayordomos. The last event of the fiesta is the entriega ceremony at the old mayordomo's house, where the dancers are joyfully returned to their families. A verse about each one is sung. The secular components of the fiesta are parties, dances, family reunions, a carnival, a rodeo, a parade, an art show, an antique car show, a historical society exhibit, and of course, the food (Lamadrid 1998).

Spring Festival at El Rancho de las Golondrinas

An invented celebration held during the first weekend of June, this weekend event features demonstrations of spring activities in a

The Piñata

The piñata is another Mexican tradition that is widely known in New Mexico as a papier-mâché shell decorated with strips of clipped and crimped colored paper and filled with candies and favors. It is suspended by a rope from a ceiling beam or tree limb, then raised or lowered as blindfolded party-goers attempt to smash it open with a stick or baton. The term piñata *is derived from the Italian* pignatta *(fragile). In Renaissance Italy, party-goers at masquerade balls would suspend an undecorated pineapple-shaped pignatta filled with candies from the ceiling. It, too, was meant to be broken as in the modern piñata custom. The Spanish took the undecorated pignatta and built paper figures around its exterior to dress it up.*

In Mexico, Aztec priests prepared offerings for their god of war that were similar to the Spanish piñata. It was a clay pot filled with small treasures and covered with finely woven feathers and plumes. It was then placed on a pole in the temple where it was later broken open with a club.

typical Spanish colonial village in New Mexico, with demonstrations by costumed docents, and performances of colonial and nineteenth-century music and dance. Demonstrations include traditional foods, wool washing and dyeing, weaving, carpentry, blacksmithing, winemaking, colcha embroidery, and weaving.

Autumn Season

SANTA FE FIESTA

Probably the oldest fiesta in the nation, the Santa Fe Fiesta, as it is celebrated today, includes the requisite religious functions as well as a parade, entertainment, food and craft booths, a costumed children's pet parade and blessing, the crowning of a fiesta queen, the knighting of Vargas, a costumed reenactment of Vargas's *entrada* into Santa Fe, a formal ball, and a candlelight procession to the Cross of the Martyrs for a final blessing. The fiesta is preceded by two weeks of pre-fiesta events and begins the Friday after Labor Day, lasting all weekend. A twentieth-century Anglo contribution to the festivities is the burning of Zozobra, or Old Man Gloom, on the Friday evening of the fiesta weekend. The first Santa Fe Fiesta was held in 1712 to commemorate the recapturing of Santa Fe by Vargas.

DIECISÉIS DE SEPTIEMBRE

September 16 is Mexico's Independence Day, celebrating the end of three hundred years of Spanish rule. This event is more frequently celebrated in southern New Mexico. It has been celebrated in Mesilla since 1848, with a brief hiatus in the 1970s. Today it includes a parade, crowning of a fiesta queen, mounted *vaqueros* (cowboys), dancing, and food booths.

3.10

Reenactment of a Vargas Entrada along Palace Avenue. This entrada is from the 1919 Fiesta in Santa Fe. Courtesy Museum of New Mexico, neg. #52375. Photo by T. Harmon Parkhurst.

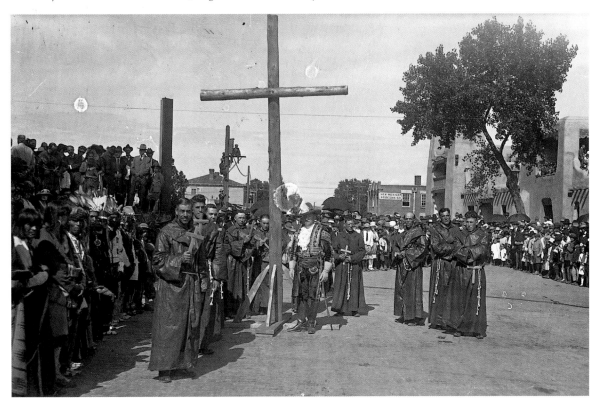

FEAST DAY OF SAN FRANCISCO

This feast day is observed throughout New Mexico on October 4 to honor the saint whose order provided missionaries to serve in New Mexico from the earliest days of the sixteenth century through the late eighteenth century. As a result, the fundamental devotion for San Francisco is especially strong among Nuevomexicanos.

OLD TAOS TRADE FAIR

This is a reenactment of the historic Taos Trade Fair with music and dancing, contests, food, demonstrations of blacksmithing, carving, and other colonial skills. The event was introduced in 1985 and is held in September at the Martinez Hacienda southwest of the plaza.

FESTIVAL DE OTOÑO

Introduced in 1990 by a group of Nuevomexicano teachers, artists, and writers led by Rudolfo Anaya, the *Festival de Otoño* (Autumn Festival) features the burning of the *Cucui* (or Kookooee or *El Coco*), a Meso-American bogeyman of folkloric origin used historically by parents to instill obedience and respect in children. Children write their fears on pieces of paper and stuff them into Cucui's bag. The effigy itself is created each year by various artists, with assistance from children and adults in the community. Then Cucui and its bag are burned. This invented festival is usually held outdoors at schools around Albuquerque's South Valley, and was created in order to give the area its own festival and to introduce children to the oral tradition of Nuevomexicano culture. Supporting that objective are the learning activities on the legend of Cucui, including poetry contests, sculptures, artwork, storytelling, a parade, and scholarships to the creators of the best work in these areas.

HARVEST FESTIVAL AT EL RANCHO DE LAS GOLONDRINAS

Held in early October, this festival features typical harvest activities in colonial New Mexico, such as a mule-driven sorghum press, the making of apple cider, musket shooting, flour milling and other activities. Costumed docents explain the activities and several harvest products are for sale. Enter-tainment includes music, traditional dancing, food, and crafts.

DÍA DE LOS MUERTOS

As introduced by the missionary friars in colonial days, the Day of the Dead was for centuries New Mexico's traditional Memorial Day until the American Civil War holiday of May 30 supplanted it. The style in which it has been celebrated in Mexico (specifically, in Michoacán) has grown in popularity in late twentieth-century New Mexico. It is held on November 1 and 2—also known as All Saint's Day and All Soul's Day, respectively—to honor relatives and friends who have died during the year. Families clean and decorate the graves and even hold a picnic there. Altars are also decorated and special foods made for the occasion. The belief is that the dead return for one day to share a feast with the living. This celebration has its roots in traditional Catholicism and Pre-Columbian cultures, and has been continuously celebrated in the Indian Pueblos of New Mexico. The striking visual imagery (skeletons) and symbolism of the Mexican observance of the celebration continue to inspire contemporary New Mexican choreography and visual arts.

Winter Season

Agrarian cultures worldwide generally hold more celebrations in the winter months when the gatherings will not keep the people from time in the fields or herding stock to and from the highlands.

FEAST DAY OF NUESTRA SEÑORA DE GUADALUPE

Celebrations are held throughout New Mexico on December 12. At the church of Our Lady of Guadalupe in Santa Fe, celebrations begin at 6:00 A.M. with a mass at which *Las Mañanitas* is sung, accompanied by violins and guitars. At Tortugas, an Indian village near Las Cruces, the three-day fiesta begins on the evening of December 10 as the faithful, accompanied by musicians, singers, and dancers, make their way up Mount Tortugas in a five-mile, two-hour torchlight procession. At the summit, they hold a mass by firelight, sing, and recite the rosary. The mountain procession is

repeated in the morning hours with mass held just before noon. The Tortugas celebration also includes Tiwa drumming and dancing before a small santo of the Virgin, an all-night prayer vigil, and the dancing of Matachines and *danzantes* in accompaniment of the procession bearing the Virgin.

La Virgen de Guadalupe is probably the brightest star in the firmament of saints and holy personages of Latin-American Christianity. She is special to the Indian and Hispanic peoples, whose struggles and triumphs she has inspired and encouraged as no European saint can. In addition to hope, she represents mediation as well—between God and humanity, and among the many cultures and subcultures of her followers in the hemisphere.

LAS POSADAS (THE INNS)

Beginning December 16 and ending December 24, *Las Posadas* is widely performed throughout New Mexico. A chorus of singers accompanies two actors portraying Joseph and Mary seeking shelter in Bethlehem. They proceed from one house to the next, singing their request. The refusal is also sung, from within the house. Finally, the last house accepts the pilgrims and a celebration with

music and refreshments follows. The process can occur all in one evening (on Christmas Eve) or one house may be visited per night, beginning on December 16. Traditionally, after the celebration of music and food, a performance of *Los Pastores* follows (figure 3.13). For this reason, the last "house" is often the church or community hall. The singing of *Las Posadas* involves a specific text that reenacts the search for shelter and that imparts a moral message. Traditional Christmas carols are also sung after the ceremony.

LOS ABUELOS (THE GRANDFATHERS)

Frightening figures dressed in rawhide and rags, wearing masks, and described as half men and half beasts, appear before Christmas to taunt children and serve as teachers, according to Arsenio Córdova (1997). They were supposed to have huge mouths, or no mouths. *Los Abuelos* (the grandfathers) appeared during the nine-day novena before Christmas, visiting homes where shelter was refused to Joseph and Mary of the *Posadas* ritual.

Córdova (1997) records:

Unexpectedly the *Abuelos* enter; the creatures are frightening even if they are

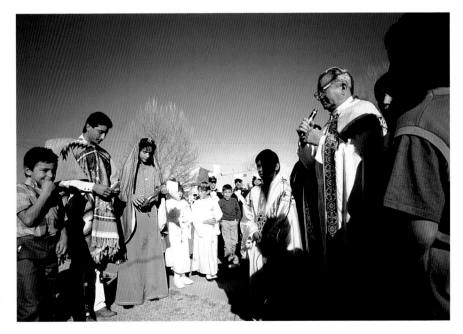

3.11
Young participants portray Juan Diego and Nuestra Señora de Guadalupe during a feast day procession in the San José barrio of Albuquerque, December 12, 1986. Photo by Miguel Gandert.

3.12
Pilgrims at a mountain near Las Cruces, New Mexico, during the Tortugas observances. Writer and Las Cruces resident Denise Chávez is at right. Photo by Miguel Gandert.

The *Abuelos* are cooking breakfast as they are preparing to come down from the mountain. Tonight they will be here to see what you have learned from your prayers. Do not worry, *mi hijito*, they will not take you far; we have taught you well. (Córdova 1997)

After midnight mass on Christmas Eve, the Abuelos waited outside the church dancing around a fire and menacing those who emerged. On Christmas Day, the Abuelos encountered children and adults alike, making them dance and menacing them with whips. Espinosa studied the musical rhythms used by Abuelos as they danced around the luminarias. Los Abuelos is thought to have derived from the clown-like leader of the Matachín dances. Córdova has played the role of an Abuelo for fifteen years in the Taos community. According to his parents and grandmother, the Abuelo is a teacher of history, genealogy, religion, and culture. The tradition continues in rural communities.

expected. Children flee to all parts of the house. There are always those less fortunate who are caught. A test then begins. In front of all present, the child is asked to recite the prayers which have been taught to all family members. The entire community watches and judges the parents on how well they have taught their children. The test is not only for the children but for the parents. The *Abuelo* is taken seriously by all and children were rewarded when they were able to answer questions about their culture, traditions, and religion.

If the child answered correctly, a celebration began. The children sing and do a circle dance called *La Palomita*, while the Abuelos watch.

Much of the children's fright was the possibility of abduction to the mountains where, the Abuelos claimed, the children would be trained to become Abuelos too. Córdova's grandmother, María de las Nieves Martínez, would point to the top of Taos Mountain. "Do you see the smoke?" she would ask him.

NOCHE BUENA/LA NAVIDAD (GOOD NIGHT OR CHRISTMAS EVE/CHRISTMAS DAY)

On Christmas Eve, the faithful attend midnight mass, which is called *La Misa del Gallo*, or Mass of the Rooster—named for the rooster of Bethlehem who crowed the good news, thus alerting the shepherds. During the nine days prior to *Noche Buena*, families conduct a novena. On the afternoon of December 24, luminarias and poinsettias are placed at the gravesites of loved ones, as well as small Christmas trees and candy canes. This is a practice that seems to be more prevalent in rural areas in the late twentieth century. At Christmas, luminarias border the graves or are placed there in the shape of a cross or a heart. The grave is prepared in the afternoon and the luminarias are lit at sunset. The family will also sing

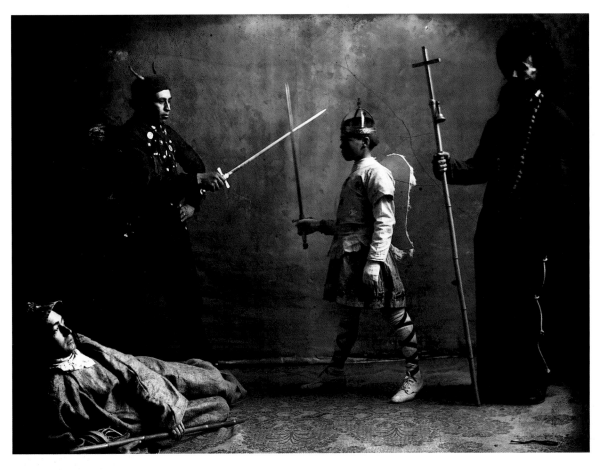

3.13
Los Pastores. Courtesy Museum of New Mexico, neg. #13695. Photo by Aaron B. Craycraft.

alabados and canciones at the grave. The family returns home for a reunion and for a festive dinner.

For interior decoration at Christmas, families laid out the nacimiento (nativity scene of small figurines). American immigrants in the nineteenth century introduced the Christmas tree, which in many homes is set up along with the nacimiento.

LOS COMANCHITOS NATIVITY PLAY
On Christmas Eve or Epiphany, the residents of several villages in the area of Mount Taylor, and at Bernalillo, perform this unique *indita* nativity play with music and dance. Reflecting the genízaro history of colonial New Mexico, this play depicts the approach of a group of Comanches (portrayed by costumed Nuevomexicano villagers) to a home where a prayer vigil is in progress for the Holy Child. Because they have no gifts, they offer to dance for the Child. As they dance, the Comanches become so enchanted by the *Santo Niño* that they capture him. The villagers ransom the Child by committing to host the following year's Christmas celebration. The Comanches also take other children as captives; their ransom requires offerings to sponsor dances, fiestas, and prayer vigils over the coming winter months.

In Bernalillo, the tradition has evolved to include Comanche-costumed children dancing in the church to the music of the following *indita* (excerpted) as sung by the parish choir:

LOS COMANCHITOS	THE LITTLE COMANCHES
Aquí estoy, Santo Niño	Here I am Holy Child,
Para cumplir mi promesa,	To fulfill my promise,
Este grupo de comanchitos	This group of little Comanches
Me vienen a acompañar.	Comes to accompany me.
En el marco de esta puerta	In the threshold of this door
Pongo un pie, pongo los dos,	I put one foot, I put both,
A toditita este gente	To all of these people,
Buenos noches les dé Dios.	May God give you a good night.
A mí no me lleva el río	The river won't take me
Por muy crecido que vaya,	No matter how high its flood,
Y yo sí me llevo al Niño	I'll take the Child along
Con una buena bailada.	With a good dance.
Coro	Chorus
Ana, jeyana, jeyana, jeyó	Ana, heyana, heyana, heyo,
Ana, jeyana, jeyana, jeyó	Ana, heyana, heyana, heyo,
Anayana yo, anayana yo,	Anayana yo, anayana yo,
Anayana yo, anayana yo,	anayana yo, anayana yo,
Ana, jeyana, jeyana, jeyó	Ana, heyana, heyana, heyo,
Ana, jeyana, jeyana, jeyó	Ana, heyana, heyana, heyo.

(Translation by Enrique Lamadrid)

After nearly disappearing in the 1960s *Los Comanchitos* nativity play is currently experiencing a revival.

LOS OREMOS (THE "LET'S PRAYS")

Early on Christmas Day, children go door to door carrying flour sacks and asking for treats. At each residence, they recite the following poem:

Oremos, oremos	Let us pray, let us pray
Del cielo vinemos	From Heaven we come
Angelitos semos	We are little angels
A pedir oremos	To ask for gifts
Y si no nos dan oremos	If you don't give us any
Puertas y ventanas Quebraremos.	Doors and windows We shall break.

(Translation by Arsenio Córdova)

Some children simply shout *Mis Crismes* (My Christmas) instead of the poem, a tactic which was considered a rude shortcut even if it resulted in

3.14
A gathering of Abuelos in Amalia, New Mexico, 1987. Photo by Miguel Gandert.

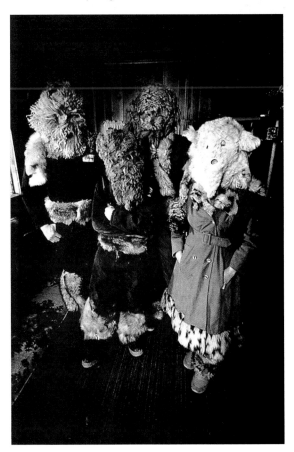

Luminarias and Farolitos

Traditional luminarias consist of cut piñon branches crossed and stacked in a square three feet high. The European definition indicates that luminarias provide lighting for church altars, while the farolito is simply a lantern (Augé 1948). In New Mexico, a farolito is a brown paper bag with a votive candle at its bottom, nestled in sand. The top edges of the bag are folded once or twice to reinforce its open position. In 1748, Fray Lorenzo Antonio Estremera wrote of a celebration in Santa Fe in honor of the new king of Spain, Ferdinand VI. He wrote, "And that night there were many luminarias" (Adams 1960). Some scholars suggest that the first farolitos in the Southwest were Chinese paper lanterns, which became available in the early 1800s. Beginning in 1821, brown wrapping paper was available from the traders of the Santa Fe Trail. The idea of stringing festival lights for outdoor celebrations came from the Moors of southern Spain. The combination of these influences may have eventually resulted in today's methods of outdoor Christmas decoration in New Mexico.

Scholars speculate that the bonfires lit the way to midnight mass for the townspeople. Another idea is that the bonfires are cultural remnants from Spain, where shepherds built bonfires on cold winter nights. Yet another hypothesis focuses on the bonfires as a Native American tradition. Espinosa asserts that it is the duty of Christians to illuminate the way for the Magi Kings on Christmas Eve. Josephine Córdova states that every night of the novena (see Noche Buena/La Navidad), a new luminaria was lit until on the final night there were nine. Espinosa noted that in Spain, the well-known bonfires were also called luminarias. "Even the modern lights, such as candles, lanterns, or electric lights that are placed in balconies and windows on festive days in Spain are called luminarias," he wrote (Espinosa and Espinosa 1985). He noted that Taos kept the tradition of nine bonfires during the novena. "A novena," he wrote,

is held in honor of the Blessed Virgin Mary, and the luminarias are lighted in the evening, after dinner, when the family begins to recite the rosary. Formerly the luminarias were placed sometimes on the roofs of houses. The Pueblo Indians of Taos, San Juan, and Isleta place lanterns or lighted candles on housetops on Christmas Eve today, probably a Spanish survival.

3.15
Building luminarias nine days prior to Christmas in Amalia, New Mexico. Photo by Miguel Gandert.

treats. Treats include ribbon candy, peanuts, *empanaditas* (pastries filled with sweetmeats or dried apricots), cakes, cookies, or apples. Children started early in order to get the best treats before supplies dwindled, according to Córdova. Sometimes money was given. To add to the drama, the Abuelos were out and about, observing and correcting the children's behavior, particularly those who called out *Mis Crismes.*

At one time in the pueblos of Acoma, Zuni, and Laguna, children went from house to house asking for treats on All Souls' Day, repeating only one word, *tsalemo,* at Acoma and Zuni, or *saremo* at Laguna. Acoma potter Emma Mitchell remembers taking part in this tradition as a child; however her daughter Monica Mitchell never experienced it. The similarities in the words *tsalemo, saremo,* and *oremos* are notable and suggest a common origin, possibly from the days of the friars.

MATACHINES AND COMANCHES AT ALCALDE
Alcalde is the village closest to the original colonial settlement of San Gabriel. Although its patron saint is San Antonio, its feast day was moved to December 27 decades ago, because of all the other San Antonio fiestas in the region.

Alcalde is famous for its graceful Matachines, and is the last village with a performance tradition of the spectacular equestrian folk play, Los Comanches, which celebrates the end of the devasting Comanche wars of the 1770s (see chapter 8).

DÍA DE LOS INOCENTES (DAY OF THE INNOCENTS)
The anniversary of the killing of the infants by Herod's soldiers is observed on December 28. In New Mexico, the practice is to try to borrow items from neighbors and then make them pay a ransom to get the items back. Items range from property to children. A child may be ransomed with food, while money will get one's property back; that, and a lot of ribbing for having forgotten that it is a day to remember the innocence of others. Those who did not forget and who were asked to loan an object or child would reply, *¡Dios se lo pague por inocente!* (May God reward you for being so innocent) (Córdova 1997).

LOS DÍAS DE LOS MANUELES (THE DAYS OF THE MANUELS)
This New Year's Day tradition is based on the Hispanic tradition of honoring individuals on the feast days of the saints for whom they are named. January 1 is the feast of Emmanuel, therefore anyone named Manuel or Manuela is honored on this day. Emmanuel means "God's Word" and is another name for Jesus Christ. In the early days of Christianity, Christmas may have been celebrated on January 1.

On this day, the whole community visits the homes of those individuals to sing verses in their honor and to feast. They are accompanied by violins and guitars, and partake of *bizcochitos, capulín* wine, *posole,* chile, and empanaditas. Because the visitors arrive just after midnight, one of the songs is *Las Mañanitas.* Córdova remembers a group of visitors he accompanied in 1997 that serenaded two bars, a dance at a Knights of Columbus Hall, and then broke up to visit individual homes in at least five towns. One of the revelers, José Ortega, lives in California but comes to New Mexico to take part in *Los Días de los Manueles.* "I will continue to come back to learn more of my culture and traditions which I miss so much," he said to Córdova (1997).

FEAST OF EMMANUEL AT RANCHOS DE TAOS
At this village south of Taos, the day is taken up with Comanche Dances, performed by villagers of mixed Comanche and Hispanic blood. As many as six groups of dancers and singers crisscross the community all day long, beginning in the early morning. They perform a set of dances at the church in the central plaza and proceed to the homes of the Manueles or Manuelas, as well as to homes of those in need of support or those who are ill. At each home, they perform a set of dances before moving on. The repertoire, as performed by the members of several extended families, includes round dances, line dances, a buffalo dance called *El Toro,* an eagle dance called *El Águila,* an enemy war dance called *El Espantao,* courtship dances, and *La Rueda,* a captivity dance in which someone is captured and ransomed. Lamadrid has studied the *Comanchero* dances at Ranchos de Taos extensively and is particularly

3.16
Francisco Gonzales, Jr., costumed as a genízaro for the Comanche dances at Los Ranchos de Taos on New Year's Day. Photo by Enrique Lamadrid.

American Indian music (Lamadrid 1998). The singers and dancers are descendants of the genízaros and of Nuevomexicanos raised as Comanches after being taken captive. The language is gone, but they have the music.

FEAST OF THE CONVERSION OF ST. PAUL

The Comanche Dancers of Ranchos de Taos also perform on January 23 in honor of the conversion of San Pablo, to which event the province of northern New Spain was dedicated by the missionary friars. On this day, anyone named Pablo or Pablito receives a serenade. The theme of this feast is conversion of the gentile (i.e., the non-Christian Indian), according to Lamadrid. The number of dancers on this day is somewhat diminished because it is not a national holiday (as is January 1) and many must work. The Comanche Dancers of Ranchos de Taos also perform for weddings, baptisms, and fiestas.

FEAST DAY OF SAN JOSÉ

This universal feast day is held all over New Mexico. At Albuquerque's San José Church, the celebration includes a mass and procession, followed by a carnival, craft and food booths, and entertainment. A respite from strict Lenten observances, this feast day falls on March 19.

moved by the captivity dance. Older members of the community respond with some emotion when this dance is performed because some are old enough to remember their genízaro Comanche nannies (called *chichihuas*), the last of whom died in the 1920s. It is these elders, who were raised by the captive Comanches, who are captured and ransomed during the dance.

The singers are comprised of former dancers who perform a variety of "Comanche" music that, according to Lamadrid, is of diverse origins, including Pueblo, Comanche, Kiowa, and Navajo influences. A few of the songs have lyrics that date to the middle eighteenth century. All of the songs feature vocables or syllabic singing characteristic of North

Glossary

Compadrazgo—Ritual parenthood between godparent and godchild.

Corrida de los Gallos—A rooster pull. The rooster is buried up to its neck in the ground and men on horseback gallop by and reach down to pull the rooster up and claim it.

Dando calabazas—Literally, giving pumpkins. The negative response to a proposal of marriage. The origin of this phrase is unknown.

Donas—Personal gifts to the bride from the groom consisting of a chest containing the wedding gown, accessories, and additional gowns for the wedding dance.

Entregador or entregadora—The singer of an entriega. This singer must be an expert at improvising verse to describe or comment on individual guests at a wedding, or in any special situation.

Farolito—A brown paper bag with a votive candle at its bottom, nestled in sand, and its upper edge turned under once or twice to strengthen it.

Feria—An annual fair to exchange trade goods.

Fiesta—The feast day of a saint or religious personage for whom there is a special allegiance by the community. The saint might be the patron of a town, church parish, or historical event.

Fiesta queen coronation—Several young women will compete for the title of fiesta queen. In many communities, the contestants raise money for charity, with the winner becoming queen. The coronation, in full formal dress, takes place early in a fiesta's schedule so that she may ride in the parade and reign over the full two or three days of the event.

Invented celebration—A term created by anthropologists to describe cultural events that are purposefully initiated, in contrast to those that arise from a long community tradition.

Luminaria—Traditional luminarias consist of cut piñon branches crossed and stacked in a square three feet high. The European definition (votive candles) indicates that *luminarias* provide lighting for church altars, while the *farolito* is simply a lantern.

Madrina—Godmother.

Mayordomo—Fiesta steward or sponsor. The man with specific duties year round regarding the maintenance of the santo of the patron saint of a community and its feast day, as well as its chapel or church.

Nacimiento—Nativity scene comprised of figurines.

Novena—A nine-day series of prayers and services.

Novio(a)—Sweetheart or newlywed.

Padrino—Godfather. Also, in plural, godparents.

Prendorio—Betrothal ceremony.

Promesa—A holy vow to God or the saints for favors granted. Also, a thanks for blessings already received. The promise usually is to perform some act of devotion.

Rosary—The string of beads used for counting off each prayer of a rosary, which was a series of prayers consisting of five sets of ten "Hail Marys," each set preceded by an "Our Father" and followed by a Gloria Patri. During each set, one of the mysteries or events in the life of Jesus or the Virgin Mary is contemplated.

Velorio—Wake or vigil. The body of the deceased was not to be left alone the night before the funeral, so the community gathered to pray, sing, and visit through the night while keeping vigil over the body.

Vigil—A devotional service of prayers and singing held throughout the night prior to a fiesta, or as part of a wake. Prayer vigils are also held in honor of saints.

Bibliography

Adams, Eleanor B. "Viva el Rey!" *New Mexico Historical Review* 35 (1960): 284–92.

Augé, Claude, ed. *Pequeño Larousse Ilustrado: Nuevo Diccionario Enciclopédico*. Translated by Miguel de Toro y Gisbert. Paris: Librería Larousse, 1948.

Catanach-Hamm, Elizabeth. "La Fiesta de San Antonio." *Herencia del Norte* 14 (Summer 1997): 21.

Chávez, Fray Angélico. "The Conquistadora Processions." *New Mexico Magazine*, June 1977, 32.

Cohen, Hennig, and Tristram Potter Coffin, eds. *The Folklore of American Holidays*. Detroit: Gale Research Company, 1987.

Córdova, Arsenio. "The Winter Traditions of Hispanic Northern New Mexico and Southern Colorado". Master's thesis, New Mexico Highlands University, 1997. 29–31, 37, 40, 41.

Delgado, Casimira. "El Velorio." *Herencia del Norte* 8 (Winter 1995): 25.

Espinosa, Aurelio M. *Los Agüelos de Nuevo Méjico*. Santander, Spain: Boletín de la Biblioteca de Mendenez Pelayo, 1945.

Espinosa, Aurelio M., and J. Manuel Espinosa, eds. *The Folklore of Spain in the American Southwest: Traditional Spanish Folk Literature in Northern New Mexico and Southern Colorado*. Norman: University of Oklahoma Press, 1985. 71–72.

Gemoets, Lee. "Fiesta Rekindles Cultural Pride in Mesilla." *New Mexico Magazine*, September 1990, 38–43.

Horgan, Paul. *Lamy of Santa Fe: His Life and Times*. New York: Farrar, Straus & Giroux, 1975.

Jensen, Carol. "Cleofas M. Jaramillo on Marriage in Territorial Northern New Mexico." *New Mexico Historical Review* 58 (1983): 153–71.

Jones, Oakah L., Jr. "Hispanic Traditions and Improvisations on the Frontera Septentrional of New Spain." *New Mexico Historical Review* 56 (1981): 333–47.

Kincade, Kathy, and Carl Landau. *Festivals of the Southwest: Your Guided Tour to the Festivals of Arizona and New Mexico*. San Francisco: Landau Communications, 1990.

King, Scottie. "Los Comanches de la Serna." *New Mexico Magazine*, January 1979, 25.

——. "Pilgrimage to a Hallowed Place: Good Friday at Chimayo." *New Mexico Magazine*, March 1979, 26.

Lamadrid, Enrique. "Las Entriegas—Ceremonial Music and Cultural Resistance on the Upper Río Grande: Research Notes and Catalog of the Cipriano Vigil Collection 1985–1987." *New Mexico Historical Review* 65 (1990): 1–19.

———. Personal communication, 1998.

Lamadrid, Enrique and Jack Loeffler. *Tesoros del Espíritu: A Portrait in Sound of Hispanic New Mexico*. Albuquerque: El Norte/Academia, 1994.

Lea, Aurora Lucero-White. *Literary Folklore of the Hispanic Southwest*. San Antonio: Naylor, 1953.

Miera, Rudy J. "La Noche Buena y Nuestros Antepasados." *La Herencia del Norte* 12 (Winter 1996): 14–15.

Mitchell, Monica, and Emma Mitchell. Personal communication, March 1998.

Montaño-Army, Mary, Carol Guzmán, and Juanita Wolff. *The New Mexico Directory of Hispanic Culture*. Albuquerque: Hispanic Culture Foundation, 1990.

Montaño, Celida. Personal communication, March 1998.

Rael, Juan B. "New Mexican Spanish Feasts." *California Folklore Quarterly* 1 (1942): 83–90.

Salinas-Norman, Bobbi. *Indo-Hispanic Folk Art Traditions, I: A Book of Culturally-based, Year-Round Activities with Emphasis on Christmas*. Oakland, Calif.: Piñata Publications, 1988. Spanish version by Larry Miller and Paula Terrero.

———. *Folk Art Traditions, II: A Book of Culturally-based, Year-Round Activities with an Emphasis on the Day of the Dead*. Oakland, Calif.: Piñata Publications, 1988. Spanish version by Amapola Franzen and Marcos Guerrero.

Steele, Thomas J., S.J. "The Spanish Passion Play in New Mexico and Colorado." *New Mexico Historical Review* 53 (July 1978): 239–59.

Weigle, Marta, and Peter White. *The Lore of New Mexico*. Albuquerque: University of New Mexico Press, 1988.

The Wiz Kids with Serafín R. Padilla. *Ernesto's Encounter with El Kookoóee*. Albuquerque: Armijo Elementary School, 1997.

World Book. *Christmas in the American Southwest*. In *Christmas around the World*. Chicago: World Book, 1996.

———. *Christmas in Mexico*. In *Christmas around the World*. Chicago: World Book, 1996.

4

Artes de la Vida: Secular Arts

THIS CHAPTER PRESENTS the reader with fascinating details, heroic deeds, and puzzles to be researched and worked out. The subjects presented are architecture, furniture, weaving, colcha embroidery, tinwork, ironwork, silverwork, gold jewelry and filigree, and straw appliqué.

The frontier challenge was more than met by a handful of early Franciscan friars whose assignment it was to build temples to God in the middle of nowhere, using local materials, unskilled labor, and the memory of Mexican cathedrals as their blueprints. Their monuments remain, and lest their names be forgotten, they are listed in this chapter. Environmental and economic influences in New Spain's northern frontier contributed in various degrees to the alteration of European forms to suit local supplies and necessities. For example, the wrought-iron window gratings of Spain and Mexico became, in New Mexico, wooden gratings because iron was scarce and expensive. Today, wooden gratings are part of what can be called New Mexico style.

Equally fascinating are the many ways in which the Spanish, Indian, and Anglo peoples shared technologies and materials. For centuries, Nuevomexicano women spun with a Pueblo tool, the *malacate*, even after the expensive, and therefore largely unavailable, spinning wheels were introduced from the East. The tin containers brought to New Mexico by the American military were essential to the tinsmith's craft, which began in earnest only after the arrival of Brigadier General Kearny and his men. The Navajos quickly learned silversmithing and weaving from the Spanish and are now world-famous for both crafts.

Then there are the mysteries. How is it that the ikat dyeing and weaving style found its way from Guatemala to Chimayó, New Mexico? Is there a relation to *Nuestro Señor de Esquipulas*, a holy personage also "native" to both Guatemala and Chimayó? Nor are there any explanations for the fact that Spanish colonists in New Mexico did not build kilns to manufacture bricks and tiles for building, when their cousins in California and Texas built and used kilns. As many questions seem to arise as to be answered when studying material culture in New Mexico.

Architecture

It was the dawn of the sixteenth century when the Spanish drove the Moors out of Spain after eight hundred years of occupation. To celebrate, they built elaborate Gothic churches all over Spain, newly reclaimed in the name of the Roman Catholic Church. Since then, Gothic style in Spanish religious architecture has always been identified with Christianity. Yet, Moorish stylistic influences are as long lived because many Christianized Moors remained in Spain to live and work as craftsmen. They imbued their decorative work with Moorish stylistic elements that came to be known as the Mudéjar style, a hybrid Moorish-Christian style used in the service of Christianity.

Inevitably, these styles, along with Renaissance and baroque styles, would find expression in New World structures over the next three centuries. Somewhat symbolically, Seville is both the site of what is considered the largest Gothic cathedral in the world, and the port from which ships sailed to the New World throughout the colonial period. In Mexico and New Mexico, church builders often

intermingled several styles within a single structure, as if to celebrate all the styles reminiscent of their homeland.

Gothic Style

Elements of Spanish Gothic church architecture include pointed or "broken" arches, vaulted ceilings, the classic rose window (a large, elaborate, circular stained glass window often found at the rear of the nave, above the front door), and a floor plan that included a long and narrow nave with or without side aisles ending in a polygonal apse (that portion of the nave behind the altar), and an attached *convento* (friars' residence) to one side of the church. The convento usually contained an interior courtyard. Aspects of the Gothic style were well represented in New Mexico mission churches.

Mudéjar Style

Mudéjar elements include adobe as building material, geometric designs, *artesonado* ceilings, and rectangular frameworks around curved doorways. Moorish design never depicted humans or animals, but instead focused on highly detailed and repetitive vegetal, geometric, or calligraphic patterns. A Mudéjar element is the artesonado or wooden mosaic ceiling found in Spanish churches and used in modified versions as far afield as New Mexico. The use of adobe in building New Mexican churches and other structures goes back to medieval Spain where Moors introduced adobe, including the technology to build adobe domes.

Renaissance Style

Renaissance architects attempted to revive the classic look of ancient Greek and Roman architecture because they were revisiting and celebrating the roots of European culture. The term *renaissance* is derived from the French word for rebirth. Proponents of this movement sought new ideas and challenged old ones in reaction to the oppressive centuries of the Dark Ages, during which time the Church prevailed and punishment for heresy was severe. It was also a reaction against the self-denying sensibilities of the Middle Ages, when the promise of heavenly riches rendered the pursuit of earthly comforts as self-centered and sinful. In Spain, where

the Church remained strong and the monarchy remained conservative, Renaissance architecture took a rigid and austere look, as if to reaffirm the futility of earthly comforts. The Escorial is the finest example of this style, with its imposing yet relatively undecorated structural elements, and its monotonous succession of identical small windows appearing along the long, high exterior walls, not unlike those found in fortress churches in New Mexico.

The early Renaissance in Spain and Mexico is marked by the rounded arch, the gridiron floor plan, triangular pediments, miniaturized Greek and Roman decorative patterns, and the Greco-Roman atrium, manifested as a courtyard flanked or surrounded by *portales* (porticoes). In Mexico, these large courtyards served as outdoor naves for holding mass for large native populations. While the true rounded arch was nonexistent in New Mexico, the atrium was used frequently, and excavated church walls reveal some Renaissance-inspired decorative patterns.

Baroque Style

One of the intentions of elaborate Gothic and baroque church architecture was to dazzle the faithful with the heavenly brilliance of the Roman Catholic Church, which was in competition with the Protestant Church after the Reformation. The Reformation was a religious movement of the sixteenth century which sought to reform longstanding abuses of the Roman Catholic Church, and which gave rise to Protestantism in all its variations. The Reformation prompted the Counter Reformation, which was the Church's attempt to win back followers.

The Counter Reformation began with the Council of Trent (1545–63), at which Roman Catholic leaders reaffirmed the use of art and imagery despite criticism from Protestants. This reaffirmation was expressed as baroque design, which introduced theatrical and artful church interiors, created as elaborately and as reflective of heaven's glory as was affordable. The Council of Trent in effect initiated the baroque period, which spread quickly throughout Europe and the New World, lasting to the mid-eighteenth century.

Baroque architects revived the cross-shaped (cru-

ciform) floor plan, and domes with clerestory windows that allowed sunlight to stream into sanctuary interiors, creating the illusion of celestial light and, by implication, divine endorsement. In New Mexico, the transverse clerestory window served as a light-producing substitute for domes, which were not possible with existing technology.

The distinctive twisting "Solomonic" column and the angular estípite column graced baroque churches worldwide. The Solomonic column grew in popularity after it was employed at St. Peter's Basilica in the 1630s. Artists typically applied representations of grapevines to the baroque version of the Solomonic column, a popular element which, in Mexican churches, grew extremely elaborate and in New Mexico, was represented in two-dimensional paint as well as the occasional three-dimensional carved and painted wood column. The estípite column became popular in Spain in 1700. Patterned after Roman columns, it was already in use in Mexico City by 1717 on the Altar of the Kings.

In New Mexico, this column style saw expression in stone and on painted surfaces.

All of these stylistic elements were realized in New Mexico church architecture to varying extents, and with the added challenges unique to the region.

Architecture in New Mexico

Life in New Mexico offered many challenges to builders, including the low level of technology, the lack of capital for ranching, farming, or industry, and the lack of water-driven sawmills, or brick- or tile-making operations. The general consensus today is that the colonists simply had their hands full maintaining their settlements in the face of constant Indian attacks, harsh winters, and Mexico City's disinterest—and resulting lack of financial or technical support—in developing the region's economy. As a result, European architectural design in New Mexico was remarkable when considering the builders' resources, limited tools, local nonmanufactured materials, the absence of professional

4.1

Mission church at Abó after excavation and repair in 1940. From George Kubler, *The Religious Architecture of New Mexico* (Albuquerque: University of New Mexico Press, 1940), plate 62.

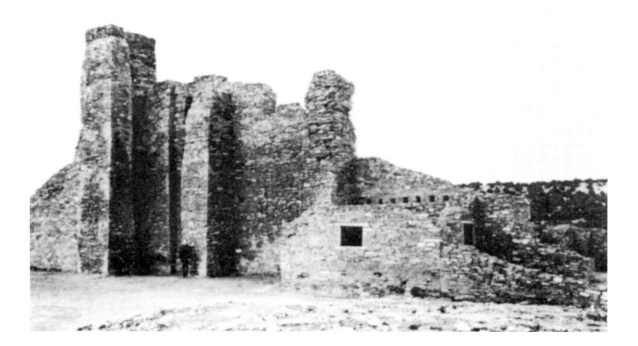

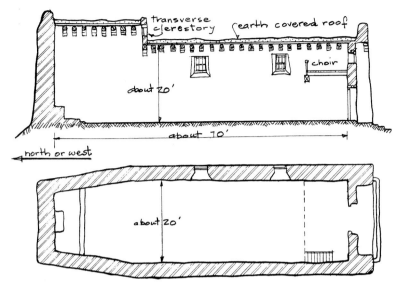

transverse clerestory

earth covered roof

about 20'

choir

about 70'

north or west

about 20'

4.2
Hypothetical plan and section of a New Mexico mission church, including transverse clerestory. From Bainbridge Bunting, *Early Architecture in New Mexico* (Albuquerque: University of New Mexico Press, 1976), 56.

builders, and only a fond memory of the styles and structures of Spain and Mexico. In addition, progress and change came so slowly that forms and building methods employed in 1610 were still in use more than two centuries later.

Church Architecture in New Mexico

Adobe as a building material was known in New Mexico prior to the arrival of the Spanish, but in a different manner. Pueblo Indians built their homes by piling up the wet mixture layer upon layer to a level of one foot. After drying, another foot would be added, and so on, to a maximum possible height of six to eight feet. The long-drying walls were thick at the bottom and narrow at the top.

In the construction of mission churches, the Spanish friars introduced the adobe brick, which increased the potential height of walls to as much as thirty feet. For the Pueblo people, this innovation represented a whole new concept in interior space, while the friars' proselytizing goals were served because the larger interiors also dramatically under-

scored the glory of God's earthly dwelling. The mission church was built in or near a pueblo, with Indian labor, and under the direction of the friars.

The friars also built with fitted limestone or sandstone. At Abó, Quarai, Humanas, and Jémez, they built churches and other structures with these fitted stones, the strength and durability of which made possible the use of the Mudéjar carved-wood artesonado ceilings. There is archeological evidence of such ceilings at Abó, Jémez, and Sandía.

Friars built between thirty and fifty mission churches between 1607 and 1637. The basic style of the early churches was a combination of Gothic, Renaissance, and Mudéjar styles. These "fortress churches" featured high walls; rare, small, and high windows resulting in relatively dark naves; and the medieval *almenas* on the roofline. Early photographs of the community churches of Santa Fe show these squared battlements. While the friars favored the typical Gothic elongated nave with polygonal apse as a basic design, they frequently combined different stylistic elements in a single structure. An example of combined elements is San Esteban del Rey, the seventeenth-century mission church at Acoma Pueblo in western New Mexico. Its Gothic features are the attached two-story convento and interior courtyard. It also has a Renaissance tower and large atrium, later converted to a cemetery after tons of dirt were hand-carried up the high mesa on which the Pueblo is situated. As with similar building projects, wood had to be cut in the uplands and dragged by horse or manpower to Acoma.

All over the Spanish Americas, mission churches were built and staffed with royal funding. Spanish settlers also built churches, but with their own resources. These smaller churches were known as *visitas* and were visited periodically by priests

They Built Monuments in the Wilderness

The following excerpt by noted New Mexico scholar George Kubler (1990) comments on the friar builders, who

> *aside from the task of diverting a massive population from its ancient beliefs . . . executed ambitious building projects for which they themselves were the architects, contractors, foremen, and building-supply agents. . . .*
>
> *Nothing has been said about the architectural knowledge or training of the friars. If their status as men of education is admitted, it must follow that they were capable of acquiring the principles of construction. As Gillet has pointed out in the case of the religious architecture of the sixteenth century in Mexico, the friars were self-trained architects,* artistes d'occasion, *working out their solutions in direct practice. But they occasionally had the benefit of Spanish workmen, quarry workers and stonemasons, to instruct the Indians in special techniques. Even then, design and the theory of construction were independently acquired. . . . In New Mexico, the situation was generically similar. Certain architectural elements based partly upon native practice, and partly upon formal conventions inherited from Europe, were organized by nonprofessional designers into a coherent, practical system. The solution can have been worked out only during construction itself, by men of exceptional teaching and creative ability. Exactly who they were cannot now be determined among the poorly documented names: Alonso Peinado at Santa Fe and Chililí before 1617, Estevan de Perea at Sandía in 1609, Cristóbal de Quirós at Zía, Ascencio de Zárate at Picurís, Martín de Arvide among the Jémez, Juan de Escalona at Santo Domingo before 1607, Alonso de Lugo at Jémez before 1601, Cristóbal de Quiñones at San Felipe before 1609, Juan de Salas at Isleta in 1629, Gerónimo de Zárate Salmerón among the Jémez before 1626, Antonio de Arteaga at Senecú in 1630, Francisco de Letrado and Diego de Santander at Humanas, Francisco de Acevedo at Abó, Tenebó, and Tabirá before 1659, García de San Francisco y Zúñiga at Socorro and at El Paso in 1662, Juan Ramírez of Oaxaca at Acoma, Roque de Figueredo at Hawikuh, Francisco de Porras at Awatovi in 1629.*

from neighboring missions. Late seventeenth- and eighteenth-century settlers built their churches using the baroque cruciform floor plan. These modest buildings did not have a convento or courtyard, but rather a separate or attached building, called a rectory, to house the visiting priest. Examples of eighteenth-century community churches include those at Las Trampas, built in 1761, Santa Cruz, 1733, Ranchos de Taos, 1780, and Albuquerque, 1790. San José de Gracia Church at Las Trampas features a walled U-shaped atrium surrounding the church on three sides, a cruciform plan with deep transepts, and a transverse clerestory window. The clerestory window at Las Trampas is the only surviving example not covered with modern roofing.

Franciscan friars also built the baroque-inspired transverse clerestory windows into some New Mexico mission churches for the same reason—to admit light to brighten up the altar with morning sunlight, often in sharp contrast to the darker nave. Many New Mexico churches were built facing east or south to take advantage of the morning sunlight on the altar.

Surviving Churches

Frequent remodeling over the past 175 years has altered the look and structure of surviving churches to the extent that, even with previous descriptions by such careful inventory recorders as Fray Atanasio Domínguez, and nineteenth- and early-twentieth-

century photographs, today's scholars still find it difficult to determine the original floor plans and interior designs with any certainty.

The Pueblo Revolt of 1680 resulted in the destruction of many seventeenth-century churches. The foundations of these churches were not discovered until the 1960s during archeological excavations. Only their foundations have survived. Some of the nineteen seventeenth-century churches that survived to one degree or another include:

- San Agustín at Isleta Pueblo (before 1629), made of adobe, some original walls remain, still in use today
- San José at Giusewa Pueblo, (in Jémez, ca. 1621), made of fitted stone, ruins
- San Esteban del Rey at Acoma Pueblo (before 1644), made of adobe, some original walls, still in use today
- Nuestra Señora de los Ángeles de Porciúncula at Pecos Pueblo (before 1625), made of adobe
- La Concepción at Quarai Pueblo (Salinas, ca. 1632), fitted stone, ruins
- San Gregorio at Abó Pueblo (Salinas, ca. 1630), fitted stone, ruins
- San Buenaventura at Gran Quivira Pueblo (ca. 1660), fitted stone, ruins
- Nuestra Señora de la Asunción de Zía at Zía Pueblo (ca. 1613), made of adobe

The eighteenth century saw the de-emphasis on mission activity and the increase in community churches.

Examples of eighteenth-century churches still in use today include:

- San Felipe de Neri in Albuquerque (1790s), adobe
- Santa Cruz de la Cañada in Santa Cruz near Española (1733–48), adobe
- San José de Gracia at Trampas (1760–76), adobe
- Nuestra Señora del Rosario in Truchas (1760), adobe

Examples of nineteenth-century churches include:

- Santuario de Nuestro Señor de Esquipulas at Chimayó (1816), adobe
- San Antonio at Córdova (1832), adobe
- San Francisco at Santa Fe (cathedral, 1869), sandstone
- San Juan de los Lagos, later Nuestra Señora de San Juan, at Talpa (1840s), adobe

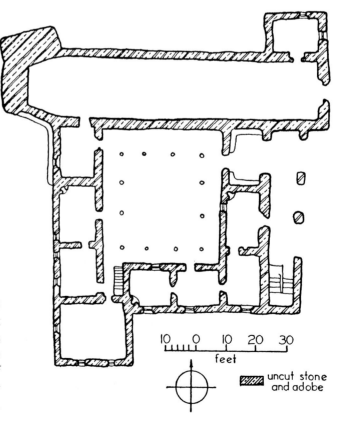

4.3
Plan of mission church at Laguna, showing monastery and posts for interior portal. From George Kubler, *The Religious Architecture of New Mexico* (Albuquerque: University of New Mexico Press, 1940), 111.

- Mission churches at Taos, 1849, and Santo Domingo, 1890

Church Interiors

Archaeologists have excavated some wall decorations, but they are very fragile and rare because early painters applied water-soluble paint (using local pigments) to mud and plaster—all very unenduring materials. The interior wall decorations excavated thus far reveal simplified versions of Renaissance borders, *Majólica* tile patterns, solid colors achieved with red iron oxide, or patterns presumed to have been copied from Mexican crockery (sherds of which have been found in many mission sites). Painted interior wall fragments have been found in church ruins at Quarai, Awatovi, and Giusewa. Other sites have many layers of paint. As recently as 1968, colonial paint has been whitewashed or otherwise covered over.

The baroque spirit in New Mexico manifested itself in representations of Solomonic and estípite columns. However, New Mexican artisans necessarily drew

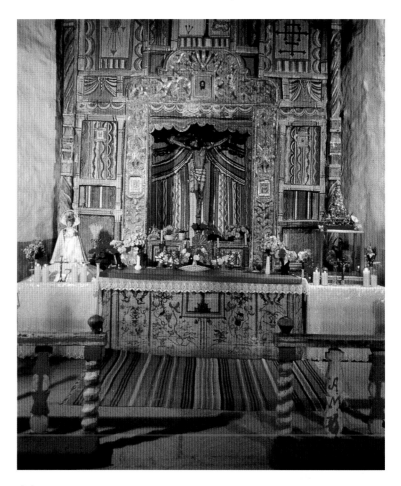

4.4

Example of attached and freestanding Solomonic columns, at the Santuario de Chimayó in New Mexico. Note the bulto of the Santo Niño at left. Photo by Miguel Gandert.

on available materials and their memories to represent these designs, and others. So while artisans in Mexico worked their surfaces in gold leaf, New Mexican artisans worked theirs in paints of many colors. The realistic or stylized grapevines of the Mexican interiors are found in New Mexico as border and corner vines and vegetable images. Rendered in colorful, two-dimensional paint, the Solomonic column in New Mexico often resembles a barbershop pole; but it also appears in three-dimensional carving on reredoses (altar screens) such as at Laguna Church or San Miguel Church in Santa Fe. The estípite column found its best

expression in New Mexico in the stone reredos screen originally built in 1761 for a military chapel on Santa Fe's plaza. That reredos now graces the Church of Cristo Rey in Santa Fe, built in the twentieth century to house it. New Mexico artisans also rendered in paint the estípite column, transforming it into a series of abstracted geometric patterns rather than a painted picture of an identifiable column. Examples are to be found at Las Trampas or in the south chapel at Santa Cruz. Rope borders were popular and seemed to represent both the Solomonic column and the Franciscan order, whose followers wore ropelike belts.

Altar tables were made of wood, adobe, or of stone slabs filled with adobe. In the absence of window glass, settlers carved wooden grills, set them vertically in small window openings and sealed them with hand-shaped squares of selenite or mica laid like shingles between the grills. Other window treatments involved the use of wooden shutters on pintle hinges built into the walls, and/or windows with animal skin coverings. Interiors were relentlessly dim for centuries (except for spaces with clerestories) until the availability of window glass in the mid-nineteenth century. An example of a rare colonial window can be found at the Santuario de Chimayó.

Floors in both churches and homes were of packed earth, and laid each year with a mixture of new mud, animal blood, and straw. Such floors are still maintained in churches at Acoma, Laguna, Santa Ana, and Zía. The faithful attending mass sat on the floor or stood throughout the service. No traces of fireplaces have been discovered in the churches, so scholars speculate that early morning mass, especially in winter, was uncomfortable for the body even as it uplifted the spirit.

Domestic Architecture in New Mexico

Spanish colonial homes were of two types, depending on the resources of the builder. The typical hacienda style, patterned after the Spanish-Mediterranean home, was a square plan of rooms surrounding, and opening into, an interior courtyard. Building material was adobe brick or a combination of stone and adobe. Rooms did not necessarily interconnect, but an interior *portal* ran around the inside length of the courtyard. The family quarters included a kitchen, storage, living quarters, and possibly a large room where bailes were held. The courtyard held a well and *hornos* for baking; vegetables and fruit were strung up and dried in the sun along the portal.

This floor plan frequently had two squares with two interior courtyards. The second courtyard (or *plazuela*) was used to hold livestock during raids or bad weather; its rooms were used for storing farm or ranch equipment, and feed. The two courtyards connected through a small breezeway. Access to the outside was through a large double door known as a *zaguán* gate, which led into the wide zaguán (vesti-

bule) itself. A good example of the hacienda residence is the Martínez Hacienda in Taos, built in the late eighteenth century by the father of Padre Antonio José Martínez. Its reconstruction in the twentieth century was achieved with the help of old photographs; it is now a museum and open to the public. Other fine examples of Spanish colonial architecture are to be found at El Rancho de las Golondrinas, located south of Santa Fe.

While wealthy merchants and ranchers lived in haciendas, if they could manage it, most New

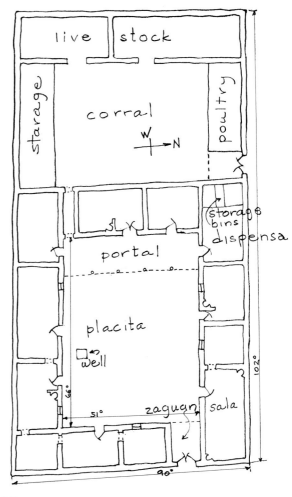

4.5
Hypothetical plan of a New Mexico hacienda. From Bainbridge Bunting, *Early Architecture in New Mexico* (Albuquerque: University of New Mexico Press, 1976), 62.

Mexicans lived in more modest adobe-brick structures, consisting of a straight line of rooms attached end-to-end to form an I, L, or U. New rooms were added to accommodate sons or daughters who married; unused rooms often were left to weather away. *Jacal* construction was often used for storage or animal pens. In jacal construction, the builder set wooden beams vertically in the ground at short intervals, and filled the spaces with mud.

The central courtyard plan was also applied to entire villages for defensive purposes. The only surviving example of a central fortified plaza is the Plaza del Cerro in Chimayó, built in the late 1700s in a rectangle of contiguous homes, all of which open only into the center area. The settlers

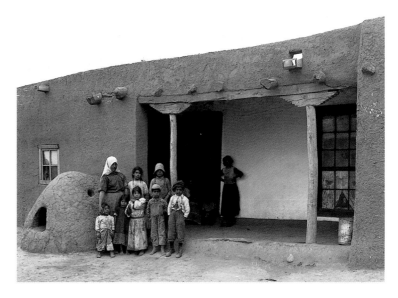

4.6
Facade of a house on Agua Fría street in Santa Fe showing the typical adobe construction with a portal, about 1905. Courtesy Museum of New Mexico, neg. #14104.

built large exterior gates which are now gone. The outer walls of the individual residences that make up this plaza were built with little or no openings in order to discourage entry by attacking forces.

New Mexico architecture scholar Bainbridge Bunting observed that Pueblo builders piled their basic adobe rooms in irregular triangles (as at Taos Pueblo), whereas Spanish colonists embraced the I-, L-, or U-shaped single-room configuration arranged in defensive plazas. Because Pueblo and Spanish communities adopted many of their construction features from each other, the Spanish colonial adobe-brick architecture of New Mexico came to be called Spanish-Pueblo style by twentieth-century scholars. Some of its more salient features include:

- The use of adobe brick as the basic building material
- The use of pintle hinges for doors and shutters
- The corner *fogón* or fireplace with parabola-shaped opening
- Ceilings constructed with vigas, latillas, and dirt with straw

- Small windows with vertical wooden dowels fitted with selenite, covered with animal skins, and/or fitted with shutters
- Wooden *canales* (channels) built into the roof for drainage
- Small, low doorways

All but the first two features listed above were in use by Pueblo Indians before the arrival of the Spanish. Ceilings and roofs of colonial structures consisted of large, spaced *vigas* (beams) supported by cross pieces and vertical posts. Between the large vigas were *latillas*, lengths of narrower wooden poles, hand-split cedar or small branches, placed at right angles to the vigas, or in a herringbone pattern. On top of the tightly spaced latillas the builders placed about a foot of dirt and some straw to seal the roof against moisture. Often, the roof's surface slanted toward one side or corner to allow for drainage. Parapets (adobe elevations topping the outside walls along the roofline) also aided in drainage by directing the rainwater to one or more drain areas where wooden canales were built into the parapet. However, rain and snow had their

cumulative effects on the dirt, latillas, and vigas, all of which had to be repaired or replaced periodically to avoid rot and collapse. The walls of the structures also required annual replastering to counter the effects of the weather. Replastering, a process of applying and smoothing adobe mud, was traditionally a woman's job, in both Spanish and Pueblo communities.

The front of the typical I-, L-, or U-shaped structure often featured a portal with vertical beams braced by *zapatas* (corbels, or corner brackets of aspen, juniper, or cottonwood) that fit at the joint between the cross and vertical beams. The corbel, as well as the capital (the top of the vertical beam), presented opportunities for decorative exterior design, which remained simple until the nineteenth century.

Interior architectural features include the built-in *banco* and shelf (see the section on furniture later in this chapter), and the fogón, or fireplace. The distinctive Spanish colonial fogón was built into a corner. If a fireplace was needed in the middle of a large room, a corner was first created by building a small wall, called a *paredcita*, at right angles to the main wall. The parabola-shaped opening of the adobe fogón, together with its quarter-round size, are probably its most distinctive elements. Usually the firebox was so small that firewood was placed vertically. Larger fireplaces were constructed using beams and poles set vertically to form a smoke hood.

Interior walls were plastered and colored with a finishing layer of *jaspe*, homemade calcimine, or any light-colored clay. Because the clay powder could rub off on contact, wide strips of calico or other cloth was often attached to the walls when available.

Nineteenth-Century Developments

The most important development in New Mexico architecture in the nineteenth century was the introduction from the eastern United States of new

4.7
Women plastering adobe at Llano Quemado, New Mexico, ca. 1966. Courtesy Museum of New Mexico, neg. #66646. Photo by Mildred Crews.

How to Make Adobe Brick

Adobe is composed of clay, sand, and straw in the right mix. Too much clay will result in excessive shrinking, cracking, curling or warping; too much sand will result in easy breakage and a tendency to erode quickly in a rain. Good adobe-making soil holds the following characteristics:

- *Easy to mix with a shovel or hoe when water is added, which means the soil should separate free of the tool rather than gumming it up;*
- *Soil should not fall apart when turned with a shovel into a small 8-inch-high mound;*
- *Soil should slip free of the mold when it is lifted;*
- *Soil should not curl, warp or crack during drying;*
- *The dry block should be easy to move with little tendency to break or chip at the corners;*
- *Light to moderate rains (ten to fifteen minutes in length) should result in little erosion or washing of the brick.*

Do not use gray or black soils, as they contain humus and will combine with rain to create carbonic acid, negatively affecting the adhesion of the clay binding the sand. Also avoid soils with alkali, gypsum, pebbles, and large stones. The use of straw is suggested if the organic content is too high or the clay content is too low. Certain types of straw cut very short can be aesthetically pleasing when combined with certain colors of clay and micaceous materials, and used as a plaster. (A good example is the interior plastering at the Nicolai Fechin House in Taos as maitained by master adobero Joseph R. Martínez of Taos Pueblo.)

Mixing the soil, water, and straw requires a shallow pit at least ten feet in diameter. When soil is thoroughly mixed using a shovel and/or the feet, wet the wooden mold so that the brick will easily slide out of it. Some molds are lined with tin. Fill the mold, making sure to pack the mud down carefully to avoid air pockets and cracking. A good mold will have handles to facilitate turning it over to slip the brick onto the ground. A typical modern brick of 10 × 4 × 14 inches, with a finished weight of thirty-five to forty pounds, is considered the best size for optimum insulation, weight, and wall strength.

Lift the mold evenly so that the brick and the mold separate cleanly on a flat earth-surface in full sunlight. Clean the mold carefully between uses. Leave the bricks to dry. After about three days, turn the bricks on their narrow sides to continue drying for another three days. The best time of the year to make bricks in New Mexico is in late spring and early summer. Avoid July and August, when the rains come.

To test for dryness, break open one brick. If the color is uniform throughout the inside, then the brick is dry. A dry brick will resist the scratching of a knife and will sustain a drop of two feet with minimal damage. Do not use partially dried bricks in construction. When laying adobe bricks, cement is often used as mortar, but is not as forgiving as adobe mortar. Add a new coat of adobe plaster to adobe walls just before the rainy season. Hands are preferable to trowels when plastering. (Romero and Larkin 1994; Lumpkins 1974; McHenry 1973)

design styles and building material brought in after 1880 on the railroad.

The American military built permanent quarters in Santa Fe in the Greek Revival style, including columns, white picket fences, pitched roofs covered in terneplate, dormer windows, and doorways with sidelights and transoms. The application of these Greek Revival details to homes and public buildings made with adobe resulted in a hybrid style known today as New Mexico Territorial. This unique style flourished between 1848 and 1912, the years during which New Mexico was a United States territory. It

4.8
Making adobe brick in La Cueva, east of Mora, New Mexico. Photo by Miguel Gandert.

was made possible by the initial introduction of milled lumber and window glass in the 1850s, and of kiln-fired brick in the 1880s. Its main features are:

- Greek-inspired pedimented lintels of doors and windows
- Wooden portal posts with beveled corners, bead moldings and horizontal moldings hand cut to resemble classical Greek capitals and bases
- The use of white paint on wood in the manner of Greek Revival elsewhere in the United States
- The continued use of adobe brick and flat, earth packed roofs
- The introduction of pitched, terneplated roofs
- The symmetrical organization of rooms along a central hallway, and windows around the entire structure
- Elaborate entrances, including side and overhead window panels framing the door

- Walls capped along the roofline with three to six layers of brick, laid in a number of styles imitating classical dentils or the crown of a cornice

Other nineteenth-century innovations included the use of metal hinges on doors rather than wooden pintles, double doors between rooms (in more elaborate homes or buildings), paneled doors on cupboards, and fireplaces set in the middle of a wall rather than in a corner of the room.

On arriving in New Mexico in 1851, Bishop Jean-Baptiste Lamy determined to build a cathedral like those of his native France. He found the "mud palace" that served as Santa Fe's parish church distasteful and unworthy for worship. The new stone cathedral, begun in 1869, was built in the Romanesque Revival style. The Parroquia de San Francisco—the older adobe church situated in the nave of the new cathedral—continued to serve as the parish church even as the new stone cathedral rose around it.

With the help of French architects, Lamy's French and Italian priests worked to repair existing churches and to modernize them with what Bunting called "Folk Gothic" details, such as pointed wooden towers. An example is the 1870–80 remodeling of San Felipe de Neri Church in Albuquerque. The rectory, convent, and school of that parish were built at the same time in the same style, which also displayed elements of Territorial style.

The pacification of raiding nomadic Indians in the late nineteenth century had a powerful impact on New Mexico building design, which shifted emphasis from defensive enclosed courtyard and plaza patterns to a more open layout with porches and large windows running around the entire structure. Interiors could now be illuminated by natural light through mid-level windows, rather than by candles and small, high windows. The use of milled lumber had already allowed the expansion of interior spaces beyond the colonial standard of fifteen feet. Home interiors now featured the American central hallway—unheard of in colonial times. Still, the enclosed courtyard plan continued to be used, even into the late twentieth century.

Twentieth-Century Developments

In the nineteenth century, New Mexico designers and builders had created a unique architectural hybrid—the Spanish Mediterranean enclosed patio plan, made of adobe with American Greek Revival details. It was left to twentieth-century designers and builders to pick and choose from the wide variety of architectural legacies. It was also a time of restoration, focusing not on nineteenth-century Revival styles, but on the original Spanish-Pueblo style.

In 1905, the University of New Mexico officially adopted Spanish-Pueblo style for its buildings. The first attempt at Spanish-Pueblo restoration began in 1909, when a group of Anglo-American residents convinced the territorial legislature to establish the Museum of New Mexico and to house it in the Palace of the Governors, which was in sad repair at the time. Jesse Nusbaum immediately began the restoration of the Palace of the Governors to its "original" Spanish-Pueblo style. The truth was that the building had undergone so much remodeling over the years, that the original design was long gone. Undaunted, Nusbaum remodeled the interior in what was termed the "ancient style," with installations of new woodwork as well as wooden parts taken from other colonial structures. The Fine Arts Museum in Santa Fe was built around the same time and in the same style.

In 1912, the first Santa Fe City Planning Board began making recommendations to the city council on preservation issues. One such issue was the renaming of streets like "College Avenue," "Railroad Avenue," "Telegraph Road," and "Manhattan Street" with Spanish names; and designating certain roads and buildings in Santa Fe as "historic." In 1957, the city council adopted a proposal that new construction should conform to the "Santa Fe style." This proposal had been made in 1912, but while it was not adopted at that time, it nevertheless became the basis of preservation activity from then on.

From 1912 to 1927, a number of public buildings in Santa Fe were constructed in the Spanish-Pueblo style, including the Museum of Fine Arts, La Fonda Hotel, the Cassell Building, and the new Federal Building. Interior and exterior woodworking designs were based on those photographed by Jesse Nusbaum at authentic Spanish colonial sites in northern New Mexico, and at Gran Quivira, Abó, and Quarai mission ruins.

Builders also remodeled private homes acquired by the large numbers of wealthy Anglo-Americans who moved to Santa Fe during these early decades. One such transplanted American was a civil engineer named John Gaw Meem, who arrived in 1920 as a patient at a sanitorium. His fascination with Spanish-Pueblo style led to his work in architectural designs for homes and in church restoration. He also created structures for the University of New Mexico and the state government. His home designs incorporated original beams, corbels, and doors taken from church ruins at Gran Quivira, Truchas, and elsewhere. In fact, two Meem patrons, Eleanor Brownell and Alice Howland, "hunted down their own architectural artifacts, obtaining many of them from houses in Truchas, [and] once wrote Meem that they were having so much fun they wished they were building a whole village" (Taylor and Bokides 1984). Cyrus McCormick obtained nearly fifty such items for his home near Pojoaque.

Probably not a moment too soon, the Committee for the Preservation and Restoration of New Mexican Mission Churches was founded in 1922 by Anne Evans and Mary Willard of Denver, and Mary Conkey of Santa Fe. Meem and Mary Austin were among its members. In the years following its founding, the Committee put new roofs on churches at Laguna, Zía, Santa Ana, and Trampas. They also conducted extensive restoration to the mission church at Acoma, and after merging with a similar organization and incorporating as the Spanish Colonial Arts Society, they bought the Santuario at Chimayó to keep it from being destroyed.

In Corrales, New Mexico, Ward Alan and Shirley Minge spent almost forty years researching and writing on Spanish colonial life in New Mexico and restoring their home, a *placita*-style hacienda known as Casa San Isidro. It now represents the only fully furnished, correct representation of late-eighteenth- and early-nineteenth-century domestic architecture in the Albuquerque area. The house was built in the mid-eighteenth century by Felipe Gutiérrez, the original recipient of the 1704 Bernalillo township grant, and a participant in Vargas's reconquest of

New Mexico. The Minges' neighbors, Mr. Tony García and the Gutiérrez family, assisted with their restoration and preservation work. Casa San Isidro consists of the main hacienda with its interior patio, a chapel, and numerous rooms, as well as exterior features such as a stone granary, berry garden, log bunkhouse, log cookhouse, tack room, stables, and storeroom. In the mid-1990s, the house was placed in the care of The Albuquerque Museum of Art and History, with the intention of making it available for public viewing.

There are still adobe structures in New Mexico dating from the Spanish colonial, Mexican, and Territorial periods, attesting to the durability of adobe when maintained. In the late twentieth century, Spanish-Pueblo style continues to inspire builders, notably those at the University of New Mexico, where variations on the basic theme have given expression to new "Southwestern" exterior colors and elegant lines. Concurrently, the New Mexico State Office of Historic Preservation, as well as several nonprofit organizations, continues to work with private and public entities, including the Roman Catholic hierarchy, to maintain and restore older religious and domestic structures throughout the state.

Furniture

The Colonial Period

The furniture of New Mexico's Spanish colonists was a mix of pieces brought in from Mexico—particularly the Michoacán area, famous for its furniture making—and items made in New Mexico using local materials and simple tools. Scholars estimate that two-thirds of the furniture of New Mexico was made in New Mexico. Objects of any large size would have been expensive and inefficient to transport over the long and difficult Camino Real. However, the woodworkers were not without stylistic influences from Spain and Mexico, and to a degree, France and Italy, and even the Orient.

Up to the seventeenth century, Spanish furniture brought to the Americas was, like the Moorish furniture that inspired it, often collapsible for easy transporting. This portability was ideal for settling a new world. Chests were important items on both sides of the Atlantic, and served many purposes other than storage and transport. They were also used to write on, sit on, and support flat surfaces for sleeping or dining.

The furniture of Spain and Mexico was constructed around a basic rectangular shape established in the sixteenth century, to which was applied stylistic decoration and design prevalent in different eras. In the sixteenth century, the designs were Gothic and Renaissance; in the mid-seventeenth century, they were French and Spanish baroque; and later in the eighteenth century, they evolved into the new rococo style. Among the Mexican furniture-making centers, Puebla, Oaxaca, and Campeche were known for marquetry and

Mi Casa Es Su Casa*

It is ironic that the recent resurrection of the aesthetic component of Spanish-American culture and village life was accomplished in the main for certain Anglos and by certain Anglos; and it is they who have become its heirs. . . . Restoring old buildings and accommodating the regional style to modern technology (electricity, water pipes, etc.) was, however, an expensive matter which few Spanish Americans could afford. So-called Spanish residences were typically restored, built, and owned by affluent Anglos, while most Spanish Americans lived in houses that might be called slums by contemporary standards or in standardized, lower-middle-class tract dwellings. Spanish Americans seemingly wanted what most middle-class Americans wanted for themselves and their families; quaint restoration in architecture and folk art were something less than a consuming interest to them. (López 1974)

*My house is your house, a Spanish saying.

4.9

Exterior of a late-eighteenth or early-nineteenth century dovetailed caja with the classic round rosette motif, lions and pomegranates carved into its surface. Courtesy Museum of International Folk Art, A.82.10.1. Photography by Mary Peck.

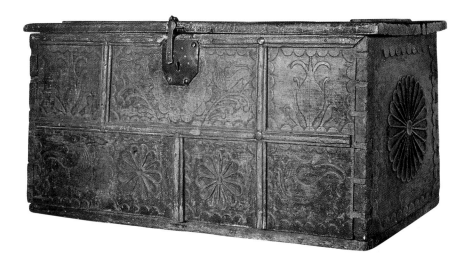

inlay work. Chip carving, colorful painting, and lacquerware (influenced by the Orient) were characteristic of the furniture made in Michoacán.

The elaborate decoration found on furniture made in Spain and Mexico was mostly absent, or at least abstracted, on furniture made in New Mexico, largely due to the tools and types of wood available to carpenters. In New Mexico, *carpinteros* (carpenters) used ponderosa pine, red spruce, and scrub oak. Cottonwood was too tough and fibrous to serve for anything other than wheels, carts, troughs, barrels, and *canoas* (water canals along acequias). By contrast, hardwoods were widely available in Spain and Mexico. Unlike hardwoods, pine is soft and dry, and hard to manipulate for decorative purposes. For an added challenge, New Mexico colonists' tools were limited to rough versions of the adz, Spanish ax, auger, awl, hammer, knife, chisels and gouges, and two kinds of handsaws. As a result, decorations were limited to shallow-surface carving—including chip carving, relief carving, gouging, and incising—painting of designs and motifs, and geometric cutouts.

The mortise and tenon joint was most commonly used in building New Mexico furniture, including the practice of passing the tenon entirely through the board, creating an exposed flush tenon or "through tenon." Dovetail joints were also used, but because of the crude tools, the joints were rough and woodworkers usually covered them with moldings. Oftentimes, wedges or dowels were inserted into the tenon to tighten the joint, particularly on chairs and tables. Metal nails were not used until the nineteenth century when metal was more available. Conservators observe that dovetail and mortise and tenon joints have held up better than nails.

Furniture styles adopted by New Mexico carpinteros remained constant in New Mexico through the nineteenth century, most likely because it was passed on from generation to generation within families of furniture makers. There was little innovation in colonial furniture form or decoration. Traditional Spanish/Moorish designs used in New Mexico were rosettes, pomegranates, shells, lions, scallops, and floral designs. The geometric cutout patterns found on New Mexico furniture may have any or all three of the following origins:

- The blocked and turned elements of seventeenth-century baroque design in use in Spain and Mexico
- A stepped design found in Moorish-influenced chairs made in Spain and Mexico
- A Pueblo Indian cloud terrace motif already in use in New Mexico

The last option is most intriguing in light of the fact that Fray Alonso de Benavides visited New Mexico's missions in 1630 and reported that Franciscan friars were training the Indians at Pecos Pueblo in carpentry. Carpentry continued to be practiced until the late eighteenth century at Pecos, and at Cochití until the mid-nineteenth century. Pueblo Indians at Sandía, Isleta, Alameda, Jémez, Zía, and Santa Ana Pueblos also worked in carpentry. Pueblo carpenters became quite skilled and received many commissions from both Indian and Spanish customers. Gouging or chip carving may also be reflective of Pueblo style.

4.10
Tarima or bench dating from the nineteenth century. Courtesy Museum of New Mexico Collections at the Museum of International Folk Art, A.1972.19.1. Photo by Mary Peck.

Don Juan de Oñate's settlement party included six men who brought carpenter's tools, though only one listed himself as a carpintero. Aside from some burned fragments found at the ruins at Abó, no seventeenth-century furniture of New Mexico has survived; scholars assume most furniture was destroyed during the Pueblo Revolt of 1680. In addition, no identifiable furniture of the early or mid-eighteenth century has survived. The earliest surviving pieces date from the last quarter of the eighteenth century.

Scholars speculate that New Mexico santeros probably doubled as furniture makers. Carved or painted patterns followed formulas passed on through the generations over four hundred years. Influenced by the highly popular Michoacán pieces imported to the area, New Mexicans often applied gesso and paint to their furniture. (The artisans at Michoacán were, in turn, influenced by the Oriental lacquerware brought to Mexico over the Spanish trade route to the Philippines, which opened in 1565.) Recent analyses show that the same pigments used on santos were used on furniture, and that some pine chests were painted a solid dark color, possibly to mimic the dark-hued hardwoods of Spain and Mexico. New Mexican artisans also applied straw appliqué on furniture to imitate the look of Spanish and Mexican marquetry and inlaid wood. From a distance, straw looks much like gold.

The most frequently listed item in New Mexico wills and estate inventories was the chest, followed by chairs. Cupboards, tables, and built-in or free-hanging shelves were also listed. Inventories of well-to-do and impoverished colonists alike reveal relatively little furniture in the home in comparison to contemporary usage.

CAJAS (CHESTS)
Since the days of the reconquest of Spain from the Moors, chests and boxes have been used in the Hispanic world to store valuables, clothing, and food. Decorative styles popular in Mexico included marquetry and lacquerware as well. All these styles went into chests made in Mexico, some of which made their way to New Mexico. Chest types included the *baúl* (trunk), *cajita* (small box or trunk), *caja* (chest), and *petaca* (leather chest). As mentioned previously, chests were the most frequently listed item in New Mexico wills and estate

inventories during the seventeenth and eighteenth centuries.

Some New Mexico chests were made with leather overlay, an influence of Mexico's Aztec Indians, who called their leather chests petacas (derived from the Nahuatl term *petlacalli*, indicating the pre-Columbian interwoven strips of cane or palm fiber, and later, cloth and leather). The term is still used in New Mexico and southern Colorado. Large chests called *harineros* or *graneros* were used to store grain or milled flour through the winter. Spanish colonists traveled to trade fairs in Chihuahua, bringing back painted chests made in Michoacán, which stayed in the family for generations. Their design and decoration also influenced local furniture makers. Painted designs on New Mexico-made chests have been matched to specific New Mexico-based santeros including Molleno, the Santo Niño Santero, and Rafael Aragón, all of whom flourished in the first half of the nineteenth century.

In New Mexico, furniture types remained consistent with those of Mexico and Spain, with one exception. In the late eighteenth century, New Mexican carpinteros invented the chest-on-legs, a very useful, back-saving item found nowhere else in Spain or Latin America. Some scholars believe the Valdez family of Velarde created the chest-on-legs because of the similarity in construction, format, layout, and dimensions among many of the surviving pieces, and by a unique wavy-line chip-carving design peculiar to the Valdez workshop.

Virtually all of the surviving chests date from the nineteenth century; a handful date from the last quarter of the eighteenth century.

They vary in size, wear, and design, with most locks and hinges having long been replaced.

SILLAS (CHAIRS)

Even though chairs are the next most frequently listed items in household inventories, there is some disagreement among scholars regarding the frequency and use of chairs in the typical Spanish colonial and Mexican period home. Some believe chairs were rare in New Mexican homes, where residents preferred to sit on the floor or on cushions on the floor, notwithstanding the built-in adobe benches. Sitting on the floor or on cushions on the floor was introduced into Spain by the Moors and became a widespread custom throughout Spain and Latin America, and across all classes, until the mid-nineteenth century. In New Mexico, the custom was already part of Pueblo life. Nineteenth-century journal writer Susan Shelby Magoffin describes visiting a New Mexican home where the women retired to a room with cushions, after having sat in chairs at a table entertaining visitors for three hours. She also describes the sitting room of another home as having no chairs at all (Boyd 1974; Magoffin 1982). Lieutenant Colonel W. H. Emory, assigned to New Mexico in the mid-nineteenth century, was reminded of the Romans as he described in his diary a New Mexican home having only floor coverings, cushions, and pillows on which to sit and recline (Emory and Abert 1848). E. Boyd suggested that if a chair was found in a New Mexican home, it was a status

4.11
Chair dating from the nineteenth century. Courtesy Historical Society of New Mexico Collection at the Museum of International Folk Art, A.9.1957.32. Photo by Keith Bakker.

symbol indicating frequent visits from the clergy (Boyd 1974).

An armchair was known as a *silla de asentar* (sitting chair) to differentiate it from a *silla de montar*, which was a saddle. A little chair was a *silleta* and an armless side chair or stool was called a *taburete*. The word silleta is still used in New Mexico and southern Colorado today, while *silla* is the standard term for chair elsewhere. Armchairs and side chairs were either made in New Mexico or imported from Mexico. Carpenters used standard mortise and tenon construction, and based their designs on the simple rectangular lines of the early Spanish *sillón de frailero*, which was often slung with leather or fabric, and was collapsible for easy transport. Later examples were made entirely of wood, often upholstered with embroidered or fringed velvet or *guadamecil* (a Moorish technique of embossed leather), and sometimes painted or gilded. They had distinctively high, wide front stretchers (the horizontally placed piece of wood that connects and braces the legs), which were often carved or fretted. This stretcher was known as a *chambrana*. These solid wooden chairs were popular in the New World throughout the colonial period. Several New Mexico armchairs have wide front and back stretchers reminiscent of the chambrana. According to Fray Domínguez, visiting in 1776, several armchairs made in New Mexico were slung with painted buffalo hide. In the early nineteenth century, carpenters living in mountain areas of New Mexico began making dowel-rung hardwood chairs, probably from scrub oak, slung with rawhide strips.

Armchairs made in New Mexico have very little elaborate carving. Several side chairs dating from the late eighteenth century and throughout the nineteenth century are decorated with a particular gouge-carved pattern, possibly associated with Indian carpentry of Cochití Pueblo. Also, cornhusk-like patterns are found on the back posts of side chairs, which some scholars believe relate to Indian influence, although wheat and cornhusk patterns are also typical of the Neoclassic style found in Europe and Mexico at the same time. One surviving armchair shows painted decoration identical to that found on early Pueblo pottery.

MESAS (TABLES)

During the late Gothic and early Renaissance, Spanish tables consisted of boards laid on trestles or chests. When portability became less of a concern in the seventeenth century, two types of tables were developed, and are still made today. One was the trestle table, in which splayed trestles were connected to the table top with iron braces. No trestle tables have been found in New Mexico, probably because of the lack of iron in colonial times. The other table type, involving fixed legs braced by side or box stretchers, is better known in New Mexico.

Decoration included grooving, scalloping, and chip carving on the drawers, stretchers, and legs, and cutout designs on the stretchers. Boyd suggests that the long and low tables made in New Mexico were specifically designed to serve food to people sitting or reclining on the floor; however recent research suggests that these may have been seat stools instead of, or in addition to, low tables. With the exception of these serving tables, most tables made in New Mexico were of roughly the same size and height. No large dinner-type tables are known. As with chairs, scholars largely support the idea that tables were used primarily in affluent homes and by the clergy.

ARMARIOS (CABINETS)

Cabinets came into being in Spain after portability became less important in the seventeenth century. The first cabinets were used in church sacristies. Tall cabinets, known in Spain as *fresqueras*, featured a top food-storage level of spindled panels, which ventilated the interior, as the name implies. This ventilated top level was carried through in Mexico, where spindled and wire grille doors are found on cabinets made in the seventeenth and eighteenth centuries, and in New Mexico, where hand-carved spindles reappear in top sections.

New Mexico's tall, locking cabinets were known as *armarios* or *almarios* during the colonial period and as *trasteros* beginning in the nineteenth century. They were used to store kitchenware, household items, or weapons. Because they take up little room due to their narrow depth, and are so practical, they were very popular in small colonial homes. Some cabinets featured interior drawers; some held secret

or hidden drawers, shielded within by blind panels, and accessible only by removing the larger drawers. Cresting began appearing atop cabinets in the eighteenth century both in Spain and in the New World, with rosettes or scalloping being the most popular crest designs. Other decoration often included painting, grooving, and carving. Some late-nineteenth-century cabinets copied the low, deep form and design of the meat safes brought to New Mexico by Anglo-Americans. Some late painting simulated marble finishes.

The *alacena* is a cupboard built into the wall at the time the wall is made. Alacenas were very popular in colonial New Mexico because they were practical and took up no added space. The panels were attached with eyelet hinges (which were common in Spain) or were constructed as puncheon shutters, a technique that eliminated the need for metal hinges.

BUILT-IN FURNITURE
Introduced by the Moors to Spain, built-in adobe furniture continues to be popular in twentieth-century New Mexico long after its introduction by Spanish colonists. Aside from the alacena, colonial built-in adobe furniture included benches (bancas or bancos), which were used for sitting and sleeping, and adobe tables, which were frequently used in homes. In churches, they were used as altar tables.

MISCELLANEOUS FURNITURE
Visiting dignitaries probably brought traveling desks (*escritorios*) on which to write reports. These desks may have inspired local carpenters to develop the chest-on-legs. In any event, the earliest known locally made desk dates from the early nineteenth century. New Mexicans also developed a wooden lock, examples of which are listed in church inventories. Wooden benches were used in

4.12
Room in the home of Isleta Governor Lente, ca. 1900, illustrating the use of built-in adobe bancos, and cloth-covered walls. Courtesy Museum of New Mexico, neg. #12331.

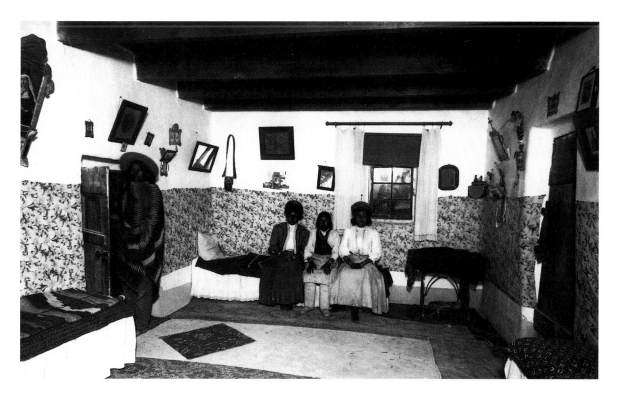

homes, as evidenced by their presence in wills and estate inventories as early as 1727.

The *repisa* is a free hanging single or double shelf. Repisas vary widely from the very crude to the elegant, both in design and decoration. Dowels or bent blacksmith nails were added to repisas to make coat racks or racks for hanging various objects. Few stools (known variously as *tarimas, tarimitas* and *escabeles*) survive today, probably because they were well used and simply wore out. Stools for sitting were very commonly used in Spain and Latin America throughout the seventeenth, eighteenth and nineteenth centuries, even among the upper classes, including the royal palaces of Spain. Women particularly preferred them. Some stools that survive show care in design and decoration, including Gothic arches, grooving, and painting. Unfortunately, the words for stools have been translated incorrectly into English by non-Hispanic scholars as *foot*stools, rather than as just stools for sitting.

Beds consisted of wooden frames strung with rawhide or topped with boards (the latter known as *camas altas de tablas*). The cama alta featured a headboard, footboard, and side rails. Even with the *colchón* (mattress), both types were considered uncomfortable and most people preferred to place the colchón on the floor and sleep there. Still, beds were considered a luxury and one was kept in most homes for honored guests at family events and for bridal couples. Most rural New Mexicans slept on the floor up until World War II (Boyd 1974).

Other items made of wood in colonial New Mexico were doors, spinning wheels, collapsible harness floor looms, plows (depicted in representations of San Isidro and much preferred in the Pueblos over the ancient digging sticks), wheels for carts, barrel troughs, molasses presses, and canoas. Smaller pieces included candleholders, sconces, chandeliers, lanterns, drums, flutes, rattles, and violins.

The Nineteenth Century

Several hundred years of uniform craftsmanship came to an end in 1821, when Mexico declared its independence from Spain. Almost overnight, new tools, materials, and styles from the United States began exerting changes in New Mexico workshops. New woodworking techniques were made possible by milled lumber, trimming saws, mitre boxes, jigsaws, and molding planes, as well as factory-made hardware such as hinges and locks. Jigsaws made curved lines easier to create. Aniline dyes and later, enamel, introduced a more colorful palette. Wagon trains along the Santa Fe Trail also brought screws, brass nails, glass windowpanes, and pocketknives. Relatively inexpensive furniture could be specially ordered from eastern manufacturers. As mass-produced furniture from the East began to reach New Mexico by the end of the Civil War, demand diminished for local colonial-style furniture products.

4.13
Molasses press made of hollowed tree trunk, nineteenth century. Courtesy Museum of International Folk Art, FA.1979.64.59V. Photo by Cradoc Bagshaw.

4.14
4.14 Wooden *araña* (chandelier) at El Rancho de las Golondrinas.
Photo by Mary Montaño.

In 1847, the U.S. Army built the first lumber mill just east of Santa Fe. The army also employed American cabinetmakers and woodworkers, many of whom stayed on to set up shop in New Mexico. The 1790 population census in New Mexico listed fourteen carpenters in Santa Fe and nine in Albuquerque. By 1850, the census showed seventy-five carpenters working in Santa Fe, twenty of whom were born in the eastern United States or in Europe.

In the 1880s, the railroad made possible larger, more frequent shipments of goods, building materials, and furniture from the East. American manufacturers introduced new design styles, including Victorian, Queen Anne, American Federal, Greek Revival, Renaissance Revival, and Gothic Revival. They also introduced bedsteads, large tables, washstands, ironing tables, and armoires. While Anglo-Americans and well-to-do Nuevomexicanos were indulging in new furniture styles, the majority of middle- to lower-class Nuevomexicanos maintained a preference for their older furniture, oftentimes out of necessity. Even so, Eastern cabinetmakers living in rural New Mexico were reportedly making a good living by the early twentieth century.

The Twentieth Century
After 1880, the railroad also brought Anglo-Americans to New Mexico. Those who stayed—particularly artists, convalescents, and upper-class retirees who built houses and settled in Santa Fe and Taos—sought an alternative to modern industrial American life. They embraced the idea of the "simple" yet exotic life of New Mexico and, between 1900 and 1940, created what is now called the Spanish Colonial Revival. This revival coincided with a similar colonial revival on the eastern seaboard. The New Mexico revival affected furniture making, crafts, and architecture by emphasizing a return to colonial design for the sake of its historic appeal and tourist value. Many Anglo-Americans began ordering or making furniture in the Spanish colonial style for use in public buildings and private homes. One revival enthusiast, Jesse Nusbaum, traveled New Mexico's back roads photographing furniture and other objects for replication by contemporary Anglo-American woodworkers. Others hired locals to search out and remove authentic corbels, vigas, and doors from church ruins for use in their newly built homes in Santa Fe.

A concern for authenticity varied from one enthusiast to another. In 1926, William P. Henderson designed and manufactured furniture that combined elements of imported Spanish furniture with Art Deco and Indian motifs. Working out of Santa Fe, he mass-marketed his pieces, selling to hotels and homes all over the state and Southwest, before the Great Depression caused him to go out of business. Others who made revivalist furniture were

B. J. O. Nordfeldt, Freemont Ellis (a Cinco Pintores member), and Josef Bakos. In Taos, Nicolai Fechin, the well-known Russian painter who had escaped the Russian Revolution, was also a trained wood-carver. He studied local woodworking, then combined elements of Hispanic and Russian wood-carving in the furniture and interior structures of his home, which serves as a museum today.

The differences between authentic Spanish colonial furniture and its Spanish Colonial Revival counterpart (that eventually made its way into hotels, government buildings, and private homes) included:

- Protruding mortise and tenon joints, which never occur in Spanish colonial pieces
- Chip carving added to the edge of a chest lid, also not found in Spanish colonial pieces
- The combining of Spanish colonial and Art Deco design
- Painting inside chip-carved depressions with red or green oil paint, which never occurs in Spanish colonial pieces
- The emphasis on vertical lines rather than the more authentic horizontal lines, which were originally dictated by traditional Spanish colonial measurements unknown to modern revivalists
- The introduction of pieces unknown in

Spanish colonial times, including sideboards with drawers and doors, china cabinets, lazy Susans, bedside tables, and swivel chairs.

In the 1930s, the fascination with Spanish colonial objects took the form of antique collecting. "Pickers" did the actual gathering of antique pieces throughout New Mexico. The pieces were then processed prior to reaching their buyers or collectors. Processing included carving pieces that were not originally carved, dismantling old pieces to provide parts for new pieces, or "repairing" old pieces, sometimes twice. This would explain such present-day anomalies as genuine Spanish colonial chests sporting early twentieth-century hinges. In addition, pickers rarely recorded the places of origin for their finds.

The Spanish Colonial Arts Society operated the Spanish Arts Shop in Santa Fe in the 1930s. There shoppers could buy crafts and other items, including furniture made at the Normal School at El Rito, which taught Spanish colonial furniture making, among other crafts. (The school was established in 1909 to train Spanish-speaking teachers for service in northern New Mexico schools.) The Spanish Arts Shop also sold furniture made by José Dolores López (1868–1938) of Córdova, New Mexico, who took special orders for such nontraditional items as lazy Susans and bedside tables. Several other independent carpinteros, trained through the community vocational schools established by the State Department of Vocational Education (SDVE), also sold their wares through the Shop, so that by 1936, the Shop was representing fifty such artisans. The carpinteros

4.15
Wooden *cerradura* (door lock) with three wooden tumblers and one key (bolt and one tumbler missing), nineteenth century. Courtesy Fred Harvey Collection of the Museum of International Folk Art, FA.1979.64.182V. Photo by Cradoc Bagshaw.

welcomed the business and provided whatever product variation their Anglo-American patrons requested, thus trading the authenticity of traditional form for commerce; but times were hard in the early twentieth century for the Nuevomexicanos, and any opportunity to make a decent living was welcomed.

Aside from the schools, the SDVE also funded the research and publication of several how-to books on Hispanic arts and crafts, including furniture making. Bill Lumpkins, an SDVE teacher-trainer and architectural draftsman, wrote and illustrated the *Spanish Colonial Furniture Bulletin,* which contained thirty-seven design standards for "traditional" eighteenth- and nineteenth-century furniture pieces he studied in museum collections. Carpinteros used this publication for many years as a reference in designing their products. It was, according to Taylor and Bokides (1987), "undoubtedly the primary vehicle for carrying the 'tradition' of Hispanic cabinetmaking from the nineteenth to the twentieth century in New Mexico."

As World War II loomed on all fronts, welding and sheet metal training replaced weaving and cabinetmaking in the community vocational schools. When the war finally broke out, many men left for the front or the aircraft factories in California and the schools were closed as funds went toward the war effort.

Anglo-Americans drove the revivalist movement in New Mexico, seeking a simple life and a return to preindustrial times. They were the primary market for Spanish colonial products. Concurrently, the simple life held no allure for Nuevomexicanos who purchased Eastern goods whenever they could afford them. The curious result was that these two very different cultural groups traded tastes in furniture, as well as architecture and crafts.

Weaving

The weaving of wool has occupied New Mexicans for centuries. Woven products have been used as clothing, bedding, carpeting, decorating, and sacking. Throughout the Spanish colonial and Mexican periods, New Mexico textiles, as well as sheep on the hoof, were traded south to buyers in Mexico for much needed revenue and import items. Textiles also circulated through North America where both Native American and European traders sought New Mexico homespun blankets.

The Spanish introduced sheep and the treadle loom to the New World, and made weaving with wool a major industry in eighteenth- and nineteenth-century New Mexico. In the nineteenth century, weaving with cotton was reintroduced, but it never matched the demand for wool homespun. Mexico's textiles, particularly the extraordinary Saltillo *sarape,* offered excellent standards to strive for, but New Mexico weavers were also challenged by unrefined equipment and the exigencies of frontier life. As a result, the Río Grande blanket was coarser than the Saltillo sarape, yet with as much bold, creative strength. In the twentieth century, weaving is making a comeback as a source of economic self-sufficiency in northern New Mexico and, as it happens, as an art form appreciated and collected by an international market.

History

Coronado's expedition left Mexico with five thousand churro sheep in 1540. The flock was taken as food, but it fared poorly on the journey—only twenty-eight survived the trek as far as Zuñi Pueblo. Coronado and his men found Pueblo Indians growing and weaving cotton and agave fiber on vertical looms. The Spanish called the cotton cloth *campeche* or *manta.* Cotton fields flourished in the semi-arid climate of southern New Mexico and Arizona. The Pueblo Indians had been weaving cotton since prehistoric times, and continued to do so throughout the Spanish colonial period. They wore the dyed cotton fabric tied at the shoulder, with colorful hand painted or embroidered figures, and embroidered sashes and tassels.

Scholars are still unclear as to when the first Spanish settlers built looms and began weaving. It is clear no loom was transported to New Mexico because of their bulk and weight. It was much more efficient and inexpensive to build one, from memory if necessary. Oñate's party took four thousand churro sheep to their new settlement in 1598, as well as ready-to-wear garments and bolts of fine fabrics from Europe and China. As months went

by and supplies ran low, Oñate began exacting mantas as tribute from the Pueblos. In this way they acquired two thousand cotton blankets each year. In the meantime, as the missions were built and operations began, the friars oversaw the training of Pueblo Indians in a variety of crafts, including weaving the wool from the friars' flocks. Records also show that Spanish and Indian laborers worked in *obrajes* (workshops) operated in Santa Fe by the New Mexican governor Luis de Rosas (1637–41), who traded the yardage and blankets in Mexico, apparently for personal gain. Finer materials continued to be imported by the wealthy and for the missions, while both New Mexico homespun and sheep were traded south to Mexico. Sometime after 1650, the Navajos began weaving wool on vertical looms similar to those used by the Pueblo Indians.

Spanish settlers continued to pursue weaving during the years of residence near El Paso following the Pueblo Revolt. They had managed to gather and drive some sheep with them during their escape from New Mexico. So it was that one Pedro de Chávez operated a loom near El Paso on which he wove yardage for trade in Sonora and Casas Grandes. Vargas recruited new settlers from Zacatecas to resettle northern New Mexico as part of his reconquest. The Zacatecans were primarily artisans. They originally settled in the Santa Cruz de la Cañada area in 1693, and as New Mexico's population expanded in the eighteenth century, they resettled throughout northern New Mexico, taking their

Who Were the Moors?

They invaded from the south in 711 A.D. and thereafter occupied Spain for seven centuries. The Moors were the mixed native Berber and occupying Arab peoples of northwest Africa. They comprised the westernmost portion of the new Islamic civilization that reached to the borderlands of India in the east and in the north to the Danube River. Islam was a multicultural civilization united by the same official language (Arabic), social order, religion, and laws. The heart of the Muslim world was Saudi Arabia, which was, and is, the center of the Islamic religion. Mohammedanism—another term for the Islamic or Muslim faith—emerged in the seventh century when men of many races were attracted by the teachings and dynamism of Mohammed, its spiritual leader who proclaimed that all men were equal in the sight of Allah (God). From this religious base, a whole civilization flowered.

In the eighth century, the Omayyad caliphate ruled northwestern Africa where the Byzantine faith had once dominated. In 711, Tarik ibn Ziyad (Tarik, son of Ziyad) and a force of seven thousand Berbers and Arabs invaded Spain, defeated the last of the Visigothic rulers, and renamed it al-Andalus, after the Vandals who had once ruled there. The victors named the Rock of Gibraltar after Tarik ibn Ziyad (Jabal Tarik, or Tarik's Mountain).

The Islamic civilization is most noted for its emphasis on international trade, technological advances, and on recording and preserving knowledge. The Muslims introduced papermaking to the West in 751 after capturing several Chinese paper makers in a skirmish in Central Asia and organizing a factory for them in Samarkand. They also acquired the compass from the Chinese. As consummate merchants, they organized a system of international banking and a postal service that facilitated the traveling merchants as well as government intelligence gathering. There was even a homing pigeon system for communications from those at sea, and an early form of the telegraph. Their governments provided farmers with assistance to reclaim abandoned farmlands. They developed the guild system on which the European system was modeled.

artisans' skills wherever they went. The weavers of Chimayó may be descendants of these original Zacatecan artisans.

The Eighteenth Century

Weaving and export to Mexico became a major part of New Mexico's economy in the eighteenth century. After the reconquest in 1693, Mexico City awarded land grants throughout the Río Abajo area, which soon became a sheep ranching region. It had a ready market for sheep and textiles in El Paso, and at trade fairs in Taos, Chihuahua, Saltillo, and San Juan de los Lagos. While much trading occurred in Mexico, there was little trading activity in New Mexico (except at Taos), so that the steady stream of sheep southward created a shortage by the end of the century. The governor then sought to correct the trade deficit by prohibiting the export of both sheep and wool.

Eighteenth-century sheep raising and wool weaving communities included Albuquerque, Atrisco, San Antonio, Tomé, Belén, Alameda, Bernalillo, Corrales, Peralta, and Socorro, as well as some areas of the Río Arriba. In Albuquerque, Atrisco, and Alameda, fifty-five weavers, sixteen spinners and thirty carders were listed in the 1790 census, while only two weavers and one carder were listed in all of Santa Fe. This imbalance may be attributed to the fact that weaving was a full-blown trade industry in the Río Abajo, but merely an everyday household endeavor in the Río Arriba. As such, individuals in northern New Mexico were unlikely to call

Among the greatest achievements of the Islamic civilization was the preservation and translation into Arabic and then into Latin of the scientific, medical, and philosophic works and technological treatises of the ancient Greek, Roman, Persian, and Indian civilizations. The province of Andalucía was pivotal in passing on to the Christian West the knowledge of both the Islamic and classical worlds. Under Archbishop Raymundo, major works of Greek science and philosophy, which had already been translated into Arabic (Galen, Euclid, Ptolemy, Archimedes, Aristotle, and Plato), were translated into Latin. Christians had systematically destroyed the "pagan" centers of knowledge in the Middle East during the fourth and fifth centuries. Were it not for the Arab universities such as those founded in Spain, much of the scientific work of the Greeks and Romans would be lost.

The Moors occupying Spain were never in the majority, and in fact intermarried and melded with the populace, as in nearby Sicily. Their occupation was thus marked by a spirit of tolerance and a flourishing of intellectual and artistic pursuits unmatched since that time. The Spanish cities of Córdoba and Toledo emerged as international centers of intellectual activity in the tenth century. Alfonso VI reconquered Toledo in 1085, but the city remained multicultural and multireligious. Poetry was a special love of the Islamic people, and so it was in southern Spain as well. In the late eighth century, an academy of music was founded in Córdoba by Ziryab, a Persian singer who fled to Spain to escape the wrath of the runner-up in a singing contest he won before Caliph Mahdi.

The quality of life improved with the arrival of the Moors in Spain. Planners installed street lighting and pavement in the cities, as well as houses with hot-air ducts under mosaic floors for heating in winter. Pools and artificial cascades adorned gardens, and orchards of peaches and pomegranates graced the landscapes. Prophets proclaimed that all men were equal before Allah (God).

themselves weavers, anymore than they would call themselves candle makers or cooks.

Returning Spanish settlers discovered that the Pueblo Indians had been careful to maintain the flocks abandoned by the Spaniards during the Revolt of 1680. In the new spirit of cooperation following the Revolt, the Spanish government initiated a policy that allowed selling or presenting sheep as gifts to Pueblo and allied nomadic tribes, together with related goods, including dyes, imported fabrics, braiding, laces, stockings, and shawls. Enemy tribes acquired sheep by stealing them so that by the end of the eighteenth century, virtually every Native American community in the Southwest kept flocks of sheep.

Because the Crown funded the mission churches, they were decorated with imported satins, metallic trimmings, damasks, silk, ribbons, lace, fringe, velvet, linens, lamé, and tapestries. There is also evidence that the friars accepted homespun and colcha items. Domínguez reports the presence of colcha-embroidered wool at one church. Friars used cloth for tapestries, clothing for statues of saints, altar cloths, canopies, banners, and vestments.

The Nineteenth Century

By the end of the eighteenth century, weaving was in decline, due partly to competition from Navajo weavers and partly to the shortage of sheep. To revive the industry, and improve the quality of weaving, the governor of New Mexico initiated the first government-funded weaving residency in New Mexico in 1807. He arranged for Juan and Ignacio Bazán—certified master weavers and members of the same weavers' guild in Mexico City—to travel to New Mexico to introduce Mexican weaving techniques to the local youth. The Bazán brothers brought looms with them, but also built new ones in Santa Fe, where they proceeded to teach wool and cotton weaving for two years before returning to Mexico City.

The demand for textiles increased significantly with Mexican independence from Spain and the opening of the Santa Fe Trail in 1821. These two events allowed trading to open up on a competitive basis to more than one outside market. In addition, the new government abolished trade tariffs, which boosted commerce even more. In the meantime, the sheep population had recovered in both the Río Abajo and Río Arriba areas such that in 1835 alone, a record eighty thousand sheep were traded to Mexico. The 1822 census revealed that Albuquerque had 71 operating looms, El Paso had 131, and Santa Cruz de la Cañada had 14. The Pueblo of Cochití had no looms in 1822, but the next year reported fourteen looms. In 1841, Santa Fe listed one spinner, twelve tailors, and two hundred seamstresses.

Textile items included *jerga*, a twill-woven woolen cloth often used for carpeting; *sabanilla*, a simple homespun woolen cloth; sarapes, blankets or ponchos worn by men, with designs drawn from the famous Saltillo sarapes of Mexico; manta, unbleached sheeting woven in quantity for commercial trade; and the Río Grande blanket. Despite the Bazán brothers' involvement in teaching cotton weaving, woven cotton blankets did not gain in popularity, probably because cotton was cheaper to buy from Eastern manufacturers after the Santa Fe Trail opened.

What did gain in popularity was the Río Grande blanket, a wool blanket of infinite varieties of design influenced by the woven designs of Mexico, of Navajo and Pueblo weavers, and later, by the quilts made by American pioneer women. Production was considerable, and based on demand, which attested to the popularity of the Río Grande blanket. In 1840 alone, twenty thousand blankets were traded at the Chihuahua Fair.

During this time, genízaros—Hispanicized Indians who lived and worked in Spanish households—created what came to be known as "servant," or "slave," blankets. Due to the unique combination of the genízaros' Indian heritage and Spanish training, their weavings oftentimes combined Spanish materials and technology with Indian designs. The servant blankets were uniquely cross-cultural. The work was of such quality that Spanish settlers in the Abiquiú area are known to have actively sought out Navajo *criados* (servants) for their facility with weaving wool. Surprisingly, only three documented examples of slave or servant blankets have survived, although scholars suggest there may be more as yet unidentified blankets in Colorado.

Yard goods and clothing formed the bulk of trade goods with the United States. New Mexicans acquired printed cottons or calicoes, linens, silk, cotton and wool flannel, serge, taffeta, quilting, pile cloth, list cloth, gingham, velvet, baize, wools, cashmere, mandarín, stockings, handkerchiefs, and gloves. New weaving materials also came across the Santa Fe Trail, including three-ply Saxony wool yarns dyed with natural dyes, and silk and cotton threads. Vermilion dye was introduced in the 1830s, Prussian blue in 1846 and synthetic dyes in the 1860s. It is interesting that no wool mill machinery was imported from any trade source, and sewing machines were not common until after 1890.

Navajo weavers continued to produce blankets of many colors and fine waterproof sarapes—they had learned the sarape style from their contact with the Mexican imports, and continued to produce them because they were highly prized by Indians, Mexicans, and Americans. They also continued to raid sheep ranches throughout New Mexico. Military campaigns carried out against the Navajos recovered thousands of sheep and woven items. Such steal-and-recover activity continued through 1844. Navajo-made blankets were sought after—despite the difficulties and inconveniences of warfare—because of their fine quality.

Several factors had an impact on the Hispanic weaving industry of New Mexico in the nineteenth century. Eastern trade over the Santa Fe Trail brought comparatively inexpensive, commercially made blankets, which gradually replaced the market for homespun blankets. After 1848, open grazing land—a right under Spanish and Mexican governance—was gradually reduced as Anglo farming, ranching, and mining activity burgeoned and land grants were bought up or illegally transferred out of Hispano hands in order to accommodate these new enterprises. The loss of land precipitated a gradual shift from the traditional barter economy to a cash economy. This, in turn, necessitated a shift from traditional subsistence farming to wage work, such as migrant farming and logging. With the men working away from home for weeks and months at a time, the family unit, which was at the core of Hispanic New Mexican life, faced new challenges in adjustment and accommodation. Weaving, traditionally done by men, presented an opportunity for some men to work at home once again, and to maintain a traditional family life.

In the late nineteenth century, the railroad brought greater quantities of competitively priced textiles from eastern manufacturers. Eventually, weaving in New Mexico was carried on primarily to fill the needs of individual households or of a neighborhood. The quality of weaving remained steady in some areas, but declined in others. Decline occurred after the introduction of merino (and Rambouillet) sheep and of synthetic dyes, both appearing around 1859. The dyes were brilliant at first but tended to fade over time. The short, coarse, greasy wool of the merino sheep—or of the hybrid of merino and churro sheep—yielded relatively lumpy, coarse weavings with uneven coloring. Due to its substandard quality, the merino-churro hybrid eventually led to the collapse of New Mexico's wool market in the early 1900s, together with a shift to weaving with commercial wool yarn and synthetic dyes.

Despite the technical setbacks, much creative experimentation took place in the late nineteenth century as weavers tried new materials, colors, and design ideas. Quality was uneven; and although novice weavers produced numerous pieces of questionable quality for the tourist market, fine quality weaving by experienced weavers prevailed in sections of the San Luis Valley and small villages in northern New Mexico until the 1930s.

In the meantime, the ascendancy of consistently high-quality Navajo weavings continued as the Navajo weavers responded to the demands of the trading post managers by creating blankets that appealed to tourists. This change in patronage from residents to visitors would ultimately affect Hispano weavers as well, causing changes in style and function in their work. While crafts were in decline in other parts of the United States, New Mexico crafts were evolving to meet the demands of new markets, and in the process, surviving.

The Twentieth Century

Unlike other parts of the West, there was no attempt to establish a textile mill in New Mexico, because of competition from eastern mills and the

What They Wore

Clothing in Spanish colonial New Mexico was made of homespun wool, leather, buckskin, or, less frequently, imported fabrics. Homespun was still used by impoverished New Mexicans while the ricos, preferring imported items, used home-spun only for sacking. Most Spanish colonists dressed simply in practical, long-wearing apparel, including trousers or breeches made of jerga, collarless shirts of sabanilla, and the universally favored buckskin for the men. They also wore overcoats and a tilma or conga, a short version of the sarape. Retablos or bultos of certain saints, such as San Isidro or San Acacio, are usually dressed in the typical Spanish colonial settler or soldier attire, and give a good idea of the style, which lasted for many decades.

Women wore laced, boned bodices of saban-illa over a linen chemise, and a full, ankle-length homespun skirt, allowing the wearer more free-dom—the relatively short length shocked Anglo women visitors in the nineteenth century, espe-cially when they observed free-spirited New Mexican women hiking their skirts even higher than their ankles to cross a creek or river. Blouses replaced laced bodices in the nineteenth century. Before tailoring improved the fit of clothing, much of what was worn was simply tied on the body without fitting. The ubiquitous rebozo (shawl) of imported silk—or some com-bination of cotton, silk, wool, and/or ikat-dyed bands with fringed ends—was worn around the head with one end thrown over the left shoul-der. Rebozos, or long narrow scarves, were introduced by the Moors, who preferred to see their women covered as much as possible. Heavy woolen rebozos were used in winter in New Mexico, usually with blankets; only a few wealthy women could afford cloaks. In New Mexico, black, fringed, square rebozos called

tápalos were especially common. The fine silk rebozos were passed on from generation to gen-eration within a family, and listed in inventories of the eighteenth and nineteenth centuries. There is no evidence that rebozos were woven in New Mexico.

Franciscan friars wore blue habits and vest-ments in honor of the Virgin Mary, and as a special privilege for their missionary work, while those not assigned to foreign service wore gray or unbleached habits as worn by St. Francis. New Mexico's friars also wore a knotted-cord girdle, leather sandals, and a broad-brimmed, low-crowned hat. The wearing of blue drew criticism from the secular clergy in the early nineteenth century, but opposition ended after independence from Spain became a reality and the friars became a memory. Still, it was not until 1897 that the Order discontinued the wearing of blue habits by any of its members.

Colonial soldiers wore whatever European armor they owned until it wore out and became unserviceable. Even when first brought to New Mexico, the average suit of armor was one hun-dred years out of fashion—judging from the one excavated piece found in New Mexico—due to the European custom of sending obsolete equip-ment to remote outposts. Metal shields were ingeniously replaced by those of buffalo or bull hide laced together in a geometric pattern that drew the shield into a convex shape on drying. Leather vests were a lighter substitute for armor. In a frontier colony, iron and steel had much more practical uses when forged into farm implements and knives.

Men, women, and children also wore knitted woolen stockings, socks, caps, and mittens. Colonists made their own buckskin shoes called teguas.

absence of fast-moving water. This left the market safe for the cottage industry that evolved in the nineteenth century. The invention of the automobile allowed tourists to go directly to the weavers in their rural homes. This gave the weaver more creative and economic independence from the city-centered curio-and-textile dealer, who had already carved out a lucrative niche in the weaver-to-buyer chain. In addition, a new awareness of weaving as a traditional art form led to its being revived, taught, collected, studied, and written about throughout the century. In Los Ojos, New Mexico, weaving became a major source of income and creativity for a whole community.

The same twentieth-century craft-revival movement that affected other crafts also affected weaving. Weavings have always sold well at the annual Spanish Markets held by the Spanish Colonial Arts Society. The Society began a collection of the best of all the crafts, including textiles. The Colonial Arts Shop in Sena Plaza sold Chimayó weavings. The Native Shop, which operated from 1934 to 1940, also found textiles to be the most popular items. Spinners and weavers worked continuously in the shop, where tourists could watch the process. As the weaving concerns in Chimayó grew more successful in drawing tourists north to Chimayó, demand grew for Chimayó blankets and dresser scarves. No matter where the point of purchase was, however, it was the new, and enthusiastic, Anglo-American patron who made the difference in keeping traditional weaving alive in the twentieth century.

In the 1930s, the New Mexico State Department of Vocational Education sought to revive the rural economy by offering classes in traditional crafts. Spinning was taught at San José and Chupadero, weaving at Taos, and colcha at Puerto de Luna. Under the auspices of the DVET, employee Dolores Perrault Montoya wrote a booklet on natural dyeing which was distributed to home economics teachers statewide. Weaving was a welcome source of income during the Great Depression.

In the 1970s, David Ortega and John R. Trujillo, owners of the two central retail weaving shops in Chimayó, began to encourage the production of traditional Río Grande blankets using natural and dyed wool from southern New Mexico and later

Icelandic wool. Another initiative, Del Sol, Inc. at Truchas, produced a variety of traditional woven products for sale nationwide in the late 1960s and early 1970s. Del Sol was supported by the Ford Foundation and the Home Education Livelihood Program (HELP). Another initiative, assisted by HELP and the Ghost Ranch Foundation, bought seven looms for traditional weavers in La Madera, New Mexico. The weavers, all women, emphasized traditional Río Grande weavings. Ganados del Valle was established in 1983 at Los Ojos, New Mexico, to revive the economy of the Chama Valley, including a wool washing-and-processing operation and a weaving cooperative and retail outlet called Tierra Wools. The company employs many native New Mexicans who might otherwise have had to leave the valley to find employment.

The Chimayó weaving tradition is a central part of the late twentieth-century textile industry. Major weaving families of Chimayó include the Ortegas, Trujillos, Jaramillos, Ortizes and Vigils. As a measure of growth over this century, there were seventy to one hundred weavers and seven dealers in Chimayó at the height of the 1930s craft revival. In the 1990s, there are over two hundred Hispanic weavers working in northern New Mexico. The Ortega Weaving Shop alone has eighty producing looms throughout the state. Some are multigeneration weavers like the Ortegas, whose weaving tradition goes back eight generations to Nicolás Gabriel Ortega, born in 1729. David Ortega is currently the titular head of the famous Ortega family of Chimayó, although his son Robert runs the business. The secret of the Ortega family success is an uncanny ability to respond to the changing business climate and consumer needs of its buyers. They operate a store in Albuquerque's Old Town to capture a tourist market that may never reach northern New Mexico. The family has been featured in several national publications, including the *New York Times*, *National Geographic*, and the *Saturday Evening Post*.

Eusebio Martínez's family, headed for decades by the late Agueda Salazar Martínez, began weaving in the seventeenth century in Chimayó. Doña Agueda (1898–2000) of Medanales, New Mexico, was a traditional Hispanic weaver who favored bold colors, and Saltillo, classic Río Grande, and

4.16
Weaver Reyes Ortega at work in Chimayó, New
Mexico, 1940. Courtesy Amon Carter Museum,
Fort Worth, Texas. Photo by Laura Gilpin, Chimayó
Weavers, P1979.202.241, nitrate negative.

Chimayó patterns. She also occasionally incorpo-
rated Native American designs as did some of her
Navajo ancestors. Her work is collected on an inter-
national market. Five of her seven daughters are pro-
fessional weavers, including Cordelia Coronado,
Eppie Archuleta, and Georgia Serrano. A grand-
daughter, Norma Medina, is also a well-known
weaver. One source indicated that in her family of
204, 64 are weavers, spanning five generations
(Clark 1994). Doña Agueda had spent most of her
life in rural New Mexico where she began her life at
the loom as a young girl creating rag rugs.

In the late twentieth century, experimentation is
allowed and encouraged. For example, pictorial
weavings have gained more popularity in the
twentieth century. One prominent example is
the woven portrait of the former Archbishop Robert

Sánchez, executed on a challenge by Eppie
Archuleta. Teresa Archuleta-Sagel's contemporary
weavings are intriguing combinations of color and
design. The contemporary designs of Irvin Trujillo
of Chimayó sometimes include people, birds, and
insects. Both Irvin and his wife and fellow weaver,
Lisa, diligently studied historic weavings before
developing their own highly contemporary styles.
Irvin's father, Jacobo (1911–90), was an innovator
and master of every style of New Mexican weav-
ing, including Saltillos, classic Río Grandes, and
Trampas/Valleros, among others. Lisa is a master of
Saltillo weaving; and both Lisa and Irvin's work has
evolved away from the standard Chimayó style to a
fine-art approach, with painterly designs, attention
to color value and hue, and weaving sizes deter-
mined by the image rather than function. Their
thoroughly contemporary interpretations are based
on a careful study of what has gone before. Both are
college educated, and Irvin is a fine musician. Based
in their Centinela Traditional Arts Shop in
Chimayó, they have exhibited in national and inter-
national venues and won many awards for their
work. In the mid-1990s, their works brought from
two thousand to forty thousand dollars each.

Materials
To understand the process of weaving, its materials
must be understood. After wool was sheared from
the sheep, it was placed on rooftops where the sun's
heat softened the lanolin and killed the ticks. Then
it was either washed in soapy water to remove excess
dirt and grease, or it was combed or carded, and
spun prior to washing. Churro wool was easier to
work if it was readied for weaving prior to washing.

There are two ways to hand-process wool for spin-
ning. One is to comb it, which ultimately results in
a "worsted," or firmly twisted, yarn with uniform
fiber length. Another is to card it, creating a
"woolen," or bulkier, looser yarn, with varying fiber
length. Churro yarn is combed to create worsted
yarn. Carding and combing removes extraneous
materials and smoothes out the wool. It is then spun
into long fibers that may then be dyed in hot baths
of natural or synthetic dyes. When dry, it is wound
onto a bobbin and is ready for weaving.

Wool is the raw material in New Mexico His-

panic weaving. The Spanish brought the churro sheep to New Mexico from southern Spain, which is similar in climate and vegetation to that of New Mexico, including rocky slopes and the high, dry climate. The churro sheep has long, silky, relatively nongreasy fleece, even though it gives little wool relative to other varieties of sheep. The merino sheep—the royal sheep of Spain—was introduced to New Mexico by Anglo-Americans in the nineteenth century. While higher yielding than the churro, the merino's fleece is short, silky, stubby, relatively greasy, and not well suited for shearing, hand spinning, or weaving. Weavers find merino wool to be impossible to hand-scour thoroughly, so it dyes unevenly.

A carding tool consists of bent-wire teeth set in close rows in a piece of leather fastened to a sturdy back. The carding tool was held and worked by hand to clean and untangle the fibers. Combing was done with a long metal fork. Spinning twisted the fibers together to form a continuous thread. The spinning tool of choice in New Mexico was the *malacate*, a simple drop spindle of Pueblo origin with the whorl set in a bowl that rested on the floor near the seated spinner. The traditional European sloping-style spinning wheel was infrequently used in New Mexico until the twentieth century.

Washing wool first required swishing dried and crushed *amole* (yucca root) in cold water before adding hot water, then the yarn. The amole, which had been used as a shampoo and cleaning agent by Pueblo Indians for centuries, has a slight bleaching effect on the wool.

Natural dyes were indigenous and imported, and were prepared by boiling and steeping the roots, leaves, bark, flowers, fruit, insects, or powder, depending on the dye source. (Even iron nails provided a black dye.) The natural colors were oftentimes more durable than synthetic dyes. Here is a short list of some plants and their resulting colors:

Mountain Mahogany	twelve different colors
Capulín (chokecherry)	brown to purple; green from leaves
Nogal (wild walnut)	brown

Ganados del Valle

Los Ojos, New Mexico, is headquarters for Ganados del Valle, a highly successful nonprofit development corporation that has given rise to six more businesses based on traditional arts and livestock practices of Spanish colonial New Mexico. Founded in 1983, Ganados del Valle has become the largest year-round private employer in the Chama Valley. When commercial land acquisitions around Los Ojos threatened the economic livelihood of its residents, community organizer and businesswoman María Varela and sheep ranchers Gumercindo Salazar and Antonio Manzanares, established Ganados del Valle to develop projects that would "reconnect natural and agricultural resources to traditional cultural practices and create products that sell." First year revenues totaled eleven thousand dollars; in 1994, revenues exceeded four hundred and forty-four thousand dollars. The organization made it possible for families to remain in the Valley, and to rekindle the optimism and pride of a community that is self-sufficient.

Among its six land-based businesses, Ganados del Valle includes a wool washing-and-processing operation and a weaving cooperative and retail outlet called Tierra Wools. Tierra Wools, which has since separated from the parent company, operates an apprenticeship program. Unlike nineteenth- and early-twentieth-century weavers, members of this cooperative resisted outside design suggestions proffered by New York dealers, and instead instituted a rigorous training program to create its own designs. In a unique effort to regain what had been lost, Ganados del Valle collaborated with the Navajo Sheep Project at Utah State University to locate surviving churro sheep in remote Hispanic villages and on the Navajo reservation, and through careful breeding, develop a modern churro. Churro wool is now used by several contemporary weavers and a large number of Tierra Wools weavers (New Mexico Office of Cultural Affairs 1996).

Chamisa flower (rabbit brush)	yellow
Yerba de la Víbora (snakeweed)	yellow
Cañaigre (a type of dock)	orange/gold/rust
Cota (Navajo tea)	orange/deep gold/ bronze/rust
Madder Root	red/red-orange/brown
Añil	indigo (imported)
Cochinilla (cochineal)	red (imported)
Brasil (brazilwood)	red-brown to tan

Cochinilla was an expensive dye made from the crushed bodies of insects meticulously picked off the *nopal* cactus in parts of Mexico and the Southwest. Mordants used to fix or set the dye included juniper, oak, wild cherry, native alum, or children's urine. In 1856, Sir William Henry Perkins of London developed synthetic aniline dyes, providing a bright new palette of colors, which dazzled the eye but which were not very durable. San Luis Valley weavers were especially inventive in combining and using the new dyes. Favorite colors included lavender, pink, orange, red, and blue.

Carding, combing, spinning, and dyeing was most often done by women or servants. The men washed the wool and wove following the traditions of the Old World Spanish cloth guilds, which were male-only organizations, although there were no official guilds in New Mexico. Despite this tradition, women weavers were common in New Mexico during the late nineteenth and early twentieth centuries, especially for weaving fabrics such as jerga and sabanilla.

In weaving, the vertically stretched yarns are called "warp" yarns and the horizontally placed yarns are called the "weft" yarns. These are some standard warp/weft yarns-per-inch ratios used to determine a textile's origin:

- Río Grande blankets have 5 to 7 warp yarns per inch and 25 to 50 weft yarns per inch.
- Pueblo blankets have 3 to 5 warp yarns per inch and 10 to 20 weft yarns per inch.
- Navajo blankets have 6 to 12 warp yarns per inch and 20 to 100 weft yarns per inch.

- As a point of reference, Saltillo sarapes commonly had 15 to 20 warp yarns per inch and 100 to 120 weft yarns per inch, as dictated by Mexican law.

The treadle looms (*telares*), unlike the upright Indian looms, were capable of accommodating long lengths of woven fabrics, which could be stored on the loom as it was being woven. If multiple pieces were woven on one set of warp yarns, they were removed from the loom and cut apart. The warp ends would then be individually tied using various knots. Navajo and Pueblo looms yielded pieces that came off the loom already finished on all four sides, with a twisted cord worked in during the weaving. For this reason, Navajo and Hispanic textiles are easy to differentiate by the absence or presence of fringe. Treadle looms, so named for the foot pedals used by the standing weaver, were handmade of wood and strips of leather for bindings. Boat shuttles, used to carry the weft yarn from one side to the other during the weaving process, were handmade of wood. Metal joinery was not commonly available until the 1880s.

Because most treadle looms were limited in width, weavers created the two halves of the same blanket separately and then sewed them together. If there was a complex design, the weaver had to be very careful to ensure that the designs matched up where they were sewn together. Four-harness treadle looms were capable of double weaving a large piece—thus alleviating the need to stitch two separate pieces together—by allotting two harnesses to weave a top layer of cloth and another two harnesses to weave a continuation of the same cloth. Both layers were woven with the shuttle inserted in a special sequence that closed the two layers along one selvage edge while leaving the layers separate along the other selvage. Once removed from the loom, the blanket was opened up to its full width.

Types of Textiles

New Mexico's weavers produced five basic textile types:

- Weft-faced weave—used for *frazadas* and sarapes (*frezada* in New Mexico)

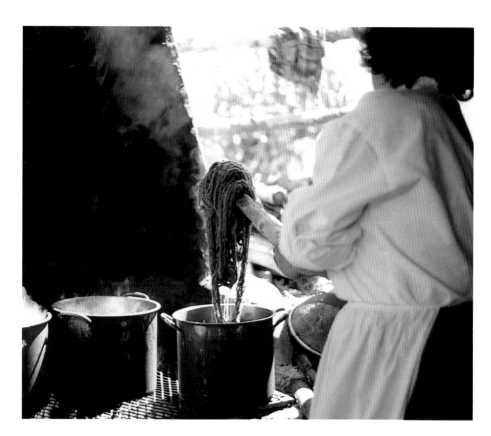

4.17
Demonstration of dyeing wool fiber in indigo at El Rancho de las Golondrinas, 1996. Photo by Mary Montaño.

- *Bayeta*—a tightly woven fabric used for clothing (*bayetón* was a heavier version of bayeta)
- Jerga—a thick twill-weave fabric used to make carpeting, blanket batting, clothing, and sacking (Its familiar checkerboard pattern can be seen in old photographs of pack animals laden with jerga-wrapped bundles.)
- Sabanilla—a plain weave cloth of fine-to-medium weight used for sheeting, mattress covers, clothing and backing for colcha embroidery
- *Sayal*—a strong, rough cloth used for sacking, tents, wagon covers, and to make the Franciscan friars' habits

From these textiles, the Spanish made a number of needed products, including:

- *Colchones*—mattresses
- Frazadas (also known as *frezadas*)—blankets, or bed covers of either wool or cotton. *Fra-zadas de cama* (bed blankets) were wider and longer than camp blankets; *frazadas atilmadas* were elaborately designed blankets.
- *Sábanas*—sheets
- Sarapes (the term serape is the English spelling of sarape)—worn by men, the most common were known as *sarapes del campo* or camp blankets. *Sarapes de labor* had elaborately woven designs; *sarapes atilmados* were elaborately designed sarapes.
- *Tápalo*—a form of rebozo, generally square and fringed
- Tilmas—blankets used as cloaks, a short version of the sarape (also, a saddle blanket made by Navajo or Pueblo Indians of New Mexico)
- *Calcetines*—knitted socks made from the short inner fleece of the churro. New Mexicans made hundreds of pairs of woolen socks for export and domestic use.

New Mexicans recycled their worn-out woolens

by using them as filler in quilts. Many nineteenth-century textile fragments have been found inside such items.

Styles and Designs

Despite their isolation, New Mexico weavers were greatly influenced by the weaving traditions of Mexico, which in turn were influenced by those of Europe, and the Middle and Far East. From these stylistic sources, the weavers created their own styles and designs.

SALTILLO SARAPE (1700–1850)

The ideal to which weavers could strive was found in the classic Saltillo wool sarape, designed and woven by the Tlaxcalan Indians living near Saltillo, in the present state of Coahuila. (The Tlaxcalans had been awarded land there for their assistance in the overthrow of Moctezuma.) Little is known about the origin of the sarape; however, the indigenous weavers of Mexico wove mantas of cotton or other native fibers. Mantas were rectangular, and some had slits in the center so they could be used as both ponchos and bedding. Scholars find it reasonable to believe that the indigenous manta was the model for the larger and more elaborate sarape of the Spanish colonial period.

The Saltillo sarape is renowned for its intricate, colorful, dense mosaic designs and very fine, waterproof weave resulting in an unusually soft but sturdy fabric. A typical sarape took two years to complete and was highly prized by the Mexican *charros* (cowboys) and caballeros, who comprised the largest group of customers in Mexico. The sarape was worn poncho style with open sleeves. Some were made using silver or gold thread. The sarapes were traded north to New Mexico at the annual Saltillo fair, which was established in the late seventeenth century.

The sarape was created in the shape of a rectangle with a distinctive border on all four sides and a slit in the middle of a central serrate diamond or cir-

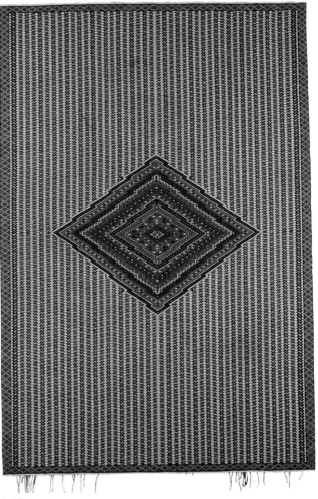

4.18
Saltillo sarape, 1750–1800, one width, natural dyes. Courtesy Fred Harvey Collection of the International Folk Art Foundation at the Museum of International Folk Art, FA.79.64.101. Photo by Cradoc Bagshaw.

cular design. Its detailed designs were drawn from a combination of Moorish, Chinese, pre-Columbian, and Spanish influences. The intricate patterning found in most sarape examples reveals the Moorish predilection for overall coverage of surfaces with intricate patterns. These patterns—including stepped, serrated chevron, and hour-glass designs (see line drawings)—were woven in diagonal rows, a grid of tiny figures, or vertically oriented

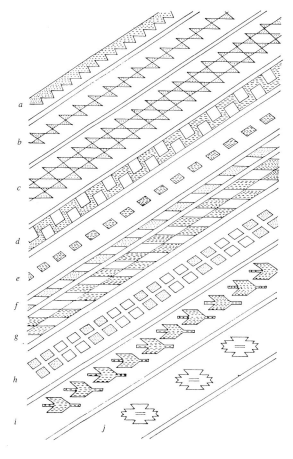

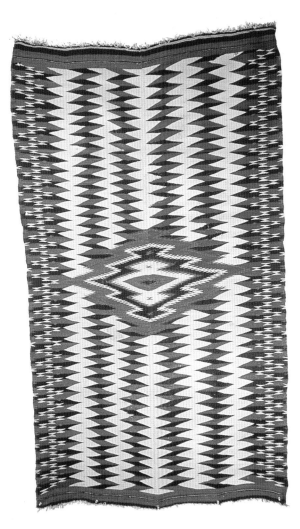

4.20

Río Grande blanket, pre-1860, two widths seamed together, showing heavy influence of Saltillo sarape. Colors include natural undyed light and dark indigo, cochineal, and commercial yarn. Courtesy International Folk Art Foundation Collection at the Museum of International Folk Art, FA 67.16.1. Photo by Cradoc Bagshaw.

4.19

Design patterns on Saltillo sarapes (drawn by Nora Pickens)

a. Serrated line
b. Double serrate or "hourglass"
c. "Hourglass" net
d. Truncated zigzag stripe
e. Inset rhombs or diamonds
f. Diamond stripe
g. Double diamond stripe with offset
h. Clustered diamond stripe w/alternating color scheme
i. "Saltillo leaf" (manita)
j. Serrate diamond pattern

From *Spanish Textile Tradition of New Mexico and Colorado* (Santa Fe Museum of International Folk Art, 1979), 80.

4.21
Río Grande blanket, ca. 1840, one width. Five colored stripes separated by four bands; undyed natural white and indigo. Courtesy Museum of New Mexico Collection at the Museum of International Folk Art, A.55.86.451. Gift of Florence Dibell Bartlett. Photo by Blair Clark.

figures. The sarape's circular pattern variation is thought to be drawn from Chinese influence.

New Mexican weavers were intrigued by these basic Saltillo figures as they approached the design of their own Río Grande blankets, yet they favored less detailed designs than that found on the Saltillo sarape. Their work shows fewer bands, but the same use of contrasting colors. New Mexican weavers often added secondary diamond shapes above and below the central diamond. There were also a large number of Río Grande blankets that combined plain bands with bands of Saltillo design elements in tapestry weave. The Río Grande blanket never approached the fine weave and complex design of the Saltillo sarape. Instead, Río Grande weavers compensated by using bolder designs and simple, harmonious colors.

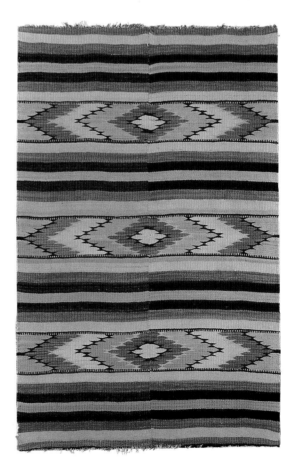

4.22
Río Grande blanket, ca. 1880, two widths seamed. Colors include natural undyed light and dark, and synthetic pink, red, orange and yellow. Stripes show Saltillo-influenced design. Photo courtesy Museum of International Folk Art.

Río Grande blanket (1820–80)

The most frequently produced and widely distributed textile of nineteenth-century New Mexico, the Río Grande wool blanket was traded all over Mexico and in North America to Indian and Anglo communities alike. Like the Saltillo sarape, the Río Grande blanket was used as apparel during the day and as bedding at night. Unlike the slitted sarape, the Río Grande blanket was folded lengthwise and wrapped around the shoulders. After 1860, the blankets were used exclusively for bedding.

Typical designs included the varicolored band-and-stripe style consisting of wide bands alternating with narrow stripes. In later examples, the stripes showed Saltillo design elements or Native American "step" designs. The band-and-stripe style was probably the most common Río Grande design, offering as it did an infinite variety of color and design possibilities. As a rule, each blanket had either five or seven colored bands separated by white. The most common colors were natural undyed white and brown combined with natural dyed yarns of blue, yellow, some red, and much reddish to golden tan. Indigo was very popular. The indigo blue, dark brown, and white band-and-stripe style was known as the Moki pattern, after a type of blanket woven by the Hopis and other Pueblo Indians. Among Indian weavers, the band-and-stripe design was known as the Mexican Pelt.

Design patterns used by Río Grande blanket weavers include greatly enlarged versions of the Saltillo hourglass and chevron designs, as well as *manitas*, or "little hands," a design that is believed to have originated in the San Luis Valley. Two subtypes of the Río Grande blanket were the wedding blanket and the camp blanket.

Trampas/Vallero blanket (1865–1904)

This style is a variation of the Río Grande blanket and is named for its area of origin in Las Trampas and El Valle, New Mexico. The Trampas/Vallero blanket—also known simply as a Vallero blanket—is distinguished by its use of the Vallero or Le Moyne eight-pointed star in its design, and by its position as a transitional style between the nineteenth-century Río Grande blanket and the twentieth-century Chimayó blanket. The Le Moyne star has become

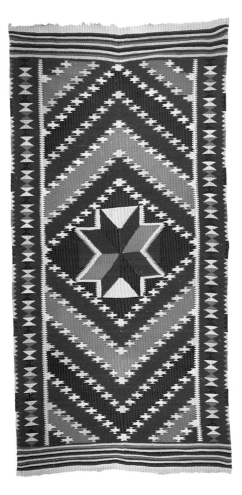

4.23
Río Grande blanket, El Valle style, woven wool yarn, late nineteenth century. Courtesy Taylor Museum, acc. #6165.

the hallmark for the area's Montoya sisters, who contributed to its popularity.

The most popular blanket design shows a center star and one in each corner. The star is presumably influenced by one of two sources: the Anglo-American quilt tradition, in which it is known as the Le Moyne star; and the Saltillo sarape, with its complex backgrounds, corner diamonds, borders, and zigzag patterns, all design elements simplified for inclusion in the Trampas/Vallero blankets. Later pieces also showed the influence of seamed quilt squares. It is not unreasonable to imagine that an

4.24
Trampas/Vallero pictorial blanket, ca. 1900, one width. Natural undyed light and dark, synthetic red and yellow. Courtesy Museum of New Mexico Collection at the Museum of International Folk Art, A.71.20.1. Photo by Cradoc Bagshaw.

ders. Earlier blankets used natural dyes; later examples used the more widely available synthetic dyes. Some examples had pictorial designs of horses, elk, or even buildings. Trampas/Vallero blankets are still woven today.

WEFT IKAT BLANKET (1800–60)

This beautiful and complex dyeing and weaving style represents a fascinating mystery in the story of New Mexico's weaving tradition. Weft ikat is a type of dyeing of the weft yarns, which scholars once thought was practiced in the Western Hemisphere in only two places—Guatemala and northern New Mexico. How the technique reached New Mexico is the mystery.

Ikat is a Malay word meaning "to tie or bind." There is no known term for it in Spanish. Ikat refers to the resist-dyeing process that takes place prior to preparing weft and warp yarns. In the case of weft ikat, the weft yarns are grouped, wrapped, bound, and dyed according to a predetermined pattern. The binding resists the dye, producing a design in the yarn that is revealed only in the final woven product. Warp ikat is accomplished by binding and dyeing *warp* yarns, a much simpler process than weft ikat. Ikat weaving was developed in Indonesia and practiced throughout the Far East, Middle East, North Africa, Europe, pre-Columbian Peru, and present-day Guatemala. Recent evidence reveals that ikat weaving may have been produced in Michoacán, Mexico.

How did weft ikat weaving reach nineteenth-century New Mexico? Ikat woven rebozos (shawls) were imported from Mexico to New Mexico in the early nineteenth century. Also, Chimayó and Guatemala shared a devotion to Our Lord of Esquipulas. The Santuario at Chimayó was built in 1813–16 and dedicated to Our Lord of Esquipulas. An altar screen at Ranchos de Taos and three other works by the santero Molleno are dedicated to the same personage. The tie to Guatemala is that there is an Esquipulas in southwestern Guatemala, as well as a cult dedicated to Our Lord of Esquipulas. Scholars speculate that somehow the Guatemalan cult may have been introduced into New Mexico during or prior to the building of the Santuario, and with it the weft ikat technique.

Anglo-American quilt made its way into New Mexico during the nineteenth century to be admired and wholeheartedly copied by New Mexican weavers as easily as they copied sarape designs. As in other arts and crafts, Nuevomexicanos seem to have appreciated and absorbed outside styles with much enthusiasm as their centuries-old isolation came to an end in the nineteenth century.

As with other Río Grande blankets, many of the Trampas/Vallero blankets were woven in two widths, then seamed at the center, necessitating much care in uniformity of design. Most examples show a bold approach to color, and an emphasis on vertical design, particularly in the use of side bor-

4.25

Weft ikat blanket, ca. 1800, Río Grande area. Courtesy Fred Harvey Collection of the International Folk Art Foundation Collections at the Museum of International Folk Art FA.79.64-93. Photo by Blair Clark.

The weft ikat textiles of New Mexico were not discovered until 1958. Only about a dozen examples exist today. Nor did they all come from one workshop, though they have certain similarities. They are all dyed with indigo and woven in one width. Some pieces use handspun cotton in the weft; others use cotton mixed with an unidentified plant fiber in the warp. The dyed weft yarns create horizontal designs including arrowhead patterns.

CHIMAYÓ BLANKET (1880 TO THE PRESENT)

As the last creative expression of the nineteenth-century Río Grande blanket, the Chimayó blanket by necessity represents an alliance of tradition and tourism. It also represents "the way in which Hispanos and Anglos have participated in the task of defining the craft which has, in turn, contributed to the shaping of Hispanic ethnicity" (Lucero and Baizerman 1999). For in developing the Chimayó blanket, Hispanic artisans and Anglo distributors worked together to define a product that represented the Nuevomexicano culture to the outside world.

Retail establishments in Santa Fe and other tourist centers played a large part in the creation and maintenance of the Chimayó market. These include the Candelario family in Santa Fe, Julius Gans's Southwest Arts and Crafts, McMillan's Spanish and Indian Trading Company, and the Fred Harvey Company, which operated curio stores throughout New Mexico. Fred Harvey also served as a distributor of Chimayó textiles throughout the United States. The owners of these outlets, who interacted daily with the buying public, placed orders with the weavers, who worked in rural homes far from the marketplace. The weavers were only too happy to create new products foreign to their way of life in order to create needed income. Blankets were not popular sellers, but rugs, table covers, table runners, chair throws, purses, pillows, jackets, and even curtains were.

The most frequently requested Chimayó blanket designs were generally a mix of Spanish and Indian patterns, which continued to characterize this genre well into the twentieth century. The basic Chimayó design consisted of two bands, top and bottom, framing a center design. Dealers standardized the dimensions in order to standardize prices. Because dealers often provided materials to their weavers, the finished product was made of yarns purchased from eastern sources, including commercially processed wool and cotton using synthetic dyes in a wide variety of colors.

New Mexico's weaving tradition is a classic case of how a culture survives through its craft, and how

4.26
Chimayó blanket, ca. 1930–40. Commercial yarn, wool warp and weft. International Folk Art Foundation Collection at the Museum of International Folk Art, FA.1987.440.1. Photo by Miguel Gandert.

its craftspeople adjust to shifting demands and tastes to survive, and by so doing, assist the culture in its own survival. The flexibility and willingness of the weavers to consider myriad outside influences regarding design and function are major factors in the continued economic and artistic success of the cottage textile industry in New Mexico.

Colcha Embroidery

New Mexico embroidery is much coveted by museums and collectors because the generous use of soft wool yarn in warm vegetable colors gives it a richness and intimacy rarely encountered in textiles. Designs are free and graceful, executed with little of the tedious detail which characterizes most needlework. More often than not, native embroidery was an act of devotion, an altar cloth lovingly planned to ornament a little village church.
—*Roland F. Dickey,* New Mexico Village Arts

Colcha is a term applied to two different styles of embroidery created in colonial and nineteenth-century New Mexico. The first style, known as wool-on-wool, flourished in colonial New Mexico and involved homespun wool yarn embroidered onto a homespun wool backing called sabanilla. The second style, known as wool-on-cotton, emerged in the first half of the nineteenth century, and featured homespun wool yarn embroidered onto homespun or factory-made cotton backing.

The term *colcha* evolved from the word *colchón*, meaning mattress; today it most often refers to a bedspread. Colcha also referred to a tapestry or wall hanging, most likely for church use, or to the embroidery stitch that covered the entire surface of the backing material. Sabanilla, the backing material, was a fine plain or twill-weave fabric of natural white. Colonial women dyed the wool yarn for embroidery in soft colors using imported and local vegetable dyes. The double-stranded yarn and large stitches, resembling crewelwork, facilitated fast coverage. The stitch is created by first pushing the needle through from the underside of the cloth, passing it across the top of the design, and pulling it through the cloth to leave a long straight line. Then the needle is brought to the middle of the stitch and passed over it at right angles in a short catch stitch to hold the longer stitch in place. The next long stitch begins beside the first one, parallel to it. It is an economical stitch because very little yarn is seen on the reverse side. This stitch is known in other parts of the world as the Bokhara, convent, laid Oriental, figure, Deerfield, or Romanian couching stitch.

While colchas are unique in their extensive use of the colcha stitch, other types of stitches are sometimes used in colcha. For example, on rare occasions, the embroiderer uses chain stitches to outline in a dark color, and double or single outline stitches

to create thin lines for flower stems. Vertical, horizontal, or diagonal threads following a design element create subtle shading.

The finished work is thick but not stiff, with stitches covering the entire surface of the backing fabric. The early colcha cloths were often over six feet in length and four or five feet in width in order to hang in a church or chapel, or to cover a bed. Some of the finest colonial colcha pieces were altar cloths.

A typical colonial design element, Far Eastern in origin, is the split scroll-shaped leaf in which one half of the leaf is one color and the other half is

4.27
Colonial style colcha embroidery on handspun and woven wool sabanilla. Colorado, 1929. Courtesy The Spanish Colonial Arts Society Collection at the Museum of International Folk Art, L5.1958.41.

another color. Other visual images favored by colonial women include all manner of flowers, animals, and zigzagging bands of color. The Hapsburg eagle was a popular image, as was the pomegranate blossom. In the 1930s, the Varos Graves sisters expanded the visual repertoire to include saints, Indians, Peniente processions, covered wagons, stagecoaches, adobe houses, fireplaces, candlesticks, and Navajo blanket patterns.

In the late nineteenth century, cotton backings replaced wool backings. White space came into its own as an important design element. No longer did colcha stitching cover the entire surface of the backing material; rather, designs were scattered over a field of white or off-white cotton, either in an orderly, patterned style or a random style. Commercially processed yarns replaced the earlier handspun yarns.

History

There are references to colcha in New Mexico as early as 1743. Church inventories at La Castrense and the church at Santa Cruz de la Cañada, among others, mention wall hangings, a curtain for a portrait of a saint, and coverings for altar steps. Colonists also used colcha as covers for colchones and occasionally as trade items.

The Iberian influences on colcha design are evident in the use of rose and pomegranate designs, leafy scrolls, clove pinks (a type of flower) with crosshatched filled elements, peonies, small birds, and the occasional cornucopia. The open designs of the nineteenth-century pieces can be traced back to the work of Persia and other Middle Eastern areas—for example, the colcha stitch itself is similar to stitches used by contemporary Turkish and Israeli women. Persian pieces were traded in the West, where European women incorporated Persian design elements into their own work. Spanish embroidery was also greatly influenced by the *indianilla*, a type of chintz cloth imported from India in the late seventeenth century. Spanish embroidery, with all its borrowed Middle Eastern elements, then made its way to Mexico, where silk embroiderers combined those design ideas with those found in Oriental pieces. In turn, the solid embroidery of New Mexico's colonial colcha work may have been an attempt to copy

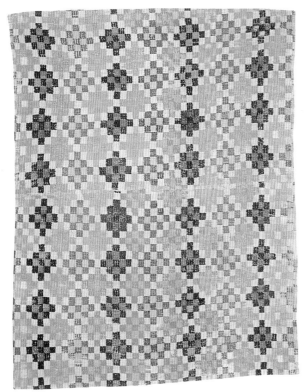

4.28
Wool-on-wool colcha fragment with a geometric design, dating from 1750–1825. Courtesy Museum of New Mexico Collection at the Museum of International Folk Art, A.5.54.9. Gift of the Historical Society of New Mexico. Photo by Blair Clark.

4.29
Wool-on-wool colcha piece with combination pictorial showing the popular double-headed Hapsburg eagle, 1790–1850. Courtesy International Folk ArtFoundation Collection at the Museum of International Folk Art, FA.67.43.4, Photo by Blair Clark.

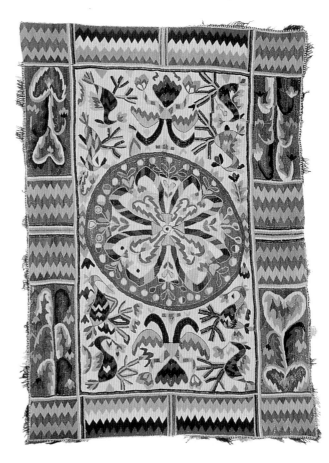

the solid embroidery of the elaborate vestments imported from Mexico.

Boyd states that the colcha stitch is not found in Mexico, but rather on embroidered silks imported from the Orient in the eighteenth century. The split, scroll-shaped leaf, so evident in New Mexico work, is an Oriental design pattern. The look of colcha patterns is strongly suggestive of the highly popular *mantones de Manila* (Manila shawls) that were imported to Mexico from the Philippines via the Manila galleons, and that made their way to New Mexico.

With the opening of the Santa Fe Trail in 1821, factory-made muslin and calico arrived in quantity in New Mexico. Cotton products, particularly *cotonilla*, had long been available through Mexican trade, but at a high cost. It, along with muslin, replaced sabanilla as backing in the late nineteenth century. Wool-on-cotton embroidery was pursued, but it, too, was difficult work.

Compared to colonial colcha work, early twentieth-century colcha has been described as

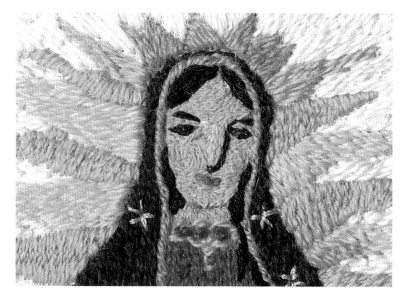

4.30
Detail of Our Lady of Guadalupe from a colcha piece by María Vergara Wilson entitled "Las Tres Marías." Courtesy Museum of New Mexico Collection at the Museum of International Folk Art, A1982.43.1. Photo by Blair Clark.

coarse, asymmetrical, and crudely stitched. By the end of the nineteenth century, women were finding wool-on-cotton easier to work. They also pursued crochet, patchwork, feather stitching, and cross-stitching on pre-stamped patterns. Boyd suggests that the decline of fine colcha embroidery coincided with the introduction of new materials and techniques from the eastern United States, specifically the use of Saxony and Germantown yarns, synthetic dyes, and wool thread from other breeds of sheep. Such wool was short-fibered, harsh, brittle, and difficult to work. Boyd (1961) added, "Trade yardage, wallpapers, oil cloth, and other innovations aroused interest in new, if meretricious, designs and color combinations, as did new forms of domestic busywork."

The 1930s saw a revival of colcha activity in the Taos area—specifically Carson, New Mexico—where Frances and Sophie Varos Graves produced pictorial colcha items. They also repaired older colcha pieces or created new ones from unraveled textile items that were too tattered to repair. The primary impetus for the Carson colcha pictorial designs was the sisters' Mormon husbands (the Graves brothers), who not only drew the images, but arranged for Mormon trader Elmer Shupe to sell the final products throughout the region.

The Varos Graves sisters used colors of mixed vegetal and synthetic dyes, while threads were combinations of salvaged wool and commercial yarns. Their designs merged colonial floral patterns and scenes of nineteenth-century life, such as wagon trains, processions, and candlesticks. The women of Taos were still producing interesting and profitable work well into the second half of the twentieth century. In 1935, Carmen Espinosa wrote an instruction booklet on colcha as part of her work for the New Mexico Department of Vocational Education and Training.

The Varos Graves sisters and their descendants continued to pursue colcha embroidery in the late twentieth century, exhibiting their works at the annual Spanish Market in Santa Fe. Notable colcha artisans are Mónica Sosaya Halford, Kathleen Sais Lerner, Donna Wright de Romero and Teresa Archuleta-Sagel. New colcha pieces by these contemporary embroiderers pay homage to the work of their colonial and nineteenth-century sisters with traditional designs and colors and a mix of traditional and contemporary materials, including commercially and naturally dyed yarns, and backings of Irish linen, muslin, or sabanilla. Kathleen Sais Lerner's goal is to create colcha from the basic elements. She intends to master spinning and weaving so that with her skills at natural dyeing, she will have "a true feeling of what it was like to be an artisan back in Spanish Colonial times" (Toomey 1997). Teresa Archuleta-Sagel refutes any notion that colcha embroidery is a dying art:

If you look at the vast amounts of textiles that

4.31
Colcha embroiderer and weaver Teresa Archuleta-Sagel with a traditional wool colcha piece. From *Tradición Revista* (Winter 1997), 45. Photo by Don Toomey.

were woven in colonial times, and compare them to the handful of *colcha* that has survived you can say it was popular, but it was also rare. I believe the ratio is about the same today as it was then. (Toomey 1997)

Tinwork

Nineteenth-century New Mexico *hojalateros* (tinsmiths) were unique among their peers in other regions of the United States in that they dedicated their efforts almost exclusively to creating pieces for use in their churches, household chapels, and moradas. The earliest pieces were simple sconces to light the interiors of churches and frames to hold the colorful European and American prints of saints and holy personages that were widely distributed by the newly arrived French and Italian priests. There is speculation that the prints, mostly lithographs,

were part of a campaign by Bishop Lamy to eradicate the use of retablos and bultos in New Mexico. Later, Santa Fe and Albuquerque merchants began selling the religious pictures to meet the demand.

Other items made for church, chapel, and morada included:

- *Nichos* (niches), to hold bultos or candles
- *Cruces* (crosses), either free-standing or for use on walls
- *Candelabros* (candelabras), *candeleros* (candlesticks) and *arañas* (chandeliers)

Tinwork was rarely used for secular purposes in the nineteenth century, though travelers report private residences where the walls held numerous tin-framed mirrors. The mirrors were most likely used to reflect candlelight, because they were hung too high to see one's reflection.

Prior to the nineteenth century, Fray Atanasio Domínguez reports the use of tin crosses, boxes, and a lamp in the churches he visited in 1776. These items, as with most colonial pieces, are not extant. In fact, the earliest known New Mexico-made tin pieces are sconces described in 1846 as hanging on the walls of La Castrense, the military chapel on the Santa Fe Plaza. About the same time, the ubiquitous Lieutenant Abert describes an unnamed church in Santa Fe as having "looking glasses trimmed with pieces of tinsel" (Abert 1848).

Whatever the level of production that took place in colonial New Mexico, it most likely did not rival the output during the years 1840 to 1915 when roughly twenty-five known tinsmiths were active in New Mexico (Coulter and Dixon 1990). Thousands of tin items were made during that time, prompted by the new availability of tin, window glass, mirrors, and wallpaper. These materials were brought to New Mexico by the American military, which began its occupation of New Mexico in 1846, and by

merchants across the Santa Fe Trail. Military quartermasters received shipments of lard and lamp oil in five-gallon tin containers, as well as window glass for officers' quarters. Merchants sold foodstuffs in tin containers. Tinsmiths bought or collected the used containers.

The years between 1860 and 1890 saw the greatest tinworking activity in the nineteenth century. Tinsmiths turned out frames, *pantallas* (sconces), crosses, boxes, and nichos. Then the railroad, established in the 1880s, made it possible to ship larger items safely, particularly window glass. Shipping by rail was also less expensive, so mercantile inventories expanded. Greeting cards and calendars with easy-to-frame images began appearing in nichos and frames.

By the 1890s, gas and coal-oil lighting dominated, and candle sconces were unnecessary. Demand dropped. Commercial frames manufactured in the eastern United States gained in popularity, so demand for tin frames dropped. Even though bultos were still being made, tinsmiths made fewer nichos to hold them. Tinwork production rapidly declined from 1890 to 1910. By 1915, José María Apodaca, the

José María Apodaca, Master Hojalatero

One of Coulter and Dixon's designated workshops is based on the work of a single tinsmith, José María Apodaca, whose life and work are described by the authors in the following excerpt.

José María Apodaca (1844–1924) was a prolific tinsmith whose work combines sophisticated design, fine craftsmanship, and a superb sense of color, resulting in some of the highest quality New Mexico tinwork produced in the late nineteenth and early twentieth centuries. He was born in El Paso del Norte (Juárez, Mexico) and immigrated to Santa Fe County while still in his teens. He homesteaded land in Ojo de la Vaca in the 1880s and lived and worked for the remainder of his life in the small village (now abandoned) twenty miles southeast of Santa Fe.

Mr. Apodaca was a producing tinsmith for at least forty years, from 1875 to 1915. His grandson, Ben Apodaca Martínez, remembers that he worked in the kitchen of his home surrounded by stacks of tin cans, constructing the tinwork on the kitchen table and heating his soldering irons in the cast iron stove. Mr. Apodaca packed his tinwork in canvas bags and traveled by horseback to Santa Fe and along the Pecos River, *selling his work in the villages of Colonias, San Isidro, San José, and Villanueva. Owing to his age and failing eyesight, Mr. Apodaca stopped producing tinwork about 1915.*

Sophisticated and imaginative combinations of wallpapers, cloth, printed materials, and colored portions of tin containers are a benchmark of Mr. Apodaca's work. Color lithographed or varnished tin is used in the interiors of nichos, as structural tubing, and more prominently on concentric rosettes. These overlapping layers of small scalloped rosettes retain the colored labels of the original cans in combinations of blue, rose, orange-red, and acid green. The coated interior of cans (a transparent golden color) produces a dazzling effect in combination with the silver tone of the exterior. In less talented hands, this technique might have seemed garish, but Mr. Apodaca produced pieces of extraordinary beauty by judicious use of this detail. Light— even ephemeral—in appearance, the work also owes much of its charm to a selective use of pastel-colored paper, seed packets, and pages from seed and nursery catalogs. (Coulter and Dixon 1990)

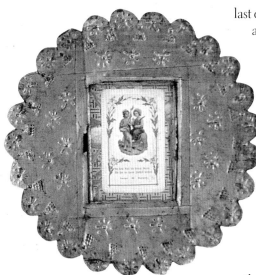

4.32
Frame in the style of the Río Arriba workshop, c. 1875. Courtesy Spanish Colonial Arts Society, collection on loan at the Museum of International Folk Art, L.5.1952–38. Photo by Michael Monteaux.

last of the finest nineteenth-century tinsmiths, had stopped creating tinwork.

Tin Forms

Tin items created in New Mexico took on several forms based on the needs they were created to fill.

ARMAZONES (FRAMES)

Frames comprise two-thirds of all surviving nineteenth-century tin items. They range in size from two inches (for lockets) to nearly three feet high (for churches) and are most often square or rectangular. The most common fabrication method was to cut four strips of tin and join them at the corners, then cover the joints with decorative, cut tin shapes, such as rosettes or fans. A backing panel kept the framed item in place, whether it was a lithograph or a piece of glass or mirror, and was soldered in place with tin frame strips. The vertical and horizontal strips were stamped, embossed, or scored to create designs. Often, the tinsmith decorated these areas by placing wallpaper under a similarly sized piece of glass and attaching it with narrow tubes of tin soldered to the backing plate. The glass strips also were used to keep the decorative item in place. The initial scarcity of glass caused early tinsmiths to piece together larger panels from small pieces of glass.

"Combed glass" was created by painting the glass first with oil paint (first brought to New Mexico over the Santa Fe Trail), then combing it to create wavy designs. In the process, areas of clear glass were exposed, thus allowing foil, tissue, or another layer of paint to show beneath the painted surface. The Isleta tinsmith used many layers and colors of paint to create his richly decorated glass panels. The tinsmiths of the Río Arriba Painted Workshop combed in such a fashion as to create floral and other designs. Tinsmiths also added simple or elaborate crests to the top of the frame, and shaped pieces to either side. Outside edges might be cut in scallop designs.

NICHOS

Nichos, the second most common tin form created in the nineteenth century, were created to house and protect

4.33
Painted frame by the Isleta tinsmith. Courtesy Spanish Colonial Arts Society, collection on loan at the Museum of International Folk Art, L.5.1973–3. Photo by Michael Monteaux.

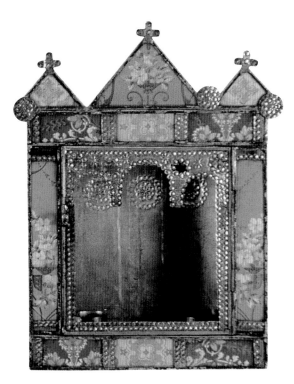

4.34
Tinware nicho by José María Apodaca, ca. 1880. Courtesy Girard Foundation Collection at the Museum of International Folk Art, A.1980.36–312. Photo by Michael Monteaux.

scholars speculate may be representations of the Holy Spirit (although some bird shapes were often fierce looking). Another interesting element was the use of diagonally scored Solomonic half-round columns, which were incorporated into the vertical design on either side of the nicho box. Nichos ranged in size from six inches to more than three feet tall.

CANDLE HOLDING FORMS

Less than ten percent of surviving tin pieces are forms of lighting, which include sconces, candlesticks, lanterns, candelabras, and chandeliers.

Pantallas (sconces) were used to light interiors. They are one of the earliest forms of tinwork made in New Mexico, and the demand for sconces probably contributed to the growth of tinwork in the late 1840s. Prior to tin sconces, wooden sconces were used, but they tended to burn. Another advantage of

bultos or commercially printed sacred images. They were most often used in home chapels or moradas. In churches, nichos held images of the patron saint of the village as well as other saints. Colonial nichos were made of wood. Standard construction was a box with hinged glass doors. The inside rear of the tin nicho was often stamped with complex designs or grids, then filled with paper or tin flowers, or *milagros*, once the bulto or sacred image was in place. Side panels were decorated with wallpaper, or scroll-shaped appendages, as in frames. Candlesticks were often attached to either side. Crests could be very elaborate, and often included bird shapes, which

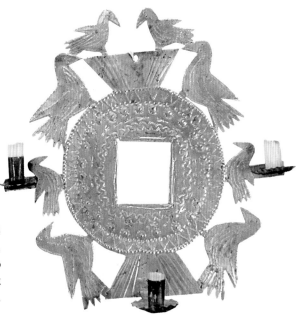

4.35
Candle sconce with birds, nineteenth century. Courtesy Historical Society of New Mexico Collection at the Museum of International Folk Art, A.5.59–15a. Photo by Michael Monteaux.

Making a Round Tin Mirror Frame

Tin comes in large rolls from which sections are cut. The most common thickness for tinworking is 26 gauge. To make a ten-inch round frame, measure and cut an eleven-inch-wide piece of tin, using tin shears. Lay the cut piece flat and measure the outer circular edge using a compass (divider). Cut the edge with the shears.

New Mexico tinsmiths make their own steel punches, which are hand tools applied to the surface of the tin and struck with a rawhide mallet to leave the pattern of the punch on its surface. When struck hard enough, punches designed with sharp curved edges will cut right through the tin. Others are meant only to leave a pattern on the surface of the tin. Patterns may be crescents, dots, full circles, or serrations.

To cut a scalloped outer edge on the frame, measure carefully with a pencil where each scallop will go. Measuring is important in order to avoid having a half scallop at the end of the punching. Place a sharpened curved punch against the measured edge and strike it with a mallet hard enough to cut through the tin. Continue all the way around the circle of tin until the entire edge is scalloped. If a smooth edge is

desired instead of a scalloped edge, simply cut the edge with tin shears. With either style, smooth out the rough edges with steel wool.

To cut out the center hole where the mirror will go, measure that opening with the compass and then pierce the tin inside the measured area using a sharp-edge punch. Work the tin shears into the pierced hole to carefully cut the measured tin away. Once again, if a scalloped or other edge is desired, measure and punch. Finish the edge with steel wool.

The frame's surface design is created by scoring, stamping, or embossing with punches and chisels. Scoring results in long straight lines. Stamping leaves a discrete design on the tin's surface, such as crescents which, when linked and alternated, make a fanciful yet linear design. Unlike stamping, embossing results from punching the tin on the back surface rather than the front surface. When scoring, stamping, or embossing, place the tin on an old magazine or other cushioning surface.

- *To score. After measuring and marking the scoring lines that will comprise the design, run a chisel stamp or a pointed tool along the*

tin over wood was the reflected light they gave off to help light the room. When mirrors or other reflectors, such as bits of glass, were added to the vertical panel of a sconce, the lighting potential increased. Sconces were usually plain L-shaped items, but could be embossed, scored, stamped, or painted. A boxed-in bottom caught drippings from the hand-dipped tallow candles used. More elaborate sconces were comprised of several cut shapes, but the beauty of a straightforward simple sconce design was that it required no soldering, being assembled with interlocking tabs. Sconces were still being used in the 1930s in rural northern New Mexico.

Tinsmiths also made portable candlesticks and lanterns (*faroles*). Less frequently produced were candeleros (candlesticks), candelabras, and arañas (chandeliers—*araña* meaning spider—although New Mexican chandeliers more often resembled a corona) for churches and ranch houses. Candlesticks were also added to the side panels of nichos and bottom corners of frames.

Old photographs show hand-held candlesticks placed around altars in small churches and moradas. They were decorated simply with stamped patterns. Lanterns were patterned like those of northern Europe and New England with cylindrical bodies and conical tops. A unique lantern type used by the Hermanos for processions featured numerous holes pierced throughout the body of the lantern to create complex patterns and swirls. A rare nineteenth-

scoring line using a straight edge. Do this on the reverse side of the tin so that the scoring shows as a raised line on the front side. Measuring correctly contributes to a jewel-like effect.

- *To stamp or emboss. Mark the design with a pencil, or if working along an edge, use the edge of the tin as a guide. Place the punch on the tin at right angles to its surface and strike the top of the stamping tool once with the mallet. Remove the stamp and continue until the design is completed.*

To create the tabs that will hold the mirror in place, cut four squares of tin, each one-half-inch by one-half-inch. Using a stiff straight edge, bend each piece lengthwise twice to form a lazy Z pattern. The mirror should be precut to the size of the frame's opening, plus a one-quarter- to one-half-inch overlap all around. It's best to simply cut the tin to suit the mirror, especially if the mirror is bought precut. Place the frame face down and the mirror on the frame's inside opening and make four equidistant marks on the back of the frame, flush with the mirror's edge. Remove the mirror and solder each tin tab in place.

Cut a sturdy piece of cardboard or matting to fit the mirror and to serve as a backing for it. For large mirrors needing more sturdy support, cut formica and tin for double backing, layering them as follows: mirror, formica, tin. To assemble the mirror and frame, place the frame face down on a surface. Bend back the four tabs carefully to allow the mirror and backing to slip past them face down over the opening. Bend the tabs back over the mirror and cardboard, securing them on all four sides. To make a hanging loop, cut a three-inch length of picture hanging wire and solder it in a C shape at one end of the mirror. Do not place it too close to the cardboard (to avoid it catching fire during soldering), or you may cover the cardboard with fireproof material. Using steel wool and glass cleaner, polish the frame and clean the mirror.

The procedure given here is a combination of the methods of Bonifacio Sandoval of Albuquerque and the late Robert Romero of Santa Fe. When teaching young students, Mr. Romero often used mylar paper instead of tin.

century lantern style used glass panels. This style was adopted and electrified by the Revival artisans of the twentieth century.

The least frequently produced nineteenth-century lighting forms were the candlesticks, candelabras, and chandeliers. As of 1990, there were one known surviving nineteenth-century candelabra, two known sets of candlesticks, and less than a dozen chandeliers. Arañas were used in churches, ranch houses, and dance halls, where they hung from a rope attached to the ceiling for raising and lowering. Chandeliers may have been fashioned after items brought from Mexico. Revival artisans created many examples of all three forms and added electrical fixtures.

CRUCES (CROSSES)

Cruces represent another very early tin form. While most were made to hang on a wall, tinsmiths also created freestanding crosses of which only two known examples have survived. They also created processional crosses attached to the tops of tall staves. Wall and freestanding crosses range in size from eight inches to almost three feet. Typical decorative elements included wallpaper or cloth strips under glass, oil-painted panels, mirrors, or painted glass. The ends of the horizontal arms might be crescent shaped and the intersection of the horizontal and vertical pieces might be covered with a rosette or other circular design. The space between the arms may have quarter-round brackets representing

rays, and even brace-like linkages. Crosses represent only five percent of the surviving nineteenth-century tin pieces.

BAULITOS (DOCUMENT OR TRINKET BOXES)

Also known as cajitas (small boxes), baulitos were rare in New Mexico until the twentieth century. Although its Spanish prototype was the reliquary, the New Mexico version was probably the only form not strictly for religious use. They were used instead to hold documents, jewelry, or other items. The standard structure was rectangular with a three-paneled hinged lid and a two-part hasp. The lid, along with the bottom panels, was decorated with wallpaper under glass, painted floral designs, and combed glass. Less than forty known boxes have survived.

MISCELLANEOUS ITEMS

Scholars believe that household goods made of tin, such as buckets and cups, have not survived because they were heavily used and then discarded. On the other hand, some items were decorative and lasted longer, such as flower holders, which were shaped like a sconce, but with a tube for the flower's stem rather than a candlestick; small frames for use as lockets; and vases made from coffeepots. Religious items included crowns for bultos; one surviving host box that once belonged to Padre Martínez; six-foot processional torches used during Holy Week and for funerals; and lanterns affixed to poles for processions. Tinsmiths applied tin as decorative hardware on furniture, although only one example remains.

TIN STYLES

The most recent and authoritative work on New Mexico tinwork is *New Mexican Tinwork 1840–1940*, by Lane Coulter and Maurice Dixon Jr., published in 1990. In preparing this definitive work, the authors studied over one thousand pieces of New Mexican and Mexican tinwork and identified thirteen separate and recognizable "workshops" and individuals, basing their categorizations on identical stamps, forms, and decorative details, materials used, and areas where most of a specific style were collected. They are:

- Santa Fe Federal Workshop
- Río Arriba Workshop
- José María Apodaca
- Taos Serrate Tinsmith
- Río Arriba Painted Workshop
- Mora Octagonal Workshop
- Río Abajo Workshop
- Valencia Red and Green Tinsmith

4.36
Tin cross with colcha embroidery by Emilio and Senaida Romero, 1988. Courtesy International Folk Art Foundation Collection at the Museum of International Folk Art, FA.1988.49.1. Photo by Michael Monteaux.

- Valencia Red and Green II Workshop
- Isleta Tinsmith
- Mesilla Combed Paint Tinsmith
- Fan Lunette Tinsmith
- H. V. Gonzales

The individual attributes of each workshop or area are discussed, with illustrations, in Coulter and Dixon's book. The authors propose that each style was developed by one or more tinsmiths working in a single workshop. Even so, some workshops developed several styles, possibly due to a change in one individual's style over a number of years, or by the presence of several tinsmiths whose designs and techniques influenced one another so that their work overlaps in styles and workmanship. In any event, the lack of collectors' records keep researchers today from identifying tinsmiths by name except in rare cases. Only one signed piece, a nicho by H. V. Gonzales, is extant.

Twentieth-Century Revival
The arts and crafts revival initiated through statewide vocational schools, together with the emerging interest among Eastern transplants to Santa Fe and Taos, contributed to a renewed flourishing of tinsmithing in the 1930s. The craft shops in Santa Fe operated by the Spanish Colonial Arts Society and by private individuals often employed an in-house tinsmith. There, visitors and residents alike bought framed mirrors, candelabras, sconces, and lamps made by such revival tinsmiths as Pedro Quintana, Francisco Sandoval, Francisco Delgado, Frank García and Eddie Delgado. In Taos, Max Luna taught tinsmithing at the state-operated vocational school where he was also director. It is interesting to note that Mr. Luna came from a family of gold-filigree makers and silversmiths. Carmen Espinosa also worked on the State Department of Vocational Education staff, and in 1937 produced a Blue Book entitled *New Mexico Tin Craft*. Published by the SDVE, the book featured drawings of twenty-five tin forms based on nineteenth-century examples.

Tinworking was no longer pursued for devotional purposes. The tourist and the collector were the main customers of this new generation of tinsmiths.

4.37
Master tinsmith Robert Romero surrounded by his work at Spanish Market. Photographer unknown.

Frames were no longer used to display religious images, but rather mirrors. The law of supply and demand gave rise to new tin forms including electric lamps, flowerpots, tissue holders, and ashtrays. In the late twentieth century, the list expanded to include knickknack shelves, business-card holders, hand mirrors, edging on wooden wall shelves, hanging electric lamps, Christmas tree ornaments, and design elements on bultos and furniture. Religious forms continue to be created in the late twentieth century. Tinsmith Robert Romero's extraordinary work continued to receive recognition at Spanish Markets until his death in 1998. His parents, Emilio and Senaida Romero, received the National Endowment for the Arts' National Heritage Award for their innovative combination of colcha embroidery and tinwork. The exquisitely crafted result is a large tin cross featuring floral colcha designs under glass panels.

A Brief History of Spanish and Colonial Guilds

Guilds are associations of tradesmen formed to maintain standards and protect the interests of its members. Formal guilds began in the late Middle Ages in Europe, but the Moors of northern Africa also had guilds. The Moors instituted the designations of master (maestro), journeyman (oficial), and apprentice (aprendiz) to describe the levels of skill. Spanish guilds were highly organized to carefully regulate the lives and work of its members. Guilds maintained high standards through regulations that governed examinations, prices, work hours, and the distribution of materials. Guilds assessed penalties for substandard work, and assured that the techniques of their crafts were kept within the membership. They also functioned as social and charitable institutions, holding regular meetings,

participating in religious services through a separate confraternity (St. Eloy was the ironworkers' patron saint), providing pensions and burials for its members, and aid to their families. Guild members marched together in war under their own flag.

General blacksmiths, farriers, gunsmiths, cutlers, locksmiths, swordsmiths, and nailmakers all had their own guilds. In Mexico, similar guilds for blacksmiths, farriers, armorers, and other ironworkers were established. While New Mexico had no guild system, there is one documented instance of a Santa Fe man apprenticing his son to a blacksmith for five years. Mexican guilds declined in late eighteenth century but the offices of master, journeyman, and apprentice are still recognized in some traditional Mexican shops today.

The tinplate used in the nineteenth century was largely replaced in the twentieth century with terneplate, a lead-tin alloy. Tinplate was sheet iron coated with a thick layer of pure tin. Terneplate's darker color probably resembled the oxidized nineteenth-century tinplate and was preferred for restoration projects of the 1930s and 1940s. In the late twentieth century, containers of imported foodstuffs such as olive oil provide tinplate to some New Mexico tinsmiths, who prefer real tinplate to terneplate.

Because of their proximity to other tinsmiths' works in shops and schools, Revival tinsmiths of the 1930s became more generalized and flexible in style. By contrast, in the geographically separated nineteenth-century workshops, a tinsmith could go a long time without seeing the work of other tinsmiths. Still, certain tinsmiths of the first half of the twentieth century revealed distinctive and recognizable styles, including Francisco Sandoval, Francisco Delgado, and Eddie Delgado. Revival tinsmiths created a new hybrid of nineteenth-century New Mexican tinwork and the more florid

and finely crafted Mexican tinwork, which had always been an influence in New Mexico, particularly its complex decorative images, fine craftsmanship, and metalworking techniques. For example, both Mexican and New Mexican tinsmiths drew from the same design sources and used virtually identical metalworking techniques for creating frames.

Ironwork

Ironworking was unknown in the Americas prior to the arrival of Europeans. The Spanish set up forges wherever they settled in order to create the tools and hardware needed to build churches, towns, and ships, and to pursue farming, mining, carpentry, and more. There were several types of smiths working throughout the Spanish Colonial world, including the:

- *Herrero* (blacksmith), who made and repaired a variety of fixtures and tools

- *Herrador* (farrier), who shod horses and served as veterinarians
- *Armero* (armorer and gunsmith), who made and repaired arms and armor
- *Cerrajero* (locksmith)
- *Espadero* (swordsmith), who made and repaired steel swords and daggers (steel was made by carburizing iron)
- *Cuchillero* (cutler), who made and repaired knives for domestic use

The New World was rich with deposits of iron ore, but colonists were not inclined to mine and process it because the Crown required that all iron be imported from Vizcaya in Spain, where an old and powerful ironworks industry flourished, and because colonial investments were focused on the mining and processing of silver and gold.

Smiths worked diligently to create weapons, armor, kitchen tools, home fixtures, locks, door bolts, carpentry tools, mining tools, horseshoes and nails, and wagon fittings. The missionaries required all these plus decorative items for the mission churches, including grilles, crosses, and elaborate altar screens. However, these latter wrought-iron pieces seldom reached the northern borderlands; they were more prevalent south of the Río Grande.

Only a relatively small number of colonial items have survived because iron corrodes or rusts if it is exposed to dampness and air without benefit of oil or paint. Salts and water will damage iron that is buried in soil; thus pieces uncovered by archaeologists are often misshapen. Also, colonial blacksmiths did not mark or date their work, so scholars must use other factors to determine their origin and date.

Ironwork in Spain

The ironwork of medieval Spain combined European and Moorish decorative styles. Its European components featured Romanesque, French Gothic, and, after 1550, Renaissance styles. The direct and massive hammerwork of the European smith was softened by the delicate, pervasive North African decorations developed by the Moors. Because the Moors disliked empty space, their decorative intent was to cover an entire surface. The resulting hybrid style is called Mudéjar (a term also applied to Christianized Moors). In addition, the Spanish adopted the decorative window grille from the Moors, who developed it to protect their women. During the sixteenth century, Spanish smiths created thousands of grilles, exporting a number of them to the Americas where smiths subsequently created more to fill the demand throughout Spanish America. Other Moorish ironworks to reach the Americas were inventive doorknockers and ornamental nail heads found in profusion on Spanish chests and doors.

Another Spanish-Moorish collaboration gave rise to a golden age of ironworking in Spain in the sixteenth century. The Catalan forge produced three times the amount of iron using less fuel than the older furnaces and as such contributed greatly to the rapid expansion of the wrought iron industry in Spain. By 1550, three hundred ironworks were in operation in Vizcaya, a mountainous Basque province near the Pyrenees, which provided iron ore. By the seventeenth century, wars and governmental mismanagement resulted in the end of the ironworking industry, which caused a concurrent shortage of bulk iron in Latin America.

Ironwork in Colonial Mexico

At least three smiths arrived with Cortés in Mexico. Their first job was to forge an iron scale and weights with which to weigh the gold and silver presented by the Aztecs. As more Spanish arrived and began to settle in, demand arose for *picaportes* (latches), *vizagras* (hinges), *chapas* (locks) and *llaves* (keys), *trancas* (hasp and hook locks), *clavas* (nails), *cucharas* (spoons), *comales* (tortilla griddles), *tenamastes* (trivets), *asadores* (pokers), *tenazas de ascua* (ember tongs), *chispas* (fire steels, used to spark fires), candeleros (candlesticks), *tijeras* (scissors), *agujas* (needles), *dedales* (thimbles) and *hebillas* (buckles). Farmers needed *cavadores* (hoes), *rastras* (rakes), *hoces* (sickles), *guadañas* (scythes), *arados* (plows), *machetes, puntas de buey* (ox goads), *fierros* (branding irons), *cadenas* (chains), and *balanzas* (scales). Horsemen needed *frenos* (iron bits), *espuelas* (spurs), *estribos* (stirrups) and *herraduras* (horseshoes). The military needed *lanzas* (lances), herraduras (horseshoes), *clavas de herrar* (horseshoe nails), *mosquetes* (muskets) and *armadura* (armor).

Coachmen needed wagon parts and harness hardware. Miners, carpenters, and masons needed specialized tools. Churches needed building hardware, decorative grilles and altar screens, *hostiarios* (wafer presses), and *aspersorios de agua bendita* (*aspergillums*, an instrument for sprinkling holy water).

Despite these never-ending demands, the blacksmiths were plagued from the outset with a chronic shortage of iron, which arrived from Spain in bars or sheets. By decree, Spain was the only source of this raw material. The importation of such items as locks, hammers, hoes, plow points, axes, cutlery, and firearms was not enough to relieve the demand. As with silver and gold, the Church was the largest consumer of iron products, principally for building and interior designs.

In northern Mexico, iron was in even shorter supply than central Mexico due to high overland shipping costs. There were many rich deposits of iron ore discovered in northern Mexico, yet iron tools were so scarce and expensive that the silver mine at Zacatecas almost closed down for lack of such tools (Simmons and Turley 1980). To make matters worse, war between Spain and England from 1779 to 1784 cut off all iron shipments during those years.

When iron was not available, Mexican colonists used wood as a substitute, such items as pegs, bolts, latches, and grilles made of bars of mesquite or cedar. The practice of substituting wood reached New Mexico, where iron was extremely expensive due to the vast distance covered on the Chihuahua Trail leading to Santa Fe.

Ironwork in Colonial New Mexico

Although the records do not specify the presence of blacksmiths traveling with Coronado in 1540, historians assume there was at least a farrier, armorer, and gunsmith. Farriers were especially important because horses needed iron shoes to negotiate the often-rough terrain of the frontier. Reports by the Castaño de Sosa expedition to Texas in 1590 indicate the conquistadores' horses could go through a set of

4.38

Indian blacksmith shop at Zuni Pueblo, 1853. Drawing by R. H. Kern. Courtesy Museum of New Mexico, neg. #38177.

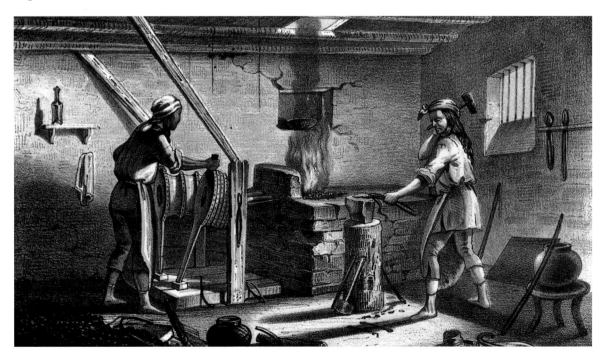

shoes in as little as two to three days (Simmons and Turley 1980). Without horseshoes, the animals went lame, leaving the riders on foot. Hence, in 1598, Oñate brought 5,256 horseshoes and 141,338 nails to New Mexico, as well as 30 hundredweight of iron in bars and sheets, 55 pounds of steel, and a large assortment of smithing equipment (Simmons and Turley 1980). Some of his fellow settlers carried farriers' tools, bellows, gunsmithing tools, and tools for repairing mining equipment and nail making. A blacksmith arrived in 1600, along with more equipment and materials.

While records show that the settlers made what they needed, rather than import manufactured items, they initially brought iron items with them, including *rejas de arado* (plowshares), *piquetas* (pickaxes), hoes, sickles, *hachas* (axes), goads, *desjarretaderas* (hocking knives), branding irons, sets of chains with iron collars for prisoners, *martillos* (hammers), *mazos* (mallets), *cuñas* (wedges), *barrenas* (augers), *cinceles* (chisels), *sierras* (saws), hinges, *pernos* (pintles), latches, tortilla griddles, trivets, iron spoons, *sartenes* (skillets), culinary knives, scissors, fork rests for harquebuses, candle snuffing scissors, and *cucharones* (iron ladles). The Spanish also brought items specifically for trading with both Pueblo and nomadic Indians, including *alesnas* (awls), thimbles, *agujas* (needles), *campanitas de halcón* (hawk's bells), and *medallones* (medallions). The iron and steel trade among Indians throughout the West was initiated from both South and East, beginning with the Spanish and the French.

Upon settling in, the missionary friars immediately began teaching ironworking to the Pueblo Indians, as well as carpentry and masonry. Items that have been unearthed at mission sites by twentieth-century archaeologists include plowshare points, hinges, *apagavelas* (candle snuffers), horse and mule bits, *caro de cincho* (cinch rings), and ember tongs. Because missionary work took precedence over all other frontier pursuits in seventeenth-century New Mexico, much of the bar iron that arrived was claimed for the missions' use. Not to be ignored, the colonists complained to the authorities. One letter to the viceroy was sent after Father Estevan de Perea had claimed much of the 1628 iron shipment:

> Iron tools for cultivating and plowing are needed . . . and in particular iron for horseshoes, for without it, it is not possible to make any punitive expeditions as the enemy lives in rough mountainous country and on stony mesas . . . Consequently we are perishing, without a pound of iron or a plow. (Simmons and Turley 1980)

The government in Santa Fe set up an armory there in the seventeenth century. Unfortunately, some governors sold as many iron tools and weapons as they could gather to the ever-expanding Indian market, principally at the yearly frontier fairs. This caused more

Spanish Horsemanship in New Mexico

Colonists introduced two styles of Spanish horsemanship into New Mexico. Traditional European saddles, bits, stirrups, and spurs are associated with knighthood and the crusaders of the late Middle Ages. Known as a la brida, this style favored a heavy saddle, complete or partial armor, much horse armor, and long stirrups. By 1598, the a la brida style was going out of fashion, but Oñate still brought one set to New Mexico for special occasions such as parades.

The other style, known as a la jineta, was adopted from the Moors, who used a lighter saddle, a high pommel and cantle, short triangular stirrups, and minimal armor. While both styles could be highly decorative, the a la jineta saddles were used by Oñate's men as work or war saddles. As such, they outnumbered the a la brida gear by three to one in seventeenth-century New Mexico.

shortages for the struggling colonists, and was especially unfortunate in that the governors were doing this for personal gain.

When the Spanish returned to New Mexico after the reconquest, they found that the Indians had continued blacksmithing in their absence. Some had gathered iron bell clappers to make lance points and knives, and the residents of Sandía Pueblo had organized a blacksmith shop with a forge, bellows and a plowshare serving as an anvil (Simmons and Turley 1980). At this point (after the reconquest), the viceroyalty determined that colonists' needs took precedence over those of the missionaries. As both the Spanish population and commerce grew, more smithing shops opened, despite the chronic iron shortage. Blacksmiths reworked every scrap of available iron, and made tools and hardware that were unusually small in size.

The colonial practice of substituting wood for iron is evidenced today in the form of decorative elements unique to New Mexico design, including wooden window grilles, spindles of wood set in frames to imitate iron railings in church interiors, and wooden crosses. Colonists also devised other substitutions such as wooden *cucharones* (dippers), *guajes* and *jicaritas* (gourds), rawhide lashings for roof joinings, rawhide *baldes* (buckets), *coladores* (strainers), *cedazos* (sieves) and *embudos* (funnels).

Leather and buckskin *cotas* (coats) and *adargas* (shields) replaced metal armor. Friars also painted pictures of iron fixtures directly on church walls, such as the fleur-de-lis found at the ruins of Guisewa Mission.

As in Mexico, if there was decorative iron to be had, it was most likely in a Church. The eighteenth-century church at Las Trampas, New Mexico, has several iron crosses that are unique in construction among all northern provincial crosses. In addition, they are topped with a stamped ornament that is a silhouette of the Hapsburg two-headed eagle.

The best-known blacksmith family of New Mexico was that begun with Bernardino de Sena of Mexico, who arrived in New Mexico in 1693 and grew wealthy from his blacksmithing trade. His son Tomás (d. 1781) was a smith for fifty years. Several of his seven sons became smiths, including Manuel Sena who operated the shop during the early nineteenth century. The Senas were armeros (gunsmiths and armorers) as well as herreros (blacksmiths). Records show that over twenty-four herreros were active in New Mexico by 1821, and that ironworking was more active in New Mexico than any other northern frontier province, particularly after the Santa Fe Trail opened and more bar iron was imported. Bear grease was used to protect the iron from water and corrosion.

4.39
Spanish colonial replicas forged by blacksmith/scholar Frank Turley for the National Park Service, including 2 hocking knives (Y and T shaped tips), 1 sickle, 1 cinch ring (buckle), 1 cruciform stirrup (top center), 1 pair scissors, 1 buffalo lance point (far right), 1 adze (lower left), 1 ox goad (directly below sickle), 1 spur, 2 fire steels, and 1 dagger. Courtesy Frank Turley, Forge Blacksmithing School, Santa Fe, New Mexico. Photo by Joan Neary.

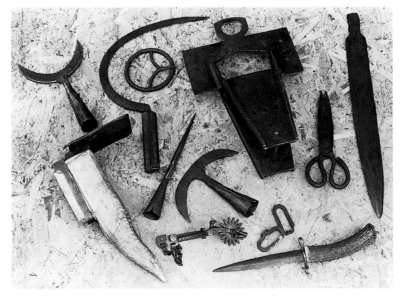

In the nineteenth century, trade with the East, beginning with the opening of the Santa Fe Trail, brought the tools and techniques of the American blacksmith, which gradually replaced the traditional Spanish tools and techniques. Curiously, the last Spanish ironworking holdouts were in the outlying Indian communities. By the turn of the twentieth century, Spanish ironworking was no longer conducted in New Mexico.

Silverwork

The American colonial surface, whether it is of silver or adobe or clapboard or walnut or mahogany, can be called a strong surface, in the sense that the entire shell of the container or the instrument is generously measured out from the marvelous abundance of raw material in America. If the notion of a strong surface is difficult to imagine, please think of a poorly made flaking veneer or buckling plywood surface, and you have a weak surface. The strong surface is integral and no cleavages weaken its inner structure.

It is a real difference between mother country and colony that weak surfaces were actively sought after in Europe. Veneering, for instance, was new in 1664, but its American use remained unnecessary until long after. There is little marquetry in rural America. Sheffield plate, made by fusing silver on copper, was invented in England in 1742, but the American use of fusion did not appear until much later. The point is that material scarcities in Europe enforce the technical achievement of weak surfaces, whereas the abundance in America made weak surfaces less necessary.

—*George Kubler,*
Time's Reflection and Colonial Art

Silver in the New World

Pre-Columbian metalworking is thought to have originated in Ecuador or Peru where there was an abundance of precious metals, including silver. Native metalsmiths were highly inventive. Their work, including small silver animals with moving parts, delighted the Spanish explorers.

The Spanish viewed silver strikes, such as the ones at Potosí in 1545 and at Zacatecas in 1546, as God's reward for their having brought Christianity to the Indians. The overwhelming amount of silver mined in the New World brought much wealth to Spain as additional strikes occurred at Taxco and Guanajuato.

By far the richest silver mine in the New World was at Cerro de Potosí in northern Peru (now Bolivia). At its height of production, there were over three thousand entrances into this single hill (*cerro*). It was also one of the most tragic sites in the New World, as hundreds of slaves lost their lives mining the silver of Potosí. In the meantime, the town of Potosí grew rapidly, to about 140,000 by 1571. A mint was built there in 1572 for the purpose of collecting the Crown's fifth share (*quinto*). Throughout the rest of Peru, over two hundred mines were in full operation by the eighteenth century. The richness of the Peruvian highland mines can be grasped by the fact that some chunks of pure silver weighed nearly four hundred pounds. Potosí's silversmith guild was one of the richest in the hemisphere. *Plateros* (silversmiths) in Cuzco, Lima, and Ayacucho also produced masterpieces for church and home.

Throughout the Spanish colonial period, visitors commented repeatedly on the solid weight and high quality of silver items, particularly those of the Church, which tended to baroque and rococo styles even into the late eighteenth century when the less ornate Neoclassical designs prevailed in Europe. Spanish colonial churches were furnished with breathtaking, ornate silver masterpieces in order to visibly illustrate the glory of God and thus promote native proselytization. European travelers commented repeatedly on the abundance of silver, diamonds, and gold in both homes and churches. Even "commoners" could afford silver. One visitor wrote,

A hat-band of pearls is ordinary in a tradesman. Nay, a blackamoor or tawny young maid and a slave will make hard shift, but she will be in fashion with her necklace chain and bracelets of pearls, and her ear-bobs of some considerable jewels. (Gage 1958)

The first Spanish plateros arrived in the New

World in 1495. Their activities were closely regulated by the Crown, which was ever vigilant in collecting its share and guarding against theft. Consequently, silversmiths were not allowed to operate smelting or refining equipment, and for a while, presumably as an experiment, all silverwork was done in Spain alone. This proved to be impractical, so in an effort to maintain an industry in Mexico and to facilitate inspection, the viceroy established the Calle (Road) de los Plateros in Mexico City where the plateros lived and worked. Visitors and buyers found here the *platero de plata* (silversmith), *platero de oro* (goldsmith), the *batihoja* (goldbeater), and *tiador de oro* (wiredrawer for filigree). The Calle de los Plateros is known today as Avenida Francisco Madero.

Silversmithing in colonial times was an important position, and was referred to as a "noble art." Because of the materials worked, plateros were wealthy. The guilds sponsored elaborate festivals and bullfights, and established pensions for aged or disabled members. In addition to the guild, some plateros could join a cofradía, an exclusive organization for men within the Catholic Church. Those lucky or influential enough to be inducted into a cofradía got special commissions from the Church, as well as important positions within the lay hierarchy. At the other end of the spectrum were the Indian plateros, who were relegated to assistant positions in workshops and who were prohibited from joining guilds.

Silver works made in Mexico City and in other areas were stamped with various hallmarks indicating the maker, the assayer, location, and taxation. The assayer assured that quality standards were met by scratching a portion, usually a zigzag line (called a *burilada*), from the item. Sometimes the burilada was missing, especially if the item were made outside of Mexico City.

Silver in Colonial New Mexico

The men and women of Oñate's settlement party packed silver items for personal use, including table services, jewelry, and hair ornaments. They carried silver daggers, swords, and equestrian equipment decorated with silver. After Oñate's men failed to find silver deposits in New Mexico, subsequent settlers continued to import silver items from Mexico. Not until the nineteenth century, when the first silver mine began operations in 1867, was much activity to occur in the area of natural resource extraction.

Personal wills of New Mexico colonial residents listed silver jewelry, table services, candeleros (candlesticks), candle snuffers, *bandejas* (trays), *cántaros* (pitchers), *picheles de plata* (mugs), *palanganas* (basins), armazones (frames), covered cups, *tabaquerías* (tobacco keepers), *braseros* (braziers; passed at table for guests to light cigars and cigarettes), and medicine cups. Equestrian items included silver *bridas* (bridles), stirrups and spurs, and silver-decorated *arneses* (harnesses) and sillas de montar (saddles). Items listed in New Mexico church inven-

4.40

Silver *tabaqueras* (tobacco boxes) from Mexico, late eighteenth and early nineteenth centuries. Courtesy Fred Harvey Collection at the Museum of International Folk Art, FA.79.64.12, 13 and 14. Photo by Cradoc Bagshaw.

4.41
Colonial silverware owned by New Mexicans,
ca. 1810. Courtesy Museum of International Folk
Art, A.5.56.31/33. Photo by Paul Smutko.

tories include silver *cálices* (chalices), *custodias*
(monstrances), *relicarios* (reliquaries), *ampolletas*
(cruets), *patenas* (patens), candleholders, and
frascos pequeños (vials). When Fray Alonso de
Benavides visited New Mexico in 1626, he brought
supplies for the missions, including eleven silver
chalices and patens. Later, Diego de Vargas's will
listed quite a bit of silver, including a twelve-pound
tray, all of which he instructed his executor to sell
upon his death.

According to scholars, there is no documentation
proving that any given silver item found in today's
museum collections was actually made in New
Mexico. What evidence there is points to little or no
manufacture in colonial New Mexico and some
manufacture in nineteenth-century New Mexico.
While a platero is known to have lived in Santa Fe
around 1639, by 1776, Father Olaeta of Taos found it
necessary to send his melted-down silver to Chi-

huahua to be reworked into altar items (Domínguez
1975). Part of the identification problem is that items
thought to have been made in New Mexico are very
similar in style to Mexican items, though simpler
and more utilitarian in design—two elements that
are often the only hint. Also, lack of local materials
and resources kept the art from being fully devel-
oped in New Mexico until the nineteenth century
when materials trade opened up. Scholars believe
that many pieces were made by visiting Mexican
plateros.

Silver in Nineteenth-Century New Mexico

In the 1830s, two Spanish blacksmiths, Ramón
Sena of Santa Fe and José Castillo of Cebolleta,
taught forgework and silverworking to some
Navajo acquaintances. New Mexico blacksmiths
often served as workers of fine metals like silver
and gold. Castillo may be the "Cassillo" men-
tioned by Navajo silversmith Atsidi Sani (meaning
the Old Smith) who was said to have learned to
work silver from a blacksmith and silversmith
named "Cassillo" in the 1850s. Other plateros
taught their craft to Navajo apprentices in the
1850s and 1860s (Wroth 1977).

In the nineteenth century, the people of Isleta
and Laguna Pueblos, who had close ties to their
Spanish neighbors, made coral and silver-beaded
necklaces (derived from rosaries) with silver crosses
interspersed, as did the Acoma Indians. The Pueblo
Indians most likely had learned to make these items
in previous centuries. By the late nineteenth cen-
tury, both Spanish and Indian plateros were using
Mexican coins for their raw materials. Some Indian
jewelry designs of the nineteenth century are trace-
able to Mexican designs (Wroth 1977). It is likely
that Mexican blacksmiths, rather than plateros, were
the ones to stamp, engrave, cast, and repoussé silver
to make ornaments for equestrian clothing and gear.
This Hispanic tradition is evident in Navajo bridles,
large conchas, buttons, buckles, bowguards, and
heavy bracelets.

In the early nineteenth century, visitors com-
mented on the abundance of silver items in the
Spanish New Mexican homes they visited, mostly
of well-to-do merchants and hidalgos. There
is evidence that at least three plateros worked in

New Mexico in the first two decades of the nineteenth century (Boylan 1974). One Santa Fe resident was Antonio José Ortiz, whose 1806 will listed 132 silver items, including plates, platters, place settings of utensils, table knives, serving spoons, a carving knife, a cruet, a tureen, a salt saucer, candleholders, and decanter cases. When his wife died about ten years later, the list had grown. Lieutenant J. W. Abert (1848) wrote, "All the hildagos [sic] pride themselves on allowing nothing but silver to approach their tables; even the plates are of silver."

Little or no *documented* New Mexican examples of silver have survived to the present. Scholars suggest that family silver was probably sold for ready cash as New Mexico changed from the old colonial barter economy to the new American cash economy with its array of new products from the East. Cultural differences may also have played a part in that Anglo-American preferences in personal attire may have gradually influenced New Mexicans to wear less jewelry and more conservative riding gear. Also, as few locally made items had ever been stamped with hallmarks at the time of manufacture, it has been difficult for researchers to identify the origin of some pieces. It is likely, then, that some Spanish-made pieces have been inadvertently attributed to Navajo silversmiths. Spanish-made jewelry was traded in quantity to the Navajos, yet records were not kept. Later, as Anglo-Americans began documenting silverwork in New Mexico, they concentrated only on Indian work.

Observers often assumed that the more "crude" pieces originated in New Mexico, and were surprised if something showed a little refinement, as in this entry by Josiah Gregg:

> Gold and silversmiths are perhaps better skilled in their respective trades than any other class of artisans whatever . . . Some mechanics of this class have produced such singular specimens of ingenious workmanship, that upon examining them we are almost unwilling to believe that rude art could accomplish so much. Even a bridle-bit or a pair of spurs it would no doubt puzzle the 'cutest' Yankee to fashion after a Mexican model—such as I have

seen manufactured by the commonest blacksmiths of the country. (Gregg 1954)

Lt. W. H. Emory wrote, "The plates, forks, and spoons were of solid New Mexican silver, clumsily worked in the country" (Emory 1951). He may have been reacting to the size of local pieces as well as their workmanship. Because of the abundance of silver in the New World, Mexican silver pieces were heavier than European-made pieces. Also, plateros in remote areas were often unskilled workers using fewer and sometimes inferior tools, as revealed by the visible tool marks, asymmetrical shapes, and lack of finishes or decorations. In the provinces, functionalism was more important than baroque excess. These blacksmiths or plateros, being removed from the center of activity in Mexico City, were less familiar with the original forms, so they overcompensated as they shaped their pieces. The objects were heavier and more strongly articulated than necessary, and carried some influence of local traditions (Boylan 1974). Also, the further one got from the assayers of Mexico City, the less likely one was to find a stamp on a piece of silverwork.

There are several silver collections in New Mexico museums today. The Mary Lester Field Collection consists of ninety-four pieces and is the most important collection for New Mexico study because it was gathered in New Mexico in the nineteenth century by the wife of an Albuquerque attorney. Unfortunately, as she was primarily interested in gathering a table service, she did not record her acquisitions. As such, no information on sources is available.

Gold Jewelry/Filigree

Filigree has been called "metal lace" because it is made of fine metal wires curved into delicate scrolls and arabesques to create an airy, lacy look. The wires are made by pressing gold or silver (and sometimes brass or copper) through a metal plate to produce fine strands which are then curled, twisted, crimped, and braided to form floral or geometric designs soldered onto a framework of flat wire. Small grains of metal, called *guachaporo* beads, are added to the overall design at junctures or intervals

to accent the work. Flat or round gold or silver chains and cords are also part of the art of the platero (jeweler), who uses filigree in neck-laces, earrings, bracelets, brooches, rings, and combs. The term *platero* encompasses jewelers who work filigree, whether gold or silver, despite the origin of the word (*plata* means silver).

Filigree originated over four thousand years ago when soldering was developed. The Phoenicians introduced filigree to Spain roughly three thousand years ago during the Bronze Age. It was further developed through the ages by the early Greeks and Etruscans, the Egyptians, the East Indians, the tenth- and eleventh-century Irish, the Moors of Spain, medieval Europeans, and the Mixtec and Aztec peoples of Mexico (Kubler 1984). Peruvians and Mexicans furthered the development in Spanish colonial times. In fact, the Peruvian Indians' plateresque filigree was called "true silver lace" by those who admired its lighter, more elegant designs.

In New Mexico, filigree jewelry was not the only kind of jewelry New Mexican women wore, but it was consistently popular from the eighteenth century through the early twentieth century. Today, filigree is still popular in Italy, the Middle East, Spain, and Central America. In Europe and the United States, interest in filigree waned after World War I. The earliest filigree pieces known to have existed in New Mexico were recorded in wills dating from around 1720. Eighteenth-century filigree is also recorded in church documentation of votive offerings, particularly to statues of the Virgin Mary. Interestingly, the majority of jewelry handed down within New Mexico families has been gold, not silver. Wills list the following types of jewelry:

- *aretes* and *zarcillos*, eardrop earrings;
- *arracadas*, earrings with a pendant;
- *coquetas*, long dangling jeweled earrings;
- *pendientes*, eardrops of any style;
- *bejucos*, rounded braided chains with a fish pendant attached to the chain (also known in Peru & India);
- *cordones* or cords, flat or rounded braided chains (without fish pendant);
- *soguillas*, flat braided chains with slides of filigree (a slide is a jewelry device that holds two strands together, but that can be slid up and down to shorten the loop around the neck; the slide is a major component of a bolo tie);

4.42
Gold filigree *pendiente* (pendant), late-nineteenth and early twentieth century, Santa Fe. Courtesy Fred Harvey Collection of the International Folk Art Foundation Collection at the Museum of International Folk Art, FA.79.64.70. Photo by Cradoc Bagshaw.

4.43
Filigree *gargantilla* (necklace) of 20 carat gold with imitation stones, mid-nineteenth century New Mexico. Courtesy Museum of New Mexico Collection at the Museum of International Folk Art, A.8.57.5. Photo by Blair Clark.

- *gargantón* or *gargantilla*, a flat necklace with a floral brooch sometimes decorated with red or green stones;
- *tumbaga*, a wide, heavy gold circlet with raised leaves in various hues of gold, set with stones or embossed leaves;
- *memoria*, a ring in four sections, each part fitting together as one, with intersecting leaves of different hues of gold surrounding a stone of low-grade garnets or rubies.

Colonial women also favored hair combs and the *tembladea*, a silver hairpin tipped with a filigree flower at the end of a spiral. With each movement of the head, the flower trembled and glittered. Gold guachaporo beads in the center of the flower added to the delicate effect.

After 1565, when trade with the Philippines began, Mexican plateros had ivories, coral, diamonds, garnets, carnelians, and emeralds to work into their pieces. Emeralds came also from mines in South America. Glass jewelry had also been introduced to Mexico. Used originally for trade, glass beads were made in Puebla, but also imported from Europe and China. They reached many parts of the New World including New Mexico, where they were an important part of personal dressing throughout colonial times.

In eighteenth- and nineteenth-century New Mexico, a well-to-do bridegroom was expected to provide his wife's trousseau, including jewelry. The trousseau would traditionally include a gargantilla, earrings, bracelets, brooches, rings, and a rosary, all done in gold filigree. Fortunately, itinerant plateros were usually available to live with a family long enough to create the trousseau of gold and gems.

Gold camps flourished in New Mexico from the 1860s through the turn of the century. As a result, a local filigree industry also flourished, coinciding with the passion for Mexican silver and gold filigree developed by Eugénie, the wife of Napoleon III of France. She single-handedly brought filigree into fashion, and inspired its production on both sides of the Atlantic (Boyd 1974). During this time, New Mexico filigree was made with the twenty-carat gold mined locally, together with glass or low-grade gems. Josiah Gregg, who had described filigree and

silver plate activity in the 1830s, mentioned that New Mexicans were all "passionately fond of jewelry" and wore too much of it at one time, in his opinion (Gregg 1970).

After 1880, the railroads imported jewelry fashions from the eastern seaboard, providing New Mexican women with alternatives to filigree. Demand dropped. While New Mexico's golden age of filigree seemed over, there were still a number of filigree workers making a living into the mid-twentieth century. The earliest known plateros in New Mexico were Rafael Luna of Taos, his son Antonio José, and his daughter Hilaria (the only woman mentioned in any of the sources), who flourished in the first half of the nineteenth century. Four generations of Lunas passed on the craft through the late 1960s. In Las Vegas, Teodoro Lucero (related to the Lunas) and his nephew, Miguel González, made filigree, as did Juan Antonio Espinosa of Wagon Mound. Espinosa lived to be over one hundred. In southern Colorado, the Luján family, the Mondragón family, and J. Nestor Ortiz of Los Pinos were filigree craftsmen.

Santa Fe platero Adolfo Ortiz continued making filigree into the 1960s, having learned the craft from his father, Francisco Ortiz. They both learned it by working in a mercantile store in Santa Fe around the turn of the century. During the filigree boom of the 1860s and 1870s, several Santa Fe merchants hired plateros to demonstrate making filigree jewelry in their stores. One storekeeper employed ten workers, while another actually brought six craftsmen from Naples, Italy, to work full time at filigree work (Boyd 1974). The Italians made items inspired by Italian, French, and New York styles. Business was brisk because visitors to New Mexico and Colorado bought filigree as souvenirs. By contrast, anyone seeking out Navajo silverwork had to go out of their way to search for it. This situation reversed after World War II when filigree faded in popularity and Indian-made silver jewelry came into its own.

Straw Appliqué

Just as tin was the poor man's silver, straw was the poor man's gold, and in the right light, the straw shone like gold against the black pitch background

4.44
Arturo Ortega examining a display of straw appliqué work at the Museum of International Folk Art in 1986. Mr. Ortega, an Albuquerque attorney, co-founded the Hispanic Culture Foundation in the 1980s to preserve and promote the traditional arts of Hispanic New Mexico. He was also an active supporter of La Compañía de Teatro de Alburquerque. Photo by Miguel Gandert.

on which it was painstakingly placed. Early artisans worked only geometric designs. Twentieth-century artisans explored and mastered representational images, covering the surfaces of crosses, boxes, sconces, and furniture with small pastoral or religious scenes, as well as combinations of floral and abstract patterns.

The New Mexican craft of applying small bits of precisely cut oat or wheat straw to a surface draws its inspiration from marquetry, a method of covering a surface with small, thin pieces of materials of different colors, which was widely developed in ancient Greece, Rome, and Egypt. From Egypt it spread west to Spain during the Roman period. Marquetry was popular in Europe throughout the Middle Ages, particularly in Italy where both abstract and representational marquetry was created. Materials may be metals, woods, shell, ivory, and others. Traditional marquetry artisans use inlay and veneer to set the materials in place. The straw appliqué work of nineteenth-century New Mexico was neither inlay nor veneer, however, but a combination of the two in that only portions of the surface are covered with straw, as in inlay work, and the pieces lie only on the surface, as in veneer. By contrast, in inlay work, the pieces are placed in a shallow indentation on the surface.

The terms *inlay* and *appliqué*, according to straw artisan and researcher Jimmy E. Trujillo of Albuquerque, are misnomers arising from the observation of indentations left behind on the resin when straw was lifted from colonial pieces. Early scholars assumed these indentations meant the straw had been inlaid. After studying colonial and contemporary pieces at the Museum of International Folk Art, Trujillo determined that the indentations were actually from the straw being imbedded in the *trementina* (pine rosin used by colonial artisans), which served as both a glue and a varnish. The term "encrusted straw" should have been used from the very beginning, according to Trujillo, to reflect the fact that the straw is *surrounded* by pine rosin. Trujillo has worked on this issue with santero Charles Carrillo and at the Museum of International Folk Art in Santa Fe since 1984.

In Spain, marquetry was introduced by the Moors. Known as *ataracea*, it flourished in southern Spain, where the Moorish influence was strongest. The Moors created intricate geometric designs of inlaid enamel, ivory, multicolored woods, and gems. They favored chevron and star patterns, which would later reappear in New Mexico work. A second major influence on New Mexico straw appliqué came from Oriental artisans, who created straw designs on wood and cardboard, examples of which were imported into Mexico in the early nineteenth century. Nineteenth-century New Mexican artisans were

attracted to the Oriental use of straw, and the Moors' geometric designs.

In Mexico, European marquetry techniques continued, with the addition of feather and shell mosaics, which were elements of pre-Columbian Aztec design. Geometric designs dominated the marquetry work on furniture of sixteenth- and seventeenth-century Mexico. A third major influence on New Mexico artisans included alternative materials such as satinwood, a light-colored wood often displayed against dark ebony or mahogany backgrounds, less expensive woods, cornhusks, and straw. All of these materials began appearing in Mexican marquetry of the late eighteenth and early nineteenth centuries, precisely when straw appliqué was most popular in New Mexico. At this time, New Mexico artisans applied created straw appliqué on small crosses, boxes, chests, nichos, bultos, cupboards, candlesticks, and retablo frames. The interior of the central niche in a side altar at the Santuario at Chimayo is a rare early example of straw appliqué.

Scholar Donna Pierce notes that the highly popular silk shawls (rebozos) made in Santa María del Río in Mexico were often sold in small boxes or chests decorated with marquetry work. As several such shawls have been noted in New Mexico family inventories and wills, it is possible that the shawl boxes and chests helped introduce straw appliqué to New Mexico.

In creating contemporary straw appliqué, the wood's surface is coated with *yeso*, or gesso, made of gypsum and animal glue. The next step is to apply pine pitch, made by baking green pine boughs over live coals and mixing it with grain alcohol and soot to create trementina. The dark color of the resulting trementina creates a fine dark background that enhances the lightness of the pale yellow straw. The oat or wheat straw is split and flattened, then cut into tiny shapes as needed. They are then applied to the pitch surface. The blue and red paint used on some pieces is made with imported indigo or mercuric

sulfide, respectively. A final coat of trementina seals the finished piece. The trementina serves as an excellent preservative for both the wood and the straw. Applying tiny cut pieces of wheat or oat straw to the prepared surface was tedious work that rivaled filigree for causing eye strain and even blindness.

The popularity of the craft ran its course by 1850, roughly the same time that it died out in Mexico. Then, along with other traditional arts and crafts of New Mexico, it was revived in the 1930s and today is crafted by several individuals. The best-known straw appliqué artisans of New Mexico are Eliseo and Paula Rodríguez, who began creating their work in 1936 after studying older examples on furniture, retablos, and bultos. The Rodríguezes are credited with reviving straw appliqué in the twentieth century. In addition, Mr. Rodríguez elevated the craft to a new level by introducing the use of different shades of natural straw pieces to intricately shade his images. It is his experience as a painter that brings this new dimension to straw appliqué. The Rodríguezes' daughter, Vicki, and four grandchildren also create straw appliqué.

Other artisans include Jimmy and Debbie Trujillo, who began creating straw appliqué in the mid-1980s. The Trujillos researched the old nineteenth-century pieces and recreated the pine rosin trementina. They, too, emphasize traditional processes. Santero Felix López of Española taught himself the craft after seeing an example in a museum. Now his pieces are also collected by museums and private collectors. His daughter Krissa has also mastered the craft. Leo Coriz of Santo Domingo Pueblo is another straw appliqué artisan who recalls his family creating straw

4.45

The Life of Christ straw appliqué cross by Eliseo Rodríguez. Courtesy Museum of New Mexico Collections at the Museum of International Folk Art, A1986.565–2. Photo by Miguel Gandert.

4.46
Detail from *The Life of Christ*.
Courtesy Museum of
International Folk Art,
A1986.565.2. Photo by
Miguel Gandert.

appliqué work when he was a child, an indication that the craft didn't die out entirely in the mid-nineteenth century. Elmer León of Santa Ana Pueblo sells straw appliqué at Indian Market.

Late twentieth-century variations of straw ap-pliqué include dyed-straw scenes by Luis P. Olay of Albuquerque. Born in Mexico, Mr. Olay is a fifth-generation straw mosaic artisan who has lived in New Mexico for two decades. His large scenic images are created with a whole-surface straw layout strongly resembling colcha stitching, but it is more likely related to *popote*, a dyed-straw craft developed in Mexico in the early twentieth century.

Chronology

1495 The first plateros arrive in the Americas.

1545 Silver strike at Potosí.

1546 Silver strike at Zacatecas.

1565 Trade with the Philippines opens up, introduc-ing lacquerware, silk (including the famous *mantón de Manila* shawls), ivories, coral, dia-monds, garnets, carnelians, and emeralds to New World consumers.

1626 Fray Alonso de Benavides visits New Mexico, bringing supplies for the missions, including eleven silver chalices and patens.

1631 Official contract established with Mexico for the mission supply caravans that had been operating since 1609. Scheduled to arrive every three years, the caravans brought woodworking tools, cloth, clothing, Majolica pottery, church furnishings, and holy images.

1638 Trade invoice from weaving workshop of Governor Luis de Rosas indicated use of treadle loom in Santa Fe. Textiles exported to Mexico.

1639 Silversmith Rodrigo Lorenzo, a Flemish arti-san, is documented as living in Santa Fe.

1693 Blacksmith Bernardino de Sena arrives from Mexico and sets up a smithing shop in Santa Fe. His family operated a blacksmith business until the 1920s.

1729 Birth of Nicolás Gabriel Ortega, first recorded weaver in the Ortega family of Chimayó.

1754 First documented artist with surviving artwork, Captain Bernardo Miera y Pacheco, arrives in New Mexico.

1761 Stone reredos, reportedly carved by Bernardo Miera y Pacheco, completed for La Castrense.

1776 Fray Francisco Atanasio Domínguez makes his official ecclesiastical visit to New Mexico's missions. His report is the first comprehensive inventory and description of New Mexican churches and their furnishings.

1778 Father Morfí suggests to the viceroy the establishment of cobalt and mercury mining industries in New Mexico to provide some income to the area.

1790 Census reveals numbers of various artisans living in New Mexico.

1802 Birth of Rafael Luna of Taos, first recorded filigree maker, whose family carried on the tradition for five generations.

1807 Arrival from Mexico of Bazán brothers to set up shop in Santa Fe and to improve the technical skills of New Mexican weavers. They lived and worked in Santa Fe until 1809, when they returned to Mexico.

1821 Mexico achieves independence from Spain and claims New Mexico as its province; Spanish restrictions on foreign commerce are officially lifted. The Santa Fe Trail opens for transporting goods from the eastern United States. These goods, including new tools, furniture, and luxury items, greatly affect the material culture of New Mexico.

1823 Birth of José Concepción Trujillo, first identified weaver in the Trujillo family of Chimayó.

1840 Trade documents reveal over twenty thousand blankets exported to Mexico in this year.

1842 Birth of Higinio V. Gonzales, tinsmith, santero, and musician. Died circa 1922.

1844 Birth of José María Apodaca, tinsmith. Died 1924.

1850 First lumber mill opened in New Mexico.

1856 Aniline synthetic dyes developed in England by William H. Perkins. This discovery has a profound effect on New Mexico handwoven blankets, which were previously limited to natural dyes.

1859 First merino sheep introduced into northeastern New Mexico, eventually to replace the hardy churro sheep brought by the Spanish colonists.

1860s Commercial Germantown, Saxony yarns introduced into New Mexico.

1860 Beginning of most active thirty-year period of tinwork production; first gold mines in New Mexico begin operation.

1867 First silver mine in New Mexico begins operation.

1878 Railroad reaches New Mexico, increasing the availability of mass-produced products, and fostering tourism and the sale of New Mexican arts and crafts.

1880 First kiln-fired brickworks opens in New Mexico.

1898 Birth of Agueda Salazar Martínez, matriarch of New Mexico Hispanic weaving. Doña Martínez was still weaving in the late-1990s and in 1994 headed a family numbering 204, with 64 weavers, spanning five generations.

1905 University of New Mexico adopts Spanish-Pueblo style of architecture for all of its buildings.

1918 Nicasio Ortega establishes his general store in Chimayó to be known later as Ortega's Weaving Shop. The shop establishes the dominance of Chimayó as New Mexico's major weaving center specializing in Chimayó blankets.

1922 Committee for the Preservation and Restoration of New Mexican Mission Churches founded.

1957 Santa Fe City Council adopts proposal directing new construction conforming to "Santa Fe style."

1962 Home Education Livelihood Program (HELP) launched. Many Hispanic women taught to weave through this program.

Glossary

Adz (*azuela*)—A tool with a thin arching blade set at right angles to the handle. Used to trim wood surfaces.

Alacena—Spanish term for small cupboard built into a niche in an adobe wall.

Alfombra—Floor covering. May be woven or pile carpet.

Almenas—Battlements or crenellations.

Altar Screen—See Reredos.

Aniline dye—Any of a large number of synthetic dyes derived from aniline, a colorless, oily, slightly water-soluble coal tar product.

Appliqué—Term denoting material applied or laid over a surface for decoration, as opposed to inlay, which requires incising a surface prior to setting materials in the incised area.

Araña—Chandelier.

Arcabús (harquebus)—A small-caliber long gun invented around 1400.

Armario, almario—In colonial New Mexico, a free-standing cabinet for storage of various items. In the eighteenth century, storage was limited to clothing.

Armazón—Picture or mirror frame.

Armero—Armorer, also gunsmith.

Artesonado—A Mudéjar-influenced wooden mosaic pattern applied to the ceiling of a room.

Auger (barrena, *varrena*)—A tool for boring holes in wood.

Awl—A pointed tool for piercing small holes.

Banca, banco—A bench; refers to both freestanding wooden benches, with or without arms or back, and adobe benches built into an adobe wall.

Baroque—A stylistic movement in art and architecture that flourished from the late fifteenth century to the mid-eighteenth century in Europe and the Americas, characterized by theatrical use of light, elaborate surface textures, Solomonic columns, cruciform churches, towers added to church structures, grapevine motifs, and the clerestory window. The late baroque saw the development of the estípite column.

Baúl—Large or small traveling trunk.

Baulita—Small box.

Burilada—The assayer's zigzag mark assuring quality standards had been met in producing the silver item on which the mark appeared.

Caja—A box or chest.

Cajita—Small box or chest.

Cama alta—A bed slung with rawhide. The bed featured a headboard, footboard, and side rails. *Alta* refers to the sleeper's position relative to the floor.

Cama alta de tabla—A bed consisting of a wooden frame topped with boards.

Chamisa—A yellow dye derived from the chamisa plant (Chrysothamnus nauseous). Mexicans use the term chamiso; Nuevomexicanos use the term chamisa.

Candelabro—Candelabra.

Candelero—Candlestick.

Cerrajero—Locksmith.

Chip carved—Hand carving done with strokes of a chisel, leaving a distinctive lengthwise cut in the wood's surface.

Churro sheep—Common sheep of Spain brought to the Americas.

Cloud terrace motif—A frequently used Pueblo image depicting a cloud in a balanced step design configuration.

Cochinilla (cochineal)—A red dye derived from the crushed bodies of insects. In colonial days, this dye was imported from Mexico.

Colchón—Mattress used in colonial New Mexico. This term also refers to quilts. Colcha derives from this term.

Combed Glass—A decorative surface created by painting glass with oil paint, then combing it to create wavy designs. Used to decorate tin items.

Conservator—A trained technician, who restores, repairs, preserves or otherwise maintains objects of art or historical artifacts.

Cotonilla—A durable cotton fabric made in Mexico and imported to New Mexico; used in colcha embroidery as backing material.

Crest—The highest horizontal element on the front and sides of a cupboard or other piece of furniture, or on decorative items, such as mirrors and frames.

Cruciform—A term designating the cross-shaped floor plan of a church popular in the baroque period.

Cruz—Cross.

Cuchillero—Cutler.

Dovetail—A type of wood joint accomplished by cutting one piece with tongues (shaped like the tail of a dove) that fit tightly into corresponding cutouts of the second piece of wood.

Dowel—A wooden pin that secures two pieces of wood together by fitting into holes on each piece.

Encrusted Straw—The term suggested by straw artisan and researcher Jimmy Trujillo to replace the term *straw appliqué* because it more accurately describes the process and results.

Escabel, *escabul*—In seventeenth-century Spain, a stool; in eighteenth-century New Mexico, a low, backless stool for sitting.

Escritorio—Writing desk in colonial times. More recently called *vargueño*.

Espadero—Swordsmith.

Estípite column—An architectural element revived in the early eighteenth century in Spain and copied in the Americas.

Eyelet hinge—Also, snipe hinge or *gozne*, forged in the form of two interlocking cotter pins, the straight ends being driven through the wood, bent outward, and clinched.

Frazada—Woven blanket. Also known as frezada in New Mexico.

Gesso—See Yeso.

Gothic—A stylistic movement in art and architecture that flourished from the mid-twelfth through mid-sixteenth century in Europe, most notably in architecture. It is characterized by the pointed arch, ribbed vaulting, flying buttresses, long narrow "coffin" church naves, and ornamental wood and stonework.

Grille—A grating of iron placed over windows and as decorative elements in balcony railings.

Grooving or gouging—Cutting so as to form channels or grooves. The carpenter's grooving plane was known as a *canalador.*

Guachaporo—The small grains or dots of metal added to the overall design at junctures or intervals in filigree work.

Harinero—A large chest specifically made to hold grains or milled flour.

Herrador—Farrier.

Herrero—Blacksmith.

Hojalateros–tinsmiths

Iconography—Symbolic representation through two- or three-dimensional imagery. The term became pejorative when Protestants used it to refer to the Roman Catholic Church's use of statues and pictures of saints.

Incise—To cut into; to make marks by cutting or carving.

Inlay—A type of surface decoration achieved by setting flat pieces of fine materials in a shallow indentation in the surface. Often, only a portion of the decorated surface is covered.

Jerga—Twill-woven fabric used for floor covering, under mattresses, and for packing material and clothing. Also spelled *herga, gerga,* and *xerga.*

Lacquerware—Goods, such as chests, hand mirrors, bowls and boxes, made of lacquered wood.

Manta—Unbleached sheeting woven in large quantities for commercial trade and often used as tax payment or tribute. Its meaning has changed several times, and also has been used to indicate an Indian dress or a shawl.

Marquetry—Inlaid work of various colored materials such as wood or gems. In Spain, marquetry was introduced by the Moors. Known as *ataracea,* it flourished in southern Spain.

Motif—A pattern or design that is carved, painted, hammered or otherwise applied to a two- or three-dimensional surface.

Mortise and tenon—A type of wood joint in which a projection formed on the end of a piece of wood (tenon) fits into a hole or slot cut into another piece of wood (mortise). Iron mortises were also used by blacksmiths in order to assemble gates, grilles, and locks.

Mudéjar—A unique Christian-Moorish decorative style developed in Spain after the reconquest in the late fifteenth century. Characteristics include use of geometric, calligraphic, and vegetal motifs, absence of human or animal depictions, and highly patterned surfaces.

Nave—The main lengthwise area of a church, extending from the entrance to the altar.

Neoclassicism—An eighteenth- and early-nineteenth-century stylistic movement in art and architecture that flourished in Europe and the Americas. It emphasized Greek motifs, simplicity over detail, plain surfaces over highly patterned surfaces, and the use of geometric patterns, low relief, and moldings.

Nicho—Niche. In New Mexico, a three dimensional structure used to hold two- or three-dimensional religious images, such as commercially printed sacred images or bultos.

Pantalla—Sconce.

Petaca—A leather chest.

Puncheon door—A door made with a piece of wood (pintle) extending vertically above and below the outer edges of the door so that it swings within sockets of the frame, eliminating the need for metal hinges. Also known as a pintle hinge.

Quinto—The Crown's fifth portion of all silver and gold mined in the Americas.

Rail—A horizontal brace connecting two vertical supports.

Relief carving—To carve wood so that there is a foreground pattern set against a low or flat background. The raised portions are usually a design or motif such as a rosette.

Renaissance—French for "rebirth," this stylistic movement in art and architecture flourished from the fourteenth century to the seventeenth century in Europe, most notably in art and literature, as the transition out of the long-lived medieval period. Also designates the architectural style of fifteenth- and sixteenth-century Italy, characterized by the use of Greek and Roman motifs, rounded arches, and attention to symmetry.

Repisa—A hanging shelf.

Reredos (altar screen)—The large facade situated behind the altar of a Roman Catholic Church, usually decorated with two- or three-dimensional representations of saints or Biblical scenes.

Sabanilla—Homespun wool cloth used as backing material for colcha embroidery in colonial New Mexico.

Sarape—A blanket or shawl worn by men. The Mexican sarape, adopted in colonial New Mexico, is a rectangle with a slit allowing the wearer to slip it over his head in the style of a poncho with open sides.

Sconce—Wall-mounted candleholder.

Secular—Of or pertaining to worldly things or to things that are not regarded as religious, spiritual, or sacred.

Servant or Slave Blanket—Blanket woven by a genízaro, generally characterized by the melding of Native American and Spanish design styles, but using Spanish materials and weaving techniques.

Silla—A chair. A silla de asentar, by contrast, is an armchair, and a silleta is a small chair.

Silla de montar—A saddle.

Sillón de frailero—An armchair of rectangular-shaped construction, sometimes slung with leather or fabric.

Solder—Material used to join metal pieces together. In tinsmithing, the solder is a lead-tin alloy.

Solomonic column—Also known as *salomónica*. A spiral column, used as a decorative element on retablos, furniture, and tinwork, particularly frames and nichos.

Spindle—A short upright piece, turned or hand-carved. Found as a decorative item on furniture, particularly cabinets and chairs.

Stile—One of the upright or primary pieces of a frame into which secondary pieces are fit.

Stretcher—A horizontal brace between two legs of a chair or table.

Taburete—An armless side chair or seat stool.

Tarima—A low stool or bench. Tarimita is the diminutive form of tarima.

Terneplate—A lead-tin alloy, darker in color than tin, and available in sheets. In the twentieth century, terneplate largely replaced tinplate for tinworking.

Tinplate—Sheet iron coated with a thick layer of pure tin, used throughout the nineteenth century for tinworking.

Tongue and groove—A type of wood joint in which a raised area on the edge of one board fits into a corresponding groove in the edge of the other to produce a flush surface.

Transept—The major portion of a church's body that crosses the nave at right angles.

Trastero—Late-nineteenth-century New Mexico term for freestanding cupboard.

Telar (treadle loom)—Loom brought to the Americas by the Spanish. The treadle loom features beams used for storing long lengths of warp and cloth, and treadles that control the warp threads.

Vara—A Spanish colonial unit of measure roughly equivalent to thirty-three inches.

Veneer—A very thin layer of wood or other material applied to a surface as decoration.

Vernacular—Native or originating in the place of its occurrence or use. Also, the native speech or language of a place, as opposed to "standard" language.

Vertical loom—A loom indigenous to the Americas. The Navajo loom is one example of the vertical loom.

Wafer iron—An iron implement for heat-pressing communion wafers for use in the Roman Catholic Mass. Each wafer mold was carved with a religious emblem that transferred onto the wafer.

Warp—In weaving, the set of yarns placed vertically on a loom.

Weft—In weaving, the set of yarns that are interlaced horizontally with the vertical warp yarns.

Yeso (gesso)—A gypsum compound applied to wood as a ground for painting. It fills in cracks and holes and allows for a smooth surface.

Bibliography

Abert, J. W. *Report on His Examination of New Mexico in the Years, 1846–1847*. Washington, D.C.: Senate Executive Document No. 23, 30th Cong., lst Sess., Vol. 4, 1848. 34, 452.

Adams, Eleanor B., ed. *Bishop Tamarón's Visitation of New Mexico, 1760*. Albuquerque: Albuquerque Historical Society of New Mexico, 1954.

Baca, Elmo. *Río Grande High Style Furniture Craftsmen*. Layton, Utah: Gibbs Smith, 1995.

Barker, Ruth Laughlin. "The Craft of Chimayó." *El Palacio* 28, no. 26 (1930): 161–73.

Boyd, E. "New Mexico Tin Work." *El Palacio* 60, no. 2 (February 1953): 61–67.

———. "Ikat Dyeing in Southwestern Textiles." *El Palacio* 68, no. 3 (1961): 185–89.

———. *Popular Arts of Spanish New Mexico*, 251, 263. Santa Fe: Museum of New Mexico Press, 1974.

Boylan, Leona Davis. *Spanish Colonial Silver*. Santa Fe: Museum of New Mexico Press, 1974.

Briggs, Charles L. *The Wood Carvers of Córdova, New Mexico: Social Dimensions of an Artistic "Revival."* Knoxville: University of Tennessee Press, 1980.

Brown, Lorin W., with Charles L. Briggs and Marta Weigle. *Hispano Folklife of New Mexico: The Lorin W. Brown Federal Writers' Manuscripts.* Albuquerque: University of New Mexico Press, 1978.

Bunting, Bainbridge. *Of Earth and Timbers Made: New Mexico Architecture.* Albuquerque: University of New Mexico Press, 1974.

———. *Early Architecture in New Mexico.* Albuquerque: University of New Mexico Press, 1976.

———. *Taos Adobes: Spanish Colonial and Territorial Architecture of the Taos Valley.* 1964. Albuquerque: University of New Mexico Press, 1992.

Burr, Gertrude H. *Hispanic Furniture.* New York: Archive Press, 1964.

Burroughs, Jean M. "From Coronado's Churros." *El Palacio* 83, no. 1 (1977): 9–13.

Campa, Arthur L. *Hispanic Culture in the Southwest.* Norman: University of Oklahoma Press, 1979.

Cash, Marie Romero. *Built of Earth and Song— Churches of Northern New Mexico: A Guide.* Santa Fe: Red Crane Books, 1993.

Chávez, Fray Angélico. "The Carpenter Pueblo." *New Mexico Magazine* 49 (Sept.-Oct. 1971): 26–33.

Clark, Neil M. *The Weavers of Chimayó.* Santa Fe: Vergara Printing Co., 1953.

Clark, William. "Dancing on the Loom." *El Palacio* 99, nos. 1 and 2 (1994): 32–37.

Coulter, Lane, and Maurice Dixon, Jr. *New Mexico Tinwork, 1840–1940.* Albuquerque: University of New Mexico Press, 1990.

De Borhegyi, Stephen F., and E. Boyd. *El Santuario de Chimayó.* 1956. Santa Fe: Ancient City Press, 1987.

Dickey, Roland F. *New Mexico Village Arts.* Albuquerque: University of New Mexico Press, 1970.

Domínguez, Francisco Atanasio. *The Missions of New Mexico, 1776.* Translated and edited by Eleanor B. Adams and Fray Angélico Chávez. 1956. Albuquerque: University of New Mexico Press, 1975.

Drain, Thomas A. *A Sense of Mission: Historic Churches of the Southwest.* San Francisco: Chronicle Books, 1994.

Dunton, Nellie. *The Spanish Colonial Ornament and the Motifs Depicted in the Textiles of the Period of the American Southwest.* Philadelphia: H. C. Perleberg, 1935.

Emory, Lt. Col. W. H., and Lt. J. W. Abert. "Notes of a Military Reconnaissance from Fort Leavenworth, in Missouri, to San Diego, California . . ." Report written in 1846–47. Report of the Secretary of War, 30th Cong., Executive Document 41, Washington, D.C., 1848.

Emory, William H. *Lieutenant Emory Reports: A Reprint of Lieutenant W. H. Emory's Notes of a Military Reconnoissance.* Introduction and notes by Ross Calvin. Albuquerque: University of New Mexico Press, 1951.

Espinosa, Carmen. *New Mexico Tin Craft.* Santa Fe: New Mexico State Department of Vocational Education, 1937.

———. *Shawls, Crinolines, Filigree: The Dress and Adornment of the Women of New Mexico, 1739 to 1900.* El Paso, Texas: Western Press, 1970.

Fisher, Nora, ed. *Río Grande Textiles.* 1994. Reprint of *Spanish Textile Tradition of New Mexico and Colorado.* Santa Fe: Museum of New Mexico Press, 1979.

Fleming, Jeanie Puleston. "Ganados del Valle: A Venture in Self-Sufficiency." *New Mexico Magazine* 63, no. 9 (September 1985): 38–42.

Gage, Thomas. *Thomas Gage's Travels in the New World*, 72. Edited by J. Eric S. Thompson. Norman: University of Oklahoma Press, 1958.

Gavin, Robin Farwell. *Traditional Arts of Spanish New Mexico.* Santa Fe: Museum of New Mexico Press, 1994.

Gregg, Josiah. *Commerce of the Prairies.* Edited by Max L. Moorhead. Norman: University of Oklahoma Press, 1954.

Hackett, Charles Wilson, ed., *Historical Documents Relating to New Mexico, Nueva Vizcaya and Approaches Thereto, to 1773, collected by Adolph F. A. Bandelier and Fanny R. Bandelier; Spanish texts and English translations, edited with introductions and annotations by Charles Wilson Hackett.* Washington, D.C.: Carnegie Institution of Washington, 1923–27. Vol. 3, 71–73.

Hayes, Alden C. *The Four Churches of Pecos.* Albuquerque: University of New Mexico Press, 1974.

Hewett, Edgar L., and Reginald G. Fisher. *Mission Monuments of New Mexico.* Albuquerque: University of New Mexico Press, 1943.

Hotz, Gottfried. *The Segesser Hide Paintings: Masterpieces Depicting Spanish Colonial New Mexico.* 1970. Santa Fe Museum of New Mexico Press, 1991.

James, Peter and Nick Thorpe. *Ancient Inventions.* New York: Ballantine, 1994.

Jeter, James, and Paula Marie Juelke. *The Saltillo Sarape.* Santa Barbara, Calif.: New World Arts, 1978.

Jones, Hester. "Uses of Wood by the Spanish Colonists in New Mexico." *New Mexico Historical Review* 7, no. 3 (1932): 273–91.

Kay, Elizabeth. *Chimayó Valley Traditions.* Santa Fe: Ancient City Press, 1987.

Kent, Kate Peck. *Prehistoric Textiles of the Southwest.* Albuquerque: University of New Mexico Press; Santa Fe School of American Research, 1983.

Kessell, John L. *The Missions of New Mexico Since 1776.* Albuquerque: University of New Mexico Press, 1980.

Kessell, John L., and Rick Hendricks. *The Spanish Missions of New Mexico.* 2 vols. New York: Garland Publishing, 1991.

Kozikowski, Janusz. "Agueda Martínez: Weaver of Many Seasons." *New Mexico Magazine* 57, no. 8 (August 1979): 44–46.

Kubler, George. *Time's Reflection and Colonial Art.* Winterthur Conference Report, Winterthur, Delaware, 1968. Henry Francis du Pont Winterthur Museum, 1969.

——. *The Art and Architecture of Ancient America,* 3rd ed. New York: Penguin, 1984.

——. *The Religious Architecture of New Mexico in the Colonial Period and Since the American Occupation,* 8–9. 4th ed. Albuquerque: University of New Mexico Press, 1990.

Kubler, George, and Martin Sebastian Soria. *Art and Architecture in Spain and Portugal and Their American Dominions, 1500 to 1800.* Baltimore, Md.: Penguin Books, 1959.

López, Thomas R. *Prospects for the Spanish American Culture of New Mexico.* San Francisco: R & E Research Associates, 1974. 91.

Lumpkins, William. "A Distinguished Architect Writes on Adobe." *El Palacio* 77, no. 4 (1971): 3–11.

Lucero, Helen R., and Suzanne Baizerman. *Chimayó Weaving: The Transformation of a Tradition.* Albuquerque: University of New Mexico Press, 1999.

McHenry, Paul Graham, Jr. *Adobe: Build It Yourself.* Tucson: University of Arizona Press, 1973.

McIntyre, Kellen Kee. *Río Grande Blankets: Late Nineteenth-Century Textiles in Transition.* Albuquerque: Adobe Gallery, 1992.

McIntyre, Kellen Kee, and Eric Lane. "Río Grande Blankets." *New Mexico Magazine,* February 1992, 50–57.

Magoffin, Susan Shelby. *Down the Santa Fe Trail and into Mexico: The Diary of Susan Shelby Magoffin, 1846–1847.* Edited by Stella M. Drumm. Lincoln: University of Nebraska Press, 1982.

Mather, Christine, ed. *Colonial Frontiers: Arts and Life in Spanish New Mexico—The Fred Harvey Collection.* Santa Fe: Ancient City Press, 1983.

Mera, H. P. *Spanish-American Blanketry: Its Relationship to Aboriginal Weaving in the Southwest.* Santa Fe: School of American Research Press, 1987.

Miller, Michael. *Monument of Adobe: The Religious Architecture and Traditions of New Mexico.* Dallas: Taylor Publishing, 1991.

Moorhead, Max L. *New Mexico's Royal Road: Trade and Travel on the Chihuahua Trail.* Norman: University of Oklahoma Press, 1958.

Morrow, Mabel. *Indian Rawhide: An American Folk Art.* Norman: University of Oklahoma Press, 1975.

Nestor, Sarah. *The Native Market of the Spanish New Mexican Craftsmen, 1933–1940.* Santa Fe: The Colonial New Mexico Historical Foundation, 1978.

——. "Río Grande Textiles—A Living Tradition." *New Mexico Magazine* 57, no. 8 (August 1979): 20–27.

New Mexico Office of Cultural Affairs. *On Fertile Ground: Assessing and Cultivating New Mexico's Cultural Resources.* Santa Fe: New Mexico Office of Cultural Affairs, 1996.

Noble, David Grant. *Pueblos, Villages, Forts and Trails: A Guide to New Mexico's Past.* Albuquerque: University of New Mexico Press, 1994.

Olson, Audrey Janet. *Trujillo Weaving at Centinela Ranch: Old Traditions, New Explorations.* Roswell, N.Mex.: Roswell Museum and Art Center, 1990.

Ortiz y Pino de Dinkel, Reynalda, and Dora Gonzales de Martínez. *Una Colección de Adivinanzas y Diseños de Colcha: A Collection of Riddles and Colcha Designs.* Santa Fe: Sunstone Press, 1988.

Palmer, Gabrielle, and Donna Pierce. *Cambios: The Spirit of Transformation in Spanish Colonial Art.* Santa Barbara and Albuquerque: Santa Barbara Museum of Art and University of New Mexico Press, 1992.

Pierce, Donna, and Marta Weigle, eds. *Spanish New Mexico: The Collection of the Spanish Colonial Arts Society.* Santa Fe: Museum of New Mexico Press, 1996.

Prince, L. Bradford. *Spanish Mission Churches of New Mexico*. 1915. Glorieta, N.Mex.: Rio Grande Press, 1977.

Reeve, Agnesa Lufkin. *From Hacienda to Bungalow: Northern New Mexico Houses, 1850–1912*. Albuquerque: University of New Mexico Press, 1988.

Rodee, Marian. *Southwestern Weaving*. Albuquerque: University of New Mexico Press, 1977.

——. *Weaving of the Southwest from the Maxwell Museum of Anthropology, University of New Mexico*. West Chester, Pa.: Schiffer Publishing, 1987.

Romero, Orlando, and David Larkin. *Adobe Building and Living with Earth*. Boston: Houghton Mifflin, 1994.

Romero, Robert. Personal communication, Summer, 1996.

Sagel, Jim. *Los Cumpleaños de Doña Agueda*. Austin, Tex.: Place of Herons Press, 1984.

Sayer, Chloë. *Arts and Crafts of Mexico*. San Francisco: Chronicle Books, 1990.

Simmons, Marc. *The Sena Family: Blacksmiths of Santa Fe*. Santa Fe: Press of the Palace of the Governors, 1981.

——. *Coronado's Land: Essays on Daily Life in Colonial New Mexico*. Albuquerque: University of New Mexico Press, 1991.

Simmons, Marc, and Frank Turley. *Southwestern Colonial Ironwork: The Spanish Blacksmithing Tradition from Texas to California*. Santa Fe: Museum of New Mexico Press, 1980.

Spears, Beverly. *American Adobes: Rural Houses of Northern New Mexico*. Albuquerque: University of New Mexico Press, 1976.

Sperling, David. "Teresa Archuleta-Sagel Weaving a Link with the Past." *New Mexico Magazine*, vol. 62 no. 3 (March 1984): 9–15.

Stoller, Marianne, Dorothy Boyd Bowen, Paula Duggan, and Kathryn Nelson. *Las Artistas del Valle de San Luis*. Arvada, Colo.: The Arvada Center for the Arts and Humanities, 1982.

Taylor, Lonn, and Dessa Bokides. *Carpinteros and Cabinetmakers: Furniture Making in New Mexico, 1600–1900*. Santa Fe: Museum of International Folk Art, 1984.

——. *New Mexican Furniture, 1600–1940: The Origins, Survival, and Revival of Furniture Making in the Hispanic Southwest*. Santa Fe: Museum of New Mexico Press, 1987.

Tobin, Judith. *Symbols of Faith: A Visual Journey to Historic Churches of New Mexico*. New York: Independent Publishers, 1993.

Toomey, Don. "Colcha: A Distinctive Traditional Embroidery Craft." *Tradición Revista: The Journal of Contemporary & Traditional Spanish Colonial Art & Culture*, Winter 1997, 41–46.

Toulouse, Joseph H. Jr. *The Mission of San Gregorio de Abó: A Report on the Excavation and Repair of a Seventeenth-Century New Mexico Mission*. Albuquerque: University of New Mexico Press, 1949.

Toussaint, Manuel. *Colonial Art in Mexico*. Austin: University of Texas Press, 1967.

Trujillo, Jimmy E. Personal communication, April 1998.

Vedder, Alan C. *Furniture of Spanish New Mexico*. Santa Fe: Sunstone Press, 1977.

Wall, Dennis. "Chimayó Weavers." *New Mexico Magazine*, vol. 73 no. 11, (November 1995): 40–47.

Warren, Nancy Hunter. *Villages of Hispanic New Mexico*. Santa Fe: School of American Research Press, 1987.

Weber, David J., ed. *The Extranjeros: Selected Documents from the Mexican Side of the Santa Fe Trail, 1825–1828*. Santa Fe: Stagecoach Press, 1967.

Weigle, Marta, ed. *Hispanic Villages of Northern New Mexico*. 1935. Santa Fe: Lightning Tree, 1975.

Wheat, Joe Ben. "Spanish-American and Navajo Weaving, 1600 to Now." *Collected papers in Honor of Margery Ferguson Lambert. Papers of the Archeological Society of New Mexico*. 3 (1976): 199–226.

——. "Spanish Colonial Weaving." In *The North American Indian Collection of the Lowe Art Museum*, University of Miami. Coral Gables, Fla.: Lowe Art Museum, 1988.

Wroth, William, ed. *Furniture from the Hispanic Southwest*. Santa Fe: Ancient City Press, 1984.

——. *Hispanic Crafts of the Southwest*. Colorado Springs: The Taylor Museum of the Colorado Springs Fine Arts Center, 1977.

——. "New Hope in Hard Times: Hispanic Crafts are Revived During Troubled Years." *El Palacio* 89, no. 2 (1983): 22–31.

——. *Weaving and Colcha from the Hispanic Southwest: Authentic Designs*. Santa Fe: Ancient City Press, 1985.

Yoder, Walter D. *The Big Spanish Heritage Activity Book: Hispanic Settlers in the Southwest*. Santa Fe: Sunstone Press, 1997.

5 La Música de la Gente: Secular and Religious Music

Like the *mayordomo* of the *acequia*, the leader of the altar society, and the *hermano mayor* of the *penitentes*, the *músico* is highly valued in Hispanic society. For without that *guitarrista*, *cantadora*, and *violinista*, the voices of the past might lapse into silence.
—Jim Sagel, Straight from the Heart: Portraits of Traditional Hispanic Musicians

OVERVIEW

The music tradition of Hispanic New Mexico is an oral tradition. Even in the late twentieth century, the vast majority of Hispanic musicians still prefer sound recording to written recording. As a result, there is very little information on the region's music prior to the nineteenth century. What we know of the early musicians comes to us through experiences reported in journals by visitors to New Mexico, or inventories of musical instruments reported by church officials in their reports.

What scholars deduce about the music of Spanish colonial New Mexico is that it was initially associated with the proselytizing efforts of the missionaries. It was given to improvisation. The Franciscan friars brought organs, trumpets, bells, clarions, guitars, and violins to teach Christianity to the Pueblo Indians through music. The Spanish settlers used music to break the monotony of geographic isolation and strenuous frontier life; the self-reliance of today's self-taught Nuevomexicano musicians harkens back to those early days. The inspiration for New Mexico Hispanic music and musical genres is drawn from Spain and Mexico, and, in the case of the Matachines music, from the cultures bordering the Mediterranean. While scholars have found it difficult to establish *direct* Spanish sources for such forms as the *alabado* and some folk dramas, there are Spanish precedents for these New World expressions. New Mexico's music reveals much stronger influences of Mexican and Pueblo music. In addition, the nineteenth century saw Polish, German, and French music and dance introduced to the area from the South and the East, adding a new dimension to an already eclectic musical palette of forms and styles.

Inventories of the Franciscan missions in New Mexico were conducted in 1672, in which a set of trumpets and a bassoon were listed among the items at Socorro (Twitchell 1914). Fray Francisco Atanasio Domínguez records the existence of violins and guitars at three missions in 1776 on his inspection tour of New Mexico missions. At San Gerónimo de Taos he listed "a useless violin and guitar;" at Santo Domingo he noted that the local friar maintained musicians with guitars and violins; and at San Diego de Jémez he noted that the friar in charge had acquired a violin and guitar. It is also known that Mexico City had one violin-maker in the sixteenth century and it is highly possible, though not yet proven, that these violins originated there, if not in Spain.

At the suggestion of Charles V of Spain, the friars in Mexico used music extensively for proselytizing and pacifying the Indians, especially resistant ones. Prayers were taught to the natives using their own chants, and they were taught to play instruments. Charles V authorized the presence of singers and musicians at the missions for this purpose. In 1523,

Peter van der Moere of Ghent (known in Mexico as Friar Pedro de Gante) established a music school in Mexico City that emphasized music training for missionary work. He lived there fifty years, teaching choral and instrumental music to hundreds.

The first music teacher in New Mexico was the friar Cristóbal de Quiñones, who accompanied the Oñate expedition in 1598. Before he died in 1609, he learned the Queres (Keres) language, built the church and monastery at San Felipe, installed an organ there, and taught music to the Pueblo Indians. The Spaniard Bernardo de Marta arrived in New Mexico in 1605 and taught many Pueblo Indians throughout the region to sing and play instruments. Called "the organist of the skies," he died at Zía in 1635 (Vetancurt 1968). The friar García de San Francisco y Zúñiga was at Senecú by 1630, and was buried there in 1673. He installed an organ at Senecú, and was also active in El Paso, where he founded the mission of Nuestra Señora de Guadalupe. In 1630, Alonso de Benavides reported to the king that at Isleta, Pecos, and Sandía,

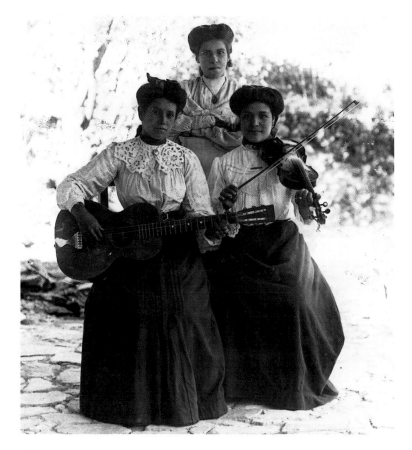

5.1

Three musicians, 1890–1909, illustrating the typical New Mexican ensemble of a guitar and a violin. Courtesy University of New Mexico Center for Southwest Research, neg. #179-0644. Photo by Henry A. Schmidt.

the friars taught the Pueblo Indians reading, writing, singing, and the playing of instruments. He mentioned the use of bells, clarions, and trumpets. The Pueblo Indians also performed on hollowed gourds and pierced cane.

At the mission in Santa Fe, which Benavides founded in 1622, choirs of boys and girls sang at the morning mass, high masses, and vespers. Some New Mexico friars organized boy choirs to sing sacred chants and even to accompany themselves on pottery bowls half filled with water and played through a reed with holes in it, creating high birdlike trills.

Further documentation from the seventeenth century indicates that friars traded pine nuts and animal skins for trumpets and organs. For example, the organ at Abó was bought with the proceeds from the sale of pine nuts, which were provided by the Pueblo Indians. The friars' means of obtaining musical instruments was sometimes used against them by government officials in the longstanding battle for ascendency between the clerics and the governors. It was this kind of internecine friction that contributed to the Pueblo Revolt of 1680. After the Revolt, fewer music resources and materials were dispatched to New Mexico as funding from the Crown declined. Yet scholars know that music

and dance flourished in New Mexico by the late eighteenth century. It also can be safely assumed that music and poetry were part of the cultural baggage that traveled to New Mexico's Spanish colonists from Mexico with the caravans of goods and supplies. New Mexico song forms that were inspired by Spanish antecedents are the *romance*, the *décima*, the *relación* and the alabado. Those that originated in Mexico and became popular in New Mexico as well are the *corrido* and the *canción*. The *indita*, and possibly the *cuando*, originated in New Mexico.

The enormous influence of St. Francis, brought to New Mexico by the Franciscan friars, molded the music and poetry of New Mexico. The Hermanos' rituals reflect the teachings of St. Francis on the importance of faith, the Passion, and sacrifice. The Franciscan friars used corporeal penance in their personal worship; their ritual emphasized the sufferings of Christ, giving rise to yearly reenactments in the Passion plays and the Stations of the Cross, accompanied by antiphonal hymns. All of these traditions were embraced by the Hermanos, or Penitentes. The Franciscans' love and respect for nature, as first demonstrated by St. Francis, also greatly influenced the Spanish colonists for centuries. In New Mexico this has led to a reliance on, and reluctance to leave, the land and sky of New Mexico, which has become central to the Nuevomexicano worldview. The ancient influences are reflected in the music and art of the region.

Many traditional *músicos* were born in the first quarter of the twentieth century, and many have died. Some who were interviewed tell of having made their first instruments as young boys, working with a sardine can to create a makeshift guitar, a syrup can, or even an old wooden shovel, to make a homemade violin. José Domingo Romero found an old guitar neck when he was shepherding, and attached it to a box to create his first guitar. As the family slaughtered animals for food, he collected intestines for making strings. Then he taught himself to play his uniquely hybrid instrument. Intergenerational teaching was the main source of training. It has been a longtime custom for musicians to gather on the sunny side of a home for informal jam sessions, to teach tunes and techniques to apprentice musicians, to develop repertoire, and to rehearse. These leisurely sessions, known in New Mexico as *música de la resolana*, often attract an appreciative crowd.

Over the centuries, musical and textual styles evolved, and local variants developed into new traditions, even given the cultural isolation and independence of the músicos of New Mexico. Unique among public events were the visits of touring *carpas* and maromeros, entertainment festivals which included tumbling, singing, drama, dancing, and even sixteen-millimeter films. Lydia Mendoza—*la alondra de la frontera* (the lark of the frontier)—toured the Southwestern United States in these spectacles, bringing the

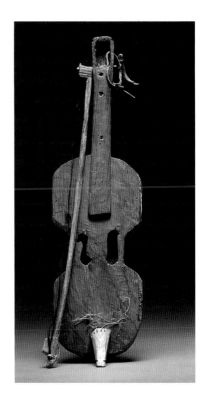

5.2
A homemade violin from New Mexico, nineteenth century. Courtesy Historical Society of New Mexico Collection at the Museum of International Folk Art, A.5.52.40. Photo by Blair Clark.

world to rural Hispanic America. With the subsequent introduction of the radio, television, and recording, Nuevomexicanos found their old and new music more widely disseminated, while they, in turn, heard musical styles that intrigued, entertained, and invited assimilation. Nuevomexicano music continues to be a living, evolving art form.

Song is the basic unit on which music builds more complex forms, such as folk dramas or masses. In the following sections, the song types that form the musical history of this region are discussed.

Romancero — Narrative Song Types

The singing and poetic tradition of all Latin America, including the American Southwest, ultimately begins with the Spanish *romance*. The romance is a millennial tradition that is as old as the Spanish language itself. Enrique Lamadrid (1995) of the University of New Mexico's Department of Spanish and Portuguese explains:

> To appreciate the millennial tradition of the romance ballad is to appreciate not only the Spanish language, but the temperament and world view from which it emerges. The children of Iberia remember their history through language, poetry and music.

The indita, relación, décima, cuando, and corrido are romance derivatives and as such are part of the ongoing *romancero* tradition.

The basic poetic structure of the romance is two sixteen-syllable lines, either rhymed or assonated. (Assonance is rhyme in which the same vowel sounds are used with different consonants in the last two syllables of the rhyming words.) The text is a narrative—it tells a story. The romance as music began developing in the thirteenth century as ballads loosely based on old Spanish epics, narrating the exploits of noblemen and soldiers. A romance is not to be confused with a *romanza*, which tells of a battle. By the sixteenth century, a rich tradition of historical, religious, novelesque, and burlesque ballads was in full flower in Spain. Through the romancero, or romance tradition and repertoire, the Spanish music and culture seeded the New

World, in which new romance forms sprung, including the corrido of Mexico and the alabado and indita of New Mexico.

The novelesque romance focuses on courtly subjects while the Carolingian romances tell stories of the court of Charlemagne. The oldest surviving romance in Spain or Latin America was found in New Mexico at the turn of the century. "Gerineldo, Gerineldo, Mi Camarero Aguerrido" (Gerineldo, My Veteran Steward) dates to 950 A.D. and is an example of a Carolingian romance. It relates the legend of the love between Emma, Charlemagne's daughter, and Eginhard, his chamberlain. There are 160 versions of this romance that have survived into the twentieth century.

An example of a novelesque romance is "La Delgadina," which became highly popular in Latin America and in New Mexico. It tells the story of a king who wishes to take his daughter as his lover. When she rejects him, he imprisons her without food or water. She begs for water from each member of her family, but they are afraid to help. Scholars have noted that in the Sephardic version, she never gives in, and dies of thirst. In the Christian versions, she agrees to give in, but is found dead by those bringing water. Versions of "La Delgadina" have been collected in every country in the Spanish-speaking world, attesting to its lasting popularity.

New Mexico's geographic and cultural isolation again asserts its influence, serving as a kind of cultural amber to preserve its oral traditions with a purity rarely found elsewhere. John Donald Robb, a music professor at the University of New Mexico and a collector of hundreds of Spanish folk songs in the mid-twentieth century, determined that many New Mexican romances were better preserved than those found in Spain itself. Certainly, the New Mexico "Gerineldo" is considered the oldest and best preserved of the romance examples found thus far.

Indita

A romance in form, the indita is one of a small number of song types thought to have originated in New Mexico during the late eighteenth century. It is unique in its sound because it incorporates Indian musical elements, such as refrains that use vocables (syllables without precise meaning),

The "Indita de San Luis"

The "Indita de San Luis," as sung by the late Manuel Mirabal

De mi casa he venido *a pasear este lugar,* *denme razón de San Luis* *que le prometí bailar.*	*From my house I have come* *to visit this place,* *tell me about Saint Aloysius* *I promised to dance for him.*

Coro

Yana heya ho,
yana heya ho,
yana heya ho.
Yana heya ho,
yana heya ho.

chorus

Yana heya ho,
yana heya ho,
yana heya ho.
Yana heya ho,
yana heya ho.

En el marco de esta puerta
el pie derecho pondré
denme razón de San Luis
y luego le bailaré.

Coro

In this doorway
I will put my right foot,
tell me about Saint Aloysius
and then I will dance for him.

chorus

San Luis Gonzaga de Amarante
aparecido en un puente,
esta indita te compuse
cuando mi hijo andaba ausente.

Coro

St. Aloysius Gonzaga of Amarante
appeared on a bridge,
I composed this indita for you
when my son was absent.

chorus

San Luis Gonzaga de Amarante
aparecido en la mar,
concédeme este milagro
que te prometí bailar.

Coro

St. Aloysius Gonzaga of Amarante
appeared on the ocean,
grant me this miracle
Because I promised to dance for you.

chorus

Dicen que la golondrina
de un volido pasó el mar,
concédeme este milagro
que te prometí bailar.

Coro

They say the swallow
in one flight crossed the sea,
grant me this miracle
I promised to dance for you.

chorus

Dicen que la golondrina
de un volido pasó el mar,
de las Islas Filipinas
que acabaron de pelear.

Coro

They say the swallow
in one flight crossed the sea,
in the Philippine Islands
they have stopped fighting.

chorus

Santo Niñito de Atocha
tú solito no más sabes,
el corazón de cada uno
también todas sus necesidades.

Coro

Holy Child of Atocha
only you know
each of our hearts
as well as all our needs.

Chorus

pentatonic harmonies, drumlike rhythms, and descending melodies. Most are sung a cappella. Spanish and Mexican influences include the use of guitar accompaniment and Spanish lyrics. Some guitar accompaniments often are made to imitate the sound of the drum.

The strict translation of *indita* is "little Indian woman," presumably from the first inditas that praised the charms and beauty of Pueblo women. The subject matter of this unique mestizo song type also included tragic interactions between Hispanos and Indians, buffalo hunts on which both Hispano and Indian *ciboleros* (buffalo hunters) rode; or the sad stories of women and children kidnapped by warring nomadic tribes such as the Comanches, Utes, Apaches, and Navajos. In fact, inditas telling of the trials of captives are a category apart, called *cautivas*. In the nineteenth century, a dance called "La Indita" featuring steps reminiscent of Pueblo social dances was popular at New Mexican *bailes* and *fandangos* (community dances). Given the many decades of struggle against raiding nomadic tribes, the intercultural conflicts of colonial times are poignantly reflected in these songs and in the fact that *El Santo Niño de Atocha* was especially revered in New Mexico as a special protector of captives.

The genízaro tradition of New Mexico emerges in song and dance at festivals such as the feast of Santo Tomás at Abiquiú and New Year's Day at Ranchos de Taos where Comanche songs and inditas are sung by Nuevomexicanos. At Sabinal, New Mexico, a beautiful tradition of gratitude to San Luis Gonzaga and the Virgin developed at the time of the Spanish American War when a poem was written asking for the war's end and the safe return of the sons of Nuevo México. As time passed and the poem was set to music and incorporated into local oral tradition, it became the vehicle of prayers and promesas, or promises to dance for San Luis in return for miracles or blessings. These miracles might include the safe return of a soldier from war, or recovery from illness or accident. The "Indita de San Luis" provided the music for a unique dance, which is performed on June 21 in the aisle of the Church in San Luis and other places honoring San Luis in New Mexico. The dance steps are uniquely Indian in style and represent an extraordinary meld-

ing of native and European worship, to say nothing of dancing in church.

Los Comanchitos is an indita nativity play performed on Christmas Eve or Epiphany in San Mateo, Seboyeta, San Luis, and other villages in the shadow of Mount Taylor, according to Lamadrid (1997), who writes:

A curious "group of Comanches," actually neighbors in costume, drops by the house where the "velorio" or prayer vigil for the "Santo Niño" is being held. Since they have no presents to offer the Holy Child, they ask permission to dance for Him. Once inside, they are so entranced by his love that they decide to take him captive. He is ransomed by the family that commits to hosting the Christmas celebration the following year. In San Luis, the Comanches would take other children captive as well. Their parents would ransom them by offering to sponsor dances, fiestas and prayer vigils over the coming winter months.

In Bernalillo, where many people from western New Mexico settled, the Comanches nativity play was sponsored for many years by Losa and the late Cipriano Apodaca. The late Ezequiel Domínguez brought one of the dances from Los Comanches into the church as part of *Las Posadas* and Christmas Eve Mass. Today, children are dressed as little *Comanchitos* to dance for the Santo Niño to this indita sung by the parish choir, 'el Coro de Nuestra Señora de Dolores' of Bernalillo. [See chapter 3 for sample of lyrics.] After nearly disappearing in the 1960s the Comanches nativity play is currently experiencing a revival.

A similar play is performed at the Mt. Carmel Church in Alameda during the Mass for the Virgin of Guadalupe on December 12. Parishioners dressed as Comanches request permission to dance and sing an indita for the Virgin.

Relación

Another example of the Spanish romancero tradition is the relación, a song of more frivolous or

Excerpt of a New Mexico Corrido

The following twentieth-century New Mexico corrido was written about the Río Arriba County Courthouse raid by Nuevomexicanos angry over land grant disputes. This is one of over a dozen corridos written about this event, which drew worldwide attention.

Corrido de Río Arriba
by Roberto Martínez

Año del sesenta y siete
cinco de junio fue el día,
hubo una revolución
allá por Tierra Amarilla.

Allá en la casa de corte,
pueblo de Tierra Amarilla,
Nuevo México el estado,
Condado de Río Arriba.

Un grupo de nuestra gente
muy descontentos bajaron.

Y en oficiales de estado
su venganza ellos tomaron.

Su jefe les suplicaba
"No debe de haber
* violencia."*
Pere no los controlaba,
pues perdieron la
* paciencia.*

Un diputado en el suelo
se queja con agonía,
con una bala en el pecho,
allá por Tierra Amarilla.

Las mujeres y los niños
iban corriendo y llorando.
En ese instante pensaban
que el mundo se iba
* acabando . . .*

In the year of sixty-seven
the fifth of June was the day,
there was a revolution
there in Tierra Amarilla.

There at the court house,
town of Tierra Amarilla,
New Mexico the state,
Río Arriba the county.

A group of our people
came down very
* discontented.*
and on state officials
they took vengeance.

Their leader begged them
"There should be no
* violence."*
But he didn't control them
Well, they lost their
* patience.*

A deputy on the floor
complains in agony
with a bullet in his chest,
up there in Tierra Amarilla.

The women and children
went running and crying.
At that moment they thought
that the world was
* ending . . .*

lighthearted content than the heroic or tragic romances. Often, it tells of the relationship, including commonalities, between humans and animals. A frequent textual characteristic of the *relación* is the list. In the *relación aglutinante*, the song grows with each verse, because the previous verses must be sung every time a new verse is added. An English-language example is "The Twelve Days of Christmas." A New Mexico example is "La Rana" (The Frog), in which the final verse provides a challenge to the singer who must sing a long list of animals' names in one breath. Many children's songs are of this type.

Corrido

This ballad form serves as the romance of the nineteenth and twentieth centuries. It originated in Mexico in the second half of the nineteenth century as a means of communicating and commemorating great events or personages. *Corridistas*—composers and singers of corridos—served as the newsgivers of their time. The corridista had to be gifted in both poetry and music to condense all the news of the day into a song, and to be understood by all listeners, be they well or poorly educated. In New Mexico, villagers gathered round a corridista in the town plaza to hear the news. The term corrido (to run on or go without stopping) implies a lengthy song that continues without interruption or pause.

The early corridos related the adventures of heroes. These heroes were not of the noble classes,

but were "uncommon common men," like the vaqueros (cowboys) or heroes such as Pancho Villa. Corridos were written about events surrounding the French occupation of the 1860s, the American occupation, and the Mexican Revolution, to name but a few.

By the mid-twentieth century, the mood had changed, particularly along the border between Mexico and Texas, and corridistas began focusing on injustice and tragedy. In New Mexico corridos were composed to tell of the famous raid on the Tierra Amarilla Courthouse in 1967, and the New Mexico State prison riot of 1980—"Corrido de la Prisión" by Al Hurricane, Jr. Another recounts the Challenger disaster, which killed seven astronauts. Corridos have focused on renegades, the railroad, *machismo*, drug smuggling, drug dealing (called *narco* corridos), famous politicians, César Chavez, Vietnam Veterans, alcoholism, and the Chicano movement. Chicano theater playwrights of the 1960s and 1970s wrote about such border figures as Juan Nepomuceno Cortina, Gregorio Cortéz, Jacinto Treviño, and Joaquín Murrieta, who were also sung about in *corridos fronterizos*, or border ballads dealing with conflict between Anglos and Mexicans. The heroes of these ballads were considered by corridistas and playwrights alike to be social bandits or primitive revolutionaries.

The oldest known New Mexico corrido, "Corrido de la Muerte de Antonio Maestas," was written by Higinio Gonzales in 1889. The Texas-Mexican scholar, Américo Paredes, wrote that the borderlands were the birthplace of the modern corrido, which takes intercultural conflict as its primordial theme.

Cancionero—Lyric Song Types

The canción is a highly popular lyric song form that has survived into the late twentieth century. The term *canción* refers to any lyric song, often about love, that is not narrative in style. The original Spanish canción emerged in medieval Spain and was brought to the New World along with the romance. New Mexico canciones employ the *copla* form (see below) and emphasize the literary quality of the lyrics.

The *canción de amor* of the nineteenth century added a dimension of cultural identification and Hispanic pride in response to the wave of Anglo-Americans that followed the opening of New Mexico's borders to the east. As such it became a song of cultural resistance. A popular canción in New Mexico is "Las Mañanitas"(The Little Mornings), sung on birthdays and saint's days. Though originating in Mexico, its lyrics are known in every country in Latin America. In the twentieth century, canciones have many styles and are known by many names, including the *canción ranchera*, the *nueva canción*, the *nueva canción nuevomexicana*, the *canción mexicana*, and the *canción norteña*.

To better understand the canción, it is important to understand the text types or structures on which it is constructed.

Copla

The copla (couplet) is the basis of the most common poetic form in New Mexican folk song. It is comprised of four octosyllabic lines in abcb rhyme or assonance. Because each two-line copla forms a complete thought, it is highly useful in improvisation, as in entriegas and *trovos*.

Mi compadre y mi comadre	My godfather and godmother
los adoro con cariño	I adore with much love
ahí tiene a su hijito	there is your little child
guíenlo por buen camino.	guide him/her on a good road.

(From an entriega de los ángeles.)

Décima

The décima is the most complicated poetic form in the folk tradition of New Mexico. It evolved in fifteenth-century Spain from the romance and is comprised of a series of ten-line stanzas with a rhyme scheme of abbaaccddc. Most décimas were sung to the same tune with some variations to adjust to the lyrics.

No hay hora que me sujete,	There is no hour, my love,
vida mía, de ti el desvelo	That will let me sleep
porque la luz de tu cielo	Because the light of your heaven
en pie me tiene a las siete.	Keeps me on my feet until seven.
Y a las ocho me promete	And by eight it gives me the promise
que mis penas cesarán	That my sorrows will cease
y que a las nueve serán	And that by nine my acts of love
mis caricias bien pagadas.	Will be well rewarded.
¡A qué horas tan dilatadas	But, how long these hours are
y qué a poco a poco, dan!	And how slowly they strike!

[From "Qué largas las horas son,"
collected from Próspero Baca, Bernalillo, 1945,
by John Donald Robb 1954)]

The very popular *décima glosada*, as it was known in Spain, was introduced by a quatrain or *planta*, which contained the essential philosophical message of the intended song or poem (or the décima proper). This example of a planta is from *Los pastores*, in which Lucifer addresses the angels:

Aprended, flores de mí	Learn, my flowers
lo que va de ayer a hoy	that which goes from yesterday to today
que ayer maravilla fui	for yesterday I was a morning glory
y hoy sombra de mí no soy.	and today I am not even a shadow of myself.

This planta was written by Góngora (1561–1627), one of the greatest poets of Spain's Golden Age, and is one of the oldest décimas found in New Mexico. In a décima glosada, the sentiment of the planta is expanded

upon in four décimas, each ending with a line from the original planta. *Glosar* is "to comment or explain." Each of the four décimas expands on the original sentiment.

The décima became very popular in Mexico, but New Mexicans preferred the romance, probably because the music of the romance was simpler. Scholars found two singers of décimas in the 1940s who, like their predecessors, sang the same music for all the décimas they knew. The décima form was also used in some inditas. Although it is still current in the Caribbean and in Andean countries, décimas are no longer composed in New Mexico.

Trovo

These improvised singing duets, between two competing troubadours, were known to have been popular on the yearly caravans between Mexico and Santa Fe. They were also popular on special occasions, when they were either sung or recited. The term *trovo* derives from the troubador tradition of Europe, which may have been transported to Mexico; medieval troubadors were poet-musicians who often served as the news givers of the day. The *trovadores* were also called *poetas* (poets) and were known by special nicknames such as "el Negro,"

"Gracia," "Vilmas," and "Chicoria." Poetas had to be good improvisers, especially if working with the complex décima form. Poetas sang trovos to the same tune, indicating the greater importance of the text.

In the first part of the trovo contest, the trovadores taunted one another, using word plays or riddles to insult the other. Literary or religious references in their riddles were evidence of their brilliance and the basis for deciding who was the winner. In addition, some skilled trovadores improvised in the more complex décima form. In contemporary Latin American contests, the poetas are given a planta on which they must improvise forty lines within ten minutes. Such contests are still staged for prizes in Puerto Rico. Trovos are also still popular in Ecuador, Chile, and the Caribbean. The last of the old New Mexico trovadores died in the 1960s, so performances are seldom heard anymore.

Music of the Folk Dramas of New Mexico

Much is known about the religious folk drama *Los pastores* because at least eighteen versions are still performed throughout New Mexico. By contrast, many other once popular folk dramas are rarely pre-

The Poetic Craft of *Los Pastores*

Richard B. Stark, a twentieth-century scholar, comments on the expertise of early New World poets.

The folk drama, Los pastores, *for years an integral part of the folkways of the Spanish-speaking people of New Mexico and the American Southwest, is written in verse. The original writers of this play, undoubtedly ecclesiastics interested in illustrating the gospel in a dramatic form for their converts, show themselves to be well-versed in the art of poetry. This is demonstrated by their judicious employment of such poetic devices as synaloepha, diaeresis, hiatus, and compensación entre versos. Their knowl-*

edge of versification is shown in their use of such poetic types as the romance, the redondilla, *the* décima, *the* glosa, *and versos pareados, and in the way they handle a wide variety of lyric songs and ballads. In the shorter compositions the poets of* Los pastores *display great ability in the use of all types of lines, such as the tetrasyllabic, hexasyllabic, and pentasyllabic in combination with heptasyllabic lines. The majority of the poetic types used in* Los pastores *are patterned after similar poetic forms developed and used by the classic writers of Spain's Golden Age (1550–1680). (Stark 1969)*

sented. Because memory of these folk plays relies on one or two individuals within a community to keep and maintain copies of texts, and one or two musicians to maintain memory of the music, infrequent use can be the beginning of the end for many plays. Very few copies of many of New Mexico's folk plays are known to exist. Few if any recordings of music have been made, and only a handful of dedicated practitioners have made a conscious effort to revive them or keep them alive.

New Mexico scholar Arthur L. Campa grouped the types of plays known to have been performed in New Mexico into the following three categories:

- Old Testament subjects
- New Testament subjects, including plays of the Christmas season and Passion plays
- Prolonged struggle or an important incident

Of these, some copies have been preserved at the Museum of International Folk Art in Santa Fe, as indicated by the asterisks.

- Old Testament dramas
 *Adán y Eva**
 *Caín y Abel**
- New Testament dramas
 *Los pastores**
 *Los reyes magos**
 La pastorela
 El auto de los pastores
 El nacimiento
 El coloquio de los pastores
 El Niño Dios
 Los pastores chiquitos
 Camino de la pastorela
 *El niño perdido**
 *El coloquio de San José**
 La pasión
- Event or struggle dramas
 *Los Comanches**
 *Los Tejanos**
 *Los Moros y Cristianos**
 *Las cuatro apariciones de Nuestra
 Señora de Guadalupe**
 *Los Matachines** (technically a
 dance drama with pantomime)

Music is known to have been performed with some of these plays, and texts indicate that music was performed with others; however, aside from *Los Matachines*, *Los pastores*, *Los Comanches*, and a handful of melodies from *El Niño Perdido*, no music has yet been found for these plays.

Campa believed that missionaries wrote most, if not all, Old and New Testament plays and music principally for purposes of instructing New World converts. He found striking similarities between sixteenth-century Spanish religious drama and that of the New World. Campa also found that a natural evolution of purpose has occurred in that late twentieth-century performances of these dramas emphasize entertainment—as in the clowning of Bartolo or the riveting fearsomeness of Lucifer in *Los pastores*. In colonial times, the emphasis was on religious instruction.

Los Pastores (The Shepherds)
Until recently, scholars assumed that this play originated with the medieval morality plays of Spain. In the 1950s, Dr. Juan B. Rael of Stanford University researched this matter and concluded that there were no direct sources in Spain for this or any other New World *pastorela* (shepherd's play). He theorized that the missionary friars created *Los pastores*, drawing on their own musical and poetic abilities, to assist in the conversion of New World inhabitants. If anything, the spirit of the European morality plays is found in *Los pastores*, which teaches audiences as it calls upon them to react to dramatic action, and determine good from evil. *Los pastores* tells the story of the shepherds hastening to Bethlehem on hearing from the angels of the birth of Christ. Lucifer and the Archangel Michael, a major figure in New Mexico Catholicism, figure largely in the action, as do individual shepherds.

The different variations of *Los pastores* have been traced to the colonial Franciscan seminaries in Guadalajara, Durango, and Zacatecas, from which they were carried by the friars to California, Arizona, New Mexico, and Texas. Dr. Rael found eighteen versions of *Los pastores* in New Mexico that originated in Durango and Zacatecas, and another five in northern Mexico. (At the time of

Producing a Play in Old New Mexico

Formerly each placita *had its own troupe of entertainers and* danzantes *who performed* autos *(plays) and gave* danzas *(dances) during church fiestas. Parts were usually handed down from father to son. The whole village attended the rehearsals, hence the performance became a community enterprise. The night of the play, should an actor develop stage fright, the audience took on the role of prompter. Village women made the costumes, gathered the properties, decorated the hall, or church, as the case might be. No fee of admission was charged for the performance and the only remuneration received by the director and actors was the silver offering taken up the night of the play. Of course expenses were reduced to a minimum, the community sharing in the cost of production. The owner of the hall made no charge; the kerosene lamps and chairs were loaned by the neighbors; in winter each family contributed a few sticks of wood for the rehearsals and again for the play. Each actor furnished his own costume. Plays were nearly always given during the Christmas season, and in the villages where there was no resident priest, the performance took on the importance of the corresponding church service.*
(Weigle and White 1988)

his research in the mid-twentieth century, he found that the Texas plays had been published; the California and Arizona plays had been collected and housed in libraries and museums; and northern Mexico plays were still maintained as an oral tradition. In New Mexico, he encountered plays in hand-written form kept by individuals within their communities. Through time, new copies of each play would be made as the old copy wore out.)

With the exception of one shepherdess role, all of the music of *Los pastores*, including choruses, was traditionally sung by men. This changed during World War II when most of the men were gone and women temporarily took over principal roles as well as the chorus. Today, women sing in the chorus, and Gila (the shepherdess) is sung by a woman. Generally, no instruments are used. The music is harmonized when someone can provide it; otherwise the men and women sing the same choral melodies an octave apart. Some versions have as many as forty tunes within the play, alternating with spoken dialogue. Costumes are often homemade and colorful. One old gentleman interviewed by historian Richard Stark in the 1960s stated that *Los pastores* was performed in the outdoor patio of the Palace of the Governors by the light of oil lamps when he was a child. The play is still performed today from Las Cruces to Alamosa, with textual and musical variations from one community to the next.

Los Comanches (The Comanches)

A historical play and a religious enactment both carry this name; they are still performed in Alcalde. They were once performed in Taos, Galisteo, Mora, El Rancho, and many other northern communities. The religious enactment was also performed at San Mateo, Atrisco, and Seboyeta.

The late eighteenth-century historical play commemorates the final battles between the Spanish and the Comanches in New Mexico and is representative of the third type of New Mexico drama, as defined by Campa, the "Prolonged Struggle." Its music has been recorded only in Ranchos de Taos and Alcalde. The two main characters of this play are the Spanish general Carlos Fernández and the Comanche chief, Cuerno Verde. An analysis of the play reveals an intimate knowledge of the Comanche personality and battlefield tactics.

A Nativity enactment, also known as *Los Comanches*, is a dance drama performed on Christmas Eve or Three Kings Eve, depending on the community. Indian impersonators dance in procession to the house of the mayordomo. At the home of the mayordomo, or at the church—where the Santo Niño is kept—they are admitted ostensibly to admire the Holy Child. There, they sing an indita, which includes shouts and syllabic chanting, praising the Child, and singing of their visit. Then they steal the Santo Niño and rush out of the house, pursued by members of the audience. A mock

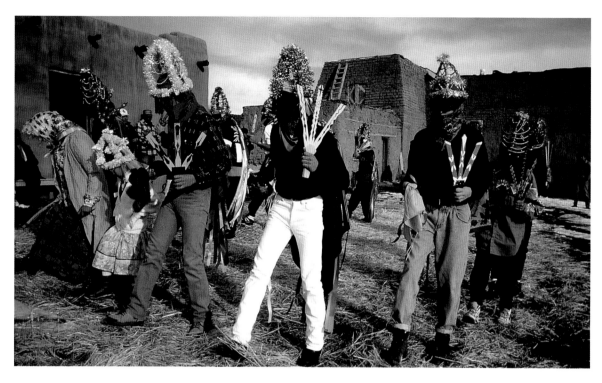

5.3
Matachines at Picuris Pueblo, December 24, 1992. Photo by Miguel Gandert.

battle follows in which the chieftain's daughter is captured and ransomed for the Santo Niño. Music and text—including a cautiva or an indita about an Indian captive—accompany the various *desempeños* (bargaining sessions) in which the ransom is completed and the new mayordomo is chosen for the following year. At Ranchos de Taos, the dancing occurs on New Year's Day and the music is fully pentatonic with syllabic chanting. All told, there are over twenty different known songs with dances in the Indo-Hispano Comanche repertory of northwest New Mexico.

Enrique Lamadrid has conducted extensive research on this extraordinary cross-cultural music and dance, and concludes that one of the reasons for the emergence of both plays described here was admiration for the Comanches by the Hispanic and Pueblo peoples of the Río Grande Valley. Having endured raids and kidnappings by the Comanches since the early 1700s, they grew to admire the persistence and courage of the Comanches. Another

reason for the plays was to remember the kidnapped children who never returned. At San Mateo, the Nativity play dictated that the Holy Child—a metaphor for kidnapped children—was gone, "never to return again." The Comanches were worthy opponents who, after being subdued in the late eighteenth century, became loyal traders. All Río Grande Pueblos still perform Comanche dances today to honor their former adversaries.

Los Matachines (The Matachines)
One of the oldest ritual, religious, dance dramas of New Mexico, *Los Matachines* was most likely introduced to the area by the early Spanish-Mexican settlers and their Tlaxcalan allies. Some Native American performers claim it to be of Aztec origin. Its roots are still not clear to scholars, although it has been narrowed down to Spanish-Arabic, Aztec, and/or Roman Catholic. The term *matachines* has been researched (Champe 1983; Romero 1993; Rodríguez 1996), but still remains

uncertain, although possibilities range as far afield as the British Isles and the Far East, and as far into antiquity as the Roman Empire. Some proposed translations include "to assume a mask" (Arabic), "dance of fools" (French), "to turn or make circles with a windlass" (Aztec), or "kill the china man" (Jemez Pueblo).

Los Matachines is unique because it is performed by both Hispanic and Native American communities. It is universal in its representation of the struggle between good and evil, old and new, conqueror and conquered. Visually, it is extraordinarily dramatic, with vivid colors, mesmerizing music, and an otherworldliness that is difficult to describe. Twelve men and, recently, women, in distinctive costuming, move as two units of six. Several individual dancers play out a drama in and around the twelve through a series of musical numbers and in pantomime. A Roman Catholic mass generally precedes the performance, followed by a feast. In Bernalillo, three days of religious and secular activities are scheduled around it.

According to popular tradition, Don Diego de Vargas made a vow to San Lorenzo (a Spanish martyr) to forever commemorate the saint in song and dance if his troops successfully reconquered New Mexico in 1692. Since that time, Vargas's *promesa* has been observed in Bernalillo, where every year on August 10, *Los Matachines* is performed following a Roman Catholic mass. In this context, it is a spiritual dance drama of the conquest. Today's dancers in Bernalillo also perform *Los Matachines* in fulfillment of private *promesas*, such as the survival of a war or a disease. The Bataan Death March in WWII was an event that initiated *promesas* among its many New Mexican participants and their families.

While sixteenth-century Pueblo Indians rejected participation in *Los Moros y los Cristianos*, they later embraced *Los Matachines*, which is still performed in Pueblo communities throughout New Mexico, often calling on Hispanic *músicos* from nearby villages to accompany the performances.

The music of this timeless and fascinating ritual dance is played on violin and guitar, but may also be heard as drumming and chanting at Pueblo performances. The violin and guitar music is repetitive,

hypnotically monotonous, and sometimes angular, with rhythmic reminders of Pueblo music. The tunes are short, varying in length from four to twenty measures, and repeated as many as thirty to eighty times. There is no singing. Pantomime rather than text tells the story of *Los Matachines*, thus facilitating communication with non-Spanish speaking observers. As in Pueblo dancing, the meaning and action of the drama is conveyed by the movement of dancers and the sounds of the music. The mood of the music follows the drama of the dance, and varies from solemn to playful. The story, meaning, and possible origins of the Matachines dance and the *Moros y Cristianos* drama are discussed further in chapter 8.

Music of Secular Ritual

In addition to folk dramas, New Mexicans have developed unique community celebrations and secular rituals that involve music.

Matar el Año Viejo/Dar los Días (Kill the Old Year/Give the Days)

Just before midnight on New Year's Eve, residents pull out their guns and rifles and "kill the old year" by shooting into the sky. *Dar Los Días* follows after midnight with music and singing to wake everyone who isn't already up after *Matar el Año Viejo*. Strolling musicians and singers walk from home to home singing complimentary verses to the residents, who then invite them in for warm refreshments, including empanaditas, bizcochitos and spirits to brace against the cold. Originally, this custom was called *Día de los Manueles* to honor the homes of those named Manuel (Emmanuel), the patron saint of January 1. On January 6, the ritual is repeated for those named Reyes (kings) in honor of the three kings. New and old canciones are sung, including "Las Mañanitas." Poems are also sometimes recited.

Sacar el Gallo (Take Out the Rooster)

To announce an upcoming baile, musicians rode through town on a horse or in a wagon, singing, rehearsing, and announcing the upcoming dance. In the twentieth century, musicians ride in a car with the windows rolled down, or in the back of a

pickup truck. They also ride farther than their predecessors, including through neighboring towns. Inevitably, politicians adopted this method of reaching the people. The origin of the phrase "take out the rooster" as it applies to this practice is unclear. The arrival of radio and television has contributed to the end of *Sacar el Gallo*.

Game Songs

Lively game songs helped Nuevomexicanos entertain themselves on long, winter evenings or lonely shepherd watches. Game songs were enjoyed equally by adults and children. One highly popular singing game was *El Cañute* (hollow reed), which was originally a semireligious Native American game. The Spanish settlers adopted El Cañute from the Pueblos. In El Cañute, the player who correctly guesses in which reed a slender stick or nail is hidden gets to sing the verse of victory. The music of El Cañute is similar in melody and harmony to the original Navajo and Pueblo chants, and is considered an indita. Navajo and Apache versions of this gambling game use moccasins as hiding places.

In the 1930s and 1940s, Works Progress Administration compilers collected songs that were later incorporated into a booklet entitled *Spanish American Folk Songs of New Mexico* (1936–37) and a book by Richard B. Stark entitled *Juegos Infantiles Cantados en Nuevo México* (1973). According to Stark and Campa, the songs in these collections are known throughout Latin America, but some of the older songs are the best preserved in all of the New World. In 1942, New Mexico educator Dolores Gonzales also collected fifty-one games and songs published under the name *Canciones y Juegos de Nuevo México*. The book, which includes game instructions and translations, was reprinted in 1974.

Music of Religious Ritual

The Spanish settlers' need to provide their own religious ritual in the absence of clergy naturally resulted in community-wide involvement, which in turn was instrumental in maintaining social order and function within the community. It bears repeating that in colonial days, the friars were assigned to convert the Pueblo Indians, not to serve the settlers, who for centuries made do with circuit-riding priests who appeared for major feasts whenever possible.

For the Spanish colonists, then, religious life was a cycle to be marked by music, song, and recitation. Birth, marriage, and death were observed and finalized through a folk liturgy developed over the centuries. The entriegas (the modern spelling is *entregas*) are songs improvised by a designated singer, customized for the participants of a baptism, wedding, or funeral. A casorio (wedding) is not considered complete until the entriega is performed. It is interesting to note that entriegas are not a part of the celebrations of southern New Mexico.

The French and Italian priests brought to New Mexico by Bishop Lamy in the mid-nineteenth century initially spoke little or no Spanish and were zealous in their efforts to codify religious practice in the area. Both the alabados and the entriegas became symbols of the natives' cultural resistance, and an excuse for the new clerical hierarchy to frown on nonauthorized religious practices. In the late twentieth century and early twenty-first century, these rituals and songs serve as strong cultural reminders after 150 years of American assimilation.

Entriega de los Ángeles (The Delivery of the Angels)

This baptismal ceremony with music and verse underscores and acknowledges the commitment and role of the Roman Catholic godparents (padrinos) as spiritual teachers of the child. The sung verses speak of this commitment and role. (See chapter 3 for full discussion of the baptism.)

Entriega de los Novios (The Delivery of the Bride and Groom)

The main feature of the wedding is an improvised entriega offering advice to the newlyweds, relating the events of the wedding, listing family members and important guests and members of the wedding party, detailing the significance of the union, and the responsibilities of the bride and groom. It is sung at the wedding reception, and is often very moving for all involved, as it often underscores the closeness and mutual love and respect between the family and the newlyweds. The multiversed

entriega—which may be written prior to the event, or improvised on the spot by one or more persons—leads into the dance of the newlyweds. During the dance, men of the community take turns dancing with the bride while women of the community take turns dancing with the groom, all paying either money or food for the privilege. The money is often pinned to the bride's veil or the groom's jacket.

Entriega de los Difuntos (The Delivery of the Dead Ones)

In colonial times, this entriega was performed at the grave site, prior to burial. The entriega singer would assume the persona of the deceased and sing an unaccompanied *despedida* (farewell song) in the form and style of an alabado. In the late twentieth century, gospel songs and Protestant hymns have become acceptable as despedidas.

Another pivotal musical form in New Mexico, the alabado, was created out of the same necessity that gave rise to the entriega. The alabado is a romance in terms of form. Its name is taken from the Spanish verb *alabar* (to praise), and in New Mexico is the musical expression of the Hermandad Piadosa de Nuestro Padre Jesús Nazareno, a two-hundred-year-old lay penitent brotherhood whose members devote themselves to year-round acts of charity and prayer. Alabados are sung without accompaniment. The *pito*, or whistle flute, *matracas*, or cog rattle, and/or drum, are sometimes heard as introduction, between verses, or as cues during Penitente rite. Alabados are sung during processions and rites in the moradas (Penitente chapels) during Semana Santa (Holy Week) and throughout the year at prayer vigils and funerals. Many alabados continue to be sung by the Penitentes throughout New Mexico.

The style of the alabado is simple, Gregorian chantlike, and generally of a mournful nature. Alabado texts reflect the sufferings of Jesus and Mary and the anticipation of life after death. The melodies and harmonies reveal the influence of Spanish, Moorish, and Arabic music. Much of the alabado repertory is unison antiphonal singing (alternating choruses), where a quatrain, or main verse, is repeated by the congregation.

Historian Richard Stark attempted to find connections between the New Mexican alabado and Sephardic (Hispanic-Jewish) hymns and/or Italian *laudi spirituali* by virtue of their common melodic ornamentation and semimodal harmonies. The Italian laudi spirituali were folk hymns that originated with St. Francis's followers and may have been brought to the New World by the Franciscans, who were exclusively chosen by Queen Isabela to convert the natives of the New World. Stark found ties to the *saeta primitiva*, an improvised song form originating in Sevilla, which was the center of Franciscan missionary activity in the sixteenth century—another logical conduit to the New World. He concluded that while the alabado may have begun in Spain, it was probably developed further in Mexico before arriving in New Mexico.

Music researcher Enrique Lamadrid believes there is very little to tie the stylistically different saeta primitiva with the alabado other than melismatic melodies, yet there are several Old World alabados sung in New Mexico singing style. Musicologist Brenda Romero identified a stylistic connection between New Mexico alabados and Arabic music, specifically the funeral laments of the Shi'ite Moslem culture of Lebanon, one of which is similar enough to a New Mexico alabado that it could be considered a variant of the same song (Romero 1993). Recent findings show that the majority of New Mexican alabados were written in Mexico, probably by priests or lay singers who were drawn to the popular folk hymn style. Today, these alabados are sung largely in New Mexico and southern Colorado.

Two other types of religious songs are the *alabanza* and the *alba*. The alabanza is a song in praise of the Virgin or the saints. The term alabanza means praise. The alba is a song sung at daybreak, especially after all-night prayer sessions called velorios. The alba traces its roots to pre-Christian songs used for greeting the sun; in Hispanic tradition, alba texts often refer to the birth of Christ, expressing the Christian notion of greeting the "son" as well as the morning "sun." Some older Nuevomexicanos still sing an alba every morning because it is uplifting as well as tradi-

tional. Albas are sung a cappella (unaccompanied) in the style of the alabado and include antiphony.

La Pasión (Passion Play)

The passion play—dealing with the suffering and death of Jesus Christ—is privately enacted during Semana Santa throughout New Mexico. It is comprised of recitation and song in the enactment of the Roman Catholic Stations of the Cross. Its structure varies from one community to the next, but generally includes ritual, prayer, processions, and community involvement, with the Penitentes at the center of activity. Its basic song form is the alabado. On Good Friday morning, stations one through nine are observed; followed by stations ten through fourteen in the afternoon. The most popular enactment is the *Encuentro*, the fourth station in which Mary encounters her son on the way to his crucifixion. Early enactments were ridiculed or otherwise disrespected by non-Nuevomexicanos, so the Hermanos began performing them privately and in remote or semiremote locations.

Las Posadas (The Inns)

This Christmas enactment of the search by Joseph and Mary for lodging on Christmas Eve generally includes the entire parish or community. A chorus of men and women approaches nine homes—one each night beginning December 16—where they sing antiphonal canciones requesting lodging. Those within the house sing in response, at first refusing lodging until those outside reveal that it is Mary and Joseph. The travelers are then invited in, where everyone partakes of hot chocolate and bizcochitos or similar Christmas fare. In some communities, all nine homes are visited on Christmas Eve, beginning at noon. The last visit may be followed by a performance of *Los pastores* at the church or school. *Las posadas* is still performed every year in many rural and urban New Mexico communities.

Las Mañanitas

This song is sung just past midnight or at dawn to a person celebrating a saint's day or a birthday. The tradition of observing a saint's day rather than birthdays is typical throughout the Spanish-speaking world, while singing "Las Mañanitas" in celebra-

tion of these days originated in Mexico. In New Mexico and southern Colorado it also is sung at many festive events.

Structurally, the song, which has been called a liturgical hymn, makes references to the Old Testament, specifically to King David, who is remembered as a singer and a poet, and the psalms. The lyrics, which are simple yet poetic, are more universally known in New Mexico than any other. The tradition of singing "Las Mañanitas" at birthdays grew out of the fact that a person was often named for the saint on whose day he or she was born, hence a saint's day and birthday were celebrated on the same day.

Music in the Twentieth Century

Soon after the coming of the railroad in 1880, the traditional music of New Mexico began to be collected, studied, commercially recorded, celebrated in festivals, and broadcast nationwide. Simultaneously, Nuevomexicano musicians began to absorb and assimilate the traditional music styles of other parts of the hemisphere as heard on radio and television, or from visiting musicians. A new generation of composers continued to create music for the Church, but now some of them were seeing their work published and disseminated around the nation. Self-awareness expressed itself in the research and performance of old folk dramas and in the use of traditional music for political protest.

The market for New Mexico Hispanic and Native American culture began in 1881 when Charles Lummis began romanticizing the Southwest in his writings, which were widely read by Americans. In 1893, he published for this nationwide readership a collection of New Mexico "shepherds' songs." Presumably to entice readers, Lummis wrote that the old music of New Mexico was no longer being created and that the existing repertoire was a relic of the remote Spanish past. At the same time Lummis was writing about New Mexico, Americans were visiting New Mexico, via the new railroad, in search of the exotic and unusual. New Mexico cultural tourism was born.

Possibly to counteract the overly romantic writings of visitors like Lummis, the serious study of

New Mexico also was born at about this time. Important New Mexico music scholars of the first half of the twentieth century include folklorists and linguists Aurelio M. Espinosa, Arthur L. Campa, Rubén Cobos, and music historian Juan B. Rael. In the first two decades of the twentieth century, Espinosa gathered material for his famous *Romancero Nuevomexicano*, a collection of romances including 248 versions of 90 Spanish romances from New Mexico. Espinosa espoused and promoted New Mexico ties to Spain when writing about music. This is understandable as it occurred during the time New Mexico was seeking statehood and New Mexicans found it necessary, among other things, to emphasize Spanish ties over Mexican to gain acceptance (see chapter 1). Hence, the numerous inditas, cuandos, décimas, and corridos he collected were labeled "vulgar ballads" of little significance and only local interest, despite the fact that many of these "vulgar ballads" were published in numerous Spanish-language newspapers in New Mexico beginning in the 1860s.

Not until Espinosa's student, Arthur L. Campa, began writing monographs and articles did Mexico receive the attention it deserved as a major influence on the music of New Mexico. Espinosa's emphasis on Spain as New Mexico's major musical influence was balanced by Campa's more nativist analysis of the material. Campa was thus able, along with other scholars who followed, to fill in the gaps of Espinosa's *Romancero*. However, inditas still went largely unstudied until the late twentieth-century work of Enrique Lamadrid and Brenda Romero.

In 1945–46, Mexican musicologist and folklorist Vicente T. Mendoza arrived in New Mexico at the invitation of University of New Mexico (UNM) music professor John Donald Robb, whose own work in gathering and classifying Hispanic music spanned many years and resulted in two published works. Working for eight months, Mendoza conducted archival and fieldwork resulting in the first comprehensive study of New Mexico folk music, written in collaboration with his wife, folklorist Virginia Rodríguez. Together, they collected, analyzed, classified and explained the texts and music of 324 New Mexico Spanish folksongs representing fifteen different genres. Their study was published four decades later. Dr. Lamadrid would later write:

Vicente T. Mendoza brought skills and

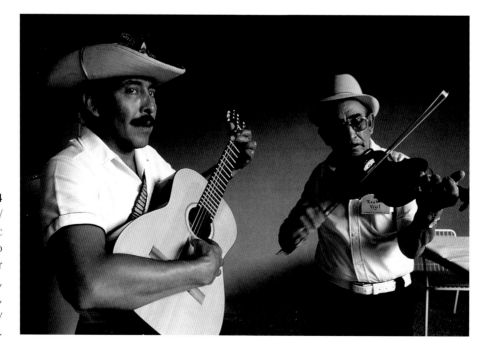

5.4
Musician/ songwriter/music historian Cipriano Vigil and his father Rubén of Chamisal, New Mexico, 1986. Photo by Miguel Gandert.

insights to bear that in New Mexico have not been surpassed before or since. His gift was that he combined the insight of a literary scholar with the finely tuned ear of a musicologist. His precise musicological analyses have unlocked the mystery of the Nuevo Mexicano musical style and his observations on genre classification, popular poetry, ballads, and lyric expression are a major contribution to the field that intimately inform John D. Robb's *magnum opus* (1980), and provide a counterpoint to the theories of Espinosa, Rael, Campa, and the distinguished Texas Mexican scholar, Américo Paredes. (1997)

In the 1960s, Juan Rael produced two books on the pastorelas in the Southwest and on the alabado. During the 1950s and 1960s, field recordings were conducted by Rubén Cobos and John D. Robb, to be followed by Jenny Wells Vincent, Richard Stark, Rowena Rivera, and Jack and Katherine Loeffler. Others working today in studying and preserving the traditional music of New Mexico are Cipriano Vigil, Brenda Romero, Enrique Lamadrid, James Leger, Peter García, and Peter White. The Loefflers' considerable field recordings and study resulted in a series of over one hundred radio programs aired on National Public Radio, a film entitled *La Música de los Viejitos*, and three major folk music festivals of the same name.

Popular Music

The first half of the twentieth century also saw a large increase in audiences for both traditional and popular Hispanic music, partially as a result of growing activity in the Southwest by the recording industry, and partially as a result of traditional music performances at festivals and other intercultural public events in the Southwest, and subsequently around the nation. Commercial recording companies set up shop in southern Texas in the 1930s to record local musicians, thus shining a spotlight on musical genres that had never before been heard outside the Southwest. Several types of music that developed in southern Texas greatly influenced New Mexico musicians, including *música norteña* (an instrumental dance music of the working class

characterized by the use of the button accordion and known also as Mexican-Texan *conjunto* or *conjunto norteño*), *ranchera* (Mexican country), and *La Onda Chicana* (Chicano Wave—a fusion of Mex-Tex ranchero, American jazz, and rock, popular in the 1970s). Other genres partially assimilated in New Mexico include Latin rock and *música tropical*, or *salsa*, from Latin America and other Hispanic population centers within the United States, such as New York, Los Angeles, Miami, and Chicago.

Also highly popular in the Southwest are mariachi bands and the *orquesta típica*, both developed in Mexico from the same nineteenth-century ensemble type. Orquesta típica is an ensemble built around the violin, always with one or more guitars and occasionally a psaltery (an instrument comprised of a flat soundboard over which strings are stretched). When this genre migrated to the Southwest in the 1920s, other instruments were added as available. Today, José Pablo García's orquesta típica of Las Vegas, New Mexico, is one of the best known in the state.

The mariachi band developed as a folk tradition in rural Mexico. It was comprised entirely of stringed instruments, the most authentic and the earliest combination being the violin, *vihuela*, and harp. When adopted in Mexico's urban areas and featured on radio broadcasts in the 1930s, the trumpet replaced the harp so that it could be more easily heard over the radio. Its success was such that the "trumpet mariachi" became Mexico's unofficial national ensemble. In New Mexico, mariachi music did not catch on until it was heard on the radio and in Mexican films during the 1930s and 1940s, and with the arrival of more and more Mexican immigrants in to the area since the 1950s. Local musicians adopted its style and New Mexicans made it highly popular, particularly for public events. Today, Mexican-American mariachi bands experiment with instrumentation by adding conga drums and accordions, for example, and by the addition of female musicians. Mariachi music is celebrated every July in Albuquerque at the Mariachi Spectacular, which invites bands from the United States and Latin America to interact with students and enthusiasts in a weeklong series of

The Roberto Martínez Family of Musicians

Roberto Martínez is the head of one of New Mexico's foremost musical families, and the founder of Los Reyes de Alburquerque, which specializes in traditional Hispanic music of northern New Mexico and southern Colorado. The group has performed at festivals throughout the nation and in Washington at the Smithsonian's Festival of American Folklife in 1985 and 1992, at the Museum of American History, and at Wolf Trap. They have joined three national tours with the National Council for Traditional Arts and Raíces Musicales Tours. A typical New Mexico ensemble, they perform mariachi with a distinct New Mexico flavor, rancheras, can-

ciones, and original corridos emphasizing social justice issues. For years the group has performed in nursing homes and senior centers throughout New Mexico. Recently they have expanded to include adult day-care centers for the disabled and homeless centers. The Mexican network, Telemundo, featured the Martínez family in a segment televised throughout Mexico and Central America.

In 1981, Lorenzo Martínez, son of Roberto, recorded an album entitled Ambos, featuring his New Mexico violin style. At sixteen, he recorded his first album, El Redondo Largo. His sister, Deborah, known to her considerable fans as La Chicanita, also

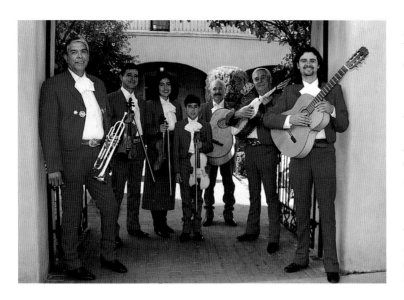

5.5
The Martínez Family and members of Los Reyes de Alburquerque. From left, Ray Flores (trumpet), Lorenzo Martínez (violin and music arranger; Roberto's son), Angela Pérez (violin), Larry Martínez (violin and vihuela; Lorenzo's son), Miguel Ojeda (guitarrón), Roberto Martínez (vihuela; patriarch of family); and Roberto, Jr. (guitar and bass guitar). Not shown are Debbie Martínez, vocalist and Roberto's daughter, and Sheila Martínez (Debbie's daughter). All are vocalists. Courtesy Roberto Martínez.

classes, discussions, rehearsals, and public performances.

With literally a world of styles from which to draw inspiration, most contemporary Nuevomexicano musicians continue to be eclectic and versatile in what they perform, and as such, defy

categorizing. Roberto Mondragón recorded two well-received albums, *Que Cante Mondragón* and *Amigo* in the late 1970s and early 1980s, comprised primarily of canciones and corridos. He has concentrated much of his time on the elderly, bilingual issues, and Hispanic cultural education

5.6
Sheila Martínez performs the violin. Music, like all traditional arts of New Mexico, is handed down within families. Courtesy Roberto Martínez.

5.7
Roberto's grandson, Larry Martínez, in performance. Roberto's great granddaughter, 6-year-old Desireé Sánchez, is learning folkloric dance, and soon will begin learning to sing and play the violin. Courtesy Roberto Martínez.

recorded several albums and cassettes of ranchera, mariachi, and canciones. Deborah's daughter Sheila plays the violin and sings, and Lorenzo's son Larry plays the violin and guitar. On some occasions, Roberto's great granddaughter, Desireé, who performs with Baila! Baila! Dance Company, dances at family performances. At such occasions, four generations may be seen performing together.

Roberto's mother taught him many inditas. He remembers his father singing old songs on their annual trips to the mountains to cut firewood. Roberto's first instrument was a guitar fashioned from a gallon-sized gasoline can with a long narrow board and some wire. "I couldn't tune it," he said, "But I used it to get inspired."

through publications and a radio program based in Santa Fe. This focus informs his music and original compositions.

The Sánchez Family, headed by Alberto "Al Hurricane" Sánchez, also has gained considerable fame in New Mexico and the Southwest in the area of popular and rock music. In the 1950s, Al Hurricane and his brothers—Mauricio, "Tiny Morrie" and Gabriel, "Baby Gaby"—succeeded in transposing the ranchera tradition into a local style that included trumpet and saxophone arrangements known as the "Albuquerque sound." They

performed original songs, plus the occasional corrido and old New Mexico tunes, bringing those tunes to a larger audience. The family's current musical focus has been on the next generation, including the internationally popular "Lorenzo Antonio" and five Sánchez girls, who have formed a highly profitable, internationally popular Latin rock group called Sparx. It is interesting that this pop-oriented group has recorded its own engaging, high-energy versions of corridos and even "La Rana" without compromising or obscuring its traditional origins.

With the increasing accessibility of recording technology, community bands and singers throughout New Mexico began producing cassettes and later, compact discs, of their music for distribution primarily in New Mexico. It was only a matter of time before an organization dedicated to recognizing and encouraging New Mexico Hispanic music of all genres would be established. The New Mexico Hispano Music Association held its first annual awards ceremony in Santa Fe in 1991. Since

then, the association has presented awards to individual performers, composers, dance bands specializing in popular and traditional music, and lifetime achievement awards. While the New Mexico Hispano Music Association was initially designed for popular, ranchera, rock, and norteño music, organizers added a folk category not long after its founding, due to popular demand.

Traditional Music

The Smithsonian Institution produced the first recording of New Mexico folk music in 1961 on its Folkways label. Entitled *Spanish and Mexican Folk Music of New Mexico*, it consisted of samples collected by J. D. Robb. Also recorded in the 1960s was Alex Chávez's *El Testamento and Other Songs* and *Duérmete, Niño and Other Songs*, anthologies of traditional songs collected and performed by Mr. Chávez, a trained singer, arranger, and composer. Only a handful of locally produced recordings were available in the decades that followed, including *Cipriano con la Nueva Canción Nuevo-*

Alex Chávez: Singer, Teacher, Composer

Alex Chávez has, for forty years, collected, composed, arranged, conducted, taught, and sung the traditional music of New Mexico and Viejo Colorado (Old Colorado), where he was born. Now in his seventies, he concentrates on incorporating his collected texts and song materials, numbering in the hundreds, into an anthology. Like other contemporary New Mexico musicians, he is not content to perform, but is drawn to experiment with and transform or combine existing styles and forms. His Wind among the Willows *(1996) is a multifaceted play with music depicting various rituals; for example, "El Día de los Santos" (patron saint's day), "El Casorio" (the wedding), "La Hermandad" (the Brotherhood). It is set in Los Sauces, Colorado, and is narrated in English.*

His music is inspired by his faith. In 1995, he completed three works as a triptych of original hymns dedicated to the Virgin Mary, entitled Tribute to Mary: A Chorale Triptych. *His arrangements include one of the songs from* Los pastores, *entitled "Es el mes de María," commissioned by Quintessence and performed later by the Santa Fe Desert Chorale on National Public Radio. It is included in an NPR-produced compact disc entitled* Christmas Around the Country. *The Albuquerque Women's Ensemble introduced it to audiences in Italy in 1996. His* El Testamento and Other Songs *and* Duérmete, Niño and Other Songs *were remastered and released by the John Donald Robb Musical Trust in 1995.*

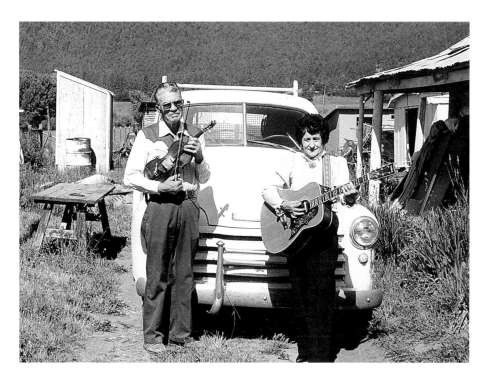

5.8
Musicians/songwriters Max and Antonia Apodaca of Rociada, New Mexico, 1987. Photo by Jack Parsons. Jack Parsons and Jim Sagel, *Straight from the Heart*.

mexiana (1985) in which musicologist-musician Cipriano Vigil of Chamisal and El Rito, New Mexico, performed folk music of New Mexico and introduced his *nueva canción nuevomexicana* (literally, new New Mexican song), accompanied by Latin American instruments. Dr. Vigil's new song represented the northern New Mexico version of the nueva canción, a folk revivalist movement of Latin America, characterized by poetry and political content. His recordings are characterized by his knowledge of and facility with seventy-two instruments of Indo-Latin-American origin (he owns another 128). His next recording, *Los Folkloristas de Nuevo Mexico*, was released in 1991, one year prior to Folkway's next effort in recording New Mexico music.

Music of New Mexico Hispanic Traditions, released by Folkways in 1992, was a significant recording milestone because it was the most comprehensive gathering of New Mexico traditional music ever assembled on a single recording. It presented examples of many genres of New Mexico music, including various dances, alabado music, Matachines music, canciones, corridos, relaciones,

entriegas, music for religious drama, romances, and hymns, with extensive notes and translations by James Leger and Enrique Lamadrid. It was also the first recording to include examples of inditas, which had remained misunderstood and ignored until this time.

This recording became one of several that were released in the early 1990s. UBIK Sound in Albuquerque, headed by electronic composer-musician Manny Rettinger, began producing and distributing recordings of traditional New Mexico music in a limited venue with limited funding. UBIK recorded music of violinist Cleofes Vigil; singer, guitarist, and accordionist Antonia Apodaca (who first gained prominence through the Loefflers' *Música de los Viejitos* festivals and would eventually be invited to perform at the White House); Chicano singer Jesus Armando "Chuy" Martínez, a gifted corridista and performer of a large repertory of songs from the farmworkers and Chicano movements; a Matachines performance; and music selected and performed by Bayou Seco.

Chuy Martínez has been an activist for decades, cultivating the nueva canción in his recording,

"Canto al Pueblo" (1993), while also using his talents to educate multicultural audiences, through radio and stage performances, about the prolific and touching music of the migrant labor camps, the Chicano movement, and the music of Mexico. Accordionist Ken Keppler and violinist Jeanie McLerie of Bayou Seco are Louisiana transplants who embraced the traditional music of New Mexico, diligently researching and recording through the years. They formed close artistic ties with Cleofes Ortiz and Antonia Apodaca. Bayou Seco's *Songs of New Mexico and Beyond* demonstrates their collaboration with these regional musicians.

In 1994, Enrique Lamadrid and Jack Loeffler published *Tesoros del Espíritu: A Portrait in Sound of Hispanic New Mexico*, a combination book-and-compact-disc, or cassette recordings, tracing the musical and literary history of New Mexico's Hispanic people through music, drama, poetry, remembrances, and official documents, read or sung on the recordings as they appear in the book (illustrated with photographs by Miguel Gandert). This project was initiated by Lamadrid and Loeffler as an audio installation of folk music and oral traditions in the Hispanic Heritage Wing, which opened in 1989 at the Museum of International Folk Art in Santa Fe.

New Mexico's leading native ethnomusicologists are Brenda Romero of Alcalde, James Leger of Las Vegas, and Peter García of Alameda. Romero wrote her doctoral dissertation on the traditional Matachines music of

Four Contemporary Composers

In the tradition of his ancestors, **Henry Rael** of Río Rancho composed one hundred hymns, even though he doesn't read or write music. In 1986, he taught offset printing at Bernalillo High School. Mary Frances Reza served as his transcriber and arranger. Mr. Rael, like his fellow músicos, considered his compositions prayers given freely to the church, and expected no reward, at least not in this world.

Eduardo P. "Lalo" Silva of Belén was a railroad car mechanic whose private life was filled with musical composition and performance. He has written thirty-two hymns and one mass, but also writes prayers and poetry. He formed a band, which performed traditional New Mexico music, including the humorous corridos he occasionally writes for friends. He writes for all seasons—on the arrival or departure of priests at his parish, on the occasion of his daughter taking vows as a nun, and his wedding anniversary. Mr. Silva owns twenty instruments, including an antique organ and upright piano, but writes no more than melodies.

Pablo Gallegos is a native of Barelas, and a former Trappist monk who left the monastery to care for his aging parents. He survives by conducting five to six prayer meetings a week, and at wakes, for freewill donations. The music he writes for these gatherings, and for the mass, is a mix of ranchera style, traditional Hispanic songs, Carey Landry, and Protestant church music. He learned to play the guitar at age thirty-six and has produced several cassette tapes.

Arsenio Córdova first began composing in 1978, and by 1986, had written thirty hymns and twelve masses. He is probably the most widely known liturgical composer in New Mexico, and the most frequently published. He is also the best trained, with college studies in music composition and voice. His music has been bootlegged (stolen to make copies for unauthorized sale), a clear indication to him that his music pleases. His highly successful Cantos a Mi Dios is sold all over the country. Mr. Córdova has also researched and revived religious folk dramas popular in Spanish Colonial New Mexico for performance near his home in El Prado, New Mexico.

Alcalde and San Juan Pueblo, and has performed for several years as a violinist for Jémez Pueblo's Matachines dance. James Leger's musical scholarship has resulted in extensive album notes for several recordings by Roberto Martínez, plus the 1992 Smithsonian/Folkways *Music of New Mexico/Hispanic Traditions* recording. He is also a talented musician and founding member of Mariachi Río Grande, another group that interprets the mariachi repertoire for Nuevomexicano audiences. Peter García has researched the history of Nuevomexicano popular music and the many-layered musical cultures of the state.

As New Mexico's traditional music became better known, musicians were invited into schools, to community gatherings, and to out-of-state festivals to perform or provide workshops and lecture-demonstrations. The cities of Bernalillo and Las Vegas followed Santa Fe's lead by establishing annual folk music festivals. The state's arts agency authorized funding for its Folk Arts Apprenticeship Program, which funded multidisciplinary artistic training from teacher to apprentice. Thus, for example, was Chuy Martínez able to teach young, promising students the intricacies of writing a corrido. La Compañía de Teatro de Alburquerque, established in 1979, incorporated old and new music into its numerous original productions dealing with historic or contemporary Hispanic New Mexico.

The Spanish *zarzuela* — a comic operetta form popular in Spain and Latin America in the late nineteenth and early twentieth centuries — made its appearance in New Mexico in the early 1980s when two companies were formed in Albuquerque to stage and tour this colorful, highly nationalistic genre. It began in 1952, when a found-object artist discovered hundreds of handwritten zarzuela manuscripts in a hillside town dump in Jerome, Arizona. They were gathered and donated to the University of New Mexico, where they were briefly examined by John D. Robb before going into storage. In 1972, they were brought out of storage to become the subject of a master's thesis by Mary Montaño, a doctoral dissertation by Sally Bissell Quintana, and a fair amount of publicity.

In 1981, La Zarzuela de Alburquerque began producing zarzuelas in Albuquerque. In 1983, ¡Viva Zarzuela! began presenting full productions and anthologies in Albuquerque, and at the international zarzuela festival in El Paso, and in schools throughout New Mexico. To produce a working score, volunteers painstakingly transcribed the old original manuscripts into new handwritten scores or onto computer-generated scores. The zarzuela is accompanied by a small stage orchestra and consists of spoken dialogue alternating with arias, duets, ensembles, and choruses. The zarzuela is uniquely peninsular; as such, it is not considered New Mexican, although like flamenco, its popularity and activity here is unique among Southwestern states.

Religious Music

In 1963, the Second Vatican Council of the Roman Catholic Church ruled that the Ordinary of the Mass, which includes the *Kyrie*, *Gloria*, *Credo*, *Sanctus*, and *Agnus Dei*, would no longer be restricted to Latin. It could now be recited or sung in native languages worldwide. This ruling resulted in a renaissance of musical creativity in New Mexico as many untrained faithful began composing hymns and masses with Spanish texts. Every week most of the Catholic churches in New Mexico celebrate at least one Mass in Spanish, which is to say it is prayed and sung in Spanish by the congregation or by a choir trained to sing old and new music. Some of the new music is created in Spanish by ordinary people, such as retired railroad worker Eduardo P. "Lalo" Silva of Belén, retired government worker Arsenio Córdova of Taos, high school teacher Henry Rael of Río Rancho, music librarian Mary Frances Reza of Albuquerque, and government case worker Juan Lucero of Torreón.

The Archdiocese created a new department, the Office of Musical Liturgy, to monitor the large amount of music being created for services. As head of that office from 1986 to 1994, Mary Reza became an informal clearinghouse of music, as well as a front line observer of musical activity during that time. She received hundreds of cassettes as part of the Church's requirement to screen all new music

for "suitability" for the mass. She referred many exceptional works to the presses. In all, about forty publications became available in the late 1980s and early 1990s. Her own quarterly publication, *El Misalito Canta, Pueblo de Dios*, a booklet that sold for twenty-five cents a copy to parishes around the nation, contained lyrics (but not music) to eighty hymns and two masses. The booklet prompted requests for the melodies from all over the nation. The renaissance of New Mexico music at first met with indifference from the music publishing industry. Then the Oregon Catholic Press in Portland took a chance, and when it turned a profit, other presses followed.

The Queen of Heaven Parish in Albuquerque supported its Spanish choir for several years with a Sunday morning broadcast every week. As such, it served unofficially as the centerpiece of Spanish religious music for its immediate area, featuring old and new songs gathered from New Mexico, Spain, and Latin America by its director, Max Madrid. Local composers also got good exposure and fine renditions under the sure hand of Mr. Madrid, a trained musician and conductor. The choir was accompanied by a minimum of three guitarists, an occasional violinist, and of course, the organist. Just after mass, those celebrating a birthday that day or that week approached the choir as it sang "Las Mañanitas" to them, a touching urban gesture reminiscent of the origin of the traditional morning serenade.

Juan Lucero was well known in the 1970s in Albuquerque as a Spanish-language disk jockey. He taught his children to play and sing, and made a recording with them. After moving back home to Torreón, he dedicated himself to composing religious music and corridos. His hit song "Soy Manito" is used in bilingual classrooms across the state.

Chronology

1598	Don Juan de Oñate's settlement party and soldiers perform first folk drama, probably with music, on the banks of the Río Grande del Norte. While it is often thought to be the first theater piece performed in North America, settlers at St. Augustine in Florida were probably staging similar plays earlier in the century. Oñate's settlers performed *Los Moros y Cristianos* pageant on horseback, with dialogue and music, which is still frequently performed in New Mexico, rendering it the longest running theater piece in North America.
1607–1680	Music employed by missionary friars to teach Indians about Christianity.
	Los pastores and other plays on Old and New Testament subjects probably brought to northern frontier missions during this period.
1672	"A set of trumpets and a bassoon" valued at eighty pesos listed in inventory at Franciscan mission at Socorro (Scholes and Adams 1952).
1706	The Comanches migrate to the southern Plains and join the Apaches and Navajos in raiding the Río Grande Valley Hispanic and Pueblo peoples. Inditas arise from the mix of Hispanic and Indian music, including a subcategory called cautivas, about kidnapped women and children.
1776	Fray Francisco Atanasio Domínguez records the existence of violins and guitars at three missions on his inspection tour of New Mexico missions.
1810–1848	American visitors to New Mexico, including Zebulon Pike, Josiah Gregg, George C. Sibley, and J. S. Abert attend bailes and fandangos and write about them in journals, diaries, and letters.
1860s	French presence in Mexico encourages growth of dance bands in Mexico. Polish and German migration into Mexico, Texas, and New Mexico gives rise to new dance forms in New Mexico, including the *varsoviana*, *polca*, *valse*, and *chotiz*.
	Emergence of the Mexican corrido.
1890s	Development of conjunto norteño music along the Texas-Mexican border. Development of "heroic" corrido in the Southwest.
1893	Collection of New Mexico Hispanic shepherd songs included in Charles Lummis's *The Land of Poco Tiempo*, a widely read book that helped launch cultural tourism in New Mexico.
1910	Mexican Revolution begins. Corridos written about the struggle and heroes of the revolution.
1915–1917	Serial publication of *Romancero Nuevomejicano* by folklorist Aurelio M. Espinosa, representing the first written history of the Hispanic music of New Mexico.

1930s Development of the trumpet mariachi sound in Mexico City.

1945–1946 Dr. Vicente T. Mendoza, Mexican folklorist and musicologist, visits New Mexico, where he collects, analyzes, classifies, and explains the text and music of 324 Hispanic folksongs representing fifteen different genres. His visit results in an eight-volume typescript, *Estudio y Clasificación de la Música Tradicional Hispanica de Nuevo México*, later published by the Universidad Autónoma de México in 1986.

1961 The Smithsonian Institution produces the first recording of New Mexico folk music on its Folkways label. Entitled *Spanish and Mexican Folk Music of New Mexico*, it consisted of samples collected by J. D. Robb.

1976 Jack Loeffler produces film entitled *Los Alegres* on Hispanic folk dance of New Mexico.

First of 150 radio broadcasts entitled *La Música de los Viejitos* aired from Santa Fe under the direction of Jack Loeffler.

1977 *La Compañía de Teatro de Alburquerque* founded. Many productions showcased traditional and contemporary Hispanic music, introducing it to new audiences throughout New Mexico.

1982 Jack Loeffler produces film entitled *La Música de los Viejos* based on radio broadcasts.

1984 First of three music festivals named after, and celebrating, *La Música de los Viejitos* held annually in Santa Fe over the next several years.

1980s–1990s Unprecedented number of recordings released featuring New Mexico Hispanic music.

Twenty-six programs from *La Música de los Viejitos* radio broadcasts circulated nationwide.

1991 New Mexico Hispano Music Association established.

1992 *Music of New Mexico Hispanic Traditions* released by Folkways, a significant recording milestone in that it was, to this time, the most comprehensive gathering of New Mexico traditional music ever assembled on a single recording.

New Mexico musicians travel to Washington, D.C., to perform at the Smithsonian's Folklife Festival featuring New Mexico.

1998 & 1994 Dr. Enrique Lamadrid and Jack Loeffler publish *Tesoros del Espiritu: A Portrait in Sound of Hispanic New Mexico*, a combination book-and-cassette-recording tracing the musical and literary history of New Mexico's Hispanic people through music, drama, poetry, remembrances, and official documents, read or sung on the two tapes as they appear in the book.

1999 Jack and Katherine Loeffler, with Enrique Lamadrid, publish *La Música de los Viejitos* as a book with three-CD sampler of the large Loeffler archive.

Glossary

Alabado—An unaccompanied song in praise of God (*alabar*, to praise) sung in paraliturgical settings in New Mexico. A romance in form, much of the alabado repertory is unison antiphonal singing (alternating choruses), where a quatrain, or main verse, is repeated by the congregation.

Alabanza—A song in praise of the Virgin or the saints.

Alba—A song sung at daybreak, especially after an all-night prayer vigil.

Antiphony—A style of music where one choir or voice sings and a second responds.

Canción—Any lyric song, often about love, that is not narrative in style. The original Spanish canción emerged in medieval Spain and was brought to the New World along with the romance.

Cautiva—An indita lamenting captivity by Indians.

Copla—Couplet, comprised of four octosyllabic lines in abcb rhyme or assonance; the basic unit of a song's lyrics.

Corrido—The romance form of the nineteenth and twentieth centuries, the corrido celebrates events and personages and was written by corridistas as a means of communicating news of the day. The term derives from *corrido*, meaning to run on or go without stopping, implying a lengthy song without interruption.

Corridistas—Composers and performers of corridos. They were gifted in both poetry and music in order to condense all the news of the day into a song, and to be understood by all listeners, whether well or poorly educated.

Danzante—Dancer.

Danza—Dance. Not to be confused with baile, which is a dance gathering.

Décima—A poetic form comprised of a series of ten-line stanzas with a rhyme scheme of abbaaccddc. Most décimas were sung to the same tune with some variations to adjust to the lyrics.

Décima glosada—A poetic composition in which the sentiments of the four-line planta are expanded upon in four décimas, each décima ending with a line from the original planta. *Glosar* means to comment or explain.

Despedida—A farewell song sung at a funeral.

Entriega—Song improvised by an entregador(a), customized for the ritual of the giving over of the newborn at a baptism, the newlyweds at a wedding, or the deceased at a funeral. Modern spelling is entrega.

Indita—One of a small number of song types thought to have originated during New Mexico in the late eighteenth century. It is unique in that it combines Indian and Hispanic musical elements, including vocables, and its subject matter usually focuses on tragedies or Indian captives' laments, although some inditas are songs in praise of the Child Jesus and the Virgen of Guadalupe.

Los Matachines—One of the oldest ritual, religious dance dramas of New Mexico, *Los Matachines* is performed in both Hispanic and Pueblo communities. There are many theories on the origin of the dance and the term *matachín*.

Mariachi—A musical ensemble and style of music developed as a folk tradition in rural Mexico. Initially comprised only of stringed instruments, the addition of brass in the 1930s created the now familiar mariachi sound. Its success was such that the "trumpet mariachi" became Mexico's unofficial national ensemble.

Matracas—Cog rattle sometimes heard as introduction, between verses, or as cues in rituals of the Hermandad.

Música norteña—An instrumental dance music of the working class characterized by the use of the button accordion and known also as Mexican-Texan conjunto or conjunto norteño. *Norteño* indicates the northern part of Mexico and the border area.

Música tropical—Another term for salsa, a highly rhythmic style of popular music developed in the Caribbean and popularized throughout the world, including the major population centers of the United States.

Nueva canción nuevomexicana—Literally, "new New Mexican song," this style of music was developed by Dr. Cipriano Vigil and features the use of Latin American instrumentation.

Nueva canción—A song form of the revivalist movement of Latin America, characterized by poetry and political content.

Orquesta típica—An ensemble built around the violin, always with one or more guitars and occasionally a psaltery. Other instruments were added later.

Pastorela—A shepherd's play, or play in which shepherds seek the Holy Child in Bethlehem.

Pito—Whistle flute sometimes heard as introductory music or between verses or as cues in rituals of the Hermandad.

Promesa—A promise made to God or the saints to pray a series of prayers, or perform some other extended form of worship, such as a Matachines dance at a feast day, in thanksgiving for a favor granted by God, or as a request for same.

Ranchera—Mexican country music, developed in southern Texas. Ranchera continues to be very popular in New Mexico.

Relación—A song of lighthearted content, often telling of the relationship, including commonalities, between humans and animals. A frequent textual characteristic of the relación is the list.

Relación aglutinante—A type of relación where the song grows with each verse, because the previous verses must be sung every time a new verse is added.

Romance—A poetic form from which a musical song form of the same name was derived. The essential difference between a romance and a canción is that the romance is a narrative. It tells a story. Later forms derive from the romance, including the indita, relación, décima, cuando, and corrido.

Romancero—The corpus of narrative poetic and song types.

Saint's day—The Catholic Church has assigned each day of the year to a specific saint, sometimes several. A Spanish or Latin American individual is often named for the saint on whose day he or she is born; hence a saint's day and birthday are celebrated on the same day.

Trovador—Spanish equivalent of *troubador*, applied to singers of trovos and other songs. Medieval troubadors were poet-musicians who often served as the news givers of the day.

Trovo—An improvised singing duet between two competing trovadores. The term *trovo* derives from the troubador tradition of Europe, which may have been transported to Mexico.

Vocables—Syllables without precise meanings.

Zarzuela—A comic operetta form popular in Spain and Latin America in the late nineteenth and early twentieth centuries.

Bibliography

Works Cited

Arellano, Anselmo. *Los pobladores nuevo mexicanos y su poesia 1889–1950.* Albuquerque: Pajarito Publications, 1976.

Boatright, Mody C. *Mexican Border Ballads and Other Lore.* Austin: Southern University Press and Texas Folklore Society, 1946.

Campa, Arthur L. *Hispanic Culture in the Southwest.* Norman: University of Oklahoma Press, 1979.

———. *Spanish American Folksongs of New Mexico.* Works Progress Administration Federal Music Project, 1936–37, Unit no. 1. (Available at the library of the Museum of International Folk Art.)

———. *Spanish Folk Poetry in New Mexico.* Albuquerque: University of New Mexico Press, 1946.

———. "The Spanish Folksong in the Southwest." *University of New Mexico Bulletin* 4, no. 1 (1933): 5–67.

———. "Spanish Religious Folktheater in the Southwest: Cycle I." *University of New Mexico Bulletin* 5, no. 2 (1934): 1–70.

———. *Spanish Religious Folktheater in the Spanish Southwest: First Cycle and Second Cycle.* Albuquerque: University of New Mexico Press, 1934.

Champe, Flavia Waters. *The Matachines Dance of the Upper Río Grande: History, Music, and Choreography.* Lincoln: University of Nebraska Press, 1983.

Cobos, Rubén. "El Folklore Nuevo Mexicano." *El Nuevo Mexicano,* October 9, 1949 to November 16, 1950.

———. "The New Mexican Game of 'Valse Chiquiao.'" *Western Folklore* 15, no. 2 (April 1956).

Córdova, Lorenzo de. *Echos of the Flute.* Santa Fe: Ancient City Press, 1982.

Englekirk, John Eugene. *The Source and Dating of New Mexico Spanish Folk Plays.* Berkeley: University of California Press, 1957.

Espinosa, Aurelio M. "Romancero nuevomejicano." *Revue Hispanique* 3384 (April 1915): 446–560; 4097 (June 1917): 215–227; 4110 (December 1917): 678–80.

———. "Traditional Spanish Ballads in New Mexico." *Hispania* 15, no. 2 (March 1932): 89–102.

García, Peter. Personal communication, October 1996.

Geijerstam, Claes af. *Popular Music in Mexico.* Albuquerque: University of New Mexico Press, 1976.

Gonzales, Dolores, ed. *Canciones y Juegos de Nuevo México: Songs and Games of New Mexico.* Cranbury, N.J.: A. S. Barnes, 1974.

Herrera-Sobek, María. *Northward Bound: The Mexican Immigrant Experience in Ballad and Song.* Bloomington, Ind.: Indiana University Press, 1993.

Kanellos, Nicolás, ed. *Mexican American Theater: Legacy and Reality.* Pittsburgh: Latin American Literary Review Press, 1987.

Lamadrid, Enrique. "Angeles, Pastores y Comanches Cantan Al Resplandor (Angels, Shepherds, and Comanches Sing to the Light): Nuevomexicano Christmas Music." Program notes for a performance on December 21, 1997, at San Felipe de Neri Church, Albuquerque.

———. "Cielos del Norte, Alma del Río Arriba: Nuevo Mexicano Folk Music Revivals, Recordings 1943–98." *Journal of American Folklore* 113 (2000): 314–22.

———. Personal communication, 1995–2000.

———. "El sentimiento trágico de la vida: Notes on Regional Style in Nuevo Mexicano Ballads." *AZTLAN* 22, no. 1 (Spring 1977): 27–48.

———. *Tesoros del Espiritu: A Portrait in Sound of Hispanic New Mexico.* Embudo, New Mexico: El Norte/Academia Publications, 1994. Book and tapes.

Loeffler, Jack. Personal communication, July 1996.

Loeffler, Jack, Katherine Loeffler, and Enrique R. Lamadrid. *La Música de los Viejitos.* Albuquerque: University of New Mexico Press., 1999.

Lucero-White, Aurora, Eunice Hauskins, and Helene Mareau, eds. *Recuerdos de la Fiesta, Santa Fe: Folk-Dances of the Spanish Colonists of New Mexico.* In *Music of the "Bailes" in New Mexico,* by Richard Stark. Santa Fe: The International Folk Art Foundation, 1978.

Luján, Josie Espinoza de. *Los Moros y Cristianos: A Spectacular Historic Drama.* Chimayó, N.Mex.: 1992.

Mares, Pablo. *Santa Fe Típica Orchestra Folio.* New York: Carl Fischer, 1947. (Music only.)

Mendoza, Vicente T. *El romance español y el corrido mexicano.* Mexico City: Imprenta Universitaria, 1939.

———. "La Canción Hispanomexicana en Nuevo México." *Organo de la Universidad de México* 1, no. 2 (November 1946).

———. *Estudio y Clasificación de la Musica Tradicional Hispanica de Nuevo México*. Mexico, D. F.: Universidad Nacional Autónoma de México, 1986.

Montaño-Army, Mary. "Hymns from the Heart: Catholic Churches Enrich the Mass with Works by New Mexican Composers." In *Albuquerque Journal* 9, no. 16, 4 February 1986, Impact Magazine.

Montaño, Mary C. "The Manuel Areu Collection of Nineteenth-Century Zarzuelas." Master's thesis, University of New Mexico, 1976.

Padwa, Mariner E. *Peter of Ghent and the Introduction of European Music to the New World*. Santa Fe: Hapax Press, 1993.

Paredes, Américo. *A Texas-Mexican Cancionero: Folksongs of the Lower Border*. Urbana: University of Illinois Press, 1976.

Parsons, Jack, and Jim Sagel. *Straight from the Heart: Portraits of Traditional Hispanic Musicians*. Albuquerque: University of New Mexico Press, 1990.

Peña, Abe M. "Los Comanches." *La Herencia del Norte* 4, (Winter 1994): 19.

Peña, Manuel. *The Texas-Mexican Conjunto: History of a Working-Class Music*. Austin: University of Texas Press, 1985.

Rael, Juan Bautista. "New Mexican Wedding Songs." *Southern Folklore Quarterly* 4, no. 2 (June 1940).

———. *The Sources and Diffusion of the Mexican Shepherds' Plays*. Guadalajara, Mexico: Libreria la Joyita, 1965.

———. *The New Mexico Alabado*. With music transcriptions by Eleanor Hague. New York: AMS Press, 1967.

Ralliere, Rev. J. J. B. *Colección de cánticos espirituales*. 9th ed. Las Vegas, N.Mex.: Imprenta de la Revista Católica, 1933.

Robb, John Donald. *Hispanic Folk Music of New Mexico and the Southwest*. Norman: University of Oklahoma Press, 1980.

———. *Hispanic Folk Songs of New Mexico*. Albuquerque: University of New Mexico Press, 1954.

———. "The Matachines Dance." *Western Folklore* 20, no. 2 (April 1961).

———. "The Music of Los Pastores." *Western Folklore* 16, no. 4 (October 1957).

———. "The Origins of a New Mexico Folksong." *New Mexico Folklore Record* 5 (1950–51): 9–16.

———. "Songs of the Western Sheep Camps." *New Mexico Folklore Record* 12 (1969–70): 17–28.

Robinson, Natalie V. "Bernalillo Hits Streets for Fiesta." *New Mexico Magazine* 70, no. 8 (August 1992): 77–85. Native American Issue.

———. *The Matachines Dance: Ritual Symbolism and Interethnic Relations in the Upper Río Grande Valley*. Albuquerque: University of New Mexico Press, 1996.

Rodriguez, Sylvia. *The Matachines Dance: Ritual Symbolism and Interethnic Relations in the Upper Río Grande Valley*. Albuquerque: University of New Mexico Press, 1996.

Romero, Brenda M. "The Matachines Music and Dance in San Juan Pueblo and Alcalde: New Mexico Contexts and Meanings." Ph.D. diss., University of California, Los Angeles, 1993.

Roybal, Georgia, and Roberto Mondragon. "Dar los Días." *La Herencia del Norte* 4 (Winter 1994): 17.

Scholes, France V., and Eleanor B. Adams, "Inventories of Church Furnishings in Some of the New Mexico Missions, 1672." In *Dargon Historical Essays*, edited by William Dabney. Albuquerque: University of New Mexico Press, 1952.

Sedillo, Mela. *Mexican and New Mexican Folkdances*. Albuquerque: University of New Mexico Press, 1938.

Spell, Lota M. "Music Teaching in New Mexico in the Seventeenth Century: The Beginnings of Music Education in the United States." *New Mexico Historical Review* 2, no. 1 (January 1927): 27–36.

Spiess, Lincoln, B. "Benavides and Church Music in New Mexico in the Early Seventeenth Century." *Journal of the American Musicological Society* 17, no. 2 (1964).

Stark, Richard B. *Music of the Spanish Folk Plays in New Mexico*. Santa Fe: Museum of New Mexico Press, 1969.

———. *Juegos Infantiles Cantados en Nuevo México*. Santa Fe: Museum of New Mexico Press, 1973.

———. "Notes on a Search for Antecedents of New Mexican Alabado Music." In *Hispanic Arts and Ethnohistory in the Southwest: New Papers Inspired by the Work of E. Boyd*, edited by Marta Weigle, Claudia Larcombe, and Samuel Larcombe. Santa Fe: Ancient City Press, 1983.

Stark, Richard B., Anita Gonzales Thomas, and Reed Cooper, eds. *Music of the "Bailes" in New Mexico*. Santa Fe: International Folk Art Foundation, 1978.

Steele, Thomas J. *Holy Week in Tomé: A New Mexico Passion Play*. Santa Fe: Sunstone Press, 1976.

Twitchell, Ralph Emerson. *The Spanish Archives of New Mexico.* 2 vols. Cedar Rapids, Iowa: The Torch Press, 1914.

Van Stone, Mary. *Spanish Folksongs of New Mexico.* Chicago: Ralph Seymour Fletcher, 1928.

Vetancurt, Agustín de. *Menológio Franciscano.* Mexico: Editorial Porrua, 1982.

Weigle, Marta, and Peter White. *The Lore of New Mexico.* Albuquerque: University of New Mexico Press, 1988.

Works Progress Administration. *Spanish American Song and Game Book.* New York: A. S. Barnes, 1924. (WPA 19)

Videography[1]

Del Valle. Albuquerque KNME-TV, 1989. Videocassette.

Del Norte. Albuquerque KNME-TV, 1989. Videocassette.

Del Llano. Albuquerque KNME-TV, 1990. Videocassette.

Del Sur. Albuquerque KNME-TV, 1992. Videocassette.

Los Alegres. Four Brothers Productions, 1979. Traditional northern New Mexico dances performed by Los Vecinos Alegres of Taos; filmed at old schoolhouse at Los Cordovas (28 minutes). New Mexico State Library Media Center.

Celebración del Matrimonio. Margaret Hixon, 1983. Traditional Hispanic wedding ceremony at El Rito. 30 min. New Mexico State Library Media Center.

Los Comanches. 1986. Filmed at Alcalde; remarks and dialogue in Spanish. 20 min. New Mexico State Library Media Center.

Matachines. Ken Marthey, 1980. The Bernalillo Matachines, commentary by Eddy Torres, dance leader. 28 min. New Mexico State Library Media Center.

Moros y Cristianos. Santa Fe: New Mexico State Library, 1979. Performed at Chimayó, July 1979. 26 min. New Mexico State Library Media Center.

Música de la Gente. Albuquerque: Blue Sky Productions, 1980. Al Hurricane, La Chicanita, and other contemporary musicians discuss their lives and work. 28 min. New Mexico State Library Media Center.

La Música de los Viejos. Santa Fe: Public Media, 1984. Music recorded at La Mesa, Tomé, Las Cruces, Taos, Santa Fe and Las Vegas. Produced by Jack Parsons and Jack Loeffler. New Mexico State Library Media Center.

Los pastores: A Shepherds' Play. Directed by Arsenio Córdova. 30 min. Studio City, Calif.: One Step Productions, 1997. Documentary, distributed by National Latino Communication Consortium (800–722–9982). Featuring Sangre de Cristo Liturgies.

Pastores. Santa Fe: Museum of New Mexico, 1976. Traditional Christmas pageant. 60 min. New Mexico State Library Media Center.

The Pimentel Family. Albuquerque KNME-TV, 1983. Interview with guitar makers of Albuquerque. 30 min. Center for Southwest Research. Videocassette.

El Ranchito de las Flores: Antonia Apodaca. Albuquerque KNME-TV, 1990. Colores series #206. Videocassette.

Violinista Nuevomexicana Cleofes Vigil. Albuquerque KNME-TV, 1990. Colores series #122. Videocassette.

1. Public libraries, civic organizations, and government agencies may rent films and videos from the New Mexico State Library Media Center. Write or call them for a catalog: 324 Don Gaspar, Santa Fe, NM 87503 (Phone: 505-827-3852 or 3827). Some films and videos are also available for viewing at the University of New Mexico's Center for Southwest Research. KNME-TV videos are sold at their offices in Albuquerque (Phone: 505-277-2122).

Discography

Dark and Light in Spanish New Mexico. Music of the alabados from Cerro, New Mexico, and music of the bailes from El Rancho, New Mexico. New York New World Records, Anthology of American Music, 1978.

Apodaca, Antonia. *Recuerdos de Rociada.* Albuquerque: UBIK Sound, 1991.

Bass, Howard, Jack Loeffler, James Leger, and Enrique Lamadrid, eds. *Music of New Mexico Hispanic Traditions* (CD/Cassette C-SF 40409). Washington, D.C.: Smithsonian Folkways, 1992.

Bayou Seco. *Songs of New Mexico and Beyond.* Albuquerque: UBIK Sound, 1991.

Los Charros. *Piezas Antiguas* (TRP-8). Taos, N.Mex.: Taos Recordings and Publications, 1969.

Chávez, Alex J. *Duérmete, Niño and Other Songs.* Albuquerque: Alex J. Chávez, 1971.

———. *El Testamento* (Cantante 95–1). Albuquerque: John Donald Robb Musical Trust, 1995.

——. *El Testamento and Other Songs.* Albuquerque: Alex J. Chávez, 1965.

Chávez, Chris. *Canciones de Nuevo México Con el Violín de Chris Chávez.* Española, N.Mex.: Pete Chávez, 1992.

Lamadrid, Enrique, Jack Loeffler, and Miguel Gandert. *Tesoros del Espíritu: A Portrait in Sound of Hispanic New Mexico.* Albuquerque: Academia/El Norte Publications, 1994.

Manzanárez, José. *La Voz de José El Tío Manzanárez.* Abiquiú, N.Mex.: TM, 1990.

Martínez, Jesus Armando "Chuy." *Canto al Pueblo.* Albuquerque: UBIK Sound, 1993.

——. *Los Niños Cantan: A Collection of Hispanic Songs for Children.* Albuquerque: UBIK Sounds, 1994. A teacher's manual to accompany this recording is due for publication and available through The Albuquerque Museum.)

Martínez, Lorenzo. *Ambos* (MO-0807). Albuquerque: MORE Records, 1981.

Martínez, Roberto. *Tradición y Cultura: Los Reyes de Alburquerque y Los Violines de Lorenzo, Silver Anniversary Album, Fiesta Nuevo Mexicana.* Alburquerque: Minority Owned Record Enterprises, 1987.

Mondragón, Roberto. *Amigo* (RC-1). Santa Fe: Mondragón Records, 1982.

——. *¿Juguemos, Niños?* Santa Fe: Aspectos Culturales, 1993.

——. *¿Juguemos Otra Vez?* Santa Fe: Aspectos Culturales, 1993.

——. *Que Cante Mondragón* (HS-10004/27790). Albuquerque: Hurricane Records, 197?

Mondragón, Roberto, and Reyes García. *El Milagro de Truchas.* Santa Fe: R & R Recordings, 1990.

Ortiz, Cleofes. *Orquesta Cleofónica: Cleofes Ortiz & Friends.* Albuquerque: UBIK Sound, 1991.

——. *Violinista de Nuevo México.* Albuquerque UBIK Sound, 1991.

Robb, John D. *Spanish and Mexican Folk Music of New Mexico* (FE 4426). New York Folkways, 1961.

Ruiz, Gregorio. *Música Antigua*, con violin y guitarra, acompañamiento de Henry Ortiz. Santa Fe: Kiva Records, 1978.

Sánchez, Joe, Delio Villareal, and Ray Casías. *Matachines of San Juan Pueblo, Alcalde, and Chimayó: Social and Religious Music of Northern New Mexico.* Albuquerque: UBIK Sound, 1990.

Santos, María. *María Santos.* Las Vegas, N.Mex.: KNMX Productions, 1991.

Trujillo, Melitón. *Taos Spanish Songs* (TRP-2). Taos, N.Mex.: Taos Recordings and Publications.

Vigil, Cipriano. *Cipriano con la Nueva Canción Nuevomexicana* (CPMC 1001). El Rito, N.Mex.: Compañía de Producciones Musicales, 1985.

——. *Los Folkloristas de Nuevo México.* El Rito, N.Mex.: Compañía de Producciones Musicales-Discos Catalina, 1991.

Vigil, Cleofes. *Buenos Días, Paloma Blanca: Five Alabados of Northern New Mexico* (TRP-122). Taos, N.Mex.: Taos Recordings and Publications, no date.

——. *New Mexican Alabados* (TRP-3). Taos, N.Mex.: Taos Recordings and Publications, 1961.

Vincent, Jenny Wells. *Cantemos, Let's Sing! Spanish-American Children's Songs.* Taos, N.Mex.: Cantemos Records, no date.

Archive and Museum Collections

The John Donald Robb Archive of Southwestern Music at the University of New Mexico in Albuquerque holds the following collections of New Mexico Hispanic music.

1. J. D. Robb Collection of Native American, Hispanic, and Anglo music, 117 reels, indexed, with field notes.
2. Hispanic folk music, Charles L. Briggs, 35 reels.
3. Mexican, Native American, and Hispanic music, Rubén Cobos, 61 reels.
4. General New Mexico folk music, Charlemaud Curtis, 35 reels.
5. Hispanic fiddlers, Ken Keppler, 3 reels.
6. Hispanic instrumental and vocal music, Jack Loeffler, 119 reels.
7. Edwin Berry of Tomé, Rowena Rivera, 24 reels.
8. Richard B. Stark, Frank M. Bond, and Juan B. Rael, collectors. Three reels from the following collection held at Museum of International Folk Art: "Folk literature and music of the Spanish colonist in New Mexico, ca. 1800–1971," 304 items, including song texts, plays, poems, tales, and articles about folk plays. Also includes 93 reels of music copied from master tapes made by J. D. Robb and 75 reels of music recorded by Stark since 1962.
9. Hispanic and Native American music, James Wright, 55 reels.

6

Bailes y Fandangos: Social Dance

WHEN CAPTAIN RANDOLPH B. MARCY arrived in Santa Fe with the conquering American forces in 1848, his impression of dance among the locals was that it was their "favorite national amusement" (Stark 1978). He observed the dancers as "really very graceful . . . [they] waltz beautifully, and go through the Spanish dance to perfection."

Social dancing was a principal form of group recreation in New Mexico at the time and Nuevomexicanos were passionate about it. This passion can be traced back to Mexico and Spain, where there are hundreds of historic folk dances still performed today, including precursors to those of old New Mexico. Hints of Spanish and Mexican roots are evident in costume, rhythms, patterns, and the use of the hands and arms. However, no systematic study of these correlations seems to have been conducted, either between New Mexican and Mexican dance, or between New Mexican and Spanish dance. Because New Mexican dance is relatively unstudied and unrecorded, many of the nineteenth-century dances are no longer known.

Spanish Roots

The caves of Spain attest to the enduring popularity of dance in prehistoric times, with numerous images of female and male dancers. Later, Greek and Roman influences colored the dances of the peninsula, including similarities between Spanish and ancient Greek movements, the use of castanets (used by both Greeks and Romans) and the Greek practice of spectators keeping time by clapping. The Romans appreciated and imported dancing girls from Cádiz, Spain.

While these and other cultural influences have shaped Spanish dance, its characteristic and perennial popularity within all classes, and its Moorish influences are the most prominent elements in New Mexican historic dance. Moorish influence on Spanish dance is difficult to discern directly because there is no pictorial evidence due to the Moslem ban on any representation of the human form in works of art. Literary references are vague, according to Ivanova. Thus, there are no clues as to groupings, movements, or postures. However, we know that during the eight hundred years of Moorish occupation of Spain, there was a constant flow of peoples through southern Spain from the Middle East and Africa, including slave dancers and musicians from as far away as Persia. Christian courts hired Moorish musicians and dancers to perform alongside the local troubadours, who liked and adopted Moorish ways. These contacts resulted in a significant Oriental influence in the dances of Andalucía in southern Spain. Evidence is found in the fluid use of the arms and wrists, the upper torso, and in the use of nonwestern, or multimetric, rhythms. In addition, the Moors introduced the idea of mixed social dancing, though it was some time before the Spanish adopted the idea. The Moors also encouraged dancing in the streets, which was unheard of in Spain before then. As time progressed, Spanish dancers came to prefer outdoor presentations against skyline and hilltop backdrops so frequently seen in images of Spanish dance. For presentations in public squares, carpeting is even laid out for the dancers in contemporary Spain.

While the Moorish culture greatly influenced southern Spain, there was less stylistic influence on northern Spain—Castilla, Galicia, Aragón, Asturias, Extremadura, and Navarra. The dances

of these areas are considered more authentically Spanish, even with the eleventh- and twelfth-century incursions from the south into Castilla in the north. Then, as Spain began to develop kingdoms, members of the ruling class intermarried with French aristocracy, who introduced French dancing to northern Spain. Court dancing for the aristocrats and open-air folk dancing for everyone else became very popular. Frequently, the folk dances were adopted and adapted by the higher classes so that ultimately, contemporary scholars cannot attribute most dances to one or the other tradition with any certainty. Competitions were held between districts, and each region of Spain developed its own styles of dancing, with stylistic variations even between adjacent towns. Itinerant dance masters taught the popular classes the latest dances by showing, rather than recording, thus there is no historic record of Spanish dance. It is interesting to note that Spanish dancing masters had their own guild in the Middle Ages.

Flamenco originated in Andalucía as a type of plaintive song of the gypsies who migrated to that region around the fifteenth century. It is unclear who invented the dances known collectively as flamenco, but scholars agree that the gypsies infused them with their own Byzantine-Oriental style and have maintained them ever since. Characteristics of flamenco that may be found to one degree or another in the Creole dances of the New World include rhythmic hand clapping and shouts by spectators (*jaleo*), finger snapping (*pitos*), rhythmic heel stamping (*taconeo*), and expert footwork (*zapateo*). Castanets are rarely used in dances of the Americas.

Other typical Spanish dances developed through the centuries were the *Jota Aragonesa*, the *Sardana* of Catalonia, and numerous Basque dances. The passionate and virtuosic Bolero, when introduced in the late eighteenth century, was most instrumental in spreading the fame of Spanish dance throughout the rest of the world. Spanish dance is renowned worldwide for its grace, fire, and beauty. Curt Sachs describes it as a dance tradition emphasizing "grace of motion more than muscular power and owing far more to an old, advanced culture than to prehistoric or primitive tradition" (Sachs 1965). Waldo Frank

writes, "The Spanish dance is organic and essential. It is the one great classic dance surviving in our modern world" (Chase 1959).

In the time of Ferdinand and Isabella, dance was incorporated into *autos sacramentales* created to bring the liturgy alive for Spain's unschooled faithful. However, some dancers took liberties, and the autos sometimes became notorious for their indecency. Church officials moved quickly to suppress the offending autos and dancers. It is during this time that Spanish settlers were introducing dances of their homeland into Mexico and Latin America. Ships to the New World set sail from the ports near Seville, in the heart of Andalucía with its strong Moorish traditions.

Mexican Roots

The regional dances of Mexico owe their diversity and uniqueness to the combined music and dance cultures of the Spanish, indigenous peoples, and the West Africans brought to the Mexican coast as slaves. This early *mestizo-mulato* style combined with European dance types of the eighteenth and nineteenth centuries. Two examples are the Gulf coast Huapangos, with combined Spanish and African influences, and the *Jarabe Tapatío* (or the Jarabe of the province of Jalisco), which is now Mexico's national dance, and known in the United States as the Mexican Hat Dance. The choreography of the Huapango resembles flamenco, particularly in the expert footwork, or zapateo. It is accompanied by the falsetto singing of couplets by a solo singer, choral refrains, and multimetric rhythms. The Jarabe is comprised of a succession of movements ranging from slow to swift, its music sounding similar to that of the Jota, while the women's costumes (red and green dominating, with black and gold ornaments) are similar to those worn in Andalucía.

Scholars agree that far too little is known about music and dance in Mexico and Latin America prior to the eighteenth century to speculate with certainty on the introductions or existence of specific dances. Carlos Vega states with certainty, however, that Andalucian songs and dances were introduced into South America as theater music in

the late eighteenth century. The vehicle for this introduction was the wildly popular *tonadilla escénica*, a thirty-minute musical comedy, initially presented on Latin American stages by Spanish touring companies, then later by resident companies. As such, they came to feature and celebrate Creole folk music and dance types. Still, certain Spanish dance names have survived the centuries in Mexico, including *Canario, Cascabel, Contradanza*, Fandango, Malagueña, *Petenera, Paracumbe, Vaquería, Zapateado*, and *Zarabanda*. Immediately recognizable from studies of New Mexican dance are the Fandango, Paracumbe (*Cumbe* in nineteenth-century reports of dance in New Mexico), and Vaquería.

The fact that Veracruz is especially rich in Andalucian music is evidence that this city was, and still is, the largest Mexican harbor and the main entryway for Spanish culture for centuries. Andalucian music, and presumably dance influences, are also abundant in Guanajuato, Querétaro, Michoacán, Jalisco, and Guerrero. Geijerstam speculates on the Basque origins of the dance tradition of Michoacán, specifically of the multirhythmic *Zorzico*. The Fandango was most developed in Exremadura, from which many of the settlers of New Mexico hailed. Therefore, it should be no surprise that the dance gatherings in New Mexico came to be known as fandangos. Some scholars speculate that Huapango, a sung dance of Veracruz, may be a corruption of fandango.

In the nineteenth century, non-Spanish European dances were incorporated into rural dance traditions of Mexico, including the Contradanza, or group dance, also known as *Cuadrilla* (all being, essentially, square dancing). In some parts of Nuevo León, Contradanzas are still performed at festivals, and retain characteristic elements of the European Contradanzas combined with nineteenth-century Mazurkas, *Galopas*, and Polkas. The Mazurka is still preserved in some areas of Mexico and Argentina, while the Waltz was best maintained because most of the late nineteenth-century Mexican canciones were written in Waltz rhythm. Many classic *Valses Mexicanos* were written in the years surrounding the Revolution. The Peruvian Waltz is characterized by syncopation and is known in Mexico as *Valse Criollo*.

While most scholars agree that the Polka was introduced with the reign of Maximilian and Carlotta, others suggest that it was introduced in 1847 from the United States during the Mexican War. Revolutionary songs were written in Polka rhythms and made popular by soldiers. The Polka was especially popular in the state of Chihuahua, where it was integrated into the canciones Norteñas. Mexican Polkas are generally played by Norteño bands, by a solo accordion, or mariachis with trumpets. One famous example is "Jesusita en Chihuahua," a classic of the Mexican repertoire often attributed to Quirino F. Mendoza.

Between the years 1860 and 1900, the popular music and dances of Mexico were greatly influenced by the music and dances of Cuba, according to Geijerstam. The Habanera became popular in Mexico with its Afro-Cuban rhythm, also known as the *ritmo de hamaca* (hammock rhythm), a slow duple ($^2/_4$) time. In Mexico, the influence of *mestizo* folk music gave rise to a Habanera in $^6/_8$ time. In the 1920s, the Foxtrot, Tango, and Cuban Bolero grew in popularity. Radios played these types and ignored corridos and canciones rancheras. However the radio did not rise in importance until the 1930s, when it was to help popularize mariachi.

In the late twentieth century, Mexican ballet folklórico companies centered their presentations around dances of the pre-Conquest, contemporary Indian, regional variety and the Revolution, while de-emphasizing Spanish colonial, nineteenth-century European, and Northern border dances. Some of the popular folklórico dances are the *Chiapanecas* of Chiapas province, the Huapangos and Bamba of Veracruz, and the Dance of the Viejitos of Michoacán. Folklórico companies began touring other countries, introducing the dances to a wider audience and helping to popularize the varied dances of Mexico. However, in New Mexico, there is now a tendency to assume that the dances of Mexico are typical of New Mexico.

Dance in Colonial New Mexico

Almost nothing is known about social dancing between 1598 and 1821 because there is little or no record. Scholars speculate that the colonists knew

the music and dances of Mexico, which they adapted over the years to suit local popular tastes. Recent research indicates that colonial craftsmen of New Mexico were aware of current trends in Mexico, so it could be postulated that the latest dances also made their way quickly to New Mexico. When Zebulon Pike visited New Mexico in 1806, he found that music and dance were flourishing. He later wrote, "Their amusements are music, singing, dancing, and gambling . . . The music is soft and voluptuous, but sometimes changes to a lively gay air. The dancers exhibit the motions of the soul by gestures of the body, snapping the fingers and sometimes meeting in stretched embrace" (Weigle and White 1988). He added, "They danced to several figures and numbers. The minuet is still danced by the superior class only. The music made use of the guitar, violin and singers, who, in the first described dance [possibly the *Paso Doble*], accompany the music with their hands and voices, having always some words adapted to the music."

According to Martínez and Sedillo, dances originating in New Mexico include *La Indita* (The Indian Woman), *El Vaquero* (The Cowboy; also known as *La Vaquera*), *La Comancha* (The Comanche Woman), *El Espinadito* (The Little Thorn) and *La Coneja* (The Rabbit).

Dance in the Nineteenth Century

More is known about social dance after 1821 because Anglo American visitors, who were allowed to enter the region through the Santa Fe Trail, wrote about it in their journals. By then, the dances were wildly popular and frequently held, particularly in the wintertime. Matt Field, an actor and journalist writing in 1839, was enchanted by the "wildness and novelty" of the dances, even though he thought them inelegant. Cooke commented on the extraordinary musicality of the Nuevomexicanos, and their love of dancing. Gregg complained that dance music could be heard all over Santa Fe at all hours of the night.

With the newcomers of many nationalities came new dances, such as the Quadrille, the Waltz, and the Two-Step. The Frenchmen of Maximilian's army, which occupied Mexico from 1864 to 1867, introduced the Schottische and the Polka of Central Europe. Weigle and White suggest that these dances were adopted by the Mexican upper classes, then abandoned as the lower classes of Mexico's rural regions took them up. Both dances became highly popular in New Mexico, where they were known as the *Polca* and the *Chotís* or *Chote*.

In addition, during Maximilian's reign as Emperor of Mexico, Polish court dances were introduced by Polish ex-patriots, who moved to Mexico to escape the Polish Revolution. These dances—the *Krakoviak* and the *Warszowanka* (named after two Polish cities, Kracow and Warsaw)—apparently grew so popular that, according to Lucero-White Lea (Stark 1978), the Mexican government found it necessary to issue a *pronunciamento* banning Polish dancing in Mexico. Also adopted and abandoned by the aristocracy, these dances came to be called *La Cracoviana* and *La Varsoviana* in New Mexico. Scholar Peter White visited Poland and noted that a Polka played by Stanislaw Klejnas in the district of Skierniewice in the region of Mazowsze, and by Stanlislaw Kaleta in the region of Opoczno, is almost identical to Cleofes Ortiz's rendition of the *Valse de los Paños*. This is one of several connections established by music historians Jeanie McLerie, Ken Keppeler, and Peter White between New Mexican and eastern European dance music (Weigle and White 1988).

Along the border between Mexico and New Mexico, people danced the *Jota*, *Zorzico*, *Zarabanda*, and *Bolero*, according to Arthur Campa. However, the *Pavana* and *Gavota* were also danced in Mexico, but only by the urban upper classes. A favorite Spanish dance was the Fandango, which became so popular that it became the term for an evening of dance.

From all indications, dances in the nineteenth century were frequent and enjoyed with gusto. In 1844, trader Josiah Webb wrote, "They do literally dance from cradle to the grave." In New Mexico from 1821 to the 1860s, the baile and the fandango were highly popular events in New Mexican life. Visitor Josiah Gregg wrote of his understanding of the difference between the two in 1832: the fandango was characterized by "ordinary gatherings

where dancing and frolicking are carried on," while the baile was a more formal event, equivalent to a European "ball." Some scholars suggest that the tone of formality was set by the *dueñas* (matrons) who accompanied the young women to ensure that the fun was above reproach. Bailes also were family affairs, with whole families in attendance. They were the only socially acceptable place where a young man and a young woman could safely meet and interact.

Thomas suggests that Saturday night fandangos began "in earliest times" as a response to the geographical isolation of the hardworking settlers, and that the gatherings became a major part of the cultural life of the lower class. By contrast, the baile was considered the social event for the upper class, who hosted them to celebrate *bodas* (weddings), saint's days, and prendorios (betrothals). Later, a school graduation also was an occasion to host a baile. While family and friends were invited to bailes, everyone could attend a fandango, even visitors from out of town. In the first half of the twentieth century, an evening of dance was an affordable event for smaller communities, where local musicians provided the music and the schoolhouse was used as a dance hall.

George C. Sibley visited Santa Fe in 1825 on business. Between December 7 and January 2 of that winter, he attended ten fandangos to celebrate not Christmas but a wedding and the fall of a fortress at San Juan de Ulloa. More than a few dances have been lost to modern scholars and dancers, such as the one in this description by Matt Field: "The party on the floor separates into two divisions to the opposite ends of the ballroom, and

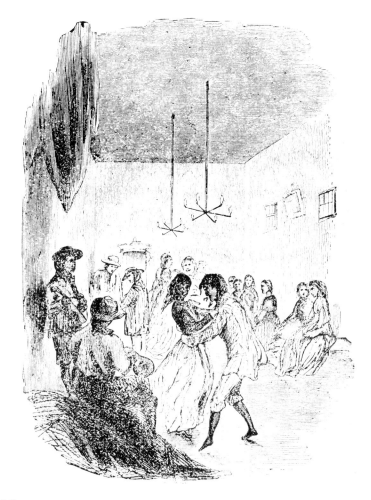

6.1

A New Mexican fandango. From Andrew K. Gregg, *New Mexico in the Nineteenth Century: A Pictorial History* (Albuquerque: University of New Mexico Press, 1968), 80. Drawn from Frank Triplett, *Conquering the Wilderness* (New York and St. Louis, 1885).

after singing a few words of defiance, they clap their hands, stamp the ground, and whirl off toward, round, and through each other, accompanying the music with short yells and other sounds vividly descriptive of a deadly contention. The effect is exciting and delightful. Few Americans can partake in this dance, as it requires a rapidity of movement which they find by no means easy to acquire" (Sunder 1960). Weigle speculates that this was a dance called The Lancers. Rudy Ulibarrí asserts

that it is a French dance. Note that it seemed to include jaleos (shouts) and taconeo (rhythmic stamping).

Bailes and fandangos were not the only occasions for dancing. The family of Cleofas M. Jaramillo went piñón picking in the mountains, where they camped for one or two weeks at a time. At night, everyone sang, danced, and told stories around the campfires (Weigle and White 1988). A dance was given on the occasion of the blessing of a new bell for the church in Córdova. Cast locally, the bell was blessed and then the celebrations began, including horse racing, a feast to which the Apaches were invited, and a dance where verses were recited in honor of the bell. Dancing continued into the next day (Brown, Briggs, and Weigle 1984).

6.2

Woodcut of a fandango in nineteenth-century Santa Fe. From John H. Beadle, *The Undeveloped West* (Philadelphia, 1873). As shown in Andrew K. Gregg, *New Mexico in the Nineteenth Century*.

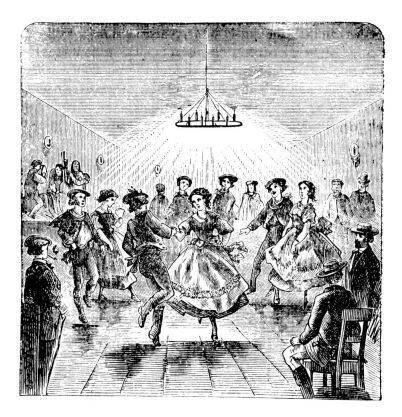

Dances enjoyed great popularity between 1821 and 1860 and most likely before that time, although there is no documented evidence prior to Zebulon Pike's report. The dances also included more and more Anglo favorites such as the *Cutilio* (cotillion), which is the last of a set of dances called the Cuadrilla (Quadrille, or Contradanzas). Matt Field noticed that Nuevomexicano women danced the Cutilio to please the American men, but didn't necessarily like the dance, "and are always dispirited until the waltz begins again" (Weigle and White 1988).

The music at these dances was an ever-expanding repertoire of popular songs and dances, both past and present, assimilated with enthusiasm from newer emigrants settling into New Mexico, giving rise to the popularity of the Polka, Waltz, Two-Step, and Schottische. Local musicians adopted the music of the square dance, Irish jigs, and Scottish reels, as well as national American favorites, "After the Ball," "Wednesday Night Waltz," "Home Sweet Home," "Turkey in the Straw," and "Listen to the Mockingbird." Friends of well-known *violinista* Gregorio Ruiz say he learned numerous Irish fiddle tunes from traveling railroad workers, which he then taught to violinistas in the Pecos area where he lived. They, in turn, played them at numerous dances. Colonel Philip St. George Cooke noticed that at the Governor's Ball, "the fiddlers accompanied their music at times by verses, sung in a high nasal key" (Weigle and White 1988). The reason for the high nasal sound was so that the voice could be heard over the noise of the dancing, according to McLerie and Keppeler. In earlier days, the musicians, and often the dancers, sang lyrics. This practice seems to have disappeared in the twentieth century, although old-

time musician Cleofes Ortiz often sang the lyrics to "La Julia," a fairly common Polka.

The Waltz developed from the Bavarian *Weller*, or *Walzer*, and from the Austrian *Landler* in the 1700s, according to Kern. It was introduced into New Mexico from the East and quickly developed into a number of local variants. The slow Waltz was called the *Valse Despacio*. The Waltz using handkerchiefs was the *Valse de los Paños*, which is found throughout Latin America, though not always as a Waltz. *La Cuna*, or the cradle dance, breaks into a traditional *Polkita* in part two of its performance. The *Valse Chiquiado* is also known as the *Valse de la Silla*. Other Waltzes are *Valse Redondo*, *Valse de la Cadena* and *El Talián*. The Waltz, Polka, and Mazurka were highly popular throughout the Southwest. In San Francisco, for example, dance types involving the Waltz, Polka, and Mazurka were popular among the *Californios*, including the Varsoviana, the Fandango, and numerous local variants, according to Rudolph.

While most references to dance in nineteenth-century New Mexico discuss their popularity, scholars Weigle and White, and Stanley L. Robe, also noted an underlying opposition to fandangos and bailes. Sometimes violence broke out over jealousies or rivalries. Paredes reports that in lower Río Grande Valley dances, violence broke out when there was rivalry between two men over a woman, or when a woman refused a dance. He cites the corrido of Rosita Alvírez, who was killed for refusing a dance. The corrido attempted to warn girls about attending such events, even with a chaperone. However in New Mexico, James Webb wrote, "I have never seen anything lascivious or [any] want of decorum and self-respect in any woman in a fandango . . . I have known of disorders and serious brawls in fandangos, but it was almost invariably where Americans and whiskey were found in profusion" (Webb 1931). Matt Field concurred in his writings.

There was prejudice against public dances because some elements of society felt that they were dangerous and a bad influence. Bishop Lamy of Santa Fe wrote, "As for dances . . . they were conducive to evil, occasions of sin, and provided opportunity for illicit affinities, and love that was

reprehensible and sinful" (Horgan 1980). In 1815, Mexican church officials found it necessary to denounce the Waltz as corrupt and pernicious. Nuevomexicanos repeated many stories of the devil appearing at dances in handsome disguise to perform various acts of mischief and deception, generally on unsuspecting women. The relationship between dance and evil, dance and the Church, or dance and death—dancing skeletons are a familiar image in Mexican "Day of the Dead" imagery, probably harking back to the days of the Black Death—are fascinating subjects for further study. Spain is probably the only European country where dancing was and is permitted in church, according to Brooks and Ivanova. One fifteenth-century auto sacramental performed in church featured the Virgin Mary dancing a Fandango with the Holy Ghost (Ivanova 1970).

To this day, parishioners at the Church of San Luis in San Luis, New Mexico, celebrate the feast of San Luis Gonzaga (June 21) with a dance performed down the center aisle of the church. As dancers face the altar, and the statue of San Luis Gonzaga, they approach the altar by taking a back and forth step, three steps forward, two steps backward. Their empty hands are held in front, palms up (as if holding a tray). On reaching the altar, the dancers pay their respects to the statue and then dance backward down the same aisle to the same steps (Lamadrid 1998). The *Indita de San Luis Gonzaga* is sung during the dance, which is called "el baile para San Luis Gonzaga." Lamadrid speculates that the dance, which is highly reminiscent of Pueblo dancing, was allowed by the church in deference to the Indians, for whom dance is a solemn form of worship. Its very existence is evidence of the significance of dance in Nuevomexicano, or at the least, Latino, culture. There is also a secular celebration of dance and San Luis Gonzaga during which the statue is carried in procession and placed between a *guitarrista* and a violinista as all celebrants sing the *Indita de San Luis Gonzaga*. A rosary follows, then a dance. During the all-night dance, the musicians dedicate their sung verses to the saint. They also assign San Luis's name to one of the dancers on the floor, who is then expected to give the musicians a coin in

acknowledgment of the honor. At daylight, the statue is carried back to the church. Interestingly, Luis Gonzaga himself detested dance, yet has become the patron saint of dance in the Catholic Church. This dance is also performed in private homes in Los Griegos, New Mexico, as described in *Shining River, Precious Land* (Sargeant and Davis 1986).

While dances, and any other kind of obvious amusement, were forbidden during Holy Week, it is interesting that Sibley wrote of a dance hosted by a Nuevomexicano priest. In a social context, Nuevomexicanos scheduled dances for any or no reason, because they provided the people opportunity to socialize with one another, and with people from other communities.

Types of Dances

Most of the dances of old New Mexico are rooted primarily in European court dances, which are differentiated from European folk dances in that, in the court dances, the dancers pair off in couples. In folk dance, the formations may be processions, closed circles, or chains of dancers, with dancers either holding hands, shoulders, or waists, or linked by handkerchiefs or other props. Some folk dances involve two concentric circles, weaving in and out. The dance steps found in Nuevomexicano dancing are rooted in folk dance, including variations of walking, hopping, skipping, and turning. The dance formations found in Nuevomexicano dancing are more reminiscent of court dances.

When European court dances gradually separated from folk dance in the late Middle Ages, the style of dancing separated as well. Where folk dancing had been extemporaneous and boisterous, the court dances were mannered, and limited in movement, apparently due in part to the more elaborate clothing worn by the aristocracy. One of the interesting characteristics of court dancing was figure dancing, where patterns were created by groups of couples dancing in sections rather than in a continuous dance. This is evident in New Mexico dances; for example, in *La Camila* (see below), where the entire group creates the pattern of a flower blossoming. While most Nuevomexicano dance styles were

based on couple dancing, there are remnants of folk dance, as in *Valse de los Paños*, where three dancers are linked by handkerchiefs. Another example is the *Redondo*, a type of waltz where the first half of the dance features all couples standing in a circle dancing left and right. By the end of the eighteenth century, the tight formation of earlier court dances began to evolve into individual couple-dancing by all classes of people as steps were simplified and made more accessible. The trend mirrored that in Europe, where the waltz was all the rage at the turn of the nineteenth century.

Albuquerque-based traditional dancer and choreographer Frances Luján comes from a family of musicians and dancers. She learned the dances from her mother and grandmother, and the music from her father, who plays the guitar and mandolin. Her mother was a seamstress who created clothing for the dance. Ms. Luján reports that dances most likely developed from informal, freestyle dance gatherings on Saturday nights in rural New Mexico. If, during the freestyling, someone created something appealing, others might imitate it, making the dance more likely to enter the traditional repertoire as a local variation. If the dance was introduced elsewhere, and began to gather widespread popularity, it eventually became a standard of the region. Variations on most of the dances described below were found in different areas of New Mexico. In any event, all dance patterns were subject to the individual interpretation of each dancer.

In the late twentieth century, the old dances are presented primarily in showcase performances. One notable exception is related by Ken Keppeler, who is a member of the popular traditional band Bayou Seco:

> As recently as 1988, Jeanie [McLerie, his wife and a member of the band] and I played in a bar near Pecos, New Mexico, with Cleofes Ortiz, at which people danced *La Cuna*, *Valse de los Paños*, *El Talián*, *La Indita*, *Valse de Cadena*, *La Vaquera*, *La Varsoviana*, *El Chote*, as well as Polkas and Waltzes. We played with Sr. Ortiz at this bar two times and we had the same experience at the Senior Center in Pecos, though by 1993, the last time

we played the Senior Center for Cleofes's birthday, fewer people knew the dances. When we played at the bar, there was no need to introduce the dances. As soon as we started playing a tune, they knew the dance and would get up and start. (personal communication 1998)

The Nuevomexicano dance culture developed several dance events at which many types of dances were performed. Here is a sampling of such events.

- The *Baile de Prendorio* to celebrate a betrothal.
- The *Baile de Gusto*, held simply for the love of it.
- The *Baile de Desquite*, or *Baile de Desem-*

peño, held as a payoff for some joyful social obligation.
- The *Baile de Cascarones*, or dance of the eggshells.

During Lent, eggs were a major source of protein for those who abstained from eating meat, particularly during Holy Week. The *Baile de Cascarones* was held after Easter and featured eggshells that had been preserved intact and filled with confetti and cologne, then sealed and decorated in bright colors. At the dance, they were sold or distributed to the attendees who would periodically break them on the heads of dance partners, friends, or romantic prospects. W. W. H. Davis (1938) describes a visit to a dance in the nineteenth century when he experienced this custom:

6.3

Dancers on the plaza at Taos, July 1940. Photo by Russell Lee. Courtesy Library of Congress, LC-USF33-12870-M3.

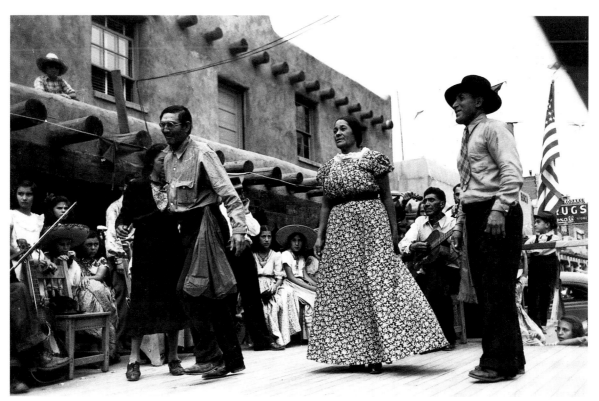

6.4
Members of Santa Fe's Sociedad Folklórica sell decorated eggshells filled with confetti at the Baile de Cascarones, April, 1998. Photo by Mary Montaño.

I had not been long in the room . . . when I observed three pretty girls coming toward the place where the governor and myself were sitting, with countenances beaming with fun as though they were bent on some mischief. They approached within touching distance and before we had time to stand on the defense, or were even aware of their object, smash! dash! went the eggshells over our heads in quick succession, and down our face streamed the *eau de cologne*.

The *Sociedad Folklórica* of Santa Fe holds a *Baile de Cascarones* in April after Easter, at a local high-school in Santa Fe. In recent years, they have scheduled a practice session prior to the dance to help newcomers learn the dances in advance. It is a popular event attended by families and coordinated with school activities such as egg decorating and learning and practicing the dances.

The dance types described below were popular during the nineteenth and early twentieth

centuries in New Mexico. Ballroom position means the man and woman face one another (i.e., round dance). The music for the dance, known as the *tonada*, is in two parts. Part A of the music introduces a distinctive melody and/or rhythm or meter of the specific dance, and Part B is usually a Waltz or Polka, depending on the meter of the music. Waltzes are always in triple time, and Polkas are always in duple time. Many of the dances are variations of two basic steps, the Waltz step (counted 1–2–3) and the Chotis step (1–2–3–hop). Footwork also might include stamping to accentuate a beat. For drawings of footwork, the reader is directed to Stark, 1978, which reprints Aurora Lucero-White Lea's original drawings as well as transcriptions of the violin dance music.

Baile de Compadres

The *Baile de Compadres* is not a specific type of dance step, but rather an activity prior to dancing a simple Waltz or Polka. The *bastonero* oversees the distribution of many sets of men's ties and women's aprons to the male and female dancers, respectively. Each tie has an apron of the same fabric pattern, and no two sets are alike. Once the wearers of the same pattern find one another, they become *compadres* (special friends). They then take their places in two large circles on the dance floor, with women on the inside and men on the outside facing their partner. Once everyone is in place, the dance begins. Throughout the following year, the compadres acknowledge their special association by addressing one another as compadre or comadre, rather than with their given names.

La Camila

Named after the flower, the floor pattern of the dancers in *La Camila* replicates the opening and closing of a blossom. Several couples stand in a large

circle facing the inside of the circle. Holding one another in a slightly open ballroom position, each couple dances the following steps into the circle and back again—man on left, facing slightly to his left, woman on right, facing slightly to her right. The man takes a large step left, and draws his right foot up to the left foot—this is called a sashay step. (Woman executes the same steps, only beginning with her right foot.) Repeat three times. Then, starting with his right foot, the man takes eight small steps back, as does the woman, starting with her left foot. Note that the large steps forward take two counts to each step, while the small backward steps take one count to each step. To Part A of the music, all couples dance as described above, and repeat. To Part B of the music, all couples break formation and dance the Polka or a rapid Two-Step.

6.5

Margaret and Alfredo Martínez of Santa Fe at the Baile de Cascarones. They wear their Sunday best in the tradition of New Mexico bailadores. Photo by Mary Montaño.

El Chotís

Also called Chote, the term is a corruption of Schottische, a nineteenth-century dance similar to the Polka. The Schottische was originally a Scottish round dance that became popular in Germany. The music is in $4/4$ time.

Partners face the same direction, with the man's left arm around the woman holding her left hand at her left shoulder; his right hand holds her right hand. They take three steps forward to the first three counts of the music, and on the fourth count, skip right. Then to count one of the following measures, they brush left back and on the second count, forward right. This is repeated throughout Part A of the music. In Part B of the music, the couple dances together in ballroom position to what Sedillo (1945) calls a "double alternating pivot two step or a fast buzz step." A Polka is also acceptable.

La Comancha

The name of this Taos dance may mean Comanche Woman or may be a corruption of "sleeve" (*manga*), but is most likely the former, given the long history of the Comanche in the Taos area. It is a regal-looking couples-dance with movements that are reminiscent of European court dances.

The man and woman touch right hands at shoulder height while facing slightly outward. To Part A of the music, they walk around to the right, then they drop the right hands, hold up their left hands and walk around to the left. Repeat. To Part B of the music, they assume ballroom position and waltz. According to McLerie and Keppeler, the music of Part A is quite possibly the tune that inspired the melody for the introductory measures of "Oh, What a Beautiful Morning" (specifically, "There's a bright golden haze on the meadow") by Richard Rodgers of Rodgers and Hammerstein. Rodgers was known to have conducted research on folk music in the Taos area where he was a houseguest of writer Margaret Larkin.

La Coneja

The choreography for this dance is unknown, but is listed here because it is thought to have originated in New Mexico.

La Cuna

The cradle dance evolved from the basic two-step. It was developed in the days when the entire family, including infants, attended community celebrations that lasted up to three days, such as weddings or feast days. In *La Cuna*, four dancers create a "cradle" with their intertwined arms, which they then "rock" to the music. Then they break formation to perform the two-step, or Polkita, as couples. The idea of a cradle was that a child was lulled to sleep while its parents continued to dance.

A square is formed by two pairs of dancers, couple facing couple, man facing woman, everyone facing in. At beginning of Part A of the music, each woman steps forward and, with her left hand, takes the left hand of the man opposite. The man turns backward and under the woman's left arm. Then each woman takes her own partner's right hand with her right hand and completes a quarter turn left under her partner's arm, finishing by facing center again. All dancers are now holding hands in close formation with their arms forming an intertwined cradle. As a unit, they dance around to the right as they swing their arms in a rocking motion. In a variation, the couples dance back and forth toward each other, creating a rocking movement. American visitors of the nineteenth century commented on the beauty of the dance when all four dancers leaned far back at this point.

At Part B of the music, the circle breaks formation and each couple dances away. At the return of Part A of the music, couples form new squares and begin again. Antonia Apodaca, a musician from Rociada, New Mexico, knows a variation of this dance that involves only one couple. McLerie and Keppeler did not encounter La Cuna in their European travels. The New Mexico-based Spanish Peninsular troubadour group, Crisol-Bufón, is not aware of such a dance in Spain.

El Espinadito

Also known as the *Baile de Espina*, this exhibition dance was performed by two men while the other dancers looked on. One man has a hat. The other does not. As the hatless man dances, he bends over to pantomime pulling a thorn from his foot, while hopping on the "thornless" foot. Contin-uing to dance, the man with the hat backs away from the other, who pursues him in order to stick the invisible thorn in the hat. This description was given to Jeanie McLerie and Ken Keppeler by Cleofes Ortiz.

La Indita

This dance is thought to have originated in New Mexico. Its steps are derived from the Polka, but reveal a Pueblo influence. Even so, Sedillo found the music and steps to resemble the Hungarian Czardas.

Rudy Ulibarrí, director of Rudy's International Dancers, grew up in Roy, New Mexico, where he learned this version of the dance. The music of Part A is played twice, then Part B is played. During the first playing of Part A, the couples have lined up facing the same direction. For eight measures, they move forward en masse, each person facing out and then in toward one another while holding hands. They bow at the last measure, or the woman twirls under the man's arm and all turn in the other direction. As Part A is repeated, so are the steps, only in the other direction. For Part B, the couples dance in place. The step throughout, as described by Keppeler (personal communication 1998), is: "For the man, who is on the left of his partner, who mirrors his moves, 1-left (foot), pause, 2-right, 3-left, 1-right, pause, 2-left, 3-right, all in a shuffling manner [numbers indicate beats of the music]." Rudy Ulibarrí remembers that the dance would be taken very seriously, almost ceremoniously, and there would be no laughing or carrying on during the dance.

Lucero-White Lea describes a version as follows: For Part A of the music, couples in ballroom position take one Polka step to the right, and again to the left. Note that the step is performed in what Lucero-White Lea calls the "shuffling manner peculiar to the Pueblo Indian women" (Stark 1978). Dancers then stand apart and, moving to the right of the other, dance in semicircle around the partner and then back, facing one another throughout. Holding right hands, each couple faces the same direction and dances toward the nearest couple and back. Repeat.

For Part B of the music, the dancers polka in

ballroom position for sixteen measures. Sedillo offers two variations of Part B In the first, couples link arms to dance in a circle. In the second variation, couples hold hands facing each other and swing each other to the right and left.

El Redondo or Valse de la Cadena

Redondo means round or circle. The redondo may be related to the Czech *redowa*, an early nineteenth-century dance in moderate triple time derived from a folk dance called the *rejdovák*. Its popularity spread from Paris to the United States in the mid-nineteenth century. This dance is also known as the *Valse de Cadena*, or Chain Waltz, which was noted for its length—it could last up to thirty minutes and

is characterized by beautiful moves executed while rotating partners. It was often one of the first to be performed at a dance in order to get the participants to meet one another, as waltz partners change regularly during the course of the Valse de Cadena.

For Part A, all couples form a large circle, holding hands. The circle revolves as all the dancers waltz to the left while swiveling. For Part B, couples break formation to waltz in ballroom formation. When Part A music returns, the circle is reformed without breaking the Waltz step, and the circle revolves to the left again, but with individuals in reversed positions relative to their first partners so that when Part B is played, a new waltz partner is at hand. According to McLerie and Keppeler, the circles can break up into smaller circles each time around, but usually end in a large circle. The tune of this waltz is used to accompany entriegas (see chapter 3).

El Talián

Also spelled *El Taleán*, the term is thought to derive from El Italiano, or the Italian, explaining its Mediterranean flavor. Lucero-White Lea describes a version as follows. Two couples form a circle, each woman facing her own partner, holding opposite hands as they pass as in a grand right and left, proceeding to the partner's right.

The woman of Couple A takes the left hand of the man of Couple B, while still holding her own partner's right hand. The woman of Couple B does the same with

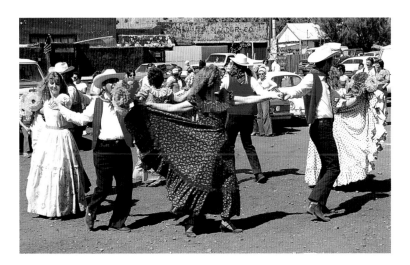

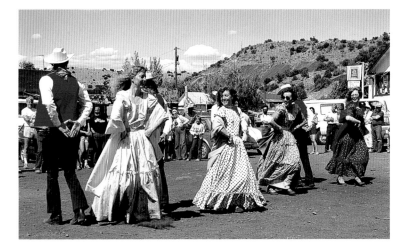

6.6 & 6.7
Members of Rudy's International Dancers perform the *Redondo Largo*, a variation of the *Redondo* that can last up to 30 minutes. Rodolfo Ulibarrí, Director.

the man of Couple A. After progressing as in Figure 1, a circle is formed with women facing in and men facing out. Maintaining this circle, the women dance forward and back, and the men dance in place.

The dancers then break the circle when the women let go with their right hands only. They walk forward and again take the left hand of the men, thus forming a circle with the men facing out and the women facing in. Now the men dance forward and back, while the women dance in place. Again, they break the circle with the right hands and reform the circle with women facing out and men facing in.

McLerie and Keppeler learned a three-part version from a Mr. Quintana of Pecos in which the grand right and left occurs as mentioned above. "The dancers could either continue this movement or do it twice through and then stop as in part one," according to Keppeler. "Another version of this is to have the couples holding hands with women facing out and men facing in and, simply holding partners' hands, turn and reverse the orientation every two measures." Then the couples break formation to perform a fast waltz in couples.

Valse Chiquiado

Also known as the *Vals de la Silla* (Waltz of the Chair), this dance required expertise in extemporaneous poetry or the assistance of a *poeta*. The *Valse Chiquiado* was a popular dance at the old fandangos because the poetry was often used for insults as well as praise. *Chiquiado* translates loosely as coaxing. As directed by the bastonero, the female dancer sat in a chair in the middle of the dance floor while her partner recited a flattering poem coaxing her to dance with him. The woman might reply with an insulting poem. When the seated dancer accepted, dancing would commence. Throughout the dance, the bastonero stopped the music to call on as many as twelve young ladies to take the chair. The men would then take the chair. Sometimes the poems poked fun at the entire community. According to Campa, if a dancer were very popular, his or her admirers would choose a different troubadour to outdo the competition.

Poetas were hired at dances to improvise the rhyming verses. In southern New Mexico, these verses were known as *bombas*. If two young men liked a girl, they would recite verse in competition for the girl. At this point, the dancing would stop in order to hear them out. Verses also were composed to flatter prominent citizens as they arrived at the dance.

<div align="center">

YOUNG MAN

</div>

Tengo una sala medida	I have a parlor filled
con cien yardas de listón	with a hundred yards of ribbon
en cada esquina una rosa	and in each corner a rose
y en media tu corazón	and in the middle your heart.

<div align="center">

YOUNG WOMAN

</div>

De las estrellas del cielo	Of the stars of the sky
voy a bajarte dos	I will bring you down two,
una para saludarte	one to say hello
y otra para decirte adiós.	and the other to say goodbye.

(Lamadrid and Loeffler 1994)

Valse Despacio

Folklorist Aurelio M. Espinosa wrote of his research in Spain in 1920,

> There was one dance, called *Danza de Corrillo*, that had a great resemblance to the old New Mexico *Valse Despacio*. Several couples . . . held hands in a circle and walked around slowly in step with the music of the guitar, and at a regular repetition of the monotonous rhythm, with quicker tempo the couples broke the circle and danced in pairs, either holding hands or separated. In the New Mexican *Valse Despacio* the circles are always of two couples and in the quick tempo repetition the couples dance holding hands in the usual manner. (Espinosa and Espinosa 1985)

He observed this dance in Calatañazor, the old

Castilian-Saracen frontier village in the province of Soria. In New Mexico, the quickened second half of the dance is called the Galopa, according to Campa. The tune of this waltz is used to accompany entriegas (see chapter 3).

Valse de la Escoba

Any number of persons may be on the dance floor to begin the dance, but there must be one extra man. The dancers line up facing one another, a few feet apart, men on one side and women on the other. The extra man waltzes with a broom (*escoba*) between the lines, then suddenly drops the broom and takes a woman and begins waltzing with her. As soon as the broom is dropped, the other men quickly pair up with the women and begin dancing. Because there is an extra man, someone will come up without a woman and must pick up the broom and dance with it. Presently, according to Campa, the bastonero calls for a change in partners, and the broom is dropped as everyone scrambles for a new partner. In another version described by Sedillo, the music stops and the dancers line up again to repeat the sequence. In yet another version performed in Río Arriba County and taught by Cipriano Vigil, the dancers do not line up, but simply dance as couples until the music stops or until the broom dancer taps the floor with the broom. Then everyone reaches for another partner, taking care not to repeat partners. When only women dance this waltz, the dancer with the broom does not drop it, but hands it to another, according to Rudy Ulibarrí.

In this dance, the protocol of asking a girl to dance is made easy as well as socially acceptable for the man, who "dances" with the broom until he works his way to the girl with whom he would like to dance. While touring France, McLerie and Keppeler encountered an old woman in Brittany who described a local dance precisely like this one. She said she had not danced it in fifty years.

Valse de los Paños

The Waltz of the Handkerchiefs is one of the most graceful dances of the regional repertoire. In each unit, two trios of dancers are formed, with one man standing between two women. Instead of holding hands, all are linked by handkerchief ends. Each trio forms a line facing the other trio. Each line waltzes forward for four measures, then backward for four measures, then repeats. Then, holding the handkerchiefs high, the woman on the man's left dances through the arch formed by the raised arms of the man and the women on his right. While this is happening, the woman on the right waltzes forward and to the left around the man, making a half-circle. The man turns right.

The man makes a half-turn left as the women progress around, completing their circles. The pattern is repeated with the woman on the right beginning the process. When they are done, everyone is back in the starting positions. Both trios have gone through the arches and face one another again. The entire sequence is repeated until the bastonero ends the dance. According to McLerie and Keppeler, a good dancer of Valse de los Paños will keep his or her handkerchief from twisting up. It must be untwisted during the dance without being dropped. There may be any mix of men and women in the dance trio. Incidentally, in universal Spanish, the term is *pañuelo* rather than *paño*. This dance is common in Eastern Europe and Mexico, where there are many variations, according to McLerie and Keppeler.

El Vaquero/La Vaquera

In this dance, performers stand shoulder to shoulder, man on the left, woman on the right, facing the same direction, and holding hands in the following configuration: the man takes the woman's right hand in his left, and her left hand in his right. To Part A of the music, both dancers perform the chotis step (skip-hop) forward and backward in time to the music. To Part B of the music, the dancers turn under their arms, taking care not to let go of the partner's hands, and to keep skipping as they rotate all the way around. Sedillo indicates that the dancers continue to wind in and out of the rotations. Or they may rotate holding only right hands, thus looking like the twirling of a lasso, according to Keppeler.

The choreography of *El Vaquero* is vague in all sources. There is a hint that the skip-hop ends in a forwardly extended foot at each hop, but this is not

clear. McLerie and Keppeler point out that the music to *La Vaquera* performed by Cleofes Ortiz is identical to a Newfoundland tune called "Uncle Manuel Milks the Cow" as performed by Rufus Guinchard.

La Varsoviana

Lucero-White Lea suggests that the New Mexico regional variation is slightly different from the Varsoviana made popular in mid-nineteenth-century Mexico. The music is in four parts. There seem to be two positions for this dance: a slightly open ballroom position, and a position in which both dancers face the same direction, with the man standing behind the woman and holding her upraised hands. In the first position, the man's choreography is mirrored by the woman's choreography. Their first step is taken with the man's left foot forward, and the woman's right foot forward. In the second position, they must start on the same foot (the left foot) and dance in unison. During the dance, the man directs the woman's crossing over from left to right while always remaining behind her. For both versions, the dance begins on the last count of the last measure of an eight-measure introduction, which is in ¾ time. It is important to know that the Varsoviana is a type of Mazurka. The Mazurka differs from the Waltz in that in the Mazurka, the accent is on the second beat of the measure.

Lucero-White Lea describes the choreography for Parts B and D of the music (numbers indicate beats of the music):

> Starting position, left foot forward; bring left foot back to right in slightly raised, crossed position—3—; step forward again—1—; draw right foot up to left [and step]—2—; again cross left over right—3—; and repeat all once. Repeat twice—only on second repeat (the third time the step is executed) the end is stepped so as to change to the other side. Cross left over right—3—; step forward left—1—; step back of left with right—2—; bring left heel to right heel—3—; make a half turn right and point right foot forward—1—; hold—2—; crossing right foot over left—3—; begin whole combination facing right. (Stark 1978)

The man dances with great emphasis in the *Varosoviana*, lifting his feet to accent, and never pointing but ending with a pronounced stamp. The dance begins again on Part B of the music, and on the repetition of Part A.

Another way to describe the step is "roll step step, roll step step, roll step step, step, point." The "roll" step is described by Lucero-White Lea as bringing "the left foot back to the right in slightly raised, crossed position" (Stark 1978). Keppeler describes it as "rolling a ball under your foot."

Other Dances

Las Cuadrillas is a suite of dances including a Polka, *Mano Derecha*, Galope, *Polka Cruzada*, and Cutilio. Cuadrillas follow the traditional European division of parts with a leader to call the changes and intermittent promenade and swinging of partners. The Cuadrillas derives from the Quadrille, an eighteenth-century French country dance comprised of five figures including *Le Pantalon* (after a popular tune), *Eté* (summer), *La Poule* (apparently after a melody that imitated the sounds of a hen); *La Pastourelle*, and *Finale*. Instructions for all the dances of *Las Cuadrillas* are available in Stark (1978).

No Nuevomexicano wedding celebration would be complete without the *Marcha de los Novios* (March of the newlyweds, or simply, the Wedding March), performed by as many of the wedding party, family, and guests as can fit into the room. Its serpentine maneuverings call for single-file hand-held lines segueing to couples marching in patterns set by the lead couple, then in two sets of couples, then back to couples and singles, again as determined by the lead couple. At one point, the couples form a long line of arched arms through which the bridal couple proceed, followed by all the other dancers as they break formation and follow the bridal couple through the arches. The dancers usually comprise a mix of children, youth, and adults. In traditional weddings, the march is preceded by a procession from the church to the site of the reception, led by the musicians. At the reception, the musicians take their places while the march proper is begun.

Sedillo mentions the *Jotita* as derived from the Spanish Zapateado and characterized by a quick

Waltz movement. The Jarabe was apparently danced in New Mexico. Other dances mentioned by nineteenth-century American visitors—but which apparently are no longer danced—are the *Cumbe*, the *Italiano* (possibly the precursor of El Talián), and the Bolero, which was reported to resemble a Negro jig. In fact, the Bolero was a highly stylized, virtuosic Spanish dance invented around 1780 in Cádiz. Accompanied by castanets or, if sung, by a guitar, the dance was performed by one or more couples, and became so popular within Spain that it became the national dance. As a matter of note, castanets are called *castañuelas* in Spain, where the term *castanet* is unknown.

The evening of dance in New Mexico was called a fandango, a term borrowed from, or named after, the eighteenth-century Spanish dance of the same name. The eighteenth-century Fandango was in $3/8$ or $3/4$ time, accompanied by castanets and guitars, and similar in melody and tempo to the Jota. The Fandango was originally a Moorish folk tune from Andalucía, a fact that is reflected in the earlier sung versions of the dance. The word itself is thought to be of Moorish origin. The gypsies of Granada were said to be the best Fandango dancers in all of Spain. The dance had regional variants within Spain, including one named after the Spanish town of Alburquerque, and the Malagueña from Málaga.

The Mexican Polka grew in popularity in the late twentieth century, with dancers executing the Polka step in a side-to-side stance rather than standard ballroom position. In this position, and with their outside arms free, the dancers moved lightly from side to side and forward and backward using shuffling steps. The Polka seems to be quite variable, as there is also the *Polka Doble* in which the man has two women partners, and a *Polka Suelta*, which is a solo dance. Anamaría Martínez of *Sociedad Colonial Española de Santa Fe* notes that in southern New Mexico in the late twentieth century, she has observed only Polkas, Waltzes, and *Marchas* performed primarily to mariachi music.

Costumes

American visitors in the nineteenth century noted the men wearing colored, cotton trousers and leather belts and jackets to the bailes and fandangos. The women were noted as wearing large sleeves, short waists, and no bustles, which was a scandal among the conservative American women.

Anamaría Martínez of Santa Fe remembers, when she was a child of four or five years in the mid 1930s, watching her mother, Anamaría Lucero Valencia, and her grand aunts, Jesusita Roybal and Felicita Martínez, dance the *Baile Chiquiado* at the bailes in Pecos, New Mexico, where the now-famous violinista Gregorio Ruiz performed into the night. Mrs. Martínez is a longtime member of *La Sociedad Colonial Española de Santa Fe*, an organization founded in 1947 to preserve and promote the old dances of New Mexico. She also remembers that weddings used to last three days, a practice that seems to have ended after World War II, in her memory.

An evening at the dance was apparently a semiformal event. Her grand aunts always wore long black or dark-blue skirts made of cotton or brocade. They all wore white blouses and white cotton underskirts. Light-colored skirts were not worn. Dancer Frances Luján verifies these choices in darker colored skirts, adding that they were flared in order to made movement easier. The women dressed up their costumes with a broach, earrings, and perhaps a pin in the hair. David Quintana, a musician from Pecos, remembers that men wore what they could afford—anything from suits to bib overalls, and big hats and ties. He remembers wide skirts on the women.

Mrs. Martínez remembers her grand aunts then adding a gray or white apron tied at the waist and reaching below the knees, but not above the waist. Hair was braided in one or two braids and wrapped into a *chonguito* at the back of the head. The men wore two- or three-piece suits, with ties and stickpins. Some wore their shirt open at the neck with a neckerchief tucked in at the neck and adorned with a stickpin. In the next generation of dancers, that of Mrs. Martínez's mother, the women wore shorter skirts and lighter colors. At the annual Baile de Cascarones in Santa Fe, many of the women who helped to plan and implement the dance were observed to favor black dresses, while other women wore their Sunday best, as well as

colorful, flared-bottom dresses and skirts. Men wore suits and fancy vests with traditional ties or bolo ties. Children wore their Sunday best.

At no time in the history of New Mexican dance have dancers worn the boldly colorful and decorated costumes typical of Mexican ballet folklórico. Many years later, when Mrs. Martínez (the younger) visited Europe with her husband, they were astonished to note the female field workers in Italy and Spain wearing long black, gray, or medium-blue skirts with aprons and white blouses. These women attended Mass in the same attire, where the Martínezes were able to get a closer look. To what extent these similarities in dress can be traced to a common source in the distant past is a matter of conjecture or, better, research.

A Typical Evening at a Nineteenth-Century Dance

Rosalía Salazar Whelan was born in 1904 in southern Arizona and was interviewed by Patricia Preciado Martín in the late twentieth century. Mrs. Whelan spoke of the old time dances:

La casa grande was also used as a *salón de baile* (dance hall) for the fiestas that we had in El Cañón. When there was a fiesta we took as many of our things out of the house as we could so people would have room for dancing. That was our main form of recreation. A group of musicians used to come to El Cañón from Safford. The band was called Los Chevarría. They played so beautifully! People came from all around—from Willcox, from Safford. And they'd ride up El Cañón on horseback from Hayden and Winkleman. It was the most direct route. We celebrated many different occasions—Christmas, New Year's, El Día de San José, El Día de San Juan, July 4, and September 16.

We danced two or three nights until the dawn. The poor musicians could barely hold up, but at least there by the river there was a lot of shade and a lot of water. They'd go there to rest or bathe and refresh themselves if they wished. They had to because at five or six in the afternoon the dancing would start all over again. Whole families would come from all the surrounding *ranchitos*, and they'd stay there also for two or three days.

They didn't charge for the dances like they do nowadays. My father and a group of men paid for the musicians and everyone danced for free.

Later my father enlarged la casa grande and added a kitchen at one end. My mother made dinners. She cooked and sold food to the people who came to the dances. She charged fifty cents a plate. My older sisters helped to serve. And she'd say to us girls, "When your partner invites you to eat, don't be shy and retiring! Bring them over so I can make a little money!" Well, now, if the bachelors didn't invite you to eat, you couldn't very well drag them over. But when they did invite me, I'd eat very little so they'd invite me again.

How I loved to dance! We used to dance "El Chotís," "La Varsoviana" (Put Your Little Foot), and "Las Cuadrillas" (reels, square dancing). Don Lauriano Moraga, who was the father of my brother's wife, Teresa Moraga, used to call the reels in Spanish. Instead of "Do-Si-Do," he'd call out, "Val-En-So!" I think we danced the cuadrillas a bit differently than the Americanos did. (Martin 1992; no italics in the original quote)

Certain types of dances were popular in California as well, including the *Valse de los Paños*, the Varsoviana, the Schottische, Polkas, and Waltzes, according to Rudolph.

Dance floors were either wooden or hard-packed clay with wheat straw scattered to keep the dust under control. The room might be lit by candles on wooden chandeliers (arañas) suspended from the ceiling by a rope. The dances could also be held in public facilities, such as a schoolhouse. Often before the public fandangos, the musicians rode through town playing and inviting people to attend.

The musicians included, at minimum, a violinista and a guitarrista. In the early days, the musicians also sang and were occasionally accompanied by a small Indian drum (*tombé*), as observed by a

nineteenth-century American visitor. Occasionally a drummer, concertina player or, later, accordionist, would join the band. The dance music, which was generally fast in tempo, had few embellishments and was described as simple, direct, and uncluttered. A few tunes switch from major to minor keys as in La Indita and El Talián, imparting a haunting feel to them. The músicos were required to announce each piece not by the name of the song, but by the name of the dance. Further, they were not to improvise if it interrupted the flow of the dance.

Well-known violinistas included Melitón Roybal (1889–1971), his brother, Bernardo (b. 1895), and Gregorio Ruiz (1889–1991), who was first hired to play at a wedding when he was nine. A *pícaro* was a musician who was particularly good at improvising verses. The bastonero, or caller of the dances, was named for the *bastón* (cane) he held to keep order and as a sign of his authority. He directed dances, called the name of the next dance, and, in the case of small dance halls, he made sure everyone got a chance to dance. For the Valse Chiquiado, he placed the chair in the middle of the room. While the musicians played a slow waltz, he looked among the dancers for the first couple to exchange verses. He would call on many couples during the evening. Even in this effort, poetry came into play as the bastonero addresses the couple:

De estos dos que	Of these two young
andan bailando	people dancing
si mi vista no me	If my eyes do not
engaña	deceive me,
anda bailando	one must be the
la reina	queen herself
con el príncipe	Dancing with the
de España.	prince of Spain.
	(Cobos 1956)

According to folklorist Marta Weigle, "The local dance has always been a curious institution in northern New Mexico because it combines great formality and structure—rules that can never be broken—with a remarkably lighthearted, democratic, and inclusive atmosphere" (Weigle and White 1988).

When a dance began, the men lined up along one side of the room. When they were in place, the women rose and took positions in regular order, opposite the men, not showing any preference. When every man and woman was matched, the music began, according to Josiah Webb. Also, it was customary for the men to clap their hands as a signal to the musicians that they had completed enough repetitions in a dance, according to Lucero-White Lea.

Dances in Santa Fe were offered to the public at no charge, but sweetbreads, whiskey, and wine were sold at inflated prices. According to Sedillo, at *bailes de mesero* (dances with refreshments), men could also buy candies and gifts for their partners. Matt Field wrote, "When the dance is over the Spanish beau hands his mistress a *chupar*, or when he chooses to be expensively polite, a glass of whiskey and a plate of sweet bread. When the refreshments are partaken of, and the segars [sic] smoked, another dance begins" (Stark 1978). To insure that another dance was to take place in the near future, a couple was tied with a handkerchief until someone at the dance agreed to host the next dance. The newly scheduled baile or fandango was called the *Baile de Desempeño* (Dance of Redemption), according to Thomas.

Dance in the Twentieth Century

Literature on New Mexican dance is limited and much more research is needed, especially as those who remember the old dances die away. In the 1920s, Aurora Lucero-White Lea began writing *Folkdances of the Spanish-Colonials of New Mexico*, a booklet on the dances of New Mexico. At the time, she was a teacher in San Miguel County. Mela Sedillo taught Mexican and Spanish folk dance at the University of New Mexico from the early 1930s to the mid-1940s. In 1937, she published *Mexican and New Mexican Folkdances*, with a second edition appearing in 1945. In 1978, Richard Stark published *Music of the "Bailes" in New Mexico*, which includes the Lucero-White Lea booklet as well as a paper by Anita Gonzales Thomas that compiled much of the American writings of the nineteenth century about the dance. It also includes fifty-eight

transcriptions of the violin music of many dances, transcribed from recordings by Reed Cooper.

In 1935, Cleofas Jaramillo and a core group of ten women founded *La Sociedad Folklórica* in Santa Fe to promote and preserve Nuevomexicano traditions. They planned several events around the calendar, including a summertime velorio for Santa Ana (patron saint of family life), a *merienda* (luncheon) in the fall, a performance of *Los Pastores* at Christmastime, and a *Baile de Cascarones* immediately after Easter. The velorio included a ceremony of reverence for family life, a buffet supper, a decorated home altar, mass at twilight, and the singing of songs. The merienda included a fashion show of historic clothing.

In 1948, Fermín and Cirenia Montes of the Hondo Valley began a student dance group called the Hondo Fiesta Dancers at the Hondo High School. Mr. Montes was superintendent of schools and principal of the small school (two hundred students) where Mrs. Montes taught the students such dances as *El Vaquero, La Raspa, La Cuna, La Camila, La Polka, La Cucaracha, La Varsoviana* and *El Valse de los Paños.* She had studied dance in Saltillo, Mexico, and in Albuquerque. The group toured California, Arizona, Tennessee, and Mexico with a showcase performance of different dances they called "Night of the New Mexican Dances."

In 1945, Clarita García opened Clarita's School of Dance in Albuquerque, where she began teaching flamenco and New Mexico social dances as well as ballet and tap. She and her students performed extensively around the city and state. For the Coronado *Cuartocentenario* in 1940, she was appointed by the U.S. Coronado Exposition Commission to train dancers in various states where the entrada was enacted. Many of her students became teachers. Campa notes that *La Varsoviana* was a favorite at the governors' inaugural balls in the early twentieth century, and that the University of New Mexico student body adopted it as the official university dance during its 1936 homecoming festivities.

Today, historical folk dancing is a spectator presentation by trained dancers in dance companies or clubs. Rudy's International Dancers, based in Albuquerque, showcases the old dances with commentary by an announcer. Frances Luján's Albuquerque-based *Los Tapatíos* occasionally presented the old dances in formal dance concerts.

In Santa Fe, a group of interested adults formed the *Sociedad Colonial Española de Santa Fe* in 1947 to preserve the dances and *cuentos* of the old days. In the late 1990s, its membership was about thirty-four, with the youngest members in their early forties and the average age in the sixties. The group meets monthly, and at one time held monthly dances. They dance at the Spring and Harvest Festivals at *El Rancho de las Golondrinas*, south of Santa Fe, the Spanish Market (occasionally the Winter Market), and at the Santa Fe Fiesta, where performers alternate cuentos and *dichos* with the dances to give the dancers a rest. Their repertoire includes the *Valse de Cadena, La Cuna, El Chotís, Valse de los Paños, La Camilla, La Comancha, El Vaquero, La Varsoviana, La Polka,* and *La Marcha.*

The *Sociedad* teaches the old dances in primary and secondary schools in Santa Fe and elsewhere. Thirty young adults at a rehabilitation center at Abiquiú incorporated costumed performances into their graduation from the center. After World War II, weddings became the one event where all these dances might be performed. Because all age groups attended the wedding dance, it was at these events that the dances might be taught to the next generation in a familial setting.

Anamaría Martínez of the *Sociedad* recalls that the musicians for dances at Pecos included Don Gregorio Ruiz on violin and Ricardo Ruiz or Tito Rivera on guitar. In Santa Fe, the violinista was Alejandro Flores and the guitarrista was Evaristo Lucero. Often, Gregorio Ruiz performed in Santa Fe as well. In the early days of the *Sociedad*, the members met in private homes where they rolled up the carpet and passed the hat to collect money for the musicians.

Keppeler recalls:

Many people we talked to from the northeastern plains of New Mexico, from I-40 to Colorado, recall dances in the 1920s, 1930s, and 1940s where dances were split between the

Spanish musicians and dances, and Anglo/ Cowboy musicians and dances. Both groups would dance the others' dances and the musicians would often help each other out. Fifteen years ago, Jeanie and I played these dances for members of my family in California. Most of them had emigrated there from New Mexico and many of them knew the dances such as the *Baile de la Escoba*, *Varsoviana*, and *La Cuna*. None of my relatives from Mexico knew the old New Mexican dances except the common *Varsoviana* and *Chotís*. (Personal communication)

Survival of these dances in the late twentieth century is dependent on the dance masters who teach them and on the professional and amateur performers who showcase them at gatherings and holidays. *La Sociedad* occasionally travels the state in groups of sixteen or twenty to teach the dances and perform, but members avoid night travel and must have their expenses paid, which can be daunting with that number of dancers. Rudy Ulibarrí of Albuquerque is another source of hands-on knowledge, as is Oma Sandoval of Placitas, Frances Luján and Lorenzo Montoya of Albuquerque, and Jeanie McLerie and Ken Keppeler of Silver City.

McLerie and Keppeler continue to teach the dances to thousands of school children and others in New Mexico, the United States, and Europe during their performance tours in the last quarter of the twentieth century. They also teach the dance tunes to interested musicians. They have recorded and interviewed numerous old time musicians, gathering one hundred hours of recording time and producing cassettes and compact discs. Independent research is also conducted by Adrián and Barbara Treviño, particularly on the Matachines dance.

The twentieth century saw new dance types introduced into the state. Clarita (b. 1918) learned flamenco from her mother and began teaching it in Albuquerque in 1945. In the 1950s, the New York-based José Greco Company began including Albuquerque in its national tours in the 1950s. Yet it was not until another generation of dancers, including Lili del Castillo, Eva Encinias-Sandoval, and María Benítez, that flamenco in New Mexico was brought to its full flower. Ms. Benítez established

6.8
Flamenco dancer Lili del Castillo of Albuquerque. Courtesy Lili del Castillo.

the *María Benítez Teatro Flamenco* in 1970, and in 1983 she established the Institute for Spanish Arts to teach and encourage emerging dancers, musicians, choreographers, and costume, lighting, and set designers through workshops. In 1975, Lili del Castillo established *Rincón Flamenco*, which also toured nationally and internationally with guest artists from the United States and Spain. Eva Encinias-Sandoval established the first university program in flamenco studies in the United States and hosts the *Festival Flamenco Internacional* every summer at the University of New Mexico. Her company is called *Alma Flamenco*.

In the late twentieth century, the baile tradition is kept alive by families of musicians, including the Roberto Martínez, Al Hurricane, and Alberto Sánchez families of Albuquerque, the Jaramillo family of Taos, and the Vigil family of Chamisal. These bands are equally at ease playing modern rock and pop music, followed immediately by traditional dance pieces. Roberto Martínez's group, Los Reyes de Alburquerque, and Los Folkloristas de Nuevo México perform acoustic (i.e., nonelectric instruments) baile music. Numerous electronic bands also perform traditional dances alongside original and rock music. One such group is the popular Blue Ventures, an eclectic group from Alcalde and Peñasco. Performances of traditional music are especially appreciated by older people who still remember the dance steps and lyrics to many old favorites. Since 1983, Los Reyes de Alburquerque has performed the old-time dance music to hundreds of viejitos and viejitas (elders) in senior centers and nursing homes throughout New Mexico.

Chronology _____

1806 First recorded observation of dance in New Mexico, by Zebulon Pike.

1815 Mexican church officials denounce the Waltz as corrupt and pernicious.

1864–
1867 The short reign of Maximilian and Carlotta in Mexico results in the introduction of the Schottische and the Polka of Central Europe, and the *Krakoviat* and *Warszowanka* (named after the city of Warsaw), to be known in New Mexico as the *Cracoviana* and *Varsoviana*.

1821–
1860 The baile and fandango reach heights of popularity during this time.

1935 Cleofas Jaramillo and a group of Santa Feans establish *La Sociedad Folklórica*, which continues to host an annual Baile de Cascarones.

1937 Aurora Lucero-White Lea publishes *Folk-Dances of the Spanish-Colonials of New Mexico*, a booklet on the dances of New Mexico.

1938 Mela Sedillo publishes *Mexican and New Mexican Folkdances*.

1947 A group of Santa Fe residents establish the *Sociedad Colonial Española de Santa Fe* to preserve the dances and cuentos of the old days.

1970–
1975 Three professional flamenco companies are established by three native Nuevomexicana women, María Benítez, Lili del Castillo, and Eva Encinias.

1983 María Benítez establishes the Institute for Spanish Arts.

Glossary _____

Baile—A dance event, especially a private dance gathering.

Bolero—A Spanish national dance apparently invented in the late eighteenth century in Cádiz. It is both a couples dance and a group dance, accompanied in Spain by castanets, voice, and guitar. It began as a folk dance and was adopted by the elite, who made it fashionable. It consists of five parts: *paseo, traversía, diferencia, traversía,* and *finale*. There is no surviving description of how it was danced in New Mexico, although it was popular along the Mexican border, according to Campa. May be in duple or triple time.

Duple time—A rhythm in which there are two beats, or multiples of two beats, in a measure.

Fandango—A Spanish dance invented in the eighteenth century, accompanied by castanets and guitars. In triple time, this dance was originally a vocal dance. In New Mexico, a public dance came to be called a fandango. The term means disorder or topsy-turvy. Spanish variations are the Malagueña, the *Rondeña*, the *Granadina*, and the *Murciana*.

Jota—A dance of Aragón, in Spain, although found in other Spanish regions. Characterized by muscular agility and physical endurance, including high leaps and runs. Steps are rapid, strong, and energetic, and represent rustic courtship.

Landler—An Austro-Bavarian dance in slow triple time dating from at least the seventeenth century. It is considered the precursor of the Waltz.

Pavana—Originally a Spanish dance characterized by slow, stately walking steps, it later came to be associated with Italy (Pavane). It was the most popular dance of the sixteenth and seventeenth centuries, usually performed in duple time. The term is derived from *pavo*, the Spanish word for peacock.

Quadrille—A French dance of the late eighteenth century, derived from the French country dance, and performed by two or four couples in a square pattern, somewhat comparable to the American square dance. It was adopted in nineteenth-century New Mexico, where it was called the Cuadrilla.

Round dance—A dance characterized by circular movement and performed by couples, as in a Polka or Schottische, usually in ballroom position.

Schottische—A nineteenth-century dance similar to the Polka.

Triple time—A rhythm in which there are three beats, or multiples of three beats, in a measure.

Waltz—An eighteenth-century dance of Austrian and German origin, the term is derived from the German term, *walzen*, meaning to roll or turn. Usually performed in moderate triple time.

Zarabanda—A slow dance originating in Central America, then refined in Spain. Danced with gliding steps.

Zorzico—A dance thought to have originated in the Basque region of Spain.

Bibliography _____

Brooks, Lynn Matluk. *The Dances of the Processions of Seville in Spain's Golden Age.* Kassel: Edition Reichenberger, 1988.

Brown, Lorin W., Charles L. Briggs, and Marta Weigle. *Hispano Folklife of New Mexico: The Lorin W. Brown Federal Writers' Project Manuscripts.* Albuquerque: University of New Mexico Press, 1984.

Campa, Arthur L. *Hispanic Culture in the Southwest.* Norman: University of Oklahoma press, 1979.

Chase, Gilbert. *The Music of Spain.* New York: Dover Publications, 1959.

Cobos, Rubén. "The New Mexican Game of Valse Chiquiao." *Western Folklore* 15, no. 2 (April 1956): 95–96.

Cooke, Philip St. George. *The Conquest of New Mexico and California in 1846–1849.* Chicago: Rio Grande Press, 1964.

Coues, Elliott, ed. *The Expedition of Zebulon M. Pike.* Vol. 2. New York: Francis P. Harper, 1895.

Davis, W. W. H. *El Gringo Or, New Mexico and Their People.* Santa Fe: Rydal Press, 1938.

Espinosa, Aurelio M., and J. Manuel Espinosa, eds. *The Folklore of Spain in the American Southwest: Traditional Spanish Folk Literature in Northern New Mexico and Southern Colorado.* Norman: University of Oklahoma Press, 1985.

Geijerstam, Claes af. *Popular Music in Mexico.* Albuquerque: University of New Mexico Press, 1976.

Gregg, Josiah. *Commerce of the Prairies.* Edited by Max L. Moorhead. Norman: University of Oklahoma Press, 1954.

Gregg, Kate L., ed. *The Road to Santa Fe: The Journal and Diaries of George C. Sibley.* Albuquerque: University of New Mexico Press, 1968.

Horgan, Paul. *Lamy of Santa Fe.* New York: Farrar, Straus, Giroux, 1980. 172.

Hughes, Russell Meriwether. *Spanish Dancing.* Pittsfield, Mass.: Eagle Printing and Binding Co., 1967.

Hyatt, Frieda Bryan. "Folk Dance Fiesta." *New Mexico Magazine* vol. 46 no. 4 (April 1968): 5–7.

Ivanova, Anna. *The Dance in Spain.* New York: Praeger, 1970. 61.

Kern, Mansi. "New Mexico Folk Dances and Music of Northern New Mexico." 1967. Manuscript housed at the Museum of International Folk Art, Santa Fe.

Lamadrid, Enrique. Personal communication, February 1998.

———. *Tesoros del Espiritu: A Portrait in Sound of Hispanic New Mexico.* Albuquerque: El Norte/Academia, 1994.

Lea, Aurora Lucero-White. "Folk-Dances of the Spanish-Colonials of New Mexico." In *Music of the Bailes of New Mexico,* edited by Richard B. Stark, Anita Gonzales Thomas, and Reed Cooper. Santa Fe: International Folk Art Foundation, 1978.

Luján, Frances. Personal communication, January 1998.

McLerie, Jeanie, and Ken Keppeler. Personal communication, February 1998.

McGraw, Kate. "Children of the Dancing Valley." *New Mexico Magazine* vol. 55 no. 3 (March 1978): 28.

Martín, Patricia Preciado. *Songs My Mother Sang to Me: An Oral History of Mexican American Women.* Tucson: University of Arizona Press, 1992.

Martínez, Anamaría. Personal communication, January 1998.

Matos, M. García. *Danzas Populares de España Extremadura, I.* Madrid: Industrias Gráficas Magerit, S.A., 1964.

Paredes, Américo. "The Love Tragedy in Texas-Mexican Balladry." In *Folk Travelers: Ballads, Tales, and Talk,* edited by Mody C. Boatright, Wilson M. Hudson, and Allen Maxwell. Austin: Texas Folklore Society, distributed by Southern Methodist University Press, 1953.

Phillips, Aileen Paul. "A Spring Tradition—Los Cascarones." *New Mexico Magazine* vol. 58 no. 3 (March 1980): 54–55.

Quintana, David. Personal communication, April 1998.

Rudolph, Beth Chanin. "Dance in San Francisco: A Study Focusing on Theatrical Dance, 1849–1859." Master's thesis, University of California at Los Angeles, 1971.

Sachs, Curt. *World History of the Dance.* 1937. New York: W. W. Norton, 1965. 98.

Sargeant, Kathryn, and Mary Davis. *Shining River, Precious Land: An Oral History of Albuquerque's North Valley.* Albuquerque: The Albuquerque Museum, 1986.

Sedillo, Mela. *Mexican and New Mexican Folkdances.* 1937. Albuquerque: University of New Mexico Press, 1945. 30.

Stark, Richard B., Anita Gonzales Thomas, and Reed Cooper, eds. *Music of the "Bailes" in New Mexico.* Santa Fe: International Folk Art Foundation, 1978. 82.

Sunder, John E. *Matt Field on the Santa Fe Trail.* Norman: University of Oklahoma Press, 1960.

Thomas, Anita Gonzales. "Bailes y Fandangos: Traditional Folk Dances of New Mexico." In *Music of the Bailes of New Mexico,* edited by Richard B. Stark, Anita Gonzales Thomas, and Reed Cooper. Santa Fe: International Folk Art Foundation, 1978.

Ulibarrí, Rudy. Personal communication, January 1998.

Vega, Carlos. *El orígen de las danzas folklóricas.* Buenos Aires: Ricordi Americana, 1956.

Webb, James Josiah. *Adventures in the Santa Fe Trade, 1844–1847.* Glendale, Calif.: Arthur H. Clark, 1931.

West, John O., comp. and ed. *Mexican-American Folklore: Legends, Songs, Festivals, Proverbs, Crafts, Tales of Saints, of Revolutionaries, and More.* Little Rock: August House, 1988.

Weigle, Marta, and Peter White. *The Lore of New Mexico.* Albuquerque: University of New Mexico Press, 1988.

7

Cocina y Salud: Foodways and Healing Arts

Haciendo tamales mi mamá wouldn't
 compromise—
no mfgr chili, no U.S.D.A. carne
nomás handgrown y home-raised, todo.
Orégano had to be wildly grown
in brown earth bajo la sombra.
Tamale wrappers had to be hojas
dried from last year's corn
nurtured by sweat—¿cómo no?
Trabajos de amor pa'enriquecer el saborcito.
To change or country
she wouldn't sacrifice her heritage.
Entonces, como su mamá antes y su abuelita
she made her tamales from memory
cada sabor nuevo
como el calor del Westinghouse where
she cooked them with gas under G.E. lights—
bien original to the max!
 (*Cordelia Candelaria, "Haciendo Tamales"*)

FOODWAYS

The cultural revolution initiated by Columbus's voyages made an enormous impact on the foodways of the world—from Europe to Africa to China—which in turn influenced nutrition, population growth and vigor, and even political activity. In New Mexico, the introduction of new foods by the Spanish forever changed the largely vegetarian diet of the native populations. The Spanish in turn adopted the foods native to their new home—notably corn, beans, squash, and certain wild vegetables and herbs—and became ever dependent on their Pueblo neighbors in times of shortage.

The Spanish response to New World foods was notably more open-minded than that of other European cultures, where initial reactions were often that of suspicion and fear. Today, European cuisines are healthier and more varied because of the New World foods introduced by the Spanish. Prior to 1492, many foods now considered basic were unheard of in Europe.

Old World foods introduced to the Americas include cattle, sheep, pig, chicken, goat, cow and goat milk and cheese, honey, wheat, Asian rice, sorghum, barley, oat, soybean, sugarcane, onion, beans (broad, garbanzo, lentil, mung), radish, lettuce, okra, peach, apple, plum, quince, cherry, pear, watermelon, citrus fruit, banana, and the olive.

New World foods introduced to Europe include corn, potato, tomato, turkey, chile peppers (of the genus *capsicum*), sweet potato, chocolate, vanilla, tobacco, beans (lima, pinto, black, string, navy, kidney), pumpkin, squash, cassava root (*manioc* or *yuca*), avocado, guava, papaya, peanut, pecan, cashew, sunflower, pineapple, blueberry, and strawberry. The sweet potato and peanut were introduced by early explorers to Africa, where they were widely grown and used as provisions on slave ships heading west. Because of this, there is a widely held misconception that the sweet potato and peanut originated in Africa.

Prior to the introduction of New World foods, the average European family survived on rye bread, wheat bread, cabbage, onions, and cheeses. Upper-class Europeans ate these with meats heavily spiced to mask the smell and flavor of decay, as there was no refrigeration. The potato was at first thought to be a poison *and* an aphrodisiac, to cause leprosy and scrofula, and was avoided even in the face of famine. In 1840, Russian peasants

revolted when forced by the government to plant potatoes on common lands. The French started a rumor that chocolate produced dark offspring in the women who ate it. The tomato was also thought to be an aphrodisiac, hence its early common name in France, *pomme d'amour*, or love apple. The British thought the tomato caused gout and lacked any real nutritional value. Not until the twentieth century did they accept the tomato, preferring it as a soup, while Anglo-American cooks were almost as slow to adopt it. Most Europeans still find corn useful only for feeding livestock.

Despite the prejudices, specific foods had profound effects on humanity. Fortunately for both sides of the Atlantic, corn provided far more nutrition per acre than anything known prior to its introduction. Scholars credit corn and potatoes for making possible the growth and expansion of Germany's population, and even facilitating the rise of its industrial age. By the mid-sixteenth century, corn had been widely accepted among the Mediterranean cultures, as well as in Asia and the Philippines, where it was introduced by Magellan. In China, corn became a life-saving crop for migrants forced into the hills from the overpopulated Yangtze delta region. Corn made possible the shift of the ancient Aztecs, Mayans, Incans, and Anasazis from foraging to farming, which in turn gave rise to their advanced civilizations. On the down side, the potato caused unprecedented population growth in Ireland, followed by a nationwide potato blight because the Irish had planted very little besides potatoes. The resulting famine of 1845 precipitated one of the largest migrations in history as many Irish immigrated to the United States.

New World Foods

While geographically remote, New Mexico was nevertheless tied to the rest of humanity in its use of foods that brought the whole world together at the dinner table. Here are a few examples.

TOMATO

By the sixteenth century, the horticulturally gifted Aztecs had cultivated the tomato into a wide variety of types, which they prepared and ate at every stage of growth. For example, thin shavings of the green tomato enhanced many Aztec dishes, while ripe tomatoes were mixed with capsicum peppers (chile) into a sauce served with beans—the forerunner of today's salsa. Historians suggest that the Aztec tomato was more like the cherry tomato than larger present-day varieties.

The first tomato introduced into Italy was one of the yellow varieties, because the Italian word for tomato is *pomodoro*, meaning "golden apple." The tomato took well to the warm Italian climate and became the basis for Italian cuisine thereafter. The Spaniards more accurately called this vegetable *tomate*, after the Aztec word *tomatl*.

CHILE (CAPSICUM)

Columbus himself mistakenly referred to capsicum as *pimienta* (pepper). Since then, the confusion has never ceased. Although he may have been aware that pepper is an entirely different food (*Piper nigrum*), scholars speculate that Columbus may have been anxious to validate his spice-finding mission. The term *chile* is derived from the Aztec word for capsicum, *chilli*. The Aztecs had developed forty varieties of chile by the sixteenth century. They used them fresh, fried, roasted, or smoked in soups, stews, and vegetable dishes—as many as five varieties in one dish—and they dried or pickled them for storing or traveling. When introduced in the Old World, chile, in all its varieties from bell pepper to *habanero*, flourished in the warmer climates, and eventually made its way into the cuisines of India, China, (Szechwan and Hunan provinces), the Ottoman Empire, and the Balkans, where in Hungary it became known as paprika. Today, there are over ninety varieties of chile.

CORN

Maíz, or corn, originated in ancient Peru and/or Mesoamerica, probably as a hybrid of two wild grasses. While no one knows which grasses these were, the Jémez Indians claim that a canelike, tasseled grass growing at Bandelier's Frijoles Canyon is the original strain. Sophie Coe postulates that maíz was introduced into northern Mexico around 2,200 B.C. The word *maíz* is thought to be derived from *mahiz*, which may be the Taino word for corn, or the Aztec word for "our life." There are five

major groups of corn including dent, flint, flour, sweet, and pop, differing in sugar and starch content. Within these groups are a wide variety of sizes and colors, including white, yellow, red, blue, black, and variegated. The pre-Columbian corn varieties were relatively small in size compared to later hybrids.

Corn grows quickly and withstands neglect, drought, and harsh sun better than other grains; it is also very adaptable to selective breeding, as evidenced by the two hundred varieties that were already developed by the time Cortés advanced on Mexico. (His advance troops reported passing through a cornfield that was eighteen miles long.) Corn, beans, and squash have been called the holy trinity of native cuisine because together they provide all of the essential amino acids necessary for life and health. These three essentially tropical vegetables supported populations not only in Mexico and Central America, but in New Mexico and the Southwest as well.

The Aztec nobility ate corn as round flat breads known as *tlaxcalli*, which varied in size, color, and thickness. The Spanish called them tortillas, a term derived from *torta*, meaning a round, filled pastry. The tlaxcalli, or tortillas, were steamed under cloth or on a hot surface, and served open or folded, filled with fish, insects, or fowl, and flavored with chiles and herbs. Maíz was also the basis of carefully seasoned or sweetened gruels and stews. In Latin America, the very poor, usually Indians, ate maíz breads, while wheat breads were eaten primarily by the Spanish.

Prior to cooking with corn, the Aztecs pretreated it through nixtamalization, a simple process where corn is cooked with lime or wood ashes in order to remove the hard, transparent skin from the grain, rendering it easier to grind and enhancing the protein value for humans. The de-hulled grain, which was then washed five times, was known as *nixtamal*, from the Aztec word *nextli*, meaning ashes and *tamal* meaning dough. (The term *nixtamal* is still used in New Mexico.) They then ground the nixtamal using a *mano* and *metate*. Metate is derived from the Aztec word *metlatl*, meaning a large, flat sitting stone. Mano is Spanish for hand, indicating the stone held in the hands. At first the Spanish did

not pretreat corn, so when it was adopted as a staple food by certain peoples of Europe, there was less protein available. Without complementary foods such as beans and squash, inadequate nutrition led to outbreaks of pellagra, a disease caused by a deficiency of niacin, and kwashiorkor, a disease caused by a protein deficiency.

In the United States, corn became the basis for bourbon whiskey, an American invention. The Venetians transported corn to the rest of the world, including Great Britain, Germany, Holland, and Russia, where it was known as Turkish wheat. The Portuguese introduced corn to African countries, where it grew rapidly. Scholars suggest its abundance there resulted in a population increase that kept the slaving industry well supplied. Corn was a staple on the slave ships as they traveled to the sugarcane fields of Brazil and the Caribbean.

THE POTATO
We may thank the ancient Peruvians for developing the indigenous potato into many varieties beginning as far back as 8,000 B.C. It was known to them as *papa*, to the Spanish as *patata*, and to Nuevomexicanos as *papa*. For centuries, the Peruvians froze, pounded, and dehydrated the potato into a flourlike substance from which they made bread (a modern recipe for this bread is given in Rozin's carefully researched cookbook *Blue Corn and Chocolate*). The potato was introduced to Britain by Francis Drake, who acquired a shipment in Cartagena in 1586 on his way to England via Virginia. For centuries thereafter, the British thought the potato had come from Virginia. Because potatoes grew well in poor soil, they were successful in Europe for use by the poor and to feed livestock. Today, there are approximately one thousand varieties enjoyed in Peru, where Potato Feasts are still held.

CHOCOLATE
The ancient Aztecs believed chocolate to be the food of the gods. Their word for the cacao bean was *xocolatl* (*xoco* meaning bitter, *atl* meaning water). The cacao bean has been traced back to the Olmecs of approximately 2,000 B.C. These ancients gathered, husked, sun-dried, fermented,

and roasted the beans before mixing the final product with powdered flowers to create their chocolate drink. Not until some Spanish nuns in a Mexican convent mixed chocolate with sugar was the more familiar modern drink developed. The Aztecs also used chocolate as a spice in main dishes, but this never caught on with the Europeans. Chocolate as a seasoning in foods is still popular in Mexico and Latin America.

The importance of cacao beans to the ancient Aztecs, as the basis of currency and wealth, was exploited by the Spanish to break the tribute system the Aztecs had in place with their neighbors. Chocolate then became an important cash crop for the Spanish. While other New World foods could be grown in the Old World, the cacao tree did not transplant well, leaving Spain with most of the cacao-growing lands and a market monopoly.

One Spanish recipe for hot chocolate dating from 1631 calls for chile, anise, the powder of "roses of Alexandria," logwood pods, cinnamon, almonds, flowers known as *vinacaxtlides* and *mesasuchil*, hazelnuts, sugar, and *annatto* (a dye). At that time, chocolate paste was exported to Italy and Flanders, and by the mid-seventeenth century, it was highly popular in England and France. Not until the nineteenth century was the idea of chocolate in block form conceived by the Swiss.

SUGAR

European monasteries were for centuries the largest producers of honey, a by-product of their main concern: liturgically correct beeswax candles. The Reformation's campaign against monasteries naturally resulted in a falling off of honey production. All the while, the Moors controlled Old World sugar production and prices—which were restrictively high—through the end of the Renaissance period. Almost as if on cue, the Spanish began cultivating sugarcane in 1506, but then just as precipitously turned their attention to gold and silver mining. The Portuguese—and later the Dutch, Danes, and British—assumed sugar-plantation management and production, and the necessary slave trade that they required. Sugar became even more important in Europe when it was discovered in 1600 that fruits could be preserved in it as jams and jellies.

TURKEY

Cortés's troops noticed a strange bird wandering freely in the palace of Moctezuma. Several of these turkeys were sent to Spain, where the flock grew, and were gradually exported elsewhere in Europe. In Venice, only the ruling class was privileged to eat the new and expensive delicacy, and the ruling Council of Ten decided which families could dine on turkey. In France, only King Francis I was allowed (or could afford) to eat turkey, though he was known to toss bits of meat to his courtiers.

East Meets West

The Spanish settlers in Mexico and the Southwest brought the traditional cuisine of their land, which included many items introduced into Spain by the Moors. In this category were citrus fruits from Persia; almonds, Asian rice, and sugarcane from India via Persia; and saffron from the eastern Mediterranean region.

Like the Chinese, the Arabs transformed eating into colorful and varied dining experiences at a time when medieval Europeans were eating dull, dreary foods in less than sanitary conditions. In the court of the caliphs, guests were expected to create improvised poems on the banquet they enjoyed, or to suggest new dishes that cooks were to produce immediately for that occasion. Spain stood geographically and culturally between the Arabs' exciting approach to cuisine and the monotony of European fare. It expressed itself in Spain's greater acceptance of new foods discovered by its explorers, motivated no doubt by its economic interests in such successful cash crops as chocolate and sugar. The Spanish may also have been motivated to try new foods when production of more familiar foods failed, as in New Mexico, where early settlers used cornmeal until they found ways to grow sufficient amounts of wheat.

In fact, the food known today as "Mexican" is a blending of Aztec and Spanish foods and preparation techniques. The Aztecs developed tamales and enchiladas, which they prepared with the corn tortilla or *masa* (dough), filled with several different types of chile, and even insects, a wide

variety of which was part of the Aztec foodways. The Aztecs had five domesticated animals, including the turkey, the Muscovy duck, the dog, the bee, and the cochineal insect. Dairy foods and frying were unknown to the Aztecs. The Spanish contribution to what was to become today's Mexican cuisine included olive oil, onions, pork, beef, lamb, wheat, sugar, cheese, garlic, vinegar, and limes. The pomegranate, the image of which appears in New Mexican colcha designs, was used in Mexican cooking. Its seeds were part of the traditional Christmas Eve salad.

Much of what we know of pre-Columbian foodways was recorded by a Franciscan friar named Bernardino de Sahagún in his sixteenth-century work *Historia general de las cosas de Nueva España* (General History of the Things of New Spain) and by Bernal Diáz del Castillo in his *Historia verdadera de la conquista de la Nueva España* (The True History of the Conquest of New Spain), also an eyewitness account of the conquest.

The foodways of northern Mexico were developed by and for the vaqueros (cowboys), sheepherders, landowners, and adventurers who frequented the northern reaches of the country. In the wide-open ranch country, cooks adapted the traditional Mexican fare to local availabilities. Beef, lamb, and goat were cooked over mesquite wood or charcoal and served with flour or corn tortillas. Northern Mexican cooks developed the first fajitas, or "skirt" meat (cuts resembling ruffled skirts) sautéed in spices and served with flour tortillas and sauces.

The Spanish introduced Spanish wine, beer, grape brandy and cane brandy. Vineyards established in Peru and Chile produced much of the New World wine. Natives produced *chicha* and *pulque*. Chicha, or *tesgüín* as it is called in Mexico, is a fermented drink made from cornmeal and fruits found throughout Spanish America but most popular in the Andes. Pulque was fermented sap of the agave plant, widely consumed in Mexico. Used during planting, harvesting, and community activities to invoke divine intervention, these drinks strengthened the social bonds of Indian life and caused alarm among the missionaries, who wanted the beverages outlawed.

New Mexico

On April 30, 1598, Don Juan de Oñate and his settlement party celebrated their safe arrival at the Río Grande after days of travel over dangerously dry terrain south of El Paso. It was on this day that a great feast was held—some call it the first Thanksgiving in North America—with games, entertainment, and a solemn mass preceding the celebrations. In their spring-green bosque, even some Indians brought fresh fish traded for clothing. Later, as the travelers pushed on into New Mexico, a missionary friar noted the fields of corn all along the Río Grande Valley, and wrote, "Here, corn is god" (Hammond and Rey 1953).

Oñate's colonists gradually adopted the local foods and preparations that they found practical, including foods for which they had no Spanish equivalent, like squash. They also brought foodstuffs with them, but the winter of 1598–99 was unusually harsh and the first crops did not do well. Ultimately, the Spanish became a burden on the Pueblo Indians, who were forced to share their food with the newcomers as a form of *encomienda*, or tribute, a practice begun in Mexico by Cortés, who also ran short of food. Because the Indians stored food against difficult times, they became a convenient source of available food. In later years, the Spanish would purchase grains from their stores whenever needed. However, during the Oñate years, the food was simply appropriated.

Native American Foods of New Mexico

The pre-Columbian Pueblo Indians of New Mexico tended crops of corn, beans, and squash. The women fished and gathered pine nuts, berries, and other wild plants. The men hunted rabbit, antelope, buffalo, deer, elk, prairie dog, and beaver. They domesticated the turkey, which was especially prized for its feathers, which were woven into blankets.

The Pueblo Indians developed agriculture, unlike nomadic Indians, who practiced limited agriculture while concentrating on gathering and hunting. According to one archaeological study, the residents of the Arroyo Hondo Pueblo grew corn, beans, and squash; they gathered chenopod, purslane, winged pigweed, bee plant, sunflower,

7.1
Woodcut of Pueblo women grinding corn in sequence. From Andrew K. Gregg, *New Mexico in the Nineteenth Century: A Pictorial History* (Albuquerque: University of New Mexico Press, 1968). (Original source *Report of an Expedition Down the Zuni and Colorado Rivers*, by Capt. Lorenzo Sitgreaves, Washington, 1854.)

chokecherry, Indian rice grass, hedgehog cactus, pincushion cactus, prickly pear cactus, amaranth, banana yucca, *piñones*, and ground cherry. Evidence shows that drought, malnutrition, iron deficiencies, and hunger were constant problems, which led to migration and the demise of entire pueblos. Hopi and Zuni farmers developed drought-resistant and short-season strains of flint corn as well as dry farming methods, including compartmented areas called "waffle gardens" that are being studied and utilized today. From the Indians, the Spanish learned how to space out corn seedlings between the previous years' stalks, which remained in the ground as fertilizer and as indicators of what part of the soil needed to "rest" that year. From the Spanish, the Indians learned how to plant wheat by the broadcast method of sowing. To store food, it was first dried in the sun. Grains were stored in the beauti-

fully decorated clay pots they created. Later they established orchards of peaches and apricots, introduced by the Spanish.

Grinding grains or seeds to flour was a large part of Pueblo preparation, using the metate and mano—and singing. Agnes Dill of Isleta Pueblo describes the scene:

> Whenever corn is being ground, there are certain things that go with it . . . the men come and sing. And in the grinding songs they tell you almost what to do. And you have to grind to the beat, to the rhythm of the songs. You have your *metate*, or your four grinding stones in degrees of coarseness and fineness. The first one is a coarse one, then the next one . . . and the women are all sitting in back of these . . . And in the

singing, it tells you to keep grinding, and you grind in rhythm. It's a beautiful song. (Keegan 1987)

In 1582, Antonio de Espejo explored New Mexico and commented in his report on the wide variety of breads made from the ground corn.

In addition, the women had techniques for processing hundreds of varieties of plants, including the wild potato, onion, spinach, and celery. Each tribe maintained regional crops and variations on processing that dated back to ancient times. The Pueblo Indians knew more than forty ways to prepare corn, including thickening for soups and stews, and puddings of the scraped kernels. After chile was introduced to them by the Spanish and their Mexican Indian servants, the Pueblo Indians incorporated the piquant staple into every aspect of their cuisine. Pine nuts, which the Spanish called piñones, were used in soups and other dishes, or roasted and eaten alone. A paste of unroasted pine nuts was used to make flat fried cakes. Beans were highly prized by the Indians, who cultivated many varieties and colors. They boiled beans alone, added them to stews, combined cold cooked beans with cornmeal to make a wafer-bread, or ate beans raw.

Apache cuisine included wild onions, selected parts of the amaranthus plant, yucca, tule, prickly pear, wild greens, saguaro fruits, strawberries, chokecherries, sumac and juniper berries, wild potatoes, groundnuts, pine nuts, acorns, sunflower seeds, native grass seeds, wild honey, and wild game except fish and bear. They dried meat by hanging the strips on tree saplings. While the Navajo are cousins of the Apache, they evolved into a pastoral culture with the introduction of sheep. They also adopted Pueblo foodways.

A typical Pueblo meal today might include red chile, green chile stew, baked wheat bread, and bizcochitos (a type of anise-flavored cookie)—a menu that includes wheat, lamb or pork, oil, garlic, sugar, and anise, all introduced by the Spanish.

Foods of Hispanic New Mexico

Food historian Reay Tannahill suggests that the foodways developed in any given area are depend-ent on available food and available fuel. In the case of New Mexico, it would also depend on available land and the environment in which a culture lives. When the Spanish arrived in 1598, all of the arable bottomland between present-day Socorro and Española was under cultivation by the Pueblo Indians. Spanish law forbade the settlers from taking Indian fields, but this eventually didn't matter because land was vacated as famine, disease, and warfare began taking their toll on the Indian population. The soil of the Río Grande Valley has been compared favorably with the Nile River Valley for its continued fertility, due primarily to the rich alluvium carried there annually by the river waters. The Spanish set up *acequias*, or ditch systems, to divert the waters to their fields. The water in the acequias was controlled by gates and gravity. Acequia is an Arabic word meaning ditch. The Pueblo Indians had already learned to divert water for irrigation but later shared the more elaborate acequia systems.

The settlers' field crops included horse beans, peas, squashes, pumpkins, melons, and chile. In their gardens, they grew onions, garlic, and later cucumbers, lettuce, and tomatoes. Potatoes were uncommon until the nineteenth century. Wheat was planted in the cooler areas near Taos and Peñasco. In addition, the Spanish introduced barley, cabbage, radishes, and cantaloupe into New Mexico. Much of the produce was measured in *fanegas*, an Arabic word borrowed from the Moors; each fanega equaled approximately one and a half bushels. They also introduced Mexican foods, such as the tomato and two new types of corn that greatly increased the yield of Pueblo fields. These types, specifically Cristolina de Chihuahua and Mexican Dent, resulted in a more diverse Pueblo diet and a better hedge against famine.

In addition to homegrown foods, the missionary friars received shipments that included boxes of salt pork, cheese, shrimps, haddock, dogfish, lima beans, lentils, beans, white sugar, salt, pepper, saffron, rosemary, lavender, cinnamon, cloves, ginger, nutmeg, preserved peaches, quinces, sweetmeats, noodles, condado almonds, Campeche honey, Castile rice, wine, olive oil, Castile vinegar, frying pans, brass mixing mortars, tin wine vessels with pewter dishes, and leather wine bags.

7.2
Irrigating a field. Photo by Miguel Gandert.

Both Pueblo and Spanish farmers watched for the exact moment to gather crops, or leaves, blossoms, seeds or roots of specific plants. Both cultures shared a reverence for the land and water, and a reliance on Providence, through ritual and prayer, to provide for the sustenance of the community. Neighbor assisted neighbor with bringing in the crops. What wasn't eaten fresh had to be dried for storage. They relied on the hot New Mexico sun, adapting the European practice of drying fruits to also drying vegetables, as the Pueblo Indians had been doing for centuries. In the Río Abajo area, the growing season was longer and the need to dry food for storage was not as critical as in the Río Arriba area, where sun-drying became standard practice. Throughout the colonial period, Spanish settlers who could afford to traded for chocolate, sugar, coffee, and spices from Mexico.

Many have assumed that the current Mexican cuisine of tacos, enchiladas, and similar items are indigenous to New Mexico. In fact, the settlers of the sixteenth century were familiar with the foods and preparation techniques of Mexico's bicultural cuisine to the extent that it had developed at that time. However, the continued development of Mexico's cuisine was, for all practical purposes, too distant from the geographically isolated New Mexicans of later centuries to effectively adopt it and its tropical ingredients. For this reason, New Mexicans relied heavily on the original settlers' traditional Spanish cooking, adaptations of Pueblo cooking, and such hybrids as wheat tortillas. In other words, tacos and enchiladas were unheard of in New Mexico until very recently.

CHILE

No one knows how chile first reached New Mexico. One theory holds that chile was introduced by the Mexican-Indian servants who accompanied the Spanish settlers. Others believe that the Anasazi most likely traded for it along with the seashells and exotic bird feathers that have been excavated at Chaco Canyon and other sites, or that chile grew wild along the Mexican border. Food historian Joseph M. Evans determined that the word for chile in Tewa, Tiwa, and Towa is of recent origin, suggesting an introduction from a foreign source.

It is known that the Anasazi and later Pueblo Indians developed selective horticultural breeding practices for better yield and quality in specific soils and climates. This resulted in a chile hybrid that is, to this day, especially well suited to the soil and climate of the valleys around Chimayó, Dixon, and Española (which were all Indian lands prior to Spanish acquisition). Spanish settlers adopted the local chile and its variations of preparation. Powdered red chile is called *chile molido*. *Chile caribe* is made by reconstituting whole dried red chiles in water, then blending and straining. It is the basis of *carne adovada*, which was a colonial method of meat preservation and storage. Chile continues to serve as the mainstay of modern New Mexico cuisine.

DAIRY

The Spanish introduced goats, cattle, and sheep to New Mexico. Goats and sheep adapted well because they could forage the dry areas that offered little to cows. Cattle were left to roam the general terrain and to fend for themselves, while milk cows were kept close to the homestead. Sheep exports to Mexico became very important to the local economy, especially in the eighteenth century. These exports discontinued at the outset of the Mexican War in 1846, and began westward after the discovery of gold in California. Throughout New Mexico, goat cheese was more popular than cheese from cow's milk. Carnuel, a village east of Albuquerque, became famous for its *queso de cabra* (goat cheese). It is not surprising that Carnuel is surrounded by hilly, goat-friendly terrain. Milk was made into cheese, butter, and sour cream. The whey was used to make a finely textured cottage cheese called *requesón*, which was often enriched with cream. Sour milk and sweet milk were combined with tomatillo juice to make a cheese called *asadero*, which was then used to make *chile con queso* (chile with cheese). The most prized milk was *leche de apoyo*, or the rich milk held back by a cow for her calf. It was used to make a highly prized cheese called *queso de apoyo*. Sheep milk was also used to make cheese.

According to Fabiola Cabeza de Baca Gilbert, cheeses were sliced, dried in the sun, and stored in cloth bags. All of the traditional cheeses described here bear little resemblance in taste to the salty, yellow cheeses used today in so-called Mexican dishes.

MEATS

Beef, pork, mutton, and goat were all part of the colonial diet. As in all subsistence cultures, all parts of the animal were used. Cooks used the blood to make a sausage called *morcilla*; the head was used to make a kind of lunch meat called *cabeza de queso* (head cheese); and pigs feet were cooked in posole. In this regard, the Spanish shared with the Indians the same resistance to waste that was an integral

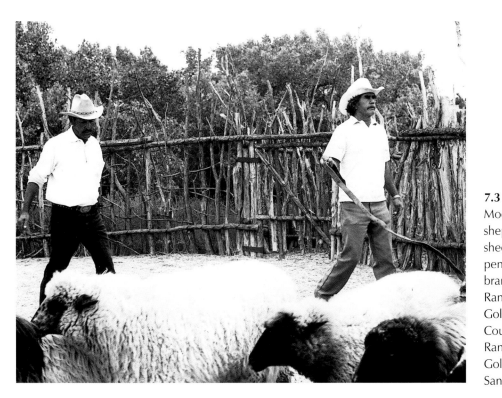

7.3
Modern day shepherds tend sheep held in a pen made of branches at El Rancho de las Golondrinas. Courtesy El Rancho de las Golondrinas, Santa Fe.

element of their abiding stewardship of the land and animals.

Because pork tends to rancidity when dried, settlers slaughtering a pig prepared a large feast at the time of slaughter, and also preserved some of the meat by a process called *adobo*. The slaughter is still called a *matanza* (killing), and it generally occurs in the fall. The guests enjoy morcilla, which could be either sweet (with raisins and nuts) or spicy (with garlic and herbs, but not chile). In the adobo process, the pork is marinated for up to ten days in a mixture of vinegar, wine, garlic, chile caribe, and spices, and then dried. To serve, the adobo is rehydrated, grilled, and basted with the same sauce. Some scholars suggest that this eventually evolved into the modern barbecue, while others cite the Gulf Coast or Caribbean populations for developing barbecue. The Spanish word *barbacoa* is apparently derived from the Carib Indian word for the greenwood lattice frameworks erected over a fire for smoking meat.

Guests also enjoyed *chicharrones* (cracklings), a preparation that originated in Extremadura, Spain, the home province of many New Mexico settlers. In making chicharrones, strips of pork skin were cut into pieces and rendered of their oil, which were then cooled into lard. Today, chicharrones are served primarily at fiestas.

From the 1780s—when the Spanish and Comanches made peace—to the 1880s, the ciboleros (Spanish buffalo hunters) brought buffalo meat to households all along eastern New Mexico from Las Vegas to Roswell. They had learned to hunt buffalo from the Comanches. Like the Comanches, the Spanish wasted none of the buffalo they hunted. The meat was cut into strips to hang for drying; the fat was rendered into tallow for cooking and making candles; and the hides were made into ropes, robes, rugs, mattresses, and cloth.

Beef and buffalo meat was dried into *tasajo* or *carne seca* (dry meat), which Americans later called jerky. ("Jerky" is a mispronunciation of a Peruvian word written by the Spanish as "charqui" meaning sun-dried meat.) Prior to hanging the meat to dry, the women rubbed it with salt, vinegar, and powdered red chile. To use the carne seca, it was soaked in cold water, then boiled. It was also pounded and added to sautéed onions to make a kind of stew. Carne seca was highly popular because it was the best way to preserve meat in a semiarid climate, and it served as a good travel food. Carne seca was a trade item at the annual fair in Chihuahua.

When the Spanish arrived in New Mexico, the Southwestern tribes' main source of meat was rabbit, which the Spanish also

7.4

Hanging meat to dry in Chamisal, New Mexico. Courtesy Library of Congress, LC-USF33-12833-M2.

began hunting, as well as antelope and deer. Meat was prepared in roasts or stews. The *asado*, or roast, was more often served on cold winter days, when the meat was grilled in the fireplace. Women also made stews of meat and leftovers, spiced up with chile and spices. They added tomatoes to temper the heat of the chile. Salsa appeared on the table as a side dish. New Mexico women also used an old Aztec cooking method of first stewing the meat, then frying it with spices.

From the mid-nineteenth century to the 1930s, widespread ranching in New Mexico contributed to the dominance of meat in the New Mexican diet. By the 1930s, the ranges had been over-grazed, meat production dropped, and the diet changed accordingly, illustrating the impact of land and environment on a culture's foodways.

FISH

Settlers throughout New Mexico found an abundance of fish in the rivers, mountain streams, and lakes. Fish was particularly welcomed on Fridays, when the Roman Catholic settlers and friars were prohibited from eating meat. The loss of common lands in the nineteenth century cut off this important source of food to the Spanish. Curiously, oysters were introduced to New Mexicans in the nineteenth century. New Mexicans immediately created such an enormous demand for them that oysters were imported in large quantities even before the railroad made it economical to do so.

CORN

While corn grew in New Mexico in a variety of colors, blue corn was preferred. Blue corn is higher in the amino acid lysine than yellow corn, resulting in twenty percent more protein. It also has fifty percent more iron than other varieties. For centuries, Pueblo Indians grew only flint corn, which they nixtamalized and ground, or parched or boiled to serve as hominy, tortillas, or *chaquegüe*. They also prepared dumplings with meat (an Aztec invention known as tamales) or ate it on the cob, raw or cooked. The nixtamal could be dried or parched for later use. Roasted cornmeal was also a good traveling food. An early Hopi and Zuni practice was to dig a hole twelve feet deep and three feet wide, and

7.5
Hand-hewn canovas leading to a Spanish colonial gristmill at El Rancho de las Golondrinas near Santa Fe, 1996. Photo by Mary Montaño.

7.6
Close-up of canovas. Photo by Mary Montaño.

Buffalo Hunting on the Eastern Plains

In her historical narrative, We Fed Them Cactus, *Fabiola Cabeza de Baca Gilbert (1954) describes the annual buffalo hunts that took place on the eastern plains of New Mexico. In this excerpt, Ms. Gilbert is quoting the remembrances of El Cuate, an old ranch hand on her homestead, whom she knew as a girl.*

"After the harvest in the settlements along the Río Grande and Pecos rivers were finished, the ciboleros, the buffalo hunters, started their march towards the Llano. Each village had a cibolero and a trained horse, or perhaps two, for the hunt. These horses were guarded with care and never used for any other purpose but the buffalo hunt.

"I do not remember the day of the carretas [wooden-wheeled carts], but my father went to the cíbolos [buffaloes] when only carretas were used for loading the meat. In my day, we had wagons which were pulled by oxen.

"Caravans of ten to thirty wagons were formed from the different villages; each wagon pulled by four or five yokes of oxen. It was a beautiful sight to see these processions on the march. There were burros and mules, and these belonged to the men who went along as agregados, assistants. . . . Our job was to help skin the animals and to cut the meat into strips to make tasajo, jerky. We were too poor to organize a caravan of our own, so we were glad to be allowed to join as helpers and in that way secure meat for our families. . . . When the caravan was organized, one man was made mayordomo or comandante, and he had full control of the outfit. His word was law.

"We traveled very slowly, for the roads were bad and the oxen moved at a turtle's pace. It took about two weeks to make the trip from Las Vegas to Palo Duro Canyon and the Quitaque Country. As we traveled along, we met other caravans on the way, and when we reached the bluffs of the Llano Estacado, the Staked Plains, we were many companies. Some were already there and it became a small world, this big land of New Mexico.

"On reaching the buffalo country, the caravans pitched camp. . . . We made preparations by getting the horses and hunters ready. At daybreak the hunters from the different outfits gathered together, mounted their prancing steeds and off they went towards the herd. The hunters used no saddle, only a pad on the horse's back. This protected the rider from tangling in the stirrups if he fell off the horse. The hunter used lances five or six feet long made of the finest steel.

"The hunters formed a group before dashing into the herd, bowed their heads in prayer and invoked Santiago [St. James], the patron saint of Spain, to help them and guide them in the hunt. After making the sign of the cross, into the herd they rode, jabbing their lances inside the left ribs

layer hot ashes, embers, new corn still in the husk, and stones. After the corn roasted overnight, everyone enjoyed the first fruits of the field after a winter of dried foods. *Piki*, a thin wafer bread, was the most important corn bread made by Pueblo women, and involved much skill. Also popular was chaquegüe, a blue-corn mush.

The Spanish settlers expanded corn's use by combining it with other ingredients. *Pinole*, a cereal of parched and ground cornmeal was served with brown sugar, cinnamon, clove, and milk. Spanish cooks made *chacales*, or *chicos* as they are called in the north, by parboiling, drying, and husking green corn and storing it like grain; today

of choice fat animals, directly into the heart. A run, or corrida, *usually would be three miles, during which each hunter killed from fifteen to twenty-five animals. This number was sufficient for one day, as they had to be skinned and the meat cut up for jerky. . . . The* agregados *and the* carreros, *wagon drivers, followed the hunters into the herd to pick up the carcasses and bring them into camp. We had one man in each crew who was an expert in bleeding the animals, and he always was ahead of the crew."*

"Why didn't you use guns for hunting, Cuate?" I asked.

"In the early days, the firearms of the Spaniard were of the musket type and they were not very effective. The early Spanish hunters learned from the Indian that the lance was the swiftest method, and being fond of excitement, they found that hunting with a lance was a real sport and that it took much valor to pursue it. We enjoyed hunting the buffalo, and had not the Americanos come in with their guns, we might still be enjoying the sport, but it did not take them long with their rifles to clear the Llano of buffaloes.

"In the camps there was great activity—the meat had to be cared for quickly or it would spoil. The agregados *cut the meat into strips. Some of the hides were cut into strips to be used as lines on which to hang the meat for drying. When the meat was dry, it was placed on the wagon beds and tramped down so that the wagon could be loaded to full capacity. It took four yokes of oxen to pull one of the heavy wagons. The fat was rendered into tallow to be used for cooking and for making candles. We had many uses for the hides. Some were made into* reatas, *ropes, and others were tanned with the hair left on them for robes or rugs. . . . We plucked the wool from the buffaloes' shoulders and necks; this was used for filling mattresses and it also was spun into cloth.*

"We remained in the buffalo country for a long time and when we were ready to leave, it was cold enough so that we could carry fresh meat in our wagons to supply our tables during cold weather. With wagons and pack animals loaded, we were a happy bunch of ciboleros, *saying* adios, hasta el año venidero. *We headed west to our homes along the rivers and to our mountain habitations to spend a good winter well supplied with meat. . . . But there came a day when we did not return because the wonderful sport had vanished. We have only the tales to remind us of when the Llano belonged to the Indian and to the New Mexicans of Spanish descent. Ballads are still sung in the villages about the* cíbolos *and the* ciboleros, *but never again will the colorful processions be seen where the Hispanos and the Comanches met in friendly terms."*

both Mexicans and New Mexicans call them *chicos.* They are reconstituted in soups and stews, adding to the flavor and texture of the dish. Like the Pueblo peoples, the Spanish enjoyed roasted corn on the cob.

Posolli is Nahuatl for an ancient Mayan corn drink as recorded by the Spanish in 1517. Like the more finely ground *atolli* (also Nahuatl), it was a ceremonial drink or gruel made by cooking eight parts water with six parts of maíz, and lime, until the maíz softened. *Atole* has a wide dispersal among all of the cultures that use corn and are influenced by the Aztecs. In New Mexico, an atole—as the Spanish called it—was made with

7.7
Otoño en el Valle
(Autumn in the
Valley), a painting by
Edward Gonzales.
Courtesy of
Edward Gonzales.

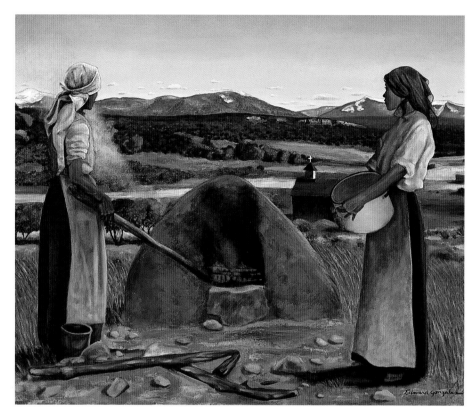

honey and chocolate and served on feast days. Posole—again, a Spanish derivative—was made with additional ingredients, including fruit, *epazote* (an herb), beans, and chile, or with roasted corn, pine nuts or red amaranth, *chía* or pumpkin seeds. The evolution from a gruel to modern posole had begun. *Atole de pinole* became a coffee substitute made from pinole flour.

WHEAT

Flour tortillas eventually replaced corn tortillas in Hispanic homes in northern Mexico and most of the Southwest because there was a class identity associated with the use of corn and wheat. In both Mexico and New Mexico, to be Spanish meant to eat bread made with wheat; to be Indian meant to eat corn tortillas. As soon as wheat was a viable crop in colonial New Mexico, it became the grain of choice for the Spanish, while corn remained the staple of the Pueblo diet. Evans suggests that the connection between wheat and

the Spanish culture was strengthened by its use in the Eucharist (the communion host used during Mass); while the Pueblo cosmology is related to corn, which is, like the Eucharist, also used in religious ritual.

If Indian servants were available, they prepared corn tortillas. Spanish women used wheat flour to prepare *sopaipillas*, a Spanish bread, as well as the *buñuelo*, made with egg batter, cinnamon, and clove, and served with a brown-sugar syrup made from *piloncillo* (brown-sugar cones). New Mexican kitchens also developed *panocha* cakes and atole made from ground sprouted wheat. The word panocha is a New Mexico variant of *panoja*, meaning "ear of grain," an obvious reference to the sprouting process. Panocha is a traditional ingredient during Lent and Holy Week due to the belief that all old flour and wheat products must be used or thrown out before the passing of Easter. The bizcochito, an anise-flavored sugar cookie, remains a favorite sweet today, often served at Christmas and

special occasions in New Mexico and northern Mexico. Spaniards first ate bread in the form of *biz-cochos*, which were dry, hard wafers later known as *galletas*. This item may have come to New Mexico in colonial soldiers' packs.

Up to the beginning of the twentieth century, wheat was cut with a hand sickle, as it had been in Spain for centuries. Then it was threshed in the old European method using a hard-packed threshing floor over which goats, sheep or horses were walked in circles to loosen the grain from the husk. Winnowing (separating the grain from the husk) also followed the medieval Spanish method of tossing the wheat in the air using baskets; the light husks were carried away in the wind and the grain fell back to the basket. Then the grains were washed in a stream using a loosely woven basket as a sieve. These methods were practiced by the Pueblo Indians, who learned all they knew about wheat farming from the Spanish. Wheat bread was baked in an horno, the beehive-shaped outdoor ovens made of adobe. For yeast, the baker used the ferment in a little dough saved from the last baking. It was mixed with the flour and water, and shaped into loaves.

The baker started a fire in the horno to heat it up, then swept out the coals and placed the bread within using a wooden paddle on a stick. Hornos work through the dissipation of heat, so their use is maximized by baking several different things at different times as the oven loses its heat. Cookies and pies would go in first to take advantage of the initial high heat; next bread would go in and perhaps a pot of beans would go in too for the entire duration of baking. The last thing to go in the oven would be panocha, which might remain in the oven all night. The staging of baking would have to be precise in order to take advantage of fuel and time. In addition to calculating the rising time of the bread with the readiness of the horno, there were factors such as time of year, outside temperature, and humidity. The horno was developed in the Middle East and Arabian Peninsula, and was introduced to Spain by the Moors. The Spanish introduced hornos into the Southwest, where they were widely adopted by the Pueblo Indians. When not in use as an oven, the horno served as a comfortable doghouse in both village and pueblo.

VEGETABLES, FRUITS AND NUTS

Spanish women dried prepared vegetables and fruits on their rooftops, which were flat and sometimes sloped toward the south. First, they spread out bedsheets or paper, then laid the cut foods over them. If rain came, it was easy to gather the four corners of a sheet to bring in the food. Today, drying methods include clotheslines and clothespins. To prepare for drying, squash—the large green *Cucurbita moschata* and the smaller, striped *Cucurbita pepo*, and pumpkin—was cut into slices called *rueditas* (little wheels), or into long, circular spirals. After drying, the spiral was cubed and

7.8

Hornos at El Rancho de las Golondrinas. The outdoor ovens were introduced into the Southwest by the Spanish. Photo by Mary Montaño.

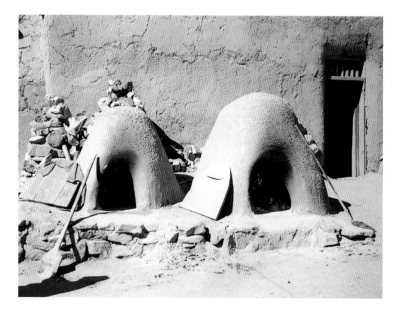

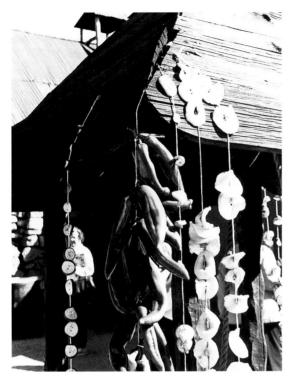

7.9
Rueditas (squash rounds), chile and sliced apples hanging from a well roof to dry in the sun at El Rancho de las Golondrinas. Courtesy El Rancho de las Golondrinas, Santa Fe.

stored. Pumpkins were cut in half and staked for drying, then cut into spirals as practiced by the Pueblo Indians, who boiled squash or roasted it fresh in ashes. Squash seeds were toasted and eaten, or pounded to yield cooking oil.

The Spanish roasted, peeled, and hung green chile by the stem to dry in bunches, or on lines, or laid on the scrubbed bark of a tree. Numerous red chile pods were strung on one continuous string, then braided into *ristras* and hung to dry on the eaves of a house, or on frames. When dry, the pods were powdered and stored.

When the Spanish arrived in New Mexico, they found a wide variety of beans (of the genus *Phaseolus*) to enhance their traditional Spanish fare of lentils and peas. The *bolita*, a round, brown bean, grew in the high mountain farmlands of the San Luis Valley and was the basic bean used from the mid-nineteenth century to the 1930s, according to Evans; and the anasazi bean which flourished in semiarid climates. The pinto bean was also cultivated prior to the arrival of the Spanish; *pinto* means painted, and refers to the brown and tan coloring of the raw bean. Beans were threshed and winnowed to separate them from their pods. String beans were parboiled and strung like beads with needle and thread to dry and store.

Most orchards established in the seventeenth century by friars or settlers were destroyed during the Revolt of 1680. Still, the Pueblos were quick to cultivate fruit trees. Vineyards were known to have been established near El Paso by at least the early

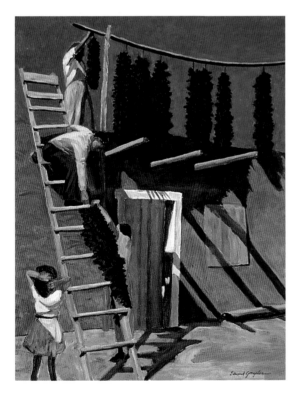

7.10
Familia con Ristras (Family with Ristras), a painting by Edward Gonzales. Courtesy of Edward Gonzales.

eighteenth century, but not in the north where the climate was too cold.

Some scholars suggest that melon seeds and chile were distributed among the friendly Indians encountered by Coronado's party as they explored the Southwest. Melons were widespread within one generation of their introduction; orchard fruits were quickly assimilated. The speed with which this phenomenon occurred leads some historians to assert that melons may have already been part of the Pueblo diet. In any event, fruit trees became important in the Pueblos; the Hopis and Zunis planted them where underground water could keep them alive.

The whole family took part in picking and drying the fruit of their own trees. Peaches and apricots were broken open, stoned, and laid to dry on scrubbed boards. Apples were cored, quartered and also laid in the sun. Plums were dried whole, while grapes hung on hoops or poles (and stored with the same hoop or pole). The so-called Castillian plums were already native to New Mexico; they were later mistaken by historians as having been introduced by the Spanish, according to Evans. Visitors in the nineteenth century mention raisins as dried clusters known as *pasas*. Melons were quartered, seeded, lanced on poles, and dried in the sun. The dried fruits were rehydrated by soaking in warm water, and used in empanaditas (turnovers) during the winter. Families also picked wild plums and berries. The Spanish learned from

Two Traditional New Mexico Recipes

These recipes are from Fabiola Cabeza de Baca Gilbert's Historic Cookery, *in which she records traditional New Mexico recipes. Panocha and atole were enjoyed in both Pueblo and Spanish New Mexican households.*

Panocha

To sprout the wheat, wash and drain it but do not dry. Place the wheat in a cloth bag in a warm place to sprout. When sprouted, dry it in the sun. Grind into a flour.

5 cups sprouted wheat flour	2 cups sugar (optional)
	4 tablespoons butter
2¹/₂ cups whole wheat flour	7 cups boiling water

Mix the two flours thoroughly. Add one-half the boiling water and stir well. Set aside and cover. Let it stand for 15 minutes, then add the rest of the water. If sugar is used, caramelize the sugar, adding one cup of boiling water. When sugar is dissolved, add to flour mixture. Boil the mixture for two hours, add butter and place, uncovered, in the oven for one hour or until the mixture is quite thick and deep brown in color (Gilbert 1970).

Compare the following recipe for New Mexican atole with the ancient Aztec recipe for atolli, which called for eight parts water to six parts cornmeal, plus lime. In colonial days, atole was a poor man's substitute for chocolate or coffee; an even cheaper drink called atole blanco *was made using wheat flour. It is also interesting to note that sixteenth-century Spaniards living in Mexico enjoyed this drink, as it reminded them of similar homeland gruels called* mazamorras *and* poleadas; *yet in the twentieth century atole is drunk primarily for its medicinal benefits for the elderly and the ill.*

Atole

¹/₂ cup blue cornmeal	2¹/₂ cups boiling water

Stir blue cornmeal in ¹/₂ cup water. Add it to the boiling water and boil until it reaches the consistency of cream. Cook. Place in cups half full, adding enough salted boiling milk to fill the cups.

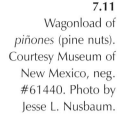

the Apaches how to prepare the bitter chokecherry. They called the berry *capulín* and used it to make jam, jelly, and wine.

The Spanish introduced the almond to New Mexico for use in sauces and puddings. The Pueblo Indians had been for centuries gathering piñones, which they ate toasted or raw. Gathering the nuts was a family affair not only with the Indians, who could be gone for as long as a month gathering nuts by the flour-sack full, but with Spanish families, whose outings lasted a day or two. In the nineteenth century, the nuts were an important commodity sold in markets around New Mexico. Piñón picking is still a tradition today. Ciboleros who traveled as far as the Arkansas Valley were known to bring back walnuts.

Herbs

The Spanish introduced saffron, anise, cinnamon, cloves, black pepper, ginger, sesame seed, and coriander. The Pueblo Indians introduced the Spanish to *yerba buena* (wild mint) growing along streams and shady places of the Río Grande Valley, and to wild *orégano* and *chimajá* (wild parsley). Orégano, also known as wild marjoram,

was gathered, sun dried, and powdered between the fingers to store in jars. Coriander and anise seed were dried, ground, and stored. Yerba buena was strung, dried and stored, stem and all. Black sage and saffron, which grew wild in higher altitudes, were gathered, dried, and stored. Early settlers substituted safflower for saffron, which was hard to come by.

Many herbs were used for both cooking and healing. Chimajá, for example, was used in beans, soups, stews, or on meats, and was once the main flavoring of the famous Chimayó whiskey. *Mistela*, a favorite local cordial, was made by boiling a handful of dried chimajá, a stick of cinnamon, and a cone of piloncillo (brown sugar) in a quart of water, then adding the mixture to a jug of brandy or Chimayó whiskey. It was then allowed to stand for several weeks. Chimajá was also eaten or drunk as a tea for stomach ailments.

Cilantro and coriander are from the same plant: coriander refers to the seeds, while *cilantro* refers to the fresh leaves. Orégano is used with red or green chile and meat. Yerba buena can be used as substitute for cilantro, and is used on meats. The Spanish of New Mexico chewed *chicle de trementina*, or

pine tree sap, as gum just as the Pueblos chewed the sap of milkweed or chicory.

As with cultures the world over, holidays were showcases for the traditional foods of Spanish New Mexico. Traditional meals during Holy Week, for example, might include trout, *torrejas* (an egg dish), *verdolagas* (purselane) with chile, garlic and onions, chicos, *quelites* (spinach with boiled egg), *rueditas de calabacita* (squash rounds), peach or apricot-filled empanaditas, panocha, and buñuelos.

Christmas foods included morcilla (blood sausage), carne adovada, tamales, chicharrones, buñuelos, posole, sweet anise seed rolls, *pastelitos* (little pastries) made with rehydrated apricot, bizcochitos, meat or fruit empanaditas, *cajeta de membrillo* (sliced quince preserves), *melcocha* (molasses taffy), *piñónate* (pralines with pine nuts), and *ponte duro* candy (made with toasted white corn and boiled molasses). The children drank pinole and the adults enjoyed mistela.

During Semana Santa, the traditional *Cuaresma* (Lenten) meals were prepared, including torrejas or *torta de huevo* (deep fried egg omelet), quelites (sautéed wild spinach with red chile seeds), rueditas de calabacita (steamed squash), panocha, and buñuelos (fried bread dipped in flavored syrup or honey, or dusted with cinnamon sugar). Another dish was verdolagas (wild or homegrown purslane) with chile, garlic, and onions. Both quelites and verdolagas grew in the meadows during this time of the year, according to Célida Montaño, who lived in Ortiz, New Mexico, near the Colorado state line in the 1920s and 1930s.

TOOLS AND TECHNIQUES

Except for wild bee's honey, the only local sources of sweetening available were corn syrup and, after the nineteenth century, sweet sorghum. The annual crushing and straining of stalks into syrup was a community event to which families brought their stalks to the *mielero* (syrup processer) who processed them on a mule-driven press. Other syrup-making devices included a disc-shaped press with a wooden mallet, and a hollowed-out log with another piece of wood that pounded the contents in the hollow.

A typical farm kitchen included a fireplace hearth, micaceous clay pottery for cooking, and wooden utensils. Sometimes cooking was done on an outdoor cooking fire, and the horno was used for baking. The family sat on the floor and dipped into the main dish using pieces of tortilla. Forks, knives, and plates were not common until the nineteenth century. In finer homes, iron pots and utensils were used to prepare meals, while some wealthy homes in Santa Fe had silver plates and utensils. The lack of uneven heat was a way of life for the New Mexican cook until the introduction of modern stoves via the railroad. Until then, it took considerable skill to coordinate and create meals, given also the lack of running water and refrigeration.

Once food was dried and ready for storage, it was placed in the *almárcigo*, an outdoor earth-covered room (from Spanish *almáciga*, or plant nursery). Also known as a *bodega*, or *soterrano*, this storage cellar was used to store wine, root vegetables, and

7.12
Pressing sorghum. The worker on the right is feeding the sorghum into the press as the mule pulls the lever that keeps the press in motion. Courtesy El Rancho de las Golondrinas, Santa Fe.

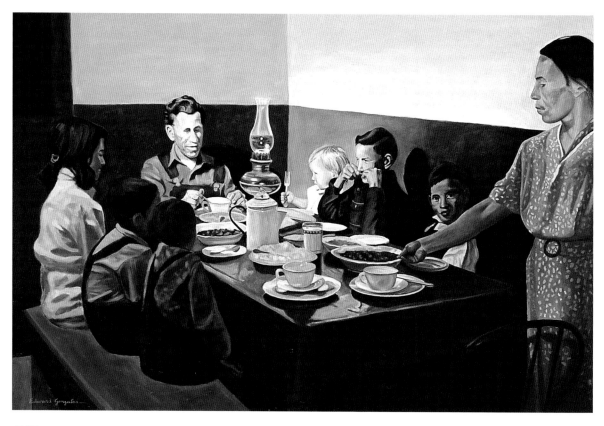

7.13
The Meal, a painting by Edward Gonzales. Courtesy of Edward Gonzales.

late maturing melons or tomatoes. The almárcigo was built partially into the ground, and its roof was insulated by a foot of dirt. In Trampas and Truchas, Evans (personal communication) learned of the use of dug pits as storage for vegetables and chile.

A long, wide trench would be dug down about 3–5 feet and lined with gravel, stones or even cornhusks. The vegetables from harvest would be laid out in long rows and then covered with dirt. This method would keep vegetables like cabbage, chile, onions, radishes, and potatoes cool and preserved until needed.

TWENTIETH CENTURY DEVELOPMENTS
As in many other areas of New Mexican culture, the coming of the railroad had an effect on the local cuisine. Because of the inexpensive ship-

ping costs of equipment and raw materials, the railroads gave rise to commercial mills, where wheat, chile and corn could be ground quickly instead of laboriously on metates. Also, white sugar and citrus fruits were shipped to New Mexico inexpensively and in large quantities, and new heavy equipment included icemakers and iron stoves.

In the 1930s, the New Mexico Agricultural Extension Service introduced food canning to New Mexican households with mixed results. Assisting in the training effort was the Country Life Movement, a progressive reform program led by white Protestant professionals whose goals were to keep farm families on the farm and encourage urban families to return to the land. Social historian Joan Jensen (1986) described the leaders of this movement:

The reformers who led the movement—primarily white Protestant professional groups dedicated to an orderly transition to industrial capitalism—were worried that rural conditions would drive yet more farm folk into the chaotic cities, thus further compounding the social conflict there.

Trainers arranged English-speaking demonstrations to groups of women in individual rural homes. The program was well intentioned but not as successful as it might have been without the language barrier and the initial distrust of the women. The Country Life Movement had been motivated by statistics that indicated farm families to be culturally isolated, badly overworked, poor, and in danger of losing their lands. That this may have been a matter of interpretation was not an issue. Some extension agents saw the stability and simple life of some Hispanic households as "primitive" rather than as a way of life carved out of centuries of living in close harmony with the land. The agents found it difficult to understand why the farmers weren't interested in taking their instruction.

7.14

Farmer with wooden plow sitting on an almárcigo, also known as a bodega (storage cellar) in Chamisal, New Mexico. Courtesy Library of Congress, LC-USF34-37014-D.

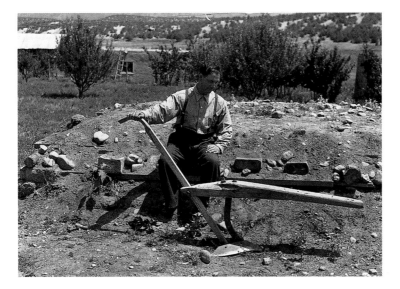

The difficulty was alleviated in part by the hiring of Carmen Espinosa and Fabiola Cabeza de Baca, who conducted canning trainings in Spanish and wrote Spanish-language bulletins on canning. Still, canning was expensive for many households due to the initial expense of pressure cookers, jars, and other necessary items. During World War I, women's clubs and the Women's Auxiliary of the State Council of Defense united in promoting canning as part of the war effort. The Extension Service also organized "clubs" to train New Mexicans in cooking, sewing, field crops, gardening, and husbandry. In the summer of 1918, the influenza epidemic struck New Mexico, preceded by a two-year drought that had brought severe wheat shortages to the state. Home demonstrations were temporarily suspended during the epidemic when the government banned all public gatherings.

The endurance of Spanish New Mexicans rested in their flexibility, conservationism, reverence for the land, and sense of community. In their flexibility, New Mexicans adopted new foods and their preparation techniques. Their conservationism and stewardship of the land resulted in very little waste and a remarkable symbiosis with the land matched only by their Pueblo neighbors. Their reverence for the land and water as life-givers played no small part in this symbiosis; and the hardships of the far northern frontier established from the outset a strong sense of community that benefited everyone as fieldwork and harvests were shared in times of need.

The centuries-old tradition of stewardship is now being studied extensively by a team of researchers headed by sociologists Devón Peña and Rubén Martínez of Colorado College. Their interdisciplinary study covers Hispano farms and ranches in a two-county area straddling northern New Mexico and southern Colorado.

It is the first study of Hispano farms and land ethics in the Southwest. The researchers have found a wide range of diversity in the native crops and wildlife present on these farms and ranches. They are also discovering areas where the topsoil is remarkably deep compared to other agricultural areas of the United States where so-called primitive farming is not practiced. These discoveries are suggestive of a cultural tradition that endures because it is based on wise stewardship of land and water and careful adaptation to the constraints of an arid high-altitude environment. The research project, funded by the National Endowment for the Humanities, will ultimately result in a permanent museum exhibit, publications, and a research archive.

Healing Arts

When the Spanish arrived in the New World, their medical knowledge was an eclectic combination of Arabic medicine and health practices, Judeo-Christian religious symbols and rituals, and medieval European folk medicine. Practitioners of this tradition encountered and partially embraced a highly evolved Aztec herbal tradition. It was this new hybrid tradition that reached New Mexico in 1598.

At the time of the conquest, the Aztecs had a system of socialized medicine, including hospitals where treatment was free. Also, unlike Europeans, the Aztecs had made the connection between sanitation and health. They conducted medical research at the Huaxtepec Garden. According to Cervantes de Salazar in his *Dialogues*, written in 1554, this garden included approximately two thousand species of trees, shrubs, and herbs within its seven miles of walls. There, the Aztecs researched and developed three hundred herbs and other cultigens for preventing and treating disease.

To the detriment of subsequent generations, the Franciscan friars destroyed the Aztecs' research records in an effort to acculturate them to Christian ways. The little we know about Aztec herbal tradition was gathered by Spanish recorders under the direction of the Spanish government. Concurrently, European medical practice was quickly established in Mexico, first at the Colegio de

7.15

Five *parteras* (midwives) of the Taos area, ca. 1940. Courtesy Farm Security Administration Archives, LC-USZ62-072219-903557. Photo by J. Valentine.

Santa Cruz in Tlaltelolco, and then at the University of Mexico in 1580.

As with foods introduced into Europe, reactions were not always positive to new medicines. For example, conquistadores noticed that Peruvians were not dying from malaria because, as a Jesuit priest discovered, they were treating it with the ground bark of the *Chinchona* tree (also known as Peruvian bark), which contained quinine. Malaria was, at the time, the number one killer in the world. When the explorers sent Peruvian bark to European physicians for consideration, it was rejected as dangerous. Because it was not mentioned in the works of the ancient Greek physician Galen, the father of all European medicine at the time, it was suspect. In the twentieth century, Peruvian bark was used

successfully during the Vietnam War against a strain of malaria that had proved resistant to a modern synthetic quinine.

New Mexico

Self-sufficiency meant survival for New Mexico's Spanish colonists and their descendants. Because the nearest physician was hundreds of miles away in Mexico, the colonists brought their own home remedies and healing herbs to New Mexico. Unlike the Spaniards in Mexico, they learned from the Pueblo Indians and from their genízaro servants how to prepare native herbs, minerals, and animal medicines, and they adopted some of the indigenous healing methods. Over time, specialization developed, inspired by Mexican counterparts. These include the:

- *Curandera(o)*—A healer who specializes in herbal preparations and rituals. The root word for curandera is curar, meaning "to heal."
- *Sobador* or *Sobadora*—One who gives healing massages.
- *Partera*—A midwife and advisor on children's health.
- *Yerbero*—A specialist in healing herbs. Scholars disagree over the definition of the *arbularia*, which is either an alternative term for yerbero, or a practitioner of magic.
- *Espiritista* or *materia*—In Mexico and Texas, a medium or psychic (also more prevalent in Texas); in New Mexico, a curandera materia was a healer who worked with herbs.
- *Curandera(o) entero*—The healer who is knowledgeable in the entire repertory of material and spiritual cures. Another term is *curandera total*.

The Indians of the Southwest excelled at bonesetting, and shared their knowledge with the Spanish, who called the specialists *hueseros*, or bonesetters. Hueseros have almost all vanished.

Beyond their technical knowledge of herbs, rituals, and the body, the healers of old possessed a sensitivity to individual and group psychology, and the complex relationship between the spiritual, mental, and physical. As such, Hispanic and Native American healers of the New World were holistic in their approach, anticipating the late twentieth-century movement by several hundred years. Religion and spirituality are central to the curandera's practice. She will recite a short prayer on offering a medicinal tea or preparation to a patient—"*Alabado sea el Santísimo Sacramento del Altar*," for example—or suggest a spiritual cleansing or a change of attitude as part of the healing. Eliseo Torres (1983a) writes,

> . . . *curanderismo* is a system of medicine which recognizes the profound effect the emotions can have on health. It takes into account the physical manifestations of such feelings as anger, sorrow, shame, rejection, fear, desire, and disillusionment.

Because of this metaphysical, holistic component, and because few practitioners have effectively recorded and distributed their knowledge, healing remains primarily a master/apprentice tradition even today.

The New Mexico healer's methods are based on the balancing of what are called the "humors" of the body: blood (air), phlegm (water), black bile (earth), and yellow bile (fire). The theory of humors was introduced into Spain by the Moors, who acquired it from the ancient Greek physician Galen, and before him, the Chinese physician, Ho, whose six humors also included wood and metal. The Chinese humors were subclassified into yin and yang components, which continue to figure largely in modern Chinese medicine. The consensus is that humors determined mental disposition and physical health by virtue of their relative proportions. It was the healer's art to ascertain the imbalance of humors and correct it.

The ancient Chinese and ayurvedic principles of hot and cold properties of foods and physical conditions also came with the Spanish to the New World. Foods were considered hot or cold in essence rather than actual temperature, and certain combinations were considered healthy or unhealthy. Hence, milk and pork are still never served at the same meal in traditional New Mexican households. Other exam-

ples of cold foods are lemon, avocado, and cucumber; hot foods include chile and most red meats (anything that takes much energy to digest). Certain physical conditions were considered hot or cold, and were treated with the opposite type of food. Colds or asthma, which are cold conditions, are treated with hot foods; fever and *bilis* are hot conditions treated with cold foods. According to curandera Elena Avila, the hot/cold approach is fading from use in New Mexico.

The Judeo-Christian contribution to the healer's art was the concept that all healing ability was a gift from God, and all that resulted was the will of God. If God determined that the curandera's art will not effect a cure in a given instance, the curandera will refer the patient to a physician with no sense of failure or resentment, because of her abiding faith in God's will at work through her. Also, most curanderas even today will not charge for their services, but prefer to accept whatever the patient can pay. Curanderas often call on saints to assist in healing, particularly Teresa of Avila and the Holy Family.

The curanderismo of New Mexico found several similarities among the healing traditions of the Navajo, Apache, and Pueblo cultures. The Pueblo worldview held that the spirits imbue food with great powers to heal the body and mind. Food is medicine. Plant-based remedies were and are numerous, with 180 known types of wild plants from the Río Grande Valley being used by the Pueblo peoples for healing and ritual. Some useful plants include wild dock, puccoon, wild geranium, and willow bark for treating sore throats, skin abrasions, and rashes. A cleansing tea is comprised of juniper, wild buckwheat, feather dalea, and piñon pine. A paste is made from blue corn to relieve aches in the joints, and wild potatoes are used in the treatment of headache. In addition to healing herbs, the Spanish adopted the Indian method of childbirth, which had the laboring mother positioned vertically and bracing herself with a rope hanging from above.

The Apache healers included herbalists, social medicine men or women (comparable to psychologists), midwives, and psychics. Apache medicine is psychically oriented and founded, like Navajo medicine, on spirituality. Navajo healers observe imbalances and disharmony between the patient and the earth, sky, and universe, with which humans are viewed as one. Through chants and other methods, the healer restores oneness with the earth, sky, and universe, and restores obedience to the laws of the universe in the patient. These principles of restoring balance—the holistic ties between physical, emotional, and spiritual elements; the attention to the patient's attitude; the belief of oneness with all; together with the use of psychic ability in diagnosis and the use of ritual and symbolism—all are at the heart of both Spanish and Indian traditional healing in New Mexico.

In total, the curandera had (and has) at her disposal several approaches to healing:

- Tools, such as herbs, oils, candles, incense, holy water, eggs, mud, plaster packs, etc.
- Ritual, which varies widely according to the illness
- Psychic ability, including mediumship or channeling

In colonial times, it was necessary for settlers to know something about healing wounds, curing ailments, and surviving childbirth. Each household held a medicine chest or cupboard of *remedios caseros* (home remedies). Herbs hung upside down in bunches from the vigas of kitchens, drying. Herbs introduced to New Mexico by the settlers—chamomile, rosemary, saffron, anise, cilantro, garlic, and *flor de San Juan* (evening primrose)—were tended in gardens and allowed to grow wild. Others, like cinnamon, could only be imported. The Spanish also introduced lemons, oranges, and onions, which figure largely in many cures. Only in cases where remedios caseros did not work did the family turn to the community's resident curandera.

One such situation was childbirth. In colonial times through the twentieth century in New Mexico, pregnancy was a fragile and perilous situation because so many things could go wrong. It was not only important for women to take care of themselves physically during their pregnancy, but spiritually and emotionally as well in order to achieve the physical, emotional, and spiritual health of both mother and child. Hence, practices

7.16
Herbalist Maclovia Zamora of Albuquerque. Photo by Oscar Lozoya.

evolved that dictated a range of preventative activities, from keeping peace in the home and avoiding angry people to not looking at an eclipse. Still, prior to modern obstetric care, New Mexico had one of the highest infant mortality rates in the nation until the 1930s, when health programs were expanded, the water supply improved, and agricultural extension programs provided nutrition education (Jensen and Miller 1986).

As the Spanish population of New Mexico grew, so did specialization. Because Nuevomexicanos relied more and more on the curanderas' advanced knowledge of healing, the number of curanderas grew. Generally, men preferred to see curanderos, yet the majority of healers in New Mexico were women. Sandra L. Stephens studied some of the letters of Nuevomexicana women of the past 150 years to learn that they discussed health quite a bit, and that they had much to face,

including miscarriages, infant deaths, and epidemics of smallpox, influenza, and pneumonia. The influenza epidemic of 1918 killed more Hispanic and Native American persons than Anglos. Stephens speculates that this may have been due to the intensification of rural poverty by World War I, and a two-year drought in 1916 that caused a severe wheat shortage. Because no rural relief existed, those people were on their own. Another factor is the intensity of the work that women did on a farm in the field. If all hands were needed, women helped. With the dual work of housework and fieldwork, they left themselves vulnerable to exhaustion and illness.

By 1832, at least one physician was practicing in Santa Fe. An attorney, Antonio Barreiro, visiting Santa Fe in 1832, wrote:

> There are many medicinal herbs of extraordinary value for curing all kinds of diseases. The sedentary Indians, as well as the wild Indians, know these herbs well and use them to great advantage. These are the only medical means available—thanks to Providence for them—since there is not one single medicinal dispensary in the entire Province, and only one physician. (Chávez 1987)

Barreiro referred to Don Cristobal María de Laranaga, a physician paid by the military to serve the soldiers and a practitioner who had an excellent "practical knowledge of drugs and the aforementioned herbs" (Chavez 1987).

Curanderismo was maintained through the generations by the master/apprentice system in which a young girl was trained through adulthood by a practicing curandera. Both master and apprentice were either members of the same family or of the same community. The young apprentice had displayed an affinity for healing and was taken in hand by the curandera with the family's approval. On reaching the age of fifty-two—coincidentally a significant number in the Mayan mathematical system—the healer was thereafter considered an elder and master of healing.

Today, according to a study done at the Pan American University, curanderismo continues to

7.17
Curandera Elena Avila of Río Rancho, New Mexico. Photo by Delilah Montoya.

healthy environment to hundreds of Americans who relocated to the area along with numerous doctors in the late nineteenth and early twentieth centuries in search of recovery from tuberculosis, arthritis, and other illnesses. Many Anglo-Americans who were responsible for encouraging the folk art revival of the 1920s and 1930s were patients who had moved to New Mexico to recover, and who decided to stay.

Curanderas are still active in New Mexico in the late twentieth century for several reasons. They are affordable to many low income patients; there is a personal relationship between the curandera and the patient, who often share the same culture, religion, language, and health beliefs and practices; there are no papers to fill out and no appointments are needed; and most healers can be found in one's own neighborhood. While curanderas are allowed by law to practice in the United States, Maclovia Zamora, one of Albuquerque's best known herbalists, is concerned about recent attempts by the FDA to regulate the vitamin and herb industries. She argues that healing with herbs is an ancient practice, much older than allopathic (Western) medicine, which has proven its worth.

draw from Judeo-Christian religious symbols and rituals, early Arabic medicine and health practices, medieval European witchcraft, and Native American herbal lore. In the twentieth century, modern western medicine and Chinese medicine have also been embraced by the curandera, who has no hesitation in referring a patient to a medical doctor, and vice versa. Often the need for penicillin is a major reason for referring a patient to a medical doctor. Parteras will instruct a new patient to have the usual prenatal tests done as soon as possible. In Mexico, prescriptions are not necessary to get penicillin. Because *doctores chinos* (Chinese doctors) also rely heavily on herbal medicine, they have been welcomed into the New Mexico Hispanic community.

New Mexico's dry, sunny climate offered a

Curanderas are aware of the latest medicines and how the healthcare system works. Several work within the medical community. Elena Avila, a contemporary curandera based in Albuquerque, works with nurses and other health practitioners to forge a melding of traditions that ultimately benefits patients. She has worked within healthcare systems

in addition to accepting numerous apprentices into her home for one-year trainings in curanderismo. A Denver mental health facility, Centro de Familia, has had a curandera on its staff for several years. Because of these outreach efforts, the curandera's art is continuously evolving.

Famous Healers

Don Pedrito Jaramillo did not begin his healing practice until he was fifty-three years old. He lived in Falfurrias, Texas, and was well known for his simple, often odd, but effective cures. One example is described by Ruth Dodson in her study on Don Pedrito Jaramillo as published in Hudson's *The Healer of Los Olmos and Other Mexican Lore* (1975):

> A man had a very fine horse that got sick. Don Pedrito told the man to tie the horse to a chinaberry tree at twelve o'clock sharp, and at one o'clock sharp to take him away from the tree. With this the horse would get well and the chinaberry tree would die.

Don Pedrito's psychic abilities aided him in determining the causes of *susto* in his patients. He did not charge for his services, but accepted any donation his patients offered; the money he was given was used to feed the pilgrims who visited him, and to help him travel to the sick who could not come to him. It is likely that he visited New Mexico, although there is no written record.

Don Pedrito was a healer from Texas. The most famous healer in the history of Mexico was Niño Fidencio (1898–1938) who began healing at age eight. His fame began when he healed the daughter of the Mexican president, Plutarco Calles. Called "the curandero of curanderos," Fidencio's healing techniques were as unusual and effective as those of Don Pedrito. He is said to have cured mental as well as physical illnesses. Today, thousands of Mexicans travel twice a year—on the anniversaries of his birth and death—to his home in Espinazo in Mexico to pay homage and to celebrate his life. Pilgrims arrive at Espinazo from all over North America, including Chicago, where there is a shrine to El Niño. The pilgrims approach on foot, crawl-ing, walking or on their knees, carrying a cross, or costumed or playing music. Among the visitors are "Fidencistas" who are said to assume El Niño's spirit, or the spirit of other holy persons. In recent years, a religion has developed around El Niño. In contrast, the town of Espinazo takes on the same commercial atmosphere that one finds at other pilgrimage destinations, such as Lourdes, France.

Teresa Urrea (1873–1906) was a famous Mexican healer and psychic, born illegitimately of an Indian mother and aristocratic Spanish father. Her healing life took her as far afield as San Francisco and New York. Like El Niño, she loved music and festive events. Unlike El Niño, she inadvertently inspired worship among the Indians of Mexico,

7.18

Woodcut image of Teresita, the famous Mexican healer, by José Cisneros. From William C. Holden, *Teresita* (Owings Mills: Maryland Stemmer House Publishers, 1978).

7.19
Procession to the Santuario de Chimayó on Good Friday, 1994.
Photo by Miguel Gandert.

thus inflaming the Church against her, and the Mexican government against the natives who worshipped her.

According to Eliseo Torres, healers such as Don Pedrito, El Niño and Teresita (as she was known) were highly popular in their day because there were few physicians, religious leaders, or even priests to serve the medical and spiritual needs of the people. These folk healers filled a need. In the latter half of the twentieth century, the closest phenomenon there is to the old healers of renown are the Hispanic and Native-American curanderos from Mexico, who regularly visit New Mexico for two or three weeks at a time, bringing with them a new palette of practices and regional herbs to deal with chronic and other maladies. According to Maclovia Zamora, who is usually apprised of their presence in Albuquerque, the healers will see many patients during their visits. Visiting Mexican-Indian healers have given workshops in Albuquerque in the ancient Aztec healing system known as *Nawi Ollin Teotl*, which is based on organic workings and relationships within the body, nutrition, herbs, breath-

ing, exercise, ecology, and self-evaluation. It is a system familiar to Ms. Avila, who knows the practitioners and sponsors their visits to New Mexico. They, in turn, have given her a long Aztec name meaning "The flower that attracts medicine through laughter."

For New Mexicans who cannot visit healers elsewhere, there is the Santuario de Chimayó in Chimayó, New Mexico. Here, a small chapel to the side of the main nave of the Santuario reveals a hole in the packed mud floor where pilgrims will find the *tierra bendita* (holy earth) that is said to have healing properties. The small chapel and adjoining room are lined with crutches, letters, photographs, and other mementos left by those healed by the miraculous soil. Every year during Semana Santa (Holy Week), approximately forty thousand faithful make the pilgrimage to Chimayó, walking from as far away as Albuquerque and Grants.

Chimayó has served as a holy site for at least six centuries, according to scholars who have found ruins nearby dating from between A.D. 1100 and 1400. According to Tewa legend, Chimayó was a place where once the Earth gave forth fire, smoke, and hot water. It was a place where twin war gods killed a giant that threatened the people. When he died, fire burst out of the Earth and dried a sacred spring, leaving only mud. The name Chimayó is a Spanish mispronunciation of *Tsimajopokwi*, the Tewa word meaning "pool where the big stones stand." The ancient Tewas knew of and used the blessed soil, or *nam po'uare*.

By the early nineteenth century, the Spanish of Chimayó had adopted this Pueblo into their worship of the Lord of Esquipulas—a Guatemalan Christ figure—probably introduced into the valley by Bernardo Abeita in the nineteenth century. Additionally, the site of the Santuario is the subject of several Hispanic and Pueblo legends regarding

7.20
El posito (little hole) with the holy earth at the
Santuario de Chimayó. Photo by Miguel Gandert.

the appearance and self-relocation of a miraculous crucifix. Curiously, the Guatemalan Lord of Esquipulas is also a pilgrimage destination that involves sacred, healing soil. (In the section on weaving, a discussion of the unusual weft ikat style of weaving harks back to Esquipulas and Guatemalan weaving techniques. Clearly, the ties between Guatemala and Chimayó are multilayered and probably a result of trade and travel.)

The soil of Chimayó is said to be effective on pains, rheumatism, depression, sore throat, paralysis, and childbirth. Pilgrims carry away samples of the soil in bottles and handkerchiefs. The earth is dissolved in water and drunk, or smeared, over the affected area.

In addition to the healing soil, a complementary legend surrounding a statue of the *Santo Niño de Atocha* centers on its nocturnal healing visits throughout the region. The two phenomena are so intertwined that the Santuario is often called the Santuario of the Santo Niño. Many believe that the statue was found in the hole from which the soil comes (see chapter 2). The pilgrimages to Chimayó, and the healing miracles of its soil, continue today in supporting the enduring sense of community that has nurtured and maintained the Spanish-speaking people of New Mexico.

Types of Afflictions
Curanderas most frequently treat the following ailments.

MAL DE OJO (EVIL EYE)
This affliction is caused not by malice but by excessive admiration, usually of babies or animals, or the

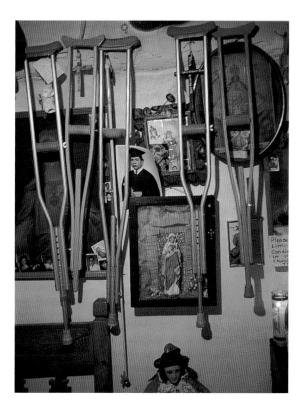

7.21
Crutches and photos in side room at the Santuario de Chimayó. Photo by Miguel Gandert.

weak. Its principle is that excessive admiration can result in projected energy of the admirer onto the child or animal. Symptoms of mal de ojo are similar to colic: irritability, fever, headache, vomiting.

To counteract mal de ojo, the admirer must touch the child or animal. Another cure is achieved by sweeping a raw egg three times in the form of a cross over the length of the reclining child. While sweeping, the curandero recites the Apostles' Creed three times. The egg is cracked into a jar of water, which may be placed on the child's head while the creed is once again recited. The jar is then placed under the child's bed. The egg is either burned or discarded the next morning at sunrise, also in the shape of a cross. The analysis of the egg's color and condition will also tell whether mal de ojo was indeed the cause of the symptoms.

Susto (Fright; Loss of Spirit or the Soul)

Susto (literally, fright or dread) is caused by a bad scare, or bad news, which will temporarily drive the soul from the body. The spirit is thought to be nearby, and treatment brings it back into the body through ritual. Delaying treatment may result in *susto pasado*, which is more difficult to treat. Symptoms, which include weakness, palpitations, indigestion, depression, dyspnea, loss of interest, irritability, insomnia, anorexia, anxiety, and weakness, sound very similar to panic attacks.

The cure for susto involves covering the prone patient with a sheet. The curandera sweeps the patient with a broom while reciting the Apostles' Creed three times. At the end of each prayer, she whispers in the patient's ear, "Come, don't stay there." The patient responds, "I am coming." The patient is given a tea of *yerba anís*. A cross made of holy palm is placed on the patient's head while more prayer is recited. Another cure involves an egg, sweeping with a broom or a bundle of horehound and rosemary. This cure takes three days. Both cures require invocations for the return of the spirit, with the patient actively involved in the dialogue. Don Pedrito Jaramillo's cure for susto involved first determining the cause of the fright. He was also known to use fright itself to cure susto.

Caída de Mollera (Fallen Fontanelle)

The falling in of a baby's fontanelle, or soft spot (on the top of the skull), is easily spotted. The cause is thought to be careless handling, the premature withdrawal of a bottle or breast, or a fall, resulting in symptoms such as irritability, diarrhea, vomiting, and dehydration.

To cure caída de mollera, the baby is turned over and the roof of the mouth is pushed up with the thumb. The fontanelle may or may not be packed with moist salt prior to binding the area with a sticky substance such as soap or egg white.

Empacho (Intestinal or Stomach Blockage)

This condition reflects the need for humoric balance. It is thought to be caused by eating cold and hot foods at the same time, eating in improper sequence, or eating too quickly. Empacho often afflicts children with diarrhea, a feeling of weight in the pit of the stomach, and loss of appetite.

An egg is used to determine the site of the empacho, often followed by a massage, a laxative, and ingesting castor oil, olive oil, or shortening.

Mal Aire (Head Cold)

Symptoms are earache, stiff neck, chills, dizziness, and headache. This ailment is treated with tea, lemon juice, liniments, poultices, and whiskey.

Desasombro (A Type of Susto)

Desasombro is recognized as a susto with a more significant cause, but distinct from susto pasado. Eliseo Torres (1983a) describes it thus in *The Folk Healer*: "If stepping on a snake resulted in a susto, stepping on a poisonous snake would result in *desasombro*."

Because desasombro is a serious ailment, the ritual to cure it is elaborate. At 11:00 A.M., the curandera digs four holes in the ground in the shape of a diamond, representing the head, hands, and feet. The area is covered with a white sheet and the patient lies, face down, on the sheet in the form of a cross. Another sheet is placed over the patient and the curandera sweeps the patient with either bundles of *granada* or *cenizo*, or with a broom, while reciting the Apostles' Creed three times.

The patient stands, while the curandera strikes the patient's shadow prior to dragging a piece of the patient's clothing into the house while calling the patient's spirit. Inside, the patient drinks a tea of yerba anís, leaving a little in the cup. The curandera mixes soil from the holes into the tea and then marks the sign of the cross on each of the patient's joints with the mud. The patient is then made to sweat under blankets while the curandera sweeps the patient with cenizo and recites the Apostles' Creed three times. The cure is then complete.

ESPANTO (A SEVERE TYPE OF FRIGHT OR SPIRIT LOSS)

Unlike susto, *espanto* can also occur when the person is asleep. Causes of espanto include sudden waking by something frightening, such as nightmares, a fall, or noises, thus taking the spirit by surprise and keeping it from fully returning to the body. The concept of espanto is a good example of how curanderismo anticipated some of the recent psychological research.

The cure for espanto is the *limpia*, or ritual cleansing of the body, mind, and spirit, and combinations of *consejos* (counseling), *pláticas* (chats) and ceremonies.

BILIS (EXCESSIVE BILE)

Thought to be precipitated by suppressed anger, bilis is recognized by symptoms of gas, constipation, sour taste in the mouth, and a pasty-looking tongue. The cure is to take Epsom salts or a laxative once a week for three weeks.

MUINA (ANGER SICKNESS)

Thought to be precipitated by expressed rage, *muina* is evident from the patient's trembling, tension, and even temporary paralysis, such as a locked jaw or loss of hearing. This condition may also result in a discharge of bile throughout the body thus unbalancing the humors. Contemporary curanderas compare muina to hysteria.

Flowers figure largely in the cure for muina. The curandera sweeps the patient with three red flowers on three consecutive days. The patient then takes a decoction of flowers and leaves of the orange tree, or another citrus fruit. If a cure is not

achieved, the patient is struck, shaken, or verbally assaulted until the anger dissipates.

LATIDO (STOMACHACHE)

Originally *latido* applied to a condition of palpitations, a throbbing, jumpy stomach, and weakness. It has been variously described as a nervous stomach or hypoglycemia. Symptoms occur when the patient has gone without food for a long time.

Healers begin by feeding the patient. The healer may offer the patient any of three combinations: a mixture of raw egg, salt, pepper, and lemon juice taken for nine consecutive days; or bean soup with onion, coriander, and garlic; or a hard roll which has been split and sprinkled with alcohol, peppermint leaves, nasturtiums, cinnamon, cloves, and onions. The roll and its ingredients are not eaten, but wrapped in cloth and bandaged over the pit of the stomach.

Eliseo Torres postulates that the intangibles involved in the effectiveness of curanderismo include the use of touch, the undivided attention of the curandera on the patient, the involvement of the family, and the fact that the rituals are carried out in the patient's home.

There are a series of ailments that are thought to be caused by witchcraft, and are motivated by envy or revenge, including *envidia* (envy), *mal puesto* (hex by a witch), *salada* (sprinkling salt around a house to bring bad luck to its residents), and *maleficio* (bad intent against others). These are inflicted by "black" curanderas, as distinct from "white" or regular curanderas, who greatly outnumber the former. White curanderas heal in the name of God, while black curanderas are more properly known as *brujas* or *brujos* (witches). They set out to harm others through spells or hexes. To make the drama interesting, white curanderos are adept at countering spells and hexes with numerous rituals.

According to Ms. Avila, women healers outnumber men five to one today. She estimates that currently there are twenty practicing curanderas in New Mexico. She specializes in emotional ailments and in over twenty years of practice, has seen a rise in susto and envidia. Susto, she says, is on the rise with depression, insomnia, and manic

behavior as its most common indicators. Envidia, or envy, is "epidemic" due to rising obsessions with power, money, material gain, and personal appearance. The unfortunate side effect of envidia is that it can hurt the one who is envied through its focused negative energy.

Herbal Remedies

Herbs are applicable in several forms:

- Teas, or decoctions of any part of a plant (leaf, flower, stem, root).
- Homemade pills, using herbs (active ingredient) mixed with tobacco, piloncillo (brown sugar), onion, and other fillers. These may be taken orally or as a suppository.
- Balms, salves and poultices created with powdered herbs.

All healers, whether midwives or massage healers, have in common a good working knowledge of herbs. Their art, however, is a continuously evolving one. They are not above suggesting "Anacin" for headaches, as was related to researcher Tibo J. Chávez in preparing his book on herbs, *New Mexican Folklore of the Río Abajo*. Mr. Chávez interviewed about seven curanderas and fifty *viejitos* (oldtimers) in the Río Abajo area from Alameda to Socorro, New Mexico, during a three-year period in the 1970s. During his interviews, Mr. Chávez heard the same situation described many times: the patient would go to the clinic and receive a prescription that didn't do any good. Then the patient used a remedio that had been in the family for many generations, and the condition cleared up.

In his book *Green Medicine*, Eliseo Torres relates a revealing reaction Evelyne Winter reported while studying folk medicine in Mexico in the 1950s.

[Ms. Winter] reported . . . that one of her informants had a hard time convincing a cab driver that she wasn't daft when she admitted to drinking tea just for the pleasure of drinking tea, rather than to effect a cure for some ailment or other!

There are literally hundreds of plants and vegetable items used by healers. Most herbs were gathered in autumn when the plant had achieved its full potency. There was also a time of day or night to pick certain plants.

Maclovia Zamora lists the following most frequently used herbs in the late twentieth century as evidenced by her practice at B. Ruppe Drugs in downtown Albuquerque. Her domain, including hundreds of containers of herbs and other medicinals, dominates the front of the store. A pharmacy operated by Tomás Sanchez dominates the rear of the store, which was established in 1883 as both a pharmacy and source of natural herbal remedies. It is described in Rudolfo Anaya's book *Atzlán*.

The information given here is not prescriptive, but informative. The reader should not self-medicate, but always seek the help of a professional. In addition, many poisonous and nonpoisonous herbs are similar in appearance, a fact that underscores the need for a professional even in picking wild herbs and plants.

ALFALFA (MEDICAGO SATIVA)

Highly nutritious, alfalfa has inspired recent government publications that recommend alfalfa as a green for human consumption. A tea of the leaves and flowers is used as a tonic and blood thinner, and is helpful for arthritis or gout. The seeds boiled in water aid stomach troubles and hangovers. Placed around a room, alfalfa serves to drive away bedbugs. The term is derived from the Arabic word for the plant, *alfaçfaçah*.

AÑIL DEL MUERTO (VERBESINA ENCELIODES; GOLD WEED)

This herb is recommended for stomach distension, taken as a tea or in cold water. Also used for rheumatism, windburns, chafed skin, and as a menostatic. When cinnamon, cloves, and soda are added to the tea, it is helpful in treating diarrhea. As an anti-inflammatory, it is used to treat ulcers, colitis, and hemorrhoids. A powder of the entire plant (including flowers) with oil will treat cancer and sores. When mixed with dry lime, the dry ground leaves are used to treat dropsy. Also used in swelling of the lungs or liver when taken as a salted tea.

ARTEMISA OR ARTEMISIA (ARTEMISIA VULGARIS; MUGWORT, SAGEBRUSH)

A tea of the flowers and leaves treats female disorders, including menopausal complications. Pregnant and nursing women are to avoid artemisia, however. An infusion of the entire plant will stimulate appetite, while the powdered flowers aid colic. When simply carried on the person, artemisia serves as a protectant against danger. Finally, those who sleep on a pillow stuffed with artemisia will dream of the future.

CAÑAIGRE (RUMEX HYMENOSEPALUS; RED DOCK, WILD PIE PLANT)

Also known as *caña agria* and *canaigra*, the tubers contain high concentrations of tannin, which were used by colonists in preparing hides. Cañaigre is used as a gargle for sore throats, as a mouthwash for pyorrhea and gum inflammations, and its powder is applied to prevent skin irritations. Sucking on a slice tightens the teeth. The tea is used as a wash to treat acne and related ailments.

CAÑUTILLO (EPHEDRA TORREYANA; MORMON TEA)

Also known as *cañatilla* and *cañutillo del campo*, this herb is used primarily as a diuretic and for minor kidney inflammations, weak kidneys and weak lungs, as well as colds and allergy symptoms. Cañutillo is known also to relieve the symptoms of a hangover.

CARDOSANTO (CIRSIUM UNDULATUM; THISTLE)

Known to the Romans as *carduus* and to the Spanish as *cardo*, its juice is effective in treating earache and its tea, held in the mouth, treats toothache. Cardosanto is also effective as a decoction in treating gonorrhea and diarrhea. As a bath mixed with alcohol it relieves rheumatism. Tibo Chávez (1987) relates a riddle about cardosanto told to him by Alberto Moya:

> *Fui al campo y encontré uno que se cruza. Dice que es Santo y no es Cristiano. ¿Quién es?* Answer: *El Cardo Santo.* I went into the country and I found someone who crosses himself;

he says he is a saint and yet he is not a Christian. Who might it be? Answer: The Holy Thistle.

CHIMAJÁ (AULOSPERMUM PURPUREUM; PARSLEY FAMILY)

The water-seeking root of chimajá was incorporated into the diet of the Spanish settlers, and later aged in whiskey to make a popular drink called mistela, a type of cordial. As a remedy for weak stomach, the root may be eaten or the dry leaves and flowers made into a tea and drunk. It is also used as a seasoning for stews, soups, beans, and peas. When cooked, the roots taste like a mix of parsnips and potatoes.

COTA (THELESPERMA GRACILE; NAVAJO/HOPI TEA, WILD TEA)

Also known as *té silvestre* or *té del campo*. Spanish settlers used cota as a beverage substitute for expensive imported tea or coffee. With sugar, it serves to reduce fever. Babies bathed in a weak solution are relieved of chafed skin. As a tea, it serves as a diuretic when drunk nine days in succession, and is said to treat high blood pressure. It is also known to be an excellent vermifuge and laxative. Native Americans also use cota as a dye in basketmaking.

ESTAFIATE (ARTEMISIA MEXICANA AND ARTEMISIA LUDOVICIANA; WORMWOOD, ROCKY MOUNTAIN SAGE)

Estafiate is derived from the original Aztec name for *Artemisia mexicana, yztauhiatl.* In New Mexico, the old Aztec and Mayan applications have not been forgotten, as it is used to relieve diarrhea, coughs, and stomach troubles. A bath of estafiate relieves the symptoms of arthritis and rheumatism. It is also taken today for relief of menstrual cramps and, as a steam inhalant, for sore throats. Estafiate is not appropriate during pregnancy or for patients with liver disease.

INMORTAL (ASCLEPIODORA DECUMBENS; ANTELOPE HORNS, MILKWEED FAMILY)

Inmortal is used in childbirth to relieve pain and to facilitate the birth of the placenta, and it is said

to stimulate delayed menses. It is also used to treat asthma, enlarged heart, gall bladder attacks, abdominal pain, and internal bruises, and to reduce fevers and the pain of headaches. Combined with *oshá*, inmortal is used to prevent disease. Its scientific name harks back to the Greek god of medicine, Asklepios.

MANZANILLA (MATRICARIA COURRANTIANA; CHAMOMILE)

Most popularly known as a treatment for childbirth and colic, this plant is also useful in treating earache by warming dry flowers and placing them on a small piece of cotton and applying in the ear. It is also used for stomach trouble, insomnia, colds, flus, menstrual cramps, fever, gonorrhea, and aching joints caused by weather changes. For colic, a tea of manzanilla, yerba buena, and *alhucema* (lavender) is used. Manzanilla is also used to cure caída de mollera. It is also considered an excellent hair rinse, especially in combination with *romero* and salvia.

MASTRANZO (MENTHA ROTUNDIFLORIA; HOREHOUND, APPLE MINT)

As a tea, mastranzo is used on stomachaches and intestinal cramps. In combination with *flor sauco* or *ajenjibre*, mastranzo is used to break a fever by inducing sweating. It is applied topically in powder form to cure wound infections or new wounds.

ORÉGANO DEL CAMPO (MONARDA PECTINATA; WILD OREGANO, HORSEMINT)

For stomach pain, a tea made of the flower balls is taken. Orégano is also useful as a seasoning in cooking.

OSHÁ (LIGUSTICUM PORTERI; CHUCHUPATE)

Oshá is thought to be the most widely used medicinal herb in the Southwest, and was used as a barter item all along the Río Grande. Either chewed or taken as a tea, oshá soothes upset stomachs. The powder added to hot water and a touch of whiskey and sugar will break chronic coughs and combat flu, pneumonia, and consumption. The grated root steeped in whiskey treats malaria and incipient colds. The root is an effective disinfectant and anesthetic for sore throats and a disinfectant as a skin wash. Chewing the root serves the same purpose as taking a tea for the throat or stomach, but it is highly bitter to the taste. It will induce sweating when other herbs fail. A paste made of the root powder and water will draw out the poison of snakebite. It is also carried on the person to ward off snakes, and the powder is sprinkled around a camp bedroll for the same reason. The Apaches and Spanish smoked the fried hollow stems instead of cigarettes. Later, the stems were chewed to break the tobacco habit. A salve of oshá, mutton tallow, candle wax, manzanilla, *contrayerba* (*Kallstroemia brachystylis*), and turpentine is used to treat cuts, bruises, and sores. When used in combinations with several other herbs, oshá treats

7.22

Manos de la Sobadora (A Massage Healer), a painting by Pola López, after a photo by Miguel Gandert. From the collection of the artist.

intestinal stasis. Curanderas carry oshá to attract good luck and to ward off black magic. Pueblo farmers leave oshá root in acequias to drive off cutworms and similar pests.

PASOTE (*CHENOPODIUM AMBROSIOIDES*; EPASOTE, MEXICAN TEA)

The original Aztec word for this herb is *epazotl*; the Mayan word *lucum-ziu* (worm plant) indicates its use as an effective vermifuge. In addition, when taken with salt, its leaves stimulate menses, relieve the pains after childbirth, and induce abortion. Pasote is used by parteras to stimulate childbirth. Afterward, as a tea with sugar, pasote stimulates the production of milk by nursing mothers. The herb is also used in the treatment of symptoms of appendicitis and as a blood purifier. It should be avoided by people with heart conditions.

PLUMAJILLO (*ACHILLEA LANULOSA*; YARROW)

The name means "little feather," which is descriptive of the foliage at the base of its small white blossoms. This herb will relieve chills when taken as a cold tea, and induce sweating when taken as a hot tea. It will treat nausea and poor digestion. In combination with *poleo*, it is used to treat spots in the eyes, dizziness and biliousness. *Plumajillo* is considered a good love potion, especially if picked by a young woman from the grave of a young man. While Zuñi Pueblo Indians used plumajillo to cool the skin prior to dancing in fire or taking live coals in the mouth, the Spanish used its cooling properties to reduce fever. It is also used as a blood coagulant on cuts and bruises.

POLEO (*MENTHA ARVENSIS*; PENNYROYAL)

The Moors used poleo to treat headaches and colds, and in postpartum care. It is a fever reducer when added to beaten egg white and a little salt and applied as a poultice to the bottom of the feet and on the forehead. Pinpricked paper is applied over the poultice.

PUNCHE MEXICANO (*NICOTIANA RUSTICA*; NIGHTSHADE FAMILY, WILD TOBACCO)

Native Americans burned this herb to appease divine forces. Spanish settlers smoked it in hand-rolled cigarettes made of brown paper or cornhusks, and in pipes. It was also ground and used as snuff. A poultice of powdered *punche* is applied to the chest for colds. A wash or direct application relieves the pain of rheumatism, arthritis, bursitis, and muscle pain. It is combined with *yerba de buey* to treat kidney problems, and with raw fat and salt to treat hemorrhoids. Moistened leaves are bound to a snake or insect bite to disinfect and to stop bleeding. Punche prevents jaundice, and is said to stimulate growth in small children who chew the herb. The smoke is blown under a baby's clothes to relieve colic and into the ear to relieve earache. Overweight persons smoke it to lose weight. A strong wash draws out ticks.

ROMERO (*ROSMARINUS OFFICINALE*; ROSEMARY)

The tea will relieve headache and chest pain from colds, aid digestion, and improve memory. The cooled tea used as a skin wash prevents wrinkles and blemishes, and erases freckles. When rubbed on the head, romero is said to prevent baldness. The powdered leaves are used as a dressing for the navels of newborns. Smoke from the wet leaves dropped on hot bricks treats postpartum bleeding. A salve made with romero relieves windburns and irritations. Sprigs are used in ritual spirit cleansing to absorb negative energy.

TOMATITO (*SOLANUM ELEAGNIFOLIUM*; TROMBIYO, NIGHTSHADE FAMILY)

Tomatito berries may be used instead of rennet to curdle milk. The Zuñis placed chewed root in the cavity of an aching tooth. Other preparations relieve tonsillitis, sinusitis, respiratory inflammations, and headache. Tomatito is named for the berry, which resembles a small tomato.

YERBA BUENA (*MENTHA SPICATA*; SPEARMINT)

The Mayans used this herb to induce labor. Parteras administer the herb throughout the birthing process. It is also considered the most effective tea for stomach disorders, particularly indigestion, when combined with manzanilla or alhucema. It is also useful as a vermifuge, for diarrhea, as a wash for wounds and sores, and for kidney ailments.

Jesusita Aragón, Partera

The story of Jesusita Aragón of Trujillo, New Mexico (near Las Vegas), is told in a first person dictation edited by Fran Leeper Buss in 1980 in a book entitled La Partera. Ms. Aragón's story is entertaining and informative not only from a medical point of view, but in that it tells an engaging story of a young woman living in transitional times in northern New Mexico in the twentieth century. In her work as midwife, she delivered twelve thousand babies by her count, including twenty-seven sets of twins and two sets of triplets. Her career as a midwife spanned seventy-three years.

Born in Las Vegas in 1908, Ms. Aragón presided over her first delivery (an emergency) at age fourteen. Her grandmother, Dolores Lola Gallegos, was also a midwife. When she was twenty-three, she became an unwed mother and was treated harshly by her family. She was not allowed to attend church, she was banned from dances, she was made to work during her pregnancy, and she was denied the dieta after giving birth. Women who have given birth enter a period called the dieta, which dictates at least eight days in bed, fifteen days indoors, and forty days before resuming any hard work. The woman must remain on a special diet, and is not allowed to take a full bath or wash her hair, but to take only sponge baths. If these rules are not followed, a difficult menopause will be in store for her.

The responsibility and experience of being ill-treated as an unwed mother gave her a new kind of compassion as a midwife. In the old days, women gave birth the old way:

> They squat down when they have their baby. They tie a little round stick on a string, on a little rope. Then they put the rope over the vigas, the beams in the ceiling. They put it over so it's like a handle for her, and she squats down and holds onto the stick. Oh, it helps. (Buss 1980) [The rope brace is a Native American method of childbirth adopted by the Spanish.]

Like most healers, Ms. Aragón combines religion with healing.

> You know, when that lady is having her baby, I'm praying but not loud. Praying for that lady to be OK, and for that baby, 'cause I learn to pray from my grandmother. My grandmother says, "Pray when you have a patient, pray for her and

YERBA DE BUEY (GRINDELIA APHANACTIS; GUM PLANT, PEGAPEGA)

"Herb of the ox" is used to treat sore throat and incipient chest colds. For "cold in the bones," the moistened herb is placed on a hot adobe brick, which is wrapped and placed next to the affected areas. Placed in a hot bath, yerba de buey treats paralysis. When combined with *yerba santa* and honey, it serves as an expectorant. The flowers are used to treat bladder and urethral infections, and to prepare salves for burns and slowly healing ulcers.

YERBA MANSA (ANEMOPSIS CALIFORNICA)

Considered a lifesaver and killer of infections, *yerba mansa* in a strong liquid was used in colonial times to soak the affected areas. As a tea, powder, or poultice, it is excellent in treating abrasions, burns, and sores in humans and animals. It is taken as a gargle for inflamed throats. Yerba mansa reduces fevers, and works on ulcerated gums, kidney ailments, sinusitis, vaginitis, hemorrhoids, and diaper rash. Its wilted leaves will reduce swellings, and as a bath, or poultice, will relieve arthritis and rheumatism. As a tea, it acts as a blood purifier and treatment of irritations of mucous membranes, and digestive upsets.

YERBA DE LA NEGRITA (SPHAERALCEA FENDLERI; MALLOW FAMILY)

A tea of the fresh leaves is taken to treat tumors. For swellings resulting from mosquito and other insect

pray for that baby." So I learn everything. I pray in my mind, not loud. I pray in my heart by myself. . . . I have paintings of the saints in the room I use for the babies . . . And I learn how to baptize from my grandmother, too. I baptize many. When the mothers think their baby is going to die, they tell me, "Baptize my baby." (Buss 1980)

She speaks of helping a premature baby survive by placing it in a small box on the oven door, with a little wood in the stove to maintain low heat. When the baby was born, the option of taking it to the hospital was out of the question because it was too far away and the baby was too small to make the trip. They ministered to the baby at the stove for two months, feeding it with a dropper and maintaining a night watch to keep the stove fire just so. The child survived and flourished.

The *dieta* dictated omission of certain foods, including beans, tortillas, potatoes, and chile. The new mother was encouraged, instead, to eat atole, beef, lamb, chicken, and bread made with lard. (When atole is prepared as a medicinal aid, it is comparable to the barley broths recommended by Hippocrates, according to John C. Super.)

One of Ms. Aragón's treatments for a fever, other than aspirin, is to rub alcohol and saffron tea on the body. She uses mastranzo for ulcers and, with añil del muerto, for yeast infections. Romerillo *is for hemorrhages.* Manzanilla *tea and* pasote *were given to mothers to relieve afterbirth pain.*

My grandmother showed me how to use these things. When I was little. She learned them from her mother. Everybody knew them back then, and they teach other. Yes, I know many things now. I'm partera, a midwife, and some people say I'm médica. I'm médica, the healer. (Buss 1980)

Ms. Aragón has received many honors for her work as a partera, including the "Living Treasure" award presented by the governor, together with a "Jesusita Aragón Day" celebrated in Las Vegas, where she lives. She was recently honored as Midwife of the Year at a Midwife Alliance National Association convention in Denver.

bites, the plant is crushed and salt added and applied. The mashed roots are mixed with flour to create a poultice for broken bones. The mashed leaves and flowers make a shampoo that promotes hair growth. A plaster applied to the forehead relieves headache.

Yerba de la víbora (*Gutierrezia tenuis;* Escoba, Rattlesnake weed)
The name means snake broom. The tea treats stomach ailments, rheumatism, and hemorrhoids. Jesusita Aragón (see sidebar) uses this herb to treat ulcers. Mixed with *coyaye* and honey, yerba de la víbora is used to stimulate menses. A bath of the greens and flowers assists in the recovery from malarial episodes. The herb is used to relieve uterine swelling after childbirth.

Nonherbal Healing
The sobador was like a combination of osteopath and chiropractor, adept at relieving pain on the spot rather than over the course of many visits. The sobador could set a dislocated shoulder or administer what was called the *apretón de arriero*, or driver's hug, to those whose aching back and shoulders resulted from long periods of sitting or driving over long arduous roads. Massage also figured largely in labor and delivery. The Indians of the Southwest were adept at body massage.

The healer's art also incorporates the use of

rituals and tools. The egg and the lemon are thought to absorb negative energies from a patient. The lemon is combined with *agua preparada*, a prepared water. Holy water is considered to be a tie to the spirit world, and the curandera will often dip objects in holy water to enhance their effectiveness in curing. Also useful are aromatic oils, candles, and incense.

A *barrida*, or spiritual cleansing, eliminates negative energies by transferring them to an object, usually an egg, a glass of water, a lemon, or herbs, which are then discarded carefully. The following story illustrates the principle behind the barrida. Evelyne Winter, in her *Mexico's Ancient and Native Remedies*, collected this story from a woman who lived in Mexico for a time. It was related by Eliseo Torres in *The Folk Healer* (1983a).

> My late husband one time had a very bad eye and headache. A man came to see him to cure him. This "doctor" asked me for a raw egg, which I gave him. While the egg was still in its shell he passed it many times over my husband's head and face. Then he asked me for a dish and he opened the egg, which had become hard-boiled. We asked if it had cured him and he said not entirely. The "doctor" came the next day and went through the same procedure with a fresh egg but after the treatment the egg was not hard-boiled, only coddled. The "doctor" was not satisfied that the cure had been completed and came the third day. The egg the third day was unchanged by the treatment and the man pronounced him cured. And my husband *was* cured.

Unusual or unlikely rituals continue to mystify today. A newborn pig was rubbed on the patient with epilepsy; ground baked badger mixed with magpie soup was good for asthma, and cat's flesh for tuberculosis. A spouse's drawers around the neck would relieve a crimp in the neck. A compress of cobwebs stopped bleeding from an open wound, as did the thin membrane of an egg. A love potion was a pinch of jackrabbit bone in the person's soup or coffee. Don Pedrito Jaramillo directed a patient who had a burr stuck in his esophagus to drink salt water, which made him vomit up the burr.

The numbers three and nine, made mystical by the Roman Catholic Church, are often the numbers used when giving directions on the use of medicines or the rituals to be performed in the curing process. For example, three times three flower buttons of yerba del buey must be boiled in three pints of water until one pint remains. Then it is administered for kidney ailments three times a day.

Preventive Maintenance

Amuletos (amulets) are used to prevent problems, such as the deer's eye charm known as the *ojo de venado*, which is said to ward off mal de ojo. A bag of parsley or oshá is worn around the neck to repel snakes, while a pregnant woman will hang keys around her waist during a lunar eclipse to prevent deformities in her baby due to the moon's shadow. Garlic and purple onion are considered powerful preventatives when worn.

The use of incense to promote good luck is derived from Aztec and Mayan practice as well as the Judeo-Christian tradition. Candles are used for a similar purpose: burning a black candle brings freedom from evil, blue candles bring peace, harmony, and joy, and red candles bring love and affection. Various types of perfumes and oils are said to attract wealth or success, to achieve a cure, to reverse hexes, and to inflict revenge. Eliseo Torres (1983a) quotes a freelance writer in Texas who was assigned to report on a curandera in Houston. When the writer mentioned jokingly that she needed to change her life, the woman showed her something called "Special Brown Oil." According to the writer, it smelled like bathroom disinfectant, but she used it anyway, dabbing some on. "The next week," she said, "I had a call from a publishing company. They wanted to publish my doctoral dissertation, which I'd done more than ten years earlier. Then an old boyfriend called—my high school sweetheart." The writer is now engaged to marry him. "Trouble is," she said, "I'm almost out of the oil."

Chronology

1492 The Moors are driven out of Granada, Spain—their last Spanish stronghold—after eight hundred years of occupation. Some scholars suggest that the Spanish were motivated to remove the Moors, who occupied southern Spain, by a need for summer grazing lands for their sheep.

Columbus reaches the Americas and begins a cultural encounter between East and West that will have a profound impact on the cuisines of the world.

1579 Friar Bernardino de Sahagún completes his *Historia general de las cosas de Nueva España*, which records Aztec foodways and medicinal practices. It is not published until 1793.

1598 On April 30, Oñate's settlement party celebrates the successful passage over waterless terrain by holding a large feast with mass and celebrations along the banks of the Río Grande near El Paso.

1598–99 The first crops planted by Oñate's settlers are disappointingly small, prompting Oñate to exact tribute from neighboring Pueblos in the form of food.

1680 The Pueblo Indians revolt against the Spanish settlers in New Mexico, driving them south as far as El Paso. The Indians destroy everything left behind by the Spanish except the livestock and the orchards.

1693–1846 New Mexico ranchers export sheep to northern Mexico. After 1846, exports focus on California where demand is great as a result of the Gold Rush.

1816 Construction completed on the Santuario de Chimayó, housing a small hole holding soil that has been used in healing since ancient times.

1880 The Public Land Commission is established. It disqualifies many New Mexican land grants, essentially shutting out New Mexicans from the common grazing, hunting, and fishing lands of much of northern New Mexico.

1930s New Mexico Agricultural Extension Service establishes statewide training program in food canning, cooking, sewing, field crops, gardening, and husbandry.

1990s Mexican cuisine grows in popularity nationwide, giving rise to mass production and distribution by major food producers and fast-food restaurant chains of salsa, corn tortilla chips, chile con queso, and variations of the burrito.

Glossary

Adobo—A method of curing meat.

Almárcigo—An outdoor, earth-covered room for storing food. Aso called a bodega or soterrano.

Amuleto—Amulet, or protective charm, used to ward off evil.

Arroz—Rice.

Arroz dulce—Rice pudding.

Asado—Roast.

Atole—A blue cornmeal gruel served as a drink with sugar, or as a hot cereal with milk and sugar. From the Aztec *atolli*.

Bilis—Excessive bile in the system, requiring a curandera's attention.

Bizcochitos—Anise-flavored rolled cookies.

Blue cornmeal—Cornmeal ground from dark blue corn.

Brujo or Bruja—Witch (male or female).

Buñuelo—Puff pastry that is fried and served with a glaze or with cinnamon and sugar.

Burrito—Beans or meat, or both, rolled into a tortilla and topped with melted cheese, chili and/or lettuce, tomato, and onion.

Cabrito—Young goat.

Caída de mollera—Fallen fontanelle or soft spot on a baby's head.

Calabaza—Squash or pumpkin.

Calabacitas—A casserole of squash, corn kernels, onions, green chile and seasonings.

Capriotada—Sweet bread pudding with cinnamon, raisins, nuts, and cheese. Called *sopa* in the north.

Capulín—Chokecherry, used to make wine, jam and jelly. Juice and bark used as a dye.

Carne—Meat.

Carne adovada—Pork marinated in red chile sauce.

Carne asada—Brazier-cooked meat.

Carne molida—Ground beef.

Carne seca—Dried meat, or jerky.

Chacales—Dried fresh corn kernels, also known in the north as chicos.

Chalupa—Fried corn tortilla filled with cheese, beans, and lettuce.

Chaquegüe—A cornmeal preparation similar to grits.

Chicle de trementina—Pine tree sap, chewed as a gum.

Chicos—Dried fresh corn kernels, also known as chacales.

Chile—In New Mexico, the hot- to mild-tasting long, green pepper that may be roasted, peeled, and served, or dried in the sun, then ground into a powder for storing or processing into other forms as listed below. Of the genus *capsicum*, which includes numerous varieties from the mild bell pepper to the very hot habanera pepper. Chile is not to be confused with "chili," a stew in which chile is only one of several ingredients.

Chile caribe—Red chiles ground and blended with water.

Chile colorado—Red chile.

Chile con queso—Chile with cheese, served as a dip with fried corn tortilla chips.

Chile molido—Powdered red chile.

Chile pequín—Very hot red chiles, small and thin.

Chile powder—A commercial blend of red chile and spices such as cumin or coriander.

Chile relleno—Green chile stuffed with cheese, dipped in egg batter and fried. The older style resembles fried croquettes of dried chile, carne seca, piñones, and raisins.

Chile verde—Green chile.

Chili—A thick stew of chile, meat, beans, onions, and seasonings.

Chimichanga—Fried burrito topped with salsa and/or sour cream.

Chicharrones—Cracklings of pork fat and meat.

Chorizo—Highly seasoned pork sausage.

Chuleta—Pork chop with red chile sauce.

Ciboleros—Buffalo hunters. In the nineteenth century, the Comanches showed the Spanish how to hunt buffalo on the eastern plains of New Mexico and further east.

Conejo—Rabbit, the most frequently hunted game in pre-Hispanic New Mexico.

Corn tortilla—Unleavened flat bread of yellow or blue cornmeal, cooked on a griddle.

Cristolina de Chihuahua—A Mexican strain of corn introduced by the Spanish into New Mexico that greatly increased yield.

Curandera(o)—Healer.

Decoction—A liquid made by boiling herbs or vegetable matter in water for a set length of time, and then straining out the solids before drinking.

Desasombro—A more serious type of susto.

Despensa—Store room or pantry.

Empacho—Intestinal or stomach blockage.

Empanadita—Fried turnover.

Enchiladas—Corn tortillas served flat or rolled and filled with a number of ingredients, including chile, cheese, onions, meat, and sauces.

Envidia—Envy.

Espanto—A severe type of spirit loss requiring a curandera's attention.

Espiritista—A medium or psychic.

Fajita—Literally means "skirt." The term describes the thin cut of meat used in a dish originating in northern Mexico.

Flan—Baked custard with caramel sauce.

Flauta—A tightly rolled, fried corn tortilla filled with meat and dipped in *guacamole* or sour cream.

Flour tortilla—Unleavened flat bread of white flour cooked on a griddle.

Frijoles—Beans.

Gorda—Thick tortilla popular among New Mexico sheepherders.

Gordita—Masa stuffed with seasoned meat and fried.

Guacamole—Avocado dip.

Guisado—Plainly cooked, then seasoned.

Harinilla—Meal ground from lime hominy.

Harina—Flour.

Horno—Outdoor oven made of adobe and shaped like a beehive. Introduced into the Southwest by the Spanish.

Hot and Cold—A healing principle that assigns non-temperature-related hot and cold properties to various foods and to physical conditions. "Hot" and "cold" foods were used to cure the opposite conditions in patients.

Huesero—Healer who specialized in setting broken bones.

Huevos rancheros—Ranch-style eggs served with corn tortillas and salsa.

Humors—Healers believed that disease resulted from the imbalance of the four humors of the body, including blood, phlegm, black bile, and yellow bile. This theory harks back to ancient China and Greece.

Jerky—A mispronunciation of a Peruvian word written by the Spanish as *charqui*, meaning sun-dried meat.

Latido—Stomach ache.

Leche—Milk.

Maíz—Original Indian name for corn.

Mal aire—Head cold.

Mal de ojo—Literally evil eye, a physical condition in need of treatment.

Mal puesto—A witch's hex.

Maleficio—Bad intent against others.

Mano—The hand-held stone used with a metate to grind corn, seeds or wheat.

Marquesotes—Sponge cakes.

Masa—Dough, usually of cornmeal or flour.

Matanza—A slaughter, usually of a pig, followed by a feast.

Materia—A medium or psychic.

Metate—The bottom stone on which corn, seeds, or wheat are ground.

Menudo—Stew made from honeycomb tripe.

Mexican Dent—A Mexican strain of corn introduced into New Mexico by the Spanish that greatly increased yield.

Mollete—Anise-flavored bread.

Morcilla—Blood sausage.

Muina—Called "anger sickness," as it results from expressed rage.

Nachos—Fried corn tortilla chips topped with green chile and cheese, then heated; in more recent times, the term refers to chips and salsa or chile con queso dip.

Natilla—Pudding sprinkled with cinnamon and nutmeg.

Nixtamalization—The Aztec process by which corn kernels lose their outer hard membrane, making the resulting hominy easier to grind, and releasing more nutrients.

Panocha—A sweet cereal/pudding made from sprouted wheat flour.

Partera—A midwife and advisor on children's health.

Piñón—Pine nut.

Pastelitos—"Little pies" cut in squares and filled with cooked fruit.

Pollo—Chicken.

Posole—Stew of hominy, pork and seasonings and generally served at Christmas or other important occasions. Posole is also known as nixtamal. From the Aztec *posolli*.

Poultice—A soft, moist mass of cloth, bread, meal, or herbs applied to the body as a medication.

Quelites—A plant, *Chenopodium album*, also called Lambs' quarters. A dish consisting of the its leaves mixed with pinto beans, bacon, and red chile.

Queso—Cheese.

Queso de apoyo—A type of cheese made from leche de apoyo.

Remedio casero—Home remedies.

Requesón—A finely textured cottage-type cheese made from milk whey and often enriched with cream.

Ristra—A long bundle of chiles held together by one string.

Refrito—Refried. Usually describes beans that are cooked, mashed, and refried.

Rueditas—Little wheels, referring to cut pieces of squash.

Salada—The sprinkling of salt around a house to bring bad luck to its residents.

Salsa—Mixture of chile, tomatoes, onions, and spices; used on dishes and as a dip.

Salsa pequín—Very hot salsa made from the small chile of the same name.

Salsa rancherita—Very thick salsa.

Señora—A fortune teller whose principle tools were tarot or playing cards.

Sobador or Sobadora—One who gives healing massages.

Sopa—Sweet bread pudding with cinnamon, nuts, cheese, and raisins.

Sopaipilla—Deep fried bread made with yeast or baking powder.

Susto—Fright or loss of spirit or the soul.

Taco—Corn tortilla folded in half, fried to hold its shape, and filled with meat and/or beans, cheese, lettuce, tomatoes, onions, and salsa.

Tamal—Masa filled with meat and red chile and cooked by steaming while wrapped in a cornhusk. Plural is tamales.

Tasajo—A term for carne seca, or jerky.

Tequesquite—A sodium nitrate commonly used in colonial times as a type of baking powder.

Torta—A stiffly beaten egg, fried and served with red chile.

Tortilla—Flat round bread.

Torreja—Fritter.

Tostada—Open-faced taco.

Tostados—Fried corn tortilla chips.

Yerbero—A specialist in healing herbs.

Bibliography

Anaya, Rudolfo. *Bless Me, Ultima.* New York: Warner Books, 1994.

Arnold, Samuel P. *Eating Up the Santa Fe Trail.* Niwot, Colo.: University Press of Colorado, 1990.

Baxter, John O. *Las Carneradas: Sheep Trade in New Mexico 1700–1860.* Albuquerque: University of New Mexico Press, 1987.

Brown, Lorin W., Charles L. Briggs, and Marta Weigle. *Hispano Folklife of New Mexico.* Albuquerque: University of New Mexico Press, 1978.

Buss, Fran Leeper. *La Partera: Story of a Midwife.* Ann Arbor: University of Michigan Press, 1980. 79.

Cameron, Sheila MacNiven and the staff of New Mexico Magazine. *New Mexico Magazine's More of the Best from New Mexico Kitchens.* Santa Fe: New Mexico Magazine, 1982.

Campa, Arthur L. *Hispanic Culture in the Southwest.* Norman: University of Oklahoma Press, 1979.

Candelaria, Cordelia. *Ojo de la Cueva: Cave Springs.* Colorado Springs: Maize Press, 1984.

Chávez, Tibo J. *New Mexican Folklore of the Río Abajo.* Santa Fe: William Gannon, 1987.

Coe, Sophie D. *America's First Cuisines.* Austin: University of Texas Press, 1994.

Crosby, Alfred. *The Columbian Exchange: Biological and Cultural Consequences of 1492.* Westport, Conn.: Greenwood Press, 1972.

Curtin, L. S. M. *Healing Herbs of the Upper Río Grande.* Los Angeles: Southwest Museum, 1965.

De Borhegyi, Stephen F. *El Santuario de Chimayó.* Santa Fe: Spanish Colonial Arts Society, 1956.

Dent, Huntley. *The Feast of Santa Fe.* New York: Simon and Schuster, 1985.

Díaz del Castillo, Bernal. *Historia verdadera de la conquista de la Nueva España.* Madrid: Instituto Gonzalo Fernández de Oviedo, 1982.

Doane, Nancy Locke, comp. *Indian Doctor Book.* Charlotte, N.C.: Nancy Locke Doane, 1983. Distributed by Aerial Photography Services.

Dunmire, William W., and Gail D. Tierney. *Wild Plants of the Pueblo Provinces: Exploring Ancient and Enduring Uses.* Santa Fe: Museum of New Mexico Press, 1995.

Echevarría, Evelio A., and José Otero, eds. *Hispanic Colorado: Four Centuries History and Heritage.* Fort Collins, Colo.: Centennial Publications, 1976.

Fergusson, Erna. *Mexican Cookbook.* Albuquerque: University of New Mexico Press, 1934.

Frazer, Robert W. "The Army and New Mexico Agriculture, 1848–1861." *El Palacio* 89, no. 1 (Spring 1983). Special Issue on New Mexico's Agricultural History.

Gilbert, Fabiola Cabeza de Baca. *The Good Life: New Mexico Traditions and Food.* Santa Fe: Museum of New Mexico Press, 1982.

———. *Historic Cookery.* Las Vegas, N.Mex.: La Galeria de los Artesanos, 1970.

———. *We Fed Them Cactus.* Albuquerque: University of New Mexico Press, 1954.

Gonzales, Pedro Alvarez, M.D. *Yerbas Medicinales: Como Curarse con Plantas.* Mexico, D. F.: El Libro Español, 1975.

Greer, Anne Lindsay. *Cuisine of the American Southwest.* 2d ed. Houston, Tex.: Gulf Publishing, 1983.

Hammond, George P., and Agapito Rey. *Don Juan de Oñate: Colonizer of New Mexico, 1595–1628.* 2 vols. Albuquerque: University of New Mexico Press, 1953.

Holden, William Curry. *Teresita.* Owings Mills, Md.: Stemmer House, 1978.

Horgan, Paul. *The Heroic Triad: Essays in the Social Energies of Three Southwestern Cultures.* New York: World Publishing, 1954.

Hudson, Wilson M., ed. *The Healer of Los Olmos and Other Mexican Lore.* Dallas: Southern Methodist University Press, 1975.

Jaramillo, Cleofas M. *The Genuine New Mexico Tasty Recipes.* 1942. Santa Fe: Ancient City Press, 1981.

Jensen, Joan M., and Darlis A. Miller. *New Mexico Women: Intercultural Perspectives.* Albuquerque: University of New Mexico Press, 1986.

Jensen, Joan M. "Canning Comes to New Mexico: Women and the Agricultural Extension Service, 1914–1919." In *New Mexico Women: Intercultural Perspectives*, edited by Joan Jensen and Darlis Miller. Albuquerque: University of New Mexico Press, 1986.

Kavasch, E. Barrie. *Enduring Harvests: Native American Foods and Festivals for Every Season.* Old Saybrook, Conn.: Globe Pequot Press, 1995.

Keegan, Marcia. *Southwest Indian Cookbook.* Santa Fe: Clear Light Publishers, 1987.

Kiev, Ari. *Curanderismo: Mexican-American Folk Psychiatry.* New York: The Free Press, 1968.

Kimball, Yeffee, and Jean Anderson. *The Art of American Indian Cooking.* New York: Simon & Schuster, 1965.

Latorre, Dolores L. *Cooking and Curing with Mexican Herbs.* Austin, Tex.: Encino Press, 1977.

Miller, Mark, Mark Kiffin, Suzy Dayton, and John Harrisson. *Mark Miller's Indian Market Cookbook.* Berkeley, Calif.: Ten Speed Press, 1995.

Moore, Michael. *Los Remedios: Traditional Herbal Remedies of the Southwest.* Santa Fe: Red Crane Books, 1990.

——, comp. *Los Remedios de la Gente: A Compilation of Traditional New Mexico Herbal Medicines and Their Uses.* Santa Fe: Michael Moore, 1977.

Muller, Frederick R. *La Comida: The Foods, Cooking, and Traditions of the Upper Río Grande.* Boulder, Colo.: Pruett, 1995.

Naranjo, Hector A. Alvarez. *Diccionario de herbolaria.* Mexico, D. F.: Editorial Posada, 1986.

Ortiz y Pino III, José. *The Herbs of Galisteo and their Powers.* Galisteo, N.Mex.: Galisteo Historical Museum, 1972.

Perrone, Bobette H., Henrietta Stockel, and Victoria Krueger. *Medicine Women, Curanderas, and Women Doctors.* Norman: University of Oklahoma Press, 1989.

Peyton, James W. *El Norte: The Cuisine of Northern Mexico.* Santa Fe: Red Crane Books, 1990.

——. *La Cocina de la Frontera: Mexican-American Cooking from the Southwest.* Santa Fe: Red Crane Books, 1994.

Rivera, Lydia. "Recipes for Holy Week." *La Herencia del Norte* 10, (Spring 1994).

Romano, Octavio Ignacio. "Charismatic Medicine, Folk Healing, and Sainthood." *American Anthropologist* 67 (1965): 1151–73.

——. "Don Pedrito Jaramillo: The Emergence of a Mexican-American Folk-Saint." Ph.D. diss., University of California, 1964.

Rozin, Elisabeth. *Blue Corn and Chocolate.* New York: Alfred A. Knopf, 1992.

Sahagún, Bernardino de. *Historia general de las cosas de Nueva España.* Mexico City, D. F.: Porrúa, 1982. Also, *General History of the Things of New Spain: Florentine Codex.* Santa Fe: School of American Research, 1950–82.

Sánchez, Charles, Jr. *Yerbas y Remedios: A Booklet of Herbs and Spices of the Southwest.* Albuquerque: Rio Grande Herb Co., 1993.

Sánchez, Irene Barraza, and Gloria Sánchez Yund. *Comida Sabrosa: Home-Style Southwestern Cooking.* Albuquerque: University of New Mexico Press, 1982.

Sauvageau, Juan. *Stories That Must Not Die.* Kingsville, Tex.: Oasis Press, 1976.

Schwartz, John. "The Great Food Migration." *Newsweek* 118 (Fall/Winter 1991): 58–62. Special Quincentennial edition.

Simmons, Marc. *Witchcraft in the Southwest: Spanish and Indian Supernaturalism on the Río Grande.* Flagstaff, Ariz.: Northland Press, 1974.

——. "New Mexico's Colonial Agriculture." *El Palacio* 89, no. 1 (Spring 1983). Special Issue on New Mexico's Agricultural History.

——. *The Last Conquistador: Juan de Oñate and the Settling of the Far Southwest.* Norman: University of Oklahoma Press, 1991.

Sokolov, Raymond. *Fading Feast: A Compendium of Disappearing American Regional Foods.* New York: Farrar, Straus, Giroux, 1981.

——. *Why We Eat What We Eat: How the Encounter Between the New World and the Old Changed the Way Everyone on the Planet Eats.* New York: Summit Books, 1991.

Super, John C. *Food, Conquest, and Colonization in Sixteenth-Century Spanish America.* Albuquerque: University of New Mexico Press, 1988.

Tannahill, Reay. *Food in History.* 1973. Revised, New York: Crown Publishers, 1989.

Thomas, Anita Gonzales. "Christmas in Old New Mexico." *La Gaceta* 10, no. 1 (1986): 1–9.

Tierney, Gail. "How Domesticated Plants Came to the Prehistoric Southwest" in *El Palacio*, Vol. 89, no. 1 (Spring 1983). Special Issue on New Mexico's Agricultural History.

Torres, Eliseo. *The Folk Healer: The Mexican-American Tradition of Curanderismo*. Kingfield, TX: Nieves Press, 1983a.

——. *Green Medicine: Traditional Mexican-American Herbal Remedies*. Kingfield, TX: Nieves Press, 1983b.

Trotter II, Robert T., and Juan Antonio Chavira. *Curanderismo: Mexican American Folk Healing*. Athens, Ga.: University of Georgia Press, 1981.

Underhill, Ruth. *Life in the Pueblos*. Santa Fe: Ancient City Press, 1991.

Viola, Herman J., and Carolyn Margolis, eds. *Seeds of Change*. Washington, D.C.: Smithsonian Institution Press, 1991.

Wetterstrom, Wilma. *Food, Diet, and Population at Prehistoric Arroyo Hondo Pueblo, New Mexico*. Santa Fe: School of American Research Press, 1986.

Wills, H. W. *Early Prehistoric Agriculture in the American Southwest*. Santa Fe: School of American Research, 1988.

8

El Arte de la Palabra: Language Arts

Nuevo México insolente
Entre los cíbolos criado;
¿Dime, quién te ha hecho letrado
Para hablar entre la gente?

Insolent New Mexico
Bred among the buffalo
Tell me, who made you learned
To speak among people?
(Gracia, from Campa, 1946)

IN COLONIAL TIMES the settlers of New Mexico referred to themselves as *Españoles Mexicanos*. Today, they still refer to their language with both terms, *español* and *mexicano*. The extent to which the Spanish language enchanted its speakers is evidenced by the numerous poems and poetic forms that continued to be recited well into the twentieth century in the remotest corners of the region. As in most cultures, storytellers were the center of attention at many hearths and gathering places across the land. Yet it was poetry that seemed to accompany every stage of a Nuevomexicano's life, from birth to marriage to death. The entriegas sung or recited at these milestones were another opportunity to express the wonder and humor and grief of life.

Scholar Francisco Lomelí states that in the Hispanic concept of literature there is no dichotomy between oral and written modes of expression. There is, then, a vast body of Hispanic literature in the form of folklore that does not reach the reader in published form. As a result, non-Hispanic compilers of western literature assume there is no traditional Southwestern Hispanic "literature" because there is no list of published colonial authors and the list of self-published territorial authors has been ignored. Late twentieth-century scholars have suggested that this lack of a tradition of publishing did not signify the lack of a literary tradition. The distance between New Mexico and the nearest bookstore in Mexico

City did not keep its people from singing or reciting romances transmitted orally from generation to generation so accurately that scholars declare them some of the best preserved in all of Spanish America. Nor did it prevent the development of a colonial literature comprised of explorers' chronicles and government and religious officials' diaries and letters.

The first known printing press in New Mexico was brought over the Santa Fe Trail to Taos by Padre Antonio José Martínez in the first half of the nineteenth century. It was used to print newspapers and school texts in Spanish. Then it was appropriated by the conquering Anglo-Americans in 1847 to print the Kearny Code in English. With the arrival of more presses, Nuevomexicanos of the second half of the nineteenth century entered a golden age of journalism unlike anything before or since. It began a period of creativity that supported the emergence of men and women writers into the twentieth century.

University of New Mexico Spanish professor and folklorist Enrique Lamadrid says that not only is language inextricably embedded in culture, it is also one of the primary components of identity. Professor Lamadrid notes that while many English-only opponents equate language loss with culture loss, culture in fact looms larger than either language or religion. Nuevomexicanos are bilingual in

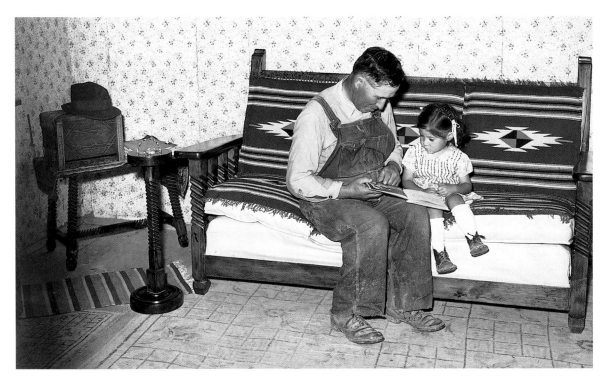

8.1
A father and daughter reading together in Chamisal, New Mexico, ca. 1940. Courtesy Library of Congress, LC-USF34-37180-D.

varying degrees, but they all live between languages and cultures, negotiating their identity every step of the way.

One effective method of preserving both the culture and the language has been the theater, which is represented in New Mexico in a variety of expressions in both sacred and secular content. While not fully in the mainstream of national or even regional theater activity, New Mexico is unique in the nation in its adherence to and expression of tradition in its theater works.

The Literary Legacy of Spain and Spanish America

The oral and written literary traditions of New Mexico reach back to the medieval romances of Spain, composed before Spain was a nation. Those Castilian poems were still being sung from memory in twentieth-century New Mexico.

The Romance

Standing at the root of both the oral and written traditions of Spain and its colonies is the romance, a narrative poem characterized by concise, lively, and dramatic dialogue and written in long sixteen-syllable assonanced verses. Linguist Aurelio M. Espinosa, who collected many romances in New Mexico in the early twentieth century, determined that the surviving romancero throughout Spain and Spanish America includes some one thousand works that evolved through two hundred years or more of collective oral elaboration and written compilation.

Overall, there are nine types of Spanish romances.

- Historical romances, which tell of the reconquest of Spain by Castilian heroes, and of their subsequent political and religious ascendancy
- Frontier romances, relating the history and legends of the conquest of Granada, the last holdout of the Moors in southern Spain

- Carolingian romances, which tell of Charlemagne and the twelve peers of France
- Novelesque or chivalric romances, steeped in the folklore of Europe
- Religious romances of the sixteenth and seventeenth centuries, retelling in verse the stories of the Bible and the Passion of Christ
- Erudite romances, in which traditional sixteenth-century themes of love and honor are rendered more personal and learned
- Artistic romances, composed by known poets
- Burlesque romances, in which insignificant persons, or even animals or insects, are heroes
- Contemporary local romances, also known as corridos or ballads, on heroes of revolutions, labor, or politics of the late nineteenth and twentieth centuries

Espinosa found historical, Carolingian, novelesque, and burlesque romances in New Mexico.

The first four categories listed here make up the best of the romancero, according to Espinosa. Historical romances are the oldest, most admired, and most imitated. They originated from the epic poems of the eleventh, twelfth, and thirteenth centuries, when Spain began to achieve some success in its centuries-long struggle against the occupying Moors. For this reason, these romances reveal the ardent national and religious spirit of the Castellanos, who emerged as leaders in the struggle. They also told the deeds of kings, heroes, and leaders in what Espinosa described as the first centuries of a national consciousness. Historical romances were created for, and enjoyed by, Spain's ruling class.

The oldest example of the historical romance—and most important for understanding the Spanish spirit—derives from the *Cantar de mío Cid* (Poem of my Cid). *Cid* means leader or hero and refers to a legendary hero of the eleventh century by the name of Rodrigo Díaz. Díaz was also known as *El Cid Campeador*, meaning "the hero, champion in battle." El Cid was a commoner from Burgos and a crusader, whose personal magnetism and exceptional qualities as a leader and warrior rallied the knights and vassals of the provinces of Castilla and León to capture the Moorish-occupied seaside city of Valencia in southwestern Spain in the last decades of the eleventh century. Zaragoza, Córdova, and Sevilla were also captured, and came under the command of El Cid and the Castellanos. As a Christian hero who dared to oppose an occupying force that had maintained a grip on the Spanish peoples since the eighth century, El Cid has come to define and represent the spirit of Spain and its birth as a civilization. In like terms, the *Cantar de mío Cid* is comparable to the French *Chanson de Roland* and Great Britain's Arthurian legends in that they, too, defined their respective cultures as they were first forming.

The crowning significance of the *Cantar de mío Cid* is that it is the first written literature in the Castellano language. The Castellano dialect emerged from among all other dialects of Old Spain as the unifying language of the land largely because it was the warriors of

Castilla that led the resistance, and then organized a monarchy to unite
and rule the land.

Note the archaic Castellano in this excerpt from *Cantar de mío Cid:*

. . . Quando lo sopo mío Çid el de Bivar
quel creçe compaña por que mas valdra,
a priessa cavalga, reçebir los sal(i)e,
tornos a sonrisar, legan le todos, lamanol ban besar.
Fabló mío Çid de toda voluntad
'Yo ruego a Dios e al Padre spirital,
vos, que por mi dexades casas y heredades,
Enantes que yo muera algun bien vos pueda far,
lo que perdedes doblado vos lo cobrar.'
Plogo a mío Çid por que creçió en la yantar,
plogo a los otros omnes todos quantos con el están.
Los vi dias de plazo passados los an,
tres an por troçir sepades que non mas.
Mandó el rey a mio Çid (a) aguardar,
que si después del plazo en su tierral pudies tomar
por oro nin por plata non podrié escapar.
El día es exido, la noch querie entrar,
a sus cavalleros mandolos todos juntar
'¡Oid, varones. non vos caya en pesar!
Poco aver trayo, dar vos quiero vuestra part.
Sed membrados commo lo devedes far;
a la mañana quando los gallos cantaran
non vos tardedes, mandeles ensellar;
en San Pero a matines tandra el buen abbat,
la missa nos dirá, esta será de Santa Trinidad;
la missa dicha, penssemos de cavalgar,
ca el plazo viene açerca, mucho avemos de andar.'
Cuemo lo mando mío Çid assi lo an todos ha far.

When My Cid, the man from Vivar,
knew that his company was growing and with it his prestige,
he rode out quickly to greet them;
he smiled again, and they all came to him and kissed his hand.
With deep feeling, my Cid spoke
"I pray to God, our Heavenly Father,
that you, who on my behalf leave houses and estates,
may receive reward from me before I die,
and may win back twice what you lose."
My Cid was pleased that he had more men to feed,
and all those in his company were equally glad.
Of the time he had been given, six days had passed
and but three remained, no more, I tell you.
The King ordered that My Cid should be watched,

so that if, when the time had expired, he should catch him in his lands,
neither gold nor silver would save him.
The day was closing in and darkness was descending;
he ordered all of his knights to come together
"Listen, my men, do not be downcast!
I have little money with me, but I want to share it with you.
Be prudent as you must;
in the morning, at cock crow,
have your horses saddled without delay;
at San Pedro the good abbott will ring the bell for matins
and will say the Mass of the Holy Trinity for us.
When mass is over, let us set off,
for our time is running out and we have far to go."
　They all did as My Cid commanded.

(Such, Hodgkinson, and Smith 1987)

　Scholars still debate the development of this epic poem. One school of thought asserts that it was written in its entirety in 1207 by Per Abad, a lawyer or scribe of Burgos. Another, older school argues that the poem developed orally in the tenth and eleventh centuries and was not written down until the thirteenth century, rendering its author(s) anonymous. The poem is so long that most singers and poets could only recite portions of it, according to Professor Lamadrid. These episodic fragments became romance ballads with time.

　However, once the romance genre was established toward the end of the fourteenth century, other types of romances also were developed. The theory is that an individual created a romance in writing; it then passed into the public domain where it was made popular, elaborated, or changed over a period of time. Then by the sixteenth century, they were gathered into several written collections. In this way, the romance became a traditional if anonymous work, representing *both* the written and oral traditions of Spain. This interconnecting of oral and written traditions continued in Spanish America.

　The old romances inspired the dramatic literature of Lope de Vega (1562–1635), Guillén de Castro, and others. They have also given rise to important literary genres and a national theater tradition. In 1823, John Gibson Lockhart published *Ancient Spanish Ballads*, the first published English translation of romances, including stories of El Cid and some of the Carolingian and novelesque romances.

　The frontier ballads flourished in the fourteenth and fifteenth centuries and center on the conquest of Granada in southern Spain. The subject matter of these ballads includes the lamentations of the defeated Moors; the heroic deeds of the young bishop of Jaén, Don Gonzalo, who fights off the Moors in battle single-handedly and is then captured and taken to the dungeons of the Alhambra; the courageous deeds of the Moorish knight Tarfe, who makes his way to the camp of the Catholic kings and insults them by riding around with a portrait of the Virgin Mary

tied to the tail of his horse; and the rescue of the portrait by an equally daring Castellano knight, Garcilaso de la Vega.

The Carolingian romances are French in origin and emphasize sentimentality, love, fantasy, and the supernatural. An example is the story of the Marquis of Mantua who finds his slain nephew Baldwin in a forest and takes a solemn oath never to shave his beard, eat at a table with a tablecloth, or sleep on a bed until he avenges Baldwin's death. Another relates the story of the ardent Melisenda, imprisoned by the Moor Almanzor. Through a window of her prison she speaks amorously to another royal captive who, it is revealed, is her husband, Gaiferos. The most widely known Carolingian romance is the story of the Infanta, the daughter of Charlemagne, who makes passionate love to Gerineldo, the king's page. The best-preserved version of this romance, in either Spain or Latin America, was collected in New Mexico.

The novelesque romances embrace the classical and medieval folklore of Europe, and some are almost as old as the historical romances. Subject matter includes love, honor, chivalry, courage, vengeance, and ideal justice. *Gerineldo* is also considered a novelesque romance. Others include the stories of the Germanic hero Tristan, the French hero Lancelot, and even Virgil. Themes center on persecuted wives and daughters, the female warrior who goes to war in the king's service, the returning warrior whose wife does not recognize him, faithless wives, and prisoners' lamentations. This latter theme may have influenced the development in New Mexico of inditas, or cautivas, which are lamentations of individuals captured by Indians.

In the early twentieth century, Aurelio Espinosa began collecting romances in northern New Mexico and southern Colorado, recited or sung to him by Nuevomexicanos. He found novelesque, Carolingian, burlesque, and religious romances, and fragments of the *Cantar de mío Cid*. In 1915, he published twenty-seven versions of ten different traditional Spanish romances dating from the sixteenth and seventeenth centuries. They had changed little since the sixteenth century, according to Espinosa, who relied on old assonance patterns and the octosyllabic verse to detect any changes or missing lines. In subsequent decades, he collected over one hundred versions of twenty-seven romances in New Mexico and southern Colorado. He found a fragment of the *Cantar de mío Cid* in Santa Fe (first line only)—the only other known fragment to surface in the modern New World having been found in Chile.

Espinosa also collected two old expressions that referenced El Cid: "¡Este (Esta) sí es el (la) Cid Campeador!" meaning "this boy (girl) is certainly unruly (or brave)." The other is the phrase, "No se ganó Zamora en una hora" meaning "Zamora wasn't won in an hour," which Espinosa found throughout New Mexico, referring to the siege of Zamora by the Cid and Sancho II in 1072.

All other romances found by Espinosa in New Mexico and southern Colorado are of the novelesque and Carolingian variety. The novelesque romances dominate in New Mexico, and deal with war and legends origi-

nating in Arabic culture. An example found in New Mexico is *Delgadina*, which is discussed in the music chapter. According to Espinosa, there are numerous peninsular versions of *Delgadina* collected in New Mexico. The New Mexican version of the Carolingian romance, *Gerinaldo*, has been determined by scholars to be the most archaic and the best preserved version available anywhere.

—Gerineldo, Gerineldo,—mi camarero aguerrido,
¡quién te pescara esta noche—tres horas en mi servicio!
—¿Tres horas, dice, señora?—¡Ojalá que fueran cinco!
Si porque soy vuestro criado—quiere usted burlar conmigo.
—No quiero burlar de ti;—*de deveras* te lo digo.
—¿Para qué horas de la noche—iré yo a lo prometido?
—Entre las ocho y las nueve—cuando el rey esté dormido.
A las ocho de la noche—Gerineldo va al castillo;
halla la puerta entreabierta,—da un fervoroso suspiro.
—¿Ese atrevido, quién es,—que ha venido a mi castillo?
—Señora, soy Gerineldo—que vengo a lo prometido.
Ya lo agarra de la mano—y se van para el castillo;
ya se acuesta Gerineldo—con calenturas y fríos;
se acuestan boca con boca—como mujer y marido.
Cosa de la media noche—el rey pidió sus vestidos;
se los lleva un criado dél;—de Gerineldo es amigo.
—¿Dónde está mi Gerineldo,—mi camarero aguerrido?
—Señor, se metió en la cama—con calenturas y fríos.

"Gerineldo, Gerineldo, my valiant chamberlain,
would that I could have your services for three full hours tonight!"
"Three hours you say, my lady? I wish that they might be five!"
"But because I am your servant you are making sport of me."
"I'm not making sport of you; I mean all that I have said."
"At what time, then, of the night can I come to visit you?"
"Come by between eight and nine, when the king is fast asleep."
To the castle Gerineldo went as soon as it was eight;
the door he found slightly open and he gave a fervent sigh.
"Who can be that daring person who thus comes into my castle?"
"I'm Gerineldo, my lady; pray remember what you promised."
Now she takes him by the hand and leads him into the castle.
When Gerineldo retires, he feels now cold, now with fever.
They go to sleep mouth to mouth truly as husband and wife.
When it was about midnight, the king called for his day clothes;
one of his servants helped him; he was Gerineldo's friend.
"Now, where is my Gerineldo, my valiant chamberlain?"
"He has retired, Your Majesty; he feels now cold, now with fever."
(Espinosa and Espinosa 1985)

Espinosa also found many religious romances in New Mexico and

southern Colorado. Known as alabados, they are eloquent poems sung as hymns describing the Passion of Christ from an eyewitness point of view, generally of the Virgin Mary, whose following of the way of the cross is a favorite theme in Spanish tradition. One such example, entitled *Por el rastro de la sangre* (in Spanish, titles are not capitalized after the initial word), narrates the story of the Virgin following the traces of the blood shed by Jesus as he carries the cross. Another entitled *Un angel triste lloraba* tells of the Virgin Mary coming upon an angel weeping for a soul that had been given over to its care and has been condemned to hell. The Virgin intercedes, of course, because the soul had prayed the rosary in her honor. A number of these romances have been used as prayers.

Espinosa also found burlesque romances in New Mexico, such as *Señor Don Gato*, which tells of Sr. Cat who, while seated on a chair, hears that a bride has been found for him. He gets so excited he falls off the chair and is fatally hurt. The mice celebrate by dressing in red and black, in the style of the French and Spanish soldier. In *El piojo y la liendre*, the animals prepare for the wedding of two lice. Then a cat appears and eats the best man—a mouse. In *Ora que estamos solitos*, a crow flies with a wagon on its back, a frog takes a walk all dressed up, and a cricket drinks in a bar, among other scenes.

The Language

The language of northern New Mexico is Castellano, the language of Cervantes. New Mexico Spanish is unique in the persistence of sixteenth- and seventeenth-century Castellano found in late-twentieth-century speech. After the conquest, it also acquired many terms from the Náhuatl and a few from Pueblo languages.

As previously mentioned, Castellano itself paralleled the political emergence of the provinces of Castilla and León in the Middle Ages. Prior to the tenth century, the important dialects of medieval Spain were Leonés, Castellano, Gallego-Portugués, Navarro-Aragonés, the Catalán dialects, and Mozárabe, which was spoken in central and southern Spain in the areas occupied by the Moors. In the tenth century, Leonés became widespread as the kings of León dominated the struggles against the Moors. During this time, Castilla was a small area ruled by counts, and subject to León. Then Fernando I, the first of the Castellano rulers to be called king, inherited the kingdom of León in 1037, thus beginning the ascendancy of Castilla. As Castilla grew to include most of Spain, Castellano absorbed elements of other dialects.

The language was called *español* by 1492, the stellar year in which Granada was captured from the Moors and Columbus arrived in the New World. In the New World, Spanish took on elements of some Indian languages, including words of the Aztecs for which Spanish had no equivalents (such as examples given in chapter 7 on foodways). Also in 1492, the great humanist Nebrija published the first Spanish grammar book. It was the first grammar book to be published anywhere in Europe. The fifteenth century also was a time of great Spanish poets such as the Marqués de Santillana, Juan de Mena, and Jorge Manrique. Historians such as Pérez de Guzmán, Hernando del Pulgar, and Enríquez del Castillo flourished, as well as dramatist Juan del Encinia and novelist Diego de San Pedro, all of whom used Castellano as the language of their works.

The language reached its fullest development in the late sixteenth and early seventeenth centuries, where it was the vehicle for a great body of literature, written during what has come to be called Spain's Golden Age of Culture. Great names of the Golden Age include lyric poets Fray Luis de León, San Juan de la Cruz, and Góngora. Dramatists include Lope de Vega, Tirso de Molina, and Calderón de la Barca. The Golden Age encompasses historian Juan de Mariana, philosopher Baltazar Gracián, humanist Juan de Valdés, and playwright Miguel de Cervantes, author of *Don Quijote*. Historians of the New World included Gonzalo Fernández de Oviedo and Bartolomé de las Casas, who fought with his pen against abuses of Indians.

The Franciscan missionaries of the New World set about learning the languages, customs, and psychology of the natives. They preached in the native languages and prepared grammars, diction-

aries, and catechisms in the native tongues in order to bring Christianity to as many Indians as possible. In the process, elements of Spanish and native languages were inevitably adopted by each culture throughout the Americas. In the meantime, the development of Spanish in the New World was very slow and surprisingly uniform throughout, according to Espinosa, with grammar, syntax, idioms, and much vocabulary essentially identical within Spanish America, and relative to peninsular Spanish.

Friars and church officials, educated *criollos*, and government administrators were familiar with folk Spanish but spoke and wrote a more formal, standardized Spanish as part of their work and duties. This official language changed little because it was formalized by its users, and is, in fact, still used today in Latin America. The users of the informal folk Spanish were unaware of changes in the formal language, because it was not their vehicle. Theirs was what Campa called "the language of the hearth," spoken at home and among friends. Literacy was not necessarily widespread among speakers of folk Spanish. Over time, according to Campa, folk Spanish and formal Spanish developed in different directions. While formal Spanish maintained a codified pronunciation supported by a written tradition, folk Spanish evolved in its own direction—a direction with which literary expression later caught up. Being far removed from the ongoing development of Spanish in cultural centers like Mexico City, Nuevomexicanos continued to use late-sixteenth- and early-seventeenth-century forms, intonations, and words that eventually became obsolete everywhere else.

Espinosa's exhaustive research in the early twentieth century showed that the Spanish spoken by the people of northern New Mexico and southern Colorado not only developed from the language of Spain's Golden Age during the sixteenth and seventeenth centuries, but kept some of its characteristics. He found the sources of New Mexican Spanish in the dialects of Castilla, Andalucía, and Extremadura, and to a lesser extent in the dialects of Asturias, Santander, León, Galicia, and Hispano-Portugués dialects. After spending six months on a research grant in urban and rural Spain in 1920, Espinosa noted:

> If Cervantes were to return to the Spanish world and speak with natives from Castile, Andalucía, or New Mexico, he would observe practically the same words, idioms, grammar, and syntax today that he himself used in the sixteenth century, but his pronunciation would be different from that of all of the above regions. (Espinosa and Espinosa 1985)

Because of Espinosa's work, the Spanish dialect of New Mexico continues to be one of the most minutely studied regional variations of Spanish. At the time of his research, Espinosa estimated that the Spanish-speaking population of New Mexico was about one hundred and seventy-five thousand and about fifty thousand in southern Colorado. His fieldwork took place in an area populated by one hundred and fifty thousand Spanish-speaking persons of which he estimated eighty thousand did not speak English at all.

Espinosa found that in New Mexican Spanish, *z* or *c*, when appearing before *e* or *i*, is pronounced as *s* in *set*, as in the rest of Spanish America. Modern Castellanos pronounce the *z* or *c* as *th* in *think*. Another trait is the aspiration (breathing out) of *f*, *h*, *s*, and related *s* sounds as in *No je* (No sé), *jondo* (*hondo*) and *nojotro* (*nosotros*). Also, New Mexicans still pronounce *ella* (she) as *eya* or *ea*, whereas in modern Castilian, the double ll is sounded as a kind of "ly" combination. In New Mexico, *silleta* (chair) is shortened to *sieta*, and *gallina* becomes *gaína*. These types of pronunciations also are typical in northern Mexico, Nicaragua, some regions of Ecuador and Guatemala, and in Sephardic Spanish.

Also, in New Mexican Spanish, *d* can fall away in rapid speech, as in *nada* (nothing) becoming *naa*, then *na*, or *pedazo* (piece) becoming *peazo*. Another shortening takes place in the ending –ado, as in *comprado* (I buy), which becomes *comprao* or *comprau*. *Estados* (we are) becomes *estaos* or *estaus*. "¿De 'ónde viene su mercé?"

(from where does your grace come?) is an example quoted by Campa that shows the dropped *d* (from *donde* and *merced*) typical of old folk Spanish. This is an example of old Castellano that is still found in modern Spain, particularly rural Castilla. There are numerous such peculiarities in New World Spanish that are discussed in detail by Espinosa and Cobos.

Espinosa and Cobos have studied words still used today that date from sixteenth- and seventeenth-century Castellano, and that are no longer used in modern Castellano.

OLD CASTELLANO USED IN NEW MEXICO TODAY	MODERN SPANISH	ENGLISH TRANSLATION
agora	ahora	now
alverjón	guisante	pea
anque	aunque	although, even though
ansí, ansina	así	so, thus
arismética	aritmética	arithmetic
camalta	cama	bed
celebro	mente	mind
cuasi	casi	almost, nearly
dende	desde	since, from, after
emprestar	prestar	to lend
escrebir	escribir	to write
escuro	obscuro	obscure
Ingalatierra	Inglaterra	England
mesmo	mismo	same, own, very
mijor	mejor	better, best
muncho	mucho	much
tresquilar	trasquilar	to crop, to shear (sheep)
trujo	trajo	he brought
vide, vido	vi, vio	I/he saw

There are hundreds of words derived from Náhuatl that survived in New Mexico. Here is a sampling.

SPANISH	NÁHUATL	TRANSLATION
cacahuate	cacahuatl	peanut
coyote	coyotl	coyote
jacal	xacalli	hut with vertical pole construction
jícara	xicalli	gourd drinking vessel
nesha	nexectic	yellowish
shocoque	xococ	sour, spoiled
tecolote	tecolotl	owl
tinamaishte	tenamaxtli	trivet
tomate	tomatl	tomato
zacate	zacatl	grass, hay
zoquete	zoquitl	mud

These words were borrowed from the Pueblo Indians.

coi or coye	underground cellar
cunques	coffee grounds or crumbs
chaquegüe	a kind of mush
chiguata	woman
teguas	buffalo skin sandals
tosayes	sun-dried strips of pumpkin

(Espinosa and Espinosa 1985;
Cobos 1993)

In the nineteenth and twentieth centuries, Nuevomexicanos were exposed to English at schools, in business, industry, politics, radio, and television. In the process of becoming a bilingual culture, many English words were adopted and Hispanicized.

HISPANICIZED TERM	ENGLISH TRANSLATION
bequenpaura	baking powder
Crismes	Christmas
cuque	cookie
gaselín	gasoline
güincheste	Winchester
cloche	clutch
copa	cup
dipo	depot
jamache	how much
juisque	whiskey
granma (granpa or granpo)	grandma or grandpa
queque	cake
troca	truck or wagon
espichi	speech
telefón	telephone
saxofón	saxophone
chequiar	to check
sobrechuses	overshoes

Note: In Spanish, *i* is pronounced "ee" and *e* is pronounced "eh," thus *dipo* would be pronounced "deepoh" and *que* is always pronounced "keh," not "kay" or "kee."

Another response to English was a phenomenon scholars have dubbed "code switching," in which Spanish and English are used in the same sentence in accordance with very specific rules of syntax and grammar, rendering the process far from chaotic, as often assumed by observers. The following excerpt from Jim Sagel's humorous essay "¿Cómo se dice 'Big Mac' en Español? The Cultural Dynamics of 'Spanglish'" is an

example of both code switching, often called "Spanglish," and Hispanicized English words.

Don Ramón no hace enjoy en los restaurantes. He'd rather eat at home, even if it's only *frijoles viejos y tortillas duras.* But it's Father's Day, and all of the *familia* is taking him out for dinner at Red's Steakhouse. So don Ramón is dressing up and he's going because, as doña Clotilde says, *"Más que no love it, él va a ir."*

Pero, más que no love it, don Ramón y doña Clotilde arrive bien tarde at Red's porque el carro está liquiando aceite, and don Ramón has to add a quart of Ward's All-Season 10–40, but he gets his *calzones puercos* in the process and has to go back inside the *casa a cambiar.* Then, on the way to the restaurant *don Ramón y doña Clotilde encuentran un road-block en el highway, y tienen que hacer detour. Pronto pierden el way,* and before they know it the couple ends up stuck behind a long *caravana* of lowriders *tirando el cruise por el main drag. Al fin,* don Ramón is able to *meterse* into the left-hand turn lane, but he doesn't put his *brecas* in time *y—¡zaz!—se requea con una troca Ford.* By the time the *chotas* fill out their *reporte* and allow don Ramón and doña Clotilde to drive away in their battered car with the right fender *bien tuistiado,* Red's has already closed, and the members of the family have all gone back to the *chante.* So don Ramón and doña Clotilde pull into McDonald's *a comerse un Big Mac.*

Now you know the *triste historia* of don Ramón's and doña Clotilde's Father's Day adventures, but the question still remains *¿Cómo se dice 'Big Mac' en español?*

It is a question because certain individuals would cringe at the language used in the preceding *cuento,* pejoratively terming it "Spanglish." Such code-switching between English and Spanish, these linguistic purists warn, bastardizes both *lenguajes* and renders its users doubly illiterate.

But this narrow view ignores the fact that there are cultural and historical reasons for speaking "Spanglish," reasons reflected in the

old *dicho, "Pobre México, tan lejos de Dios y tan cerca de los Estados Unidos*—Poor Mexico, so far from God and so close to the United States." (Sagel 1992)

Some Spanish words adopted into English usage are bronco, burro, corral, pinto, pronto, rancho, arroyo, lariat, mesa, paisano, patio, poncho, peon, chile, and hacienda.

The Church continued to staff its missions in New Mexico with Mexican or Spanish priests whose use of the formal language influenced villagers and their children, whom they taught in their spare time. In the twentieth century, folk and formal Spanish merged as New Mexicans merged into one class. What is now heard in the Southwest is a traditional folk language with additions from English, literal translations, and additions from such diverse developments as *pachuco* and *jerga callejera,* or street slang.

Bishop Lamy's educational reforms served as a transition from Spanish to English for Nuevomexicanos. At the same time, Protestants were opening schools in the 1840s in New Mexico where both English and Spanish were taught. Protestant services were held in Spanish and Catholic services were held in Spanish and Latin, exposing the people to a more formal Spanish during services. Religious dramas presented during holidays also exposed them to more formal Spanish. The exposure to the classics and the Bible became evident in the names given to babies, a tradition continued well into the twentieth century. The following names were gathered from the 1997 Albuquerque telephone book: Adán, Andrólica, Apolinaria, August, Bonifacio, Celso, Cesar(io), Cipriano, Cordelia, Dante, Elijia, Epifania, Eulogia, Flaviano, Flavio, Héctor, Hilario, Higinio, Homer, Horace, Julián, Julius, Justo, Lázaro, Leandro, Librada, Marcial, Melcor, Melesendro, Narciso, Nestor, Odilia, Ologio, Onésimo, Orestes, Porfiria, Premetivo, Próspero, Román, Sabine, Saturnino, Senaida, Sendalio, Severo, Telesfor, Ubaldo, Urbano, Velia, and Vitalia. One theory regarding the prevalence of Greek and Latin given names by Nuevomexicanos is the influence of Padre

Martínez's Greek and Latin studies at his Taos school, and at the Jesuit College in Las Vegas.

As the villagers of northern New Mexico were introduced to English in the nineteenth and twentieth centuries, they responded by Hispanicizing unfamiliar words (to park became *parquear*, to brake became *brequear*). They also substituted words that in Spanish were used for comparable situations, such as *arrear* instead of *manejar* for "to drive a car." *Arrear* means to drive cattle and horses; *manejar* means to drive a car. Also, Spanish speakers found it easier to translate literally some English idiomatic expressions directly into Spanish, syntax and all, such as *traer pa'atrás* (to bring back) or *tener buen tiempo* (to have a good time).

The appropriation of the cattle industry by Anglo-Americans resulted in some language appropriation as well.

- Buckaroo is derived from *vaquero*, which means cowhand (vaca = cow).
- Lariat is derived from *la reata*, "the rope" used to keep animals in single file.
- Lasso is derived from *laso*, meaning tired or weary.
- Wrangler is derived from *caballerango*, meaning head horseman.
- In Spanish and English, *remuda* refers to a group of spare horses.
- Hackamore is derived from *jáquima*, meaning rope or headstall. In English it is the same looped bridle.
- Corral from corral and mustang from *mesteño* mean the same in English and Spanish.

Spanish fell from use in New Mexico when it stopped being the language of commerce, industry, and public administration and became only the language of the hearth. Yet, according to Campa, the mandatory translations into Spanish of legislative proceedings in New Mexico and Colorado promoted the deterioration of Spanish through the addition of English words. This pushing aside of traditional languages also was occurring with German in Pennsylvania, Italian in New York, and French in Louisiana.

Spoken Spanish was less affected in the remote areas where English was rarely spoken and where Anglo-Americans rarely ventured. In the borderland areas, the cultural traffic with Mexico has served to keep the language alive and current, including Mexicanisms. Fluency and bilingualism is high along the border too, according to Campa, with a minimum of Hispanicized English until recently. Universities in these areas have promoted cross-cultural flow through new programming. Mexican universities began their cross-cultural programming a half-century ago, offering summer courses for Anglo-American students. Today, universities along the border, and the larger ones in the interior of Mexico, have extended bicultural programs by adding bicultural Anglo-Americans to their faculties. American universities hold summer sessions in Mexico, such as at Puebla, Movelia, and Guadalajara, while the national University of Mexico has an extension in San Antonio.

El Paso and the Southwest gave rise to *pachuco*, a picturesque, urban subdialect derived imaginatively from a combination of old Spanish, Náhuatl, Spanglish, and new words created by its inventors—young urban dandies, punks, and delinquents. Examples of some original pachuco terms still in use are *chante* (house), *vatos y rucas* (guys and gals), *mota* (marijuana), *tivar chancla* (to dance), *ranfla* (cool car), *órale* (hey), *wacha* (watch out), and *ponte trucha* (get with it).

Many pachuco words were standard Spanish terms with arbitrary new meanings. Fathers were respectfully known as *jefe* (chief), and pinto beans were *maromeros*. Pachuco spread throughout the Southwest before it became associated with what Campa calls "questionable elements" and waned after World War II. It became satirized, as the speakers of pachuco were also called *pachucos*. The rebellious, iconoclastic figure of the Pachuco later became a kind of culture hero for Chicano writers, who admired his interculturality and his verbal skill, according to Lamadrid.

The recent movements to reinstate the Spanish language among North American Latino populations has given rise to differences over which Spanish language to reinstate, the folk or the for-

mal, the academic language of the Spanish Academy or the language of the hearth. Some Chicano activists promote "Chicano Spanish" as more relevant to their culture, while Campa calls Chicano Spanish a deteriorated dialect insufficient for communicating with the rest of the world. He writes,

> Another generation should see a reflection of the present interest in the language, provided what is taught and spoken is allowed to develop freely and responds to cultural conditions rather than to political and propagandistic considerations. (Campa 1979)

Written Tradition of New Mexico

The recording of life in New Mexico began with the astute, detailed observations of the men who first explored it in the early sixteenth century.

The Early Chroniclers

This group includes Alvar Núñez Cabeza de Vaca, although scholars continue to differ on whether or not his party traversed the southeastern portion of New Mexico. Also included are Fray Marcos de Niza, Pedro de Castañeda, Hernando Gallegos, Antonio de Espejo, and Fray Francisco de Escobar and Gaspar de Villagrá. Villagrá was the only one of these men to write his chronicle in poetry. They were all Spaniards and represented the Renaissance ideal of men of both letters and arms. Because they recorded their impressions in letters, epic poetry, reports, histories, and chronicles, we know today the details of their exploratory expeditions. Clark Colahan (1989) writes that "the form taken by these accounts is closer to literature than to social science. They bear the stamp of each writer's personality and life situation." Also, they were largely unaware of other chroniclers' works because of the lack of access to printing, and because of government secrecy.

Alvar Núñez Cabeza de Vaca

In 1542, Cabeza de Vaca published *La relación*, describing the land and people he encountered in his eight-year odyssey through the Southwest after being shipwrecked off the coast of Florida. He writes in a straightforward, simple manner, absent of all the flourishes found in European chivalric writing of the time. He reports actions and observations precisely yet completely. His writing reveals little or no ethnocentrism, but rather a fascination with the family of man. He was a great empathizer who began to identify himself with the Indians in a touching and primeval spirit of brotherhood and human kinship that would thwart North Americans for centuries. Yet his observations are even-handed. Colahan (1989) writes,

> We do not feel that he overlooks or excuses, or that he in fact looks out at the world from a completely foreign cultural perspective, but rather that he has simply looked longer, more clearly, and more thoughtfully than other chroniclers.

The following excerpts are thought by scholars to describe the part of New Mexico that he visited, and where the natives lived in permanent dwellings:

> Those who knew we were coming would not come out to the trails to welcome us as the others had done. Instead they remained in their houses and had others ready for us. They were all seated and had their faces turned toward the wall, their heads lowered and their hair in front of their eyes, with all their possessions piled in the middle of the room. From here on, they began to give us many animal skin blankets, and gave us everything they had. . . . These people had the best physiques of any we saw. They were the liveliest and most skillful, and the ones who understood and answered our questions best.
> They gave us beans and squash to eat. Since their way of cooking them is so novel, I want to tell about it here, so that people may see and know how diverse and strange human ingenuity and industriousness are. They have no pots; so to cook what they want to eat, they fill a large pumpkin halfway with water. They heat many stones in a fire, and when the stones are hot, they grab them with wooden

tongs and put them in the water inside the pumpkin, until the water boils with the heat of the stones. Then they place in the water whatever they want to cook. The whole time they remove stones and add other hot stones to bring the water to a boil and cook whatever they wish. This is their method of cooking. (Cabeza de Vaca 1993)

The members of his party (two white men and a black man) were perceived by the Indians as healers, no doubt helped by their varying skin colors, which to the Indians may have seemed miraculous or strange. On reaching a new tribe, which welcomed them into their homes, Cabeza de Vaca writes:

The very night we arrived, some Indians came to Castillo telling him that their heads hurt a great deal, and begging him to cure them. After he made the sign of the cross on them and commended them to God, they immediately said that all their pain was gone. They went to their lodges and brought many prickly pears and a piece of venison, which we did not recognize. Since news of this spread among them, many other sick people came to him that night to be healed.

La relación is one of the most widely read of the chroniclers' reports today. Cabeza de Vaca's story has, more than others, fascinated modern readers and given rise to retrospectives (Haniel Long), numerous translations, films, and even an artist's rendition of his experiences (De Grazia). Among the best contemporary translations to date is that by Favata and Fernández (Cabeza de Vaca 1993).

Fray Marcos de Niza

Prior to his involvement with New Mexico, this Franciscan friar served as a vice *comisario* in Peru and Guatemala where he gained a reputation for exaggeration (he was called "the lying monk") and for competency as a geographer. He was authorized to accompany Estebanico, one of Cabeza de Vaca's party, to further explore the regions they traversed, and to report his findings. Because his report consisted of fiction engineered to encourage development of the Southwest, he stands out as an example of the power of literature to change or influence history, according to Colahan. His glowing report of New Mexico as a land of plenty led to the authorization of the Coronado expedition of 1540.

Colahan doubts that Niza ever saw New Mexico. His advance guard reached only Zuñi Pueblo. Some of his elaborations include the seven cities of gold, when in fact Zuñi consisted of six pueblos of adobe. He told of the cities being established by seven bishops who had escaped from Spain (which later gave rise to the erroneous idea that these bishops served as inspiration for the Matachines dancers' bishop-like costumes). He reported stories of pagan temples with altars of gold and a town twice the size of Sevilla. Niza describes buffalo as having one horn curving down to the chest (he had obviously never seen one), and that three hundred Indians traveling with Estebanico were killed with him, a lie that prompted the viceroy to authorize subjugation of the Indians in the name of peace and Christianity.

Colahan compliments Niza's dramatic writing, noting the building to a climax as his most sophisticated technique. Each description of the seven cities is a little grander than the previous one, with progressively more food, clothing, buffalo hides, and turquoise decorating the doors. His description of how he learned of Estebanico's death is another suspense builder. First word of his death comes from an escaping Indian, and then from two eyewitnesses, with more details. One of the witnesses narrowly escapes detection by hiding in a pile of dead bodies. Niza's writing is heavily inspired by European legends and myths, and is as far removed from the truth as Cabeza de Vaca's was distilled through suffering into the truth.

Niza's work, entitled "Descubrimiento de las siete ciudadas de Cíbola" (Discovery of the Seven Cities of Gold), is available in English by Hallenbeck (1949) and in Hammond and Rey (1940).

Pedro de Castañeda

Castañeda was a common soldier who traveled with the Coronado expedition, and who wrote his

account twenty years later, at his home in northern Spain. Like Cabeza de Vaca, his writing style is simple rather than florid, as was the style of his times. His story is an even-handed account revealing a genuine curiosity about the new land and people he encounters. His attitude toward the native populations is highly positive and respectful; he paints neither Indian nor Spaniard as good or evil. Unlike Niza, he is a first-hand witness, describing the land, details of native culture, and features of society and rituals. He reveals a sense of amazement, as when writing of the grass, which was so tall and resilient that after their large retinue had passed, including horses, livestock, and soldiers, there was no evidence that they had ever been there. To avoid losing their way, the men erected piles of livestock bones as markers.

A careful writer, Castañeda recorded not only the heroics of the Spaniards, but also their violent and lustful activities. If he hadn't personally seen something claimed by someone else, he would say so—yet still pass on the information for the reader to judge on its own merits. Before recounting the heroics of a certain captain Juan Gallego, who returned in record time to Mexico City to secure reinforcements, Castañeda gives the following interesting preface praising Gallego and the men of the expedition.

I am not writing fables, like some of the things which we read about nowadays in the books of chivalry. . . . there are some things which our Spaniards have done in our own day in these parts, in their conquests and encounters with the Indians, which, for deeds worthy of admiration, surpass not only the books already mentioned, but also those which have been written about the twelve peers of France, because, if the deadly strength which the authors of those times attributed to their heroes and the brilliant and resplendent arms with which they adorned them, are fully considered and compared with the small stature of the men of our time and the few and poor weapons which they have in these parts, the remarkable things which our people have undertaken

and accomplished with such weapons are more to be wondered at today than those of which the ancients write. (Winship 1990)

He then describes Captain Gallego in hostile territory:

With six or seven Spaniards, and without any of the Indian allies whom he had with him, he forced his way into their villages, killing and destroying and setting them on fire, coming upon the enemy so suddenly and with such quickness and boldness that they did not have a chance to collect or even to do anything at all. (Winship 1990)

Scholars generally agree that Castañeda's account is the most valuable for his open-mindedness and his appreciation of the people and land. Colahan (1989) calls him a "thoughtful representative of his country's Renaissance ideal of arms and letters rather than the ruthless and driven conquistador that lives on in the stereotypes of Spain's Black Legend." Originally titled "Relación de la jornada de Cíbola," Castañeda's work is now available in English by Winship.

Hernando Gallegos

A clerk for the Rodríguez-Chamuscado expedition of 1581, Gallegos was a native of Sevilla, a miner and Indian fighter in Mexico prior to joining the expedition. Scholars consider him the first cultural reporter because he describes, for the first time, a wedding and the Hopi snake dance. He records, in several local dialects, lists of words for the items most encountered or needed by the party, such as corn, water, or turkey. Like others before him, he compared what he saw to what his reader might understand, as in comparing Pueblo women's shawls to those worn by Jewish women of the Old World.

He had read Cabeza de Vaca's account. Scholars believe his motivation for writing a report was royal reward, therefore as a soldier his report was written to favor the acts of the soldiers rather than those of the friars. In reporting on the natives, he admired their intelligence, cleanliness, and

craftsmanship but also referred to their rites as "evil practices." He reported on potential benefits to future colonists, such as Acoma as a strong fortress, the large number of mineral deposits in certain areas, and the ease with which tribute could be exacted from the Indians since they paid tribute to one another already. Gallegos's report is found in English in Hammond and Rey (1966).

Antonio de Espejo
Espejo was a wealthy Spaniard living in Mexico City when the opportunity came to lead an expedition in 1582 to aid the friars left in New Mexico by the Rodríguez-Chamuscado expedition. Because his interests focused on exploring the mining and ranching potential of the area, his written report to the viceroy centered on the area's resources and potential for settlement and development, with less emphasis on details of local culture and landscape. He viewed the land with an eye for its usefulness. He noted that the Indians were good workers, and he examined their homespun blankets, while comparing their irrigation methods with those in Mexico. He noted how hides could be used. He was intrigued when the Indians told him they were planting extra corn that year in anticipation of more Spanish visitors the following year. He compared plant species with those found in his native Spain. Espejo's report is found in English in Hammond and Rey (1966).

Fray Francisco de Escobar
Escobar wrote a diary, rather than an official report, of Oñate's exploratory work from the Río Grande to the mouth of the Colorado River in the late sixteenth century. The diary describes life in New Mexico but focuses primarily on Arizona and features the now famous Indian descriptions of fantastic human types supposedly living in Southern California (which Escobar recounts with a disclaimer of belief). Escobar was the comisario for the Franciscan friars in New Mexico. He was known as a man of much learning with a facility for languages, and he was even-handed in his comments. His tone is factual and objective, if somewhat gullible. Of New Mexico, he wrote,

It is a very poor and cold country, with heavy snows, but is quite habitable for a small number of Spaniards if they have clothing with which to dress, and if they take from the pacified country cattle with which to sustain themselves and cultivate the soil, for the country produces none of these, although cattle taken to it multiply rapidly, though it is too barren to raise great numbers of them. (Colahan 1989)

The fantastic human types of California included people with ears so long they dragged on the ground, others with only one foot, and those who slept under water and wore bracelets of yellow metal. The Spanish later discovered that they had encountered Native American humor. In the meantime, Escobar was inclined to give these tales the benefit of the doubt in light of the mythical figures of classical literature and their potential for Christianization of the Indians.

Escobar also was impressed by the cordial hospitality of the Indians and distressed by the pressures placed on them by the Spaniards, who constantly needed clothing and food. The constant friction between friars and soldiers in colonial New Mexico was already evident in the distress expressed by Fray Escobar over the cruelty of the Spanish soldiers. His account can be found in Bolton (1919/20).

Gaspar Pérez de Villagrá
Known as "our New Mexico Homer" and as a poet-chronicler, Villagrá earned these titles with his epic poem, *Historia de la Nueva México*. He was a soldier with the Oñate expedition who chose to present his report in verse rather than narrative. As such, it takes its place as the inaugural work of Nuevomexicano literature and the epic to accompany the birth of a culture, much like the *Cantar de mío Cid* did in medieval Spain. The only other comparable literature of the New World is *La Araucana*, a poem by Alonso de Ercilla describing the conquest of the Araucanian Indians of Chile in the mid-sixteenth century. Not only is *Historia de la Nueva México* the first American epic poem, it is the first published history of any American

commonwealth, predating Captain John Smith's *General History of Virginia* by fourteen years.

Written in rhymed endecasyllabic verse, its poetry is considered conventional, but as a piece of history, it is of exceptional value. It consists of 24 preliminaries and 287 folios of text. The preliminaries contain nine laudatory poems. It tells the story of Oñate's settlement expedition from the earliest preparations to the attack on Acoma Pueblo in 1599. Villagrá reveals the region as a place of striking contrasts, from the unforgiving barrenness and heat of La Jornada del Muerto and frigid winters of the Río Arriba, to diverse natural settings of exquisite beauty.

Villagrá was born in Puebla, Mexico, in 1555. Like other Creole sons of the aristocracy, he was sent to Spain to study and spend time at the royal court. He earned a bachelor's degree at the University of Salamanca and spent time at the court of Philip II. In Zacatecas, Mexico, he met Oñate who made him procurator general of his army. He was also commissioned as a captain and made a member of the council of war. He took part in the attack on Acoma in 1599, undertaken as a punitive move to avenge the death of thirteen Spanish soldiers in an earlier clash. Acoma was wiped out and the survivors, including women and children, were punished. Villagrá wrote his epic poem in 1609 and published it a year later in Alcalá de Henares, Cervantes's birthplace. In 1612, Oñate and his lieutenants were called to answer for the harsh treatment of the Acoma survivors. Villagrá was charged with killing some captured Indians and taking seven Acoma girls to Mexico for placement in convents and with wealthy families. His punishment was banishment from New Mexico and Mexico for a number of years. He died in 1620.

In 1900, the Museo Nacional at Mexico City published a facsimile of the 1610 edition along with documents relating to the book and Villagrá himself. In 1933, the Quivira Society of Los Angeles produced the first English translation with introduction and notes by F. W. Hodge. The translator was Gilberto Espinosa—a direct descendant of Captain Marcelo Espinosa of Oñate's army—who chose to render the translation in prose instead of poetry. Scholars suggest

that as prose, it reads more like history. In 1992, Miguel Encinias and Alfredo Rodríguez produced a new translation to coincide with the Columbian quincentennial commemorations in that year. It is the first English translation of the original verse—in verse rather than narrative form—and it is the first critical annotated translation of this extraordinary work.

The writing style is florid, with many references to ancient classical mythology and the Bible. The poem begins with a history of the Aztecs and a recounting of the efforts of previous explorers of New Mexico. It then presents the activities of the Oñate expedition. Villagrá includes biographical information about Oñate, the Zaldívar brothers, various officers and soldiers, and himself. Historians have attested to the historical reliability of the poem. In Canto 22, Villagrá begins his description of the battle at Acoma.

O mundo instable de miserias lleno,
Verdugo atroz de aquel que te conoce,
Disimulado engaño no entendido,
Prodigiosa tragedia portentosa,
maldito cáncer, solapada peste,
Mortal veneno, landre que te encubres,
Dime traidor aleve fementido,
Cuántas traiciones tienes fabricadas,
Cuántos varones tienes consumidos,
De cuanto mal enredo estás cargado,
O mundo vano, o vana y miserable
Honra con tantos daños adquirida,
O vanas esperanzas de mortales,
O vanos pensamientos engañosos,
Sujetos siempre a míseros tamores,
Y a mil sucesos triestes y accidentes . . . (22117b)

How miserably we mortals live in this
 ungrateful world!
We endure this false and untrue existence,
teeming with dangers so hid
by deceit which we can neither fathom
nor understand. Ungrateful
world, a festerous cancer; what poison
reeks within your bloody fangs!
What reason and betrayals have you in store for
those who place their trust in

earthly hopes! O, fickle hopes of mortal
man, subject always to a thousand ills and
wrongs! (189)

(Leal 1989)

In his 1933 translation, Gilberto Espinosa edited
the florid language in favor of a direct telling of the
story, as in this example.

The sergeant cried out for someone to bring
another log to bridge the span. Thinking he
was talking to me, I stepped back nine paces,
running toward the edge of the chasm, and
like Circio, with a terrible leap left the edge.
The sergeant had sought to stop me, but
missed his hold. Had he not, that day would
most certainly have been my last upon this
earth. My desperation lent me wings, and I
landed safely on the other side, where I fran-
tically seized the beam and bridged the cre-
vasse. The trumpeter blew a blast and our
soldiers dashed across.

Villagrá's story is often touching, as when the
sisters of Zutancalpo, an Acoma warrior, discover
his dead body in the fury of battle.

With a cry of anguish Mocauli [the elder sis-
ter] suddenly threw herself upon the corpse.
Her sisters heard her and hurriedly, as though
summoned, came to the spot where, recogniz-
ing the noble youth who in life had meant so
much to them, they cried out in anguish and
tore their hair and beat their breasts. Long and
piteously they sobbed and cried as though their
hearts would break, calling to their brother
with many sad, endearing words. After a long
time they placed his body on a plank and sadly
wended their way to the smoldering ruins of
what had once been their happy home.
When the sad procession arrived with their
precious burden, they were met by the aged
mother of Zutancalpo. Too well she had
guessed the burden they brought. When she
saw them, she uttered a cry of anguish, and
tearing her hair, she scourged her face and
tore her breasts in mortal sorrow, as she cried:

"Oh, gods of Acoma, why have you saved for
these declining years of this unhappy life this
terrible blow? Why have you cut down in the
flower of his happy youth this loved son thou
gavest me?"
Desperate in her sorrow, she embraced the
bloody corpse, still and cold in death, and
together with the body of her loved son threw
herself into the flames. The four sisters fol-
lowed her example, and there in the raging
fire of their ruined home they embraced one
another and, intertwined in each other's arms,
like a mass of snakes entwined and knotted in
one solid mass, they perished. In their dying
moments they tenderly caressed those features
of the unhappy youth so dear to them. Thus
they chose to leave this life, happy after all the
misery of the day, united until death, and after
death mingling their ashes in a common heap.
(Espinosa 1933)

In an earlier scene, the soldiers are caught in an
ambush. Villagrá, who was there, describes the
scene.

The sturdy Spaniards stood their ground like a
rocky cliff which firmly holds its own against
the onslaughts of a tempestuous sea.
Zutacapán angrily upbraided his followers
and urged them on. Seeing three Spaniards
who alone were holding at bay a great number
of Indians, he directed his attack on them.
Despite their heroic efforts, they were forced
back to the very brink of the terrible heights,
and striking a last blow, they leaped into the
awful abyss and into eternity. First leaped
Camacho, then Segura and lastly Ramírez.
The battle continued. Escalante and Sebas-
tián Rodríguez fought like two enraged tigers.
Surrounded on all sides, assailed with spears,
arrows, and clubs, and pelted with stones, they
fought to the very last, dying together in a final
effort against the formidable odds.
The brave Araujo grappled in single combat
with a tall, powerful warrior. They fought like
two wolves. It was a terrible sight to see them,
streaming with blood from many grievous

wounds. Face to face they fought, neither giving nor taking a single foot. They fell together, perishing nobly, bathed in each other's blood. (Espinosa 1933)

Villagrá also writes of the civilization they encountered among the Pueblos.

We visited a good many of these pueblos. They are all well built with straight, well-squared walls. Their towns have no defined streets. Their houses are three, five, six and even seven stories high, with many windows and terraces. The men have as many wives as they can support. The men spin and weave and the women cook, build the houses, and keep them in repair. They dress in garments of cotton cloth, and the women wear beautiful shawls of many colors. They are quiet, peaceful people of good appearance and excellent physique, alert and intelligent. They are not known to drink, a good omen, indeed. We saw no maimed or deformed persons among them. The men and women alike are excellent swimmers. They are also expert in the art of painting, and are great fishermen. They have neither king nor law, and we did not notice that any evil-doers were ever punished. They live in complete equality, neither exercising authority nor demanding obedience. They are superstitious in the extreme, and are given to complete idolatry.

These people till the soil and raise beans, pumpkins, melons, berries, and in the more desolate regions great quintets of [wild] grapes. After coming in contact with them they readily adopted such vegetables as we brought them, such as lettuce, cabbage, peas, chickpeas, cumin-seed, carrots, turnips, garlic, onions, artichokes, radishes, and cucumbers.

These Indians also had great flocks of turkeys. They have no sheep, cows, or goats. The rivers abound with many fish such as bagre, mojarra, amadillos, corbina, shrimp, perch, needle-fish, turtles, eels, trout, and sardines. These exist in such quantities that a single Spaniard in one day, with a bare hook, was able to catch more than six arrobas weight of fish. (Espinosa 1933)

Well-received nearly everywhere they ventured, the Spaniards nonetheless were unsettled by what they saw while visiting the pueblo of Puarai, near present-day Bernalillo.

The Indians took the priests to the quarters which had been prepared for them. The walls of their room had been recently whitewashed, and the rooms were cleanly swept. The next day, however, when the white-wash had dried, we were able clearly to see, through the whitewash, paintings of scenes which made our blood run cold. God always finds a way to make known the glory of those who suffer for His holy faith. There, pictured upon the wall, we saw the details of the martyrdom of those saintly men, Fray Agustín, Fray Juan, and Fray Francisco. The paintings showed us exactly how they had met their death, stoned and beaten by the savage Indians.

Our governor, showing rare judgment, admonished us that we should not allow the Indians to suspect that we had seen these paintings, and should not gaze at them. We determined that in the dead of the night we would leave this pueblo and go toward the direction pointed out to us by the Indian. (Espinosa 1933) [The Espinosa translation was reprinted in 1967 by Arno Press, but it is now out of print and available only in libraries. The Encinias translation is currently in print.]

The Colonists' Libraries

Because colonists of the seventeenth century were occupied with surviving in an isolated and demanding environment, writing was restricted to government and church record keeping, and friars' proselytizing efforts among the Indians. Scholars have deduced a thirty-two percent literacy rate among males during this period by analyzing signatures on old documents, noting that the rate was higher in Santa Fe. While the usual amenities of a literate culture were lacking (i.e., publishers and

widespread public education), some activity was present, and there was a rich oral legacy reaching back to Spain's dual written and oral traditions.

Reading material was scarce because of distance from Mexico and the cost of shipping. A study of old inventories and wills shows that most of the books were owned by governors and friars. Listed in the study, which was published in the 1940s by Eleanor Adams and France Scholes, were seventy-six items belonging to the friars, eighty-two belonging to various governors, and eleven belonging to various settlers. The inventory of items belonging to the friars Alonzo de San Juan, Juan de Vidania, Nicholas de Freitas, and Felipe de la Cruz, includes missals, a Holy Week *enquadernado*, spiritual instruction books, devotional meditations, sermons for Advent, works by Aristotle, Ovid, Justinian, St. Augustine, and St. Thomas Aquinas, Caesar's *Gallic Wars*, books on St. Teresa de Jesús, and a book on astrology (Adams and Scholes 1942).

Adams and Scholes give examples of how the friars, particularly Vidania, used his learning to battle with government officials over ascendancy in pueblo matters. The letters that passed between these two groups at times got heated, and may explain why Pedro de Peralta of Albuquerque would keep in his library a copy of *Práctica criminal eclesiástica*.

Among the eighty-two books owned by various governors were

- *Práctica criminal eclesiástica*
- Medical manuals and books on surgery
- Life of Christ
- *Don Quixote* by Cervantes
- A discourse on Christian patience
- A Latin/Spanish dictionary
- A book on the saints' attributions ("oficios")
- A life of Santa Teresa
- Works by Marcos de Obregón (a prominent writer of the Golden Age)
- A book of plays
- A children's primer
- A book on public contracts
- Novels, such as *Orlando furioso* by L. Ariosto Ludovico
- *The Christian Governor*

- *Historia de la Nueva México* by Gaspar de Villagrá
- *Arte de la lengua castellana* (Art of the Castilian Language)
- *Séneca impugnado de Séneca en questiones politicas y morales* (Seneca Challenged in Questions of Politics and Morality)
- *Política indiana* (Indian Politics)
- Books on criminality, including one by Tiberius Decianus published in Venice.

Settlers' books included devotional and medical books. Other books may have been owned, but because of the presence of officers of the Inquisition, they may not have been reported. Censorship of reading material was "very important for the maintenance of the official world view." There were occasional requests to confiscate books such as Rousseau's *Social Contract*.

The monastery at Santo Domingo Pueblo contained the most extensive library in New Mexico because it was the ecclesiastical capital of the religious province, called the *Custodio de San Pablo* (like an archdiocese). There were also large numbers of books at the monastery in Santa Fe. The inventories of these two locations are lost, but other records list some of their contents. During the reconquest, Vargas traveled to Zuni, and specifically to Corn Mountain where the pueblo of Alona was situated. In a room there, he found various church ornaments and seventeen books, all of which were religious in content except a book by Quevedo.

There are only two records of books from the eighteenth century, including a list of Don Diego de Vargas's property, inventoried when he died in 1704. The other is a catalog of the library at Santo Domingo as recorded by Fray Atanasio Domínguez in 1776.

The Vargas list consists of thirty-three items, including a large number of books and biographies on nobles and rulers of Spain. He also owned books on law, religious devotions, architecture, *Política indiana*, Vargas Machuca's *Milicia y descripción de las Indias*, *The Life of Gregorio López* (a New World figure), dated Mexico, 1613, and *Mística Ciudad de Dios* by Sor María Jesús de Agreda in three volumes, dated Madrid, 1670. Sor María Agreda was an abbess

of a convent of Poor Clares in seventeenth-century Spain. She was better known as the famous Lady in Blue who went into trances prior to appearing in visions throughout the New World speaking to native peoples in their own tongues to prepare them for conversion. Finally, Vargas owned a copy of the very popular cookbook, *Arte de cocina, pastelería, bizcochería, y conservería*, by a Portuguese poet Martins Coutinho. Vargas's library contained no light reading.

Domínguez reports the books at Santo Domingo were in bad shape. He counted 256 items including some duplicates, so that the actual number of items was larger. The library later burned. The 1785 estate settlement of Francisco Trébol Navarro of Santa Fe showed not only books but 500 sheets of Floriente paper, 250 recut sheets, an inkwell, and a quill cutter. Another large library was inventoried in an estate settlement in 1815, belonging to Manuel Delgado, a captain and second in command of the Santa Fe presidio. His library included a book on Mexican theater (*Teatro Mexicano*), together with books on government, the military, law, and agriculture.

Domínguez reported that the only bookcase outside of Santo Domingo and Santa Fe was at Acoma. Gallegos presents evidence of small-time booksellers operating in Albuquerque. The 1733 estate of Francisco de Jesús y Espejo lists fourteen *libritos* (booklets) about San Albador de Orta, valued at three pesos each. That he owned multiple copies of the same book suggests that he sold them, as he was also known to sell rosaries and other items (Gallegos 1992). Because a booklet does not have the same shelf life as a bound book, numerous such items would not survive, particularly if they were passed to many hands.

Education in the seventeenth and eighteenth centuries was limited to schools set up at the pueblos by the friars, and whatever villagers might initiate, usually with the help of the friars or lay teachers. One early teacher was Fray Antonio de Acevedo, who taught at Santa Fe in the early eighteenth century. In 1776, Fray Anastacio Domínguez praised the work of Fray Joaquín Ruiz at Jémez Pueblo, where Indian children were reading and teaching others to read. He asked Ruiz to write a procedural

manual for his successors, so we know today how Ruiz conducted his work at Jémez. Ruiz wrote, "The Latin language should be emphasized, for this is the principal goal. They read this better than Castilian." Reading materials in the missions included boards, cards, missals, and catechisms.

Another school around this time was operating in Santa Fe. It was to this school that Ecueracapa, a Comanche chief, sent his son to learn the language and customs of the Spanish in 1786. He attended under the sponsorship of Governor Juan Bautista de Anza. Another Comanche chief named Maya also sent his son there under the sponsorship of Lieutenant Don Vicente Troncoso. Pedro Bautista Pino later wrote in 1812, "When Maya died, his tribe recalled the youth to teach him the art of war. He was sent to them, knowing how to read. Today, he occupies his father's position, holding the Spaniards in highest regard" (Gallegos 1992). These young men probably learned to read from Antonio Ortiz, the only person in Santa Fe to claim teaching as a profession on the 1790 census. The only other teachers listed in New Mexico on this census date were José Rodríguez, a mestizo working at Isleta, and Andrés Romero working at Los Chávez.

Education in the eighteenth and early nineteenth centuries continued to be conducted in missions and in village schools, as well as at home. Domínguez reported a school for settlers' children at Santa Cruz de la Cañada operated by a priest at the villa, however the school was faltering because the priest was mortally ill. From 1770 on there was a growing number of community schools as a result of increased interest by the authorities. The Presidio School was established in the early nineteenth century in Santa Fe for the children of soldiers and officers.

Some families could afford to send their children to Mexico for higher education. Many were enrolled at the Tridentine Seminary at Durango. One famous alumnus was Padre José Antonio Martínez of Abiquiú, who was an excellent student in arithmetic, algebra, geometry, and physics, and who became a student teacher and a scholarship winner. He returned to New Mexico in 1823 to establish a school in his own home at Taos for boys and girls. Of these students, he financed the Tri-

dentine educations of eighteen young men and future priests, including Vicente Saturnino Montaño, an ancestor of the writer of this book.

The Poetry of Secular Dramas

Of the three plays discussed here, two were written in and about New Mexico, and the third has its roots in medieval Spain. All three are in the tradition of what scholars call "battle and conquest" literature, which emerges from, and serves the ideals of, conquest. Secular plays dating to Spain's Golden Age were probably performed in Santa Fe and other communities as late as the nineteenth century, but there is no surviving record to confirm this.

Los Moros y Cristianos
The first theater piece to be performed in North America, in 1598, as described by Villagrá, this work is an energetic outdoor drama celebrating the defeat of the Moors by the Spanish Christians. It is performed on horseback and is called an *auto de entrada* or *juegos de moros y cristianos*. Oñate's party wasted no time in presenting multiple performances of *Los Moros y Cristianos* on first arriving in New Mexico, along with jousting matches, bullfights, and the performance of a comedy, all during a week of celebratory feasting and merrymaking.

The play has a long history in Spain and the Americas. Early productions in Spain, where it probably originated in twelfth-century Aragón, included structures to be stormed, ships on artificial lakes in simulated battles, and pageants lasting several days. In the fourteenth and fifteenth centuries, it became associated with the festival of Corpus Christi. The intervention in the battle by St. James, known in Spain as Santiago Matamoros—St. James

8.2
Actor delivering lines in production of *Moros y Cristianos* at Chimayó's Fiesta de Santiago y Santa Ana, 1993. Photo by Miguel Gandert.

Moor Killer—was carried over in the Americas as Santiago Mataindios (Indian Killer).

The play enjoyed a long and vigorous tradition in the lower provinces of New Spain and was performed elsewhere in the Americas as well. The cult of Santiago was maintained in the Americas, representing what scholars call the culture of conquest. Scholars speculate that the play was purposely staged to impress the Indians, who could see graphically what happened to those who disagreed with the Spaniards: they were defeated, then forgiven and incorporated into society. *Moros y Cristianos* also helped the Spaniards reinforce their objectives of civilizing through Christianity. According to Reed Anderson, they gave individual Indians parts as Christian warriors in order to consolidate loyalties and provide a sense of integration.

Aurelio Espinosa found abundant evidence that the play was staged on special occasions throughout New Mexico through the beginning of this century and that the Pueblo Indians even included modified productions in some of their festivities. Manuscripts have been found all over New Mexico. Espinosa reported a manuscript copy from Cuenca, Spain, which he found to be very similar to the New Mexico version, collected by Aurora Lucero-White Lea at Santa Cruz de la Cañada in 1937. The Cuenca version is entitled *Entrada de Moros y Cristianos* and is dated June 3, 1889. The people of Santa Cruz and neighboring Chimayó have performed the play throughout the twentieth century.

The story of *Los Moros y Cristianos* as performed in New Mexico, opens near a castle held by the Moors. The sultan sends a spy down to the Christian army. The spy tempts a sentry with wine and steals the Holy Cross. The next day King Alfonso begins a two-day siege of the castle. The sultan demands a ransom and Alfonso refuses, saying the Holy Cross is priceless. The only answer is the force of arms. After a pitched battle the Christians prevail. The sultan surrenders on his knees, renounces Islam, and is granted a full pardon, along with his army.

In this excerpt, Don Alfonso has just received word that the Holy Cross has been taken.

8.3
Player in *Moros y Cristianos* at Chimayó, 1993. Photo by Miguel Gandert.

¡Eduardo, Federico! todo está perdido	Edward! Frederick! All is lost
Y nunca en mi vida en tal	And never in my life have I
trance me había hallado.	Encountered such a dilemma
Vamos, fuertes Españoles,	Come, valiant Spaniards
con ánimo, esfuerzo y valor	With spirit, strength and valor
A restaurar lo perdido.	To restore that which is lost
Hay que darle valor	We must restore lost el perdido valor
a nuestras armas.	To our arms and troops.
Pues, sin la Cruz,	Because, without the Cross
le falta el brío al sol,	The sun is less brilliant,
La luz al norte,	The north is dimmed,
el candor al viento.	The wind is stifled.
Aunque en puerto seguro y asilo	It will be secured by
Al blasón del triunfo de los Cristianos	The honor and triumph of Christians
¡Santiago en nombre de Dios!	St. James in the name of God!

*(Lucero-White Lea 1953,
translation by Enrique Lamadrid)*

The *arengas*, or long, impassioned military speeches, that characterize *Los Moros y Cristianos* reminded Espinosa (1985) of the speech Vargas gave to the Hopi people in 1692 as related by Sigüenza y Góngora:

Ah Indians, ah you dogs of the worst breed that the sun warms! Do you think that my tolerance is owing to fear of your numbers? Pity is what I have had for you in not killing you, for by a single threat of my part, you would all perish! . . . [How is it that] you do not humbly cast yourselves upon the ground and revere the true Mother of Your God and mind, who, in the image which ennobles this banner, comes with forgiveness to offer you salvation! Kneel, kneel at once before I consume you all with the fire of my indignation!

Espinosa's point is that Vargas may have been inspired by the arengas of *Los Moros y Cristianos* when he addressed the Hopis.

Los Comanches

As in other regions of Spanish America, Nuevomexicanos developed Spanish folk plays depicting events of their world. Both *Los Comanches* and *Los Tejanos* (discussed in the next section) represent original, anonymous plays written in and about New Mexico, and they continue the conquest theme established by *Los Moros y Cristianos*. *Los Comanches*—known as *Los Comanches de Castillo* to distinguish it from other celebrations—has enjoyed a great popularity in New Mexico, a true measure of which is the fact that many people memorized its stirring speeches. The correlation between written and oral tradition is well illustrated by the fact that so many people could recite portions of a play that had originally been written down but never published.

8.4

Actor portraying Cuerno Verde in production of *Los Comanches* at Alcalde, New Mexico, December 27, 1993. Photo by Miguel Gandert.

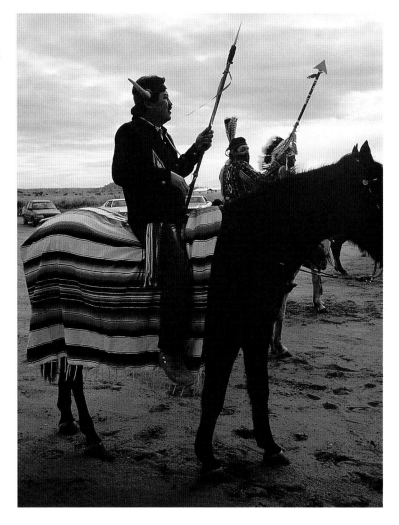

Today, it is performed in Alcalde on its patronal feast day, December 27, immediately following a performance of *Los Matachines*. When these performances were reinstated in the 1960s, the people of Alcalde made a determined effort to reconstruct the details of the traditional play by interviewing elders who remembered performances from the turn of the century. According to Dr. Enrique Lamadrid, teacher and interviewer, Dr. Robert Vialpando Lara

> was always told that the very first Comanche and Matachines celebrations came from Abiquiú, the *genízaro* town just up the Chama river valley from Alcalde. From there he traces their spread to Ojo Caliente, Alcalde, Ojo Sarco, Chamisal, Las Vegas, Belén, and Socorro. (Lamadrid 1999)

It has also been performed in Ranchos de Taos, Llano, Galisteo, El Rancho, Rainsville, Mora, and the Purgatoire Valley in Colorado. In 1929, history buff and attorney Francis T. Cheetham produced *Los Comanches* with a large cast including real Indians on the llano south of Taos.

Since then, testimonial accounts show that the play has been carefully hand copied and passed along from generation to generation, and has been maintained in memory through oral transmission. During the nineteenth century, *Los Comanches* was performed frequently during Christmas and feast days. Today's performers are young and middle-aged men from all walks of life. (Dr. Vialpando Lara also is the author of the first literary history of New Mexico.)

The play depicts the Spanish defeat of the Comanches in the late 1770s. The Spanish characters include Capitán Carlos Fernández, General Toribio Ortiz, Capitán José de la Peña, and Capitán Salvador Rivera, an unnamed Spanish lieutenant, and a camp follower named Barriga Dulce (Sweet Belly). On the Comanche side, the cast includes chieftains Cuerno Verde (Green Horn, probably named for his famous headdress; he was known to his own people as Tabivo Naritgante, meaning Brave and Handsome), Oso Pardo (Gray Bear),

Cabeza Negra (Black Head), Lobo Blanco (White Wolf), and Zapato Cuenta (Beaded Moccasin). The play's protagonist is Capitán Fernández, whose real life counterpart married the daughter of Sebastián Martín, the founder of Alcalde. His descendants live there still.

The play begins with the entrance of Cuerno Verde, who tells of his heroic deeds and, in a long speech, threatens the Spanish *castillo* — or fortress, to which the play's full title refers — before which he stands. His lines are both dramatic and beautiful, and are those which are most often memorized and recited.

Desde el oriente al poniente,	From the sunrise to the sunset,
Desde el sur al norte frío	from the South to the cold North
Suena el brillante clarín	shines the glitter of my arms
y brilla el acero mío.	and my trumpet blares go forth.
Entre todas las naciones	And boldly among all nations,
Campeo, osado, atrevido,	fearless, I excel in battle,
Que es tanta la valentía	for such is the matchless valor
Que reina en el pecho mío.	that prevails within my breast.

(Espinosa and Espinosa 1985)

His lines are not written in pidgeon Spanish or local dialect, as in *Los Tejanos*. Instead, Cuerno Verde is given full expressive range and the nobility of rhetoric equal to that of the Spanish characters. Don Carlos replies with his own arenga:

porque mentando españoles	when the name Spaniard is heard
todas las naciones tiemblan.	all nations tremble with fear.
Tú no has topado un rigor,	You have never met such valor,
ni sabes lo que es fiereza	nor do you know the great fierceness
de las católicas armas.	Catholic arms display in battle.
Por eso tanto braveas.	That is why you boast so much.

(Espinosa and Espinosa 1985)

Two captive children from Pecos are rescued in a skirmish. An eleventh hour message arrives from another group of Comanches, bearing the promise of a peace treaty, but it is too late. The two leaders assemble their forces, address their men and consult with their officers or chieftains, who are anxious to do battle. Don Carlos orders the attack in traditional Spanish fashion, calling on Santiago and the Virgin.

Y así, esforzados leones,	And so, my courageous lions,
todos al arma, guerreros.	to arms, to arms, all my warriors.
¡Suénese tambor y guerra	Let the trumpets of war sound
en el nombre de Santiago	in the name of Saint James
y de la Virgen María!	And in the Virgin Mary!

(Espinosa and Espinosa 1985)

The battle begins and the Spanish are victorious. In some versions of the play, Cuerno Verde dies, and in others he survives. Barriga Dulce provides sideline entertainment by watching the captives, commenting cynically on the unfolding events, and robbing the dead. It is his speech that ends the play.

This play should not be confused with a Nativity play also entitled *Los Comanches*. (See chapter 5 for discussion of that work.) In the preface to the 1907 publication of this play, Espinosa writes that the owner of the manuscript, a Don Amado Chaves, told him that the playwright was Don Pedro Bautista Pino. While his name appears nowhere on the manuscript, Pino seems a logical choice to many historians. He was born in Santa Fe in 1750, and was an emissary from the province of New Mexico to the constitutional convention at Cádiz, Spain in 1812 where he presented a lengthy report on conditions in the province. More importantly, he is known to have been with Fernández in battle against the Comanches.

Throughout the eighteenth century, the Comanches were formidable warriors who presented a constant threat to the Spanish colonists. In the worst years, for every Comanche casualty inflicted in raids, six colonists received the same. The Spanish governors of New Mexico sent several punitive expeditions to quell them but not until the 1770s did the efforts begin to affect the Comanches. In 1774, Captain Don Carlos Fernández defeated a large group of Comanches in battle east of Galisteo. But the raiding only intensified, so in 1779 Juan Bautista

8.5

Duel between Spanish and Comanches in *Los Comanches* at Alcalde, 1993. Photo by Miguel Gandert.

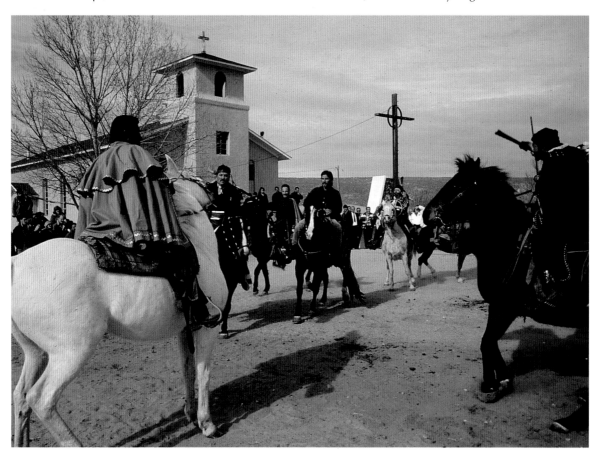

de Anza (who had assumed the governorship in 1778) led a well-organized expedition that pursued the Comanches into Colorado. There, they defeated the Comanches and killed Cuerno Verde, his son, and his chieftains.

The play is only based on history rather than attempting to serve as a factual history, and is not dated. Because it ends with Cuerno Verde's death, historians have suggested that the play was written after 1779. Until recently, however, no one could explain why Anza was not the Spanish protagonist, when in real life he was the one who delivered the final blow against the Comanches in 1779. The play, it seemed, combined two important battles: the 1774 battle led by Fernández, and the 1779 battle led by Anza. Dr. Lamadrid speculates that the author may have been disturbed by Anza's initial continuation and intensification of the all-out annihilation policy of his predecessor, Governor Mendinueta, for whom Fernández had gone into battle. Later, Anza became a skilled negotiator and master of diplomacy, and with the great chief Ecueracapa, forged the peace of 1786—a peace which has never been broken.

Historians studying the twentieth-century Alcalde performances noted that the content of the play had been revised to de-emphasize references to imperial dominion, divine right, miraculous intervention, and mention of, or allegiance to, the Spanish crown. Lamadrid attributes this to an emerging Nuevomexicano identity and shifting political environments, revealing a community's need to revise its theater to reflect the current situation. The play had also been shortened to 253 assonanced, octosyllabic verses. Other versions have been as long as 714 verses. The version published by Espinosa contains 515 verses.

Early on, New Mexicans developed an admiration of the fighting and trading prowess of the Comanches, and after the battles of the 1770s, the two groups learned to live in relative peace by trading and hunting together. Lamadrid and Anderson noted this undercurrent of admiration for the pride and courage of the Comanche nation in the play, quoting an actual letter by Anza recounting a meeting with Cuerno Verde during which he noticed and admired Cuerno Verde's superior bearing and proud spirit. As if in tribute to the Indian leader—historical fact notwithstanding—the Alcalde version does not kill off Cuerno Verde. Instead, the Spanish and Indians ride off together at the play's end.

Historians know that intercultural tolerance was necessary in light of the fact that in the 1770s, New Mexico's population was one-third genízaro, a large part of which population was Comanche. Vialpando Lara is a product of such intercultural mixing. His paternal grandfather was a captive raised with Indians, and *his* father was a Navajo raised by the Spanish. "The old differences and oppositions dissolve into a new synthesis in the edifying spectacle," writes Lamadrid. "The colonial notion of Comanches as cultural others becomes ambiguous and obscured. An implicit recognition emerges that they are also a part of the extended cultural family" (p. 19).

Los Comanches is a natural follow-up to *Los Moros y Cristianos*, and shows several commonalities with it.

- Both are products of the theater-of-conquest theme, or Spanish versus "heathen."
- Both plays call for mock battles on horseback and parading interludes.
- In both plays, the most important speeches by the opposing leaders are challenges, defining the patriotic and ideological differences that underlie the battle.
- Both plays establish local legends and history by exalting the lives and actions of Hispanic men in battle, thus continuing a peninsular tradition of national drama.

Interesting differences include:

- While the antagonist of *Los Comanches* dies unrepentant, the antagonist of *Los Moros y Cristianos* is converted to Catholicism.
- In *Los Moros y Cristianos*, a sacred object has been stolen; in *Los Comanches*, two children have been captured.
- *Los Moros y Cristianos* recalls the glory of the past while Los Comanches is a reminder of the struggles of the present.

In its way, this play depicts another battle against infidels as in the *Moros y Cristianos* pattern. It was performed in an open field in the same fashion as the older play, with spectators watching and applauding from the sidelines. At Alcalde, a bulto of the town's patron saint, San Antonio, is carried in procession and placed nearby to watch the play. Those who took the parts of the Spanish dressed in the manner of the conquistadores, riding lavishly caparisoned horses. Lamadrid records Vialpando Lara's recollection of "a particular sorrel horse, an *alazán tostado* [a dark reddish-brown horse] of his uncle, who would gracefully kneel before the image of San Antonio to pay reverence before the play began" (Lamadrid 1999).

Los Tejanos
In 1841, a small, rag-tag army of very old and very young Texans entered New Mexico intent on capturing it for the Republic of Texas. Instead, they were taken prisoner by Governor Armijo's army, marched to Mexico, and released a year later. *Los Tejanos* is a theatrical interpretation of that event, written in verse, presumably for presentation at fiestas or public events held to celebrate Texas's failed attempt. The comic and satiric tone of the play would have made it appropriate for such gatherings at a time when antipathy toward Texas was at its height.

The only known text of *Los Tejanos* was collected from Doña Bonifacia Ortega of Chimayó by Aurelio and J. Manuel Espinosa in 1931. They noted that it was written in assonanced octosyllabic verse and contained 497 verses. Because the title page is missing, the actual title is unknown, so Espinosa named it *Los Tejanos* for the sake of convenience. He published it in 1943 and 1944. It has not been recently produced.

The story centers on the capture of General Hugh McLeod, who led the failed expedition. Like *Los Comanches*, the play takes some liberties with historical truth. A group of McLeod's advance guard is captured and three are executed in Santa Fe at the same time that a Pecos Pueblo Indian is captured by the Texan forces. His presence is part of an elaborate scheme to capture McLeod (known in the play as "Menclaude"). The Indian is meant to be captured by the Texans, and then to "betray" the New Mexican Don Jorge Ramírez to the Texans. The Indian and Ramírez will then lead McLeod into an ambush, where he is captured by General Armijo's men.

The play opens with the Texan Lieutenant Navarro's questioning of the newly captured Pueblo Indian, who speaks in pidgeon Spanish (still spoken by some Pueblo Indians in Espinosa's time). In this excerpt, he has asked for food and clothing and when provided with clothing only, he subtly mocks Navarro's gullibility and how his new clothes will transform his life.

¡Agora sí, muh contento!	Now indeed I'm very happy!
¿No ves ya yo engalaná?	See how well dressed I am now?
Quizás agora fiscal,	My pueblo will now elect me
Quizás gobernadorcillo,	maybe public prosecutor
Quizás capitán de guerra	or the governor perhaps,
mi pueblo me eligirá.	or maybe even war-captain.

When the Indian reports the executions of the three members of the advance guard, Navarro is alarmed, but McLeod determines to continue on to Santa Fe. He orders that the captive be shot but changes his mind after the Indian promises to reveal the whereabouts of a New Mexican spy (Ramírez). When Ramírez is captured, McLeod tells him he will be shot if his story does not match that of the Indian. Ramírez confesses to being a spy, but that he will betray Armijo. McLeod believes him and is led into an ambush by Ramírez. When this happens, a New Mexican officer cries out these popular words,

Ah, tejanos atrevidos!	Ah, you insolent Texans!
Se atreven a profanar	You dare profane
las tierras del mejicano?	the lands of the Mexicans?
Ahora su temeridad	Now your recklessness
le pondra freno a su orgullo,	will put your pride in check.
Y a todos he de acabar!	And I will put an end to all of you!

Discrepancies between real life and the play include the fact that little or no mention is made of Don Antonio Sandoval's considerable involvement in the real-life drama. Also, the Indian may be purely fiction, although his character is well defined. Espinosa discusses several other omissions, but notes that other than details of the actual capture, the play remains generally true to the way things happened. He states that the play should be interpreted primarily as a dramatic effort, knowing that the author was attempting to present a patriotic folk play.

Jorge Huerta notes that in *Los Tejanos,* even the Mexicans are viewed in a poor light. He attributes this to the insularity of New Mexicans. He further notes that the play's portrayal of Texans as ignorant racists and liars seeking wealth and power foreshadows by several generations the angry works of the late twentieth-century Chicano repertoire. For example, McLeod's false promise to Ramírez in *Los Tejanos*—"You will be taken to Texas at my expense and there we will get you a job with a good salary"—has been repeated in many a Chicano play when wealthy growers or manufacturers promise economic benefit to hungry immigrants. Ramírez answers disingenuously:

Ahora he pensado que mi fortuna tan cabal	Now I realize that my great good fortune
me abre puerta que yo puede	has opened that door for me
el hacerme nacional	to become a citizen
de Tejas, patria adorada.	of that beloved country, Texas.
	(Anderson 1989)

Thus do the New Mexicans fill the Texans with false confidence that lead them to a humiliating defeat. The playwright deftly exploits the comedy and irony of the situation to entertain audiences that already know the story's outcome.

Additional research is needed on *Los Tejanos* because nothing is

known of any performances, or whether the only surviving manuscript is incomplete. The well-worn look of the original manuscript collected by the Espinosas would suggest that it was staged.

Los Tejanos could be considered one of the earliest plays in what Huerta has called the Theater of War, a component of the Chicano movement's dramatic forum. Its spirit is continued in El Alamo, premiered in 1973 by Héctor González of the Teatro de los Barrios of San Antonio.

The Poetry of Religious Dramas

In the Middle Ages, the Catholic Church provided official formularies for public worship called the liturgy. It included the mass and sacramental rituals. However, the people also worshipped through prayers, romances, alabados, and religious dramas, which provided them with a focus for remembering and contemplating events of the Old and New Testaments. Religious drama was so popular in Spain that it was more widely developed there than in any other European country, according to Espinosa. In the sixteenth and seventeenth centuries, the Franciscan friars carried this love of drama to the New World where they used the folk plays in their instructional work, and created new ones as needed.

Two types of these plays are the auto sacramental and the coloquio, which seem to correspond to the miracle play and the interlude, according to Major and Pearce. In medieval Europe, religious worship was always very dramatic and realistic, beginning with the mass, itself an orchestrated presentation of prayer and music, which inspired nonliturgical religious dramas. Elaborations on the liturgy eventually included the Passion and other religious plays. The people developed independent scenes, such as the Descent from the Cross or the Burial, including speaking characters like angels, saints, Joseph and Mary, Pilate, Judas, the Roman soldiers, and Mary Magdalene. At first the Church showed interest in these independent scenes, but when they became too infused with legend, and too long and complicated, ecclesiastical leaders left them to the people—except in Spain, where the autos were encouraged by priests

to strengthen the faith. There, the autos sacramentales were produced to go through the streets of Madrid on carriages, each depicting a different religious scene from a play. Such street processions also occurred in Barcelona, Sevilla, Toledo, and Valencia. Sevilla has produced such scenes since the sixteenth century.

The specific purpose of the auto was to teach Christian doctrine. Early Spanish autos were written by Juan del Encinia, Gil Vicente, Lope de Vega, Calderón de la Barca, and others. An auto typically included a contest between representatives of good and evil, with attendant abstractions personifying good and bad in varying degrees of realism and action.

The coloquio was, in comparison to the auto, briefer. Often, two coloquios were presented together to fill an evening. The term coloquio itself means dialogue or conversation, hinting at the intimate nature of the play it represented. Both the auto and the coloquio became very popular in the New World. At the festival of Corpus Christi in Tlaxcala in 1538, Adán y Eva was presented as an elaborate auto, performed by native converts in their own language. In 1672, El Arca de Noé (Noah's Ark) was presented in Lima, and that same year Tomás de Torrejón y Velasco (1644–1728) is mentioned as composer of music for the productions of a breve coloquio de música recitativa and a coloquio en forma de auto sacramental. An auto hierático called O misterio de Jesús (O Mystery of Jesus) was produced about 1583 in Brazil. Autos were complemented by vocal and instrumental music in either processions, fanfares, or dances, and occasionally made use of plainsong and popular songs of the day, much as did their sixteenth- and seventeenth-century European counterparts.

The most prominent autos sacramentales of New Mexico are Los pastores, La primera persecución de Jesús, El niño perdido, La aparición de Nuestra Señora de Guadalupe, Las posadas, and Los desposorios de San José y María Santísima. These works are either traditional or based on traditional works created elsewhere.

There are only two Old Testament autos with a history in New Mexico, Adán y Eva and Caín y

Abel. Both were popular in Spain but scholars do not know when these two plays were introduced into New Mexico. Campa discovered a manuscript of *Adán y Eva* in Bernalillo dated 1892. Lucero-White Lea found another version of the same play in Las Vegas. She attributed its excellent physical preservation to the priests at the Jesuit College there. Arsenio Córdova, a social worker in Taos, produced *Adán y Eva* in the early 1990s and toured it to Albuquerque.

The cycle of New Testament autos begins with *El coloquio de San José* (The Colloquy of St. Joseph), usually followed by *Las posadas* (The Inns), and *Los pastores* (The Shepherds) which is known in New Mexico in at least eighteen versions. The other autos in this cycle are *Los reyes magos* (The Magician Kings) and *El niño perdido* (The Lost Child), which deals with the visitation of the Christ Child to the Jewish Temple. The last of the cycle is *La pasión* (The Passion), which depicts the events of Holy Week. There are numerous plays on the Nativity; they are known collectively as *pastorelas* be-cause they include shepherds, with whom common folk can easily identify, hence their effectiveness and popularity.

The Spanish Christmas season begins on December 16 and ends on January 6. In an agricultural society, November and December were relatively inactive months during which villagers had the time to prepare and present religious dramas.

Because Nuevomexicanos typically combined or omitted many portions of different New Testament plays over the years, scholars today find it challenging to reconstruct or sort them out. Further, in reciting lines, Nuevomexicano performers would mispronounce proper names and unfamiliar words until entire lines lost their original meaning. According to Campa, meaningless sentences often were repeated in performance after performance. The typical method of preservation was to create a handwritten copy of a previous handwritten copy.

Las posadas (The Inns)

This short drama is performed outdoors, over the nine days which precede Christmas. Two performers portraying Joseph and Mary, and accompanied by a chorus of singers, approach different homes—representing the inns of Bethlehem. At each home, they sing their request for shelter and are rejected. They finally find refuge at a church or community center—representing the stable where the Christ Child is born. *Las posadas* may be carried out over several evenings, visiting one home per evening, or all on the same evening. Manuscripts abound. One of the best and longest versions is from Santa Fe, and is called *Las nueve posadas de la Virgen* (The Nine Inns of the Virgin). The verse is typically rendered in octosyllabic verse. *Las posadas* and *Los pastores* are the most frequently performed *autos* of the late twentieth century.

Los pastores (The Shepherds)

In *Las posadas*, Joseph and Mary seek and finally receive shelter. In *Los pastores*, the Child is born, and the bulk of the action centers on the efforts of shepherds to reach Bethlehem. In most New Mexican versions, the play consists of two coloquios. In the first, angels led by the Archangel Michael announce the birth of Christ and invite the shepherds to visit the Child. One by one the shepherds gather to see the Child and present gifts as they sing a famous lullaby.

Duérmete, Niño Lindo,	Go to sleep, Pretty Child,
en los brazos del amor.	in the embraces of love.
Que te arrulle tu madre,	Let your mother lull you
cantándote, "Alarrú."	singing to you, "Lullaby."
¡Alarrú, alamé,	Alarru, alame,
alarrú, alamé!	Alarru, alame!
¡Alarrú, alamé, alarrú!	Alarru, alame, alarru!
No temas a Herodes	Have no fear of Herod,
no temas a Herodes,	have no fear of Herod.
nada te ha de hacer.	for he cannot harm you.
En los brazos de tu madre	When in your mother's arms,
nadie te ha de ofender.	no one can harm you
¡Alarrú, alamé,	Alarru, alame,
alarrú, alamé!	Alarru, alame!
¡Alarrú, alamé, alarrú!	Alarru, alame, alarru!

(Espinosa and Espinosa 1985)

"A la rú" are syllables from the verb *arrullar*, which means to rock a baby to sleep.

Lucifer appears and expresses his wrath at the birth of Him who will save mankind. An angel then appears and answers Lucifer followed by a chorus praising the Incarnation and redemption through the Eucharist.

In the second coloquio of the presentation, *Los pastores* are once again on the road. The characters include angels, St. Michael, Lucifer, numerous male shepherds, the female shepherdess, Gilita, a hermit, and the lazy shepherd, Bartolo, who provides comic relief. The shepherds enter singing coplas expressing their joy at the birth of the Savior. On their way, storms of snow and hail challenge them. Then they stop to rest for the night. As they sleep, Lucifer reappears and, after a long speech, determines to prevent the shepherds from reaching Bethlehem. An angel appears, awakening the hermit to warn him against the temptations of sin. Lucifer tempts the hermit, who steals from the shepherds and is about to carry off Gilita when the shepherds awaken and beat him.

An angel appears again and informs the shepherds that they are invited to see the Christ Child. Some are incredulous and Lucifer returns. This time St. Michael appears to defend the shepherds. A con-

test of words, and then blows, results in the defeat of Lucifer. The angel reappears and again invites the shepherds to proceed to Bethlehem. Ultimately, the hermit pushes Lucifer into the mouth of Hell. They set out, singing coplas individually and as a chorus. The final coplas of the play are considered the most beautiful.

Adiós, José, adiós, María,	Good-bye Joseph, good-bye Mary,
adiós, mi manso cordero,	good-bye, my most gentle lamb,
que ya se van los pastores	the shepherds are going away
hasta el año venidero.	until they return next year.
Echanos tu bendición	Give all of us now your blessing,
a todos, y al ermitaño.	to all of us, including the hermit,
Préstanos vida y salud	Give us life and give us health
para volver al otro año.	that we may return next year.

(Espinosa and Espinosa 1985)

As Lamadrid points out,

> There were many shepherds in *Nuevo México* to appreciate this tradition. Pastoralism is not only the central metaphor of Christianity, it was also the mainstay of the economy of *Nuevo México* for centuries. The introduction of domestic animals to the region had a profound impact on its indigenous peoples. The symbolic association of the animals with the birth of Jesus played a role in the conversion of the Indians that the missionaries hardly suspected. Animals played a more allegorical role in the European imagination. (Lamadrid 1997)

La primera persecución de Jesús (The First Persecution of Jesus)

Espinosa suggests that this play came from Mexico to New Mexico in the early eighteenth century, and that it is a copy of a Spanish or Mexican play. The only complete version known to him was a copy that had been in his family for four generations, and that had come to them in Taos between 1860 and 1880. The entire play is in octosyllabic verse and is intended for recitation, as there are no sung parts. The varied vocabulary, absence of popular speech, archaisms (the use of Josef instead of José) and elevated style, including a parable, reveal a learned literary source. It begins in the style of European medieval drama.

Atención, noble auditorio!	Hear me, noble audience!
A vuestra corporación,	I request this guild of yours
y a todo este consistorio,	and all this consistory
Repito, pido atención.	to give us your kind attention.

The story presents the appearance of the star of Bethlehem, the journey of the Magi, a scene in which Herod addresses Suetonius on the

prophecies, the meeting of the Magi and Herod, and a monologue by Lucifer, who decides to bring turmoil and hatred to mankind in order to prevent its redemption. The scene changes to the stable in Bethlehem, the adoration of the Magi, the appearance of an angel telling them to leave immediately, and the Holy Family's flight to Egypt. On their way, the Holy Family encounters two farmers. The first one responds courteously when the Virgin asks him what he is planting. She tells him to ask his laborers to reap the grain with sickles. Miraculously the grain grows and ripens at once. The second farmer responds to the same question with arrogance. He harvests stones. The next scene is of the slaughter of the innocents as two women express their anger at the cruelties of Herod. Those seeking the Holy Family come upon the first farmer as he harvests his grain. Seeing this, they turn back, realizing the time of the prophecy has passed and they are beaten.

El niño perdido (The Lost Child)

This auto consists of sung romances when performed in New Mexico. Espinosa discovered two manuscripts in Cerro and Taos. Each seemed to be copies of a single original, which he speculated to be a printed seventeenth- or eighteenth-century Spanish or Mexican play. It tells the story of Joseph and Mary finding the Christ Child in the temple among the high priests. Many of its lines and even a few scenes are based on classic Spanish models as determined by Espinosa. For example, as was the custom in seventeenth-century Spanish theater, the audience is addressed as "Illustrious Senate."

Atención, Senado Ilustre,	Attention, Illustrious Senate,
que ya se comienza el auto	for the play is to begin
en que obró el Niño Jesús	in which the Blessed Child Jesus
un descuido y con cuidado.	by design made a mistake.

<div align="right">(Epinosa and Espinosa 1985)</div>

El niño perdido has little plot. Joseph and Mary have lost their son, not realizing that He has stopped at the house of a wealthy man, in the hope of being invited to dinner. The man's miserly attitude presents a lesson for the audience. Espinosa finds literary hints of Calderón de la Barca, and speculates whether the author of El niño perdido knew his work. Note the lyricism in this excerpt from the Taos manuscript.

La Virgen buscaba al Niño—por las calles y las plazas,
y a todos los que veía—por su Hijo preguntaba.
—Decid si habéis visto—al sol de los soles,
al que nos alumbra—con sus resplandores.
Dénos, Señora, las señas,—por si acaso lo encontramos.
—Es blanco como la nieve,—y como la aura encarnado.
Tiene unos cabellos—como el sol dorado;

sus labios y boca—son flores del año.
—Por aquí pasó ese Niño,—según las señas que dais
Al templo se encaminó,—id allá y lo hallaréis.
—Dios os pague, hijos,—esa buena nueva.
Ya encontrará alivio,—el alma en su pena.
Partió el Alma Divina,—al templo se encaminó.
Entre todos los doctores,—al Sol de Justicia halló.

The Virgin sought the Child through streets and squares,
and asked all those she met if they had seen her Child.
"Tell me if you have seen the sun of all the suns,
that one who gives us of His divine light."
"Describe him, dear Lady; we may meet him perchance."
"He is as white as snow, and as fair as the dawn.
The locks of his forehead are of a golden hue;
his lips and his mouth are the flowers of the season."
"That child passed by here, to judge from that description.
Go to the temple, lady, and you will find him there."
"The Lord reward you, children, for the good news.
My grieved heart will now find more comfort and peace."
The Blessed Mother to the temple directed her steps.
Among the doctors the Sun of Justice she found.

(Espinosa and Espinosa 1985)

As in *La persecución*, the play includes a sequence where a good person and an arrogant person respond in contrasting manners to a member of the Holy Family. In this instance, the Child asks for hospitality from a rich man, who is offended and sets his dogs on Him. The Child leaves there and arrives at the home of Rosaura and Gosabel, where He is received courteously and is given food and consoled when He expresses missing his mother. The plays were obviously used to teach human values. In the end, when the Virgin finds her son, He responds:

¿Pues, para qué me buscáis? Why are you looking for Me?
¿No sabéis dónde se encuentran Truly, don't you know the place
los negocios de mi Padre? where My Father's business is?
Me entrego a mi diligencia. I am merely doing My duty.

(Espinosa and Espinosa 1985)

La aparición de Nuestra Señora de Guadalupe
(The Apparition of Our Lady of Guadalupe)
This Creole play is of Mexican origin. Of the three versions Espinosa discovered in New Mexico, manuscripts from Chimayó and Santa Fe are complete. He determined the Chimayó work to originate in eighteenth-century Mexico and the Santa Fe work to be an early nineteenth-century copy definitely of New Mexican origin. The manuscripts contain dialectic or "fractured" Spanish in the part of the Indian Juan Diego, which

Espinosa believes may have been intentional. While the play is written in octosyllabic verse, its lines are irregular.

La aparición tells of the apparition of the Virgin Mary to the Indian Juan Diego in December of 1531 near Mexico City—an incident that represents the first appearance of the Virgin in the New World and the creation of the cult of the Virgin of Guadalupe, which is central to Mexican faith. The drama follows the historic and legendary accounts very closely. The Chimayó version goes as follows: Juan Diego travels to Santiago Tlatelolco to fetch a priest for his ailing uncle, Juan Bernardino, when he passes the hill of Tepeyac. There, the Blessed Virgin appears to him with an important message. Juan Diego explains the urgency of his trip and asks the Virgin to state her message quickly. She tells him she is the mother of God and instructs him to tell the archbishop to erect a temple in her honor at Tepeyac, where she can be with her children, the Indians. Juan Diego hesitates, saying no one will believe him and will call him a liar and a witch. She reassures him and he leaves. The priest at the archiepiscopal palace hears him out, calls him a liar and a witch, and sends him away. When the archbishop later hears the story, he calls for Juan Diego.

In the meantime, Juan Diego continues his search for a priest for his uncle when the Virgin appears to him once again. He tells her in his fractured Spanish:

Los mismo que lo pensé.	Just exactly as I thought.
Me lo dijeron chicero,	They said it to me a witch,
y no me dejaron ver	and they did not allow me
al sulustrísimo señor	to see His Excellency,
porque no me lo creyeron.	for they did not believe me.
Mira, Señora, es mejor	Look, it is better, dear Lady,
que lo hagas tu mensajero	that you make your messenger
un gachupín, que no yo.	a Spaniard, rather than me.
O anda tú, porque con eso	Or you go, because that way
verán lo bonito que eres,	they'll see how pretty you are,
y así te lo van creyendo.	and then they will believe you.

(Espinosa and Espinosa 1985)

She urges him to return to the archiepiscopal palace to deliver her message. This time he is received by the archbishop, who asks for a miraculous sign from the Blessed Virgin. He returns to Tepeyac for the third time and asks the Virgin for a sign. She instructs him to gather flowers from the mountaintop. It is December, and the mountaintop is covered with ice and stones, yet Juan Diego finds beautiful roses there. The Virgin further instructs him to take the roses to the archbishop in his *tilma* (poncho). When Juan Diego opens his tilma before the archbishop, the roses fall out and reveal the image of the Virgin of Guadalupe impressed on the tilma just as Juan Diego had described her. All present fall to their knees. The archbishop intones,

¡Oh! portento soberano	O sovereign sign
Milagro de los milagros.	Miracle of miracles.
Adórote, María mía,	I adore you, my Mary
Madre de Dios soberano.	Mother of sovereign God.
Ahora me resta el pediros	Now I must ask you
Pues tanta dicha he logrado	Since I am so fortunate
Que se acabe la herejía	That you end the heresy
En este Reino Mejicano	In this Mexican kingdom.
Que la Cristiandad se aumente	May Christianity grow
Y que tu Hijo sea adorado	And your Son be adored,
Y tú, Indio dichoso,	And you, fortunate Indian,
Que has merecido ser trono y colateral sagrado	Who deserves a holy throne
Pues en tus hombros pende el más bello milagro.	On your shoulders hangs the most beautiful miracle
Mas, ahora, en el oratorio	But now in the house of prayer
Preciso es depositar el ayate hasta hacer el templo.	The garment must be kept until the temple is built
Vamos, dichoso Juan Diego,	Come, fortunate Juan Diego,
Vamos y lleva cargado	Come and take your load
El tesoro más sublime	The treasure most sublime
Que en el cielo y en la tierra se ha hallado.	That in heaven and earth has been found.

(Lucero-White Lea 1953,
translated by Enrique Lamadrid)

In an effort to tell the whole story, santeros will depict all of the three apparitions and the unfolding of the tilma in complex, multi-imaged retablos.

La pasión (The Passion)

One of the earliest dramas presented in New Mexico, *La pasión* was probably enacted by the Oñate party, as they were also known to observe Semana Santa in 1598 with prayers, rituals, and flagellations. *La pasión* represents the events of Semana Santa, or Holy Week, including the Passion and Death of Christ beginning on Palm Sunday and continuing through Easter Sunday.

According to Espinosa, the Passion plays were popular up to the end of the nineteenth century, corresponding roughly to the height of the Penitente activity in the second half of the nineteenth century, including the creation of large santos for use in Passion plays. While Espinosa was unable to find texts, he found fragments of old romances that may have been parts of such plays. Throughout the twentieth century, the Hermanos have, in varying degrees, enacted parts of the Passion, including recitations and chanting of narratives and reenactments of the march to Calvary. The Hermanos have always been central to the worship and continuance of these activities and have kept the handwritten scripts, copied and handed down from one generation to the next. According to Espinosa, the Lenten and other devotions of the Hermanos were derived from traditional Spanish prayers, alabados, and Passion romances, most likely written in Spain and Mexico by

Franciscan friars of the seventeenth and eighteenth centuries. Or they may have been versions of Spanish originals printed in Spain in the sixteenth and seventeenth centuries and distributed in New Mexico. Others were written by the Hermanos themselves.

Typically, Semana Santa unfolded as follows:

- Preparatory scenes were enacted through the week prior to Good Friday, including the Last Supper, Jesus washing the feet of the disciples, the meditation in the Garden of Gethsemane, and the arrest and trial of Jesus.
- Following mass on Good Friday, a reenactment of the march to Calvary included Roman soldiers, the Centurion, and the Cyrenian. The play began with the adoration of Christ on the Cross. Then Longinus appeared with his lance, often entering on horseback, and sometimes riding right up to the altar, as at Tomé.
- The Lamentations of the Virgin were expressed in the form of romances, and the playing of the pito flute.
- The Descent from the Cross was enacted, during which a large santo of *Cristo Crucificado* (Christ Crucified) was taken off the cross and placed in the arms of the santo of the Virgin Mary.
- The Cristo Crucificado was then placed in a large wooden box, representing the sepulcher, to be venerated in the Church, and taken in procession as the *Santo Entierro*, or Holy Burial.
- The *Tinieblas*, or *Tenebrae* service, was held late Good Friday night, and represented in aural and visual terms the cosmic chaos following the Crucifixion.

The singing or reciting of alabados accompanies all action. As in Spain, church officials in New Mexico approved of these plays, took part in them and even directed them. The Lamentations and the Descent from the Cross were especially popular among Nuevomexicanos—in Taos and Santa Fe, these scenes lasted longer than the others.

The following is an excerpt from the alabado that is chanted or sung on Holy Thursday. The full piece consists of 144 octosyllabic quatrains, or 576 verses, and narrates the complete story of the Crucifixion. These are the opening lines.

Con mansedumbre y ternura	With meekness and deep affection
y señas de fino amor	and signs of the most pure love,
les previno a sus discípulos	the Lord for his twelve disciples
la última cena el Señor.	provided the Last Supper.
Y con mucha caridad,	And with the greatest charity,
que en los mortales no ves,	the charity we never see,
después de haber cenado	After having dined
les lava humilde los pies.	He humbly washed their feet
Luego consagró su sangre	He then consecrated His blood,
y con cariñoso afán	and with affectionate zeal

se les dio muy escogido	He gave Himself to them
en accidente de pan.	in the accident of bread.
Por este medio dispuso	In this way He established
aquel nuevo testamento,	the New Testament and Faith
sacrificándose así	thus sacrificing himself
para desterrar el viejo,	for in the Old they offered
era sangre de animales,	as a sacrifice animals' blood,
pues en este sacrificio	while in the New
y en el nuevo la de Cristo	it is Christ's blood
para redimir mortales.	that was shed for the sins of men.

(Espinosa and Espinosa 1985)

Miguel de Quintana (ca. 1670–1748)

Much of the written materials that have survived from eighteenth-century New Mexico are official government records, including journals, letters, and documents. The only creative writing to survive from this period are examples of the mystical prose and poetry of Miguel de Quintana, a farmer and scribe who flourished in the first half of the eighteenth century.

We know about Quintana only because he ran afoul of the Inquisition, which maintained a file on him in Mexico City. It is from this file that scholars know he was born in Mexico City around 1670 and arrived in New Mexico with the reconquest in 1693. At that time, he was twenty-two and had a fifteen-year-old wife. They settled in Villa Nueva de Santa Cruz, near present-day Española, where they reared six children. Quintana also was a notary for the people of Santa Cruz, as well as a composer of civil, criminal, and ecclesiastical documents for cases heard by the mayors of that town. He also wrote autos for parish and community celebration, and served as a public scribe. He was held in high esteem by his neighbors, who saw him as an intelligent, competent person of solid judgment. John Kessell has called him a santero working in word instead of wood, while historian Angélico Chávez describes him as a poet laureate of his time.

Quintana came under investigation in the 1730s when two friars—Fray Manuel de Sopeña and Fray Joseph Irigoyen (who was notary to the agent of the Inquisition in Santa Fe)—testified to the Inquisition that he had stopped attending mass and other religious activities. Irigoyen stated there was a correlation between Quintana's poetry, which was spiritual in nature, and his failure to attend church functions. He called Quintana a hypocrite and a heretic. Clark Colahan and Francisco A. Lomelí suggest the friars harbored professional or personal jealousy of Quintana because of his popularity in the community as a good and useful neighbor and as an intellectual who supported himself through reading and writing.

Quintana was a mystic, who claimed that his poetry was inspired by the saints, who spoke to him and even dictated the poetry. Put another way, he channeled poetry. He also had visions of his friend and mentor, Father Juan de Tagle, former director of the Franciscan order in New Mexico and frequent visitor to Santa Cruz while he was alive. Tagle had

been replaced by Sopeña, who imposed a prohibition against Quintana's writing. At the time of the prohibition, Quintana had begun a Christmas play requested by the community. He later wrote in his own defense,

> These thoughts troubled me so much that I felt I was about to faint, and so I thrust it away from me and was on the verge of throwing it [the manuscript of the play] into the fire. But in the midst of such great distress, I felt a great help and a prodigious favor encouraging and strengthening me. It seemed to take my hand and help me with the thought "Don't burn it, don't burn it. Continue and offer your play to His Divine Majesty. Pick up the pen and continue." So much was this so that I could not restrain myself. I seized the pen again and as soon as I had taken it up and resumed writing, all that storm left me. In my soul I felt such living sentiments of sweetness, love and tranquility that my heart burned in divine love as I considered the love with which His Divine Majesty was willing to become man for our salvation. (Colahan and Lomelí 1989)

Three voices dictated verse and prose that Quintana recorded as tokens of their love and in obedience to their command. Colahan and Lomelí make the point that on the altar screen of the church at Santa Cruz there was (and is) a representation of St. Teresa receiving inspiration from the dove of the Holy Spirit as she writes. They suggest that Nuevomexicanos, and Quintana in particular, knew from this image that direct communication with God was sanctioned by the Catholic faith. Nuevomexicano folklore recounts numerous instances of saintly intervention in the lives of individuals, going back to the visions of the Lady in Blue, whose story was widely known in Quintana's time. Quintana continued to write poetry despite the prohibition.

No temas inquisición,	Don't fear Inquisition,
castigo, daño ni afrenta.	punishment, harm or disgrace,
Es Dios, Miguel, quien te alienta	It is God, Miguel, who encourages you
con tan grande inspiración.	with such important inspiration
De te humilde corazón	God is in love
está Dios enamorado.	with your humble heart
Síguele, que no has errado;	Follow Him, for you have not erred;
es grande tu locución.	your words are great.
No estás, Miguel, condenado,	You are not condemned, Miguel,
ni esperes ir al infierno,	nor need you fear going to hell,
cuando Dios, amante tierno,	since God, a tender lover,
cuanto has escrito te ha dado.	has granted you all you have written.
Ese interior movimiento	That inner motion
no es en ti, Miguel, culpable,	is not a fault in you, Miguel,

cuando Dios, Benigno, afable,	since God, kind and affable,
te inspira, ayuda y da aliento.	inspires, helps and encourages you.
¿No les ves en una cruz	Don't you see Him on a cross
hecho por ti mil pedazos,	torn into a thousand pieces for you,
que te ofrece los brazos	opening His arms,
para que goces la luz?	for you to enjoy the light?

(Colahan and Lomelí 1989)

Sopeña and Irigoyen continued their investigations for five years, resulting in a large file of prose and poetry, correspondence, and testimony from others. In addition, Quintana made sure that two other friars received copies of his work. In 1735, the Holy Office in Mexico City determined that Quintana was not a heretic, but suffered from "damage" to "the imaginative faculty." He was instructed not to relate his revelations to anyone, to stop writing inspired material, and to get a good confessor (no less than Irigoyen). Quintana pretended to agree but continued writing impassioned prose and poetry, some of which condemned his prosecutors. This new material was discovered, and it is roughly at this point that the documents in the file end.

Colahan and Lomelí (1989) concluded:

> Quintana's writings are unquestionably valuable, first for their articulate documentation of a New Mexican writer's courage to differ with a powerful and jealous authority, and for their vivid testimony of terrifying fears that courage had to subdue. Second, they provide a psychological record of an imaginative and literary solution to the fundamental problem of freedom of expression, an extreme solution certainly, but one based on traditional Hispanic beliefs very much alive in the writer's community. As a kind of poet laureate, he was necessarily also a spokesman, and his words the voice of the people for whom he spoke.

Spanish-Language Journalism in Nineteenth-Century New Mexico

When the New Mexican border opened in 1821, Anglo-Americans arrived in ever increasing numbers, bringing new attitudes and their ability to publish and disseminate them widely. One attitude was a perceived need to "salvage" New Mexico and make it better in the interest of progress and civilization. Another was that Nuevomexicanos were inferior, immoral, and unworthy. These attitudes permeate the pages of works of Josiah Gregg, W. H. Davis, Ralph E. Twitchell, Hubert Howe Bancroft, the *New York Times*, and the *Congressional Record*.

In 1989, Francisco A. Lomelí would offer this analysis:

> A trend was established to supplant a relatively pastoral society by waging a carefully orchestrated war of images: slothful and backward

Mexicans were in need of salvation and redemption by the industrious and visionary newcomers. . . . When jingoism did not produce the desired results or when outright prejudice seemed too obvious, other innovative methods of displacement were devised. One was to promote biographies of outstanding civilians—almost exclusively Anglo-American—to highlight one social sector at the expense of the other. Thus, the conquest on a daily basis took on the qualities of a moral crusade against barbarism and backwardness within a justified self-righteous framework.

Lomelí observed that Anglo writers and chroniclers substituted one Southwestern type for another, obscuring earlier colonial roles and identities of the hero figure. Thus, Indian leaders became dangerous and unpredictable, while Hispanic priests became lecherous and untrustworthy. They were replaced in the minds and hearts of readers by trailblazers (Kit Carson), famous trappers (Jeremiah Johnson), sharpshooters (the James brothers, Pat Garrett), and the like. In the process, Nuevomexicanos became simple and quaint, described variously as "chili-eating," "olive-colored," "beaners," and "greasers."

As the years wore on, Anglo writers began to take their cues from previous Anglo works. Erlinda Gonzales-Berry writes of Willa Cather's *Death Comes for the Archbishop:*

> In her portrayal of Father Martínez . . . she inscribes in the creative domain the attitudes toward the native clergy disseminated by the texts of Gregg and Davis. Cloaking New

8.6

Staff of *La Voz del Pueblo*, Las Vegas, New Mexico, ca. 1898. Courtesy of the Citizens' Committee for Historic Preservation, Las Vegas, New Mexico.

Mexican priests in habits of licentiousness and immorality, the texts of the latter facilitated the Americanization of the Mexican Catholic Church and its people. Consequently, whatever Cather's intent, her novel must be viewed as part of a larger discourse of domination. (Gonzales-Berry 1989)

In the meantime, Lebaron Bradford Prince became the first director of the New Mexico Bureau of Immigration. It was his desire to see more Anglo-Americans settle in New Mexico, so he began what scholars have called a "white legend," emphasizing the noble Spanish heritage of Nuevomexicanos in a calculated effort to increase immigration from the East. While promoting Nuevomexicanos as "an elite cadre of knights on white horses" (Gonzales-Berry 1989), he simultaneously de-emphasized *mestizaje*. Beginning in 1850, this same "white legend" continued as New Mexico legislators tried for sixty-two years to convince Congress of its worthiness for statehood.

Padre Martínez was well aware of the social and political changes the Anglo-Americans would bring over the coming decades, and he began preparing Nuevomexicanos for it. One of his methods was through the written word. He used the first printing press in New Mexico to publish the first Spanish-language newspaper, *El Crepúsculo de la Libertad* (The Twilight of Liberty), although it didn't last long, and no copies have survived. The press on which he printed *El Crepúsculo* and various textbooks for his home school was brought to New Mexico from Mexico City by Antonio Barreiro, an attorney. Barreiro sold it to Ramón Abreu who then sold it to Martínez. Other Nuevomexicanos followed Martínez's lead. Their response after 1946 was a dramatic increase in writing as an exercise in coming to terms with the New Order, aided in large part by the wider availability of the printing press, thanks to the Anglo-American trade. Between 1880 and 1900, almost three hundred Spanish-language newspapers were in operation in New Mexico. (Campa estimated that between 1834 and 1960, more than five hundred Spanish-language papers were published in the Southwestern states.) Las Vegas, New Mexico, seemed to be a center of the publishing industry with forty-four newspapers begun between 1879 and 1900. The tone of their content was an affirmation of cultural identity through language, as well as the reaffirmation of the beauty and merit of the Spanish language. The publication of *periódicos* (newspapers) and *revistas* (magazines) in Spanish provided a fluency that oral transmission alone could not provide, and it promoted the use of Spanish in New Mexico at a time when English was growing in use in commerce and industry.

Many such papers were short-lived but easily replaced with another. The longest running in the entire southwest was *El Nuevo Mexicano* in Santa Fe, which used the same masthead from 1849 to 1965. During Cyrus McCormick's leadership in the mid-twentieth century, this paper employed an able editor from Chihuahua in an effort to upgrade the language and content. Spanish faculty from the University of New Mexico and other institutions wrote material for it as regular contributors, and for a number of years the traditional lore of Nuevomexicanos was featured in every weekly issue. Other important newspapers were *El Defensor del Pueblo*, *Opinión Pública*, and *Nuevo Mundo* in Albuquerque; *El Independiente* in Las Vegas; *El Heraldo del Valle* in Las Cruces; and *La Revista* in Taos.

In addition to straight news, the editors published essays, memorials, journals, obituaries, heroic deeds, birthdays, and editorials on dealings with Anglos, land grants, religion, outlaws, self-determination, the Spanish language, courage, and patriotism. They published a significant number of works from Spain and Latin America, side by side with a significant number of short stories and poems by Nuevomexicanos. In fact, more space was dedicated to creative writing than to reporting. The published décima is an example of the crossover from oral to written tradition. It seemed to be the primary poetic tool for expressing the sense of sociopolitical loss since the Anglo incursion. Prose was given equal space with poetry in the form of short narrative pieces and serialized novels. A number of ongoing political battles were waged in print, with openly Democratic or Republican editors insulting and even threatening opponents in editorial exchanges. On the other end of the spectrum, editors received

large numbers of submissions from Nuevomexicanos from all walks of life. The following excerpt dates from 1882.

<table>
<tr><td>CANTO DE UNA
JOVEN CAMPESINA</td><td>SONG OF A YOUNG
FARM GIRL</td></tr>
<tr><td>Cuando el sol brilla
No sé lo que es miedo
Libre avecilla,
Cantar yo puedo.</td><td>When the sun shines
I don't know what fear is,
Free as a little bird,
I can sing my song.</td></tr>
<tr><td>La selva hojosa
No me da espanto
Y aunque medrosa
Me anima el canto.</td><td>The leafy forest
Does not scare me
And despite my timidity
Song heartens me.</td></tr>
<tr><td>Me anima el brillo
Que el sol derrama,
Y el pajarillo
Que está en la rama.</td><td>I'm heartened by the rays
That the sun sheds
And by the little bird
Sitting on the bough.</td></tr>
</table>

(*Meyer 1996*)

The sheer volume of poetry that saw print in this period is testament to the ready creative expression of Nuevomexicanos and their centuries-old oral tradition of composing, singing, and reciting versos. As more and more scholars study and publish the newspapers and their contents, the rich lit-

8.7
Composing room of the Santa *Fe New Mexican* and *El Nuevo Mexicano*, 1899. Courtesy Museum of New Mexico, neg. #10560.

erary legacy they hold comes more into focus as one too long overlooked.

The emergence of journalism was in part a result of the growth in the late nineteenth century of *sociedades*—societies or mutual-aid societies—that began a regional upsurge in intellectual pursuits combined with social action. Anselmo F. Arellano studied sociedades and concluded that their objective was to investigate and debate questions and topics of social, literary, and moral importance. They also sponsored labor unions, protective community organizations, and education and facilities for teaching, which ultimately produced a reading public for the newspaper industry. By offering alternatives to Anglo-American institutions, they assumed responsibility for their own people. Some names are *Sociedad Literaria y de Ayuda Mutua de Las Vegas* (Literary and Mutual Aid Society of Las Vegas), *Sociedad Dramática Hispano-Americana* (Hispanic-American Drama Society), and *Sociedad Filantrópica Latino-Americana* (Latin American Philanthropic Society).

"Reading, like many other skills in the Spanish Southwest, was transmitted by tradition," wrote Campa in 1979.

> That is, a father who could read taught his son enough to get him started, and if he was lucky to receive instruction from an itinerant school teacher or at a church school, he would learn not only reading but writing and arithmetic. The well-written letters and official records found in the villages and towns throughout the Southwest attest to a greater literacy than is usually attributed to the inhabitants. Books were not numerous . . . and were not particularly abundant in American territorial days, but newspapers provided reading material for those who could read. (Campa 1979)

Lomelí compiled a list of books found in personal libraries or mentioned in book catalogs or jackets of the nineteenth century. They include Spanish novels published in Barcelona and Paris, works by George Sand, Victor Hugo, Chateaubriand, Jorge Isaacs, E. J. de Goncourt, A. Dudet, and A. Belot. Also included were masterpieces from the Spanish

Golden Age, the picaresque novel, Modernist poetry from Latin America, *costumbrista* literature of Mexico, Greek, and Latin classics, and works by Shakespeare, Shelley, and Byron. Campa lists also eighteenth-century editions of Calderón de la Barca's plays, and books on agriculture bound in vellum and published in Spain in the 1700s. According to Campa, the mountain villagers who owned these books complained about their spelling errors, unaware of the changes in the language over three hundred years. In 1898, the *Trinidad Chronicle* and *El Progreso* in Trinidad, Colorado, serialized for its readers Villagrá's *Historia de la Nueva México*, thus predating the Mexican edition by two years. In short, it was the work's first appearance in print since 1610.

Some of the more frequently published writers include Higinio V. Gonzales (also a well-known musician), José Manuel Arellano, Jesús María H. Alarid, Manuel M. Salazar, Eleuterio Baca, Urbano Chacón, Florencio Trujillo, Ezequiel Cabeza de Baca, Jesús Gonzales, Antonio Lucero, Enrique Salazar, Severino Trujillo, Antonio B. Trujillo, Pedro Bautista Pino, Conchita Argüello, Nina Otero, Aurora Lucero White-Lea, Nestor Montoya, N. Faustín Gallegos, Jovita Gonzales, and Josefina Escajeda.

At this time, few Anglo-American residents read the Spanish-language newspapers, which were viewed by the larger Anglo community as ethnocentric and exotic, according to Lomelí, who wrote,

> Despite the quantity and quality of Hispanic literature produced at the time, two parallel versions of literary history developed. One version, perhaps called "official" embarked on acknowledging only Anglo-American writings; the other, a Hispanic version, made the effort to emphasize literature written in Spanish. (Lomelí 1989)

This served to separate the two cultures even more, and ultimately to eclipse Nuevomexicano literature. After the newspaper boom was over in the 1930s, it seemed to disappear from the annals of Southwestern literature. Only recently have scholars begun reconstructing the literary history of that

8.8

Front page of *El Independiente*, Las Vegas, New Mexico, April 28, 1894. Courtesy Museum of New Mexico, neg. #160911.

period, and it is far from complete. Still, bilingualism is supported by law in New Mexico, unlike other states where English-Only amendments were voted into the constitutions in California, Florida, Colorado, and Arizona. Meyer (1996) writes:

> When English-Only advocates today speak of the need for an official language as a means of establishing a common bond between diverse peoples in our country, I think of Benjamín Read and other *neomexicanos* who knew that the only meaningful common bond is responsible citizenship, not language.

Literature in the Nineteenth and Early Twentieth Centuries

As elsewhere in Latin America, Nuevomexicano authors of the nineteenth century tended to write allegorical novels and histories. Themes of nationhood prevail, and the subordinated status of New Mexico as a nation within a nation was especially poignant. Several of the following works have only recently been discovered.

- Manuel M. Salazar's *La historia de un caminante, o sea, Gervacio y Aurora* (The History of a Traveler on Foot, or Gervacio and Aurora, 1881) a story of pastoral life in New Mexico. Being the earliest manuscript thus far, Salazar is then the first known Nuevomexicano novelist, even if only in manuscript form.
- Eusebio Chacón's *El hijo de la tempestad* (Child of the Storm) dates from 1892, as does his *Tras la tormenta la calma* (The Calm after the Storm).
- Manuel C. de Baca wrote a chronicle or historical novel in 1896 titled *Historia de Vicente Silva y sus cuarenta bandidos, sus crímenes y retribuciones* (The Story of Vicente Silva and His Forty Bandits, Their Crimes and Retributions).
- Porfirio Gonzales wrote *Historia de un cautivo* (The Story of a Captive) in 1898.
- Vicente Bernal (1888–1926) wrote *Las primicias* (Firstfruits) in 1916.
- Felipe M. Chacón (1873–1948) wrote *Obras de Felipe Maximiliano Chacón, 'El Cantor Neomexicano' Poesía y Prosa* (Works of Felipe M. Chacón, 'The New Mexican Bard' Poetry and Prose) in 1924.
- Benjamín M. Read (1853–1927) wrote *Guerra México-Americana* (Mexican American War) in 1910 and *Historia ilustrada de Nuevo México* (Illustrated History of New Mexico) in 1911.

Many of the Nuevomexicano works produced in the territorial period remained unpublished, including those of Manuel Salazar and Porfirio Gonzales, or published but out-of-print and not easily accessible. Rafael Chacón's memoirs were published through the efforts of Jacqueline Meketa in her work entitled *Legacy of Honor*. Given below are brief descriptions of three of these writers and their works. As more research is conducted, the promise of more information on these and other writers will fill in the numerous gaps in knowledge of their lives, times, and works.

Eusebio Chacón (1869–1948)

Born in Peñasco, Chacón was highly educated, having received a bachelor's degree from the Jesuit College in Las Vegas, New Mexico, and a law degree from Notre Dame University. He was an orator, public defender, and interpreter-translator for the U.S. courts in the time of land-grant disputes. In addition, he was an essayist, poet, journalist, and a member of at least two *sociedades*. He was judicious and mild-mannered, but firm and impassioned when the need arose. What is significant about Chacón is his awareness and exploration of the Nuevomexicano oral tradition as a basis for establishing the novel as a new genre in the region.

The racial strife that surrounded Las Vegas in 1889 gave rise to violence and secret organizations created to intimidate Anglo-Americans and to resist their co-existence. Chacón's two works arose from this situation, published at the same time. In *El hijo de la tempestad* the opening scene is a stormy night of terrifying proportions. A child is born in a cave during the storm, while simultaneously in a nearby town, a gypsy woman sings a prediction of a boy's birth, warning the townfolk to avoid him because he is destined to be the terror of the region. Chacón

8.9
Eusebio Chacón. From Benjamín
M. Read, *Historia Illustrada de
Nuevo México*, 1912.

uses oral tradition as a backdrop (Lomelí suggests imagining this scene being told instead of read) in an attempt to transform oral storytelling—what he called *"literatura recreativa"*—into written storytelling. The novel presents the stuff of cuentos, including fantastic duels between two sorceress-like women, a monkey that becomes a large devil figure, and a woman known as *Sombra de la Luz* (Shadow of the Light) who is swallowed when the Earth opens up. As a thief, the young man operates out of the same cave in which he was born (his mother having died in the process), and is assisted by one hundred other thieves who regularly sack surrounding communities. The novel is also a political allegory of Las Vegas, which was terrorized for several years in the 1890s by Vicente Silva, a local man who frequently crossed ethnic lines in his choice of victims.

In addition to creative writing, Chacón was anxious to write a history of New Mexico, and he collected old historical documents for that purpose. He published a series of articles in *Las Dos Repúblicas* from March 7 to May 23, 1896, entitled *Descubrimiento y conquista de Nuevo México en 1540 por los españoles* (Discovery and Conquest of New Mexico in 1540 by the Spanish). He was one of a number of Nuevomexicano writers at this time who expressed interest in writing New Mexico's history. Chacón's work was published by *La Tipografía: El Boletín Popular* in Santa Fe (no date). Also see Martínez and Lomelí (1985).

Felipe Maximiliano Chacón (1873–1949)

The Chacón family is well-represented in New Mexico literary history. Felipe M. Chacón was the son of Urbano Chacón, a respected newspaper publisher throughout northern New Mexico and southern Colorado, and a superintendent of Santa Fe schools. Urbano's older brother was Rafael Chacón (1833–1925), a military man who wrote his memoirs in Spanish and had three copies made before he died. Rafael's son was Eusebio Chacón, who is discussed above.

Felipe M. Chacón is known to contemporary scholars because he was able to publish a large number of his works in a book entitled *Obras de Felipe Maximiliano Chacón, 'El Cantor Neomexicano' Poesía y Prosa* (Works of Felipe M. Chacon, 'The New Mexican Bard' Poetry and Prose), encouraged by his friend and mentor, Benjamín M. Read. Meyer speculates that it was published on the same press as that used to put out *La Bandera Americana*, the Spanish-language newspaper in Albuquerque, where he was editor and general manager in the 1920s.

8.10
Felipe Maximiliano Chacón. From Felipe Maximiliano Chacón, *Obras de Felipe Maximiliano Chacón, "El cantor neomexicano"; Poesía y prosa* (published in Albuquerque by the author, 1924).

In style and content, Chacón's poetry, in fact, bears comparison with the popular and learned poetry published in many Spanish-language newspapers in the late territorial period, reaffirming the impression that other *neomexicanos* could have published literary volumes as Chacón did, had they had a mentor like [*Benjamín*] Read and the monetary ability to do so. The paucity of *neomexicano* literature published in Spanish therefore points to the lack of a support network, not the lack of talent. (Meyer 1996)

Chacón divided his time between journalism and other business pursuits. He was, like other upper-class Nuevomexicanos, bilingual, and wrote well in both languages. Read praised his mastery of "the Castilian language, with no help, in a country whose language is English and where there are few or no opportunities to learn Spanish properly" (Meyer 1996). *Obras* includes fifty-six poems from all periods of his life, seven of his own translations of English and American authors, two short stories, and a *novelita*. The works span forty years and touch on a variety of subjects from love to politics. He uses traditional octosyllabic verse as well as more complex meters. Here is an excerpt from a celebratory poem he listed under *Cantos Patrios* (Patriotic Songs):

A NUEVO MÉXICO
En su admisión como Estado

Por fin habéis logrado, suelo mío
De lauros coronar tu altiva frente,
Alcanzando del cielo del estío
Una estrella gloriosa y esplendente;

Estrella cuyos lampos matinales
Os proclaman Estado soberano.
Que brille de la Patria en los anales
¡Eterno en el pendón americano!

Honor para tus hijos, que han sufrido
Contigo numerosos desengaños
Y con ellos tan solo conseguido
En injusto baldón de muchos años; . . .

Ver que el honor para tu historia escriba
Con luz de su pincel inmaculado.
Hechos que lleven la mirada arriba
Y te hagan de la Unión felix dechado.

Entretanto, tus hijos hoy elevan
De yítores un coro entusiasmado.
Cuyos ecos de júbilo resuenan. . . .
"Que viva Nuevo México, el Estado!"

TO NEW MEXICO
On Being Admitted as a State

You have finally achieved, land of mine,
The laurels that crown your lofty forehead,
Plucking from the summer sky
A glorious and shining star;

A star whose morning light
Proclaims you a sovereign State,
May it shine in the annals of the Fatherland
Forever on the American flag!

An honor for your sons who have suffered
With you numerous disappointments,
And with them have only reaped
The unjust insult of many years; . . .

See that honor writes your story
With the light of its immaculate pen,
Deeds that lift our sight higher
And make you a fine example of the Union.

Meanwhile, your offspring raise today
An enthusiastic chorus of hurrahs
Whose echoes resound with joy. . . .
"Long live New Mexico, the State!"
(*Meyer 1996*)

Although in English, the following excerpt gives an idea of Chacón's style. It is from his prose work entitled *Don Julio Berlanga* about a shepherd who travels to Las Vegas to enjoy himself after a season of tending sheep in Wyoming.

It was in August of 1918 when I had the honor of meeting don Berlanga, from . . . in Las Vegas, New Mexico.

Don Julio was an industrious man of forty-eight, nearly six feet tall, erect in stature, muscularly built, with a swarthy complexion, prominent cheekbones, thick mustache, dark hair, and lively, though somewhat sunken, eyes. A man not given to jokes and pranks, though he knew how to appreciate this talent in others, he was always candid and serious in his conversation, even when dealing with trifles.

In spite of don Julio's good qualities of sobriety, laboriousness, and constancy in his occupations, he nonetheless showed a kind of innocent vanity which, in a person of his serious nature, was very amusing. To give a clearer idea of his inimitable character, I intend to relate, in his characteristic fashion, the description he himself gave me of the happiest day of his life.

We were both seated in the waiting room of the railroad station, conversing, when he said to me, "I'll never forget this place, Las Vegas, and do you know why?"

I gave him an inquisitive look and, after a brief pause, he continued, "Because here I spent, last year, the happiest day of my life. You see, I arrived here the afternoon of the third of July from Guayuma, Wyoming, where I had been working with the sheep for a year. . . ." (Meyer 1996)

Benjamín M. Read (1853–1927)

Born in Las Cruces to a Mexican-born woman and the son of a prominent Baltimore family (and descendant of a signer of the Declaration of Independence), Read would become the first native New Mexico historian. He would also serve in the legislature as a representative and as

8.11
Benjamín M. Read, ca. 1911. Courtesy Museum of New Mexico, neg. #111958.

Speaker of the House, as a successful Santa Fe attorney, translator for the territorial governor, teacher at his alma mater, St. Michael's College, and superintendent of the Santa Fe schools. His father died when he was three and his mother, Ignacia Cano, reared Read and his two brothers alone in semi-poverty.

Read will be remembered in history for his mission to carefully reconstruct Nuevomexicano history over a period of two decades, which may have begun with his job of translating old documents from Spanish into English for the territorial legislature. The impact of their accurate translation became immediately clear to him as an attorney. Further, according to Meyer (1996):

He could not have overlooked the fact that the disproportionate influence of the Anglo community in territorial society was based on its control of law, commerce, and banking—all defined by a technical knowledge of regula-

tions and documents—which was changing the informal, community-based patterns of life in New Mexico.

Like Padre Martínez, whose life and accomplishments had inspired him, Read appreciated the importance of being bilingual and even bicultural in order to meet these challenges, and that "the accurate transmission of history was critical to ensuring a stable and productive future for New Mexico" (Meyer 1996). He set about collecting books and original documents on New Mexico.

He was also acutely aware of the scholarly professionalism of Anglo historians, and knew that any historical statement he made must be supported by abundant documented evidence. Among his colleagues he gained a reputation for insistence on accuracy, and for having no patience with "romanticism" when it came to history. At his own expense, he traveled to Spain, Mexico, and throughout the territory to study archives and other primary resources. Read's objection was not to American government—which he welcomed for its democracy and freedom—but to the ethnocentrism of Protestant-Anglo culture, which permeated its histories. He felt that the history of New Mexico had, through the years, been misread and mistranslated.

His first book, published in Spanish in 1910, was *Guerra México-Americana* (Mexican American War), which dealt with the causes and consequences of the war rather than its military aspects. He ties the origins of U.S. expansionism, which caused that war, to the incursion into New Mexico under Kearny's command, and he contests interpretations of New Mexican history by such authors as H. H. Bancroft and Ralph Twitchell, who had just published a history of the American occupation of New Mexico.

In 1911, Read published his ambitious *Historia ilustrada de Nuevo México*, which was divided into four historic periods, pre-Columbian, Spanish, Mexican, and American. It included a section that presented brief biographies of 146 men and women of New Mexico, extensive footnotes, and photos of notable contemporary figures, all within 616 pages of text. It was translated into English by Felipe M. Chacón and published in 1912. It was published in

limited edition in Santa Fe and has not been reprinted. By contrast, the Bancroft and Twitchell histories are available in any library in New Mexico.

Read completed two additional manuscripts before his death in 1927, neither of which have been published. They are *Hernán Cortés and his Conquest of Mexico*, copyrighted in 1914 and originally intended for publication by a Boston publisher, and *Nuevo México en las guerras de la Unión Americana, 1855–1919* (New Mexico in the Wars of the American Union, 1855–1919).

Literature in the Middle and Late Twentieth Century

Benjamín Read anticipated the trend toward publishing in English. It was a trend that grew as the twentieth century advanced. Another prominent legislator, Adelina (Nina) Otero Warren, wrote her nostalgic autobiography (*Old Spain in Our Southwest*, 1936) in English, as did Cleofas Jaramillo (*The Genuine New Mexico Tasty Recipes*, 1939; *Shadows of the Past*, 1941; *Romance of a Little Village Girl*, 1955), Fabiola Cabeza de Baca Gilbert (*The Good Life, New Mexico Traditions and Food*, 1949; *We Fed Them Cactus*, 1954), and Aurora Lucero-White Lea (*Literary Folklore of the Hispanic Southwest*, 1953). These women sought to examine New Mexico's past and to preserve the traditional folkways before they passed into obscurity. This they did in fiction, folklore, and autobiographies, including a culinary autobiography combining recipes with memoirs. Miguel A. Otero—a governor of New Mexico—wrote a three-volume autobiography entitled *My Life on the Frontier* (1935).

A common literary theme during this period seems to be a looking back to the old life—or as someone once described reluctant audiences of contemporary music "walking into the twentieth century backwards." Nuevomexicano writers drew their inspiration from oral tradition, pre-Territorial days, and earlier writers. In his survey of Hispanic literature nationwide, Kanellos describes New Mexico as the one state where contemporary writers are strongly tied to the region's tradition and history.

The decade of the 1960s saw a renaissance of

8.12

Nina Otero Warren (1881–1965).
Courtesy Museum of New
Mexico, neg. #30263.

8.13

Aurora Lucero-White Lea
(1893–1964) in 1911. Active in
politics, women's rights, education,
literary research and journalism.
From New Mexico Normal
University Bulletin, January 1911.

Nuevomexicano literary activity comparable to the renewed activity in the visual arts. The difference was that the Chicano literary movement flourished nationwide, essentially jump-started by the Civil Rights Movement and the political climate of the 1960s, which was more open to formerly marginalized cultures, even if only by force. Further, the increase in availability of higher education and opportunities for national and international travel opened the world to Nuevomexicano writers who then interacted with kindred spirits in other areas of the nation and at gatherings and conferences focusing on the various civil rights issues. As if on cue, publishers were ready to consider the works of emerging writers, even as universities were ready to train and provide a forum for their ideas.

Chicano literature, as it was now called, helped fan the flames of the farmworker movement, and helped writers grapple with political, economic, and educational concerns, as well as concerns over the passage of cultural mores from one generation to the next. Not surprisingly, according to Nick Kanellos, many of the first writers of this period were those who could tap into the oral tradition of public performance.

In the 1970s and 1980s, a new generation of Nuevomexicanos found continued opportunities to travel, study, reflect, write, and publish, particularly women. The emergence of Hispanic-run publishers like Arte Público Press and *El Grito* was mirrored in New Mexico by the emergence of El Norte Publications and *Blue Mesa Review*. In the 1990s, Ana Pacheco founded *La Herencia del Norte*, a quarterly magazine offering reminiscences, biographies, poetry, recipes, cultural studies, and herbal advice from established and emerging writers statewide.

Numerous creative writers and poets have emerged in the second half of the twentieth century. Here is a very brief sampling. Instead of excerpts, a basic reading list is given at the end of the bibliography of this chapter, including works by these and other authors.

Fray Angélico Chávez (1910–1997)

Known as one of the most respected religious poets in the nation, Fray Chávez began writing in the 1930s. Born in Wagon Mound, he was raised in Mora and educated in the Midwest. He was the first Nuevomexicano to become a Franciscan friar (1937) and he served as a pastor in several New Mexico towns and pueblos. He also served as the historian of his order and archivist for the Archdiocese of Santa Fe.

His work is informed throughout with his abiding interest in the past and in New Mexico folklore and its people. His religious poetry is addressed to Christ and the Virgin Mary and reveals his spiritual life: *Clothed with the Sun* (1939), *New Mexico Triptych*

(1940), *Eleven Lady Lyrics and Other Poems* (1945), *The Single Rose* (1948), and *Selected Poems with an Apologia* (1969).

His historical works include *Our Lady of the Conquest* (1948) and *La Conquistadora: The Autobiography of an Ancient Statue* (1954). Other historical works are *Origins of New Mexico Families in the Spanish Colonial Period* (a compilation from archival material, 1954), *Coronado's Friars* (1968), *But Time and Chance: The Story of Padre Martínez of Taos, 1793–1867* (1981), *From an Altar Screen/El Retablo: Tales from New Mexico* (1957), *The Lady from Toledo* (1960), and his famous essay, *My Penitente Land: Reflections on Spanish New Mexico* (1974).

Sabine Ulibarrí (b. 1919)

His stories are tinged with nostalgia for the pastoral life of old New Mexico. This short-story writer, poet, and essayist was born in Tierra Amarilla in the heart of northern New Mexico, and raised on a ranch by college-educated parents. In World War II, he flew thirty-five missions as an Air Force gunner; after the war he turned to education, earning a doctorate in Spanish and ultimately teaching at every level from primary to post-secondary school. He is professor emeritus of the University of New Mexico.

His language and narrative style reveal his familiarity with the oral traditions of his homeland, Latin America, and Spain, and their presentation in bilingual format make them highly accessible. The short stories are populated with cowboys, sheriffs, folk healers, hermanos, and plain village folk. He has received numerous awards, including the White House Hispanic Heritage Award in 1989. He has published two books of poems, *Al cielo se sube a pie* (You Reach Heaven on Foot, 1966), and *Amor y Ecuador* (Love and Ecuador, 1966). His short-story collections include *Tierra Amarilla* (1971), *Mi abuela fumaba puros y otros cuentos de Tierra Amarilla* (My Grandmother Smoked Cigars and Other Stories of Tierra Amarilla, 1977), *Primeros encuentros/First Encounters* (1982), and others.

Rudolfo Anaya (b. 1937)

Born in Pastura, New Mexico, Anaya earned degrees in English, and Guidance and Counseling at the University of New Mexico in the 1960s and early 1970s. He directed the creative writing program at the University of New Mexico until his retirement. He has received numerous national and international awards for his works. His first novel, *Bless Me, Ultima* (1971), tells the story of a boy's coming of age in rural New Mexico, and is partly autobiographical. It represents a search for identity between Nuevomexicano and Pueblo cultures, and carries many references to Indian, Spanish, and Asian cultures. *Bless Me, Ultima* has touched more lives worldwide than any other work of Chicano literature, with one million copies in print in English, Spanish, French, Italian, Russian, and Japanese.

Other works include *Heart of Aztlán* (1976), *Tortuga* (1979), *The Silence of the Llano* (1982), *Alburquerque* (1992), *Zia Summer* (1996) and many more. He has also written plays, poetry, and children's stories, including *The Farolitos of Christmas*, which was produced for the stage by La Compañía. His *Aztlán: Essays on the Chicano Homeland* was co-edited with Francisco Lomelí. Ever supportive of emerging Nuevomexicano writers, he has co-edited anthologies, including *Cuentos Chicanos* (1980) and *Voces/Voices* (1987), and together with his wife Patricia, established the Premio Atzlán literary prize given annually in New Mexico. Anaya's works often recall the idea of Atzlán, the mythical origin of the Aztec culture, thought to comprise what is now the five Southwestern states. The Chicano literary movement derived much inspiration from the idea of Atzlán as a source of imagery, symbols, and myths. Another theme in Anaya's works is the reestablishment of harmony and social order by drawing from traditional folkways.

Denise Chávez (b. 1948)

Ms. Chávez holds a degree in creative writing and has taught at the University of Houston and currently teaches at New Mexico State University in Las Cruces. Her work was chosen for inclusion in the *Norton Anthology of American Literature* and *Mexican American Literature*, published by Harcourt Brace Jovanovich, representing an endorsement by the Anglo literary establishment.

Her writings include *The Last of the Menu Girls* (1986) and *Face of an Angel* (1993). In the latter, the

author explores the technical limits of the written page, using two separate yet similar stories printed in two adjacent columns in one segment of the novel. *Face of an Angel* focuses on the life of a waitress and her various adventures with men. It is a bawdy, irreverent, and humorous examination of the major tenants of the feminist movement vis-à-vis the life of a waitress who keeps making the wrong choices. The novel also includes several other unique Southwestern characters, both humorous and tragic.

She organizes the annual Border Book Festival held in Las Cruces to encourage Chicano literature. She is an accomplished actor and playwright, and has published *Shattering the Myth: Plays by Hispanic Women* (1992). She also has published several short stories.

Pat Mora (b. 1942)

A poet and El Paso native with several published collections, Ms. Mora has published *Chants* (1984), *Borders* (1986), *Communion* (1991), *Nepantla: Essays from the Land in the Middle* (1993), and *Aunt Carmen's Book of Practical Saints* (1997). Mora's works draw their inspiration from the desert landscape and Indian cultures. In *Communion*, her perspective is global as she explores ties with other women of the world; in *Borders* she explores the different kinds of borders humanity has devised, such as the one between El Paso and Las Cruces. She is included in this list because El Paso historically is part of New Mexico. Mora also has received national attention and awards, including inclusion in the Norton and Harcourt Brace Jovanovich textbooks.

Estevan Arellano (b. 1940)

A farmer, cultural activist, journalist, and photographer, Arellano is renowned in literary circles for his picaresque novel, *Inocencio: ni pica, ni escarda, pero siempre come el mejor elote* (Inocencio: He Never Digs Nor Hoes, But Always Eats the Best Ears of Corn). The only novel written in New Mexican Spanish, *Inocencio* won the prestigious José Fuentes Mares Literary Prize in Mexico in 1991. In the 1970s, Arellano was active in the *Academia de la Nueva Raza* in Embudo, New Mexico, which conducted pioneer oral history projects and published a journal and a folklore collection.

Jimmy Santiago Baca (b. 1952?)

Baca's childhood and youth have colored his life and works for many years. He was abandoned as a child (hence the uncertain birthdate) and grew up in Albuquerque's South Valley. He began writing in prison. Those works were not about being Chicano, but about being in prison, and were published in *Immigrants in Our Own Land*, 1979. Other works include *Working in the Dark: Reflections of a Poet of the Barrio* (1992), *Black Mesa Poems* (1989), *Martín, and Meditations on the South Valley* (1987). *Martín*, his autobiographical epic poem, was staged by La Compañía de Teatro de Alburquerque in the early 1990s.

Martín, like many of his works, is strongly influenced by the past, but more out of pain and profound sadness than longing and nostalgia. His work is full of contrasts. His mestizo heritage comes alive in his poetry, and yet the reader also glimpses life in the Heights of Albuquerque (i.e., Anglo life). In *Martín*, he reviews his life and determines not to repeat the mistakes of his parents, while also seeking salvation from the spirits of his ancestors. His poems are populated with authentic Southwestern figures, updated to include characters of the late twentieth century, hence the reader visits with santeros and alcoholics, healers and gang members, elders and prostitutes, *La Llorona* and lowriders. Baca's appeal lies in his vivid yet lyrical language and evocative images. In addition to his poems, he has also begun screenwriting.

Other accomplished poets of the late twentieth century include Cordelia Candelaria, Demetria Martínez, José Montoya (considered by some to be a California poet), Leroy Quintana, Cecilio García-Camarillo, Leo Romero, Juan E. Arellano, Robert Gallegos, Cecile Turrietta, and E. A. Mares. Prose writers, essayists, and playwrights include Enrique Lamadrid, M. Salomé Martínez, Robert Perea, Erlinda Gonzales-Berry, Albert Lovato, Michele Sedillo, Demetria Martínez, Nash Candelaria, Katherine Baca, Orlando Romero, Joseph Torres-Metzgar, Rudy S. Apodaca, and Kika Vargas.

Oral Tradition of New Mexico

Folklore, by definition, is the direct expression of the collective wisdom of a people from its origins to the present day, transmitted from generation to generation without the aid of technology of any kind. It consists of traditional beliefs, customs, character, feelings, manners, religious beliefs, ideas and legends—those intangibles that comprise the spirit of a people, and which represent an essential element of any culture.

Aurelio Espinosa found Nuevomexicano folk literature in romances, folktales, *dichos* (proverbs), riddles, prayers, children's games and nursery rhymes, folk drama, legends, and superstitions. Other early scholars who worked to preserve folk literature include Américo Paredes, Aurora Lucero-White Lea, Arthur Campa, Rubén Cobos, Lorin Brown, Reyes Martínez, Cleofas Jaramillo and Juan B. Rael. More recent scholars include Charles Briggs, Nasario García, Rubén Cobos, Stanley Robe, J. Manuel Espinosa, Enrique Lamadrid, Peter White and Marta Weigle.

Espinosa's research revealed that the folklore of New Mexico is for the most part of peninsular origin. On his visit to Castilla in 1920, he "met the same folktales, the same ballads, the same riddles and proverbs, the same language, of course, and even the same manners, customs, superstitions, and beliefs that I had previously found in New Mexico" (Espinosa and Espinosa 1985). For example, he found *Buenas tardes le dé Dios* (May God give you a good afternoon) used as a greeting in Tudanca, Spain, which is in Castilla. Though rare in Spain today, this phrase is very common in New Mexico. Also, *¿Quiere su mercéd tomar la mañana?* (Do you wish to take a drink?) and *Para servir a Dios y a usted* (at God's service and at yours) are two more expressions found in both Castilla and New Mexico. The latter is a phrase used by Nuevomexicano children to properly address their elders. This fidelity of preservation in its distinctive forms in New Mexico surprised Espinosa. In his studies, Arthur Campa found the Nuevomexicano language surprisingly broad and rich in folklore. He added that the challenge of rhyme required the study and use of forms of expression that common

folk seldom used, but which he found in abundance in New Mexico.

Later in the twentieth century, scholars like Américo Paredes, J. Frank Dobie, Juan Rael, Stanley Robe, José Limón and María Herrera-Sobek, among others, began demonstrating the impact of Mexico's folklore on that of New Mexico. Paredes was prolific in this endeavor, publishing about one hundred articles and books on Mexican-American folklore and the Chicano experience, including folk speech, the jest, dichos, the décima, and the corrido, among others. Chicanos of the 1960s and 1970s considered themselves not entirely Mexican, and not entirely American. To achieve self-identity, they rediscovered the legend that the ancient Aztecs had once lived in the American Southwest before migrating south to Mexico. This legend became central to their identity, and is found in abundance in Chicano literature. The incorporation of the Native American folklore of Mexico and New Mexico is also evident in the *coyote* tales of New Mexico, as well as the legend of La Llorona.

Charles Briggs's research on the "performance" of dichos, folktales, and other types of oral literature in New Mexico reveals very intricate and skillful use of stylized language and persuasive speaking—gifts mastered in large part by elders. Such a skill is called *la plática de los viejitos de antes* (the ancestors' talk) because it serves to impart values of the past while ensuring the vitality and survival of the culture. In addition, Briggs learned that the best verbal artists have the largest repertoires, samples of which they introduce into conversations only as applicable to its context. The classic setting for such interchanges is at informal gatherings of more than two elders, who invariably draw an audience by virtue of their knowledge of the folklore and the past, and by their animated verbal skills.

Because Spanish in New Mexico has continued largely through oral transmission rather than formal schooling, the role of folklore is critical because it reveals the philosophies, humor, politics, and values of colonial New Mexicans. The major source of Nuevomexicano folklore was Spain, which itself was the channel through which

Oriental tales and legends were transmitted to other European countries. Spain had been a cross-roads for Greek, Roman, Phoenician, Arab, Jewish, and Germanic peoples. Tales from India and Persia were transmitted to Spain via the Jews and Arabs who occupied Spain for many centuries. These transmissions occurred both orally and in written form, beginning with the works of Spaniards writing in Latin or Old Spanish in the twelfth century. Beyond India, Espinosa speculated that the earlier sources were Buddhist counseling stories. Folklorists tell us that over half of European folktales come from India or Persia, and that a number of them are of European origin but with Indian or Persian elements. Less than half the European folktales are exclusively European in origin. The folktales Espinosa gathered in northern New Mexico and southern Colorado are mostly of European origin.

Literature and music, and even dance, are closely intertwined in folklore. In speaking of romances, for example, it must be remembered that they can be sung, and that while they arise from an "oral tradition" they were often written down into handbooks carried by the troubadours or poetas. Unfortunately, because much of what the poetas knew was memorized, many took their works with them to their graves.

Los Poetas

Folktales were told and retold by the poetas, or popular village poets and singers, who were held in high esteem among the people. What Campa called troubadours, and other scholars call *bardos*, *cantadores* (singers), or poetas (poets), were the composers and keepers of the romances, corridos, décimas, and other poetic forms used to tell stories, relay news, celebrate events, and entertain. They were on hand at *resolanas* (informal gatherings of men), *tertulias* (social gatherings) and weddings, in taverns, and on the pack trail, such as the Camino Real or the Santa Fe Trail. On the trail, poetas engaged in campfire poetry/song competitions, outwitting one another in verse. Occasionally scholars find a number of longer pieces in the possession of someone who served as a kind of scribe for the community. However, the scribe signed only his own work, so other recorded pieces in his possession remained anonymous.

In New Mexico, there were several famous poetas identified in the mid-twentieth century by Campa and other scholars who collected numerous songs and poems from them. One was Apolinario Almanzares who died at age ninety-eight after a long and eventful life. According to Campa (1946), Almanzares's parentage was never determined.

He had been bought from the Comanche Indians by the residents of Las Vegas when he was a very young boy. It seems that because of his stature and his ability as a rider the Indians had used him as a jockey to run their race horses when they went on trading expeditions. The Spanish residents, noting the whiteness of his skin, inquired about the boy and learned that he had been taken as a child from hostile Apaches. A trade was finally arranged with the Comanches and the boy was sold to the settlers for a horse and blanket. He had some knowledge of Spanish, which he soon improved among his new foster parents. In time he became a regular member of the community and took to composing verse while still young. His early compositions were patterned after the corridos and décimas current in his childhood, but to these he added forms of his own which he simply called *versos*. Still interested in horses, young 'Polinario' became one of the best bronco-busters in the mountains of Las Vegas. Being footloose, and urged by the roving spirit acquired from living with nomadic Indians, he went from place to place as a jockey, cowpuncher, and troubadour. A prodigious memory and a good voice helped him to earn a few pesos wherever he went. In time Apolinario Almanzares came to be the best known troubadour in the vicinity of Las Vegas.

Other poetas included men such as El Viejo Vilmas (Old Vilmas), Chicoria, and El Pelón (The Bald One). Others mentioned by Campos are Taveras, Cienfuegos, and Gracía, who composed the poem quoted at the beginning of this chapter.

Their dates are almost unknown and their works have passed through a number of generations. Próspero Baca was a famous poeta of Bernalillo. El Pelón, whose real name was Jesús Gonzales, was born in Pojoaque in 1844, and began composing when he was very young. He was a sheepherder whose rawhide manuscript was found in a cave in the 1930s. Chicoria's works are thought to be primarily epigrammatic since nothing in writing has been found, but many elders will preface their proverbs with *pos como decía Chicoria* (as Chicoria said).

El Viejo Vilmas wrote *Trovos*, a long series of verses from contests between trovadores. The opening speech of *Trovos* accuses Vilmas of avoiding a new contest with other trovadores who wished to unseat him as the best in the land. Vilmas answers,

Salga el que fuere prudente	He who is prudent should
A trovar con la razón,	Come out to duel with reason,
Que el que es amante no teme	For he who is a lover does not fear
Antes busca la ocasión.	But rather looks for the occasion.

<div align="right">

*(Campa 1946,
translated by Enrique Lamadrid)*

</div>

Folktales

Aurelio Espinosa was the first to collect folktales in the Southwest, which he first began publishing in 1909. In all, he collected over a thousand, eighty percent of which he identified as traditional folktales directly of Spanish origin. The folktales he collected were of three types: (1) folktales identical to peninsular versions, (2) folktales with a mix of different folktale elements, and (3) folktales with locally added details. He also concluded that peninsular versions were never confused with New World versions in New Mexico, and both were used equally.

Espinosa studied folklore in northern New Mexico, southern Colorado, coastal California, and Spain. His work in New Mexico and Colorado occurred between 1902 and 1911. He published numerous books and articles in the first half of the twentieth century on folklore, dialectology, the science and transmission of folk literature, texts of folktales and ballads, comparative studies, and philology (the study of written texts). His culminating work on folktales was a three-volume work called *Cuentos populares españoles: recogidos de la tradición oral de España*, which has not been translated into English. He studies the earliest origins of New Mexican folktales, reaching back to European and Asian traditions, as well as basic patterns of folktales. Espinosa was born in New Mexico and had a thorough knowledge of the Spanish dialect spoken in New Mexico by older residents.

Espinosa's research in Spain in 1920 included folklore-gathering visits to Santander in northern Spain, Cabuérniga, Santillana, Torrelavega, Tudanca, and Santotís on horseback, where he collected material from poor rural folk. He then visited southern Spain, and Castilla, including Villatorre, Plazuela de Muñó, Urbel del Castillo, and Villahoz, the monastery at Santo Domingo de Silos, Contreras, Covarrubias, Ontoria, Cubillos,

Cuevas, Mambrillas, Hortigüela, Lara, Campo Lara, San Millán de Lara, Barbadillo del Mercado, and the castle at Lara. He also visited Valladolid, Burgos, Soria, and nearby villages of Garrey, Calatañazor, León, Villecha, Astorga, Porqueros, and Zamora. Later he collected in Segovia, Valseca, Fuente Pelayo, Salamanca, Medina del Campo, Avila, and Granada, including a *barrio gitano* (gypsy barrio), there called El Albaicín, which he found to be a gold mine of folktales. From El Albaicín he traveled on to Córdoba, Zaragoza, El Campo de la Verdad, Toledo, and Madrid. Espinosa reported that his folktale sources knew the older versions from the newer ones, and never confused the two. His method was to handcopy everything as recited to him, including phrasing and intonation. In Spain, he collected a total of 302 folktales, and published 280 in his *Cuentos populares españoles*. He reported that folk literature was abundant throughout Spain, and that much of it was in verse.

He concluded that:

New Mexico ballads [*romances*] are, on the whole, versions that have undergone little change since the sixteenth century. The old assonances and the octosyllabic verse help us to detect the changes and to observe here and there a necessary line. (Espinosa and Espinosa 1985)

The following tale was collected in three versions by Espinosa. A mother pigeon lives in the mountains where she had a nest in an oak tree with four young pigeons. A coyote terrorizes her into giving up a young pigeon in order to save the others. A bald-headed bird (bittern) advises her for the coyote's next threat, and she comes out the winner. The coyote becomes very angry and when he finds the bald-headed bird at a watering place, he grabs it in his teeth, and accuses it of helping the mother pigeon. But the bird tricks it into shouting aloud, "I have just eaten bittern!" allowing the bird to fly away.

The story as told above was the version told by his mother's grandmother, who had come directly from Spain to New Mexico in the last decade of the eighteenth century. He heard the story in Spain in 1920,

which featured a fox and a family of magpies nesting in a bush rather than a coyote and pigeons in an oak tree. He collected other versions from New Mexico that are very similar to the great grandmother's version (heard by Espinosa in 1890) and the 1920 version. The grandmother's version coincides with the New Mexico versions in featuring the coyote and pigeon family. Espinosa said the story is of Oriental origin and is found in the *Panchatantra*.

Nuevomexicano folktales include parallel versions of all types and classes found in Spain, including riddle tales, moral tales, religious tales, adventure, romance, enchantment, demon and ogre tales, persecuted women, Cinderella, and King Lear types, picaresque, animal tales, cumulative tales, and others.

In *El grillo y el león* (The Cricket and the Lion),

A cricket challenges a lion to battle for supremacy. The lion brings together all the quadrupeds: lions, tigers, elephants, wolves, and so on. The cricket brings together all the birds and insects. The bees and wasps lead the attack of the cricket's army, sting the quadrupeds, and make them run into the water for safety. The cricket wins. (Espinosa and Espinosa 1985)

In *Las tres adivinanzas* (The Three Riddles),

A youth in the service of a priest wins the latter's admiration by his great cleverness. On one occasion the priest is asked by the king to solve three riddles under pain of death. With his master's consent, the servant appears before the king disguised as the priest. The first question that is put to him is, "How much am I worth?" He answers, "Our Lord was worth thirty coins, but you are worth only twenty-nine." The second question is, "How deep is the ocean?" His answer is, "The distance that a stone cast into it will travel." When the king asks the last question, "Of what am I thinking?" the youth replies, "You think that you are speaking to the priest, but you are speaking to the priest's servant." The priest's life is saved. (Espinosa and Espinosa 1985)

The two foregoing stories are in truncated form for the sake of space. For full stories, see Stanley L. Robe's *Hispanic Folktales from New Mexico*, *Literary Folklore of the Hispanic Southwest* by Aurora Lucero-White Lea, and Espinosa's own *Cuentos populares españoles* and *Spanish Folktales from New Mexico* (see bibliography).

Décimas

The most complex form of popular poetry in Spanish America is the décima, which dates as far back as the later romances. It was developed by Vicente Martínez Espinel (1550–1624; author of *Diversas rimas* and *Marcos de Obregón*) and in fact is even called the *espinela*. Subject matter is limitless but the most popular types are narrative, lyric, philosophic, religious, and riddle décimas. The theater of the Golden Age reflects the popularity of the décima.

The challenge of composing a décima lies in its structure, which consists of ten verses (hence the name *décima*; the root word for ten is *deci*), with a rhyme scheme of abaabcdcdc, or abbaaccddc. The second rhyme arrangement is the most conventional. In the décima glosada, the strophes are preceded by an introductory planta, a quatrain whose lines appear at the end of the subsequent stanza. Décimas appear in New Mexico's folk poetry, such as popular Nativity plays, and in independent works written for specific needs. The following example describes the political unrest of the Nuevomexicano during the early years of the American occupation. Espinosa estimates that it was composed and published in a Spanish-language newspaper in the 1860s.

"Jarirú, Jari, camón,"
Dice el vulgo americano.
Comprende, pero no quiere
el imperio mejicano.

Nomás los gobernadores
lo han dado por decomiso;
ora no son valedores
Porque han dado libre el piso.
Varios han perdido el juicio
por esta mala invención,
que por rajar tablazón
nos han parado la fuente.
Ya nomás dice la gente,
"Jarirú, Jari, camón."

Todos los indios de Pueblo
se han hecho a la banda de ellos.
Dicen que es nueva conquista
la ley de estos fariseos.
Varios no somos con ellos,

"How d'you do, howdy, come on,"
say the American folks.
They understand but don't care
for the great Mexican civilization.

Only the authorities
Consider it an invasion;
they are now without respect
Having offered no resistance.
Many people have gone mad
on account of this attitude,
for in order to gain profit
they are bringing us to ruin.
All that people say now is,
"How d'you do, howdy, come on."

All the Indians from the pueblos
have already joined their ranks.
"It's a new conquest," they say,
"The law of these Pharisees."
Many of us are not with them,

pero hemos jurado en vano.
Nomás no digan, "Fulano
no ha prestado su atención;"
porque en cualquiera ocasión
dice el vulgo american.

but we took the oath in vain.
Less people go and declare,
"So and so's not patriotic,"
Because no matter what happens
say the American folks.

Todos los días esperamos
las fuerzas que han de venir,
pero al fin ya nos quedamos
como el arcaz del fusil.
En esto no hay que decir,
"Por si se nos ofreciere."
Que se apure quien quisiere
y adiós hasta el otro invierno,
porque el supremo gobierno
comprende, pero no quiere.

Day after day we await
the forces that are to come,
but in the end we remain
with guns and no ammunition.
And there is no use in saying,
"All this may be our defense."
There is no use for us to worry,
and good-bye until next winter,
because the persons in power
they understand but don't care.

En fin, si fuerzas esperan
espérenlas por el norte,
pero de esta misma gente
no de la suprema corte.
Cada uno con su consorte
nomás no se muestre ufano,
que Dios nos dará la mano.
Será cuando le convenga;
pero ya no hay quien sostenga
el imperio mejicano.

In short, if you expect help,
expect it all from thenorth,
but from these very same people
And not from our supreme court.
Let us protect our families
And not be overly proud,
For some day God will help us.
This will be when it's His will,
But now no one will support
The great Mexican civilization.
 (Espinosa and Espinosa 1985)

The following décima was collected from Jacobo Baca of Cedar Crest by Arthur Campa. It is an example of the extent to which poetry was involved in people's daily lives.

¡Ah qué ingrata te acreditas!
¿Por qué te muestras tan cruel
Que ni siquiera un papel
Escribirme solicitas?

Oh, how ungrateful you have become!
Why do you show such cruelty
That not even a single page
Have you written me or wanted to?

Toda tu solicitud
Se ferea en rigor extraño.
Mi vida, hace más de un año
Que no sé es ingratitud,
No enviarme cuatro letritas
Una o dos con tus manitas
Con los que vienen y van.
Ese sí es crecido afán
¡Ah qué ingrata te acreditas!

All of your concern
Is exchanged for strange severity.
My love, it has been more than a year
I know not if it be ungratefulness,
To not send me four little letters
Even one or two with your precious hands
With those that come and go
That is surely heightened fervor
Oh, how ungrateful you have become!

Es tanta la deslealtad	So great is your disloyalty
Que ni por estar ausente,	That not even for absence,
Ni por decir de las gentes	Nor for what people might say
Me envías un ¿cómo te va?	Would you send me a "How are you doing?"
Ni por saber donde está	Nor to know where he might be
Aquel que te adora fiel.	Who loves you so faithfully.
Aquí te mando un papel,	Here I send you a paper,
Abrelo con tus manitas	Open it with your previous hands
Que te pregunta a solitas	For it asks you privately
Por qué te muestras tan cruel.	*Why do you show such cruelty?*
Si piensas que te he olvidado	If you think that I have forgotten you
Porque ando en extrañas tierras	Because I go off in strange lands
Mi vida, yo en esta tierra	My dear, I on this earth
Yo en vida soy sepultado.	Am submerged in this life.
De nadie soy visitado	Nobody visits me
Te lo dirá este papel,	This paper will tell you,
Pases tus ojos por él	Pass your eyes over it
Que te lo dirá el tormento,	So it will tell you of the torment
Y lo tomo a sentimiento	And I take it to heart
Que ni siquiera un papel.	*That there is not even a single page.*
En fin, mi lucero hermoso,	In the end, my beautiful star,
No te muestres tan ingrata,	Do not be so ungrateful,
Pues el no verte me mata	Not seeing you is killing me
De un tormento tan penoso.	From a torment so painful.
Pasa gustos venturosos	For fortunate desires
En tus paseos y visitas,	For your strolls and visits,
Yo contaré en donde habitas,	I will tell where you dwell
Goza de tu ingratitud.	Enjoy your ungratefulness
Pues yo lloro pero tú	While I am crying for you
Ni escribirme solicitas.	*Have not written me or wanted to.*

(Campa 1946,
translation by Enrique Lamadrid)

There are five large collections of modern popular décimas, one from Chile, two from Argentina, a collection of 23 from New Mexico, and a collection of 245 from Puerto Rico.

> How such a complicated form as the *décima* . . . has been preserved in the oral tradition of New Mexico, often in exactly the same form as that used by Lope de Vega and other poets in the seventeenth century, can be understood only when we consider the extraordinary vigor and persistence of Spanish tradition in New Mexico in all aspects of life and culture. (Espinosa and Espinosa 1985)

Corridos

As mentioned in the chapter on music, the subject matter of corridos is varied: political campaigns, violent deaths, notorious crimes, paeans to local leaders, love triangles. Structured in octosyllabic meter and in assonance, corridos can get quite long, such as the corrido written in 1893 about Antonio Joseph, a successful territorial delegate to Congress. It consists of 52 sextains, or 312 verses. Early corridos appeared in printed broadsides and in newspapers, especially on the occasion of religious feasts. One of the most prolific of corrido writers in New Mexico was Norberto M. Abeyta of Sabinal, who recorded his corridos in manuscripts. Many contemporary singers regularly perform and write corridos.

Dichos and Riddles

The dichos, or *refranes* (refrains), of New Mexico are numerous and old. Like proverbs in any culture, they express a people's general philosophy and approach to the joys and vicissitudes of life. They may rhyme or contain assonance. Espinosa published a collection of 632 Nuevomexicano proverbs in 1913, noting that the dichos haven't changed much after centuries of use. Of the proverbs he gathered, he found about seventy percent, with few variations, in the sixteenth-century literature of Spain, including *Don Quixote* and picaresque novels. They were recorded in Spain in collections, such as the seventeenth-century *Vocabulario de refranes y frases proverbiales* by Gonzalo de Correas. Here are some examples of *dichos Nuevomexicanos.*

Caros vemos, corazones no sabemos.	We see faces, but know nothing of the hearts.
Haz bien y no acates a quién.	Do good and never mind to whom.
La mona aunque se vista de seda, mona se queda.	The monkey though she may dress in silk is still a monkey.
A palabras necias, oídos sordos.	For foolish words, deaf ears.
Más vale un pájaro en la mano que cien volando.	A bird in the hand is better than a hundred flying.
En boca cerrada no entra mosca.	No fly can enter a closed mouth.
En casa llena, pronto se guisa la cena.	Where there is plenty dinner is soon prepared.
Le dan el pie y se toma la mano.	Give him your foot and he takes your hand.

(Espinosa and Espinosa 1985)

The majority of riddles use objects of comparison and description that refer to both humans and animals. The description sets up the question, "What am I?" Other riddles involve mathematical problems, word plays, puns, and anecdotes. Some riddles are in the décima form; some may be in rhyme or assonance, with structures varying from irregular syllabic meters in two to four verses, to octosyllabic quatrains or quintains. These structures date to sixteenth-century Spain. Espinosa found New Mexico rich in riddles. He published a collection of 165 riddles in 1915, including some dating from the thirteenth to sixteenth centuries. Similar versions have been published from the oral traditions of Spain and other parts of Spanish America.

Entre dos paredes blancas
hay una cuenta amarilla. (Huevo)

Between two white walls
there is a yellow bead. (Egg)

Cuatro rueditas
van para Francia,
camina y camina
y nunca se alcanzan.
(Ruedas del carro)

Four little wheels
are going to France,
always moving, but
they never meet.
(Wheels of a wagon)

En alto vive
y en alto mora,
y en alto teje
la tejedora. (Araña)

She lives on high,
she dwells on high,
she weaves on high,
the weaver. (Spider)

Mi madre tenía una sábana
que no la podía doblar;
mi padre tenía tanto dinero
que no lo podía contar.
(Cielo y estrellas)

My mother had a sheet
that she could not fold;
and my father so much money
that he could not count it.
(Heaven and stars)

Una vieja,
con un solo diente,
recoge a toda su gente. (Campana)

An old woman,
with just one tooth,
gathers all her people. (Bell)
(Espinosa and Espinosa 1985)

Prayers
Prayers to the Christ Child, the Virgin Mary, and the Holy Family were taught to children as soon as they learned to speak. Numerous prayers have been gathered in New Mexico. Novenas (extended prayer campaigns that include services and multiple recitings of the rosary for nine days) to the *Santo Niño* are very popular in New Mexico. Here is an excerpt of a novena prayer, with translation by Espinosa, as in all of these examples.

¡Adiós, Niñito de Atocha,
mi dulzura y mi placer!

Hail, Child Jesus of Atocha,
my sweetness and my joy!

Hermosura de la gloria,	Heavenly beauty,
¿cuándo te volveré a ver?	when will I see you again?
Manuelito de mi vida	Manuelito, my life,
líbrame de Lucifer.	save me from Lucifer's wiles.
Hermosura de la gloria,	Heavenly beauty,
¿cuándo te volveré a ver?	when will I see you again?
Jardín lleno de delicias,	Garden of all delight,
y matizado clavel,	multiple-hued carnations,
delicia de los arcángeles,	joy of archangels,
¿cuándo te volveré a ver?	when will I see you again?
	(Espinosa and Espinosa 1985)

Straddling the line between prayer and drama is another formula recited on the arrival of each Penitente at the morada, primarily at the beginning of the Lenten ceremonies. The emphasis on family is extremely important to Nuevomexicanos, and that emphasis finds its religious expression in the two traditional prayers that follow. The first is from the Santa Cruz manuscripts.

—Dios toca en esta misión	"In this mission God unbolts
las puertas de su clemencia.	the gates of His boundless mercy."
—Penitencia, penitencia,	"Penance we preach, penance,
que quieres tu salvación.	for you wish your salvation!"
—San Pedro me abra las puertas,	"May Saint Peter open the gates,
bañado entre clara luz;	for me with brilliant light;
soy esclavo de María;	I am the slave of Mary;
traigo el sello de Jesús.	I have the seal of Jesus.
Pregunto a esta cofradía,	I ask this confraternity,
¿Quién a esta casa da luz?	"Who gives light to this house?"
—Jesús.	"Jesus."
—¿Quién la llena de alegría?	"Who fills it with joy?"
—María.	"Mary."
—¿Quién la conserva en la fe?	"Who keeps it in the faith?"
—José.	"Joseph."
—Luego bien claro se ve	"It is perfectly clear, then
que siempre habrá contrición	that all those will be saved
teniendo en el corazón	who hold in their hearts
a Jesús, María y José.	Jesus, Mary, and Joseph.
Para entrar a esta misión	In order to enter this mission
el pie derecho pondré,	I will put first my right foot,
y alabo a los dulces nombres	and will praise the sweet names
de Jesús, María y José.	of Jesus, Mary, and Joseph."
	(Espinosa and Espinosa 1985)

Inside the morada, more ritual and prayer follow. This formula is repeated for each person who enters. The next prayer is thought to have originated in Spain in the seventeenth century as part of a *villancico* (Christmas carol) by Gómez Tejada de los Reyes in his work called *Noche buena: autos al nacimiento del Hijo de Dios*. It is used throughout New Mexico, and taught at a very early age in several versions.

¡Bendito y alabado sea el	Blessed and praised be the
Santísimo Sacramento del altar!	Most Holy Sacrament of the altar!
—¡Ave, María Purísima!	Hail, Most Pure Mary!
—¿Quién en esta casa da luz?	"Who gives light to this home?"
—Jesús.	"Jesus."
—¿Quién la llena de alegría?	"Who fills it with joy?"
—María.	"Mary."
—¿Quién la conserva en la fe?	"Who keeps it in the faith?"
—José.	"Joseph."
—Pues bien claro se va	"It is perfectly clear, then
que siempre habrá contrición,	That all those will be saved
teniendo en el corazón	Who hold in their hearts
a Jesús, María y José.	Jesus, Mary and Joseph."
¡Salgan los espíritus malignos	May all evil spirits depart
y entre la suma bondad,	And may true virtue enter
y se estampe en mi alma	And may the Most Holy Trinity
la Santísima Trinidad!	Take possession of my soul!
Purísima Concepción,	Most Immaculate Conception,
Madre del Verbo Divino,	Mother of the Divine Word,
échame tu bendición	Give me your lessing
y guíanos por buen camino,	And show us the right way,
que yo la recibo en el nombre	For I now receive it in the name
del Padre y del Hijo,	Of the Father, and of the Son,
y del Espíritu Santo, Amén.	And of the Holy Ghost, Amen.

(Espinosa and Espinosa 1985)

The devotion to the Virgin Mary is universal throughout Spanish America. All types of prayers, invocations, folktales, and miracles are told and retold about her. Novenas are prayed to her. Up to the mid-twentieth century, Spanish homes prepared a special altar in honor of the Virgin and decorated it with flowers and fine fabrics. This occurred in May, designated the month of Mary by the Catholic Church. In the evening, the family prayed a rosary together in front of this altar, often followed by hymns. Often, such devotions took place every night of the year, accompanied by hymns and romances appropriate for each feast day or season of the year. Rosaries were often accompanied by special short prayers and ejaculations (one-verse prayers). Traditional prayers were added for special purposes, such as healing the sick or during velorios (evenings of prayer and hymns on the occasion of a death). This interesting example combines Spanish and Latin text.

Por las ánimas benditas	For the blessed souls
que en el purgatorio están	who are in purgatory
ofrezco este misterio.	I offer this mystery.
Lux perpetua luceat eas.	May perpetual light shine upon them.
¡Requiescant in pace, Amén!	May they rest in peace, Amen!

(Espinosa and Espinosa 1985)

An interesting form of prayer is the *alabanza del alba*, or prayer sung at dawn. Its origins are peninsular, and involve singing morning prayers at the first sign of dawn. Another term for these prayers is *oraciones*. The eldest in the family begins the singing, with responses sung by other members of the family. According to Espinosa, the same practice exists in country villages of Spain, Chile, and elsewhere in Spanish America. A New Mexico alabanza del alba:

Cantemos al alba;	Let us sing the matins;
ya viene el día	daylight is coming.
Daremos gracias.	We will give thanks.
¡Ave, María!	Hail, Mary!
Angel de mi guarda,	My guardian angel,
noble compañía,	most noble company,
vélame de noche	watch over me at night,
y guárdame de día.	and protect me during the day.
Ya nació María	Mary was born
para el consuelo	for the comfort
de pecadores,	of sinners,
y luz del cielo.	and to be the light of heaven.
Tan bella grandeza	Such magnificence
no quiso ver	Lucifer,
la sierpe fiera	the venomous serpent,
de Lucifer.	did not wish to see.
María Divina,	Mary Immaculate,
con ser tan pura,	although most pure,
fué celebrada	was indeed famous
por su hermosura.	for her beauty.
.
¡Viva Jesús!	Hail, Jesus!
¡Viva María!	Hail, Virgin Mary!
Cantemos todos	Let us all sing
en este día.	on this day.
Benditos seas,	Blessed be you,
sol refulgente.	shining sun.
Bendito seas,	Blessed be you,
sol del oriente.	sun from the East.
Bendita sea	Blessed be
tu claridad.	your light.
Bendito sea	Blessed be the one

quien nos la da.	Who sends it to us.
Quien el alba canta	Those who sing the matins
muy de mañana	early in the morning
las indulgencias	obtain the indulgences
del cielo gana.	granted by God.

<div align="right">(Espinosa and Espinosa 1985)</div>

Invocations to special patrons are common in New Mexico. For example:

San Isidro,	Saint Isidore,
Labrador,	tiller of the soil,
ruega a Dios	pray to our Lord
que salga el sol.	that the sun will come out.

Santa Bárbara bendita,	Blessed Saint Barbara,
que en el cielo estás escrita	your name is written in heaven
con papel y agua bendita,	on holy paper with holy water,
Santa Bárbara doncella,	Saint Barbara Virgin,
Líbranos del rayo	guard us ever against
y de la centella.	thunderbolt and lightning.

Señora Santa Ana,	Dear Saint Anne,
Senor San Joaquín,	Dear Saint Joachim,
Arrulla este niño,	lull this baby, please,
se quiere dormir.	he wishes to go to sleep.

This invocation is said when setting a hen:

Padre mío,	Dear Father,
San Amador,	Saint Amador,
Todas pollitas,	may one be a rooster,
y un cantador.	and the rest pullets.

Verso or Copla Popular (Verse or Popular Couplet)

A verso is any short poetic composition of a popular character in a single strophe or stanza. Versos generally are octosyllabic in meter and also are known in Spain and Spanish America as *coplas populares* (popular couplets). Espinosa collected fifteen hundred versos in New Mexico. Since the sixteenth century, the most common structure of the verso has been the *cuarteta*, an octosyllabic quatrain (four verses) with verses two and four in assonance or rhyme. Next in usage is the sextain (six verses), and the *seguidilla*, a quatrain of two heptasyllabic verses alternating with two pentasyllabic verses. Of the versos collected in New Mexico, about seventy-five percent are octosyllabic quatrains; the rest are primarily octosyllabic sextains.

Versos best express the sentiments and philosophy of the common people. Hundreds date from the sixteenth and seventeenth centuries with little or no change, as shown in the examples given here. Like the romances, décimas, and prayers that become hymns, versos can be sung, or made part of a song. Espinosa categorizes versos into six subject categories, including those that express happy and hopeful love; those that express unhappy or rejected love; philosophic or proverbial versos; religious versos; humorous or burlesque versos; and those that express pride and love for Castilla, the homeland.

The following is an example of a quatrain:

Antenoche fui a tu casa,	At your house, night before last,
tres golpes le di al candao.	three times I knocked at your door.
No estás buena para amores,	You do not make a good lover,
tienes el sueño pesao.	much too soundly do you sleep.

(Espinosa and Espinosa 1985)

Compare this to the version Espinosa found in Andalucía, Spain:

Anoche estuve en tu puerta,	I went to your home last night,
tres golpes le di al candado;	three times I knocked at your door;
para tener amor, niña	to be a really good lover,
tienes el sueño pesado.	you sleep too soundly, my love.

(Ibid.)

An example of a verso of rejected love:

Cada vez que cae la tarde,	Every day when evening comes,
me dan ganas de llorar;	I feel a desire to weep;
este corazón cobarde	to this poor heart of mine
no lo puedo consolar.	I can never give relief.

(Ibid.)

A humorous verso:

Cuando un pobre se emborracha	When a poor man drinks too much
y un rico en su compañía,	in a rich man's company,
la del pobre es borrachera,	the poor man is called a drunkard
la del rico es alegría.	the rich man a jolly fellow.

(Ibid.)

The verso given above is identical to one found in Andalucía and comparable to this version found in Argentina:

Cuando se emborracha un pobre,	When a poor man drinks too much
todos dicen—¡Borrachón!	everyone says, "The great drunkard!"
Cuando se emborracha un rico;	When a rich man drinks too much
—¡Qué alegrito va el señor!	"Our friend is in a jolly mood!"

Two examples of a religious *verso*:

¿Qué quieren con San Antonio, What do you wish from St. Anthony,
que tanto se acuerdan de él? you who call on him so often?
San Antonio está en la gloria. St. Anthony is in heaven,
¡Quién estuviera con él! Would that I were there with him!
<div align="right">(Ibid.)</div>

Los ángeles en el cielo The angels in heaven
alaban con alegría, sing joyous praises,
y los hombres en la tierra and men on Earth
 responden—¡ Ave, María! reply, "Hail, Mary!"
<div align="right">(Ibid.)</div>

This humorous *verso* is often sung in New Mexico:

La vecina de aquí enfrente My neighbor across the street
compró un gato muy barato very cheaply bought a cat,
y le dijo a su marido and then she said to her husband,
—Mira, hijito, tu retrato. "Behold your picture, my dear."
<div align="right">(Ibid.)</div>

This sextain recalls Castile:

Si porque me ves con teguas If because I wear moccasins
me desprecias, vida mía, you esteem me less, my love,
el domingo me verás on Sunday you will see me
con zapatos de chalía, Wearing slippers of mohair,
pisando la misma tierra and stepping on the same ground
que pisan los de Castilla. that those from Castile tread.
<div align="right">(Ibid.)</div>

Children's Games & Nursery Rhymes

As in other genres, children's games found in New Mexico are similar to those found in Spain. Animals and royalty figure largely in their stories. Like dichos and riddles, the games and rhymes have fixed metrical forms. The following game, called *Juego de los dedos* (Game of the Fingers), is found throughout Spanish America and in Spain. In the game, the child begins with the little finger and counts while reciting the rhyme, which is shown in New Mexico, Peninsular, and California versions.

Este se halló un huevito. This one found a little egg.
Este lo echó a freír. This one began to fry it.
Este lo meneó. This one turned it.
Este le echó sal. This one put salt on it.
Y este viejo cuzco se lo comió. And this old glutton ate it up.
<div align="right">(New Mexico version)</div>

Este compró un huevo.	This one bought an egg.
Este lo puso al fuego.	This one put it to fry.
Este le echó sal.	This one put salt on it.
Este lo probó.	This one tasted it.
Y éste pícaro gordo se lo comió.	And this fat rascal ate it up.

(Peninsular version)

Este mató un pollito.	This one killed a little chick.
Este puso el agua a calentar.	This one put the water to heat.
Este lo peló.	This one plucked it.
Este lo guisó.	This one cooked it.
Y éste se lo comió.	And this one ate it up.

(California version) (Espinosa and Espinosa 1985)

In the next rhyme, one child strikes another on the arm starting at the wrist and moving up with additional strikes. Each strike is progressively stronger until the last, on the words, "but from here."

Cuando vayas a los cíbolos	When you go hunting for buffalo
no me traigas carne	don't bring me any meat
de aquí, ni de aquí	from here, nor from here,
ni de aquí, sino de aquí	nor from here, but from here.

(New Mexico version)

Cuando vayas a la carnicería	When you go to the meat market
que te corten una libra de carne;	have them cut you a pound of meat;
pero que no te la corten de aquí,	but not from here,
ni de aquí, ni de aquí,	nor from here, nor from here,
sino de aquí, sino de aquí.	but from here, from here.

(Andalucía version)

Another nursery rhyme is also a prayer:

Dijo el gallo	Said the cock,
—¡Cocorocó!	"Kokoroko!
¡Cristo nació!	Christ is born!"
Dijo la cabra	Said the goat
—¡Me, me!	"Ma, Ma!
¿Dónde? ¿Dónde?	Where? Where?"
Dijo la oveja	Said the sheep,
—¡Be, be!	Ba, ba!
¡En Belén!	In Bethlehem!"
Dijo la mula	Said the mule,
—¡Vamos a ver!	"Let us go and see!"
Dijo el buey	Said the ox,
—¡No es menester!	"It is not necessary!"

(Espinosa and Espinosa 1985)

The games and rhymes frequently date from the thirteenth to the sixteenth centuries. Similar versions have been published from the oral tradition of Spain and other parts of Spanish America. Espinosa began publishing children's games and rhymes in 1916.

Legends, Miracles & Superstitions

Legends are stories about historic or legendary persons that include fantastic or unreal elements. They are sometimes associated with miracles, particularly in the case of saints. A miracle is an effect or extraordinary event in the physical world that defies the rules of the physical world and is ascribed to the efforts of a religious or supernatural entity. Superstitions are beliefs in the special significance of a specific thing, situation, or occurrence, and are not based on the reasoning or knowledge of the five senses. They are man's effort to understand Nature.

Legends surrounding saints abound in New Mexico's folklore. San Diego de Alcalá, for example, is said to have been a cook at the Capuchín convent in northeastern Spain, and that while he was cooking, he became enraptured and carried off to heaven while angels finished his cooking. San Diego de Alcalá cured one child from blindness and rescued another from an oven into which the child's mother had unknowingly locked it. The result is that, over the years, San Diego has become the patron saint of cooks and the blind. San Vicente Ferrer was a world traveler and miracle worker who was asked by the bishop to stop making so many miracles. While out walking one day, he saw a bricklayer about to fall from a building. Not wanting to disobey his superior, he suspended the bricklayer in mid-air while he went to get the bishop's permission to save the man's life. Now he is the patron saint of stone masons and those who suffer from headaches.

The Holy Child of Atocha, discussed in the chapter on religious art, is a good example of a Spanish legend made local. The original Child of Atocha aided Spanish prisoners during the Moorish occupation. He is also thought to walk the countryside of New Mexico doing good deeds and wearing out his shoes in the process. Bringing new shoes to the statue at Chimayó is considered an act of devotion. The miracles of healing performed at Chimayó are tied to the local legend of the Holy Child of Atocha.

San Antonio's local miracles are many, and similar to those in Spain and elsewhere in Europe and Spanish America. San Antonio helps individuals find lost children and lost articles. He is especially revered by women looking for good husbands. Like all petitioned saints, if praying to him shows no results, his image is placed face down on the household altar, hidden away in a drawer, or turned to face the wall.

Campa observed that for Nuevomexicanos, and others of Spanish America, superstitious activity often came to involve doing something negative to create a positive result. Thus people were advised to "avoid marrying on Tuesday, avoid cutting a child's fingernails before the baby was a year old, or refrain from eating fruit on an empty stomach in order to forestall evil consequences" (1979). The alternative was unknown because no one ventured to defy the superstitions to see what happened, according to Campa. In time, the original reason for doing, or not doing, something was forgotten, but the practice remained for sentimental reasons. For example, exterior window moldings are painted blue or turquoise in New Mexico. The original intent was to keep out evil spirits. Today, it is largely a traditional design.

There are superstitions regarding certain times of the year. *La Noche de San Juan* (or St. John's Eve) falls on June 23. Whoever wishes to know the future may empty an egg into a glass of water and put it under the bed on St. John's Eve. The next morning, one reads the form the egg has taken. For example, the shape of a ship or airplane means travel; the shape of a person means a romance or marriage; and the shape of a skeleton or coffin means death. Also, on *La Noche de San Juan*, if a woman looks into a well or fountain, she will see her reflection and that of her future husband. Or, if at noon sharp, she throws a bucket of water on the street from her door or window, the first young man to step on the wet ground will be her future husband, or one who has the same name. The practice of the egg is found in New Mexico, Chile, Castilla, Galicia, Andalucía, and Portugal. The

La Llorona

There have been so many "sightings" of La Llorona that a book of first-person accounts was compiled in 1988 by Edward García Kraul and Judith Beatty of Santa Fe. Here are two such accounts.

During the winter of 1953, I stopped at Joe's Ringside in Las Vegas, New Mexico, to watch the strip show and have a few beers. It was cold, and I was tired of driving. I was on my way home to La Joya from Denver. My dad, Antonio Lucero, had a small place in La Joya about two or three miles from the Pecos River near the Greer Garson ranch. I had decided to spend the Christmas holidays there with Dad and my two brothers.

Around 11:00 or 11:30 P.M., I left Joe's Ringside and continued to La Joya. As I was driving down the hill toward Tecolote, the bright lights from my Ford illuminated the figure of a woman on the side of the road. In those days, the road was a single lane, one way, and not the big freeway that is there now. I thought to myself, "What is this nun doing on the highway

in the middle of the night?" Her dress was a habit of the Catholic nuns I was familiar with. I pulled the car over to a stop and reached over to open the door on the passenger's side. I asked her if she wanted a ride, and she got in the car without saying a word. I could see now that it wasn't a habit she was wearing but a dark cloak with a hood that covered most of her face. I really couldn't even see if she was young or old, or what. We passed through Bernal, San Juan, San José, all without her opening her mouth. I didn't mind; I was tired and didn't much feel like talking myself. Still, I tried to be polite a couple of times and ask her some questions, but she never answered me. She sat completely still, much like a mannequin in a store window, with one hand on her knee and the other hidden under her cloak.

When we got to the Pecos cutoff, I was starting to get uncomfortable. Frankly, there was something about her I didn't feel right about. I began to imagine that maybe she had a knife, or maybe she wasn't even a woman

bucket-of-water ritual is found in New Mexico and Andalucía.

Forecasting the weather in colonial and territorial New Mexico was based on rural tradition and superstition. For example, a ring around the moon meant a storm brewing; if the roosters crowed early in the evening, the weather was about to change; and if a donkey's bray was answered, rain was imminent. The most systematic method for calculating the weather for an entire year was known as *las cabañuelas*, a tradition in which the weather as observed throughout January would correspond to the following year. It worked in this way: the weather during each of the first twelve days of January corresponded to the weather for the twelve

months of the year. Then, beginning on January 13, each day's weather represented the months of the year in reverse. Then, from January 25 to 31, each half-day represented the weather of the twelve months in succession. Finally, the weather of each hour (beginning with the first daylight hour) of January 31 corresponded to the twelve months in succession. The *average* of all these readings told the forecast for each month of the coming year. Las cabañuelas was calculated again in August.

The dark side of superstition involved the forces of the unknown. Ghosts, or *fantasmas*, are said to guard lost treasures, and to beg those passing a graveyard to pray them out of purgatory. The most famous ghost of New Mexico and Mexico is *La Llorona*

but a boy who was going to rob me. I had a big wad of bills in my pocket. I thought to myself, "What if she saw the money at the bar? Maybe he or she was in there."

As if that wasn't enough, I began to imagine the smell of sulphur, like after you've lit a match, but much stronger. That was enough for me. I stopped the car in front of Adelo's store and turned to tell him or her to get out of the car, but she had disappeared into thin air. Without opening the door. Then I heard this blood-curdling yell, very high-pitched—terrible. It raised the hair on my neck; that's the truth. Even the dogs ran off.

I told this story to some guys at the Sunshine Bar and a guy—I don't remember his name, Freddie something—said the exact same thing had happened to some other sucker a couple of weeks before. Then he said to me, "That was La Llorona, mula!"—Ray Lucero, Pecos, N.Mex.

I was listening to my shortwave radio one night four years ago, about 1984, and I had the police frequency on. I don't know what time it was, but it was late, when I heard this report that a lady in the El Torreón addition had called the police because she said she could hear La Llorona crying from down by the Santa Fe River.

There was a big rush to get over there—you wouldn't believe it! Five police cars and three sheriff's cars. Well, I sat there for about a half-hour listening to the transmissions—it was really something. They'd hear crying by a tree, and they'd go over there, and there wouldn't be anything. Then they'd hear it from somewhere else, and they'd all run over there, and of course there wouldn't be anything there, either. They were saying it sounded like a baby crying. You would have thought with all the transmitting back and forth that this was Fiestas or some other big event. Finally, after about a half-hour, one of them said over the radio, "We're never going to find her because it's La Llorona." And that was the end of it. They all left.—Cosme García, Santa Fe, N.Mex.

(pronounced yoh-róh-nah), or The Weeping Woman, who haunts waterways and who is recognized by her siren-like howl of sadness and fright. She was a widow who is said to have drowned her children in order to be free to marry another man. Her punishment is to wander along ditches, rivers, and lakes looking for her children, and drowning or scaring children who are out too late at night. In some versions, she pushes a black baby carriage; in others, she scratches at windowpanes at night with her long fingernails. She has quietly accepted rides from unsuspecting motorists driving at night through northern New Mexico. She has even been seen and heard in Albuquerque, dispelling the idea that she is strictly a rural phenomenon.

The origin of La Llorona is unknown but theories range from *La Malinche* to a mestiza woman who is jilted by the father of her illegitimate children. She kills them in a rage after witnessing his wedding to another woman. According to Herrera-Sobek, the Aztec origin of La Llorona is that she was an Aztec woman who predicted the Spanish conquest and the fall of the Aztec empire. Anticipating the end, she was seen in the streets of the Aztec capital wearing a white dress, her hair undone, and crying *Ayyy, mis hijos!* (Ayyy, my children!). A New Mexico theory tells of a battered woman in Las Vegas who grew concerned that her alcoholic husband might begin beating their two young children, so she took them to the river and

hid them under the bridge, then left to get their things and return so they might all escape together. She was delayed, and on arriving much later at the bridge, discovered the children frozen to death.

La Llorona has sisters around the world with similar legends attached, including Pele in Hawaii, and the Medea stories of southern Europe. Legend says that if La Llorona stops to wail at someone's front door, there will be a death in that household. Ghostly encounters can cause susto, a curable emotional ailment (see the section on healing arts).

Secular Theater in New Mexico

New Mexico's secular theater tradition is, at its humblest, a hearth-side storytelling tradition, and at its most ambitious, a contemporary effort to revisit and reflect on the history of Nuevomexicanos and their place in the history of the United States, as seen in the numerous original plays produced in the late twentieth century by La Compañía de Teatro de Alburquerque. In the larger context of Spanish language theater of the border states, New Mexico's classic isolation has again influenced artistic activity. The extreme distance from Mexico during colonial times, and the lack of direct rail lines to Mexico in more recent times, have contributed to isolating New Mexico's audiences, who enjoyed either home-based companies or more intrepid national touring companies.

Historical Overview

Three years after the Conquest of Mexico in 1521, fourteen Franciscan missionaries stepped off the boat in Veracruz and began the work of proselytization. They soon learned that the numerous Aztec rituals and religious ceremonies contained dramatic elements. The Aztecs produced dramatic dances representing mysteries of Aztec cosmology and historic and military events. They also enjoyed farces, with dwarf and clown acts, buffoons that imitated the Aztecs' enemies, and comic animal disguises, according to chronicler Bernal Díaz del Castillo. The Spanish colonists introduced roving minstrels and jugglers to the cultural mix that would one day become the Mexican circus.

To get their point across, the missionary friars wrote new religious plays in native languages or translated old ones from Spanish. As in Spain, these plays were first presented inside the newly built churches, but then moved outdoors into the church atrium as the congregations grew too large to fit indoors. The Indians were pressed into service as actors, and because women were not allowed onstage, boys took female roles. The first religious plays were staged on the feast of St. John the Baptist in June 1538, in the city of Tlaxcala, seventy-five miles southwest of Mexico City. On that day, four plays were presented. Many more were to follow over the succeeding centuries.

In 1748, Fray Lorenzo Antonio Estremera wrote of a celebration in Santa Fe at which a *loa* was performed. A loa is a short allegorical theater piece in honor of a famous individual. It is usually in verse. Fray Estremera described it as "very learned" and in three parts. The purpose of the celebration was the oath of allegiance to Ferdinand VI, the new king of Spain, who ascended the throne on the death of his father, Philip V. There was also a parade and a "resplendent triumphal chariot with the arms of Spain and an imperial crown and scepter" (Adams 1960). Riding in the chariot was the actor who had performed the loa. Over the next two days, there were two *juegos de toros* (playing of the bulls) and a "very good play" as well as Indian dances.

Rael suggests that many plays were written, but not published, at least until the twentieth century, and even then, certain regions were more advanced in their preservation work than others. In the 1960s, he found eighteen versions of *Los pastores* in New Mexico, which he collected from handwritten versions owned by private individuals in New Mexico and southern Colorado. By contrast, in Arizona and California, he found the plays already published and stored in libraries and museums. In Texas, the plays were published. In northern Mexico, he recorded the plays from speech because most of his sources were illiterate. In New Mexico and southern Colorado, the plays had been handcopied and recopied over generations.

According to Kanellos, theater has always been essential to all Latino populations in the United States, not only as a form of artistic expression and entertainment but also as a method of cultural

preservation. Spanish-language theater through-out the United States—whether as *maroma*, cir-cus, or professional dramatic works—served to reinforce the Latino spirit of community and to preserve and support the Spanish language, sur-rounded as it was by a "foreign" culture and lan-guage. Theater served to promote ethnic identity and to solidify the political and social ideals of the people. In the words of theater critic Fidel Murillo, Spanish-language theater kept "the lamp of our culture lighted" (Kanellos 1987).

In the mid-nineteenth century, Hispanic theater flourished on the West Coast, which had seven companies in Los Angeles and San Francisco pre-senting Mexican actors and productions brought in by ship. This easy and continuous exchange with Mexico inspired Hispanos of California to develop their own Spanish-language theater. By contrast, New Mexico in the nineteenth century was still too distant and inaccessible by rail to be reached cheaply and easily by Mexican troupes. Instead, *carpas*, or circuses, served these areas, setting up in open markets or in taverns, and playing largely to the common folk. Demand grew with the expan-sion of rail lines and the introduction of the car so that by the turn of the century, important Spanish-language companies were performing all along the borderlands, from Laredo to Los Angeles, touching New Mexico along the way. The Fountain Theater in Mesilla, New Mexico, was a busy venue in the mid-nineteenth century.

The Mexican Revolution caused thousands—including many fine Mexican actors, musicians, and producers—to seek refuge in the border states and the Midwest, resulting in a rapid expansion there in theater activity. Many Mexican artists of repute took up temporary residence in the United States at this time. Some stayed in the United States after the Revolution, preferring to work the American and Canadian vaudeville circuits during the 1920s and 1930s. A typical evening at the the-ater at this time included zarzuela, operetta, drama, *comedia*, *revista*, and *variedades*. Reper-toires shifted with public tastes. As film became popular, a silent movie could be followed by live acts. However, newspapers of the time often men-tion that the Spanish-language theaters in these cities drew their largest crowds when featuring plays by local writers.

From 1915 through 1930, San Antonio enjoyed nineteen Spanish-language theaters or venues, and Los Angeles enjoyed eighteen. Playwrights and audiences preferred works focusing on Mexican-Anglo struggles in the United States, famous bandits, historical drama, and dime-novel sensa-tionalism. Rural communities, including those in New Mexico, were still being served by touring cir-cuses and maromeros (discussed below) and were staging their own works.

The Revista
The revista was the Mexican equivalent of the vaudeville evening, with a variety of music, song, skits, and stand-up presented in tent shows, or carpas. In North America, the revista often pre-sented humor reflecting the culture shock between Mexican and Anglo cultures. Such humorous situa-tions illustrated, for example, the misadventures of a naive, recent immigrant from Mexico, or the now classic *pelado*, a raggedly dressed underdog with lower-class dialect, scandalous language, and biting satire. The pelado (literally naked one, penniless) was highly humorous and satirical, and has come to be known as the Mexican national clown. Audiences saw themselves reflected in this character and responded enthusiastically and verbally, con-versing with *El Pelado* and proposing problems for him to solve. This character was the inspiration for Cantinflas, whose characterization was more widely known through film. Charlie Chaplin also had a touch of el pelado in his Little Tramp act. Pelados emerged from the tent shows that evolved in Mexico and flourished in the border states until the 1950s. Theater scholars now consider el pelado to be a gen-uine and authentic Mexican contribution to the Spanish theater tradition of the United States.

The Circus, the Carpa, and the Maroma
There is a vague line of definition between these three genres as practiced throughout the South-west. A touring circus was held in a tent, or carpa, but was more elaborate than a carpa, which was a smaller resident or touring circus for the common folk. By contrast, large circuses were based in

8.14
A maromeros performance at Peñasco, New Mexico. Courtesy Library of Congress, LC-USF34-37099-D.

cities, performing in permanent facilities. A maroma (meaning cartwheel) is also a small touring company, with roots in the Aztec culture. The maroma borrowed from the court of Moctezuma its dwarfs, buffoons, and clowns, and their *voladores*. The Aztecs conducted a religious acrobatic ritual that involved flyers called voladores who descended upside down from a high revolving platform, hanging by their feet from ropes. A flute and small drum accompanied their descent. Over the years, this ritual evolved into a secular circus act that continues today. The early mestizo circus of Mexico was originally called *compañía de voladores* or *compañía de volantines*, then simply *la maroma*, after the rope that connected the flyers to the platform. The acrobats themselves were known as *maromeros*. Other acts included clowns, magic, popular songs, and shadow plays.

By 1670, maromeros were performing at bullfights in Mexico City. By 1785, the first compañía de volantines was documented in Mexico City, followed by musical and dramatic presentations by theater actors. The mixing of serious drama with circus acts became typical of Mexican and Southwestern circuses after that time. In 1833, Carlos E. Green's circus introduced pantomimes, including one entitled *Don Quijote y Sancho Panza*, which Kanellos cites as an example of the interchangeability of literature and entertainment for the masses.

The carpa, or poor man's circus, had been operating in poorer areas of Mexico City and in rural Mexico. *Carpa* is ancient Quechua for an awning made of interwoven branches. In Spanish it means canvas cover or tent, and later came to signify this smaller circus. The use of an Indian word may also suggest the mestizo character of the players, the audiences, or both. The true voice of the people was heard in the carpas, particularly in the satirical acts of el pelado, who could say onstage what no newspaper editor dared print. From the 1850s on, Kanellos reports considerable documentation of touring compañías de volantines and maromas throughout the southwestern United States. Also, shows began including rope walkers, characters of devils and skeletons, and women equestrians.

The nineteenth-century circuses included displays of horsemanship, acrobatics, gymnastics, drama, and poetry improvisation on topical themes. These circuses toured the southwestern United States, performing at theaters and at bullrings in a circuit that included towns between San Antonio and San Francisco, but touching New Mexico mostly in its southern regions, including Las Cruces and Socorro.

The tradition of the Mexican clown as poet and satirist was established by José Soledad Aycardo, a famous *payaso* (clown) for fifty years beginning in the 1850s. He also directed and acted in operettas, pastorelas and five-act melodramas. His contribution to the circus was to combine the new

European-type circus with the maroma and Spanish-language theater. Other companies were the Gran Circo Escalante Hermanos, Esqueda Brothers Show, Circo Rivas Brothers, P. Pérez Show Circo y Variedades, Circo Azteca de los Hermanos Olvera, Circo Carnival "Iris Show," Teatro Carpa Hermanos Rosete Aranda, La Compañía Hermanos Ortiz (see below), Los Hermanos Bell, Teatro Carpa Independencia, Compañía de Vaudeville Mantecón, Carpa Cubana, Carpa García, and the Maroma Pájaro Azul.

Eventually, it would be the popularity of the European circuses, such as the Chiarini, Bell, and Orrin family circuses, that pushed the large Mexican resident companies out of the cities and onto the North American touring circuit in the late nineteenth century. Then the Mexican Revolution caused even these companies to vacate Mexico. The Gran Circo Escalante was the most popular and long-lived in the Southwest, performing from the 1900s to 1950s. But equally long-lived were the small family-based carpas, such as New Mexico's Compañía Hermanos Ortiz. By the late nineteenth century, the carpa had became an important Mexican-American institution of popular entertainment. It even survived the Depression, and continued to perform along the border even into the 1960s, following the migrant labor stream. Today there is still an occasional carpa visiting along the Río Grande Valley.

Part of the appeal of the carpas was their comic routines, which, according to Kanellos, became "a sounding board for the culture conflict that Mexican-Americans felt in language usage, assimilation to American tastes and life-styles, discrimination in the United States, and *pocho*-status in Mexico." Later, El Teatro Campesino in Los Angeles paid tribute to the carpa by reviving one in its production *La gran carpa de la familia Rascuachi*, which featured a pelado named Jesús Pelado. In 1979, the Chicano theater festival in San Antonio was dedicated to La Carpa García, a highly popular San Antonio-based company that had closed in 1948.

In the meantime, Los Hermanos Bell, originally of England, were long time associates of Los

Hermanos Areu, whose patriarch, Manuel Areu (1845–1944), was the owner of the large collection of zarzuela manuscripts discovered in Jerome, Arizona, in 1952 and donated to the University of New Mexico (see chapter 5). The Areus had fled the Mexican Revolution and remained in the United States, settling in Los Angeles.

La Compañía Hermanos Ortiz
¡Esta Noche Maromas! That is how members of La Compañía Hermanos Ortiz announced performances along the roads of communities throughout New Mexico on the afternoon before a show. It was a touring company headed by José Torres Ortiz, also known as *El Gran Payaso Tamborín* (Tamborín the Great Clown), according to his son Steve Ortiz, a musician and singer from Albuquerque. It was their form of advertising an evening of music, acrobatics, and drama presented by La Compañía Hermanos Ortiz.

The Ortiz family has played a large part in New Mexico theater since the last decade of the nineteenth century, when the father of *El Gran Payaso Tamborín*, Jesús Ortiz de Torres, toured the Southwest with his own circus, performing as *El Chamaco* (The Kid). He called his circus The California Show, and claims it to have been the first circus originating in New Mexico. When José Torres Ortiz was eleven years old, the company performed in an unnamed border town in southern New Mexico before Pancho Villa and his men. It turned into a disaster because instead of applauding, Villa's people shot their guns in the air, leaving the tent full of holes. José was ready to join Villa as a bugle boy, but his father intervened.

When José grew up, he operated La Compañía Hermanos Ortiz, which presented trapeze, wire walking, fire eating, juggling, singing, dramatic excerpts, and comic skits. José's wife, Florinda, sang rhythm and blues, and served as straight man to her husband's comedy. The children, Reuben, Steve, Gloria, Anita, and Juanita, were also performers. In Taos, the tent was set up in an empty lot near the Plaza. One night as they performed, charges were brought against Tamborín because he apparently had made a woman laugh so hard that she had a heart attack and died. Tamborín was

8.15
José Torres Ortiz as El Gran Payaso Tamborín, ca. 1940. Courtesy of Steve Ortiz.

arrested but the charges were dropped. A better influence the group had was on Roberto Martínez of Los Reyes de Albuquerque, who credits them with inspiring him to get into the music business after hearing them in Mora.

The company played all over New Mexico, including Anton Chico, Mora, Las Vegas, Chililí, Mesilla, Las Cruces, Nambé, and Wagon Mound, to name a few places. Everyone called them *Los Maromeros de Nuevo Mexico*. They performed in

opera houses, dance halls, schools, barns, and occasionally in two-walled structures. They traveled in a Model A Ford in the early days, but also had a two-cylinder Fiat for driving through town announcing the evening's performance. Steve Ortiz made his first appearance at the Mesa Theater in downtown Albuquerque when, as a toddler, he woke up from a nap and wandered onstage. The Mesa Theater was located just east of the northeast corner of Fourth Street and Central Avenue.

Nicolás Kanellos writes that La Compañía Hermanos Ortiz was active from the 1920s to the late 1930s in Texas and New Mexico. He reports that in its May 1936 performance in San Antonio, it featured twelve acts, including magic and the clowns Tamborín and Rubiné (Kanellos 1987).

Steve Ortiz remembers his father was as sought after for his medicinal remedies as for his theater work. He had one remedy that was effective on whooping cough. "He would never charge for any of his remedies. People loved him and my mother, who was a medicine woman. She was taught by her Navajo family," reported Mr. Ortiz (1997). Florinda Naranjo was born in Dawson, New Mexico, near Springer.

José continued the touring until World War II, when the shortage of gasoline forced them to stop touring. Eventually they sold the tent and turned to playing at dances for fiestas around Albuquerque. Andy García eventually sold the tent to an American Indian Christian group in Gallup for eight hundred dollars, thus beginning his tent business, Garcia's Tent Rentals.

In 1939, in Conchos, Arizona, Florinda inadvertently killed a man in an accident with a stage prop. It crushed her spirit so badly that Steve Ortiz believes the grief eventually killed her. For years after, certain audiences would shout *matones* (killers) as an obvious play on the word *maromero*.

The company had been in nearby St. Johns, in east central Arizona, where their maroma was a big success. Also, José's medicinal sales were doing well. While in St. Johns, his remedies were used to bring many babies back to health. From St. Johns they went to Conchos, where José rented the school house because the dance hall was already

8.16
Undated playbill for the California Show, featuring El Payaso Chamaco. Courtesy of Steve Ortiz.

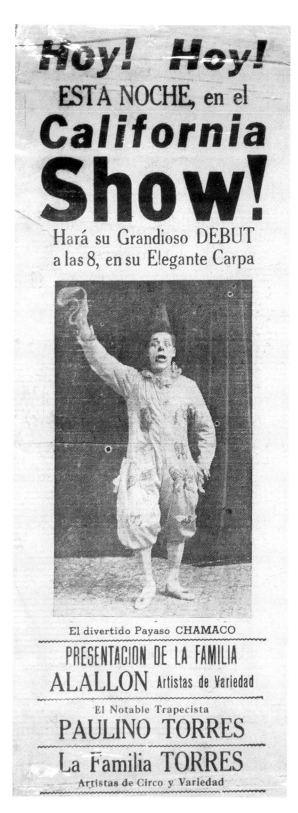

El divertido Payaso CHAMACO

PRESENTACION DE LA FAMILIA
ALALLON Artistas de Variedad

El Notable Trapecista
PAULINO TORRES

La Familia TORRES
Artistas de Circo y Variedad

booked for a dance. When he attempted to buy a permit at the sheriff's office, he was turned down. Knowing his way around these things, José chose to donate part of the evening's proceeds to the church, thereby sidestepping the need for a permit. In fact, all he needed was to pay a deputy to serve as security guard for the event.

"My father would set up the stage curtains," Steve Ortiz remembers,

> Then he would put two signs on each side of his car reading "Ortiz Brothers Show." My Mom would play the drum in the back seat of the car while my father played the trumpet out the window. My brother Reuben and I sat on the fenders painted as clowns, passing out flyers.

The family paraded up and down the streets of town in their small two-cylinder Fiat calling out ¡*Esta noche, maroma!* and playing the drum and trumpet.

> That afternoon as they got ready for the parade, a few roughnecks appeared asking for trouble. My Dad was the most peaceful man I have ever met. He told them, "Gentlemen, I'm just a man who travels around the country bringing a little joy to your hearts with my jokes, music, and songs. I'm not looking for trouble." They seem to have understood and left. Not one to take chances, José sent Lupe Ramos, a youth he had added to the circus in Carlsbad, to remind the sheriff to send the hired deputy.

Early in the evening, my father with his trumpet and my mother with her drums played in front of the schoolhouse. In most towns, other musicians would join in. When enough people gathered to hear the music, Mom put down the drums and sold tickets.

My father would say, "Ladies and Gentlemen, it's going to be show time! Come one, come all, buy your tickets!" Then he closed the door and collected tickets. This way they would know who paid and who didn't.

All of a sudden, the roughnecks appeared, and they were drunk. They almost broke the door down. They pushed their way in almost knocking my father down. He told my mother not to bother trying to charge them for tickets. Meanwhile, still no deputy. Again, my father sent Lupe to get the deputy.

Then it was showtime. Florinda was first with a song, "St. Louis Woman." As she began, the roughnecks began calling out until one yelled to the others, "Let's take this woman." As they advanced on the stage, Florinda turned and saw the gun José used for his magic act. In the act, she would hold the ace of hearts in front of her stomach. When he fired the gun, the mirror behind her would break. Then he would pass a ribbon on a sword seemingly through her stomach to show how the bullet had gone through.

"She saw the gun on the table," Steve Ortiz said,

picked it up, knowing it had only blanks, figuring she would scare them. The attacker was about two feet away when she emptied the gun on him. To her surprise, he fell dead. The deputy was there in seconds, along with the sheriff. They arrested her and because Conchos had no jail, they took her to St. Johns. It seems Lupe Ramos had anticipated trouble, so he had replaced the blanks with real bullets without telling anyone. If the show had gone on as scheduled, my father would have killed my mother.

When I woke up, I was in the car still made up as a clown. I looked out the window of the Model A Ford and on the third floor of the jail, I could see my mother waving a handkerchief with her six-month-old baby in her arms. I ran out of the car and tried to get into the jailhouse, crying my eyes out. I wanted to be with my mother.

We really had it rough. I remember it was snowing and I had to put cardboard in my shoes because they had holes. Around there, everyone was related. The law was one big family. The man my Mom killed was related to the man who owned the dance hall and also to the sheriff. The only way we got food was through the people of St. Johns who were grateful for the remedies that cured their babies. My mother would lower a string from her cell window and they would send up food to her and her baby. My father was unable to raise the $1,500 bail, so she stayed in jail over a year. During that time, my brother and I had the run of the jail, and even stayed overnight. I believe my mother died at age 39 because she could never live with the idea that she took a life.

My father went to Phoenix to visit a friend who owned Mexico Printers. He was also the Mexican consulate and had a lot of influence. This man contacted someone in Washington, D.C., and a U.S. marshall was sent to Conchos. My mother was free in a few days. I remember the people holding candles and praying in the streets of St. Johns. We are still remembered there. When I called in 1988 to look into acquiring copies of court documents, the county clerk started telling me some of my father's jokes.

Steve and Reuben began singing at ages four and five, respectively.

One night without warning, Reuben went blind. My mother thought it was a curse from God. She cried and prayed herself to sleep. Having tried everything she could, she finally took him to El Santuario de Chimayó to visit *El Santo Niño de Atocha*. Then one day, just as suddenly, his vision came back. I think her faith cured him.

But not before Reuben took a few falls.

In those days, when we were performing as kids, people would either feel sorry for us or think we were cute because they would throw

money at us. I would put a walking cane under my arm and Reuben would hold on to the other end of the cane to guide himself around the stage. As people threw money, I would forget about my brother and start picking up the money. Reuben would fall off the stage and I would get a spanking.

Steve never wanted to be a clown. "I would cry all through the parade when my father sat me on a fender made up as a clown. He would ask me, 'What would you like to be?' I would say, 'A singer, not a clown. That's what I would like to be!'" Steve later wrote the following poem in English.

Once upon a time there was
 this clown
Who was my father you see,
To me he was as funny as no
 other man could ever be,
One day he tried to make a
 little clown out
 of me
I said, "Sir, a singer not a
 clown, that's what I would
 like to be!"
And he said, "Sing a song,
 sing a song, my boy!
And find what you are looking
 for."

Steve became such a good singer that his work has been recorded by national recording artists. He formed The Trío Ortiz with his brother Reuben and sister Anita, and appeared on television and onstage nationwide. His poem, "Poor Boy," was recorded by country singer Eddie Arnold in the 1960s. It tells of the night his sister was born in a rented shack in Wagon Mound, where the cir-

cus was performing at the Opera House there. He remembers covering the windows against the cold so his sister could be born.

The Trío Ortiz came into being after World War II. In 1949, this cutting-edge group produced the first bilingual television show in New Mexico, called "The Ortiz Trío Show." Together with lyric writer Luis Martínez (father of Ted Martínez,

8.17

Florinda and José Torres Ortiz in one of their skits. Courtesy of Steve Ortiz.

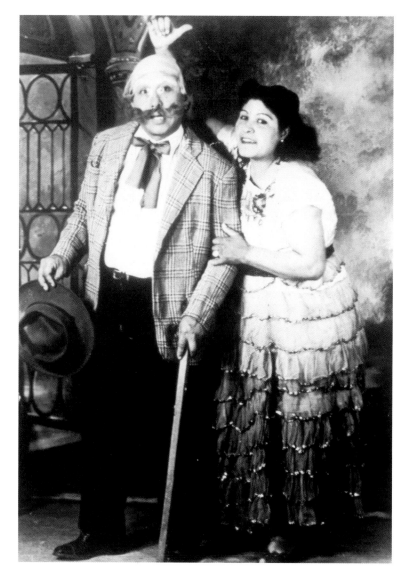

former president of Technical-Vocational Institute), Steve established in the 1940s the first recording company in New Mexico, called M & O Records, for Martínez and Ortiz. They produced 78 rpm records, which are still in existence at KNMX in Las Vegas, New Mexico.

The Trío Ortiz won first prize on the Arthur Godfrey Talent Show. Later, as The Coronados, they appeared with Sammy Davis, Jr. at the Sands Hotel in Las Vegas, Nevada, and with Tony Bennett at the Copacabana. They also appeared on many national television shows, including "The Johnny Carson Show" (six times), "The David Letterman Show," various commercials, "The Jackie Gleason Show," and a feature film, *Scenes from a Mall.* Steve has performed in Rome and Japan, and he sings in Italian, Hawaiian, and Yiddish. Today, he owns and operates a music recording studio in downtown Albuquerque.

Professional Theater in the Twentieth Century
Prior to the 1970s, no scholars or books suggested the existence of a professional, Spanish-language stage in the Southwest.

> No one mentions . . . the theater houses that bore Spanish names and that were already functioning when the first minstrels arrived from the East. Neither do they make note of the professional and amateur Spanish-language companies that represented the only available theatrical entertainment for Mexicans and Anglos alike. . . . They overlooked the large numbers of Hispanic artists that were drawn to Hollywood and participated in both the American and the Hispanic silent-film industries, as well as the success of Latin music and dance in American vaudeville, and in addition, the large-scale commercial success of the Spanish-language stage, not only for Hispanic, but also for American theatrical entrepreneurs. (Kanellos 1987)

Spanish language theater flourished in Los Angeles up to the 1920s, and in San Antonio to the 1930s. In the early twentieth century, Los Angeles became a play writing colony, attracting Mexican immigrant playwrights who wrote about nineteenth- and twentieth-century life in the Mexican and Mexican-American community there. Professional theater activity in California had begun in the late eighteenth century and was nurtured by professional companies from Mexico, Spain, Cuba, and Argentina, who traveled there by steamship. When these same companies toured the Southwest, they followed the border towns and northern Mexico, with stops including southern New Mexico. They also toured the north and east of the United States aided by American booking agencies. When vaudeville became popular, these companies toured not only the Hispanic circuits, but the American and Canadian vaudeville circuits.

Unlike the circus and maroma, the professional theater companies focused on drama and zarzuela, with occasional comedies, revistas, variedades (variety acts), and films. Presentations could include a film with variety acts in the afternoon followed in the evening by a full-length drama. Weekend offerings might be a different zarzuela and drama each day. Subject matter ranged from current events to Mexican-American life in the United States. In the late twentieth century, Hispanic playwrights would look back and pay homage to the pastorelas, Guadalupe plays, and the carpas, including their performance styles.

Los Angeles supported five major Hispanic theaters with programs that changed daily. Seventeen other theaters flourished there between 1915 and 1935. Because of this, actors from New Mexico migrated there to advance their careers. Then, as now, New Mexico could offer only the start an actor needed to establish a career. Actors, directors, technicians, and musicians from all over the Southwest and New York gathered in Los Angeles in search of work in the theater arts and film industries.

San Antonio was the other major theater center during the late 1910s and 1930s. Theater activity continued on a smaller scale after three factors came into play: the forced or voluntary repatriation of Mexicans, inexpensive admission to talking films, and the Depression. Thereafter, companies performed dramas, zarzuelas, and revistas, and many communities organized noncommercial companies to perform for local projects and chari-

ties. Other companies formed cooperatives to rent theaters and manage for themselves. While there is no record of such activity in New Mexico, future studies may show that Nuevomexicano communities mirrored activities elsewhere in the Southwest.

While these theaters closed, a number of company actors continued their careers in New York vaudeville, which survived into the early 1960s, or by working in Spanish-language radio and television after World War II. During the 1950s and 1960s, serious drama was occasionally produced by professionals like Carolina Villalongín and Lalo Astol in San Antonio, and on a more regular basis in Los Angeles by playwright Rafael Trujillo Herrera at his Teatro Intimo. In the 1970s, professional companies began to make a comeback with leaders such as Carmen Zapata, a well known television and film actor who founded the Bilingual Foundation of the Arts to encourage Latino theater.

The Chicano Theater Movement

The carpas continued into the 1960s, often setting up in the migrant farmworkers' camps to perform revistas. Then in 1965, El Teatro Campesino (Farmworkers' Theater) was formed in Los Angeles by Luis Valdez, a farmworker who would eventually become a producer of films as well as stageworks. Valdez's intent was to assist in organizing farmworkers for the grape boycott and the farmworkers' strike. As such, it was labor theater and street theater. El Teatro Campesino was unlike the professional Spanish theater in its rough, improvised nature and its outdoor presentations, usually on flatbed trucks in parking lots, parks, fields, and factory floors. The company attracted national attention as a movement by the youth of the Latino culture.

As theater scholar Jorge Huerta later wrote, Teatro Campesino

> found itself performing in the face of the "enemy," poised on its flatbed truck within earshot (gunshot) of local gendarmes eager to cause a little destruction. Members of the troupe at that time recall how they had to be constantly wary of the threat of violence, and how the term "stagefright" took on a new

meaning in the face of goon squads and fully garbed riot police. (Kanellos 1984)

Teatro Campesino was the first of one hundred similar companies on campuses and in communities nationwide, all collectively referred to as the Chicano Theater Movement. Organizers chose names like Teatro Chicano (Austin), Teatro Movimiento Primavera, Teatro Urbano (both from Los Angeles), Teatro Desengaño del Pueblo (literally "telling it like it is") of Gary, Indiana, Teatro de la Esperanza (Theater of Hope, Santa Bárbara, CA), Teatro de la Gente (Theater of the People, in San José), Teatro Alma Latina (Latin Soul Theater in New Jersey), and Teatro Trucha (Trout Theater in Chicago). Like Teatro Campesino, they performed in informal venues in order to reach the bottom-rung worker with their messages of social and political reform. Many of today's Hispanic actors got their start there, as did directors, filmmakers, and drama professors. *Zoot Suit*, the first Mexican-American play to reach Broadway and to become a Hollywood feature-length film, was created in Chicano theater.

The Chicano Theater movement didn't make an impact on New Mexico until the 1970s, according to Ramón Flores of La Compañía de Teatro de Albuquerque. At that time, the Teatro de la Calle was organized at the University of New Mexico under the direction of Veronica Sánchez and Richard Gallegos. In 1973, Anita Luna organized the Teatro Colectivo at Los Duranes, a left-wing collective center there. It closed in 1980. Little information is documented on either group. Nita Luna also organized a theater company in Roswell, New Mexico in the 1970s.

The distinctive theater form created by Chicano theater was the *acto* (act), a short, satirical propagandist sketch inspired by the sketches of the old revistas. Unlike the revista, however, the acto was designed to get people thinking and moving to social activism. Playwrights challenged the status quo through actos. They revisited American history to include the Mexican-American perspective and to promote a positive self-image or "Chicano identity," while promoting the Spanish language, and Hispanic music, heroes, and cuisine as alternatives to the established mainstream culture. In

fact, the creators of actos drew inspiration from the mainstream in order to challenge it. One example collected by Kanellos was inspired by a television commercial for Radio Free Europe showing a "blank-eyed" child with a padlock and chain on his head. A loudspeaker blares at him with brain-washing messages. From this commercial Teatro Chicano de Austin created an acto showing three Hispanic children being drilled by two militaristic drill-instructor teachers. Writes Kanellos,

These children were also padlocked and chained as they monotonously repeated the dictations of their teachers "All good Americans speak English. César Chávez is a commie. Lettuce each day keeps the doctor away. Mexicans are thugs and Pachucos. Mexicans should work in the fields because they are built close to the ground. White is right. Blonds have more fun." After the recitation, another character appears and addresses the audience, "There are over fifteen million Chicanos in the United States. First they stole our land and now they want to steal our minds." (Kanellos 1987)

Kanellos was an actor and director in Chicano theater, and then moved on to establish Arte Público Press, which has published many of the significant Hispanic works of the late twentieth century. He has also published numerous articles on the history of Hispanic theater in the United States.

Chicano theater companies performed bilingually, but switched to Spanish or English as needed. The use of code switching in the scripts reflected the real-life use of language. Playwrights often used common dialects, if their audiences did, or caló, the language of the pachuco. Language was also a political issue to be explored by the company. In another example, set on the first day of school in a kindergarten of mostly Hispanic children, Kanellos (1987) describes the scene.

Upon realizing that his students speak only Spanish, the teacher immediately admonishes, "You are in the United States now. And in the United States *everybody* speaks English. So if your name is Juan, why we change that to John. Or if your name is Ricardo, well that becomes Richard, you see." He then proceeds to change each child's name: Juan Paniaguas to John Bread and Water, María Dolores de la Barriga to Mary Stomach Pains, Casimiro Flores to I Almost See Flowers, and Domingo Nieves to Ice Cream Sunday. The acto continues with a series of humorous misinterpretations and reaches its climax when Ice Cream Sunday urinates in his pants because the teacher refuses to find out what his needs are, unless he expresses them in English.

Another theme explored by Luis Valdez drew from Mayan and Aztec myths in the context of contemporary life, or Atzlán, the land and culture of the mestizo. These sketches were called *mitos*. They also paid homage to Hispanic theatrical tradition, as in Teatro Campesino's *La Gran Carpa de la Familia Rascuachi* (*The Large Tent of the Underdogs*), which brought together the past and the present in a work that deals with the birth and endurance of the mestizo, the miracle of Our Lady of Guadalupe, and the experiences of Chicanos in the United States through three generations of the Pelado family.

In exploring and illuminating pre-Columbian and mestizo history and legend, Chicano theater replaced and made up for the oversights and ethnocentric errors of North American historians, according to Kanellos. Actos praised the lives and works of figures like César Chávez, Emiliano Zapata, and Francisco Villa. By doing so, the acto continued the same service as the corrido.

The true meaning of the Chicano movement, according to Kanellos, is that in most cases the conflict is resolved by choosing a biculturalism that accommodates and permits both modes of behavior where possible: the choice between a hamburger or a taco, English or Spanish, living in the Heights or in the Valley, Santa Fe or Española. This new dualism is expressed in the following song called "México Americano" written by Romel Fuentes, a former member of the Teatro Chicano de Austin.

Por mi madre yo soy mexicano.	Mexican by parentage,
Por destino soy americano.	American by destiny,
Yo soy de la raza de oro.	I am of the golden race.
Yo soy mexicano americano.	I am Mexican American.
Yo te comprendo el inglés.	I know the English language.
También te hablo el castellano.	I also speak Spanish.
Yo soy de la raza noble.	I am of the noble race.
Yo soy méxicano americano.	I am Mexican American.
Zacatecas a Minnesota,	Zacatecas to Minnesota,
de Tijuana a Nueva York,	from Tijuana to New York,
dos países son mi tierra.	two countries have I.
Los defiendo con mi honor.	I'll defend them with my honor.
dos idiomas y dos países,	Two languages and two countries,
dos culturas tengo yo.	two cultures are mine.
Es mi suerte y tengo orgullo	It's my fate and I'm proud,
porque así lo mando Dios.	for it's the will of God.

(Kanellos 1987)

In the late 1990s, professional companies operating in the United States included Teatro Campesino, Teatro de la Esperanza, Bilingual Foundation of the Arts in Los Angeles, and Teatro Meta in San Diego.

La Compañía de Teatro de Alburquerque
In 1976, the New York-based Spanish-language theater company, Repertorio Español, performed at the University of Albuquerque. Dr. Miguel Encinias of that institution's Multicultural Education Program invited one of the company's actor-directors, José Rodríguez—a graduate of London's Royal Academy of Dramatic Arts, and a native of Puerto Rico—to return to New Mexico to conduct a drama workshop in Spanish for the program. He accepted and the first production, in the spring 1977, marked the beginning of La Compañía de Teatro de Alburquerque, a bilingual community theater comprised of a core of professional actors working with community actors from all walks of life and of all ages. Rodríguez organized workshops in various theatrical disciplines, drawing over three hundred persons from which he chose a core of ten actors to take larger roles. The first plays produced by La Compañía were those by the poet Federico García Lorca. The repertoire expanded immediately to include plays by Nuevomexicano, regional, national, and international playwrights. It also reflected the influence of the Chicano theater movement in its concern for Nuevomexicano life and history as examined in new works.

In the late 1990s, the company presented three to four plays per season, following its mission to serve as a repertory theater company that reflects, preserves, and empowers the New Mexico community and its

8.18
Scene from *Turning*, a play by Demetria Martínez produced by La Compañía de Teatro de Alburquerque. Photo by Miguel Gandert.

culture through professional productions. La Compañía's goals are to produce works in four broad areas:

- Plays exploring the Nuevomexicano identity and history, either through original plays or through adaptations of traditional works and world classics. *Casi Hermanos* (Almost Brothers), for example, is based on an actual historical incident in 1681, when two half brothers met on a battlefield north of Cochití during the Pueblo Revolt. They were Javier Márquez, a Spanish settler, and Alonzo Catití, governor of Santo Domingo Pueblo and a leader of the Revolt. James Luján of Taos Pueblo and Ramón Flores, executive director of La Compañía, researched historical documents about the half brothers Márquez and Catití and wrote a fictional tale that follows their stories from their births in the 1630s to the Pueblo Revolt. The play explores in visceral terms the dynamics which led to the Revolt. Examples of adaptations of traditional religious folk plays by contemporary playwrights include José Rodríguez's *El Sueño Navidad del Santero* (The Saint Maker's Christmas Dream), based on *Los pas-*

tores, as inspired by previous versions, including the Lope de Vega *auto*. *Las posadas* inspired La Compañía's production of *Sí, Hay Posada* (Yes, There is Lodging) by Denise Chávez. The play focuses on a contemporary Nuevomexicano family's conflicts during a traditional Christmas gathering. While recalling ancient folk custom, the play addresses contemporary dilemmas, such as a Vietnam veteran's difficulty in adjusting to life at home. One of La Compañía's longest running shows was *Nuevo Mexico, Sí!*, a slightly satiric and often humorous musical history of New Mexico.

- Plays that explore contemporary social issues such as alcoholism, crime, racism, and gangs. M. Salomé Martínez's highly successful *Estoy en el Rincón* (I Am in the Corner) deals with the impact of alcoholism on the Nuevomexicano family and community. In the late 1990s, this play was seen by thousands of individuals statewide. La Compañía produced Jimmy Santiago Baca's epic poem, *Martín*, about the life and times of a young urban Nuevomexicano seeking his identity in the face of cross-cultural and personal adversity.

- Plays that reflect women's perspectives, in-

cluding *Turning*, a stage adaptation by Irene Oliver-Lewis based on the poetry of Demetria Martínez, *Las Nuevas Tamaleras* by Alicia Mena, *How Else Am I Supposed to Know I Am Still Alive* and *Premeditation* by Evelina Fernández, and *The Night They Stole the Santo Niño* by Lynn Butler.

- Plays on children's subjects, including *The Farolitos of Christmas* by Rudolfo Anaya, and *The Night They Stole the Santo Niño*.

In addition, Nuevomexicano life is mirrored through adaptations of works by Shakespeare, Lope de Vega, Moliere, Lorca, Arthur Miller, Ray Bradbury, Charles Dickens, and others. La Compañía has toured New Mexico, the United States, northern Mexico, and Europe. In 1984, the company performed at the Edinburgh International Festival and at the Fourth Latin American Popular Theater Festival, sponsored by Joseph Papp, in New York City. It also performs free of charge at detention centers, inner city community centers, and schools. The company has received awards for excellence from the Albuquerque Arts Alliance; from the Anti-Defamation League of B'nai B'rith for its "positively-shaped" production of *The Merchant of Santa Fe*, an adaptation of Shakespeare's *The Merchant of Venice*; and the Fourth Siglo de Oro Award at El Paso's Chamizal International Drama Festival in 1979. The most prominent artistic directors since José Rodríguez have been Irene Oliver-Lewis and Ramón Flores. Under Ms. Oliver-Lewis's administration, the company reached more audiences through improved community outreach and through touring, while its productions grew more technically and artistically professional. She emphasized contemporary issues and local playwrights over the classics. Mr. Flores contributed a profound sense of history, as it relates to contemporary life and issues, and established a balance among works by local playwrights, adaptations, regional works, and the classics. Projects such as *Casi Hermanos* and *The Merchant of Santa Fe* reflect much primary and secondary research, and a refinement of scripts and production values achieved through numerous *tertulias* and reworking of scripts.

Compañía alumni have moved on to work in professional theater and film across the nation; David Velásquez won an Emmy for his costume design for *Sesame Street* and also designed for film and television; Mónica Sánchez is a member of the San Francisco Mime Troupe, and tours overseas with that company; José García, who has a degree in drama, teaches acting and works in the film industry in Los Angeles; Benito Martínez and his sister Patrice have appeared in numerous films and on stage; Elena Parres founded Teatro Zona in Santa Fe and is now directing on both coasts; Marcos Martínez teaches drama in California; Sergio Palermo edits commercials and films; and Mariel McEwan is a successful costume designer and producer.

Theater Activity Statewide After 1970
Touring companies did very little to foster local theater activity by presenting drama workshops or encouraging the establishment of local theater groups. As a result, there has been very little sustained theater activity in rural New Mexico, while activity in urban centers has been sporadic, with the notable exception of La Compañía de Teatro de Alburquerque. Commercial theater ventures have been non-existent, and in the late twentieth century, few nonprofit theater companies have survived. Girard Martínez, founder of Teatro Mestizo in Santa Fe, attributes this to the Nuevomexicano community's lack of a tradition of serving on boards or working as volunteers for a nonprofit organization. Still, a handful of actor-directors have motivated some efforts from time to time.

Arsenio Córdova, a writer of church music for many years, organized the Sangre de Cristo Liturgies, a Taos-based group of twelve musicians and performers who began performing traditional Nuevomexicano music and drama throughout northern New Mexico and southern Colorado in the 1970s. They perform *Los pastores* in up to eight communities each Christmas season. For two years in the early 1990s, they toured a production of the traditional auto, *Adán y Eva* throughout New Mexico. They have also produced *La aparación de Nuestra Señora de Guadalupe*, and *El Santero de Córdova* by Denise Chávez.

The group's name was originally La Compañía de Arroyo Seco. Its current name is taken from the West Coast-based publisher of church music that has for many years published Mr. Córdova's original liturgical compositions. Sometimes the performers go by the name Teatro Sangre de Cristo, or Grupo Sangre de Cristo.

Mr. Córdova teaches Southwest studies, and Nuevomexicano folklore and drama at the Taos branch of the University of New Mexico, and heads the drama department at Northern New Mexico Community College, where thirty to forty students each semester produce or prepare productions, including the early plays of Luis Valdez, and original works by Córdova and other New Mexicans. Topics have included retelling local history from the Hispanic perspective, the English-only movement, the ramifications of the Treaty of Guadalupe-Hidalgo, discrimination issues, and the importance of maintaining Nuevomexicano culture and traditions.

Since the early 1990s, the group's focus has shifted more heavily to works by local playwrights. For example, *El Norte* (1997) by Arsenio Córdova and Eloy García, is described as a historical review of New Mexico from 1841 through 2038, including the creation of northern New Mexico as a new nation called El Norte. Córdova wrote a corrido for the play in which the verses introduce different periods in the history. Another historical panoramic play is *Los hijos y hijas de Juan de Oñate*, including music.

Santa Fe theater activity for decades centered on annual productions of *Los pastores* and *Los reyes magos*, faithfully carried out by Los Caballeros de Vargas, a consortium of men who, for over thirty-five years, have produced Nuevomexicano plays and pageants in Santa Fe, particularly the reenactment of Vargas's *entrada* (entry) into Santa Fe. With the influx of Anglo-American "transplants" into Santa Fe in the 1970s and 1980s, traditional Nuevomexicano theater continued while contemporary Chicano theater waned. During those decades, efforts by Northern New Mexico Community College kept contemporary Chicano theater from disappearing altogether. In the 1980s, Mexican actor-director Elena Parres teamed with local actor Victoria Cross to establish Teatro Zona. The company performed at the Armory for the Arts and toured a highly successful play called *Hecho en Mexico*.

The late 1990s has seen the emergence in Santa Fe of Teatro Mestizo and Teatro Hispano de Santa Fe. Teatro Mestizo is the effort of Girard Martínez, who initiated the group with a staged reading in 1996 of an original bilingual work called *Vecinos*, addressing intercultural issues in contemporary Santa Fe. When fully operational, Teatro Mestizo plans to produce works dealing with issues facing contemporary Hispanic Santa Feans to promote their sense of ownership of their city. Street theater will be the medium by which Teatro Mestizo will initially reach the public, at Spanish Market and during the Fiesta in September. A youth program is also in the planning stages. The group is based at the Santa Fe Playhouse, formerly known as the Santa Fe Community Theater, whose board made a commitment in the early 1990s to foster Chicano theater in Santa Fe. Teatro Mestizo receives support from Santa Fe Playhouse as well as organizational assistance from Santa Fe Stages, another mainstream theater company.

Teatro Hispano de Santa Fe was founded in 1996. This community theater company produces one work a year for presentation near the last weekend in July, when Spanish Market is held. Teatro Hispano often presents showcase performances including music, storytelling, poetry, and theater. They have also produced *El Happy Hour*, written by artistic director Robert Piñeda and directed by Joey Chávez, who is a drama teacher at Santa Fe High School. The one-act work is set in a northern New Mexico bar, with a variety of typical character types appearing during the course of the play, and spotlighting various issues facing modern Nuevomexicanos, such as racism, alcoholism, and domestic violence. Teatro Hispano's works have been well received by audiences and reviewers alike.

From 1973 to 1976, New Mexico State University at Las Cruces supported the Teatro ATM (*A Toda Madre*), consisting of fifteen members, including Carlos Corral. According to Corral, the group was a direct result of a series of workshops presented in Las

Cruces by Teatro Campesino of California. Teatro ATM produced some Teatro Campesino pieces as well as traditional regional plays like *La aparición de Nuestra Señora de Guadalupe,* and new works on local legends, like La Llorona. Their biggest success was *No saco nada de la escuela,* a Teatro Campesino play about racism in education that struck a chord with local audiences, according to Corral, because it was a major issue at the time.

In 1976, with the assistance of the Home Education Livelihood Program, Corral organized a children's theater group called Teatro Chihuahuita at Roswell, New Mexico. The purpose of the project was to teach cultural awareness and Chicano history, and to perform at a children's festival. The group of twenty-five staged several plays of cultural significance centering on Cinco de Mayo, La Llorona, gang violence and other social issues. The group also had a dance component comprised of younger children. In 1979, Corral organized a children's theater in Las Cruces called El Teatro de Las Cruces. Like the Roswell group, these children drew on personal experiences to write and perform plays on real life and social issues. El Teatro de Las Cruces performed in Washington, D.C., at a gathering of the Youth Workers' Alliance Conference in 1980. Corral discontinued his theater activity in 1985.

Lost Tribe Productions was founded in 1990 in Albuquerque by actors Jonathan and Joseph Anthony Wasson, musician John Gonzales, and actor Adán Sanchez. Its first production was *Meet the First Chicano President,* written by comedian Steven Quesada. Another highly successful production was *Ché TV,* a humorous anthology of Chicano television, including the "Jim and Tammy Fay Baca Show," "Star Trek: The Chicano Generation," "Chatos in the House" (a sitcom), "The News," and a game show called "Ch-Pardy," a take-off of *Jeopardy* and *Wheel of Fortune,* featuring co-host Wanna B. White. For several years Lost Tribe Productions offered a regular season of three productions per year, featuring actors Carol Ann Benavídez, James Chávez, Juliana Silva, Steven Quesada, and Greta Quesada, in addition to its founders. Because its members excelled in video work, Lost Tribe presentations often featured

videotaped scenes on a screen behind the stage action, keyed to that action. Other productions include *Thugs* and *Oso* (bear), both written by Adán Sánchez, and *Life in the Shadows,* a "street musical" written by Joseph Anthony Wasson and John Gonzales, with rap, reggae, and contemporary rhythm-and-blues music by Gonzales. The company is currently focusing on refining *Life in the Shadows*—a story about the effects of drugs on members of an emerging rock band—into a feature film for presentation at film festivals around the nation.

Theater activity in Las Cruces promises to re-emerge when renovation of the Court Youth Center is completed. It will then serve as a venue for original works produced under the direction of Irene Oliver-Lewis, formerly of La Compañía de Teatro de Alburquerque. The site will also serve to host touring companies from around the nation and to showcase youth theater productions.

Chronology

1207 *Cantar de mío Cid* is the first written literature in the Castellano language.

1542 Cabeza de Vaca completes his *Relación,* a report to the Spanish crown detailing his eight-year odyssey after a shipwreck off the coast of Florida in 1527.

1598 First Spanish settlers under Juan de Oñate introduce the Castilian Spanish language into New Mexico, as well as the first play and first performance of *Los Moros y Cristianos.*

1610 Gaspar Perez de Villagrá publishes, in Spain, his epic poem about the Oñate settlement in New Mexico twelve years earlier.

1730 –35 Miguel de Quintana is under investigation by officers of the Inquisition for his spiritual poetry.

1764 An uprising at Santo Domingo Pueblo results in fire destruction of mission records and possibly some books in its relatively large library.

1776 At the request of Fray Francisco Atanasio Domínguez, Fray Joaquín de Jesús Ruiz, a missionary at Jémez, writes a procedural manual for instructing the Pueblo Indians under his care, including the teaching, reading, and writing of Latin and some Castellano.

1779 The possible date of composition of *Los Comanches*, a conquest play about the final suppression of the Comanche leader, Cuerno Verde, and the first original play about an event in New Mexican history.

1808 The Santa Fe Presidio School is established for the children of the soldiers and officers stationed in Santa Fe.

1812 First New Mexican to be published is Don Pedro Baptista Pino, whose report to the Royal Court in Spain is published in Cádiz, Spain, under the title, *Exposición sucinta y sencilla de la provincia del Nuevo México*. Pino is believed by scholars to be the author of the secular play, *Los Comanches*.

1834 First book printed in New Mexico is a children's primer entitled *Cuaderno de Ortografía*, published by Padre Antonio José Martínez.

1841–46 *Los Tejanos* is written by an as yet unknown playwright.

1880–1930 The golden age of New Mexico Spanish-language journalism.

1907 Aurelio M. Espinosa publishes the first of many collected folk literature genres, including folktales, plays, dichos, and romances.

1912 Author and attorney Benjamín Read publishes his *Historia ilustrada de Nuevo Mexico*, the first carefully researched history told from the Nuevomexicano perspective.

1920 Aurelio M. Espinosa receives fellowship to study in Spain for five months, and discovers numerous striking similarities between Spanish and Nuevomexicano folk literature.

1940s La Compañía Hermanos Ortiz stops touring New Mexico and the Southwest due to gasoline shortages because of the War.

1953 Aurora Lucero-White Lea publishes texts of Nuevomexicano sacred and secular folk plays.

1960s Annual performance of *Los Moros y Cristianos* resumes in Chimayó, New Mexico.

Annual performance of *Los Comanches* in Alcalde, New Mexico.

Chicano Theater Movement flourishes.

1971 Rudolfo Anaya publishes *Bless Me, Ultima*.

1977 La Compañía de Teatro de Alburquerque founded.

Glossary

Arenga—A long, impassioned military speech delivered by a military leader to insult the enemy while motivating his own troops.

Assonance—Rhyme in which the same vowel sounds are used with different consonants in the stressed syllables of the rhyming words.

Auto de entrada—A play on horseback.

Auto sacramental—A medieval Biblical play following a procession in honor of the sacrament of the Eucharist; also, a miracle play.

Carpa—Literally, tent. Specifically, carpas were traveling tent theater companies that presented musical performances, and circus and magic acts together with drama and comedy excerpts.

Code switching—Spoken or written language in which two languages are used in the same sentence in accordance with very specific rules of syntax and grammar.

Criollo—A person born in the New World of full Spanish blood. Creole.

Décima—A poem consisting first of a four-line strophe, called the planta, followed by four strophes of ten lines each. In these rhymed, octosyllabic strophes, the last line was one of the four lines of the planta, in order of appearance. Décimas originated in sixteenth century Spain and were still being composed in twentieth-century New Mexico, up to about the 1950s.

Maroma—Type of traveling troupe of acrobats (and other types of entertainment) in the late nineteenth and early twentieth centuries. The term is borrowed from the rope used by *voladores*.

Maromero—The name given to a performer of maromas.

Mestizaje—A term that denotes both racial and cultural hybridity, literally a mixture or synthesis of people and their cultures. In the Hispanic world, expecially after the Mexican revolution (with its artists and writers), it carries a positive connotation that contrasts rather starkly with the English equivalent, miscegenation.

Oral Tradition—The body of unwritten literary works of a people or culture, handed down from generation to generation as storytelling and verse.

Pelado—A widely popular raggedly dressed theater character, characterized as an underdog with lower-class dialect, scandalous language, and biting satire.

Peninsular—Pertaining to the peninsula of Spain, as distinct from Spanish America.

Pocho—An American-born person of Mexican heritage; a derogatory term.

Revista—The Mexican equivalent of the vaudeville evening, with a variety of music, songs, skits, and stand-up acts, including *el pelado*.

Romance—A narrative poem. Pronounced "roh-máhn-seh."

Variedades—Variety show. The term seems to be interchangeable with revista.

Voladores—The Aztec flyers who descended upside down from a high revolving platform hanging by their feet from ropes. Originally an Aztec religious ritual, the activity became a circus act that continues today.

White Legend—The emphasis on the Spanish heritage of Nuevomexicanos, as distinct from their Mexican heritage, in order to make them more attractive to non-Hispanics.

Written Tradition—The body of written literary work of a people or culture, including works which may or may not be published and disseminated.

Zarzuela—a one- to three-act Spanish operetta, with spoken dialogue and sung solos, duets, and ensembles, and emphasizing life in Spain. The zarzuela experienced a renaissance from 1855 through the 1930s.

Bibliography

Adams, Eleanor B. "Two Colonial New Mexico Libraries, 1704, 1776." *New Mexico Historical Review* 20 (1944): 135–67.

———. "Viva el Rey!" *New Mexico Historical Review* 35 (1960): 284–92.

Adams, Eleanor B., and Frances V. Scholes. "Books in New Mexico, 1498–1680." *New Mexico Historical Review* 18 (1942): 1–45. Reprint.

Anderson, Reed. "Early Secular Theater in New Mexico." In *Pasó Por Aquí: Critical Essays on the New Mexican Literary Tradition, 1542–1988*, edited by Erlinda Gonzales-Berry. Albuquerque: University of New Mexico Press, 1989.

Aranda, Charles. *Dichos*. Santa Fe: Sunstone Press, 1977.

Atencio, Paulette. *Cuentos from my Childhood: Legends and Folktales*. Santa Fe: Museum of New Mexico Press, 1989.

Austin, Mary. "Folk Plays of the Southwest." *Theater Arts Monthly* 17 (1933): 599–610.

———. "Native Drama in Our Southwest." *The Nation* 124 (1927): 437–40.

———. "New Mexico Folk Poetry." *El Palacio* 7 (1919): 146–54.

———. "*Rimas infantiles* of New Mexico." *Southwest Review* 16 (1930): 60–64.

———. "Sources of Poetic Influence in the Southwest." *Poetry* 43 (1933): 152–63.

———. "Spanish Manuscripts in the Southwest." *Southwest Review* 19 (1934): 402–9.

Barker, George C. "Pachuco: An American Spanish Argot and Its Social Function in Tucson, Arizona." In *El Lenguaje de los Chicanos: Regional and Social Characteristics of Language used by Mexican Americans*, edited by Eduardo Hernández Chávez, Andrew D. Cohen and Anthony F. Baltramo. Arlington, Va.: Center for Applied Linguistics, 1975.

Bentley, Harold W. *A Dictionary of Spanish Terms in English with Particular Attention to the Spanish Southwest*. New York: Columbia University Press, 1932.

Bolton, Herbert E. "Father Escobar's Relation of the Oñate Expedition to California." In *The Catholic Historical Review* 5 (April 1919–January 1920): 19–40.

Bond, Frank M. "Los Moros y Cristianos." Unpublished edition and introduction, 1971.

———. "Los Comanches." Unpublished edition and introduction, 1972.

Bourke, John G. "Notes on the Language and Folk-Usage of the Río Grande Valley (With Especial Regard to Survivals of Arabic Custom)." *Journal of American Folk-Lore* 9 (1896): 81–116.

Briggs, Charles. *Competence in Performance: The Creativity of Tradition on Mexican Verbal Art*. Philadelphia: University of Pennsylvania Press, 1988.

Broyles, González, Yolanda. *El Teatro Campesino: Theater in the Chicano Movement*. Austin: University of Texas Press, 1994.

Cabeza de Vaca, Alvar Núñez. *Relación y comentarios*. Translated by Martin A. Favata and José B. Fernández. Houston: Arte Público Press, 1993.

Campa, Arthur León. "A Bibliography of Spanish Folk-Lore in New Mexico." *University of New Mexico Bulletin*, Modern Language Series 2, no. 3 (1930).

———. *Hispanic Culture in the Southwest*. Norman: University of Oklahoma Press, 1979.

———. "The New Mexican Spanish Folktheater." *Southern Folklore Quarterly* 5 (1941): 127–31.

———. "Religious Spanish Folk Drama in New Mexico." *New Mexico Quarterly* 2 (1932): 3–13.

———. Sayings and Riddles in New Mexico. *University of New Mexico Bulletin*, Language Series 6, no. 2 (1937).

———. *Spanish Folk-Poetry in New Mexico.* Albuquerque: University of New Mexico Press, 1946.

———. "Spanish Religious Folk Theater in the Southwest." *University of New Mexico Bulletin* 52 (1934).

———. "Spanish Religious Folk Theater in the Southwest (First Cycle)." *University of New Mexico Bulletin*, Language Series 5, no. 1 (1934).

———. "Spanish Religious Folk Theater in the Southwest (Second Cycle)." *University of New Mexico Bulletin*, Language Series 5, no. 2 (1934).

———. "Spanish Traditional Tales in the Southwest." *Western Folklore* 6 (1947): 322–34.

———. *Treasure of the Sangre de Cristo: Tales and Traditions of the Spanish Southwest.* Norman: University of Oklahoma Press, 1996.

———, ed. "Los Comanches: A New Mexican Folk Drama." *University of New Mexico Bulletin* 7 (1942).

Candelaria, Cordelia, ed. *Multiethnic Literature of the United States: Critical Introductions and Classroom Resources.* Boulder: University Press of Colorado, 1989.

Cobos, Rubén. *A Dictionary of New Mexico and Southern Colorado Spanish.* Santa Fe: Museum of New Mexico Press, 1993.

———. *Refranes españoles del sudoeste: Southwest Spanish Proverbs.* Cerrillos, N.Mex.: San Marcos Press, 1973.

Colahan, Clark. "Chronicles of Exploration and Discovery: The Enchantment of the Unknown." In *Pasó Por Aquí: Critical Essays on the New Mexican Literary Tradition, 1542–1988*, edited by Erlinda Gonzales-Berry. Albuquerque: University of New Mexico Press, 1989.

Colahan, Clark, and Francisco A. Lomelí. "Miguel de Quintana: An Eighteenth-Century New Mexico Poet Laureate?" In *Pasó Por Aquí: Critical Essays on the New Mexican Literary Tradition, 1542–1988*, edited by Erlinda Gonzales-Berry. Albuquerque: University of New Mexico Press, 1989.

Córdova, Arsenio. "The Winter Traditions of Hispanic Northern New Mexico and Southern Colorado." Master's thesis, New Mexico Highlands University, 1997.

———. Personal communication, January 1998.

Corral, Carlos. Personal communication, March 1998.

De Grazia. *De Grazia Paints Cabeza de Vaca: The First Non-Indian in Texas, New Mexico, and Arizona, 1527–1536.* Tucson: University of Arizona Press, 1973.

Deyermond, A. D. *The Middle Ages.* Vol. 1 of *A Literary History of Spain.* London and New York: n.p., 1971.

Díaz del Castillo, Bernal. *Historia verdadera de la conquista de la Nueva España.* Madrid: Instituto Gonzalo Fernández de Oviedo, 1982.

Echevarría, Evelio, and José Otero. *Hispanic Colorado: Four Centuries History and Heritage.* Fort Collins, Colo.: Centennial, 1976.

Englekirk, John E. "Notes on the Repertoire of the New Mexican Spanish Folktheater." *Southern Folklore Quarterly* 4 (1940): 227–37.

———. "The Sources and Dating of New Mexican Folk Plays." *Western Folklore* 16 (1957): 232–55.

Espinosa, Aurelio M., ed. "Los Comanches: A Spanish Heroic Play of the Year Seventeen Hundred and Eighty." *University of New Mexico Bulletin* 45 (1907).

Espinosa, Aurelio M., and J. Manuel Espinosa, eds. *The Folklore of Spain in the American Southwest: Traditional Spanish Folk Literature in Northern New Mexico and Southern Colorado.* Norman: University of Oklahoma Press, 1985.

Espinosa, Aurelio M. *Cuentos Populares Españoles.* 4 vols. Palo Alto: Stanford University Press, 1923 and 1926.

Espinosa, Aurelio Macedonio, Jr. "Spanish-American Folklore." In "Folklore Research in North America," *Journal of American Folklore* 60 (1947): 373–77.

Espinosa, Gilberto. "Los Comanches." *New Mexico Quarterly* 1 (1931): 133–46.

Espinosa, Gilberto, ed. *History of New Mexico by Gaspar Pérez de Villagrá, Alcalá, 1610.* Notes by Frederick W. Hodge. Los Angeles: The Quivira Society, 1933. (See also Villagrá for Spanish-language version.)

Espinosa, J. Manuel. *Spanish Folk Tales from New Mexico.* Memoirs of the American Folklore

Society Series, Vol. 30. New York: G. E. Stechert, 1937; Millwood, N.Y.: Kraus Reprint Co., 1976.

Flores, Ramón. Personal communication, January 14, 1998.

Gallegos, Bernardo P. *Literacy, Education, and Society in New Mexico, 1693–1907*. Albuquerque: University of New Mexico Press, 1992.

García, Nasario. *Recuerdos de los Viejitos*. Albuquerque: University of New Mexico Press, 1987.

———, ed. *Abuelitos: Stories of the Río Puerco Valley*. Albuquerque: University of New Mexico Press, 1992.

———, ed. *Comadres: Hispanic Women of the Río Puerco Valley*. Albuquerque: University of New Mexico Press, 1997.

Gonzales-Berry, Erlinda, ed. *Pasó por Aquí: Critical Essays on the New Mexican Literary Tradition, 1542–1988*. Albuquerque: University of New Mexico Press, 1989.

Gregg, Josiah. *Commerce of the Prairies*. Edited by Max L. Moorhead. Norman: University of Oklahoma Press, 1954.

Grove, Pearce S., Becky J. Barnett, and Sandra J. Hansen. *New Mexico Newspapers: A Comprehensive Guide to Bibliographical Entries and Locations*. Albuquerque: University of New Mexico Press, 1975.

Hallenbeck, Cleve. *The Journey of Fray Marcos de Niza*. Dallas: Southern Methodist University Press, 1949.

Hammond, George P., and Agapito Rey. *Narratives of the Coronado Expedition, 1540–1952*. Albuquerque: University of New Mexico Press, 1940.

———. *Rediscovery of New Mexico 1580–1594: The Explorations of Chamuscado, Espejo, Castaño de Sosa, Morlete, and Leyva de Bonilla and Humaña*. Vol. 3. Coronado Cuarto Centennial Publications, 1540–1940. Albuquerque: University of New Mexico Press, 1966.

Herrera-Sobek, María. *Beyond Stereotypes: The Critical Analysis of Chicana Literature*. Binghamton, N.Y.: Bilingual Press, 1985.

———, ed. *Reconstructing a Chicano/a Literary Heritage: Hispanic Colonial Literature of the Southwest*. Tucson: University of Arizona Press, 1993.

Hodge, Frederick W., George P. Hammond, and Agapito Rey, eds. *Fray Alonso de Benavides' Revised Memorial of 1634*. Albuquerque: University of New Mexico Press, 1945.

Huerta, Jorge A. *Chicano Theater: Themes and Forms*. Ypsilanti, Mich.: Bilingual Press/Editorial Bilingüe, 1982.

———. *Necessary Theater: Six Plays about the Chicano Experience*. Houston: Arte Público Press, 1989.

Huertado y Jiménez de la Serna, Juan, and Angel González Palencia. *Historia de la literatura española*. 4th ed. Madrid: Tipografía de Archivos, 1940.

Jaramillo, Cleofas M. *Shadows of the Past/Sombras del Pasado*. 1941. Santa Fe: Ancient City Press, 1972.

Kanellos, Nicolás. *The Hispanic Almanac: From Columbus to Corporate America*. Detroit: Visible Ink Press, 1994.

———. *Hispanic Theater in the United States*. Houston: Arte Público Press, 1984.

———. *Mexican American Theater: Legacy and Reality*. Pittsburgh: Latin American Literary Review Press, 1987.

———, ed. "Mexican American Theater Then and Now." *Revista Chicano Riqueña* 11, no. 1 (Spring 1983).

King, Scottie. "Los Comanches de la Serna." *New Mexico Magazine* (January 1979): 25–7, 42.

Kraul, Edward Garcia, and Judith Beatty. *The Weeping Woman: Encounters with La Llorona*. Santa Fe: Word Process Press, 1988.

Lamadrid, Enrique. "Angeles, Pastores y Comanches Cantan Al Resplandor/Angels, Shepherds, and Comanches Sing to the Light: Nuevomexicano Christmas Music." Program notes for a performance on December 21, 1997, at San Felipe de Neri Church, Albuquerque.

———. "'Los Comanches' Text, Performance, and Transculturation in an Eighteenth-Century New Mexican Folk Drama." In *Recovering the U.S. Hispanic Literary Heritage*, Vol. 3. Houston: Arte Público Press, 1999.

———. Personal communication, February-April 1998.

———. *Tesoros del Espíritu: A Portrait in Sound of Hispanic New Mexico*. Albuquerque: Academia/El Norte, 1994.

Lea, Aurora Lucero-White. *Literary Folklore of the Hispanic Southwest*. San Antonio: Naylor, 1953.

Leal, Luis. "The First American Epic: Villagrá's History of New Mexico." In *Pasó Por Aquí: Critical Essays on the New Mexican Literary Tradition, 1542–1988*, edited by Erlinda Gonzales-Berry. Albuquerque: University of New Mexico Press, 1989.

Lomelí, Francisco. "A Literary Portrait of Hispanic New Mexico: Dialectics of Perspective." In *Pasó Por Aquí: Critical Essays on the New Mexican Literary Tradition, 1542–1988*, edited by Erlinda Gonzales-Berry. Albuquerque: University of New Mexico Press, 1989.

Long, Haniel. *Interlinear to Cabeza de Vaca: His Relation of the Journey from Florida to the Pacific, 1528–1536. 1936.* Tucson: Peccary Press, 1985.

McCoskey, Susan. "La Compañía de Teatro de Alburquerque." *The Drama Review* 27 (Summer 1983): 50–60.

Major, Mabel, Rebecca Smith, and T. M. Pearce. *Southwest Heritage: A Literary History with Bibliography*. Albuquerque: University of New Mexico Press, 1935, 1948, 1972.

Martín, Patricia Preciado. *Songs My Mother Sang to Me: An Oral History of Mexican American Women*. Tucson: University of Arizona Press, 1992.

Martínez, Girard. Personal communication, January 14, 1998.

Martínez, Julio A., and Francisco A. Lomelí, eds. *Chicano Literature: A Reference Guide*. Westport, Conn.: Greenwood Press, 1985.

Meléndez, A. Gabriel. *So All Is Not Lost: The Poetics of Print in Nuevomexicano Communities, 1834–1958*. Albuquerque: University of New Mexico Press, 1997.

Menéndez Pidal, Ramón. *Los romances de América, y otros estudios*. 7th ed. Madrid: Espasa-Calpe, 1972.

Meyer, Doris. *Speaking for Themselves: Neomexicano Cultural Identity and the Spanish-Language Press, 1880–1920*. Albuquerque: University of New Mexico Press, 1996.

Oliver-Lewis, Irene. Personal communication, December 29, 1997.

Ortiz, Steve. Personal communication, September 1997, Albuquerque.

Otero, Miguel Antonio. *My Life on the Frontier, 1884–1982*. Albuquerque: University of New Mexico Press, 1987.

Paredes, Américo, ed. and trans. *Folktales of Mexico*. Chicago: University of Chicago Press, 1970.

Pearce, T. M., ed. *New Mexico Place Names: A Geographical Dictionary*. Albuquerque: University of New Mexico Press, 1965.

Pijoan, Teresa. *La Cuentista: Traditional Tales in Spanish and English/Cuentos Tradicionales en Español e Ingles*. Translated by Nancy Zimmerman. Santa Fe: Red Crane Books, 1994.

———. *Spanish-American Folktales: The Practical Wisdom of Spanish-Americans in 28 Eloquent and Simple Stories*. Little Rock, Ark.: August House Publishers, 1990.

Piñeda, Robert. Personal communication, January 26, 1998.

Rael, Juan B. *The Sources and Diffusion of the Mexican Shepherds' Plays*. Guadalajara, Mexico: Libreria la Joyita, 1965.

———. *Cuentos españoles de Colorado y de Nuevo Méjico*. 2 vols. 1957. Revised edition, Santa Fe: Museum of New Mexico Press, 1977.

Rebolledo, Tey Diana, Erlinda Gonzales-Berry, and Teresa Márquez. *Las Mujeres Hablan: An Anthology of Nuevo Mexicana Writers*. Albuquerque: El Norte Publications, 1988.

Robe, Stanley, ed. *Hispanic Folktales from New Mexico: Narratives from the R. D. Jameson Collection*. Folklore Studies, 30. Berkeley: University of California Press, 1977.

———, ed. *Hispanic Legends from New Mexico: Narratives from the R. D. Jameson Collection*. Folklore Studies, 31. Berkeley: University of California Press, 1980.

Robinson, Cecil. *With the Ears of Strangers: The Mexican in American Literature*. Tucson: University of Arizona Press, 1963.

Roeder, Beatrice A. "Los Comanches: A Bicentennial Folk Play." *Bilingual Review/Revista Bilingue* 3 (1976): 213–20.

Sagel, Jim. *Dancing to Pay the Light Bill: Essays on New Mexico and the Southwest*. Santa Fe: Red Crane Books, 1992.

Simmons, Marc. *Witchcraft in the Southwest: Spanish and Indian Supernaturalism on the Río Grande*. Flagstaff, Ariz.: Northland Press, 1974.

Steele, Thomas J., S.J. "The Spanish Passion Play in New Mexico and Colorado." *New Mexico Historical Review* 53 (1978): 239–59.

Stratton, Porter A. *The Territorial Press of New Mexico, 1834–1912*. Albuquerque: University of New Mexico Press, 1969.

Such, Peter, John Hodgkinson, and Colin Smith. *Cantar de mío Cid: The Poem of My Cid*. Warminster: Aris & Phillips, ca. 1987. Reprinted from Oxford University Press publication.

Swadesh, Frances Leon. *Los Primeros Pobladores: Hispanic Americans of the Ute Frontier.* Notre Dame, Ind.: University of Notre Dame Press, 1974.

Thompson, Stith. *The Folktale.* Rev. ed. Berkeley: University of California Press, 1977.

———. *Motif-Index of Folk-Literature.* 6 vols. Bloomington: Indiana University Press, 1955.

Thompson, Stith, and Jonas Balys. *The Oral Tales of India.* Indiana University Folklore Series, No. 10. Bloomington, Ind.: Indiana University Press, 1958.

Tully, Marjorie F., and Juan B. Rael. *An Annotated Bibliography of Spanish Folklore in New Mexico and Southern Colorado.* University of New Mexico Publications in Language and Literature, No. 3. Albuquerque: University of New Mexico Press, 1950.

Valdez, Luis, and Stan Steiner, eds. *Aztlán.* New York: Knopf, 1972.

Vialpando, Roberto Lara, José Timoteo López, and Edgardo Nuñez. *Breve reseña de la literatura hispana de Nuevo México y Colorado.* Chihuahua: Talleres Linotipográficos de "El Alacrán," 1959.

Warman, Arturo. *La danza de moros y cristianos.* Mexico: Secretaría de Educación Pública, 1972.

Weber, David J. *Myth and the History of the Hispanic Southwest.* Albuquerque: University of New Mexico Press, 1988.

Weigle, Marta, ed. *Two Guadalupes: Hispanic Legends and Magic Tales.* Santa Fe: Ancient City Press, 1987.

Weigle, Marta, and Peter White. *The Lore of New Mexico.* Albuquerque: University of New Mexico Press, 1988.

Williams, Edwin B. *Spanish and English Dictionary, Diccionario Inglés y Español.* Rev. ed. New York: Holt, Rinehart and Winston, 1962.

Winship, George Parker, trans. and ed. *The Journey of Coronado.* New York: Dover Publications, 1990.

Recommended Basic Reading List ⸻

The following items represent a sampling of the best of contemporary Nuevomexicano literature, and sources for historical literature or translations. They are offered as a good beginning to understanding the Hispano literature of New Mexico.

Anaya, Rudolfo A. *Bless Me, Ultima.* New York: Warner Books, 1994. Originally published c. 1972.

———. *Heart of Aztlán.* Albuquerque: University of New Mexico Press, 1988.

Anaya, Rudolfo A., ed. *Voces: An Anthology of Nuevo Mexicano Writers.* Albuquerque: University of New Mexico Press, 1987.

Anaya Rudolfo A., and Antonio Márquez, eds. *Cuentos Chicanos: A Short Story Anthology.* Albuquerque: University of New Mexico Press, 1991.

Arellano, Estevan. *Inocencio ni pica, ni escarda, pero siempre se come el mejor elote.* México: Grijalva, 1991.

Baca, Jimmy Santiago. *Black Mesa Poems.* New York: New Directions, 1989.

———. *Immigrants in Our Own Land.* New York: New Directions, 1990. Originally published c. 1977.

———. *Martín And Meditations on the South Valley.* New York: New Directions, 1987.

———. *Working in the Dark: Reflections of a Poet of the Barrio.* Santa Fe: Red Crane Books, 1992.

Bond, Frank M., ed. *Los Comanches.* Santa Fe: Museum of International Folk Art, 1972. Typescript and notes.

Cabeza de Baca, Fabiola. *We Fed Them Cactus.* Albuquerque: University of New Mexico Press, 1994.

Cabeza de Vaca, Alvar Nuñez. *Relación y comentarios.* Translated by Martin A. Favata and José B. Fernández. Houston: Arte Público Press, 1993.

Campa, Arthur L. *Hispanic Culture in the Southwest.* Norman: Oklahoma University Press, 1979.

———. "Los Comanches: A New Mexican Folk Drama." *University of New Mexico Bulletin,* Modern Language Series 7, 1 (April 1, 1942).

Candelaria, Cordelia. *Ojo de la Cueva: Cave Springs.* Colorado Springs: Maize Press, 1984.

Chacón, Felipe Maximiliano. *Obras de Felipe Maximiliano Chacón, "el Cantor neomexicano," poesia y prosa.* Albuquerque, N.M.: F. M. Chacón, 1924.

Chávez, Denise. *Face of an Angel.* New York: Farrar, Straus, and Giroux, 1994.

———. *The Last of the Menu Girls.* Houston: Arte Público Press, 1986.

———. *Shattering the Myth: Plays by Hispanic Women.* Houston: Arte Público Press, 1992.

Chávez, Fray Angélico. *My Penitente Land: Reflections on Spanish New Mexico.* Albuquerque: University of New Mexico Press, 1974.

Espinosa, Aurelio M. *The Folklore of Spain in the American Southwest.* Edited by J. Manuel Espinosa. Norman: University of Oklahoma Press, 1976.

Espinosa, Aurelio M. and J. Manuel Espinosa. Los Tejanos. *Hispania,* 27 (1944): 293–98.

——. The Texans: A New Mexican Spanish Folk Play of the Middle Nineteenth Century. *New Mexico Quarterly Review.* Autumn (1943): 299–308.

Espinosa, Gilberto. *History of New Mexico by Gaspar Pérez de Villagrá, Alcalá, 1610.* Chicago: Río Grande Press, 1962. (This is the English narrative version; see also Villagrá.)

Gerdes, Dick, ed. *The Best of Sabine R. Ulibarrí: Selected Stories.* In *Paso por Aquí: Critical Essays on the New Mexican Literary Tradition, 1542–1988,* edited by Erlinda Gonzales-Berry. Albuquerque: University of New Mexico Press, 1997.

Gonzales-Berry, Erlinda. *Paletitas de Guayaba.* Albuquerque: Academia El Norte, 1991.

Griego y Maestas, José, and Rudolfo A. Anaya. *Cuentos: Tales from the Hispanic Southwest.* Santa Fe: Museum of New Mexico Press, 1980.

Hammond, George P., and Agapito Rey. *Narratives of the Coronado Expedition, 1540–1952.* Albuquerque: University of New Mexico Press, 1940.

Jaramillo, Cleofas M. *Shadows of the Past/Sombras del Pasado.* 1941. Santa Fe: Ancient City Press, 1972.

Jones, David R. *New Mexico Plays.* Albuquerque: University of New Mexico Press, 1989.

Kanellos, Nicolás, ed. *Hispanic Theater in the United States.* Houston: Arte Público Press, 1984.

Lamadrid, Enrique R. "Entre Cíbolos Criado: Images of Native Americans in the Popular Culture of Colonial New Mexico." In *Reconstructing a Chicano/a Literary Heritage: Hispanic Colonial Literature of the Southwest.* Edited by María Herrera-Sobek. Tucson: University of Arizona Press, 1993.

——. *Tesoros del Espíritu: A Portrait in Sound of Hispanic New Mexico.* Albuquerque: Academia/El Norte, 1994.

Lea, Aurora Lucero-White. *Literary Folklore of the Hispanic Southwest.* San Antonio: Naylor, 1953. (Includes full texts of *Moros y Cristianos, Los Comanches,* and other plays.)

Lockhart, John Gibson. *Ancient Spanish Ballads: Historical and Romantic.* Edinburgh and London: W. Blackwood and Sons, 1823; London:

J. Murray, 1842; New York: Wiley and Putnam, 1942; other publications. (English translations of medieval Spanish romances.)

Mares, E. A. *I Returned and Saw Under the Sun: Padre Martínez of Taos, A Play.* Albuquerque: University of New Mexico Press, 1989.

——. *The Unicorn Poem, and Flowers and Songs of Sorrow.* Albuquerque: West End Press, 1992.

Martínez, Demetria. *Mother Tongue.* New York: One World, 1996.

Meketa, Jacqueline Dorgan, ed. *Legacy of Honor: The Life of Rafael Chacón, a Nineteenth-Century New Mexican.* Albuquerque: University of New Mexico Press, 1986.

Menéndez Pidal, Ramón. *El romancero español.* New York: Hispanic Society of America, 1910. (Spanish only.)

Mora, Pat. *Aunt Carmen's Book of Practical Saints.* Boston: Beacon Press, 1997.

——. *Nepantla: Essays from the Land in the Middle.* Albuquerque: University of New Mexico Press, 1993.

Otero-Warren, Nina. *Old Spain in Our Southwest.* New York: Harcourt, Brace & Co., 1936.

Rael, Juan B. *Cuentos españoles de Colorado y de Nuevo Méjico.* 2 vols. Stanford: Stanford University Press, 1957. Rev. ed., Santa Fe: Museum of New Mexico Press, 1977.

Read, Benjamin M. *Historia ilustrada de Nuevo Mexico.* Santa Fe, N.M.: Compañía Impresora del Nuevo Mexicano, 1911. Available at Zimmerman Library, Kit Carson Museum and Northern New Mexico Community College Special Collections.

——. *Illustrated History of New Mexico.* Translated into English under the direction of the author, by Eleuterio Baca. Santa Fe, N.M.: New Mexican Printing Co., 1912. Available at Harwood Museum Library in Taos.

Rebolledo, Tey Diana, and Eliana S. Rivero, eds. *Infinite Divisions: An Anthology of Chicana Literature.* Tucson: University of Arizona Press, 1993.

Romero, Leo. *Celso.* 1980. Houston: Arte Público Press, 1985.

——. *Rita and Los Angeles.* Tempe, Ariz.: Bilingual Press, 1996.

Sagel, Jim. *El Santo Queso/The Holy Cheese.* Albuquerque: University of New Mexico Press, 1990.

——. *Tunomás Honey*. La Habana: Casa de las Americas, 1981.

Ulibarrí, Sabine. *Mi abuela fumaba puros/My Grandmother Smoked Cigars*. Berkeley, Calif.: Quinto Sol, 1977.

——. *Tierra Amarilla: Stories of New Mexico/Cuentos de Nuevo México*. Albuquerque: University of New Mexico Press, 1971.

Vialpando, Roberto Lara, José Timoteo López, and Edgardo Núñez. *Breve reseña de la literatura hispana de Nuevo México y Colorado*. Chihuahua: Talleres Linotipográficos de "El Alacran," 1959.

Villagrá, Gaspar Pérez de. *Historia de la Nueva Mexico*. Translated and edited by Miguel Encinias, Alfred Rodríguez, and Joseph P. Sánchez. Albuquerque: University of New Mexico Press, 1992. (In Spanish and English verse.)

Winship, George Parker, trans. and ed. *The Journey of Coronado*. New York: Dover Publications, 1990. This is the account of Pedro de Castañeda.

Index